THE GHOST OF GALILEO

J. L. HEILBRON

the GHOST of GALILEO

in a FORGOTTEN PAINTING
from the ENGLISH CIVIL WAR

OXFORD
UNIVERSITY PRESS

OXFORD
UNIVERSITY PRESS

Great Clarendon Street, Oxford, OX2 6DP,
United Kingdom

Oxford University Press is a department of the University of Oxford.
It furthers the University's objective of excellence in research, scholarship,
and education by publishing worldwide. Oxford is a registered trade mark of
Oxford University Press in the UK and in certain other countries

Published in the United States of America by Oxford University Press
198 Madison Avenue, New York, NY 10016, United States of America

British Library Cataloguing in Publication Data
Data available

Library of Congress Control Number: 2020938749

ISBN 978–0–19–886130–0

Printed in Great Britain by
Bell & Bain Ltd., Glasgow

CONTENTS

Acknowledgments *vii*

Prologue 1

1. Galileo's Europe 14

2. Religious Noise 49

3. The King and his Lawyer 86

4. Cultural Threads 127

5. Heavens Above 169

6. Medicine and Melancholy 217

7. The Painter 254

8. The Setting 301

9. The Image 338

Postscript 381

Glossary of Names 389
Notes 400
Works Cited 447
Image Credits 499
Index 503

ACKNOWLEDGMENTS

It is a pleasure to thank my wife, Alison Browning, for her capital formative ideas, help in bibliography and transcription, and perfectly tempered enthusiasm; my friend and colleague Moti Feingold for the strength of his scholarship, gentleness of his corrections, and generosity in encouraging trespass into the fields he can call his own; and my editor at Oxford, Latha Menon, for her ever wise and informed advice. Since much of this book is composed of mosaics, I have a particular debt to those who have helped me to the quarries: compilers, indexers, librarians, archivists, and curators, and, among them, I must thank especially members of the staffs of the Bodleian Library in Oxford, the British Library in London, the Dorset History Centre in Dorchester, the Huntington Library in San Marino, California, and the National Trust at Kingston Lacy. Books may be written by their authors but are seldom produced by them. Among those at Oxford to whom I am indebted are Jenny Nugée and Guy Jackson, who coordinated the production, Debbie Protheroe, who gathered the high-resolution images, and Hilary Walford, whose impeccable copy-editing has removed inconsistencies in dates and format that proliferated during the decade this work has been under construction. Finally I must acknowledge the many friends who have listened to me describe the mystery of the painting that makes my story. Among them are Dan Kevles, Adriana Turpin, and the patient regulars at the Rose and Crown in Shilton, West Oxfordshire.

PROLOGUE

The age of hieroglyphs is not dead. Pictograms direct road traffic, point us to exits and toilets, and invigorate trademarks, logos, and the computer world. A little experience also makes familiar the emblems of nationhood (flags, anthems), professions (uniforms, insignia), religion (crucifix, star of David), other perils (skull and crossbones), sex (reader's choice). With more knowledge, we can identify personifications of such abstractions as Justice (with her sword and scales), War (Mars), Love (Venus, Cupid), the Seven Liberal Arts, and the Five Senses. In early modern Europe, educated people who spent most of their quality time with ancient authors could read the iconography of the old myths and Bible stories as plain text. They understood the power of icons. Francis Bacon: "Emblem reduceth conceits intellectual to images sensible, which strike the memory more."[1] Emblems, images, symbols, and hieroglyphs speak directly; they do without Bacon's "idols of the marketplace," words made ambiguous through everyday use.[2] The unmediated representation of Bacon's inamorata, Lady Philosophy, was grave of expression, disdainful of ornament, outwardly poor, and, we suppose, internally rich.[3]

The hieroglyph whose elucidation frames this book hides in a painting made in Oxford in 1643–4. The painting presents the unhappy young heir of Corfe Castle, John Bankes, and his concerned tutor, Dr Maurice Williams (see Figure 1). Neither seems to have left in print more than a Latin poem or two to mark his passage through this life, and the portraitist, the once-famous Francis Cleyn, is now almost as forgotten as his sitters. The hieroglyph is the open book lying on the table together with a telescope and globe (see Figure 2).

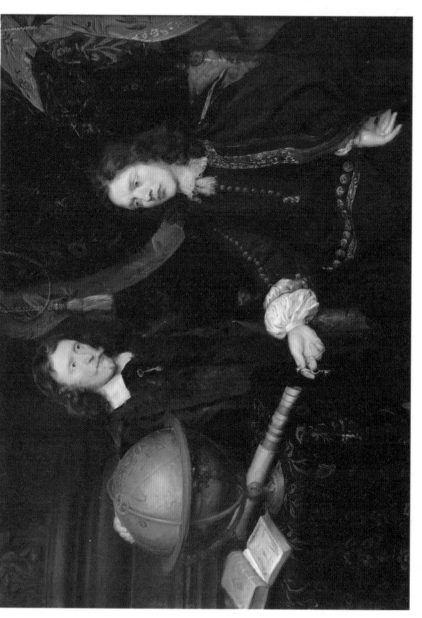

Figure 1 Francis Cleyn, "Our Painting" (1643/4): Dr Maurice Williams (standing, with hand on globe) and John Bankes.

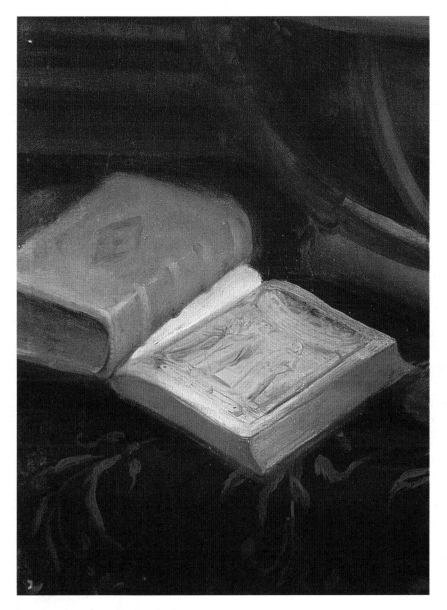

Figure 2 Our puzzle: detail of Figure 1.

 Although, as depicted, the book lacks author and title, people who had seen the illustration on its title page would have identified it immediately as the last great example of the learning, spirit, and style of Renaissance Italy. It is Galileo's *Dialogo sopra i due massimi sistemi* (1632),

Dialogue on the Two Chief World Systems, the famous defense of Copernican cosmology that earned its author the attention of the Inquisition, perpetual detention in his small villa outside Florence, and the reputation of a martyr to freedom of expression. The painting is perhaps the earliest iconographical reference to Galileo outside of portraiture. Whatever the reasons for its presence in Cleyn's work, Bankes and his friends saw more in it than the modern viewer who interpreted the "stack of books" at which young Bankes points his compass as representing "the educational value of travel."[4]

Although Cleyn's image is impressionistic, it is clear enough to show that he did not draw it from the Italian original, become rare by execution of Pope Urban VIII's order to destroy all procurable copies, but from the Latin translation made by a German Protestant, Matthias Bernegger, and printed in 1635 and again in 1641 by the Elzeviers of Leyden. The frontispiece to the Italian edition shows (from the left) Aristotle and Ptolemy, the chief ancient authorities in physics and astronomy, arguing with Copernicus (see Figure 3). All three appear elderly and bearded, Copernicus looking much as Galileo did late in life, and they are modeled softly, as if their argument had no rough edges, and flexibly, as if they might be capable of changing their opinions. The characters in the redrawn frontispiece of the Latin edition (see Figure 4) are static, with hard outlines, as if to suggest rigid positions and confrontation. Aristotle and Ptolemy retain their beards and old-fashioned dress, whereas Copernicus has been rejuvenated, appearing as he drew himself, youthful and clean-shaven. Evidently, Cleyn copied from the Protestant edition.

Before moving to England in 1625, Cleyn had studied and worked in Germany, the Netherlands, Italy, and Denmark. A genial jack of all graphic trades (see Figure 5), he had the skills for the important position of chief artistic designer of a tapestry works encouraged, and eventually acquired, by King Charles I. The works were installed at Mortlake, near Richmond, upriver from London, on the premises of the former library and laboratory of the great Elizabethan magus and astrologer John Dee. Dee's ghost will haunt these pages now and again, as, apparently, it did Cleyn (see

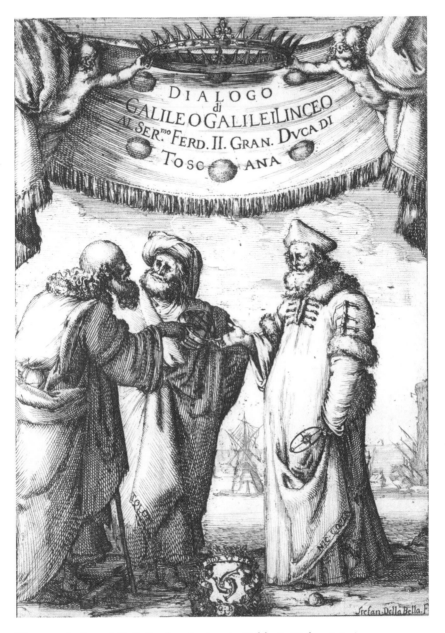

Figure 3 Stefano della Bella, frontispiece to Galileo's *Dialogo* (1632).

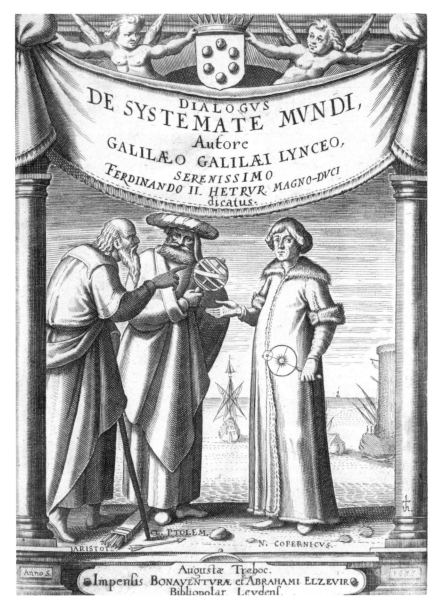

Figure 4 Jacob van der Heyden, frontispiece to *Systema cosmicum*/*Dialogus de systemate mundi* (1635), the Latin translation of the *Dialogo*. The frontispiece to the reprint of 1641 is the same, to Cleyn's approximation.

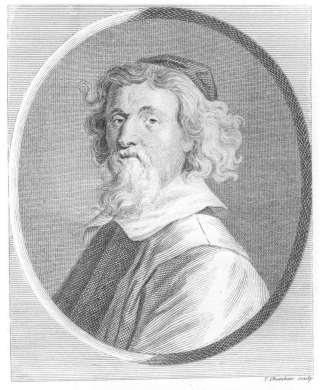

FRANCESCO CLEYN.

Figure 5 Unknown artist, *Francis Cleyn*.

Figure 6). Maurice Williams served briefly as a physician to Queen Henrietta Maria after the judicial murder of his patient and patron, Thomas Wentworth, Earl of Strafford, Lord Lieutenant of Ireland, once the most powerful of King Charles's ministers. John Bankes was the son of Sir John Bankes, a one-time opposition parliamentarian who joined Charles's government, first as Attorney General and then as Chief Justice of Common Pleas. Sir John no doubt commissioned the painting and had his own reasons for improving it with the Galilean hieroglyph. Cleyn's double portrait thus has impeccable royalist connections. The painter, the doctor, and the lawyer all owed their positions and loyalty to the king and were present with him in Oxford during the Civil War.

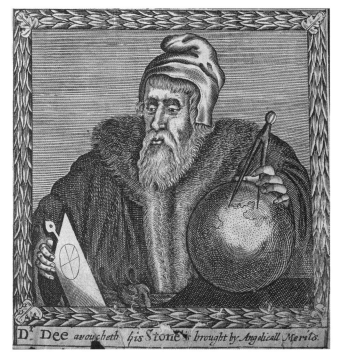

Figure 6 Francis Cleyn, *John Dee*, from the frontispiece to Casaubon, *Relation* (1659).

The painting has many more ties to Oxford. Williams and the Bankses, father and son, and many of the secondary actors in our story attended the university. And Galileo often was virtually present there. We catch an early glimpse of him at a celebration of the university library, founded by Thomas Bodley, who died three years after Galileo announced his discovery of mountains on the moon. The celebrant yanked in the discoverer with a far-fetched conceit: "I remember, O Galileo, your saying that a certain mountain protrudes above the surface of the moon...[Y]ou are deceived; for the shadow you observed is that of a high library, a Bodleian work that soon will give other marks [of eminence]."[5] Among the marks are several copies of the first editions of Galileo's *Dialogue* preserved in its collections.

Galileo delivered his opening set of discoveries in 1610 in a little book entitled *Sidereus nuncius*, which signifies both a message from the stars and

their messenger. The messenger did not then draw out the bearing of his message on the great Copernican question, whether the earth spins (creating night and day) and revolves about the sun (creating the seasons). He believed that he had evidence to decide for Copernicus; but he did not present it in full in print until 1632, when, with the permission of the censors, he published his *Dialogue*. The book belongs to an extinct genre. It presents new knowledge through a compelling mix of farce and philosophy, of wild exaggeration and exact mathematics, of goring of sacred cows and fishing of red herrings. Pope Urban regarded it as one of the most pernicious books ever written. Its gravest fault for him was its insinuation that the Copernican system must be correct and all others false. Urban might have been content if Galileo had declared the Copernican the best of the bunch and left them all as hypotheses. According to the pope's philosophy of science, we cannot do better: God in his capricious Omnipotence can always bring about the phenomena in a myriad of different ways inconceivable by us. Galileo's insistence on the Copernican worldview thus challenged an epistemology endorsed by the pope that made God's will, however capricious, paramount. Voluntarism, to give this epistemology its name, had the merit for literal believers of safeguarding interpretation of Scripture against all challenges based solely on natural knowledge.[6]

Voluntarism was but one of the victims of the two ghosts and unique booby whose conversations make up the *Dialogue*. The ghosts are Filippo Salviati and Gianfrancesco Sagredo, formerly and respectively a Florentine patron, who acts as Galileo's spokesman, and a Venetian carousing companion, who approves and supplements Salviati's teachings. The booby is Simplicio, the only gentleman among them, a philosopher who has trouble thinking for himself. Their talks take place over four days in Sagredo's palace in Venice. During the first three, Salviati destroys all Simplicio's arguments for placing the earth at rest in the center of the universe; on the last day he tries to show that he and his friends and Sagredo's palace reside on a spinning planet racing around the sun.

The magic and mystification of the *Dialogue* begin with the frontispiece that figures in Cleyn's painting. The title, which Cleyn omitted, announces

a confrontation between the two chief world systems, the Ptolemaic and the Copernican. The artist, Stefano della Bella, illustrated the confrontation, and hinted at Galileo's solution to it, by placing the figure of Copernicus alone on the right, separated by a space from those of Aristotle and Ptolemy on the left (see Figure 3). The grouping suggests the need for a philosopher to supply the physics needed to put and keep the planets in orbit around the sun. Although Galileo may have hoped to supply the great desideratum of an exact physical astronomy, he had to leave the position blank. The blank gave Salviati a decisive advantage: he could attack traditional physics without having to defend a new one against Simplicio. The depiction embodied another dissimulation: in the frontispiece, two ancients appear against one modern; in the book, two Copernicans joust with one Aristotelian.

The *Dialogue* thus has features of a teaching manual that proceeds by exchanges among a schoolmaster, a fast pupil, and a dunce. There is also something of the *commedia dell'arte* (at which Galileo once tried his hand) in the clever outwitting of plodding authority. Again, the *Dialogue* resembles a play in its noble setting and fast conversation, and in its dissembling prologue, which gives as the author's motive in writing a desire to show that the Roman censors who banned Copernicus' book on theological grounds knew as much astronomy as the Protestants who snickered at them.

Deciphering Cleyn's painting has required juxtaposing material not usually mixed, such as attitudes toward things Italian in England; Stuart court culture; gentlemanly knowledge of astronomy and astrology; information about the protagonists Sir John Bankes, Maurice Williams, and Francis Cleyn; and theatrical inventions. The frontispiece of the *Dialogue* connects with the stage by displaying the author's name and the book's title and dedicatee on a raised curtain; Galileo frequently refers to the book as a play, and Salviati as a character in masquerade; and much of the *Dialogue* is theater in the Renaissance sense of *theatrum mundi*, which might refer both to the physical world and to the world stage on which we act our petty parts.[7]

Italians, especially Florentines, led the way in theater science, which came to England via Inigo Jones's elaborate staging of court masques.

These entertainments have a strong claim on our attention, not only for their Italian and court connections, but also for their richness in astronomical and astrological wordplay. People who possessed the requisite star lore, which could be absorbed from poems, paintings, elementary textbooks, and the ubiquitous almanac, would be able to decode several messages from Cleyn's painting.

According to the great authority Giovanni Paolo Lomazzo, every competent portraitist could distinguish and represent eleven passions of the mind. Cleyn's canvas conveys one of them to perfection: melancholy.[8] Melancholia was a frequent academic complaint, occasioned, as everyone knew, by an excess of black bile. Depending on the nature and degree of the imbalance, the sufferer could be a genius or a madman. Our exploration must thus penetrate the delights and miseries of the atrabilious, especially love melancholy as experienced at Oxford when John Bankes studied there, and that ubiquitous and pernicious black-bile disease baptized by its anatomist, Robert Burton, as "religious melancholy."

Concern with religion, whether as a guide to eternal life or mundane politics, or, to the nonconformist, as an endemic background terror easily manipulated into foreground panic, was never further from people's minds than a church was from eyeshot. This was never far in England. First among the features of the country most striking to a Venetian ambassador reporting in 1613 was the "quantity of most beautiful churches so numerous as to pass belief."[9] Very numerous, too, were the shades of belief taught in these places, and very hard and belligerent the teachings of their more atrabilious preachers.

Catholics appear frequently in these pages despite arbitrary persecution and modest numbers, amounting, probably, to around 5 percent of the population of England. Unwelcome at home because allegedly (and sometimes truly) more obedient to the pope than to the king, they could travel easily in Italy and report back what they found. Several Scots and Englishmen who studied in Venice or Florence or Rome wrote about Galileo's discoveries and disputes as they happened. Catholics could also act conveniently as middlemen in the increasingly sophisticated appreciation of art and

connoisseurship in England, which brought modern Italian painting, and painters like Cleyn with Italian training, to the Stuart courts.

The largest frame for situating our inquiry is the political, especially as expressed in relations between the kings and their parliaments and in the mismatch between their ambitions and income. Sir John Bankes experienced all the vicissitudes of Charles's reign as a parliamentarian and then as a government official, and occasionally was able to help steer events. Williams understood the pathways of patronage through his connections with Strafford and the Archbishop of Canterbury, William Laud, and experienced at first hand the religious politics of the reign at the Catholic–Protestant front in Ireland. Another front, in Venice, which opened early in the English reign of Charles's father, King James I, familiarized many Englishmen with Venetian republicanism, with the possibility of a stable polity that tolerated religious dissent, with revolutionary thinkers such as Galileo and his friends, and with the allure of religious art and honest courtesans. Both Cleyn and Williams spent several years in Italy, and young John was to travel there, whence he returned, calling himself Giovanni Bankes, several years after Cleyn had painted his portrait.

I stumbled across Cleyn's painting in 2010 during a casual visit to Kingston Lacy, the Bankes's former estate in Dorset now owned by the National Trust. I have not been able to unriddle its Galilean hieroglyph in the manner of Sherlock Holmes, who worked by excluding everything not immediately relevant to his investigation. He had not heard of Copernicus before Dr Watson told him that the earth travels and he then did his best to forget it. I have been obliged to copy the melancholic Burton, raking over all sorts of material, some perhaps not strictly pertinent to my inquiry, but not known to me not to be. There is no end to the potentially relevant.

> Doubt not but in the end you will say with [Burton], that to anatomize this [painting] aright…is as great a task as to reconcile those chronological errors in the Assyrian monarchy [and] find out the quadrature of the circle….as great a trouble as to perfect the motion of Mars and Mercury, which so crucifies our astronomers, or to rectify the Gregorian calendar.[10]

I have set out what I think relevant to the painting in a manner that should satisfy the strictest Trinitarian. The first three chapters sketch the background: Rome with its resurgent papacy and Venice with Galileo and his subversive friends; conflicts among the main Christian sects and between prerogatives and privileges in the mixed and muddy Stuart government; and the eccentricities and random shrewdness of James, the culture and self-deception of Charles, and the struggles of both against Puritans and parliaments. As far as the documents allow, these wide matters are presented through the particular experiences of Sir John Bankes. Chapters 4–6 take up cultural matters pertinent to Cleyn's picture: literature, theater, art, and popular astrology; cosmology and elevated astrology; melancholy and medicine. The last three chapters are devoted to the painter; the situation in wartime Oxford, where Sir John, Sir Maurice, young John, Dr Williams, and Francis Cleyn came together to make our painting; and a Galilean dialogue between Cleyn and his sitters exploring the painting's meaning.

In treating these many themes, I have had Cleyn the designer of tapestry in mind. Threads from the histories of art, literature, science, medicine, politics, law, and religion come in and out, in a way that his contemporaries might have experienced them, which is not how modern historians have divided them. None is teased out to an extent that would have challenged the learning of an ordinary Jacobean or Caroline gentleman. This learning included cosmology, not as mathematics, but, as we learn from Henry Peacham's *Complete Gentleman* (1622), as a "sweet and pleasant study," more recreation than labor, "besides being quickly, and with much ease attained to."[11]

Galileo's image is multivalent. We see its flexibility in its contrasting employment by the anti-royalist John Milton, in his well-known argument for an almost free press, *Areopagitica* (1644), which appeared within a year of our picture, and by the royalist Sir John Bankes, in commissioning a portrait of his melancholy son. A postscript outlines the exploitation of Galileo's image by reactionary as well as by progressive forces since Cleyn began the process four centuries ago.

1

GALILEO'S EUROPE

In the Jubilee year of 1600, Galileo reached the midpoint of the eighteen years he regarded as the happiest of his life. These were the years he spent as professor of mathematics at the Venetian University at Padua, where expression was freer than elsewhere in Italy and the Roman Inquisition had little sway. Venice tolerated people who increased its wealth and welcomed well-to-do foreign students, including English Protestants, to its university. When at the end of the happy years Galileo had the misfortune to discover through his telescope stars and moons never before seen by any human being, his British students were prepared to defend his claims and to inform folks back home of the astonishing refashioning of the heavens above Padua.

Almost six years to the day after Galileo had published his *Sidereus nuncius* in March 1610, the cardinals of the Holy Roman Inquisition for the Suppression of Heretical Depravity decided that the Copernican system of the world, which Galileo believed his discoveries supported, was formally heretical because contrary to Scripture and, moreover, untenable in the Aristotelian physics to which the Christian worldview was wedded. To be precise, the cardinals found that the thesis of a stationary sun was formally heretical, that of a moving earth erroneous in faith, and both absurd in philosophy. Why the Roman Catholic Church thought it necessary to intervene in a dispute over cosmic geometry, and why it believed that it could do so effectively, take some explaining.

Resurgent Rome

The Roman Catholic Church had much to celebrate at its Jubilee in 1600. On the periphery of Europe, in Poland and Ruthenia, Jesuits were winning back Protestant souls. The King of Scotland, James VI, was intriguing for the throne of England and flirting with converting to Rome. His wife, Queen Anna, had already signed up. Beyond Europe, missionaries, Jesuit, Franciscan, Dominican, and Benedictine, successfully proselytized for the truth as they saw it. Strayed sheep—Nestorians, Copts, Maronites— had returned to the fold.[1] International Protestantism was on the defensive, although it still held its own against Spain in the Netherlands. In France, it enjoyed a measure of toleration under the Edict of Nantes (1598), and in Venice, whose nobles declined to celebrate the Jubilee, it may have had more friends in high places than the ruler of Rome. "[A]ll the world knows [the Venetians] care not Three-pence for the Pope."[2]

The division of Christian Europe between the Protestant northern German states, Scotland, England, Switzerland, and the Scandinavian countries, on the one hand, and Catholic Austria, Bavaria, Poland, Italy, Spain, and Portugal, on the other, would not change much, despite the hot spots where the two blocks rubbed together. This was the insight of Edwin Sandys, a risk-prone Oxford graduate, who acquired his objectivity by investigative travel, three years of it, in Germany, Italy, France, and Geneva. Sandys praised the Catholic Church for its training of priests, charitable institutions, and uniformity of doctrine, and excused its censorship, inquisition, confession, and ostentation as useful means of social control. On this criterion he could regard the pope, Clement VIII, as a "good Man, good Prelate, and good Prince." Where the Catholics did well, as in organization and uniformity of doctrine, the Protestants, with their splits and wrangles, scored poorly. Sandys reckoned the Anglican Church the best of the lot for its compromise between reform and tradition and dreamt that English practice might serve as "an umpire and also as a director" for bringing Christendom together again. Many of our actors,

including King James, shared this dream, with the reservation that popes and Jesuits had no part in it. In short, like many of his countrymen, but unlike his puritanical father, a former Archbishop of York, Sandys could tolerate the Catholic faith but not the Roman Church.[3] His book, *A Relation of the State of Europe* (1605), would become a weapon in the hands of Galileo's friends.

The popes had a more formidable armory. Besides Spanish and Austrian arms and money, they had new institutions and doctrines to combat the heresies of Luther and Calvin. These instruments included the Society of Jesus, formed in 1540 primarily to succor the poor, but grown by 1600 into the schoolmasters of Catholic Europe and the most disciplined and dangerous agents of their own and papal policy; the Roman Inquisition (the Holy Office), formed in 1542 to extirpate heresy within the church; the Roman Index of Prohibited Books (1557–9), appointed to ensure wholesome reading matter; and the Council of Trent (1545–63), assembled to outfit Catholics for battle with heretics. The council issued decrees on discipline and doctrine that created better educated priests, more responsible bishops, greater uniformity of dogma, and a more aggressive Papacy, and thereby insured the permanent division of Christendom.

One of Trent's reforms defined and controlled the distribution of indulgences, or remissions of penalties for sins. The council abolished their sale, which had pushed Luther to rebellion, while upholding their value.[4] Securing them was the main purpose of the pilgrims who came to Clement's jubilee by the hundreds of thousands, 1.2 million or perhaps 3 million in all, in a tremendous demonstration of the reach and power of the Catholic faith.[5] Pilgrims obtained their indulgences most readily and reliably through an innovation intended to symbolize resurgent Rome. By visiting the basilicas of S. Pietro, S. Paolo, S. Giovanni in Laterano, and Santa Maria Maggiore fifteen times in any order and proper contrition, they would receive a plenary indulgence for past trespasses. A pilgrim lucky enough to drop dead immediately after completing the course would be nearly as sinless as a freshly baptized babe. Clement expanded easy opportunities for indulgence by enrolling the four obelisks planted

in front of the basilicas a decade earlier. Whoever knelt at any of these symbols of Christian triumph over paganism and, while gazing at the cross surmounting it, prayed for "Holy Church and the Roman Pontiff," would receive an indulgence of 10 years and 10 quarantines, which exact sinners will know sum to 4,052 days, including leap years.[6]

Among the pilgrims came a number of heretics, some to laugh at, others to flirt with, the old religion. Many of both kinds converted, drawn by their countrymen who had already gone over and urged along by accomplished proselytizers. Potential recruits might receive charitable treatment followed by a hard sell and, thus softened, joyfully join their benefactors. Physicians harvested many such souls from hospitals. The prize catch of 1600 was the grandnephew of the archfiend Calvin, who had come to mock, fell ill, abjured his errors, and joined the Capuchins.[7] The English College in Rome, where Jesuits trained infantry for the spiritual reconquest of Britain, and its affiliated English Hospice, were particularly hazardous places.[8] But there was danger everywhere. A case of consequence for our story, Tobie Matthew, survived a life-threatening illness only to succumb to Rome. Like Sandys, he was the liberated son of a puritanical Archbishop of York. His friends tried to return him to England and the true faith; but Matthew had been snared by the beautiful churches, good sermons, learned men (including Galileo), and "wholesome wines… excellent pictures…and choyce music" of Italy. He ignored his friends and became a priest.[9]

As if to remind the faithful that their nourishing Mother was hitched up to an authoritarian Papa, the Inquisition sent the impenitent monk Giordano Bruno to the stake before a throng of fascinated, horrified pilgrims during the second month of the Jubilee year. Bruno had traveled Europe, even unto Oxford, shocking Protestants and Catholics alike before the Inquisition caught up with him. It did not succeed in talking or torturing him out of such heresies as denying the divinity of Christ and expounding an animistic religion purer than Christianity. He co-opted Copernicus into the congregation of animists on the far-fetched ground that a moving earth implied a living one and claimed to be the first among

Copernican exegetes. His views and fate helped to make Copernican ideas suspect and scary wherever the Inquisition impended. In England, in contrast, Bruno and Copernicus were regarded as more mad than menacing. In the influential opinion of George Abbot, a future Archbishop of Canterbury, "[Bruno] undertooke among other matters to set on foote the opinion of Copernicus, that the earth did goe round and the heavens did stand still; whereas in truth it was his owne head which rather did run round, and his braines did not stand still."[10]

Anti-Roman Trio

The form of government that insured the longevity, prosperity, and relative tranquility of the Republic of Venice, and earned it the epithet of Serenissima, presented a problem to the early Stuarts. Standard political theory held that the security of a state required at least outward conformity in religious observance. Venice, however, prospered while allowing nonconformists to worship much as they pleased provided that they did not politic or proselytize. So thick were the English in Venice that the pope demanded that its Senate thin them.[11] In vain. Venetian wealth depended on an import–export business conducted through middlemen of diverse religions who worshipped together at the shrine of Mammon. Equal application of the law stabilized the system. Or so English playgoers would conclude from the equation of trade and justice in *The Merchant of Venice*.

> The [Doge] cannot deny the course of law
>
> Since that the trade and profit of the City
> Consisteth of all nations.[12]

The despised Jew Shylock expected the fair operation of the law to grant him the pound of flesh owed him by the merchant Antonio.

The Venetian constitution reserved executive offices in the state to patricians who elected the Doge from among the older and wiser members

of their class by an elaborate semi-random procedure; and, as a further barrier to despotism, hedged the winner around with rules that made it difficult for him to accumulate power.[13] Wealth and wisdom were the state's hallmarks, and longevity their consequence. "Could any State on Earth Immortall be | Venice by *Her rare Government is She*."[14] Ben Jonson's *Volpone* enforced these characteristics by parody. The play is situated in Venice, where Sir Politic Would-Be has come to practice statecraft and his garrulous Lady ("The sun, the sea will sooner both stand still | Than her eternal tongue") to learn the style of its courtesans.[15]

Nothing could be further from dogeship than the concept of kingship that the future James I developed while only King of Scotland and wrote out in a manual for the benefit of his heir. This handbook, *Basilikon doron* (1599), or "Royal gift," teaches that a prince and his dynasty hold office by appointment from God. A doge, elected by his peers and succeeded by another so chosen, was no real prince. Fear that they might be reduced to the status of a doge haunted the first Stuart kings. And rightly so, for that is just what happened to James's son and heir Charles I.

According to James's doctrine, a prince ruled absolutely, by divine appointment, within his domains. He extended the same status to the pope, whom he acknowledged as a divine-right ruler within the Papal States as well as the spiritual leader of the Roman Catholic Church. Over English Catholics the Pope had no temporal jurisdiction. When James succeeded Queen Elizabeth I, he claimed the power to regulate religion within his three kingdoms of Scotland, England, and Ireland. He would do so, popelike, through a hierarchy of bishops. They were the key to religious discipline and could be hard or soft on nonconformity as their commitments and the royal will required. The Stuarts believed that without their episcopate they would have no jurisdiction: "no bishop, no king," as James liked to say. That, too, Charles proved to be correct.

The subjection of bishop to prince, of church to state, became a life or death matter for the Republic of Venice when, in 1606, an interdict imposed by Clement's successor, Paul V, disturbed the tranquility of the

Serenissima. Paul imposed the interdict, which prohibited clergy from marrying the quick and burying the dead, to force Venice to change policies limiting Rome's rights to inherit land and protect clergy accused of crimes. The Senate ordered priests to continue their services and expelled those, like the Jesuits, who refused to obey. Its adoption of James's view of church–state relations precipitated the equivalent of a constitutional crisis.[16] Rome chose as its principal paladin in the resultant paper war the master controversialist Cardinal Robert Bellarmine, chief of the Jesuit theologians, deep, crafty, and learned. Against him the Republic fielded the smartest man in Europe, Fra Paolo Sarpi, of the placid Order of Servites. Among Sarpi's friends was someone almost as smart as he, Galileo Galilei; and among his supporters was someone bolder than both, the Archbishop of Spalato, Marc'Antonio De Dominis. The three earned the sustained attention of the Roman authorities, which, in good time, killed the archbishop, imprisoned the mathematician, and tried to assassinate the monk. Most of the books of Sarpi and De Dominis made their way onto the Index, where Galileo's *Dialogue*, the book in our picture, joined them. The crimes of these bravos were well known in England.

The Monk

Sarpi's circle of friends included the English ambassador to Venice, Henry Wotton, who engaged him in a project to convert Venice to Protestantism. Sarpi's theology was probably closer to Protestant than Catholic; his disdain of Paul V ("timid with equals, ungrateful to benefactors, supercilious with inferiors, and passionately fond of money") was boundless; and he clung to the absolute sovereignty of the state as a bulwark against papal claims to supreme authority over Christian princes.[17] The Venetian monk and the English ambassador therefore had a firm basis for collaboration. Since Venetian law prohibited foreign diplomats from dealing privately with state officials without permission, Wotton worked for his church and Sarpi's conversion through several intermediaries, of whom the most important were Wotton's chaplain William Bedell and Sarpi's lieutenant Fra Fulgenzio Micanzio.[18]

The chaplain, a pious and upright man, frequented his friends' monastery on the pretext of teaching them English. Their choice of textbook was Sandys's *Relation*, which Bedell translated, Micanzio corrected, Sarpi annotated, and the Doge approved. Although ready for the press before 1610, the book and its anti-Roman annotations did not come out until after Sarpi's death. Its editor then was Jean Diodati, a Calvinist from Geneva, famous for his translations of Scripture, who had collaborated with Wotton's group to insinuate Protestantism into Venice.[19] Chaplain Bedell's discovery that the Roman numerals in the dedicatory phrase, PAVLO V. VICE-DEO, found in Jesuit texts, sum to the Number of the Beast (DCLVVVI = 666), no doubt encouraged them all.[20]

Knowing that a picture can be more persuasive than words, Wotton surreptitiously obtained Sarpi's portrait and sent it overland to England to display the strength and quality of Venetian leadership. The Inquisition confiscated the talisman. Wotton promptly had a second portrait made, which carried an even stronger message, as it showed Sarpi with the patch he then wore to cover scars from the Vatican's attempt to kill him.[21] Wotton shipped the new portrait by a secure route and had it reproduced in England to give to friends who could appreciate its expression of fearless determination (Figure 7).[22] Portraits have powers.

Meanwhile Micanzio was preaching openly against the Pope. The papal nuncio endeavored to shut him down. The Spanish ambassador complained to the Venetian Senate, which blithely replied that it could find nothing anti-Catholic in the sermons. The scandal rose to the attention of the kings of Spain and France, again to no avail, despite the rumor that Micanzio, Sarpi, and Wotton were promoting Protestantism with the help of a pastor from Geneva.[23] Though the Vatican rated "Fra Paolo...a pure Calvinist [who] had only heretics, and leaders of heretics, as close friends," the Republic protected him. In fact there was nothing to worry about. As Diodati came to recognize, Italians could not be saved. "Calvinist worship would seem too cold to such sensual natures."[24]

Feigning Catholicism, promoting Protestantism, and championing the cause of Venice were the least of the sins the Vatican saw in Sarpi. The

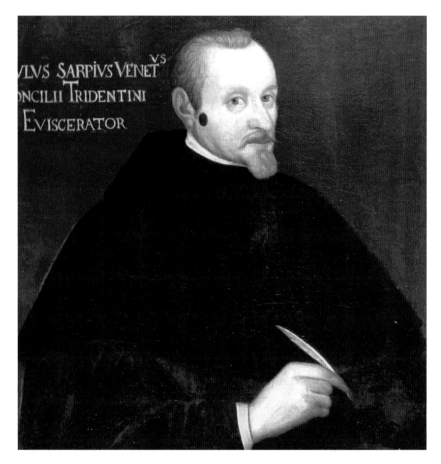

VLVS SARPIVS VENET\
ONCILII TRIDENTINI\
EVISCERATOR

Figure 7 Unknown artist, *Paolo Sarpi*, "Eviscerator of the Council of Trent" (c.1610). The black patch covers a scar left by an incompetent assassin.

worst was his undermining of Roman Catholicism by his inspired use of that most powerful form of written persuasion, history. And of all his works of the kind, his *History of the Council of Trent*, an international best-seller despite its length, was the most devastating. A witty and withering account of the stuttering assemblies that set the foundations of the Catholic Counter Reformation, it threatened all received ecclesiastical history by approaching the council as the business of men rather than of the Holy Spirit. Earlier Church historians had irresponsibly invoked the will of God rather than the usual forces at work in human endeavors and

ignored the objectives of the popes. Even the best of them had no concept of piety. Take Leo X, whose sale of indulgences precipitated Luther's rebellion. He was a noble by birth, style, education, "marvellous sweet [in] manner," of a "singular learning in humanity." "And he would have been a Pope absolutely compleate, if with these he had joyned some knowledge in things that concerne Religion."[25]

Wotton read an incomplete draft of Sarpi's *Trent*, recognized its value as propaganda as well as science, and advertised it widely after returning to England in 1611. King James thought it so important that he directed Dudley Carleton, who had replaced Wotton as ambassador in Venice in 1610, to invite Sarpi ("a sound Protestant, as yet in the habit of a friar"[26]) to England to finish it free from the dangers and harassment that bedeviled him in Italy. Fra Paolo preferred to stay in Venice. Carleton pressed him to finish the great work and offered, as the competition to beat, a book by his godly relative George Carleton, *The Consensus of the Catholic Church against the Men of Trent* (1613). Sarpi thought Carleton's *Consensus* far too indulgent of Roman arrogance and blunders.[27] Still he hesitated. Publication would offend many good Catholics and probably expose him to new dangers.

When Archbishop Abbot learned about Sarpi's manuscript history, he resolved that so useful a piece of anti-papal propaganda should not remain in a monastery. He commissioned Nathaniel Brent, a bold Italophile whose travels had aroused the interest of the Inquisition, to return to Venice and acquire the manuscript. Brent was a friend of Daniel Nijs, a Calvinist merchant of Venice, who dealt in luxury goods and intelligence, and sometimes acted as intermediary between Wotton's embassy and Sarpi's monastery.[28] Brent soon obtained a copy of the immense manuscript. With the help of Nijs's network, it found its way to Abbot between June and September 1618. It arrived in 197 *canzoni* (songs), as the archbishop called them to put bloodhounds off the scent. Their tune was to his taste. "She is an excellent musician that frameth them."[29] The combined power of church and state, of Abbot and James, decreed their immediate publication in Italian. The editorial work fell to the Dean of Windsor.

The Maverick

The dean was none other than De Dominis, who, unlike Sarpi, had accepted James's invitation and fled to England. This was his third refashioning. He began his career as lecturer in mathematics at the Jesuit College in Padua, where he would have competed for students with Galileo had the Venetian Senate not prohibited the college from teaching university subjects. He soon quit mathematics and the Jesuits to join the Church's moneymaking officialdom. The business of his archdiocese, Spalato, brought him often to Venice, where he fell in with Sarpi, Micanzio, Wotton, Bedell, and Galileo. Wotton rated him a "person... of singular gravity and knowledge," and Micanzio, who knew him well, could report nothing more defamatory about him than being in love with the books he had written (Figure 8).[30]

One of these defended King James's *Premonition to all Christian Monarchies, Free Princes and States* (1609), which instructed the Vatican about the Oath of Allegiance required of English Catholics after the Gunpowder Plot of 1605.[31] The oath did not touch religious belief, James wrote, and agreed perfectly with the true teachings of the Roman Church.[32] He continued his *Premonition* in this irenic manner, itemizing common ground between Catholicism and Protestantism before accusing Paul V of countenancing assassination, sorcery, and fornication. A strange way to seek accommodation! An astrological analogy clarified James's methods: "[Catholics] look upon his Majesties Bookes, as men look upon Blasing-Starres, with amazement, fearing that they portend some strange thing, and bring with them a certain Influence to worke great change and alteration in the world."[33] The Vatican prohibited Catholic rulers from receiving James's celestial message. Most obeyed. Henry IV of France, the only sovereign to accept it, observed in doing so that kings should not write books.[34]

It fell to Wotton to present the unwanted *Premonition*, bound in gold and crimson velvet, to the Republic of Venice. Its senators accepted the book with perfect courtesy and exquisite dissimulation: they feigned ignorance of its contents, thanked James profusely, and archived it without opening it. The Venetian Inquisition then read and banned it. Wotton expressed great outrage at this insult to his sovereign and withdrew his

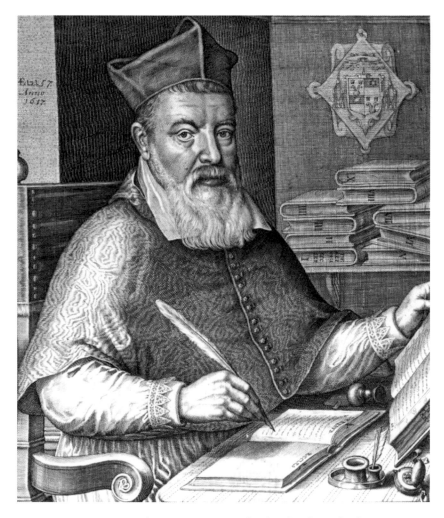

Figure 8 Marc'Antonio de Dominis among his books, from the frontispiece to his *Republica ecclesiastica*, i (1617).

embassy without mentioning that he, Bedell, and Sarpi had translated the *Premonition* to encourage anti-Roman Italians, or that their friend, the Archbishop of Spalato, who was scarcely inferior as a controversialist to the Roman gold standard Bellarmine, was writing in favor of King James.[35]

De Dominis arrived in England in December 1616 after a stop at the Stuart outpost of Heidelberg, where he published a blistering attack on papal policies. He was very fond of bickering. As he was also gluttonous,

egotistical, domineering, and avaricious, he immediately offended Abbot, with whom he boarded while preparing Sarpi for the press. The maverick soon discovered that his flight was an error: the food, the wine, the king, and the people were all as bad as the weather. When his old schoolmate Gregory XV, who succeeded Paul V in February 1621, and the King of Spain offered him safe passage back to Rome and reinstatement to his offices, he accepted.[36] He had learned nothing from his involvement with Sarpi's book. Micanzio warned him that other strayed sheep who returned to Rome had bleated their last there. But De Dominis had persuaded himself that his self-imposed mission would excuse him from the "noose, fire, or poison" that Micanzio foresaw.[37]

This mission was to realize James's program of uniting Catholics and Protestants around the core Christian beliefs of the apostolic era. In his huge masterpiece, *De republica ecclesiastica* (1617–22), De Dominis identified aspects of religious worship that he regarded as unnecessary to true belief. Among these "adiaphora" were the cult of saints, play with the rosary, recognition of the supremacy of the pontiff, and the doctrine of predestination. De Dominis's Venetian friends regarded his project of bringing Rome and Geneva under so wide a tent as crackpot. It was to overlook that the popes of Rome used religion as "a secret of state, and dominion" (Micanzio), that the political power of all religions rested on enforcing adiaphora (Sarpi), and that a united Christendom including the pope was a formal contradiction (Wotton).[38] *De republica christiana* did excite an ecumenical spirit. The Congregation of the Index and the universities of Paris and Cologne joined in banning it immediately.[39]

De Dominis returned to Rome carrying an English version of the Oath of Allegiance for the pope's consideration. Gregory preferred to debrief him about English affairs and Sarpi's dealings with heretics.[40] As anticipated, he played the stoolpigeon ("O what a perfidious fellow! what a rascall!"), and, having spouted all he wished, refused to dribble more. That was a mistake. Gregory's successor, Urban VIII, who had a keen sense of betrayal and a strong allergy to it, sent the fat bishop to slim down in prison. He soon had no need to diet. "Certainly [De Dominis] hath

published propositions by thousands every one of which is very sufficient to make him loose his life."[41] He died in custody in 1624, of poison some say and of luck according to others, since the Inquisition did not get around to burning him until three months after his death.[42] Since by then Catholics and Protestants alike regarded him as persona non grata, the churches he had failed to bring together when alive united in welcoming his death.[43]

De Dominis's enduring contribution to English letters, his edition of Sarpi's *Trent*, opened the eyes of Catholics who had not perceived that the hidden purposes of the council were "[to] weaken the lawful Rights of Kings and Princes, to pervert the doctrine and Hierarchie of the Church of God, and to lift up the papacy to an unsufferable height of pride."[44] The recurrent theme of the book is revelation: unmasking popes, penetrating mysteries, exposing secrets.[45] All Protestants and anti-Roman Catholics could enjoy Sarpi's lampoons of the learned divines and academics who played the popes' game by heaping up trifling objections and ridiculous scruples. "A general disputation arose among them, whether it be in man's power to believe or not believe." Another session considered the unanswerable question whether children who died without baptism before the age of reason could make good philosophers. And so on. Sarpi reserved his greatest censure, however, for the cruelty, stinginess (or profligacy), self-interest, and cunning of the various popes under whom the council stagnated.[46]

A copy of Sarpi's *Trent* had a place in the library of gentlemen and theologians. The famous bishops Lancelot Andrewes and James Ussher, both of whom will appear often in these pages, each had a copy, as did Sir John Bankes. It was reprinted fifty-eight times between 1619 and 1710.[47] The wealthy Buckinghamshire bibliophile Sir William Drake, whose reading habits were representative of his class, took extracts from it. Popular guidebooks relied on it. Peter Heylin's *Mikrokosmos* can stand for them all: "[The Council of Trent] hath caused the greatest deformation that ever was since Christianity began." The popes who orchestrated it were responsible for the disaster, "so [sayeth] the words of the History."[48] A modern authority on Venice holds that Sarpi's book was artistic as well

as toxic, "[with] some claim to be considered the last major literary achievement of the Italian Renaissance."[49]

The year after James's death an English translation of another of Sarpi's eviscerating works appeared as *The History of the Quarrels of Pope Paul V with the State of Venice*. The translator, the Provost of Queen's College, Oxford, Christopher Potter, advertised it as a work by the man who had revealed to the world "that piece of the *Mystery of Iniquity*, those Arcana Imperii Pontificii"—that is, the machinations of the Council of Trent. In the new book, anti-Roman Anglophones could read of the heroic stand of the late King James, who had recognized his divine duty to defend Venice and "the Liberty given by *God* to all Princes."[50]

The Mathematician

On 11 April 1609, the British royal family, the Venetian ambassador, and other guests of James's principal secretary of state, the Earl of Salisbury, gathered at a play celebrating the opening of an emporium Salisbury had built to rival the Venetian Rialto. The goods on display, which the guests took home after the performance, included several optical devices: a prism for studying the rainbow, a convex glass that "makes your lady look like the queen of the fairies and your knight like the grand duke of pygmies," a concave glass that reverses the effect, spectacles, and the jewel of the collection, a "perspective." "I will read you with this glass [says the emporium's proprietor] the distinction of any man's clothes, ten, nay twenty mile off…the form of his beard, the lines of his face…the moving of his lips, what he speaks and in what language." This device was not a "parabolical fiction," like the burning mirror that from the top of St Paul's could set a ship on fire twenty leagues at sea, but a realized object, "a perspective glass" for which the bill of purchase still exists.[51]

Salisbury's perspective was a low-power spyglass of the type then recently invented in Holland. Among the first to have one was Archduke Albert VII of Austria, Governor General of the Spanish Netherlands. It amused the court to deploy it during excursions in the countryside (Figure 9). Around April Fools' Day in 1609 the archduke showed it to the

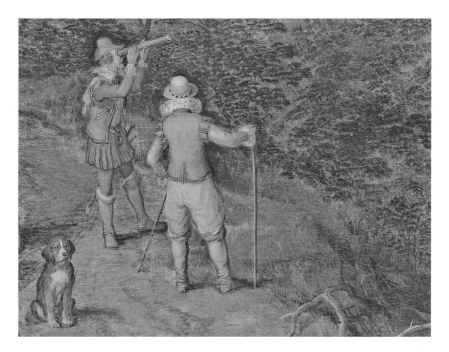

Figure 9 Jan Breughel the Elder, *Extensive Landscape with View of the Castle of Mariemont* (*c.*1610), detail. Archduke Albert and Nuncio Bentivoglio would have employed their primitive telescope in much the same way on their contemporaneous excursion.

papal nuncio, Galileo's former student Guido Bentivoglio, a man of great capacity, learned, ascetic, acute, jolly, and a frequent actor in these pages (Figure 10). Bentivoglio glimpsed the potential of the instrument; he had studied with Galileo in Padua and knew something about optics. He hurriedly acquired a spyglass and sent it to Rome, where it made its way to the Jesuits at their intellectual headquarters, the Collegio Romano. They turned it to the heavens before Galileo had one in his hands, but they did not see anything through it undreamt of in their philosophy.[52] The low-power Dutch spyglass was a toy, the sort of thing that occupied the company of Foolosophers created in 1609 by the satirical Calvinist Joseph Hall, later Bishop of Norwich. Hall arranged his Foolosphers in two colleges, one given to making such novelties as spyglasses, the other to debunking them. The debunkers doubted their senses. "Strike one of them as hard as

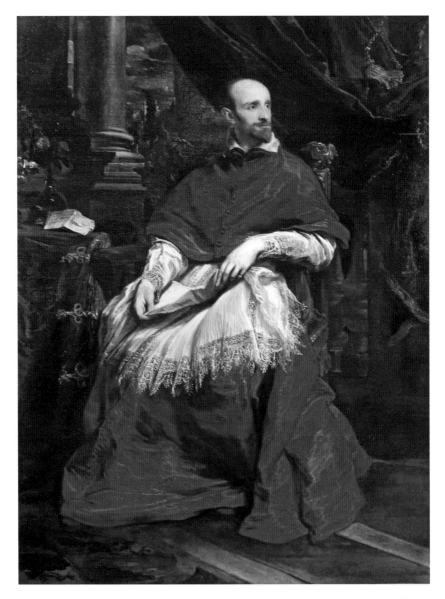

Figure 10 Antony Van Dyck, *Cardinal Guido Bentivoglio* (c.1623); the cardinal was Van Dyck's first major patron in Italy.

you can, he doubts of it, both whether you struck him hard or no, & whether he feele it or no."[53] These heroes of Foolosophy would soon have real-life colleagues who denied the reality of the celestial novelties perceived through Galileo's telescope.

A few months after the spyglass had made its debut in Salisbury's emporium and the Collegio Romano, a peddler offered one to the Venetian Senate. The senators consulted Sarpi. He examined it, deduced its operation, and advised against buying it. He knew how to make a better one: ask the mathematician at the university. Always needing money, Galileo ran a workshop that made spectacles, calculating instruments, and other small things to supplement his professorial income. Sarpi described the spyglass. Galileo perceived its military and commercial value and grasped the opportunity to add it to his inventory.

Late in 1609, Galileo turned his telescope, now capable of magnifications up to thirty times, to the heavens, and opened a new world. The mysterious Milky Way turned out to be a vast collection of dim stars. The moon, violating standard physics, was not a smooth globe of extraterrestrial quintessence, but a rocky ball much like the earth. And, most extraordinary of all, some small bright dots, never seen before, moved along with Jupiter, sometimes preceding and sometimes following him. Galileo identified the dots as four satellites circling the planet. Our earth was not unique in possessing a moon! Moreover, since Jupiter's satellites stayed with him in his travels, Copernicans did not have to worry that a moving earth might lose its companion. With an eye to his future as well as to the heavens, Galileo hurriedly published his *Sidereus nuncius* with a dedication to his former pupil, Cosimo II, Grand Duke of Tuscany, and personalized the gift by naming the four satellites of Jupiter the "Medici stars." He did not bother to explain how the instrument worked, an omission that Archbishop De Dominis tried to supply.[54]

Although Galileo did not stress the point, his discoveries, by making the moon earthlike and the earth planet-like, supported the Copernican system. But neither did he pretend, as Copernicus had, that his discoveries had ancient antecedents; he did not mention that Plutarch and many

others, including his favorite poet Ariosto, had interpreted the moon's visible features as hills and seas. Perhaps he claimed too much. But he had found great novelties in the heavens and, what was more, he took responsibility for them. In this he differed capitally from Sarpi and De Dominis. They agitated for a return to a state of Christianity that they supposed had existed before the innovations of power-grasping popes; he, for a new, revolutionary, unprecedented view of the world (Figure 11).

The news from the stars ran quickly to England. On the day of its publication, Wotton sent a copy of *Sidereus nuncius* to Salisbury for delivery to their sovereign with the following advertisement:

> [It is] the strangest piece of news...that he hath ever yet received from any part of the world...four new planets rolling about the sphere of Jupiter, besides many other unknown fixed stars; likewise the true cause of the *Via Lactea*, so long searched; and lastly, that the moon is not spherical, but endued with many prominences, and, which is of all the strangest, illuminated with the solar light by reflection from the body of the earth...So as upon the whole subject he has first overthrown all former astronomy...and next all astrology...[T]he author runneth a fortune to be either exceeding famous or exceeding ridiculous."[55]

Soon the English market was flooded with poor-quality perspectives. An Italian who proposed to sell lenses in London received the answer that "perspective glasses are here common." But not good ones; glass perfect enough for telescopes was rare.[56] Consequently, Galileo's discoveries at first did not spread by observational test, as he recommended, but by the written word, although *Sidereus nuncius* itself quickly became rare. After Galileo had lobbied successfully for the resounding position of Mathematician and Philosopher to the Grand Duke of Tuscany, the Florentine diplomatic service distributed copies of the book. Its ambassador in London, Ottaviano Lotti, offered one to King James, who thus had the new world in duplicate.[57]

Galileo's disclosures caused the stir that might be expected from the first revision of the world since that evening in October, 4004 BC, when, according to Archbishop Ussher's careful calculations, God "ushered in" (so he put

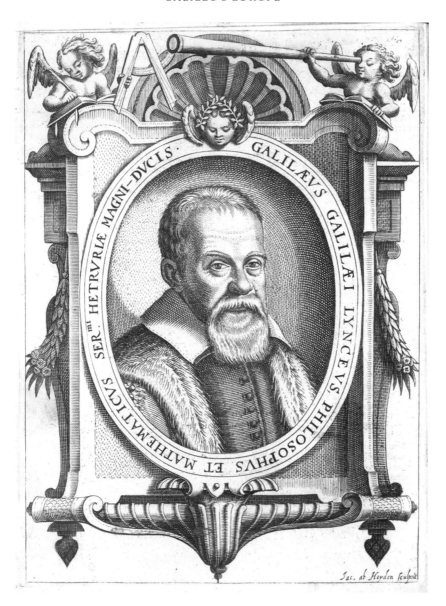

Figure 11 The Grand Duke's philosopher and mathematician: *Galileo* (c.1613), by Francesco Villamena, as reproduced in Galileo, *Systema cosmicum* (1635, 1641).

it) the universe. Some early readers extolled Galileo as the new Columbus; others denounced him as a charlatan; and many sat on the fence. Conspicuous among the denouncers was Martin Horky, a true Foolosopher, who objected that the telescope created the sights seen through it and that, even if the Medici stars existed, they would be useless, since judicial astrology did well without them. Horky's objections briefly occupied the attention of several of King James's subjects then in or around Padua. One of them hesitated whether to believe in the rocky moon or "the 4 new Medicea [S]idera, found out by Galileo," but accepted the resolution of the Milky Way into stars and the ability of Copernican astronomy to predict phenomena "as truely, as we that [think] the Heavens [in] motion and the Earth to stand still."[58] A Catholic Scot studying at Padua, John Wedderburn, a protégé of Wotton, undertook to rebut Horky. What was the use of the Medici stars? Wedderburn: To vex people like you, Horky, "who superstitiously try to apply the least glimmers in the heavens to particular effects and want to govern the free will of men." What was the use of Galileo's discoveries? "To liberate posterity from astrology."[59] Were all Galileo's observations persuasive? The disciple hesitated. Although he allowed that the telescope reliably enlarged distant objects and revealed ones undetectable without it, Wedderburn could not understand how it could show an object differently shaped from its appearance to the naked eye. He therefore doubted Galileo's detection of the phases of Venus, although many astronomers accepted them as proof that the planet's orbit encircled the sun.[60]

The Jesuit mathematicians of the Roman College entertained Galileo in 1611. A Catholic Englishman, George Fortescue, who then boarded at the English College, was present. Perhaps paraphrasing conversations he heard there, Fortescue wrote a dialogue in Latin between Galileo and two of the mathematicians, the patriarchal Christoph Clavius and his more liberal disciple Christoph Grienberger. Fortescue begins his dialogue with Clavius's account of powerful lenses and a tall story about an engraver who stared so hard at his work that his spectacles were riddled with holes; then deviates to astrology; and returns to optics with the telescope and the discoveries made with its aid.[61]

The Jesuits accepted the discoveries, both in Fortescue's report and in fact, as did other important Roman churchmen and laymen to whom Galileo demonstrated them. Among the impressed laity was the young nobleman Federico Cesi, the founder of the Accademia dei Lincei ("Of the Lynxes"), a small keen-eyed group interested in natural science. Galileo joined it and advertised himself as a lynx in several of his publications, including the *Dialogue*. By the time Fortescue wrote up his *Feriae academicae* ("Academic holidays") in the late 1620s, Cesi's lynxes included Cardinal Francesco Barberini, the powerful nephew of Pope Urban VIII. Probably the "Roman academics" to whom Fortescue dedicated his book, and among whom he specially mentioned Barberini, were the lynxes. When Galileo received Fortescue's short dialogue, his great one was nearing completion.[62] He had worked on it for twenty years, he informed Fortescue, and still it lacked important information. Do you know any unusual certain facts about the tides? "In the book I enquire into their most hidden causes, which have stirred up more commotion among philosophers than in the sea itself, and which, unless I deceive myself, I explain marvelously."[63] He deceived himself grievously.

In Fortescue's dialogue, Grienberger anticipates Galileo's subsequent career with the warning, "if you are thinking about Copernicus, go cautiously and timidly." And he points the admonition by asking what Galileo had to say about the inhabitants of other worlds.[64] Galileo's friendly rival Johannes Kepler replied to a similar question by writing a book about life on the moon. Galileo dissociated himself from such speculations for fear of association with Bruno and also, perhaps, because he did not believe in extraterrestrial intelligence. But it was so obvious an inference! Ben Jonson easily inserted it into a play in 1611: Love, helping Cupid to unravel a riddle that required finding "a world without," observes that "[it] is already done, And is the new world i' the moon."[65] Galileo did not heed the advice Grienberger gave him in Fortescue's fiction and probably also in real life.

The most important immediate response to *Sidereus nuncius* by an Englishman came from an old friend of Wotton. He was the poet John

Donne, writing in prose and exploiting Galileo's lunar observations in a lengthy satire, *Ignatius his Conclave* (1611), aimed at the Society of Jesus. Frequently reprinted, *Ignatius* helped to keep Galileo in the English mind and, by joshing with the implications of innovation, to enrich the significance of the emblem in Cleyn's picture. In Donne's satire, the Jesuits make innovation, especially of items that "gave affront to all antiquitie, and induced doubts, and anxieties, and scruples, and...a libertie of believing what [one] would," the main qualification for entry into Hell. Copernicus, deeming himself so qualified, demanded accommodation. Acting as Lucifer's lieutenant, Ignatius inquired what novelty Copernicus had produced to assist the Devil. Merely exchanging the sun and the earth did not suffice. "What cares [the Devil] whether the earth traveil, or stand still?" Perhaps Copernicus upset a few philosophers. But that achievement scarcely counted compared with the supererogatory work of confusion engineered by the Jesuits' great mathematician Clavius—that is, the Gregorian calendar, which put ten days between Europe and England. Still, Ignatius granted, Copernicus was a controversial innovator and might qualify for admission to Hell if the pope declared, "as a matter of faith, That the earth does not move." That would raise hell. Until then, Copernicus lacked the necessary qualifications.[66]

Next come the radical physician Philippus Aureolus Theophrastus Bombastus [Paracelsus] von Hohenheim, whose name sounds like an exorcism, and the more congenial Machiavelli. Ignatius defeats both; the Jesuits and the popes know as much about poisoning as Paracelsus and far outdo Machiavelli in lying. Columbus fails also, on the ground that all the mischief resulting from his discoveries was the work of the Jesuits.[67] Ignatius's high barrier makes Lucifer worry that only Jesuits will be allowed into Hell. How rid himself of them? Call in Galileo! What? Yes, Galileo, whose glasses when blessed by the pope will have the power to draw the moon as close to the earth as desired. "And thither (because they ever claime that the imployments of discovery belong to them) shall all the Jesuits be transferred." Ignatius agrees, having heard from Clavius that the lunatic queen is easy to lead and because he expected to use the moon

as a launchpad for conquering the stars. But before Ignatius can set out, news of his canonization reaches Hell. The pope had yielded to the Jesuitical argument that, since animal butchers have their saint, spiritual butchers should have one too. Saints undoubtedly have a right of residence in Hell. Ignatius remained there.[68]

Since the first version of *Ignatius*, in Latin, entered the Stationers' Register on 24 January 1611, Donne must have begun it within a few months of the publication of *Sidereus nuncius*. A year later, after he had pondered the ramifications of Copernican ideas more closely, he decided that the innovation did indeed shake the foundations of established learning, and published the famous lines:

> And new philosophy calls all in doubt
> The element of fire is quite put out
> The sun is lost, and th'earth, and no man's wit
> can well direct him where to look for it
>
> 'Tis all in peeces, all cohaerance gone
> All just supply, and all relation.[69]

With this change of tone, Donne sounded as alarmist as the cardinals of the Inquisition.

While Galileo tried to restore coherence by advocating Copernican astronomy more openly and aggressively, the Inquisition was looking into its compatibility with Scripture. We know the result of its interdisciplinary deliberations. The head of the Inquisition's Copernican committee was an Irishman, Peter Lombard, then laboring to complete a gigantic manuscript responding to King James's criticism of his activities as head (in absentia) of the Catholic Church in Ireland.[70] Perhaps the Irish Question prevented the learned Lombard from giving his full attention to the Copernican one. On the strength of his committee's brief report, the Inquisition condemned heliocentrism and the Congregation of the Index banned Copernicus's mathematical masterpiece "until corrected."

Galileo had come to Rome in 1616 on his own initiative before the rulings of the Inquisition and the Index in the hope that he could persuade

their cardinals not to act foolishly. Many prelates already knew his views on the interpretation of Scripture, which were circulating in an unpublished letter he had written to Cosimo II's mother, the Grand Duchess Christina. Although the Council of Trent had prohibited amateur theologizing, the Roman establishment did not rebuke Galileo publicly for his theology or cosmology. Instead, the pope, still Paul V, deputed battle-hardened Bellarmine to tell Galileo privately about the Inquisition's decision. Under circumstances not entirely clear, at the same session Galileo received the additional order not to hold or teach the Copernican theory in any way at all. Bellarmine acknowledged, however, that, if irrefutable proof of the earth's motion and the sun's immobility were found, the Church would have to rethink its position. This was more a statement of logic than of policy, however, since he deemed such a proof to be infinitely unlikely.

Galileo thought he might have found one in his unfortunate theory of ocean tides. In his solution, probably invented in the 1590s by Sarpi, a combination of the earth's spin on its axis and revolution around the sun agitates the waters: and, more aggressively, only if the earth so moved could there be tides at all. Galileo wrote out this theory for the first time in January 1616 as a letter to a young cardinal who was to deliver it in time to influence the deliberations of Peter Lombard's committee. Although it probably did not reach its destination, like the letter to the Grand Duchess it circulated widely in manuscript. It raised universal interest and puzzlement, since the theory had no place for the moon in generating diurnal tides. That disagreed with the experience of all mariners and also of Shakespeare's witch, the mother of Caliban, "one so strong | That could control the moon, make flows and ebbs [of the sea]."[71]

England's Sarpi

Like Sarpi, Francis Bacon, Attorney General and Lord Chancellor, revolved in the highest circles of government. They also shared political views and interests in natural knowledge and enjoyed reputations for superior wisdom and learning. Through Micanzio and the apostate Tobie Matthew,

a relative of Bacon, they knew about one another's thinking, which, in respect of Galileo's claims, differed fundamentally.[72] Sarpi approached physics as a mathematician and accepted Galileo's astronomical observations and deductions; they were obvious enough, he held, and urged Galileo to return to the important traditional philosophical problems of motion, gravity, and levity, which the Copernican system had made more difficult and pressing.[73] Bacon approached knowledge claims as a lawyer and welcomed Galileo's discoveries as so many proofs of the poverty of the physics taught in the schools. He also regarded the problem of gravity, of "the heavy and the light," as important, and wrote a little tract about them that would excite the interest of Maurice Williams. But, whereas Sarpi expected that Galileo would find a science of motion capable of handling the Copernican system, Bacon was almost as certain as Bellarmine that he would not.

Bacon's method recommended caution. Does the universe have more than one center? "Those little wandering stars discovered around Jupiter by Galileo" would confirm the concept, "if the report can be trusted." The old problem of the nature of the Milky Way seemed to be nearing resolution, "if we are to believe what Galileo has reported." We are not far from Foolania: Galileo's ongoing observations have raised "some suspicion" that the sun's face has spots.[74] Bacon soon discovered that, although Galileo's observations passed muster, his way of reasoning did not. The proof was in the tides. In an unpublished tract of 1611, Bacon supposed that the seas circulate from east to west in sympathy with the diurnal motion of the heavens; that the moon's position modulates the circulation and the continents obstruct it; and that the combination produces two high and two low tides a day synchronized to the moon's passage. In contrast, Galileo derived the ebb and flow from the rotation of the earth, "a supposition arbitrary enough, as far as physical reasons are concerned." Indeed, altogether false.[75]

While Galileo was chuckling over Bacon's tidal theory, his own came under fire from another Englishman, Richard White, a student of mathematics at Pisa. Clever enough to argue with Galileo, or, as Matthew

judged, "too soft" to know his limitations, White observed, correctly, that Galileo's theory could not easily deliver more than one high and one low tide a day. Galileo seems to have hesitated over this criticism, but only briefly; and when White returned to England via Matthew in Belgium, he had with him several of Galileo's published books, including *Sidereus nuncius*, and a few of his unpublished manuscripts, including "On the Tides." Matthew sent this last item to Bacon.[76] The chancellor was then putting the final touches on his *Novum organum* (1620), which ruled out Galileo's tides on two counts: in theory, because "devised upon an assumption which cannot be allowed, viz., that the earth moves;" and by observation, by "the sex-horary motion of the tide."[77]

When Wotton returned to Venice for his third stint as ambassador in 1621, he had several copies of his kinsman Bacon's *Novum organum* in his baggage. He thought that this famous diagnosis of the ills of received learning would be very nourishing for his Venetian friends. "[I]t is not a banquet that men may superficially taste…but in truth, a solid feast, which requireth due mastication." Micanzio had the teeth for Bacon.

> [I]f he brings his worke to the perfection he promiseth [thus Micanzio], Philosophy would be more beholding to him than it was ever yett to any, nor can I compare him to any…For the philosophy of theis tymes is but a Logick full of words, but that singular witt, truly singular, peirceth into the rootes of the defects thereof.

Another cracker of tough nuts, Kepler, received a copy of *Novum organum* from Wotton's own hands. Knowing Kepler's difficulties as a Protestant in a Catholic country and as an Imperial Mathematician living more on his title than his salary, Wotton invited him to England. Alas, Kepler was as irrationally attached to the Empire as Sarpi was to Venice.[78]

Like Galileo, Bacon advertised the innovative character of his "new instrument" for exploring the world. Unhappily, he had no practicable plan of execution. Where would he have found staff? Galileo had not met

his standard, nor could other mathematicians, owing to their "daintiness and pride," their reliance on fictions, and their tendency to domineer over other cultivators of science.[79] Oxbridge dons could not fill the bill either, for reasons given in *Novum organum*. Even so devoted a follower as Micanzio recognized that *Novum organum* was a collection of axioms, "food so substantiall that it must be taken by littles, and converted by study into nature," and not a blueprint for collective action.[80] Not until the end of his life did Bacon indicate, and only in the form of a utopia, how his vision might be achieved.

Bacon compiled human as well as natural histories, from which, and his own rich experience, he extracted such wisdom as is found in his popular *Essays* on moral matters. Both Matthew and Micanzio tried to exploit the *Essays* for cultural warfare in Italy. Matthew hoped that an edition addressed to the Grand Duke of Tuscany might persuade him that not all English Protestants were savages and that closer ties with Bacon's master, King James, were practicable. An Italian translation of the *Essays* was at hand. The translator, William Cavendish, soon to be the second Earl of Devonshire, had learned his Italian in Venice with the help of Micanzio; his errors in rendering Bacon were corrected by De Dominis; whence arose a reliable text that would have suited Matthew's purpose perfectly had it not contained two obnoxious articles. One ridiculed disputes over indifferent religious beliefs and another charged the Catholic Church with "sensual rites and ceremonies, excess of outward and pharasiatical holiness, [and] over-great reverence for tradition."[81] At Matthew's request Bacon agreed to remove the offensive essays and the Italian text intended for Florence came forth from London in 1618 without them. It also lacked the preface Matthew had added describing his author's high status in England.[82] Mention of Bacon's name and distinctions would have triggered the general ban against books by heretics. Micanzio had the book reprinted in freer Venice with the author's name, "Francesco Bacchon," but otherwise left it alone. Even in the Serenissima it would have been dangerous to include the anti-Roman essays of a heretic.[83]

Italian Attractions

Many Englishmen had hands-on experience of the art, architecture, and courtesans of Venice. Guidebooks warned against visiting these last attractions while allowing that discussing religion might be riskier. Another great draw was the ghetto. Most Englishmen had never knowingly set eyes on a Jew at home since few lived there openly between their expulsion in 1290 and their readmission in 1655. The well-traveled Thomas Coryate, who published his observations as *Crudities*, attempted the double feat of converting a courtesan to chastity and a rabbi to Christianity. His attempt on the rabbi almost ended his crudities. Ben Jonson described the adventures.

> A punk here pelts him with eggs. How so?
> For he did but kiss her, and so let her go
>
> And there, while he gives the zealous bravado
> A rabbin confutes him with the bastinado.

Luckily Wotton was gliding by in a gondola when the rabbi's entourage turned belligerent. Rescuing Englishmen who trespassed on native sensibilities was a frequent service of the "thrice worthy [English] Ambassador."[84] The worthy ambassador had several Jewish friends, including his landlord and Leone Modena, the author of a famous account of Jewish practices composed for gentiles, perhaps with Wotton's coaxing. Since Modena was one of the few rabbis in Venice who spoke Latin, he might have been the rabbi in Coryates's tale. If so, Wotton's timely appearance might not have been a miracle.[85]

More dangerous than flirting with bawds or arguing with rabbis was talking with Jesuits. According to Joseph Hall, the man of Foolosophy, these sneaks knew the names of all notable English travelers, lay in wait for them, and (as we know from Tobie Matthew) turned their heads with gorgeous churches, exquisite music, and discourses they could not answer.[86] The danger for heretics grew in proportion to distance south of

Venice. Reliable advice to non-Catholic Englishmen planning a visit to Rome recommended learning another language well enough to pass as a native; in this way the famous traveler Fynes Moryson, presenting himself as a Frenchman, succeeded in gaining an interview with the future Urban VIII. In the Papal States or Naples, the wise Englishman avoided conversations with fellow countrymen, never talked with Italians about religion, and abstained from urging anyone to convert. As further precautions, he changed his residence and restaurant frequently, and never fell sick.[87]

Wotton owed his ambassadorship to his mastery of masquerade. He became so thoroughly an Italian during his early travels that in 1601 he made it all the way from Florence, where he had earned the confidence of the Grand Duke, to Scotland, where, using the name Ottaviano Baldi, he obtained an interview with King James. He had come to warn James (so he said in Italian) against a papal plot to poison him, and to bring him, as a present from the Grand Duke, a box of infallible antidotes. Baldi then disclosed that, although the threat was real, he was a fake, not an Italian but an Englishman needing asylum. He had pretended to be a Florentine to bamboozle Queen Elizabeth's spies: as the one-time foreign secretary to the treasonous Earl of Essex, he feared imprisonment if recognized.[88] When James became King of England in 1603, he summoned Ottavio Baldi, knighted him, and sent him back to Italy as the first English ambassador to Venice since the accession of Elizabeth.[89]

Wotton had adopted a more extravagant masquerade to visit Rome. Disguised as a German Catholic (he had learned the language perfectly), he drank like a Teuton, dressed like a buffoon, and in the guise of a conspicuous idiot came to know more about the operations of the Roman establishment and the papal court than (he boasted) any other non-Catholic Englishman. He stalked the pope. "The whore of Babylon I have seen mounted on her chair, going on the ground, reading, speaking, attired and disrobed."[90] He prudently gave up this counterfeit on being recognized and returned home to begin his unfortunate engagement by Essex.

The master unmasker, Fra Paolo, was also the strongest advocate of dissimulation. He called it "moral medicine." Just as a doctor sometimes deceives his patients to promote health or ease death, so may the politician and the priest tell lies to secure the state. Feign agreement, Sarpi says, guard your thoughts, volunteer nothing. "I have to wear a mask because without one no man can live in Italy."[91] The sure way to traverse the world safely, according to an experienced Roman courtier of Wotton's acquaintance, is to keep "your thoughts close and your countenance loose [*sciolto*]"—that is, blank and open.[92] "[B]eware I You never speak a truth," echoes Jonson's Sir Politic Would-Be, summing up his Venetian lessons, "And then, for your religion, profess none I But wonder at the diversity of all." The English Sarpi advised similar behavior: "nakedness is uncomely, as well in mind as in body; and it addeth no small reverence, to men's manners and actions, if they be not altogether open . . .Therefore set it down, *that an habit of secrecy, is both politic and moral.*"[93] Copernican astronomers followed the advice: Kepler urged its use in the great cause, and Galileo's spokesman in the *Dialogue* states more than once that he wears a mask.[94]

Beguiling, inspiring, seductive, frightening, repellent—thus was Italy in the eyes of the Stuart traveler. The land of Titian, Galileo, and Sarpi, but also the headquarters of Jesuits, popes, and the Inquisition; home to the world's most accomplished artists and assassins, rational philosophers and duplicitous theologians, nuns and courtesans. The longer the unprotected Protestant tarried among the allurements and dangers, the more likely and fearful his fall. That is what Sir Thomas Parker warned in his *Essay on Travailes* of 1606. Beware of Italy! Beware the "infinite corruptions, almost inevitable, that invest travailers after small abode there."[95] Would you let your son go to Italy? Travel can be broadening, answers Wotton. "But these effects are not general, many receiving more good in their Bodies by the tossing of the Ship, whilst they are at Sea, than benefit in their Minds by breathing a foreign Air, when they come to Land."[96] Quite right, says Sir Politic, scoffing at "That idle, antique, stale, grey-headed project I of knowing men's minds and manners."[97] Yet it is also true,

answers Coryat, that knowing the bad can do a virtuous man good. "[He] will be more confirmed and settled in virtue by observation of some vices."[98]

Wotton did what he could to direct observation in the right direction. He ran something of a "college" (as Coryat called it) of art and architecture in which Englishmen could learn to appreciate things they could not see at home.[99] Few of them came with any knowledge of fine art, indeed, saw little difference between good painting, house decoration, and face painting. Bankes's patron, Lord William Howard, a man of wide experience and antiquarian tastes, engaged the same man to mend his cabinets, paint his house, and portray his family.[100] The portraits travelers may have seen at home tended to be flat and decorative, as in the gorgeous presentations of Elizabeth; or to be rough and approximate, as in the depictions of relatives; or missing, as in foregone representations of the Savior, Apostles, and Martyrs.[101] People who did appreciate fine painting knew it primarily from the work of north European masters. After 1600, modern Italian art slowly made headway among English connoisseurs; but as late as the 1620s, according to one of Francis Cleyn's painter friends, Edward Norgate, "chiaroscuro" was just plain obscure to most of James's subjects. Henry Peacham, the designer of perfect courtiers, hesitated before recommending knowledge of painting of any kind in *The Compleat Gentleman* (1622). And, when Robert Burton finally included painting among remedies to melancholy in the fourth edition of his *Anatomy* (1632), he omitted modern Italian art from his therapeutic examples.[102]

Wotton played a major role in bringing his countrymen to appreciate Venetian art. Acting as consultant to travelers and purchasers at home, he helped English connoisseurs to value the older Italian masters, above all, Titian, and, among the newer, the Carracci, Caravaggio, and Guido Reni. Occasionally he gave a valuable work to a patron able to appreciate it; less sensitive souls got cheese.[103] The greatest of the connoisseurs whose appetite he sharpened was the haughty Catholic Earl of Arundel, whom the Venetians knew as the extravagantly rich premier noble of England and treated accordingly.[104] In time Arundel's passion for collecting art and artists exceeded even his pride in the exploits of his family. A year after

regaining England in 1614 with trunksful of art objects and a gondola, he began to accumulate a virtual academy of artists and intellectuals with virtual headquarters in his Italianate London establishment, Arundel House. Among its members were the authority on gentlemanly manners Peacham and the artist Norgate, who taught Arundel's children to draw and gathered paintings for him in Italy.[105] Among other frequent visitors to Arundel House was the earl's uncle, Lord William Howard.

Arundel's Italian pictures inspired emulation in the shallow mind of King James's favorite, Robert Carr, Earl of Somerset. He and Arundel made use of Wotton, Carleton, and the same Daniel Nijs who acted as intermediary between Wotton and Sarpi to procure paintings. When Carr fell from grace, Arundel had the pick of his collection and so, until King Charles entered the competition, built up the finest collection of Italian art in England.[106] He also promoted the visits of important north European artists, including Mytens, Van Dyck, and Cleyn. Portraiture was another route by which Venetian painting came to the attention of Englishmen. Carleton, Wotton, Arundel, Lady Arundel, and others who could afford it sat for Domenico Robusti (Tintoretto junior), who painted their portraits about the same time he did Galileo's.[107]

With Wotton's advice, English travelers explored the modern churches, palaces, and villas in which the recent artistic productions of Italy were open to view. Wotton had made a particular study of the writings of Palladio, Serlio, and Scamozzi and their buildings in the Veneto, and collected their architectural drawings. At the end of his third stay as ambassador, he deposited his knowledge of the art in his *Elements of Architecture* (1624), a piece of pedagogy designed to help him to win appointment as Provost of Eton College. The book impressed the then-current favorite, the Duke of Buckingham, the King, and the Archbishop of Canterbury, and helped Wotton win the post over the formidable competition of Bacon and Carleton.[108]

Wotton's *Elements*, though an epitome of Venetian practice, is regarded as the first original English work on architectural theory.[109] It employs technical terms previously wanting in English, which Wotton introduced together with the observation that their lack indicated the relative inferiority of

English architects.[110] Neither the argument nor the evaluation applied to Inigo Jones, who had lived in Venice and had access to Wotton's collection of architectural drawings. Jones was to incorporate Venetian concepts in English buildings following a steady royal ascent: he began as "picture-maker" to Christian IV of Denmark, who passed him on as a designer of stage sets to his sister Queen Anna of England, who passed him on as a surveyor of palaces to her son Henry Prince of Wales.[111] After Henry's death in 1612, Jones returned to Italy with the Arundels. During their stay in 1613–14 he sketched villas, temples, and palaces, both ancient and Palladian, and allowed himself to be sketched by one of Galileo's portraitists, Francesco Villamena.[112]

Jones's importation of Italian styles included stage sets. The first among many extended notes that he made on his copy of Palladio's *Quatri libri dell'architectura* (1601) described the theater at Vicenza where Palladio painted scenes in perspective to give the illusion of depth to the stage. That was a great accomplishment, although Palladio's scene did not change: "the cheaf artifice was that where so ever you satt you saw on[e] of these Prospectives." Deception everywhere! Serlio's *Five Books of Architecture* (1611) treats perspective in detail before applying it to stage design. He advised that tragedies be set in grand houses in which the noble people destined for trouble can suffer comfortably and that comedies take place on a street with ordinary houses, "but especially there must not want a brawthell or bawdy house, and a great Inne, and a Church; such things are of necessities therein."[113] Jonson often followed this advice.

To effect the quick changes that made the spectacle, Jones improved on machinery he had seen in Florence and Venice. A rotatable stage with different back-to-back scenes, pairs of parallel sliding shutters with different perspective views, openings under the main stage for underground activities, rising and descending platforms for heavenly ones, created a three-dimensional hieroglyph, to use the term of the author of Queen Anna's first masque in England, Samuel Daniel.[114] The most evident hieroglyphs bound the heavens, in which the stage machinery placed the gods and personifications who appeared in the masques, to the earth of everyday

experience. Messages ran from the gods to the earthlings below as so many *siderei nuncii*; "the entire celestial world that is said to govern the universe [is revealed] as if through a magical and powerful telescope…[showing] what is happening in the moon…[and] the stars dancing."[115] Masque-goers frequently encountered astronomical hieroglyphs in Jones's engineering and his collaborator Ben Jonson's plays. And theatrical hieroglyphs reciprocally occurred in the frontispieces to astronomical books, notably Galileo's *Dialogue*.[116]

From all of which follows that no one had to face the dangers of travel to know the binary calculus of Italy. The English stage, anti-papal propaganda, the doings of Sarpi, De Dominis, and Galileo, the lure and lore of Venice, travel books, competition for artworks, Jones's buildings, and so on, kept the puzzle of Italy alive among stay-at-home gentlemen like Sir John Bankes through the reigns of the first Stuarts.

2

RELIGIOUS NOISE

The rise of the sixth James of Scotland to the first James of England brought Calvinist Scots, Irish Catholics, and English Protestants uncomfortably under the same rule. The Protestants had their own jarring sects, which Bentivoglio summarized for the Vatican soon after James had ascended the English throne. Though a papal nuncio, Bentivoglio did not admire Rome's slavish adherence to the doctrines of Trent and drew up a fair assessment of the religious scene in England.[1] He judged that the Protestants or *Anglocalvinisti*, who dominated parliament, were less fanatical than the fewer Calvinists who followed Geneva (*puri Calvinisti* or Puritans). He reported that the two sects agreed in dogma but differed over governance and liturgy. The Protestants retained ecclesiastical offices, most of the old liturgy, and the king as head of their religion. The Puritans rejected the hierarchy, the liturgy, and, as religious leader, the king.[2]

Bentivoglio rated James a convinced heretic with a ridiculous addiction to religious controversy that exposed him to dangerous flattery. Queen Anna is a Catholic and proves it by not attending Protestant services, but (in Bentivoglio's opinion) her love of entertainments and amusements, and her facile and changeable character, leave the question of her religion open. Their first born, Henry, Prince of Wales, gives signs of being a vehement heretic. The greatest nobles are openly or covertly Catholic, the rest mostly Protestant. The middling nobility contains a large component of Puritans, the lower classes a greater, the city plebs more yet. Lower-class Catholics live in the country. The open Catholics and those protected by

the great lords amount to around a thirtieth of the population. Subtracting them, crypto-Catholics, and indifferent believers, Bentivoglio estimated the number of devoted heretics at about a fifth of the English population.[3]

Continuing his report, Bentivoglio observed that the papal agent in England, Archpriest George Blackwell, supervised clergy trained at St Omer (run by the Jesuits) and at Douai (seculars), quasi-military establishments "where spiritual soldiers learn their discipline." When on mission, they make war on one another, particularly over the Oath of Allegiance. And no doubt the oath was offensive, particularly the unnecessarily obnoxious clause, "I do abhorre, detest and abjure as impious and Hereticall this damnable doctrine and position, That Princes can be excommunicated or deprived by the Pope, [and] may be deposed or murthered by their Subjects." Nonetheless, Archpriest Blackwell took the oath.[4] So did many "church papists," as the godly called Catholics who obeyed the Elizabethan statute requiring attendance at the parish church on Sundays and feast days. Dissembling church papists might escape recusancy fines and preserve their inheritances, "wear[ing] the maske of the Gospel…to save…charges."[5]

From the safety of the Spanish Netherlands, Bentivoglio advised Rome not to tolerate the stratagems of church papists. Despite fines and forfeitures, the faith seemed to be strengthening in England. "And as fire is more intense the more enclosed it is, so the zeal of the Catholics of this reign is the more enflamed and invigorated the greater the obstacles they have encountered in not being allowed to practice and proselytize openly."[6] James would vacillate capriciously over imposition of the penalties for refusing the oath, whereas the war between the Jesuits and the seculars continued dependably to divide the Catholic community in Britain.[7]

James's Polyphony

James's first act on entering England in 1603 was to attend a sermon. The preacher, Tobie Matthew senior, then Bishop of Durham, advised James

50

to accept English civil and religious life as he found it. Ignoring the advice, James doubled the number of weekly sermons.[8] Since the godly preferred sermons to prayers, they took hope from his addiction and petitioned him to enforce observance of the Sabbath, elimination of pluralism, and abolition of popish ceremonies, vestments, and terminology. James invited them to send four of their party to a conference at Hampton Court in 1604 to dispute with a force of eight bishops commanded by the Archbishop of Canterbury. James found against them, not unexpectedly, since *Basilikon doron* condemns Puritans as "verie pestes in the Church and Common-Weale." Blunting the blow, James agreed to diminish pluralism, commission a new translation of the Bible, and appoint the Calvinists Tobie Matthew and George Abbot as archbishops. Matthew went to York in 1606, Abbot to Canterbury in 1611.[9]

James balanced his religious books by accepting most sorts of non-Puritan Protestantism. Although his archbishops were Calvinists, his favorite preacher, Lancelot Andrewes, opposed them; and when he ordered up a sextet of sermonizers in 1609, three were pro- and three anti-Calvinist.[10] Among the latter was Maurice William's patron, the future Archbishop of Canterbury, William Laud. James's brother-in-law, King Christian IV of Denmark, brought in another variety of Protestantism, Lutheranism, to which James had to attend as claimant to the international leadership of reformed religion. His management of the discord among the factions represented by Abbot, Matthew, Andrewes, and Christian gave him the confidence, and Protestants at home and abroad the impression, that he was a natural leader; while his knowledge of theology and toleration of Catholics who took the oath recommended him to those who, like the Catholic De Dominis and the Lutheran Kepler, believed in the possibility of a reunited Christian church.[11]

Royal Religion

The key to forbearance was to set aside beliefs and practices of the several Christian sects irrelevant to such core doctrines as the Trinity and

Incarnation. "Our appeal is to antiquity," Andrewes said in explaining his master's message, "we do not innovate…we renovate."[12] The explanation itself was hardly innovative. Justification of every significant change as a return to sound past practice was a bromide of political and social discourse; "in reforming thinges of common practice, the cleering of the olde, which is abused, and not the breeding of the new, which is untried, is the natural amendment." So thought the Master of the Rolls, Sir Julius Caesar. Acting accordingly, one of Sir Julius's underlings recommended denying an otherwise acceptable petition because, "as from all novelties and inventions so from this, many mischiefs and inconveniences may arise."[13]

James's doctrine that Christians of various sects might live in harmony if they ignored small variations and indifferent practices disagreed with the general view that the most stable states tolerated only a single religion. Here Oligarchic Venice—impossibly stable yet innovative, quasi-tolerant yet Catholic—was a puzzle. James followed its fortunes closely. Take the time when, ignoring *Basilikon doron*'s warning, "be warre of Drunkenesse, which is a beastlie vice," James and his good brother Christian were outperforming seasoned courtiers "overwhelmed…[with] women, and indeed wine too,"[14] and the Venetian ambassador asked for an audience to discuss the papal interdict. It was not a convenient time. A tipsy Christian, playing the part of Solomon in a court masque, had tripped over a naked drunken Queen of Sheba, and had to be carried to bed.[15] These divine rites completed, the monarchs were as "abstemious…[as] the severest Italian" when they admitted the ambassador.[16]

James exhibited a "profound knowledge of [Venetian] history" and a willingness to assist Venice, "with all my heart;" as for his arms, he reserved them (the ambassador reported in disgust) for hunting.[17] Ignoring James's instructions to encourage but not promise, Wotton offered the Venetians armed intervention if necessary and a league with Protestant powers against the pope.[18] In justifying his misbehavior, he invoked an astrological metaphor: the meeting of the two kings in England at a crucial time for Venice had the look of a portent. "I see when Kings meet, it occasioneth as much discourse among politiques, as amongst astrologers

at the conjunction of stars."[19] The starry message as usual was open to interpretation: Christian thought the situation ripe for a threat of armed intervention.[20] Fortunately none was required and James gained in reputation as a Protestant leader wise enough to overlook the adiaphora of his allies.

Bentivoglio's report on religion in England had a coda about Christian. He was a dangerous man for Rome, violent and warlike, and yet possessed of an intellect and energy scarcely seen in Denmark, "so that it is a puzzle how he could have been born in such a cold and indolent place."[21] He speaks many languages, including Latin, wherein he converses with his ally James; but, despite this refinement, he and his quasi-independent nobles are fierce Lutherans. Christian will not allow even moderate Calvinism in his domains, although James, his great friend, presses him to do so.[22]

To help him find a theological position that might minimize the disharmony among the Protestant sects, James convened a virtual academy similar to the company that created the King James Bible. More than one scholar worked on both projects. The first leader of this virtual academy and also the main figure in the translation was Bishop Andrewes. He had moved around the religious landscape, from a place close to Puritanism with respect to images, Sabbaths, and predestination to a place not far from Rome with respect to liturgy, the episcopate, and good works.[23] Despite his anti-Calvinist positions, Andrewes enjoyed James's favor for the dexterity of his sermons and the strength of his championship of royal authority. Since Sir John Bankes also favored Andrewes, we must sample the flavor of his sermons.

A few months after the assassination of Henri IV, Andrews interpreted the apposite text *nolite tangere christos meos*, which James's Bible made "touch not mine anointed" (1 Chron. 16:22), as the Lord's instruction not to interfere with princes. "Allegiance is not due to him because he is vertuous, religious, or wise, but because he is *Christus Domini*." No one, not even the pope, can remove a bad prince without violating divine commandment.[24] Andrewes extended this prohibition to attacks by voice and by

pen, and to royal families, estates, and states; "not one of them is to be touched." Even to will "touching" the sovereign is a crime, whether by a seditious thought or a Gunpowder Plot. God had saved the king from that heinous conspiracy, and Andrewes too, for James had made him a bishop on the eve of the attempt, and he would have been blown up with the Lords.[25] It does not follow, however, that because God delivered us from the powder men He has freed us from responsibilities for our actions. God has not arranged every little detail, as the Calvinists proclaim; "there is somewhat belongs to our part," for instance, vigilance against touchers of the King's Majesty. They can do damage before they receive the exquisite "touches of the place whither (being unrepentant) they must needes goe."[26]

With this teaching Andrewes fell in with the most uncompromising champions of divine right, like Abbot's former chaplain Richard Mocket, risen, in 1614, to Warden of All Souls, Oxford. The warden proved, from many passages in the Old Testament and the New, that nothing, not infidelity, apostasy, or despotism, can dissolve the bond between a king and his people. All the people can do is to repent the sins that brought the tyrant over them, pray to God to correct him, and look forward to the Last Judgment.[27] In theology, however, Andrewes drifted far from the Mockets. He preferred a brand of Protestantism known under the awkward name of its main exponent, Professor Jacobus Arminius, who died in harness at the University of Leyden in 1609.

Although Arminianism agreed with his political theology in its rejection of extreme Calvinist doctrines of grace, James worried that the noisy antagonisms it inspired among Dutch Calvinists would counter his efforts to keep peace among Protestants worldwide. To root out Arminius's doctrine at its source, James demanded the ouster of Arminius's disciple and successor, Conrad Vorstius, for "monstrous…horrible…abominable" vices, one of which, "licencious libertie of disputing," James shared with his victim; and he ordered Vorstius's books burnt in London, Oxford, and Cambridge.[28] What more could he do? He consulted Sarpi; wise Fra Paolo advised him to seek some other amusement. But James persisted in regarding disturbances in the Dutch church as inimical to ecumenism

and hired a former student of the Jesuits, George Eglisham, then (1612) pushing potable gold as a cure-all for folks who did not require a licensed physician, to annihilate Vorstius.[29] The semi-Jesuit quasi-quack overkilled Vorstius for his "Atheism, Paganism, Judaism, Turcism, Heresy, Schism, and Ignorance."[30] The poor man never recovered his chair and lived to see his master's teachings damned in 1619 by the Conclave of Dordrecht, or Synod of Dort, a sort of Calvinist Trent. James liked the damnation of Dort, as did Sarpi, on the theory that it would unify opposition to Rome. Andrewes thought that mutual forbearance was the better strategy and worked hard to blunt attacks on Arminianism.[31]

James responded to his growing theological difficulties by ordering an end to public discussion of divisive doctrines, much as Paul V did in silencing Galileo; with the significant difference, however, that, whereas the king outlawed disputes but not opinions, the pope prohibited a single opinion but not disputes. James could not live without disputing, however, and, ignoring his ban, allowed an attack on Puritanism. The attacker, Richard Montagu, voiced the scandalous opinion that the Church of England accepted Tridentine teachings on justification by faith and the merits of good works. Attacked by Archbishop Abbot, defended by Bishop Andrewes, and encouraged by a weakening king, Montagu indicated the direction of motion of the English Church.[32]

Andrewes put up several more signposts. A prime example is his Easter sermon of 1620, another touching performance, based on Jesus's words to Mary Magdalene, *Noli me tangere*, "touch me not" (John 20: 11–17). Mary at first mistook the risen Christ for a gardener and recognized him only when he spoke. Two disciples who did not recognize his voice identified him by his manner of breaking and blessing bread at dinner (Luke 24: 30–1). It is folly, Andrewes inferred, to set the word, that is, preaching, against the sacraments, as Puritans do, "seeing we have both, both are ready for us...thank Him for both, make use of both, having now done with one...make use of the other." "It may be (who knows) if the one does not work, the other may."[33] A unique preacher, Andrewes, in calling for curtailing preaching!

Despite his Arminian views, liturgical preferences, confrontational style, and muted enthusiasm for sermons, James appointed Andrewes Dean of the Royal Chapel. That was in 1619. The new dean immediately refitted most royal chapels for services in the old Catholic manner and purged the royal household of its Puritan chaplains.[34] He was bold enough to reprimand James for demanding that, regardless of the place the service had reached when he entered church, the sermon should thereupon begin.[35] Thus did Andrewes and his allies purify ritual and prepare the way for Laud, who, as co-editor of ninety-six of Andrewes's sermons, confirmed the connection. Laudians expected that temperate preaching, solemn liturgy, and clerical leadership would "preserve truth and peace together," and assure the proper relation of inferior to superior.[36]

Andrewes was charitable to others and, charity beginning at home, kept a good table for himself. It is worth recording for those who can profit from it that he mastered the ancient languages by declining and conjugating them while he walked back and forth between Cambridge and London. He also knew a dozen modern languages, picked up in his youth from foreign friends of his merchant-sailor father, and Arabic, from a professional teacher of "oriental" tongues. Good cheer, good health, and polyglot reading made "his Sermons…inimitable, his writings… unanswerable."[37] Sir John Bankes studied them carefully.

Bankes's Religion

The future Attorney General and Chief Justice grew up in Keswick in Cumberland, where he was buffeted by wind from several pulpits. Catholicism loomed large in the north, and the old ceremonies lingered in Protestant churches. Perhaps the extended Bankes family included recusants, if Christopher Bankes, who entered the English College in Rome in 1642, was the relative he claimed to be.[38] Even zealous Archbishop Sandys had not been able to eradicate the old ways in his archdiocese and he had left it at his death in 1588 more exposed to recusancy and more crowded with crosses than he had found it. Ten years later the newly appointed

Bishop of Carlisle, Henry Robinson, whose diocese included Cumberland, recorded his surprise at the extent and stubbornness of recusancy, the prevalence of unreformed liturgy, the ignorance of the clergy, and the lawlessness of the Scottish borderlands.[39] To combat the last of these evils he made common cause with the chief enforcer of border order, the Catholic Lord William Howard, who would be a major patron of Bankes. To combat the other disgraces, Robinson brought in sound new preachers from the south. Many came from Queen's College, Oxford, which Robinson had headed for seventeen years before his elevation to the episcopate in 1598. He had the reputation of a strong preacher and a good administrator.[40]

One of Robinson's recruits from Queen's was his brother Giles, whom he installed as vicar of Keswick's parish church, St Kentigern in Crosswaithe, where John Bankes was born in 1589.[41] Among those Vicar Giles tried to draw to his church was a large community of German miners, many of whom, however, preferred the Lutheran preacher Queen Elizabeth had allowed them to import. The Bankes family had close ties to nonconformist miners forged by Bankes's merchant father, also named John, a relationship later cemented by the marriage of Bankes's only sibling, his sister Joyce, into their leading family.[42]

These were not ordinary miners. They possessed "no lesse judgment than industry in sundry excellent and choice experiments," which, together with their relative civility, qualified them as exemplary in a popular manual for the making of English gentlemen.[43] The Bankes family had some mining interests themselves, and later John Bankes owned graphite deposits around Keswick that gave him a monopolistic, if not an artistic, interest in black-lead drawing.[44] Mining was never far from the noses and minds of the citizens of Keswick. Smoke from the smelters and lawsuits between Germans and locals over land, water, and timber insured it. The German community in Keswick showed young John not only variety in religion and power in technology, but also the merits of foreigners, diligence, and the common law.

Cumberland boys who studied in Oxford did so at Queen's. Bankes entered in 1605 into the nourishing environment Robinson had created as

provost: a godly Protestantism that accepted bishops and did not automatically disdain more liberal viewpoints. Not only was the religious tone of Queen's familiar; Bankes also found at least one of his relatives there, his brother-in-law, David Heckstetter, who had left mining and Lutheranism and become a fellow of the college.[45] Despite these comforts, Bankes stayed only two years in Oxford. Thence he proceeded to Gray's Inn to prepare for a legal career. That did not shield him from Bishop Robinson, who had joined Gray's four years earlier.

The bishop had not come to learn the law but to participate in the inn's social life. The Inns of Court then were much like Oxbridge colleges, places of miscellaneous learning and entertainment, "the noblest nurseries of humanity and liberty," according to Ben Jonson, who supplied some of their merriment. If not noble, at least they were gentlemanly, since, by order of King James, only men so qualified could be members. The inns also offered prolonged thorny study for those who intended to earn their living by the law. These plodders were not in the majority. Like the colleges, the inns housed many young men who did not pursue degrees; almost 90 percent of those admitted sought only knowledge useful for running the estates they would inherit. They kept the inns lively and helped pay for entertainments on a royal scale. Christmas feasts at a single inn could cost £2,000 or more, over twenty times the yearly earnings of a superior artisan in London.[46] There were a few at Gray's who by brilliance or birthright spent much of their time playing and yet became successful lawyers. An example, whose career ran parallel and character counter to Bankes's, was John Finch, who entered Gray's six years before Bankes and would proceed him by the same interval in climbing the ladder of the law.

Formal instruction at the inns was in the hands of readers (instructors) and benchers (seniors), about twenty in all, and barristers (alumni in legal practice), perhaps sixty. The standard career required seven or eight years of residence at an inn to barrister and twenty-five years to bencher and reader. In keeping with this schedule, Bankes was called to the bar in 1614 and became reader in 1630–1. He held the highest office at Gray's Inn,

Treasurer, from 1631 to 1636. He thus was in command when the Crown threatened inn mates who feasted on flesh during Lent with a punishment suitable to "the haynousnesse of soe high a contempt."[47] From ordinary barrister, a chosen few might rise to serjeant-at-law after nomination by the Chief Justice of Common Pleas and examination by the existing serjeants. At every promotion the lucky candidate had to give his inn a feast. Readers' revels could cost £1,000 for the three-week term. The honor of serjeancy could be ruinous. In addition to the cost of the feast, the new man had to make a contribution to the king, some £600 in 1623, and give presents, including gold rings and livery, to administrative officers and Crown servants, and all the nobles and Members of Parliament present at the revel.[48]

Bankes became a serjeant in 1641. He had ascended owing to his "extraordinary discipline in his profession, his grave appearance, and excellent reputation," his "great abilities and unblemished integrity," and, no doubt, his generosity in feasting; in short, "an uncorrupted lawyer | Virtue's great miracle."[49] He had pursued a parallel course of teaching and practicing before taking up his readership at Gray's Inn. His lectures there extolled common law, "the common ancestor to all laws,"[50] and thus senior to the codes followed in civil, maritime, ecclesiastical, and prerogative courts. It was a proposition he often asserted when serving in Parliament. How he deployed it then against the Crown will appear in its place; here it is enough to know that he owed his parliamentary career to the Howards. The connection probably arose through Lord William's need for a good lawyer familiar with Cumberland to help with business associated with his castle at Naworth some 35 miles from Keswick. Evidence of their business connection comes from Howard's ledgers, which also support the guess that Bankes's annual income around 1620 amounted perhaps to £500.[51]

The lord and the lawyer got on well, since Catholic William had a Protestant work ethic, and, as we know, strove to introduce something like law and order into the borderlands.

> [William] Howard, than whom knight
> Was never dubbed, more bold in fight
> Now, when from war and armour free
> More famed for stately courtesy,

had occasion for continuing legal advice, since, to the annoyance of local JPs, he insisted on proceeding in accordance with the law. When his business brought him to London and the house of his nephew, the Earl of Arundel, he enjoyed the company of the learned, for Lord William was also a fair scholar, an exemplary antiquarian, and a book collector. One of his last acquisitions was Sarpi's *Trent* in its third edition, published in 1640, the year of Lord William's death. It joined a library of Catholic devotional works and some diatribes of De Dominis, an assortment consistent with William's anti-Roman Catholicism.[52] We may take him as representative of the vast majority of James's loyal wealthy Catholic subjects. James protected him from the recusancy laws, and he protected other Catholics from the king.[53]

When he acted for Lord William, Bankes probably already inclined towards Arminianism. We might imagine him early in his practice as the briefless lawyer in one of John Harington's epigrams:

> I met a lawyer at the Court this Lent
> And asking what great cause him thither sent
> He said, that mou'd with Doctor Androes fame
> To hear him preach, he only thither came.[54]

Later Bankes copied out notes of Andrewes's sermons.[55] Further evidence of Bankes's religious position derives from his connection with Laud, who considered him an ally in the reform of the church and also of Oxford, to whose statutes he invited Bankes to add "beneficiall clauses as you shall thinke fitt." Since the archbishop entertained Bankes at Lambeth Palace, it appears that their connection was social as well as political. A complaint by a Puritan accused of possessing libelous books confirms the conjecture that, soon after joining the government, if not before,

Bankes had abandoned whatever Calvinist commitments he might have taken on in Keswick. "Mr Attorney, who hath ever been esteemed a religious and godly gentleman…is now very violent against maintayners of the truth."[56]

The vicar of St Bartholomew the Less, William Hall, gives further insight into Bankes's religious–political standing in a dedication to him of a thoroughly Laudian sermon on the power of rulers and magistrates and the duty of the people.[57] A snippet of conversation between Bankes and Richard Sibbes, the popular moderate Puritan preacher of Gray's Inn, allows a similar inference. Sibbes complained often about Laud's insistence on ceremony and hierarchy.[58] Bankes advised him to stick more closely to his texts. "A good Textuary is a good lawyer as well as a good Divine."[59] Explain the writ, squeeze it dry in the manner of Andrewes and the men of Gray's Inn, and accept the outward forms of worship.

In the Royal Bed

James saw himself as a conciliator of religious differences not only among Protestants but also between them and Catholics. To prove his sincerity and fish for an ample dowry, he sought a dynastic connection with a Catholic state. Since he had pledged his daughter Elizabeth, born in 1596, to a rising Protestant leader, Elector Frederick V of the Palatinate, Henry, Prince of Wales, would have to wed a papist. In 1610, Henry then being 16, Wotton proposed the delightful, attractive, demure, and circumspect daughter of Carlo Emanuele II, Duke of Savoy, for the position; though small, Savoy had the important value of controlling strategic Alpine passes. Other Catholic powers with spare daughters then entered the bidding. The Grand Duke of Tuscany, Cosimo II, wooed Henry with wine and salami, bronzes and paintings, and the promise of one of his sisters. Marie de' Medici, as regent of France, offered her daughter Christine, who, however, was only 4, and came with a dowry proportional to her size.[60] The Spanish hinted at a double marriage should Elizabeth jilt Frederick: Philip III

for her, one of his sisters for Henry. Queen Anna plumped for Spain or Tuscany, and, to even the playing field, English Catholics promised a dowry for the Princess of Savoy.[61]

When Prince Henry's sudden death in the fall of 1612 removed the threat of the great heretical prince, the Spanish lost interest in matching with England.[62] The Italian states pursued the new Prince of Wales. Wotton went in great state to Savoy to negotiate a bride for "Baby Charles," then 12, and a dowry James could accept. Carlo Emanuele could not afford it. Cosimo could. Hoping that Henry's death might cause James to reconsider Elizabeth's betrothal, he offered her his brother Francesco, Charles their younger sister Maria, and James a million gold *scudi*. The grand duke required of the king only that he grant Maria freedom of worship, stop molesting English Catholics, and give Elizabeth Ireland as a dowry.[63] Despite these advantages and against Queen Anna's wishes, James married Elizabeth to Frederick.

Spanish Try

It remained to find a Catholic mate for Charles. Against the odds, James raised his game to Spain. This time he had his queen's support.[64] Not so his brother-in-law's. News of a union of England and Spain brought Uncle Christian angrily back to London.[65] He did not succeed in changing James's mind. Still the kings managed a little royal sport, to the tune of £50,000. "The two monarchs were guilty of great intemperance, the Dane being addicted to drunkenness, to which James had not the least objection."[66] It was not, however, the sort of behavior a well-bred Spanish princess would approve. As a better guide to capturing an infanta, James had the wheedling advice of the clever ambassador of Spain, the Count of Gondomar.

Gondomar deftly exploited James's self-image as a peacemaker to keep him from mobilizing European Protestantism, entangled him in cobwebs over terms of the proposed marriage, and sympathized with his need for the money that a large Spanish dowry for Prince Charles would assuage. It is said that "Machiavellian" became a common term in English because

of its frequent application to the Conde de Gondomar. The king and the count became close. When Gondomar left London for a brief visit home, James gave him as going-away presents the release of 100 imprisoned Catholic priests and the head of Sir Walter Raleigh.[67]

A Spanish match became all the more desirable in James's eyes after Habsburg armies dispossessed his daughter Elizabeth, then (in 1620) the Queen of Bohemia. She had risen to royalty when Frederick foolishly accepted the Bohemian crown from Protestant burgers who had no right to offer it. James judged Frederick's acceptance a violation of the Holy Roman Emperor's divine rights in Bohemia; Uncle Christian, less entangled with theory, regarded it as sheer stupidity.[68] The travail of Frederick and Elizabeth marked the onset of the Thirty Years War. They fled to The Hague. Although pressed to intervene to reestablish his kin by force of arms, and although a formal ally of Denmark against aggression by Catholic powers, James pursued peace and a Spanish union. He now hoped not only for a dowry, but also for effective pressure by the new young King of Spain, Philip IV, on his relatives the Austrian Habsburgs to withdraw their armies and their interests from Bohemia.

It was not easy for a Protestant king to bag a Spanish princess. Not only did James face tough opposition at home from people who remembered that the immediate forebears of the intended bride, the Infanta Maria Anna, had launched an Armada against them; he could not hope to gain Philip's assent to the marriage without obtaining prior approval from the pope. He chose as his emissary to Rome George Gage, a Roman Catholic who had been present and supportive when his friend Tobie Matthew received Holy Orders from Bellarmine. Gage was an acute connoisseur, a first-class broker, and a man of sophisticated charm. He charmed Pope Gregory, who approved the proposed match on Gage's insinuation that it would turn Charles Catholic.[69]

By then smitten by pictures and reports of Maria Anna, the Crown Prince of Wales and the royal favorite, the Earl of Buckingham, slipped into Spain incognito to woo the lady in person (Figures 12 and 13). They galloped the 800 miles from Paris to Madrid in thirteen days.[70] Philip IV welcomed their unexpected sweaty arrival, but not their subsequent

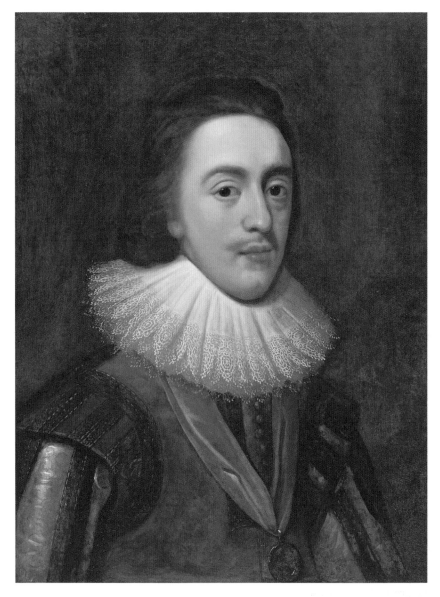

Figure 12 Daniel Mytens, *Prince Charles* (c.1623), age 23.

Figure 13 Diego Velasquez, *Infanta Maria Anna of Spain*, once Charles's inamorata, but at the time depicted, 1630, age 24, the Queen of Hungary.

lengthy sojourn. His councilors opposed the marriage, as did the intended bride, and Philip dared not act against his kinsman the emperor. To extricate himself, Philip tightened the draft marriage contract to require toleration for all Catholics, withdrawal of the laws against recusants, liberal guarantees of free exercise of religion for Maria Anna's household, and prior agreement by parliament to all provisions.[71]

In July 1623, James and his Privy Council swore to accept the terms of any marriage contract Charles, Buckingham, and Tobie Matthew, whom James sent to help with negotiations, managed to consummate in Madrid, and, on the 20th, Andrewes presided over a ratification of the marriage treaty in the Chapel Royal. In secret articles James made the unredeemable promise that Parliament would revoke the recusancy laws within three years. Nonetheless, the affair in Madrid did not prosper. Buckingham insisted that Philip agree to intercede in the Palatinate. Impossible! Matthew made a last appeal: if Philip did not accept the marriage under the conditions offered, the blood of English Catholics would be on his hands.[72] Philip did not mind running the risk. Charles returned to England without his infanta. Instead, and in fact much better, he brought back four canvases by Titian.[73]

It had been a fool's errand, literally. The royal jester Archie had greater access to the infanta and her ladies than the Prince of Wales. So far had the Spanish held the suitor from his *inamorata* that (so Buckingham quipped in a letter to his wife) he needed a telescope to see her. To which his devoted gullible lady replied by sending the best perspective glasses she could find in London and her regrets that "the Prince is kept at such a distance that he needs them."[74] Archie's jokes also were productive, as they gained him a pension without the awkward qualification Philip placed on other such grants.[75] This was to agree to die, preferably soon, reconciled to Rome. Charles's secretary Francis Cottington took advantage of the offer. Thinking himself on his deathbed, he entrusted his soul to the Roman Catholic Church; recovering, he reconverted; from which much later, again facing death, he again reconverted.[76] This last flip-flop occurred after Cottington had served Charles as a chief minister for many years.

The experience in Madrid jolted Charles's religious sensibilities, which had developed under the supervision of tutors and chaplains who had educated Henry. The chaplains included anti-Arminians such as Joseph Hall of Foolania and the Clerk of the Closet Henry Burton, an extreme Puritan fated to return to these pages, and two sober divines trained to sniff and snuff out every whiff of Catholicism. The godly had therefore delighted in Charles: "Wee have yet the Sunne and the Moone [James and Anna], and starres of the Royal firmament: and though we have lost our morning Starre [Henry], yet we have Charls-waine [the pole star] in our Horizon."[77] Andrewes alerted James to the undue influence on the prince of the godly types around him. James quickly replaced Charles's Calvinist secretary with Cottington. That occurred in time for Cottington to join the mad gallop to Madrid. His Catholic sympathies and fourteen years of experience at the English embassy in Spain made him a useful man.

Several English Catholics and Catholic sympathizers who joined the nuptial battle helped to complete Charles's liberation from Henry's militant Protestantism. Among them was Matthew, who found the infanta satisfactory as to person, rather good looking, gentle, charitable, but very stubborn and (what made a bad combination) very pious.[78] There was also Kenelm Digby, the nephew of the English ambassador to Spain, who arrived direct from Tuscany with a recipe for a powder of sympathy that cured wounds when sprinkled on the weapon that inflicted the injury. It worked for James Howell, a traveler in the glass business, who washed up in Spain after buying materials in Venice, which mayhap included telescope lenses useful for spying on princesses; we will encounter him again as a travel writer. Howell's cure won Digby's powder a reputation of infallibility, but it neither cured Charles's puppy love nor made Maria Anna sympathetic.[79] This census of informed Catholicizing Englishmen around Prince Charles in Madrid would be inexcusably incomplete without mentioning Endymion Porter, like Cottington an old Spanish hand, whose many moneymaking schemes would bring him frequently to the attention of Attorney General Bankes. Despite their failure to bring home the

bride and the waste of £48,000 in the effort, Digby and Matthew received knighthood, and Buckingham promotion to duke.[80]

Fallout

Letters from Micanzio to his friend Cavendish, which Hobbes translated into English for a wider audience, offer a Venetian view of these proceedings. Micanzio tried to understand why the wisest of kings was behaving as the greatest of fools. He could only suppose that wily James had a secret purpose that stayed his "mightie arme." He must be very deep. "For neither desire of quietnes nor hate of mutations shall never make me to beleive that the wisest King of this Age, and the most learned of many Ages will neglect the heighth of his glorie especially falling in so joyntly with the service of God, & defense of truth and Justice."[81] And yet, he stands aside as Catholic armies drive his family from Bohemia.[82]

Rumor now has it (in the summer of 1622) that James will conclude the match with Spain and free English Catholics; the pope has set up a committee of cardinals to consider the match and the recovery of England. Yet the infanta resists! The business will boomerang: "the endeavour of the Spanish Ministers to captivate the Prince [of Wales] to their opinions will make an Antiperistasis [a sort of backlash in Aristotelian natural philosophy] which strengthens all motion."[83] Could that be James's deep purpose? No! Micanzio reluctantly accepted the truth that Sarpi had seen much earlier: James was negligent, weak, indecisive, and mediocre, "the learnedest ass in Christendom," made impotent by writing, busy not with issues befitting a king, but with "Vorstius and other paper-battles."[84]

Meanwhile the tragedy of De Dominis was playing out. While rumor was rife that James would convert, De Dominis enjoyed a hero's welcome. He returned to Rome carried in a litter followed by a coach-and-six containing four pages in livery. The display, underwritten by Gondomar, implied that the apostate brought some great news. Pope Gregory absolved him of everything and gave him precedence over all other archbishops. In return, Micanzio continued, De Dominis boasts of his conquests, urges the Spanish match, and writes voluminously against the Protestants.[85]

He is sincere in his zeal for the unification of Christianity: he just does not understand that popes have no interest in religion. Gondomar is no better. He pretends to share De Dominis's cause of unification while conniving to send him for justice to Rome.[86]

Micanzio's analysis ends with the change of popes. Gregory has died, no loss, as the Spanish and the Jesuits controlled him.[87] The new man, Urban VIII, is promising. "He is a man of a fine literature, of a lively witt, obstinat in his owne opinions, a statesman and little above 50 yeares of age." His nature is now (27 October 1623) evident: "violent, confident, apt to thinke him selfe allmighty, [a]bove all he hath most vast dessignes for the extirpation of those that hold contrary opinions to the Church of Rome." One of the first to experience Urban's sting was De Dominis.[88] Galileo would be another. Already, Micanzio reported, foreign books not in conformity with the Vatican's views about the physical world system were unprocurable. Perhaps an antiperistasis will push Copernicus's work. "[S]ince it hath bene prohibited by Rome that hath found Articles of faith also in Mathematicall inventions, it is to be believed that an appetite will grow for reviving it." But there was no hope for Sarpi's *Trent*, "so much as never perhapps hath any booke so much displeased them."[89] It was a great book, so the cardinal nephew Ludovico Ludovisi conceded to the Venetian ambassador to Rome, and all the more dangerous for De Dominis for being so.[90]

The playwright Thomas Middleton had escaped censure for insinuating, more gently than Micanzio, that the situation in Bohemia demanded action, not scholarship, from James.[91] The Spanish debacle gave Middleton another opportunity for trouble. *A game of chesse* celebrated the unmasking of Gondomar and the demise of De Dominis in a hit that ran, unusually, for nine nights in a row before Spanish agents could persuade James to shut it down. Its smallest audience numbered in the thousands.[92] As the Black King, Middleton intended Philip IV; as Black Bishop, the General of the Jesuits; and, among the Whites, James as king, Charles as knight, and Abbot as bishop. The main episodes are the seduction of White pawns by the Black Bishop's (the Jesuit General's) pawn, the White Knight's trip to the Black House, and the plot of the Black Knight (Gondomar) against a fat

bishop (De Dominis). We meet the bishop in the play worrying about his polemics. "Are my Bookes printed, Pawne? My last Inventions agaynst the Blackhouse?" The Black Knight: "Yond greasie tournecoate Gourmandizing Prelate do's worke our house more mischief by his…fat and fulsome Volumes than the whole bodie of adverse partie." The Black Knight helped dupe the Fat Bishop into returning to Rome and the White Knight came back unscathed from the Black House. Among real pawns seduced by the Black side was the mother of the White Duke, Buckingham.[93]

The prince and the duke returned from Madrid spoiling for a fight. James still hoped, however, to recover the Palatinate through Spanish diplomacy. Unable to do so without money and against the opposition of the prince and the duke, he summoned a parliament.[94] He opened it in February 1624 with an uncharacteristic request for advice and assurances that everyone might speak frankly. The Commons waxed enthusiastic over war with Spain, if confined to piracy; rejected a land war for the Palatinate; and insisted on enforcement of the recusancy laws.[95] That was to require what James could not promise. He had just hurriedly arranged to wed Charles to France in the person of Henrietta Maria, the 15-year-old daughter of Henry IV and Marie de' Medici, and the marriage contract provided for protection of Catholics in England. No matter that the provision violated James's previous promise to parliament to make no such concession; among Stuart prerogatives was the right to lie.[96] Was this deception not justified by their expectation that their new in-laws would assist them in the Palatinate? Henrietta Maria's brother, Louis XIII, refused the help. That brought James to the end of his contrivances. He was also near the end of his life. He called Andrewes to his bedside, but the bishop was too ill to attend him.[97] The king committed himself to God with what other help he could muster and left his three conflicted kingdoms to his inadequately prepared son and incompetent favorite.

A Venetian ambassador drew the character of Charles a year or so before he became king: chaste, economical, prudent, prudish, and close, especially in matters of religion. "He moves like a planet in its sphere, so naturally and quietly that one does not remark it." His judgment is good.

But as his father and the favorite often overcome it, he dissimulates. He excels at manly sports, especially on horseback. He frequents a "school of arms" that Henry had set up and works there on "out of the way mathematics and methods of encamping, being very interested in inventions." He is not a student like his father but sometimes reads history or poetry. He speaks French and Latin fluently and knows some Italian. Catholics think that his wife, then expected to be the infanta, will win him over to their religion. Although his defense of Catholics against attacks on them by Puritans may support their optimism, they are wrong.[98]

To these good qualities Charles added connoisseurship and patronage of the arts and the theater. He wrote well, thought a little, and worked hard. In contrast to his father and many of his courtiers, he was sober, decorous, and healthy. In short, he had the skills, interests, and virtues to be an exceptionally good king. He was a catastrophic failure. He could not overcome hesitancy that ended in indecisiveness or impulsiveness; self-doubt that led to overreliance on under-qualified advisers; vacillation over protection of his Catholic subjects; exaggeration of his divine rights and prerogatives that alienated his parliaments; and an agility at self-deception, amounting to genius, that enabled him to ignore the magnificent discrepancies between his means and goals.

Charles's half-educated teenage wife, Henrietta Maria, added greatly to his difficulties. She brought with her a train of priests and nobles to entertain her and a bishop to oversee fulfillment of her pledge to the pope to convert her husband. The blatant behavior of her entourage intensified pressure to enforce the laws against Catholics. Charles responded by collecting recusancy fines, prohibiting the airing of new religious opinions in speech or in writing, threatening English fellow travelers attending French and Italian chapels, and, in violation of his marriage contract, dismissing most of the queen's entourage.[99] These measures did not bring bliss to Charles's wedded life. He did not get along with Henrietta Maria until the murder of Buckingham in 1628 opened political space for her and the birth of an heir, the future Charles II, in 1630 established her claim to it. They then fell in love, uncommonly for royalty, with one another. Many children followed. Being

71

the stronger of the pair and as insistent on royal prerogatives as Charles, Henrietta Maria became a reliable helpmate in precipitating his downfall.

Caroline Cacophony

Arminians

Although even moderate Protestants considered Arminianism the gateway to Catholicism and genuflections, crossings, auricular confession, icons, incense, and priestly vestments so many stations on the road to Rome, Charles came to follow it as far as Andrewes went. It was he who commissioned Laud to publish Andrewes's sermons and who chose as archbishops Laud's guide to Arminius, Richard Neile (York, 1631), and Laud himself (Canterbury, 1633). During the first years of his reign Charles promoted a few Calvinists to please parliament; but, as he grew disenchanted with the Commons, he yielded to his political and aesthetic sensibilities and to Laud's conception of order, decorum, hierarchy, and uniformity.[100] A maverick result of this regulation was the *Collection of Private Devotions* (1627) published by Laud's protégé John Cosin, which specified the number of prayers, theological virtues, good works, and acts of mercy through which anyone so minded might rise arithmetically to God. Strict Calvinists objected to Cosin's calculations. Charles made him a bishop.

Charles hoped to silence religious opponents through a declaration, approved by his bishops in December 1628, which defined the doctrine of the Church of England as the Thirty-Nine Articles and prohibited "further curious search" into theological questions. The kernel of the declaration resembled the decree of the Council of Trent invoked against Galileo: "no man hereafter shall either print or preach to draw the Article aside in any way, but shall submit to it in the plain and full meaning thereof, and shall not put his own sense or comment to be the meaning of the Article, but shall take it in the literal or grammatical sense."[101] Neither James nor Charles would have thought it improper for their fellow divine monarch the pope to silence speculation that might, in his sole judgment, endanger his state or diminish his authority.

On becoming archbishop, Laud ordered his vicar general, Nathaniel Brent, the translator of Sarpi, to enforce liturgical conformity within the archdiocese. Brent detected errors as readily as Trent had multiplied anathemas. He disciplined ministers for giving communion to parishioners standing, wearing inappropriate vestments, and misplacing the communion table. These measures encouraged Puritans weak in tolerance but strong in body to escape to the new settlements in America. The archbishop worried that their number might so increase that they would invade their homeland. He could think of nothing to do about it, however, and contented himself with trying to force English communities in Europe, and children born to European immigrants in England, to worship in the rites and language of the English church.[102]

In June 1636, Laud improved the University of Oxford, already a model establishment, with the new statutes that John Bankes helped to draft. Sir John Coke, one of Charles's two primary secretaries, presented them as the instructions of God's vicar the king, the source of all laws, statutes, justice, honor, and titles in his realm, and also of all powers of persons, parliaments, courts, churches, corporations, societies, counties, and provinces. Two months later the king and queen were in Oxford as guests of Chancellor Laud. The university diverted them with three plays, one of which, *Floating Island* by the university's orator, William Strode, was staged in Christ Church Hall with the elaborate machinery of an Italian masque. One courtier thought it the worst play he had ever seen, "but one he saw in Cambridge."[103]

In Strode's *Floating Island* characters representing Lust, Wrath, and Deceit conspire to rid their country of the laws and person of good King Prudentius. Alerted to the plot, Prudentius follows the advice of Intellectus Agens, a know-it-all concocted for academic amusement from a difficult concept in Aristotle's *De anima*, to leave his crown and disappear. The evil triumvirate offers the crown to Fancie, who finds it too heavy. She acts as queen, however, and directs her courtiers to do as they please. Confusion reigns. Prudentius returns and offers his crown to anyone able to bear its weight and responsibility. No one volunteers. All sue for grace, which wise and kind Prudentius grants. The king then marries the courtiers to one another. The happiest

arrangement couples Melancholy and Concupiscence, on condition that they live in the suburbs, "or new England."[104] According to a Catholic newsmonger, the play amused their Majesties, who fancied that Intellectus Agens was Laud and Concupiscence's mate, Melancholy, a Puritan minister.[105]

Puritans

The noisiest of the Puritans was a lawyer, William Prynne, who injudiciously published a book against play going late in 1632. Laud's chaplain, Peter Heylyn, "pounced upon the book... with unscrupulous malignity." He insinuated that it insulted the queen, who participated in masques and watched plays. In an act of solidarity with their sovereigns, Prynne's colleagues at the Inns of Court presented the king and queen with a masque, James Shirley's *Triumph of Peace* (February 1634), and a feast, at the monumental cost of £21,000, organized by such heavyweight lawyers as John Selden and the Attorney General William Noy. The crowd thronging to see it was so great that the royal couple could scarcely reach their seats. The party continued until dawn.[106]

While the royals reveled, Prynne sat in the Tower awaiting trial. Some of his fellow prisoners were Catholics. To purge himself of contagion he wrote a poem (one of 100) affirming the role of reason in religion. He was right to say that it is wrong to obey "without inquiring the reason why | As beasts obey their masters...".[107] Usually he was not so reasonable. Do you wear your hair long? A pity: you risk damnation. It has happened often.

> Though he were a Modest, Sober, Chast, Industrious, or somewhat Religious person at the first... [he] will soon degenerate into an Idle, Proud, Vainglorious, Unchast, Deboist [debauched], and graceless Ruffian: His Amorous, Frizled, Womanish, and Effeminate haire, and Locke, will draw him on to Idlenesse, Pride, Effeminacy, Wantonesse, Sensualitie, and Voluptuousnesse, by degrees; and all Prophanesse, so to the eternal wrecke and ruine of his Soule. This the woefull, and lamentable experience of thousands in our age can testifie.

QED. Much the same can be said about "that Meretricious, Execrable, and Odious Art of Face-Painting," that "Unnaturall, Detestable, Heathenish,

Proud, Lascivious, Whorish, and Infernall Practice." To stand upright in God's eyes, we must "cut, and cast off all these Love-Locks, Paintings, Powderings, Crimpings, Curlings, Cultures, and Attires" that deform our souls, "but are no luster to our bodies."[108] The language was unreasonable but not, to many of the godly, the reasoning.[109]

The same may be said for Prynne's account of toasts. By drinking the king's health, you start on a downward spiral to drunkenness, "as if you were no better than the Devill Bacchus." Dear King Charles, do you know how serious the danger is? "Many thousand persons both are, and have been drawn to drunkenness and excesse…drinking their wit out of their heads, their health out of their bodies, and God out of their souls, whiles they have been too busie and officious in carousing Healths unto your Sacred Majesty." Drive out those "gracelesse, swinish, and unthrifty Drunkards, the very Drones and caterpillars of a Common-Wealth"! Repair the "weake and sickly body of our State, (which reele[s] and struggle[s] like a drunken man,)"![110] Prynne produced his diatribes with the help of "a pott of Ale" served to him every three hours.[111]

Prynne's *Historiomastix* (1632), his scourge of plays and players, made him the mutilated public face of the purest Protestantism. By refusing to follow Star Chamber's rules of pleading, he was held in contempt. For his insults to the court and to the queen, he had both ears notched or (historians have their disagreements) one sliced off, and indefinite lodging in the Tower of London. His confinement did not abate his pamphleteering. It brought him an ideal collaborator, that Henry Burton who had been ejected from Charles's household for criticizing Laud. Burton had devoted his consequent leisure to lobbying for the slaughter of all Catholic priests found in England, although, he allowed, even such good work as destroying the Jesuits could not alter God's predetermination of the saved and the damned.

Burton and Prynne were strict sabbatarians. They collaborated in attacking Laud and his lieutenants for approving *The Book of Sports*, drawn up in King James's time, which itemized wholesome entertainments allowed on Sundays after services, "thereby so provok[ing] God, that his wrath in sundry places has broken out to the destruction of many." Burton

and Prynne gave fifty-six examples of individuals struck dead or other-wise punished for "such monstrous impieties" as Sunday sports, to which they added, on the authority of that Jesuitical servant of anti-Christ, Robert Cardinal Bellarmine, Turks and the plague.[112] Still, games and Turks were not nearly as dangerous as Laud's prayer book and his bish-ops' usurpation of authority. Burton delivered this alert in sermons on Guy Fawkes Day, 1636.[113] He soon joined Prynne in jail. Rounding out his cull of the professions, Laud tossed in scholarly John Bastwick, MD, a graduate in medicine from Leyden and Padua. Bastwick had made a hobby of hounding bishops.[114]

Star Chamber sentenced the triumvirate to facial mutilation, followed, after recovery, by indefinite imprisonment in different dungeons. Charles's viceroy in Ireland, Thomas Wentworth, a close ally of Laud, and, as will appear, a patron of both John Bankes and Maurice Williams, reckoned the treatment of the triumvirate lenient. "To be shut up and dark kept all their lives is punishment mild enough for such savages...A prince that loseth the force and example of his punishments loseth the greatest part of his dominions." Lacking Wentworth's power of ratiocin-ation, the people of London were disgusted by the barbarity of the pun-ishment and impressed by the fortitude of the sufferers. Perhaps most damaging to the king and his archbishop, the martyrs' status as gentle-men distinguished in their professions earned them the sympathy of classes unmoved by the fates of ordinary miscreants.[115]

Bastwick, Burton, and Prynne went off to their prisons in triumph; the people lined the streets and showered them with gifts. Prynne's path to prison ran through Chester. The mayor gave him a civic dinner and tapes-tries for his cell. Prynne and Burton returned in even greater glory when released by parliament in 1640. A hundred carriages, 1,500 or maybe 2,000 horsemen, and a crowd of 10,000 welcomed them to London. Robert Woodford, a Puritan country lawyer, was there. "Oh blessed be the Lord for this day; those holy livinge Martirs Mr Burton & Mr Prynne came to towne, & the Lords providence brought me out of the Temple to see them, my hart rejoyceth in the Lord for this day its even like the returne

of the Captivity from Babilon."[116] Parliament appreciated Prynne's bombastic style and appointed him its historiographer for the Civil War.

Most Puritans spokesmen of course did not rant like Prynne. The reverend John Geree's précis, *Character of a Puritan* (1646), is a fine example of their humane style. Geree's Puritan worships following God's directions, not "after the traditions of men." He is frequently at private prayer, but also requires preaching, preferably without "vain flourishing of wit." He keeps the Sabbath. He wants his church to be decent, not magnificent, and free from "sensual delight" and bishops. He "abhor[s] the Popish doctrine of *opus operatum*," the idea that good works might help the worker to salvation. Although wishing to act gravely in all things, "yet he denye[s] not himselfe the use of God's blessing, lest he should be unthankfull," and so allows himself to marry. The bottom line, however, is not far from Prynne's: the Puritan's life is perpetual warfare, "wherein Christ [is] his Captaine, his armes, prayers and teares." So armed, the Puritan is "immoveable at all times, so that they who in the midst of many opinions have lost the view of true religion, may return to him, and there find it."[117] The language is gentle but the message unbending.

Catholics

Even with the best of wills, Charles could not have kept his contracted promise to protect Catholics from persecution. Poverty as well as politics forced his hand: "for as it concerneth Religion, so it [also] has relation to his maiesty's Profite."[118] When lenient, Charles released priests from prison and recusants from fines with writs that might bear the explanation, "at the instance of our dearest consort the queene."[119] Henrietta Maria indulged her religion publicly. She maintained opulent chapels, which bold aesthetes came to see for their beauty and frequented to their peril, and reaped many proselytes.[120] Several of Charles's senior ministers had already come over, or so it was rumored: Cottington and Francis Windebank, and the Lord Treasurer Richard Weston, all of whom would die Catholics. If the queen's "religious zeale and constant devotions"

succeeded, the king would be next.[121] "We never had a greater calme," an English agent of the Vatican reported, "since the queene came in than now."[122]

This upbeat report dated from 23 July 1633, a month after the Cardinals' expert in heretical depravity had signed the sentence against Galileo; a few weeks later, on 4 and again on 17 August, Urban, apparently acting on the report, offered Laud a cardinal's hat. The new archbishop turned down the second offer with less than a resounding refusal. "My answer again was, that something dwelt within me, which would not suffer that, till Rome were other than it is."[123] He informed Charles of the offer. It did not disturb the détente then developing between king and pope, or discussions between Cottington's group and cardinals Bentivoglio and Barberini.[124]

The pope's agent in the queen's entourage, Gregorio Panzani, kept the good news flowing. He wrote that most Protestant bishops would happily combine with Catholics "for the ruine and rooting out of Puritanes" and that the king, both universities, and the nobility were likewise flexible. Catholics, though few in number, included people possessed of great wealth and high office. Charles might almost be counted among them, since, Panzani reported, he and most of his nobility "beleeve all that is taught by the Church, but not by the Court, of Rome."[125] Urban knew enough about England to replace Panzani with a more astute courtier. He was George Conn, who took up his post in July 1636 and has an important role in our story.[126]

Conn was a scion of a noble Scottish family, a historian of Scotland, a panegyrist of Charles's grandmother Mary Queen of Scots, and an intimate of the Barberini. He was also a man of the world, having served secular princes for years before entering clerical life in 1623, and, as Cardinal Barberini's secretary for Latin correspondence with German states, knew more about the affairs of the Palatinate than Charles.[127] Conn had every reason to expect that Urban would be as eager for the reconversion of England as he. On the very day of his inauguration, the pope had found time to open the question. Urban: "What news of King James and Prince Charles? Does there appear to be any hope of their conversion to

the faith of their forefathers?" Conn: "[T]he offspring of Maria Stuart…they will return to the Church…never has a King or Queen of Scotland died separated from it."[128] James had not yet made himself an exception to this rule.

Conn prepared for his mission by composing an account of the points at issue between Protestants and Catholics. He would draw only on Scripture, he wrote; Protestants had nothing to fear from him, "nothing to suspect, nothing to fear, everything sincere, safe, and hopeful." On the question of predestination, however, Conn showed his steel. Protestants who doubted the compatibility of God's foreknowledge with human free will presumptuously measured God's mind by theirs. "Is there anyone so dull and stupid as to insist that free will cannot agree with God's prevision?" Do not be duped by logic! "Impious and pertinacious sloth should be beaten with sticks until…it is willing to abstain from syllogisms."[129]

When Henrietta Maria became aware of Conn's willingness to do without syllogisms and his other merits, she urged Urban to make him a cardinal and to send him to quiet the perennial disputes among English Catholics. Perhaps she also knew that Conn had had a hand in marrying her to Charles; for, when Urban tried to impose conditions on the license, Conn kept the English negotiators usefully informed about Vatican strategy.[130] Urban did not accede to the queen's desire to make Conn a cardinal. The gambit of enticing Laud with a cardinal's hat had not worked and it would have been wasteful to give a Scot one before securing Charles.[131] Conn soon showed his acumen and diplomacy by winning the support of the secular faction of English Catholics, perhaps with the help of his brother, who served the queen.[132]

Conn had many stories to tell about the Roman court. He belonged to a circle centered on Giovanni Ciampoli, a Vatican insider and a member of the academy of lynxes. The circle included a busybody convert, Kaspar Schoppe, who had ingratiated himself with Clement VIII by devising strategies for harvesting Protestant souls during the Jubilee of 1600 and with Paul V for rebutting King James's claim to divine-right rule. During this last exercise Schoppe uncovered and exploited Wotton's famous

indiscreet quip, "an ambassador is an honest man sent abroad to lie for the good of his country." Though to Wotton he was "a mud-caked quack of the Roman curia," a "starving turncoat," Schoppe dug up more than dirt.[133] A list he composed in the 1620s of the forty deserving intellectuals in Rome is a valuable document; it includes Conn among many other people favorable to Galileo.[134] Schoppe, Galileo, and a few of the forty deserving intellectuals persuaded a cardinal, Friedrich Eitel von Zollern, to air the Copernican question with Urban. The cardinal extracted from the pope the opinion that sun-centered astronomy had not been, and would not be, declared heretical.[135] Conn abetted their good work by recommending to the Barberini that Galileo proceed with the *Dialogue*. He left Rome a hero, not, to be sure, of Galilean advocacy, but of a poem in praise of ink, for his paradoxical portrayal in so dark a medium of the eternal glory of Mary Queen of Scots.[136]

Conn quickly gained the confidence of Mary's grandson by declaring that he had no difficulty serving both the Pope of Rome and the King of England and Scotland. "The king immediately gave me his hand saying, No, Giorgio, assure yourself [I know] that."[137] The pope's man joined the king and queen at Oxford for the performance of *The Floating Island*. Lady Arundel welcomed him to her table and chessboard, and, together with the queen and Endymion Porter's wife, Olivia, helped him to make many conquests, inevitably known as Connverts.[138] Like Wotton in Venice, so Conn in London made friends among the mighty to subvert the religion of the state. So many were his Connverts that the openness with which Henrietta Maria paraded them made him uneasy.[139] Lady Olivia was if anything even less discreet. While her father's last moments ticked away, she bundled him into her carriage to be brought for conversion just before his Protestant daughter arrived on a similar errand to another place. Of Lady Olivia's deathbed rescue of her father, the learned lawyer John Selden, whom we shall consult later, observed, "[T]o turn a man when he lies dying, is just like one who hath a long time solicited a woman, and cannot obtain his end; at length makes her drunk, and so lies with her."[140] Wealthy Anglicans wishing to die Catholic took the easier course of keeping a priest at home.[141]

Conn soon ran into the minefield of the Oath of Allegiance. He made some progress with Charles, who was uncharacteristically open about it. "The King put his hand on my shoulder [Conn reported] and replied, it is not yet time."[142] Neither Rome nor parliament would yield.[143] Conn remarked to Charles that in Rome they thought the king was above parliament. Charles replied that he thought so too but added that only parliament could change the oath.[144] In none of his negotiations did Conn try to use Laud; he distrusted the archbishop for intimating friendship for Rome while urging enforcement of the penal laws against Catholics and their subscription to the Oath of Allegiance in its original form and literal meaning. Despite Laud's love of vestments, altar rails, crucifixes, statues, and bishops, God would never (so Conn judged) make use of so weak an instrument in so great a cause as the conversion of England.[145] Conn started his journey back to Rome in the summer of 1639. There he died in January 1640, leaving to his imperceptive predecessor Panzani an *occhiale prospettico moltiplicatore*—that is, a good telescope.[146]

Calvinists

When King James visited his native kingdom in 1617, he required that it observe the religious practices of the Church of England. With the Stuart genius for compromise, he told his countrymen that they were barbarians for not kneeling to receive Communion. The order to genuflect was one of the Five Articles James had declared at Perth, which defined the minimum liturgy required for conformance in Scotland; other provisions mandated confirmation by bishops and celebration of Christmas and other pre-Reformation holidays. The articles irritated the Scots almost as much as the institution of bishops, which James had imposed on them in 1612. When Charles went to Scotland for his coronation in 1633, he brought Laud and a new prayer book to ensure that the Scots approached God as decorously as the English. The following year the king ordered the Scottish bishops to devise a liturgy "as near that of England as might be." Opposition to it provoked a discovery as fine as Bedell's about Paul V. Reading vv as M, VVILL. LaVD sums to 666.[147]

The new liturgy was tried at St Giles Cathedral in Edinburgh in July 1637. The congregation rebelled; Charles ordered enforcement; the people heard popery knocking at the door; and a great popular movement against the bishops began to stir.[148] In February 1638, resistance organized and spread around a covenant whose subscribers undertook to defend the true religion against all comers and consequences. Charles explained that he had not intended any innovations, and would not press the prayer book provided that his loving people foreswore their covenant: for should they gain the control it asserted, he would be no stronger in Edinburgh than (the comparison haunted him) the doge in Venice, "which I will rather die than suffer." This bravado, offered in June 1638, responded to Scottish demands for an Assembly of Clergy. The English doge agreed. By December the Assembly had swept away from Scotland the prayer book, the canons, the Articles of Perth, and the bishops.[149]

As war rumbled, Charles put Arundel in charge of fortifying England's northern borders. Catholicizing members of the Privy Council, Arundel, Cottington, and Windebank, urged armed confrontation; the Exchequer being empty, they had to contain their impatience. In the autumn of 1638, as thousands signed the Scottish Covenant, Charles suffered a blow that can only inspire sympathy. His impossible mother-in-law, Marie de' Medici, came uninvited with a retinue of 600 and a monthly cost equal to that of keeping 1,200 soldiers in the field. Charles appealed to his brother-in-law to allow her to return to France; Louis proposed her native Florence; she preferred England. To cover her exactions and prepare for war, Charles scurried after money: English bishops and other high officials contributed £50,000; loyal Catholics gave £20,000, scarcely enough for a month of war, but something toward collecting an army of untrained pressed men who could live off the land while traveling to the Scottish frontier.[150]

The first "Bishops' War" began in March 1639 and ended in June. Charles's forces, inexperienced unwilling men commanded by inexperienced committed commanders like himself and Arundel, were no match for the willing men and war-hardened officers fielded by the Scots. Uncle Christian

offered to help in exchange for the Shetland and Orkney islands; his nephew declined the terms.[151] Quite unconscious of the superiority of the Scottish forces, Charles complacently contemplated one of their encampments a dozen miles distant through a telescope. "Come, let us go to supper," he said, "the number is not considerable." Charles further demonstrated his misunderstanding of his situation by suggesting, as a basis for peace, that the Scots "take my word, and…submit all to my judgment." They preferred a written agreement. It provided that the Scots disband their army and give back the royal castles they had taken, and that Charles disband his army and acknowledge the Assembly and the Scottish Parliament.[152]

Though Charles was well out of his war, he could not bring himself to rescind any act by which his father had established bishops in Scotland: the scaffolding would remain though the building be destroyed. He would also retain the authority "to call assemblies and dissolve them, and to have a negative voice in them as is accustomed in all supreme powers in Christianity."[153] War loomed once more. Where was the money to come from? The Crown tried to raise it from Spain against the cynical collateral of all English ships at that moment anchored in Spanish harbors. No deal. The queen and Secretary Windebank appealed to Rome. Urban replied that he would be happy to help a Catholic King of England. The Privy Council discussed debasing the currency. Charles required the nobles of the land and their servants to attend him at their expense. With £20,000 in hand, a promise of another £20,000 a year from the bishops, and a loan begun in the Privy Council that reached £250,000 in May 1640, Charles went to war again in June and suffered definitive defeat near Newcastle in August.[154] To secure a truce, he agreed to pay the expenses of the occupying Scots; to secure the money, he called a parliament, the second in the year. The first, the "Short Parliament," had sat for three weeks in April before Charles terminated it for airing its grievances instead of granting him subsidies. The second, the "Long Parliament," assembled early in November and sat for twenty years. It looked around for scapegoats. A week before Christmas it sent Laud to the Tower.

The spadework for the prosecution of Laud was the pleasant task of Prynne. He soon dug up a devastating document, of which he published

an account with pungent annotations under the title *Romes Master-peece*. The masterpiece was the reconversion of England.[155] When Laud learned about it in the autumn of 1640, the plotters claimed to be well advanced. The Jesuits fomented it, of course, and Conn had abetted it by offering the king "gifts of Pictures, Antiquities, Idols and other vanities brought from Rome." The plotters had enlisted Endymion Porter, "of the King's bed-chamber, most addicted to the Popish religion…[and] a bitter enemy of the King;" the inevitable Tobie Matthew, a Catholic priest, George Gage, a namesake of Mathew's friend Gage, who had cleverly filled a palace with lascivious pictures to distract attention from the convent of nuns he maintained underground; and Secretary Windebank, "a most fierce Papist…the most unfaithful to the King of all men."[156] Lady Arundel "bends all her nerves to the Universal Reformation," meets the Pope's agent three times a day, openly entertains him at her table, and tells him everything. Prynne: "The Jesuits learn of the Serpent to seduce Men by female Instruments."[157] If the combined efforts of the fifty Scottish Jesuits said to be in London and the blandishments of the pope did not bring Charles around, he was to be eliminated by an ornament in Conn's possession, a nut stuffed with poison. Prynne: "Jesuits make but a vaunt of poysoning Kings."[158]

The English ambassador at The Hague, Sir William Boswell, knew about the plot from a chaplain serving the Queen of Bohemia; Boswell told Laud, and Laud told the king. Boswell's assurance that the unknown informant was ready to take an oath (Laud: "A very good argument of truth and reality") and had spent a few years in the court and city of London ("Therefore a man of note and substance") seems to have made the archbishop, who initially thought the plot a hoax, a believer.[159] And yet neither he nor Charles had acted in the emergency. Prynne again: "[Laud] will farre sooner hug a Popish Priest to his bosome, than take a Puritan by the little finger."[160] Did not Rome offer him a cardinal's hat? Nor can the king be exonerated. Did he not order Laud to order the Dean of Exeter to stop calling the pope "anti-Christ"?[161] And did both of them not connive at having the psalms sung in the Gregorian manner in the Chapel Royal?[162]

It was now clear that King Charles's laxity had allowed papists to flourish everywhere, in the court, Privy Council, bedchamber, and royal bed. He had allowed Jesuits to stir up rebellion in Ireland and wars in England. To arms! The plot is "now driven on almost to its perfection." We must act, and act together, "lest we perish through our owne private dissensions, folly, cowardice, covetousnesse, treachery, and scurrility."[163] "By what Romish Strategems, Pollicies, Councels, Instruments circumvented, abused, [and] mis-councelled [have] the Kingdomes, Churches, Religions...been for sundry past-yeares reduced"! Thus, like Americans bamboozled to look for communists under every bed, many of Charles's subjects, remembering the Gunpowder Plot and the Armada, Gondomar and the Spanish match, were ready to believe, or feign belief, in "many hidden, or forgotten Roman Plots of darkness."[164]

It was not unreasonable to suspect a conspiracy. The liberty Catholics enjoyed at Charles's court in 1640 amazed Conn's successor Carlo Rossetti. A Franciscan theologian, Henrietta Maria's almoner Aegidius Chaissy, openly lectured in Oxford in 1641, and saved a few souls. It is said he almost bagged Ussher's.[165] There was no end of evidence of sedition: the queen's efforts to enlist the aid of the Vatican, Windebank's orders of reprieve for arrested Catholics, and the ferocious Wentworth's Irish army, which Charles refused to disband. In spring 1641, there came a rumor of invasion by France. Persecution of Catholics increased, with one result most satisfying to Charles. Parliament expelled his expensive conspiratorial mother-in-law.[166] In May, the Commons passed a "Protestation," modeled on the Scottish Covenant, which required the swearer to uphold the Church of England; the Lords rejected it; the Commons responded by proposing the removal of Catholics from court and attendance on the Queen.[167] Nonetheless, when Rossetti took leave of the royal couple, Charles allowed that if he again became master in his dominions he would treat the pope's spiritual subjects with the greatest gentleness. The queen clarified that in that happy circumstance it might take her husband some time to decide on the measures he would take owing to his habitual inability to make up his mind.[168]

3

THE KING AND HIS LAWYER

The English "constitution" had no logical space for the Stuart kings to exercise all the prerogatives they claimed by divine right. Their income scarcely covered their extravagant household expenses and gifts to courtiers; and for defense of the realm they depended on occasional parliaments. Parliamentary grants and military expenditures usually stayed well below £500,000, about 10,000 times the annual income of a building craftsman in London, 1,000 times a successful lawyer's, 100 times a billionaire's, and 10 times a prince's. At his accession, Charles's family debts—his own, his father's, and the still encumbered estate of his mother—stood at well over £1m.[1]

The Commons usually demanded in return for its grants that the sovereign confirm its "privileges" and redress its "grievances." Since parliaments existed only at the call of the king, and the king could meet his obligations legally only by grants from parliaments, governing required compromises on both sides. When either refused to budge, the king dismissed his sitting parliament and went away empty handed. To encourage a more cooperative spirit in the next inevitable session, he might send a few dissident members of the dissolved parliament to one of his better prisons for a period of reflection.

James had not played this game very well. Under the leadership of Edwin Sandys, the Commons of his first English parliament (1604) demanded the abolition of wardships (imposed custodianships) and purveyance (provision of goods under market value), opposed proposals for the unification of Scotland and England, and insisted that the Privileges of

Parliament anteceded the Prerogatives of Kings. James dismissed it before it had accomplished anything. He did better on his second try, in 1606–7; he received £450,000, probably more in gratitude that the state had survived the Gunpowder Plot than in admiration of his stewardship. He spent much of it on court favorites and other hunting dogs. In 1608, with a debt of £538,000, the Crown was running at an annual deficit of around £100,000. Another try, in 1610, almost reached a "Grand Contract" by which the Crown would surrender wardship, purveyance, and other perquisites in exchange for £600,000 down and an annual grant of £200,000. But disagreement over impositions (duties on goods assessed without parliamentary consent) forced dissolution without decision. And so it went. James demanded subsidies without haggling from his fourth parliament (1614); it refused; he sent it packing and imprisoned four of its former members whose speeches he regarded as seditious.[2]

The plain speaking in parliament in 1614 was not the English way. As Wotton observed, outspoken opposition was "better becoming a Senate of Venice, where the treaters are perpetual princes, than where those that speak so irreverently are so soon to return (which they should remember) to the natural capacity of subjects."[3] Again the fatal metaphor: for if the Commons were the Senate, the king was the doge. James did not call another parliament for seven years. To its advice that he desist from the Spanish match and intervene in Bohemia he replied that such questions touched inviolable *arcana imperii*, the "forbidden Arke of Our absolute and indisputable Prerogative," and prohibited their discussion. The parliament of 1621 claimed free speech as an "ancient and undoubted right;" James regarded it and all other rights he acknowledged as generous gifts from himself and his predecessors.[4] The Commons secured the removal of certain monopolies for the modest grant of £160,000 and its own removal for pressing execution of the recusancy laws while James was trying to make his Spanish match.[5]

To make do with what he had, James required effective ministers. During his first decade as King of England, he had the service of the experienced Salisbury and two of the Howard family, which he had

restored to the influence it had lost for supporting his mother. James's Howard ministers were Henry, Earl of Northampton, who "spare[d] not to conjure both priests and devils for his master's service," and Northampton's nephew Thomas, Earl of Suffolk, who conjured for his master while generously helping himself. One succeeded the other as Lord Treasurer after Salisbury's death in 1612.[6] Howard power peaked the following year with the marriage of Suffolk's beautiful and unscrupulous daughter Frances to the royal favorite Robert Carr, by then advanced to Earl of Somerset.

Their fall came more swiftly than their resurrection. Northampton died in 1614; Somerset and his wife were banished for murder; and Frances's father Suffolk, who pillaged the Treasury to pay for his vast mansion of Audley End, was cashiered in 1618.[7] The only Howard remaining close to power was the Earl of Arundel, made a Privy Councilor in 1616. Perhaps by chance, on Christmas Day 1615, he had repudiated "the worthy example of his blessed father," St Philip Howard, who had died a martyr in the Tower, and converted to the Church of England.[8] The Howards' fall created the vacuum filled by George Villiers, who rose quickly from an untitled gentleman of the Bedchamber (with duties as assigned) to member of the Privy Council and Earl of Buckingham, and, in 1619, with no knowledge of the Navy, to Lord Admiral of England.[9] He was the worst of the political liabilities that James left his son.

Member of Parliament

John Bankes's first parliament was James's last. The neophyte represented Wotton Basset in Wiltshire, which tended to return strangers, particularly courtiers and lawyers, who did not need local financing.[10] The session of 1624 offered an unusual opportunity for a newcomer to shine owing to the king's invitation to its members to speak freely. That they did, particularly about James's Spanish policy, still supported, in February 1624, by Catholic sympathizers such as Arundel, Cottington, Richard Weston (Chancellor of the Exchequer), and Lionel Cranfield (Lord Treasurer).

Parliament demanded that James break with Spain. Being broke, James broke.[11] The prince and the duke then purged the government of opponents to a Spanish war and charged the Earl of Bristol (the ambassador to Spain) with disobeying instructions from London. Bankes witnessed at first hand the working of a system with no space for reasoned dissent. Officials whose advice displeased went to the wall. Sometimes, like Cottington, Arundel, and Bristol, they bounced back. Or, like Cranfield, did not. He spiraled away from the royal sun like a "strange and prodigious comet." What he possessed of the earth passed to Buckingham.[12]

On the great question, war or peace, the parliament of 1624 favored war. But against whom? As we know, it granted the inadequate sum of £300,000 for warlike purposes, including defense of the "true religion of Almighty God." James accepted the money but declined to name the enemy. No wonder! He wanted a coalition against the Austrian Habsburgs; his son and favorite wanted a direct attack on Spain; the Commons preferred piracy. At James's insistence, parliament removed the phrase about true religion lest it hamper his efforts to bring Catholic powers into his imaginary coalition. In domestic matters, the Commons grieved as usual over illegal exactions, impositions, monopolies, and arbitrary imprisonment.[13]

Bankes made himself known to parliamentary leaders during the first few days of the session. He gave seven recorded speeches and earned thirty-two committee nominations. His first speech advocated benefits for the impoverished northern counties from which he sprang. Less parochially he worked to correct abuses in the application of habeas corpus, which he took to be the foundation of English liberties. The common law is the common foundation of law! Bankes advised, and sometimes chaired, committees on financial matters of national importance. He attacked big monopolists like the Merchant Adventurers, declaring their charters illegal and their corner on cloth exports a grievance. "[T]rade should not be left to be governed by a few private men who seek but their profit." Evenhandedly, he denounced the Crown for taxing cloth exports. He did not succeed, however, in delaying proceedings against Cranfield—not because he objected to going after a royal official, but because he

judged the case too weak. And, if he behaved as other lawyers, he opposed the Crown over foreign policy and dynastic wars.[14]

Although Bankes's experience in the frank parliament of 1624 left him with a taste and ambition for public service, he did not return for the session that Charles called almost immediately after his accession. The king needed money desperately to carry on no fewer than three simultaneous wars: one, against his was-to-be brother-in-law Philip, for insults received in Spain and other mischief; another, against his new brother-in-law Louis, for persecution of Huguenots in France; and still another, in favor of his old brother-in-law Frederick, for recovery of the Palatinate. As parliament declined to be drawn further into warfare, the warrior king killed it, after eight weeks of life.[15] Without adequate means or preparation, Lord Admiral Buckingham's Navy attacked Cadiz and La Rochelle, disasters both. They added to Charles's burdens a swarm of disgruntled, unpaid veterans. He had no choice but to call another parliament.[16] It assembled in February 1626, with Bankes sitting for Morpeth in Northumberland, where Lord William held the manor. The inaugural session began with prayers and an uncompromising sermon by the new Bishop of Bath and Wells, William Laud, who declared that "all inferior powers of nobles, judges, and magistrates" derived from the king.[17] Bankes's political ideas did not include subordination of judges to kings. Nor did the leader of his faction, Lord Arundel, accept that he owed his status to the reigning monarch. He did not have to listen to Laud, however, as he had been sent to the Tower for opposing continental wars and marrying his son against royal wishes.[18]

On the second day, after the Speaker of the Commons had praised the English constitution and the Chancellor had advised that it exercise the privileges graciously extended to it with discretion, the king asked parliament to authorize £1,067, 221, plus 13 shillings and tuppence, for the year's military and naval operations.[19] The staggered Commons offered subsidies amounting to about a fifth of it and turned to impeaching Buckingham for mishandling his many offices. The Lord Admiral had become the loudest voice in the Privy Council and the Bedchamber, Master of the

Horse, Stewart-Constable of several castles, Lord Warden of the Cinque Ports, Chief Magistrate of all royal forests south of the Trent, and the main and most expensive route to royal patronage.

Bankes spoke to all these matters. Against Buckingham he criticized the state of the Navy, sought the cause of the Cadiz disaster, and advised, if the impeachment succeeded, that the duke be expelled from the Lords and imprisoned indefinitely. Against the Chancellor's implicit claim that parliament's privileges derived from the Crown, he insisted that, as the highest court in the land, it had aboriginal authority and liberties; "as ancient as is our Commonwealth are our privileges." In other speeches (of fifteen recorded) he attacked restraints on trade (making common cause with Edwin Sandys) and discussed bills of grievance.[20] He might have said more had the king not dissolved parliament in June. Unable even to contemplate Buckingham's impeachment, he forfeited the grant, even to the tuppence, he needed. That was to do himself and the Commons serious injury. "Infinite almost was the sadness of each man's heart and the dejection of his countenance that truly loved the church and commonwealth at the sudden and abortive breach of the present Parliament."[21] Thus did the Calvinist member Simonds D'Ewes, taking time from blasting the "blasphemies of Arminius" and other "brazen-faced … Popish points," lament the break with his king.[22] Charles defiantly added the Chancellorship of Cambridge University to the employments of his Pooh Bah and sent two leaders of the Commons, John Eliot and Dudley Digges, to the Tower for orchestrating the impeachment.

To carry on, Charles continued to collect the custom duties (Tonnage and Poundage (T&P)) that his first parliament had given for a year only and its successor had not extended; and he asked for voluntary loans from his loving people, who did not prove spontaneously generous. By adding some force to his requests, he extorted the large sum of £236,000. Some merchants refused to pay on principle. Charles jailed five of these knights without specifying a charge. An important legal battle ensued. Bankes's colleague Selden argued that the imprisonment of the Five Knights without charge violated *Magna carta*; the Attorney General, Robert Heath,

replied that secret reasons of state required their detention; the Court of King's Bench, purged of its chief justice, who had refused to declare the forced loan legal, decided for the Crown. In the opinion of the greatest of common lawyers, Edward Coke, the cowardly verdict in the Five Knights' Case was the gravest threat ever to the liberties of Englishmen. It set up a showdown in which Bankes took part when parliament assembled again in March 1628.[23]

Charles's methods of extra-parliamentary finance occupied the background. He had continued to collect T&P, recusancy fines, and impositions while raising one-time money from the sale of Crown lands and jewels, empty titles, and monopolies.[24] He continued to fantasize about relieving La Rochelle and fulfilling his promise to support his uncle Christian, who had suffered a major defeat in August 1626. Charles could do nothing. Christian was able to make an advantageous peace with the emperor, by which he lost little beyond any respect or affection he had had for his nephew.[25] The nephew was still bent on bending France, Spain, and the empire to his will. The resources? Charles asked the parliament he called in 1628 for the unrealistically large sums of £700,000 immediately and £600,000 a year subsequently. The Commons preferred to discuss grievances. John Bankes, again representing Morpeth, again spoke to all the main ones, thirteen speeches in all. His earlier performance and capacity for business earned him appointment to the committee on T&P, of which he became chairman. Its deliberations sometimes ascended to the full House under Bankes's gavel; but, as parliament could not decide whether to punish the custom agents (and so exonerate the king) or take up the general revenue problem (and so confront the king), it managed to do nothing useful about either.

Bankes also sat on the key committee charged with drawing up a bill of grievances and occasionally chaired it too. He spoke out against the royal practice of granting monopolies; against arbitrary arrest and confiscation of property; and against the quartering of troops and the unilateral declaration of martial law. To ensure the liberties of the subject, he presented a bill to confirm *Magna carta* and similar statutes.[26] Against Bankes's bill,

Attorney General Heath argued that common lawyers were too inflexible (too "mathematical," as Mr Attorney put it) in refusing exceptions to *Magna carta* for reasons of state. Bankes and other common lawyers replied that *Magna carta* was the bulwark of English liberties and permitted no exceptions. The Lords hesitated. The king resolved the impasse by asking whether parliament would not "rest upon his royal word and promise." The Lords thought it safer to follow the mathematical way of the Commons, thus almost exposing the fiction that blamed ministers, never their master, for breaches of trust.[27]

Although he placed the common law above the royal will, Bankes took care not to press its priority so far as to uncover the fiction of divine-right prerogative. "I will not derogate from the power of kings. Subjects have their rights, and kings their prerogatives…Liberties and prerogatives have many hundred years gone together in sweet harmony." But, then, what happens when the king imprisons without charge and the courts refuse *habeas corpus*? The question took Bankes to an uncomfortable position. He advised that arbitrary arrest not be asserted as a grievance; rather, parliament should condemn the practice and expect the king to refrain from it. And so back to the good old times: "We will not be authors of new opinions, but maintain the old." To insure our rights and pass them on we must look backward, seek precedent, become antiquaries.[28] Above all, let us have nothing new: "We possess laws providing first in general against all forms of innovation."[29] The doctrine that all changes are for the worst had defeated John Dee's advice to Elizabeth to adopt the Gregorian calendar.[30] The leader of the Commons of 1628 asserted the same stultifying principle: "[T]ime must needs bring about some alterations, and every alteration is a step and a degree towards a dissolution."[31]

The Commons decided to put forward arbitrary commitment to prison together with forced loans, quartering of troops on civilians, and military rule in peacetime as grievances in a Petition of Right, which, of course, they advanced with the fiction that it contained no novelties. Of the four grievances, the most difficult for Charles to redress was just the power

Bankes had identified as a locus of constitutional conflict, commitment without charge. Its loss, the king said, would "soon dissolve the foundation and frame of our monarchy." For the rest, he was pleased to affirm the laws and statutes of the land. This response caused great lamentation in the Commons, "some weeping, some expostulating, some prophesying of the fatal ruin of our kingdom." A little harassing of Buckingham brought his master around, almost. On 7 June 1628, Charles agreed to the petition with the tacit reservation, based on a secret poll of the judges of King's Bench, that its provisions did not bind him.[32] Parliament turned its attention to Bankes's work on T&P. Charles prorogued it for four months and took the opportunity of its enforced vacation to promote Laud and other Arminian churchmen most offensive to the Calvinist Commons.[33]

During the prorogation, Buckingham met his end at the hands of an unpaid veteran, John Felton, who knew that the admiral had lied about the extent of his military disasters. Unhealthily given to reading, Felton armed himself with the Petition of Right and a knife and killed Buckingham two weeks before Charles's forced-loan fleet sailed for La Rochelle and another disaster.[34] The murder, perpetrated on 23 August 1628, delighted the crowd and devastated the king. It took from him his best friend and trusted adviser just as he faced a new session of an increasingly hostile parliament. He prepared for its return in January 1629 by appeasing Arundel, Wentworth, and other opposition leaders, and by raising Chancellor of the Exchequer Weston, who sat in a Howard seat in parliament, to Lord Treasurer.[35] Although as Treasurer Weston retrenched on household expenses and pensions and increased income from Crown lands, he could not hope to balance the royal books without T&P.[36] The Commons of 1629, led by the lawyers Selden and the future Attorney General William Noy, refused to hand it over. They had stiffened their backbones by reading Bankes's report, which exposed unauthorized impositions as threats to parliament's existence. A constitutional crisis loomed: "[We] take this as a highe point of priviledge, and his Majestie takes it as a highe point of a Soveragnty."[37] Charles did not like the trend of events and ordered parliament to adjourn. That was a bad miscalculation.

When the Speaker John Finch—Bankes's longtime colleague at Gray's Inn—tried to follow the king's order to end the session, several members pinned him to his chair while the House hurriedly passed resolutions put forward by Eliot: anyone pursuing T&P without the consent of parliament, or anyone countenancing Catholicism or Arminianism or other innovation in religion, would be "a capital enemy of the Commonwealth."[38] Charles responded by sending nine members to the Tower, including Selden and the unfortunate Eliot, who, despite the Petition of Right, never saw freedom again. Charles explained that he dissolved parliament in 1629 because the "malevolent . . . vipers" who led the Commons had poked into royal policy on religion and trade and the conduct of his principal officers, to the "unsufferable disturbance and scandal of justice and government." To sidestep these "innovations" (both sides used this gambit), to preclude parliament's seizing a "universal over-swaying power to themselves, which belongs to us," Charles would do without the Houses.[39] At first he did better that way. Weston continued to collect T&P, and even to increase it, without precipitating a revolution. Peace with France was achieved in April 1629 and with Spain, after lengthy negotiations, in November 1630. Without wars to pay for, Weston almost balanced the budget.

The common lawyers who had written the Petition of Right made every effort to free the nine members imprisoned without bail in violation of its terms. Charles claimed that the prisoners had no recourse by right but might be released by grace, if they asked for it. They refused: they had committed no crime. Nonetheless, the tame judges of King's Bench would not grant bail, since, technically, they did not know the unspecified crime involved. Eventually all but Eliot found words with which to buy their freedom. For example, Selden regained full liberty by humbly requesting Charles to pardon him for any displeasure he had inflicted. He requested a grace for causing annoyance, not for committing a crime.[40]

Until 1639, when he went to war again, Charles might have lived within his means. Over the five years preceding Weston's death in 1635, the average ordinary annual expenses of the Crown, at £636,000, exceeded income by only £18,000. It would not have been difficult to remove it.

Foreign visitors were amazed at the size of Charles's household, which descended from a bedchamber of two dozen gentlemen who counseled and protected him through ushers, carvers, cupbearers, guards, wardrobe keepers, cleaners, and kitchen staff to the thirty falconers and forty huntsmen who catered to his hobbies. The combined households of Charles, Henrietta Maria, and the infant Prince of Wales occupied at least 2,000 people.[41] The cost of wars and other extraordinary expenses amounted to £2.85m over the decade 1626–35 against an income of £2.60m. In 1635 the total debt stood at £1.17 million, some £340,000 less than when Weston took over as Treasurer. Although Weston managed to cut pensions, he could not quash lavish gifts to courtiers and absurd provisions for the infant Prince of Wales (born in 1630), whose household of 200 or 300 included two physicians, an apothecary, and an Attorney General.[42] The first incumbent of this last office was John Bankes.

Mr Attorney

With the assassination of Buckingham and the beginning of personal rule without the cash and counsel of parliament, Charles found himself much in need of reliable advisers and clever lawyers able to devise ways of augmenting his income. He turned to men who had demonstrated their abilities in parliament by opposing him, Wentworth, Arundel, Noy, Digges, and others. They joined the government out of ambition sometimes moderated by a sincere desire to replace Buckingham's erratic impetuosity with considered counsel.[43] John Bankes entered the lower ranks of the tergiversators as general counsel to the future Charles II, then, in 1631, a litigious infant a year old.[44] The easy duties gave Bankes the opportunity to free himself from a mathematical interpretation of *Magna carta* and Charles the opportunity to assess further a former opponent in parliament who had not wanted to raise arbitrary arrest to a grievance.

Charles's government recognized Bankes's learning and fairness not only from his behavior in parliament but also from advice he gave to the

Privy Council about some land transactions in Ireland. Weston liked what he saw of Bankes's practice and wanted him to replace Noy (who died in 1634) as Attorney General to help him and Charles's other chief ministers, Cottington and Windebank, order the financial affairs of the king and his spendthrift queen.[45] In putting Bankes forward, Weston had to do battle with Henrietta Maria, who favored John Finch, who served as her Attorney General and toadied to the king, and Laud, who feared that Bankes would not be as supportive of his activities as Noy had been. Bankes's evenhandedness, or, as Wentworth interpreted it, indifference, "betwixt the Sow's Ear and the Silken Purse," puzzled the age. But Charles and Weston needed such a man. In Bankes they had not only an "uncorrupted lawyer | Virtue's great miracle," but also one reputed to "exceed Bacon in eloquence, Chancellor Ellesmere in judgment, and William Noy in law."[46] To please Laud and the queen, the king replaced Heath by Finch as Chief Justice of Common Pleas.

Bankes's promotion brought knighthood and a goodly income, reckoned at £7,000 by Coke and £6,000 "honestly" by Bacon, although the salary was only a little over £81.[47] The large income from fees and retainers enabled Sir John to buy a castle for his growing family and to afford the servants (at least thirty) and the annual charges (at least £3,000) typical for a large country house.[48] He had married, in 1618, the daughter of Ralph Hawtrey of Ruislip, who had been at Gray's Inn a few years before him. Mary Hawtrey was a woman of mettle, quite able to defend Bankes's castle from siege when it became necessary and fecund as well as strong, giving birth to fourteen children between 1621 and 1644 (Figure 14). The extended family kept close; and John cemented the tie by buying his graphite mine in partnership with his father-in-law. Mary's three siblings who survived childhood included a younger Ralph Hawtrey, who, like Bankes, served in the parliament of 1628 and joined Gray's Inn. Mary's family on her mother's side, the Althams of Essex, produced an artist, Edward Altham, who studied in Italy and turned Catholic; his striking portrait as a ragged hermit hangs in Kingston Lacy.[49] Lady Mary celebrated the rise of her husband in the style of advancing lawyers by giving gold rings to her relatives.[50]

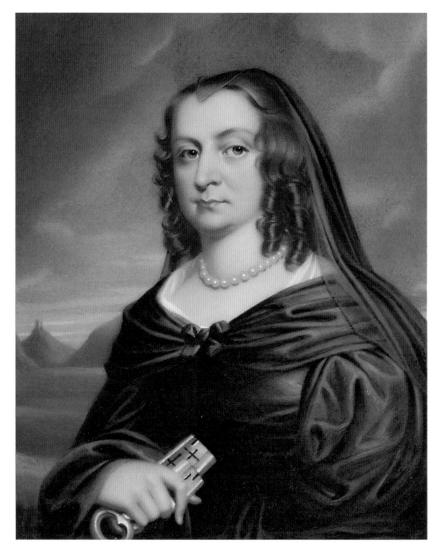

Figure 14 Henry Bone after John Hoskins, *Lady Bankes*, neé Mary Hawtry. Sir John Bankes's doughty wife is holding the keys to Corfe Castle.

The Bankes bought their castle at Corfe in Dorsetshire from Lady Elizabeth Hatton, the widow of the then recently deceased champion common lawyer Sir Edward Coke. Lady Hatton had inherited the property from her first husband, Sir William Hatton, heir of Sir Christopher Hatton, Chancellor of

Elizabeth I. None of them could put up with the castle's discomfort and remoteness to live in it for any length of time. Apparently Sir John and Lady Mary were not bothered by the castle's inconvenience and dark history, by the capital sins of bad King John, who immured some of his plentiful enemies in it and made it a stronghold for his brief failed attempt to force his barons to give up *Magna carta*. But it had the merits of fresh air and a defensible site; its reputation made it relatively cheap; and it was a perfect rotten borough. To encourage Christopher Hatton to prepare it for defense against the Spanish Armada, Queen Elizabeth had paid to equip Corfe Castle with cannon and given it and the hamlet that nestled at its feet the right to elect two members to parliament. As further inducements, she had endowed the little community with some jabberwocky privileges. It will be enough to mention soc and sac, toll and team, blodwit and fledwit, waives and strays, pillory and tumbrill, flotsam and jetsam, infangentheof and outfangentheof, to indicate the peculiar value of the Bankes's estate.[51]

The spectacular view from the hilltop on which Corfe Castle stands extends to the sea. The closer prospect centers on St Edwards, the village church, whose patronage and advowson belonged to the Lord of Corfe Castle. Though somewhat remodeled, it still boasts its original tower and flagstones of Purbeck marble made from disused coffin lids.[52] The site repaid improvement. Its new owners did what was required to make the castle the retreat that Sir John, who did not have an ambition for higher office that would keep him constantly in London, desired in the country. There were some notable paintings by Van Dyck and other fashionable masters, portraits of the very helpful Lord Treasurer Weston, of the royal family, and of Elizabeth of Bohemia's sons Rupert and Maurice, all, except the Weston, gifts of King Charles. There were many rich hangings, including, we may imagine, tapestries made at Mortlake with borders designed by Cleyn especially for the new Attorney General.[53] The castle had a notable library, for both Sir John and Lady Mary collected books, as would their eldest sons John and Ralph. Neither the library nor Corfe's other amenities lasted long. Ten years after Bankes bought it, the unlucky castle was an irreversible ruin (Figure 15).

Figure 15 The ruins of the Bankes's seat at Corfe Castle, Dorset.

An autograph "Precedent Book" preserved among the new Attorney General's papers suggests how he viewed his position and loyalty after joining the government. He noted that royal sovereignty rested on a strict construction of the Act of Supremacy (which made the monarch the Supreme Governor of the church) and a firm division between the spheres of civil and ecclesiastical authority: England was "an absolute empire" consisting of one head and two bodies, clergy and laity, obedient to the king under God. The king had almost unlimited power over both. The bishops, appointed by the king, governed the church by delegation; in civil matters, the Privy Council advised, the king decided, and his chosen ministers executed his policies. Bankes wrote out these views for a speech to the serjeants-at-law, probably with theory rather than practice in mind.[54] He would be as loyal a defender of the royal prerogative as he had been of parliamentary privilege. But he did not believe that his master stood above the law. In government Bankes would suffer more from the contradictions of the English constitution than he had in opposition.

Big Cases

As Attorney General, Bankes appeared prominently in the two most significant cases brought before the Court of Star Chamber during the decade of Charles's personal rule. One of these was the trial of the tiresome triumvirs Bastwick, Burton, and Prynne. Bankes opened the proceedings against Bastwick, but he did not play the part of prosecutor, which was performed by Laud acting as the chief bishop libelously and seditiously attacked for claiming to hold his office *jure divino*. The Puritan martyrs had argued that in so claiming the bishops committed *lèse-majesté*, since two parties could not rule independently by divine right; and that Laud had exploited this usurpation to license popish and Arminian books, alter the liturgy, and introduce other "innovations" sanctioned neither by God nor, they hoped, by the king.[55] Although Bankes received lengthy petitions from the three, he could not alter the course of injustice.

The second case concerned ship money, a tax previously levied only against seaports to provide for defense during demonstrated emergencies. Noy had suggested imposing it throughout the country whenever the king determined its necessity. In October 1634, the government demanded ship money from ports only, for defense against pirates and poachers. It was paid without much protest. A second call, in July 1635, applied everywhere; Charles's chief judges assured him that the extension would be legal if needed for defense and allowed that a qualifying emergency would exist if he said so. The second call brought in £150,000 of an expected £200,000 by March 1636; a third, launched in October 1636, raised under £10,000 in its first year.[56]

Among those who refused to pay was a wealthy country gentleman, John Hampden, who acted on principle against his assessment of £1. Charles responded by ordering Bankes to ask senior judges whether his principle—that the king had the right to command his subjects to furnish "ships, men, victual, and munition…for the defense and safeguard of the Kingdom" whenever, in his sole judgment, it was in peril—held unquestionably. The bench, leaned on by Finch, unanimously responded "yes."[57]

With this assurance, Charles let Hampden, "a very wise man, and of great parts, and possessed with the most absolute spirit of popularity...a head to contrive, and a tongue to persuade, and a head to execute, any mischief," try his case. Hamden argued that the king had not demonstrated or even mentioned an immediate threat in calling up ship money.[58] The Crown already had a permanent (if illegally collected) excise tax, T&P, then worth £300,000 a year, and other fees and taxes to defray the ordinary expenses of defense in English waters.[59]

The Solicitor General Edward Littleton replied that the other fees and taxes had not been granted for defense. Hampden's lawyers insisted: "the King out of Parliament cannot charge the subject." With this exchange, "one of the greatest cases that ever came to judgment before the judges of the law" (as Sir Edward Crawley, a Justice of Common Pleas, reckoned it) was joined, pitting "the King's right and sovereignty...and the honour and safety of the kingdom" against "the liberty of the subject in the property of his goods."[60] Bankes, who was by no means indifferent in the matter, having helped Noy draft the original proposal, rose on the king's side. An emergency exists, he said, for pirates and Turks are attacking English shipping, and a power to meet the emergency also exists, a power and obligation, innate in the king's person, to do his utmost to defend his realm. He is the sole judge of the degree and imminence of danger and of the means needed to meet it; in this respect he is, and must be, "an absolute monarch."[61]

It is unnecessary and uncharitable (Bankes continued) to worry that the monarch might abuse this power. "The King, as appeareth from all our books, is the fountain of justice...The King can do no wrong." He is God's lieutenant. "If the law trust him, we ought to trust him." (An argument reminiscent of Bankes's view, even in opposition, of the power of arbitrary arrest.) King Charles says he needs the money; let us give it to him; we are not capable of searching into the mysteries of royal finances.[62] No doubt conscious of the weakness of his case, Mr Attorney relied on what a modern critic has called "devious techniques." He did not attempt to prove the existence of an ongoing emergency that required extraordinary annual levies without the consent of parliament.

Bankes's rhetoric ended in a burst of astronomical word play. "My lords, if there were no laws to compel this duty, yet nature and the inviolate laws of preservation ought to move us…Therefore let us obey the king's command by his writ, and not dispute it. He is the first mover amongst these orbs of ours; and he is the circle of this circumference, and he is the center of us all, wherein we all, as the lines, should meet; he is the soul of this body whose proper act is to command."[63] Bankes's imagery, which might have made several world systems, fired the imagination of Justice Crawley. "Now for the prerogatives royal of a monarch, they may be resembled to a sphere; the primus motor is the king. It is observed, that every planet but one has a little orb by itself, that moveth in its petty compass: so the center is the Commonwealth, the king is the first mover."[64] Bankes's appeals to the solar system may not have helped him carry his case, but win it he did, although not unanimously.[65] The decision so exasperated Hampden that he embarked with his cousin Oliver Cromwell for Puritan New England and would have sailed, had the Privy Council in a fatal misstep not stopped their ship.[66]

The opinion of the dissenting judges gave encouragement to those who wished to see the royal prerogative curbed, and king and parliament govern together. Public opinion favored Hampden. For Simons D'Ewes, bypassing parliament to raise ship money was a highroad to political and moral collapse. "Heresy, bribery, and oppression, and a world of other notorious crimes, will be ready to walk impudently at noon-day, when the good and godly are without hope, and the evil and wicked without fear of a Parliament." The Venetian ambassador caught the intensity of feeling: "If sentence goes against the people, as seems likely, it is feared that the judges may fare badly from their fury."[67] Not being a judge, Bankes came away from ship money as he had from his prosecution of the Puritan triumvirs, with his reputation for judiciousness intact. Finch would not be so lucky.

By the end of October 1638, with all but £20,000 of ship money collected, the royal finances, though still in deficit, were not hopeless. Unauthorized T&P had increased, and grants of new monopolies were returning cash. Charles himself took on a promising monopoly in 1638.[68]

This was to drain the Great Level, the great project of the great projector, Francis Russell, fourth Earl of Bedford, whose improvements in London are commemorated in the names of Bedford Square and Great Russell Street. Bedford's drainage, completed in 1636, had flaws that inspired riots and lawsuits. Charles's courts pulled the plug, the earl's contract went down his drain, and Bankes drew up a new one by which the king undertook to improve 400,000 acres of fenland in exchange for 152,000 of them. War put an end to his plan after the investment of £20,000, £3,000 of which Charles had borrowed from Bankes.[69] Although Charles was still in debt and deficit in 1638, he might have muddled through if he had been able to control his desire to control the Scots.

Charles could survive financially during the first years of his personal rule because a sharp rise in customs dues after he had made peace with France and Spain, and improvements in his Irish income from recusant fines and higher leases, gave his competent administrators something to work with.[70] Wine poured in, taxed at £2 a ton.[71] Other trade increased too, and, with it and a crackdown on evasion, the revenue from customs rose dramatically; it amounted to almost half the royal income by 1640. Imaginative adaptation of disused medieval laws also augmented income in fees. One of these adaptations, suggested by Noy, who had the reputation of a humorist, was impressively inventive, despite his cleaving to the sound doctrine that "when wee goe in new wayes we are like to goe astray." His playfulness widened the boundaries of royal forests to include houses and even towns that thereby became guilty of encroachment. The surprised landowner could "deaforrestate" his property for a fee.[72] Fines for deafforestation would have had a very sizable yield had Charles had the courage to enforce them.[73]

Another way Charles prolonged his personal rule was to substitute talk for action in foreign affairs. He did not worry about consistency or religious affiliation. He worked on Spain and France to intercede in the Palatinate and to discipline the Dutch while urging German Protestant powers to help the Dutch against Spain.[74] One of the emergencies for which Charles collected ship money was to strengthen his navy to weaken

Spain's hold on Flanders so that Spain would need his help to transfer men and money through the Channel to tighten its hold on Flanders. As he said, his foreign policy contained mysteries too deep for ordinary minds. Charles hoped to reverse the empire's definitive assignment of the Palatine Electorate to the Duke of Bavaria (at the Peace of Prague, 20 May 1635) by putting his new fleet at the disposal of Spain, or the empire, or both. To ensure that this offer received proper consideration, he dispatched Arundel to Vienna to negotiate a restoration of the Electorate in return for fleet services. The Queen of Hungary, formerly the Infanta wooed by Charles, received Arundel warmly, the Jesuits of Austria entertained him, and the emperor gave him two albums of drawings; but he obtained not the slightest concession over the matter of his mission. He begged leave to return home. Charles ordered him to stay: his continuing presence in Vienna might worry the French enough to bring them to England's bizarre bargaining table.[75]

What then to do with the new fleet? In the fall of 1635 Charles ordered the printing of a book Selden had written twenty years earlier disputing a little treatise arguing for the freedom of the oceans by the Dutch Lawyer Hugo Grotius. Against Grotius's *Mare liberum* (1609), which dealt with taking prizes on the open seas, Selden compiled an inventory of historical claims of English rights over adjacent waters. James had refused permission to publish Selden's *Mare clausum* lest it annoy Spain; Charles had it issued in 1636 to justify the uses to which he would put his ship-money fleets. These turned out to be chasing (without catching) the fleeter boats of the Dunkirk pirates, driving Turks from the Irish Sea, and compelling alien anglers in English waters to buy fishing licenses. The Crown extracted £30,000 from the Estates General to free Dutch fisherman from fear of arrest by the Royal Navy.[76]

The financial picture at the end of the personal rule appears from a review Bankes drew up in May 1641 when Charles appointed him and four others to run the Treasury. Bankes found that the accumulated debt amounted to £1.76m (up from £1m at Weston's death) against a normal income of £889,000 (up from £636,000). Interest at 8 percent, expenses

for several royal households, pensions, annuities, support of Elizabeth of Bohemia and her sons, expenditures on art and entertainment, and so on, easily consumed the £889,000.[77] So Charles, whose credit was not good enough to borrow commercially, turned to his friends, well-paid officers, and relatives for loans. Hence Bankes's £3,000 for the fens. He and Laud were the only lenders who forewent their 8 percent.[78]

Small Pickings

Much of Bankes's work as Attorney General concerned petitions for patents and monopolies. Most of them violated the covering law, the Statute of Monopolies of 1623–4, which prohibited grants, charters, licenses, commissions, and so on, "for the sole buying, selling, making, working, or using of anything." This wholesome rule had many exceptions, however—for example, patents for new inventions and manufactures, grants by parliament or under privy seal, and monopolies on printing, armaments, drinking, glass, and alum. This last exception has the double interest that James owned the mines, and the major competitor was the pope; unfortunately, the papal product was the better, and the attempt to create a viable domestic alum industry failed. Although the failure cost James between £65,000 and £120,000, Charles repeated the error of imposing an industry disfavored by nature. He prohibited the importation of salt, granted a monopoly to domestic producers, and within a year or two could not obtain enough salt to supply his large household.[79]

Bankes knew something about the perils and opportunities of monopolies from the experience of his in-laws the Heckstetters. To work the mines around Keswick under their grant from Elizabeth, they built a large enterprise that usually ran a deficit; by 1600, after thirty-seven years of digging, the Heckstetters and their investors had lost £27,000, including £4,000 paid as "royalties" to royal Elizabeth. But they made a good profit from sublicensing their rights and operating auxiliary services like taverns for their workers.[80] As Attorney General, Bankes dealt with several projects for which his knowledge of mining in Keswick would have been

useful: extracting copper from Cornwall and salt from seawater, and improving mills, forges, and laundry houses. One of every five inventions patented between 1620 and 1640 dealt with pumping, drainage, and other technologies necessary in mining.[81]

A truly Bohemian inventor, Sir John Christopher van Berg, a refugee from Moravia, requested a monopoly to sell improved bellows, water-works, mills, surveying instruments, wagons, carts, coaches, wheelbar-rows, horse litters, corn threshers, and dredging machines. The Crown referred the petition to Bankes, who, having consulted "those who were better experienced in this faculty," decided that Berg's inventions might be "useful and beneficial to the Commonwealth." He recommended a privilege for fourteen years, which was granted.[82] Other technological projects that came across Bankes's desk included manufacturing clay pipes, mathematical instruments, sword blades, beads and bangles, glass and glasses; distilling strong waters, manuring soil, cutting timber, dig-ging turf, and, of course, draining fens.[83] Some of these measures resulted in the destruction of human habitat and drove people from the country-side. Fen dwellers appealed to Bankes because of his reputation for "faith-ful care, and vigilancy."[84] They were disappointed. Bankes had to back the fen drainers, among them Sir John Monson of Lincolnshire, who acknow-ledged Bankes's help with the gift of a dead buck, because "your worth hath forbid me presentinge you with any thinge of value."[85]

If he had a sense of humor, for which some unpersuasive evidence exists, Sir John must have smiled over the red herrings of Thomas Davys. The law required that barrels of white herrings be examined or gauged (at 2.25 pence/barrel) so that unscrupulous packers would not insert rotten fish in the middle of the container. Red herrings changed hands without gauging. "By neglect whereof [Davys observed] much deceit was daily used by the sellers of red herrings, by mingling and putting in shotten herrings, gorged herrings, plucks, stinking and corrupt herrings...among the good." Bankes was ordered to stick his nose into the business. Davys got a monopoly to examine the red at the same rate as the white, for an annual payment of £4.[86] Other attractive schemes

sent to Bankes for advice included collecting old bones (for an annual rent of £50), exporting used bones, shoes, leather, and horns (£30), gathering and selling cuttle shells (very useful to apothecaries), searching ships, shops, and warehouses for contraband or defective leather, and unplugging sewers.[87] Further evidence of Bankes's exposure to technical matters other than the law exists in his notes on coinage, salt, tobacco, and brewing. Nor did he ignore the perennial problem of the calendar. He drew up a proclamation for beginning the year on 1 January, as did most of civilized Europe, rather than on 25 March, as in ancient times, but he failed. Many people still believed that calendar reform was a papal plot.[88]

Requests for monopolies from courtiers seldom concerned products or processes as useful to the Commonwealth as policing red herrings. When that enterprising gentleman of the bedchamber Endymion Porter and his associates asked for a monopoly on making white writing paper, he was helping the public as well as himself, since, according to Solicitor General Littleton, who had filled up reams of it, "paper made in this country is very bad;" but when he asked for the farm of taxes, duties, and uncollected fines for half of whatever he could squeeze out of them, he was mainly helping himself.[89] The insatiable Porter obtained monopolies to inspect silk goods containing gold or silver threads; recover excess fees charged by insurers; hunt down misappropriated Irish livings; collect wine duties in several ports; and, public spirited at last, employ, at low wages, convicts reprieved from sentence of death. He also floated companies to compete with Dutch fishermen (in partnership with Tobie Matthew and Buckingham's widow), with the East India Company, and with fen drainers. None of these last enterprises flourished. But Porter did very well from the wardship of his insane brother-in-law.[90]

Royal servants further down the food chain also petitioned for a share of whatever fees, fines, unclaimed property, property of outlaws, and forfeits they could discover. The king's surgeon and pastry cook teamed up to ask for the benefit of a bond forfeited by a lusty old yeoman of Gloucester, who, despite receiving canonical admonition not to "consort

with" his wife's son's daughter, did so. In the same public spirit, a groom of the Privy Chamber petitioned for the authority to snatch the £4,000 he reckoned belonged to an expat recusant who had become a Jesuit, and to share the proceeds, after expenses, with the Crown, nine parts for him to one for it.[91] The wet nurse of the infant Duke of York asked for a grant for thirty-one years to check the quality of silk stockings.[92] Without a standing police force, the needy Crown had not only to tolerate, but even to encourage, greedy freelancers to collect fines and forfeits on terms unfavorable to it. Bankes deplored the use of these pursuivants, whose tendency to blackmail diminished the king's dignity as well as his income. The multitude of vexatious little monopolies he sanctioned contributed modestly to the royal finances. In 1640 the total from wine, tobacco, soap, and playing cards was around £75,000, about an eighth of what the monopolists made.[93]

Mr Attorney's business extended to several people who appear in these pages. One early assignment was to devise means to enforce a monopoly on soap granted to Arundel, Weston, Cottington, Porter, and others. Because most of the projectors were crypto-Catholics, their product was known as papal soap. It was so bad it could not launder money. Ordinary people seeking the cleanliness next to godliness returned illegally to Puritan brands until, in 1637, the projectors had to sell up, for a comfortable £43,000. Glass monopolists offering spectacle lenses through which they could not see the way forward ended similarly.[94] The mad idea of limiting beer brewers in England to twenty did not advance far enough to fail. Vintners proved an easier target; Bankes extracted £30,000 a year from them to continue their business as usual.[95]

The super-rich Earl of Arundel was always pushing for perks in his need for ready money. Around 1620 he had received a monopoly to collect a tax on currants, a bellwether to other excise duties the Crown imposed without the consent of parliament. Since the English consumed huge quantities of "Corinth grapes," some £2m a year around 1610, when the duty fell from an exorbitant 5s. 6d. to 3s. 4d. a hundredweight (cwt). Under pressure from importers, James dropped the tax to 2s. 6d./cwt and

sold the farm to Arundel for a rent of £1,100 p.a. That would have brought the earl some £2,500 less the expenses of collection were there not the curious difficulty that his monopoly, being of the product, conflicted with that of the Levant Company, which applied to the area of their production. Charles diminished the farm's value further by reducing the tax to 1s. 3d. and the rent to £1,000. Bankes had to see to the details. He was also to draw up a grant to Arundel and others of eight large parcels of land in New England similar in form to one then recently issued for Mauritius and all adjacent islands east of Madagascar.[96]

For the archbishop and the king, Bankes tried to abate the stench from breweries that drove them from their gardens. For Sir Kenelm Digby, he drew up a favorable contract for a new way to farm greenwax in places where the Crown was not harvesting its due—greenwax signifying nothing arable but certain fines and forfeitures.[97] For the royal physicians Theodore Mayerne and Thomas Candeman, he arranged a patent for distilling alcohol and vinegar.[98] As Attorney General, Bankes saw all the worst monopolistic practices and the corruption they caused. Although he may have tried to reduce them, he had perforce to draw up the charters that enabled them. As a former opposition MP who had sat in the parliament that passed the Statute of Monopolies, he must often have deplored the system that encouraged them.[99]

Monopolies, farms, and the chartered companies presented Bankes with political as well as ethical difficulties. Relations among the Crown, City, and Commons provide an example. The last parliaments of James went after the City's chartered companies (with Bankes's approval), whereas the last of Charles's cooperated with them (with Bankes's help), in both cases over illegal exactions and impositions. The turnaround came during the Bishops' Wars, when, to improve relations, Charles dismantled some monopolies the companies opposed. As the Long Parliament grew more radical, alarmed City fathers turned toward Charles's cause without, however, raising his credit rating.[100] It required skill and tact to handle these shifting allegiances and also conflicts

between the Crown and the City over recognition of new corporations and between the City and the Church over raising clerical salaries.[101]

Among the most serious crimes in Bankes's book was sedition. That explains the severity of his response to an appeal to set aside a high-court judgment engineered, so the appellants alleged, by the Lord Keeper of the Privy Seal. Bankes regarded the attack on his colleague the Keeper as a very grave offense, "of a high and transcendent nature." Why was the crime so heinous? "[F]alse rumours and unjust accusations which concern great officers and peers of the realm trench upon the King himself in his royal government." Perhaps mindful of Andrewes's doctrine against "touching" the king, Mr Attorney recommended whipping as punishment.[102] He remained on the same high ground when prosecuting one John Ray, accused of exporting a prohibited commodity, fuller's earth, and avoiding customs by claiming to ship goods within England that were destined for Holland. Bankes threw the book at him. The cloth trade, "the adamant that draws all other trade and merchandising," required fuller's earth; selling it abroad advanced foreign interests and lowered the price of English goods. Hence Ray's crimes amounted to sedition. "The King in his piety and goodness desires to advance the wealth of his people and comfort their labours." Evading customs struck traitorously at the main source of royal revenue. Ray's punishment was severe: a fine of £2,000 and exposure in the pillory.[103]

Sedition included defamatory writings or spoken words directed at government officials, judges, and ministers of the established church. "Touch not my anointed!" It made no difference whether the allegations contained in the seditious acts were true or whether the party allegedly libeled had died. With some imagination, almost any non-conforming utterance could be deemed seditious, as, for example, the advice of a preacher that Christians should not eat pork, which scandalized James and his bishops, and earned the reformer a fine and imprisonment.[104]

Bankes considered sedition to be particularly serious when urged with religious authority, as in the preaching of the reverend George Walker. Embroidering Genesis 3:17, in which God evicts Adam from Eden, Walker

111

concluded that, since no one is perfect, "inferiors [have a right] to examine and dispute the commands of their superiors." And, if examination revealed unjust orders, inferiors had the right to resist officers trying to carry them out. Countenancing this Puritan doctrine would turn the universe upside down. Bankes had no patience with Walker's sort of Copernican revolution. He wanted exemplary punishment, which Walker escaped by denying that he had written the offending sermons.[105]

Encouraged by the seriousness with which Crown officers regarded every whiff of sedition, sneaks made a living reporting small talk. An incautious statement at the pub overheard by one of these "caterpillars of the Republic" (as Bankes called them) could bring a loose talker into tight places. So one Gerard Wright found himself in court for observing, correctly, that the king wanted "a good headpiece, for he giveth too much creditt & beliefe to his Nobilitie & beleeveth any thing they speake." Our old friend Archie the Fool was foolish indeed when in his cups he accused His Grace My Lord of Canterbury of being a "monk, a rogue, and a traitor." Fools had more license than others to tell truths that might irritate the mighty. His Grace the Archbishop, feeling lenient, only had Archie banished from court.[106]

Among Bankes's papers is a request from a J. Mayne, dated Christchurch, 6 April 1636, for continuation of an allowance. Jasper Mayne, of Christ Church, Oxford, was a literary man and a poet. He could not depend on his family for financial support because their substantial wealth had melted away in recusancy fines; hence his appeal to Bankes and the interest of Bankes's contribution to his upkeep. Mayne's fortunes improved just as England's declined, in 1639, when he received a benefice and staged a farce, *The Citye Match*, before the king and queen. They liked it, although its plot was but a scaffold on which to hang sacred cows: revels at the Inns of Court, "rank Puritans," red herrings, Prynne. A character refers to Cleyn's expensive tapestries ("some Dutch peece weaved at Mooreclack"); another jokes about the riches of barristers; a third makes free with T&P. They do not spare the king's lascivious Titians.[107] Bankes's patronage does not imply that he enjoyed Mayne's foolery, which applied to him too, but it is possible.

Bankes had more independence as Attorney General than his obliga-
tions to follow ministerial orders and defend the royal prerogative would
suggest. The king and Privy Council sent many of the quantities of peti-
tions they received to him for settlement; and, even when asked only for
advice, he could influence if not determine the outcome. Sometimes he
pursued his own policy, as when he allowed the forbidden export of bul-
lion in exchange for a large fine, which he put into the Treasury; a well-
intentioned peccadillo for which Charles cheerfully exonerated him,
"telling him that he was his friend, and although he had many enemies
[the Queen's coterie?] yet so long as he was his friend, they could do him
no harm." Nonetheless, Bankes had to be careful. As the government's
chief prosecutor, he had to adjust his diligence to the fluctuating royal
will, which, as in the case of the recusancy laws, might place him between
Charles's orders and the law of the land. When not engaged on royal busi-
ness, however, he might practice as he pleased; at which he did so well
that by 1639 his estates in Dorset were yielding £5,000 a year. Against his
income he had the expense of running his own staff and office, even for
the king's business. After seven years as Attorney General, he was wealthy
and well regarded, tired of having to defend the king's dubious actions,
and ready for the highest standard step in his career path, to Lord Keeper
or Chief Justice of Common Pleas.[108] The latter office was perhaps the
most lucrative in the judicial system, as it brought not only fees (for
example, a seventh part of the profits of the court's paper work) but also
control of clerkships saleable at high prices.[109]

Chief Justice

A senior judicial appointee had to be a serjeant-at-law and leave his home
Inn for the serjeants'.[110] Bankes's valedictory speech at his separation from
Gray's in January 1641 begins with the expected expression of inextin-
guishable affection for colleagues and gratitude to the Inn; Bankes will
not be like Vespasian, who declined to know comrades from his humble

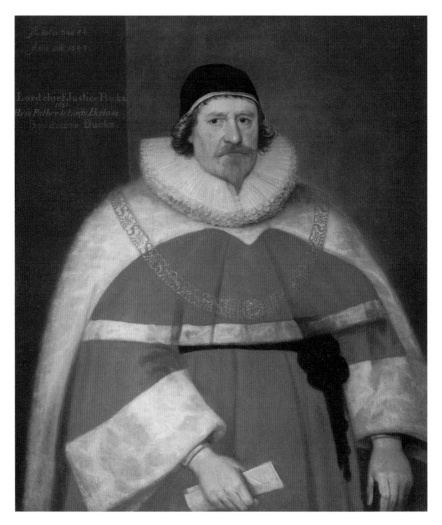

Figure 16 Gilbert Jackson, *Sir John Bankes* (*c*.1640), "greatlie increased," in the robes of Chief Justice.

past after taking over the Roman Empire. Like the emperor, the new Chief Justice had come far: "though my beginnings were but small, yet my latter end hath been greatlie increased" (Figure 16). This bit of biography Bankes had in common with Job, from whose story he took it (Job 8:7). Bankes had copied out part of Andrewes's sermon on Job 19: 23–5, one of the bishop's best, which rings many curious changes on Job's desire to

publish his later woes. "Oh that my words were now written! Oh that they were printed in a book! That they were graven with an iron pen and lead in the rock forever!" That Bankes wished to associate himself with the formerly prosperous Job is arresting. Did he foresee, in 1641, the dreadful consequences of the foolhardy policies of Charles and Laud that he had helped to put in place? And did he wish, as impotently as Job, that he could publish this warning in leaden letters embedded in stone?

More prosaically, Bankes admonished the men of Gray's Inn to work hard at their profession, as he had, for success comes only with "great labour and difficultie." More pertinently, he warned that no one would prosper unless everyone cooperated in maintaining order and good government. Slipping easily from Job's double to Charles's lawyer, Bankes declared, "noe companie or multitude can subsist together without order and in order there must be a Superiour and an Inferiour." The Commonwealth relied on men of law and reason to train learned judges for its service. "We ought by our good examples to give lawes of rules, order, and obedience."[111]

In calling on the men of Gray's Inn to go forth and preserve law and order, Bankes was speaking to the times. Lawyers had been the prime instruments of Charles's personal rule: the king acting through the judiciary having replaced the king acting with parliament. Judges had given verdicts, as in the Hampden case, against the liberties of the people, and prerogative courts like Star Chamber helped Charles impose his will. In dissolving parliament in 1629, Charles had condemned the Commons for its presumption in reviewing the behavior of his chief justices and accusing them of proffering "wicked counsel." The climate when Bankes joined the judiciary at Common Pleas may be indicated by the articles of impeachment then raining down on Sir Robert Berkeley, a justice of King's Bench, for his decisions on ship money and other impositions, for refusing to hear objections to Laudian practices, and so on, thus "traitorously and wickedly [intending] to alienate the hearts of his Majesty's liege people from his Majesty...and to subvert the fundamental laws and established government of his Majesty's realm of England."[112]

More insightful people blamed higher legal officers. Bankes's predecessor Noy and perennial colleague Finch had brought on all the miseries of the kingdom, the boldness of papists, the impoverishment of estates, the multiplication of illegal projects, ship money, forest fines. Unfortunately, Noy could not be impeached, being dead; but Finch, whose appointment as Keeper had opened the Chief Justiceship for Bankes, made an attractive and conspicuous target. To avoid being arrested he suddenly left town and the great seal he had held for under a year. Although Bankes had had a hand in ship money, monopolistic awards, and the trial of the triumvirs, parliament had raised no objection to his investiture as Chief Justice on 29 January 1641.[113]

Bankes owed his promotion to Common Pleas in part to the patronage of the Earl of Northumberland, the Lord High Admiral of England, whom he had served as counsel, and the Earl of Bedford, the leader of the moderate opposition to the king in parliament. They would have been able to judge him in action, since a chief obligation of the Attorney General was to attend the House of Lords to advise on legal questions, see to protocols, and transmit messages between the Houses.[114] Bankes's promotion in January 1641 came as Bedford neared the zenith of his influence as the man best placed to avert war. During January and February, he and John Pym were expected to join the government as Lord Treasurer and Chancellor, respectively, and the Privy Council talked seriously about a militia bill, triennial parliaments, and a modified episcopacy in return for guaranteed revenues. Placing Bankes as Chief Justice might well have been part of the negotiations. Bedford's death from smallpox on 9 May left the new Chief Justice to try his own ways toward a compromise. His efforts would cost him dearly.

The toll began almost immediately when, the day before Bedford died, Bankes had to preside over the presentation for the king's signature of parliament's Bill of Attainder against the Earl of Strafford. Charles had then only recently created this earldom for Wentworth for his faithful and energetic service as Lord Deputy of Ireland. How Strafford came to be attainted and stood up to the charges with the help of his physician

Maurice Williams will be described in its place. Here Bankes's anguishing situation claims attention. As a common lawyer he could not have favored proceeding by attainder, which amounted to extra-legal judicial murder. And as Wentworth's lawyer—he had defended the Lord Deputy against a murder charge and in other "troublesome businesse"—he knew that the redoubtable earl was not a traitor. Wentworth had come to trust him fully: "in better hands than [yours] I cannot be," "by gods blessing and your assistance I trust my innocence shall at last carry me [through], however great a weight of calumny and malice soever presse upon me."[115] Calumny and malice had prevailed. Bankes had to ask Charles to assent to the bill that would kill their mutual friend.[116]

Charles tearfully assented to the sacrifice of Strafford after summoning his bishops to assist him in adjusting his conscience. Royal tears fell more plentifully as parliament pulled more teeth from the prerogative jaw without the anesthetic of denying innovation. In December 1640 it took up the problem of bishops. The Commons voted to eject them from the Lords; the Lords were willing to deprive them of their civil functions but not of their seats; the Commons upped its game to extermination.[117] The London mob increased the persuasive power of the Commons; the bishops discontinued their attendance; and after October 1641 no more than four sat in the Lords at any one time before parliament formally abolished the episcopate in 1646. No bishops, no king, no law, no order. With the sanction of the Commons, lawless fanatics destroyed church ornaments, reoriented altars and communion tables, and did away with pictures, candles, basins, and vestments.[118]

There remained among old grievances ship money, forest fiddling, knighthood fees, and T&P. On 8 June 1641 Selden brought in a bill abolishing the first three and prohibiting the king from levying customs duty without the consent of parliament. The prerogative courts of Star Chamber and High Commission came next and on 5 July Charles acquiesced in their abolition.[119] In the old days he would have sent parliament packing; he would never surrender his power (so he had said) to create and annihilate parliaments. But parliament took away that power too: the

opposition party in the Lords made no secret of its intention to "Venetianize" the state and joined the Commons in prohibiting the king from dissolving a sitting parliament or governing without one for more than three years. Bankes again presided. The delegation from parliament that brought the Bill of Attainder against Strafford also carried the Triennial Act.[120]

In August 1641, against the protest of parliament, Charles set off for the country of his forebears. He hoped to use two of his kingdoms, the Scottish and the Irish, to bring the third to heel. His intrigues in Ireland took on an additionally sinister cast when its Catholic population rose in rebellion in October and one of its leaders claimed to be acting under his orders. Other rebels asserted the queen's authority.[121] Rebellious Irish Catholics did not make promising allies in a fight for the allegiance of English Protestants. The Scots declined to be allies of any kind. Although soon after his arrival in Scotland Charles wrote to Henrietta Maria that his devoted northern subjects were sure to help, he quickly learned that they too desired to strip away his prerogatives. Charles returned from Edinburgh as empty handed as he had from Madrid, and, as then, to a warm welcome by the relieved aldermen of London.[122]

The aldermen hoped that the king's presence might subdue the increasing radicalism of the Commons, which was pressing for a new Remonstrance (first reading, November 7–8, 1641) and blaming, as of old, papists, bishops, and evil counselors for undermining the laws and religion of the state. The remonstrators cited Laudian liturgy, illegal taxes, hasty dissolutions of parliament, Buckingham's government, tyranny of ecclesiastical courts, imposition of the Scottish prayer book, the Bishops' Wars, all of which time or parliament had corrected. But security required more: curbing the influence of bishops and recusant lords, providing a new constitution for the Church, and choosing reliable government ministers.[123]

Feeling increasingly constrained, Charles hesitatingly determined on a bold act: he would seize five members of the House of Commons, Pym, Hampden, and three others, for subverting all the laws, powers, liberties, estates, and officers of the land, and also for alienating the people's

affection from him, leaguing with foreign princes, trying to impeach the queen, and "traitorously conspir[ing] to levy…war upon the King." It would go hard with them when he had them in his clutches! But he hesitated. The firmness of Henrietta Maria finally sent him off, on 4 January 1642, with an armed guard, but the forewarned delinquents had escaped, and Charles spluttered at another humiliation. The aldermen decided that he was not their savior, and Charles fled from his capital so precipitously on 10 January 1642 that the five members of the royal family suffered the indignity of sleeping in the same room when they arrived unexpectedly at Hampton Court.[124]

Charles's continuing threat to deal with the delinquents he had tried to arrest, the need for an army to put down the Irish rebels, the endemic fear of papal plots, and general insecurity caused parliament to pass a Militia Bill demanding that the king sign away his right to command armed forces. If he had done so, his queen said, improving on the frightful image, he would be less even than a doge. That was in February 1642. On 1 February, parliament asked that only persons agreeable to it should be placed in command of fortresses and militias. On the 12th, it named candidates to replace the king's lord-lieutenants, who had responsibility for raising trained bands and militias in their several jurisdictions. In June, parliament proposed a compromise. Still blaming the state of affairs on the "subtill Insinuations, mischievous Practices, and evill Councels of Men disaffected to God's true Religion, your Majestie's Honour and Safetie, and the publike Peace and Prosperitie of your people," it demanded the vigorous prosecution of laws against papists, disenfranchisement of Catholic peers, closer alliance with foreign powers opposed to the pope, submission of nominations of high officials and royal tutors for parliamentary approval, the right to advise on liturgy, and so on. In return, "these our humble desires being granted by your Majestie, we shall forthwith apply ourselves to regulate your present Revenue."[125]

Charles declined the offer. The mischievous advisers were parliament's; the bargain proposed to him resembled Esau's; accepting it, he would abandon "the power and right Our Predecessors have had," and be

nothing "but the Picture, but the Signe of a King." In the mixed government of England, parliament guards liberties, but never did or should share in governing, which is the king's business; whereas the Lords, with judicial powers, "are an excellent Screen and Bank between the Prince and the People, to assist each against any Inchroachments of the other."[126]

Charles promised Henrietta Maria to remain firm about the Militia Bill while she went to the Continent to raise money for their cause from fellow monarchs and pawnbrokers. Following her advice, he agreed to eject the bishops (who were so many heretics to her) from the Lords. Where were the innovations to end? A leading parliamentary pamphleteer, Henry Parker, had a good and fearful answer: look to Venice! Parker envisaged a constitution that would escape domination by nobility, commonality, and monarchy, which the constitutions of Denmark, Holland, and France, respectively, had allowed. The best way to achieve an "equal, sweetly-moderate sovereignty" was to introduce the "coordinate and restrained forms of government" recommended by such European "republicists" as old Fra Paolo.[127]

Parker quoted long passages from Sarpi's *History of the Inquisition* (1639) to prove that the popes had usurped the power Christ had delegated to princes and had constructed an ecclesiastical apparatus to prosecute a worldly policy under the cloak of religion. Parker called on Sarpi, "egregious Politician…learnedst of Papists," to testify how easily Rome had hoodwinked princes. England take note! "[O]ur Prelates in *England* at this day assume to themselves almost as vast and unquestionable a power of stifling and repressing adverse disputes, and of authorizing and publishing all arguments whatsoever favouring their cause, as the Court of *Rome* does." Parker gave as the main method Rome used to stifle other opinions the censorship, from which "wee are sure to have no book true."[128] This lesson had the reinforcement of Galileo's condemnation in 1633 and the reissue, in English, of Sarpi's *Trent* in 1640.

The intrepid queen set sail on 23 February 1642 with the crown jewels, the well-traveled Arundel, and Princess Mary, whom she was to deliver to the girl's teenage husband, William of Orange. Soon rumor spread in

London that the queen would return with an army of Danes and Dutchmen inspired by her charms and paid by her jewels.[129] With his queen safely abroad, Charles again hastened north, where he supposed he still had friends, and found enough to remain intransigent. He gave his enemies this concession, however, that he hanged two inoffensive priests, one 90 years old, who had attended their flocks without trouble for years; simultaneously and contradictorily, he relied on money raised by Catholics alarmed at the progress of the Puritans and raised an army in which Catholics made up a sizable minority. A Catholic and his son raised £100,000 for Charles's cause during June and July 1642. Without this contribution from the papists, he might not have been able to construct a royalist force.[130]

The king came to rest in York, whence he summoned his court and musicians, displacing people who might have been more helpful elsewhere, as if (it is Selden's image) a man needing a piece of wood could think of nothing better than pulling the bung from a barrel of beer.[131] Faithful Endymion Porter was there, close enough to Charles to have no idea of his plans. "We have no certainty of our return for his Majesty's business runs on the wonted channels, subtle designs of gaining the popular opinion and weak executions for upholding the monarchy."[132] Some great persons, consulting politics, declined to come, and some lesser ones, consulting their pocket books, stayed away. Charles had not troubled to pay his musicians, although he could manage to put on a lavish ceremony in York to welcome his son the Prince of Wales and his warlike nephew Prince Rupert into the Order of the Garter. Preparations for this ceremony occupied him for days. Realism was represented by the refusal of the governor of the arsenal at Hull to allow him entry. Charles might have gained control of the arsenal by diplomacy alone had he been capable of decisive action. His failure at Hull cost him a relatively safe route for troops and supplies from Europe.[133] When Christian at last decided to help his nephew, the money and munitions he sent were intercepted. Charles's requests for loans with the Orkneys and Shetlands as collateral fell on deaf ears. Christian needed help himself in fighting his favorite enemy, the King of Sweden.[134]

As a senior royal official, Bankes was one of the councilors Charles commanded to join him in York in May, on an "occasion of importance concerning Our person, honour and Service." Bankes then resided in London, assisting the Lords as he had done the year before; for, like the Attorney General, senior judges had to make themselves available for consultation by parliament, especially over new legislation. Ever punctilious, Bankes asked permission of the Lords to leave London; it was freely given, as his record inspired confidence that he would "strictly pursue the genius of the Houses" in advising the king.[135] As we know, Lord Keeper Finch had good reason not to notify parliament about his travel plans. Charles sent an emissary to capture the Great Seal and thought to give it to Bankes or Selden; but his then chief advisers, who included Edward Hyde, the future Earl of Clarendon, decided for him that Selden was too old and fond of leisure and that the new Chief Justice was unequal to "the charge in a time of so much disorder, though, otherwise, he was a man of great abilities and unblemished integrity."[136] No doubt they had in mind that the Keeper presided over the Lords in the absence of the Chancellor and feared that in such cases Bankes's integrity would not allow him to assert the king's policy slavishly.

A week or so after arriving in York, Bankes wrote to his patron Northumberland about the situation he confronted. "Heere be impressions and ffeares that there bee endeavours to alter the forme of the Government...That there be such intrusions upon his prerogative as cannot stand with monarchy." There were complaints that parliament was not punishing seditious writings, or making peace in the church, or regulating the Crown's finances. But Bankes did not despair: "I do not discerne that the differences between his Majesty and the Houses are so great in substance, but if there be a willingness on all parts, they may be reconciled." Two days later, on 18 May, Bankes wrote to the opposition leaders Lord Saye and Sele in the Lords and Denzil Holles in the Commons that the king would not budge until parliament told him what it would do for him, in a few short propositions, "by calm and moderate, not by violent wayes."[137]

Bankes showed the way to compromise by the dangerous step of thwarting the royal will over the great issue of the Militia Ordinance. Charles ordered Bankes to declare it illegal. Bankes refused. The consequences for him and the country he laid out in a letter to Giles Green, one of the MPs for Corfe Castle, on 21 May 1642:

> Good Mr Green…I have adventured farre to speak my mind freely according to my conscience and what hazards I have runne of the King's indignation in a high measure you will have heard of others…I am heere in a very hard condition where I may be ruined both wayes, but I trust god will save my soule. The King is extremely offended with me touching the militia, saying that I should have performed the part of an honest man in professing against the illegalitie of the ordinance, commands me upon my allegiance yet to doe it. I have told him my opinion it is not safe for me to deliver anie opinion on things that are voted in the houses, you know how cautious I have been in this particular. I have studied all meanes which way matters may be brought to a good conclusion between the King and the houses…and [argued that] if we should have civill warrs, it would make us a miserable people and might introduce forraine powers…It hath been my daily endeavour and earnest solicitation with his Maiestie to induce business into this way. The King is pleased to have me, but how he will harken unto me and be persuaded by me I leave that to god.[138]

In insisting that a judge should not meddle with the decisions of parliament, Bankes acted in accordance with a policy earlier declared by Coke: "Judges ought not to give any opinion of a matter in Parliament, because it is not to be decided by the Common Laws."[139] The application of Coke's rule to the Militia Ordinance made a conflict of interest for Bankes. Parliament had placed him on a list of persons "fit" to be "entrusted with the Militia of the Kingdom" in the territory around Corfe Castle. Bankes had accepted the honor, hoping that Charles might be reconciled to the Militia Bill if men he trusted raised the forces.[140] Charles evidently saw some merit in Bankes's retaining his bona fides with parliament, for he directed him to certify that he had delivered "noe opinion touching the militia."[141]

The Militia Bill perplexed lord lieutenants and other gentlemen who received orders under it to raise troops for parliament. The Bill lacked the

force of the royal signature, which Charles placed on the "commissions of array" also received by the same people. These commissions empowered their recipients to raise troops for the king. Since no such summons had been issued for over a century, its legal status too was questioned. Here Bankes's opinion comforted Charles. Earlier he had advised that the king could summon subjects to defend the Scottish borderlands; now he apparently allowed that the right extended to commissions of array. Struggles with consciences, loyalties, and laws developed into fights over control of troops, ammunitions, and fortifications. The division of allegiance precipitated by the Militia Bill and the commissions of array accelerated the drift to war.[142]

Harkening to Bankes, Charles prepared to go to London to negotiate. But temporizing as usual, he consulted others and remained intransigent in York.[143] Meanwhile Bankes's parliamentary correspondents willing to compromise continued to seek his intercession. Lord High Admiral Northumberland, on 19 May, answering Bankes's letter of the 16th: "You being in a place where I hope your wise and moderate counsells may contribute toward the composure of the differences makes me desirous a little to expresses my sense unto your Lordship." The sense was that, if the king would only assent to the "few humble desires" that parliament was drawing up, the Crown would retain its prerogatives, parliament its privileges, and the country its king. On 21 May Holles replied, assuring Bankes of his and parliament's eagerness for accommodation, "upon the first indication of a change in his Maiestie, that he would [listen to Bankes and] forsake those counsells which carry him on so high a dislike and opposition to their proceedings by mispossessing himself of them." On 31 May, the Earl of Essex, the Lord Chamberlain, soon to be the commanding general of parliament's army, wrote in the same vein: "I know none but must abhor this difference between his Majestie and the Parlement, but delinquents, papists, and men that desiar to mack their fortunes by the troubles of the land."[144] According to a contemporary observer, it was these bad actors, "malignant and dangerous spirits, who are near his Majestie's person," who frustrated Bankes's attempts.[145] They included thoughtless

Queen Henrietta, reckless Prince Rupert, cavaliers eager to fight, and privy councilors ignorant of the state of the country.

Parliament's proposals, set forth in nineteen propositions, reached Charles on 2 June 1642. They were hardly humble; "overreaching," rather, and "unreasonable."[146] Parliament's desiderata included appointments to all high offices of state; control of all forces and fortresses; management of affairs of state, direction of the education and marriage of the royal children, and jurisdiction over religious conflicts; and the power to enforce the laws against Catholics, to reform the Anglican Church, and to intervene effectively for the Protestant cause in Europe. Charles haughtily rejected these nineteen forms of castration. That caused Lord Saye to appeal to Bankes to bring the king to his senses. "I beseech you, use your best indeavour to prevaile with the King to trust his Parliament before private men, his great counsel, before men engaged and interested for their owne endes." Northumberland besought Bankes to move the king to gentler language, which might yet (so he wrote on 14 June) avert the calamity of a civil war. "Let us but have our lawes, liberties, and privileges secured unto us, and lett him perish that seekes to deprive the King of any part of his prerogative or that authoritie that is due unto him."[147]

The same post brought a letter from the Puritan Lord Philip Wharton, who in a month's time would lead a parliamentary raid on the magazine at Manchester in one of the first skirmishes of the Civil War. Wharton asked Bankes for an assignment to help arrest the slide toward armed conflict if the Chief Justice could diagnose the reason for it: "the wantonness of some few interested or unprovided people," or "a judgment upon us immediately from the hand of God, for which no naturall or politique reason can be given"? He repeated his desire for an assignment on 13 July, which would have reached Bankes about the time of the skirmish in Manchester.[148]

Each side hurriedly armed while assuring the other that it intended its army only for defense. The king's Secretary of State, Lord Falkland, and his Chancellor of the Exchequer, Sir John Colepeper, both recently active

among Charles's opponents in parliament, joined with Lord Chief Justice Bankes and thirty-four peers in an engagement to defend the king and Crown against "all persons and powers." They also promised to stand up for "the true Protestant religion established by law, the lawful liberties of subjects, just privileges of the Crown and of both Houses," and to refuse to obey "any rule, order, or command concerning the militia without royal assent." That was on 8 June.[149] In desperation Northumberland suggested that "an act of oblivion and generall pardon...would incline many to an accommodation." Parliament sent one last set of propositions in mid-July. Charles peremptorily called on his Chief Justice for advice. The king's mood, as Bankes relayed it to Lord Saye on 11 July, was truculent. He complained of parliament's high-handedness in its several sets of propositions. Still, he seemed ready to grant "whatsoever is petitioned for or demanded of right either concerning the ecclesiastical or temporal state, etc. But that may not be extorted, and the King is now in a condition not to have anything inforced from him." Charles would accept no more Venetianizing. Bankes urged him again to meet with the Houses. Charles ignored the advice and answered parliament in language regarded as harsh even in York, in order, he said, not to encourage new raids on his prerogatives and discourage his strongest supporters.[150]

On 22 August the king set up his standard. Typically, he hesitated over details. At the last minute he decided to edit his declaration of war for style. The herald who was to read it stumbled over the corrections.[151] What should have been a clarion call came out in toots. It is said that the wind promptly blew the standard down, a bad omen in that age of symbols. The first major clash occurred at Edgehill in Warwickshire on 23 October. The edge went to the king. But his losses too were great and he retired to Oxford. On 22 January 1643, Charles wrote to Bankes to attend him immediately. "We have speciall occasion to advise with you concerning some Affaire [that] will admit of no delay...[It] is of that importance as is neither fit to be imparted to you by letter nor will beare any delay or excuse."[152] Bankes rushed to his sovereign in Oxford.

4

CULTURAL THREADS

King James's Handful

Jacobean Cosmology

In October 1589, a violent storm forced the ship carrying James's 15-year-old bride Anna, whom he had married by proxy, to seek refuge on the Norwegian coast. Her voyage began with a misfired salute to the Danish–Scottish alliance that blew up the guns and the gunners. Despite the omen, against all advice, completely out of character, and although he preferred no wife to any, James set forth upon the stormy deep to get his queen and beget an heir; "as to my awne nature, God is my witness, I could have abstaint langair nor the weill being of my patrie could have permitted." The ardent wooer had courage for only one winter crossing of the North Sea.[1] He spent his long honeymoon in Denmark talking Latin with the great astronomer Tycho Brahe and other learned men. Brahe worked on a small island, Hven, given him by Anna's father, where he had built the largest observatory in Europe. With the help of students and visitors he sometimes marooned there, Tycho measured the positions of the stars and planets more accurately than anyone had done before.

James visited Tycho's island for seven hours just before the vernal equinox of 1590. He and his host inspected instruments, wrote epigrams, and talked about world systems.[2] James prided himself on his first-hand knowledge of Tycho's work. "We have seen it and heard about it, with our own eyes and ears, in your castle dedicated to Urania; and in wide-ranging learned and interesting conversation with you we have been so elevated that it is hard to decide if our pleasure or our admiration is the greater."[3]

Although James advised his sons Henry and Charles against acquiring knowledge for its own sake, "nakedly…like those vaine Astrologians, that studie night and day on the course of the starres, onely that they may, for satisfying their curiosity, know their course," he had allowed himself to learn enough of this "most necessary and commendable" science to appreciate the import of astronomical discoveries.[4]

Very probably James had learned his astronomy grudgingly from a long Latin poem by his tutor, George Buchanan, an adventuresome humanist who had spent his young manhood on the Continent studying and teaching as a Catholic before returning to Scotland and the Reformed Church. James heartily hated him for his stern discipline and perverse advocacy of the right of Scots to depose a tyrannical king.[5] Among Buchanan's unwelcome teachings was respect for the Venetian constitution; as he saw it, a king should be little more than a doge, an executive of a constitutional government, an ordinary human being subject to the law. He counseled James presciently but ineffectually to despise flattery, favorites, and incompetents. Buchanan developed these liberal ideas in a book on Scottish history, *De jure regni apud scotos* (1579), that made him additionally odious to his tutee; for Buchanan judged that Scottish law and customs justified the forced abdication of Mary Queen of Scots.[6] The book became notorious: the Scottish Parliament banned it (1583); the Long Parliament took it as a fundamental text; the University of Oxford burnt it (1683); American revolutionaries consulted it. That suave defender of James's mother Mary, George Conn, likewise dismissed Buchanan's history ("infamous lies") and condemned its author ("that impostor," "that malicious dissembler").[7] But in James's time, and in Denmark, Buchanan was the prince of Scottish scholars. A portrait of him hung in Uraniborg.[8]

Tycho's successor Kepler supposed that the cosmic harmony he heard among the stars might be brought to earth by his fellow student King James. Did not James's skill in damping discord in his ill-assorted kingdoms, and in nudging most English Protestants toward the same hymnbook, betoken a healthy polyphony in church and state, conducted by a ruler in

step with the law? This was the way to manage human affairs as well as celestial motions! Midway through his wild exposé of world harmony, *Harmonices mundi* (1619), which he dedicated to James, Kepler expressed the essence of the best possible polity by an arithmetic–geometric proportion.[9] Knowing how earth related to heaven, human government to divine, and scepter to telescope, the Scottish Solomon would know how to use the perspective Kepler offered him. "O Telescope…Is not he who holds you in his right hand made King and Lord of the works of God?"[10]

In England, too, a bold thinker linked James's mastery of astronomy to the concord of Christianity. He was Thomas Tymme, a preacher devoted to alchemy.[11] In a dialogue published in 1612, Tymme made James the arbiter between a sharp docile student, Philadelph, and a dull preachy teacher, Theophrast.[12] Theophrast defends the traditional cosmology (Figure 17). Would it not be more economical, Philadelph asks, to spin the earth than the heavens, and more reasonable to place the earth in orbit than the planets on epicycles? Theophrast offers the crushing rejoinder: "[I]t seemeth you will preferre novelty before Antiquity." Such hubris! To join the crowd of arrogant fools who have "laboured to draw out of the shallow Fordes of their owne braine, the deepe and unsearchable misteries of GOD"! Aristotle had died from this intoxication. Unable to explain the tides, he had leapt into the sea crying lengthily and cleverly, "Quoniam Aristoteles mare capere non possit, capeat Aristotelem mare," a proper ending, says Tymme, for a man who "asketh to be wise without God and his word."[13]

Philadelph observes that his teacher has not answered Copernicus's arguments. Theophrast replies with Joshua's stopping of the sun and other decisive texts and, though unnecessarily, adds that he has seen a convincing material model of a geocentric universe. This was a perpetual astronomical clock with an attachment that simulated the diurnal motion of the tides. Its inventor, James's Dutch engineer Cornelius Drebbel, claimed that the motion was perpetual. Philadelph rightly doubts the pertinence and perpetuity of the model but surrenders instantly on learning that King James certified it. Tymme said nothing about Galileo's discoveries.[14] Soon,

This outtermoſt circle of this figure of all the
Sphæres (which is infinite) doth reprefent the ha-
bitacle of God, who was before all time
and place.

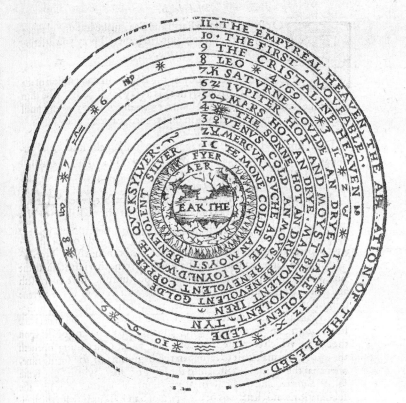

Time and Place began when this created
World began to be.

Figure 17 The universe according to Thomas Tymme, A Dialogue Philosophical (1612), 55.

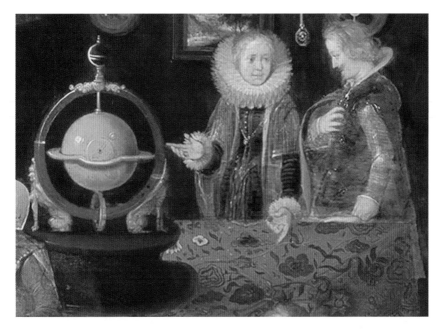

Figure 18 Cornelius Drebbel's perpetual motion machine (c.1610); detail of Figure 19.

however, his readers would be able to reinforce Philadelph's doubts by viewing Jupiter's moons through glasses made in England by Drebbel.[15]

One of Galileo's former students saw a duplicate of Drebbel's ingenious machine made for the emperor and described its tidal simulator to his master. It consisted of an air-filled metal sphere fixed to a vertical hollow ring half filled with water (Figure 18). The fixing (the vertical axis) conceals a hollow pipette and a partition that divides the ring into two branches. A small hole in the sphere's equator allows its interior and, via the pipette, the left-hand branch, to communicate with the atmosphere. When the external temperature rises, the pressure in the globe and branch increases and the water moves anticlockwise; cooling reverses the motion; thus two tides a day.[16] By 1616, when Galileo began to circulate his tidal theory, Drebbel's natural magic had spread beyond the cabinets of kings and emperors (Figure 19). Was it in response to it that Galileo claimed to have a machine (never exhibited!) that mimicked tidal motion in a semi-circular

Figure 19 Jan Brueghel the Elder and Hieronymous Franken II, *The Archdukes Albert and Isabella Visiting a Collector's Cabinet*. The yellow sphere to the rear, left, is Drebbel's perpetual motion machine.

canal? The device created for the amazement of King James might well have reinforced Galileo's commitment to the theory that capped the Copernican argument of the *Dialogue*.[17]

James picked up more than astronomy and Anna during his stay in Denmark. He adopted the theory of witchcraft he developed in his demented *Daemonologie* (1597), which accepts that witches can cure or cause disease, induce love or hate, conjure sprites, ruin digestion, sail in sieves, and "raise stormes and tempests in the aire, either upon Sea or land."[18] This last power he had experienced himself: for it was quite true, as rumor on both sides of the North Sea reported, that witches had called up the storm that detained Anna. Some crones encouraged by torture explained how to stir up a tempest by tying human body parts to a cat before throwing it into the sea; none of them, however, knew how to turn off a breeze. One terrified woman terrified the king by reporting the words he had whispered privately to Anna on their first night together; "whereat the Kinges Majesty wondered greatlye, and swore by the living God that he beleeved that all the Divels in hell could not have discovered the same: acknowledging her woords to be most true, and therefore gave the more credit to the rest." Why did the devil desire his followers to drown the royal couple? The witches' answer, that the devil feared James of all men, proves that the Evil One was a Papist; "the union of a Protestant princess with a Protestant prince…being…an event which struck the whole kingdom of darkness with alarm."[19]

James had his *Daemonologie* reissued the year he became King of England. His new subjects needed to know that witchcraft abounded among them.

> For the great wickednes of the people on the one part, procures this horrible defection, whereby God justly punishes sinne, by a greater iniquity: And on the other part, the consummation of the world, and our deliverance drawing neare, makes Sathan to rage the more in his instruments, knowing his kingdom to be so neare an end.

The wicked people heard, and presented the king with a play, *Macbeth*, in which witches sail in sieves, raise the winds, and predict the future with

dreadful accuracy. Soon some fraudulent accusations that James himself exposed caused him to doubt the Satanic pact.[20] Later he "laughed consumedly and made great fun of the Catholics saying they put their trust in the oaths and depositions of the demon and in the things which idle persons and witches say they see in their diabolical games."[21]

"Learning," opined the playwright William Davenant, "is not knowledge, but a continu'd Sayling by fantastic and uncertain winds towards it."[22] James accepted continental learning about witches until favorable winds drove him to a better position. It would have taken a hurricane to move the very learned Archbishop Ussher. Knowing from revelation that the devil had been let loose around the year 1000, Ussher was not surprised by a message delivered via a fish in Cambridge market in 1626. The fishy message was a copy of Richard Tracy's *A Preparation to the Cross* (1540), which warned about the scourges God visits upon us for indulging "luste of the fleshe, concupiscence of the eyes, and pryde of life." Ussher: "the Accident is not likely to be lightly passed over, which (I fear me) bringeth too true a Prophesy of the State to come." To reinforce the message, God, still in a maritime mood, sent a great waterspout up the Thames right into the garden gate of Buckingham's riverside mansion. Ussher again: "[L]et the Lord prepare us for the day of our visitation."[23] Ussher's alertness to such announcements may serve as a salutary reminder that in early Stuart times, as no doubt now, rational discourse and great learning can paper over a world of beliefs incompatible with them. It is as unfair to smile at Ussher's sensitivity to omens as to cavil at his error of thirteen billion years in dating Creation to 23 October 4004 BCE, towards 6:00 in the evening.

Missed Opportunities

James might have been a mighty patron of the arts and sciences had he been rich and decisive enough to support the meritorious projects submitted to him that later British monarchs saw fit to patronize. Three of these proposals if implemented would have given him a unique, and

uniquely balanced, portfolio of initiatives in history, literature, and natural science.

When James came to England, a small group of antiquaries centered on William Camden, a senior official in the College of Heralds, met regularly to discuss old charters, inscriptions, monuments, and coins. Among those who agreed with him that the study of antiquity "hath a certaine resemblance with eternity" were Arundel and Andrewes. Other members of the group were Lord John Lumley, a relation of Arundel, famous for his library; Robert Cotton, a former student of Camden, also famous for his library, in which much of Dee was preserved; John Spelman, a lawyer with a passion for Saxon studies; James Ussher, who often left his posts in Ireland to collect books in England; and John Selden.[24]

In 1603, Camden's group petitioned Elizabeth for a charter to establish an Academy for the Study of History and Antiquity and a royal library for the collection and preservation of old books and manuscripts. She died before she could act on the proposal. James signaled that he would like Camden's group to disappear. Its concern with the relative antiquity of kings and parliaments could raise difficulties for a monarch who held prerogatives by divine right. Although the group stopped meeting around 1608, the legal historians among its members found ways to continue to alarm the government.[25] Their arsenals were their libraries stocked with useful documents inaccessible in the Tower or the Exchequer, or unknown there because lost or crumbling.

The antiquarian lawyers did not confuse knowledge of the "desents, genealogees, and petygrees of noble men ... & such like stuffe" with true history. The words just quoted come from a primer on the writing of history by the Italian philosopher Francesco Patrizzi, as rendered by Thomas Blundeville, who also taught Englishmen mathematics and navigation. Blundeville–Patrizzi specify that true history seeks motives in the backgrounds, parentage, education, ambitions, and habits of the actors, and "tell[s] things as they were done without either augmenting or diminishing them, or swarving one iote from the truth."[26] The most famous of historian–lawyers, Francis Bacon, likewise advised his readers "diligently

to examine, freely and faithfully to report, and by the light of words to place as it were before the eyes, the revolutions of time, the characters of persons, the fluctuations of counsels, the courses and currents of actions, the bottoms of pretences, and the secrets of governments."[27]

A good indicator of the danger of history is Cotton's *Short View of the Long Life and Rayne of Henry the Third*, which circulated in manuscript from 1614 until published in 1627. Almost as compromising in its context as Sarpi's *Trent* in papal Rome, Cotton's *Short View* exhibits parallels between the corrupt rule of a favorite in England under Henry III and Britain under James, and a more striking anti-parallel: Henry came to his senses, got rid of his favorite and foreign intriguers, cut his expenses, and governed responsibly with the aid of a wise Privy Council.[28] Although written against Carr, when published in 1627 it had obvious reference to Buckingham. So did *Sejanus: His Fall* (1603, 1616), by Ben Jonson, written with the help of Cotton's books, which details the crimes of Lucius Aelius Sejanus, the favorite of Emperor Tiberius. Its timeliness became clear as Buckingham accumulated power. Cotton's library continued to supply unwelcome recondite precedents deployed by parliaments. In 1629, King Charles shut it down. He thereby deprived his enemies of, among many other things, two copies of *Magna carta* and the conjuring apparatus of John Dee.[29]

Notable users of Cotton's library included Arundel, Ussher, and Lord William Howard.[30] We suppose that the learned and rising John Bankes also belonged to Cotton's circle, since, like Bankes, Cotton and Cotton's son held Howard seats in parliament.[31] These allegiances by no means precluded occasional cooperation with the Crown. As Attorney General, Heath and then Noy used precedents dug up at their request by Selden, Cotton, and Spelman.[32] Selden accepted a commission from the House of Lords to settle with documents the pressing questions whether a peer could take a deer from the king's forest, whether his privilege of being free from arrest while parliament sat extended to his servants, and whether he could claim benefit of clergy if illiterate. Spelman served on a committee to review legal fees that had grown wildly over time: fees for taking

oaths, for burial, and for copying, which in one remarkable case consumed sixty-five skins and £272 more than necessary and in another forty sheets where six would have done. Spelman's reasonable proposals for reform, based on firm precedents, met with firmer opposition from profiteers and failed to be adopted.[33]

More successfully, Cotton found a precedent in the reign of Henry IV for parliament's voting a subsidy before its grievances were redressed; discovered no precedent against the creation and sale of the title of baronet, which for a time brought the crown £30,000 a year; used the relative privacy of his library to open negotiations with Gondomar over the Spanish match; and hunted up, for Buckingham, precedents for ridding the country of obnoxious ambassadors. None of these services kept him out of the Tower in 1629 or reduced his sojourn there.[34] Although Bankes supported Cotton and Selden, as usual he managed to avoid compromising himself.[35] He did not write books.

The exemplar of the symbiosis between antiquarian research and legal argument was Selden. After training in the Inner Temple, he became a copyist for Cotton's library and a most effective exploiter of its holdings. He annoyed the Stuarts by demonstrating that laws and assemblies preceded the institution of kingship. In *Titles of Honour* (1614) he went after the regalia and status of the nobility, including the kings of England, whose crown and scepter, and notions of divine right, he showed were relatively recent inventions. The title "Majesty" came in with Henry VIII, and a "Stuart" was but a thane, a dignity scarcely higher than a baron. Selden reached these conclusions with the help of "that *Medium* only, which would not at all, or least, deceive by Refractio,"—that is, the perspective (the metaphor of the age) offered in the libraries of Cotton and "my beloved friend that singular Poet Mr Ben Jonson."[36]

Selden's answer to his fellow antiquarian Henry Spelman's defense of tithes as a divine right of clergy showed what examination through the perspective of document-based history could do. Selden found no evidence of tithing in the early church and no evidence of its establishment in Europe until Charlemagne and in England before Henry III. The claim to

dole by divine right was an invention of the popes of the later middle ages. "Experience and Observation" thus wiped out "so much headlong Error, so many ridiculous imposters."[37] The erring establishment did not welcome this enlightenment. The bishops (apart from Selden's close friend Andrewes) read Selden's book as a slur on their learning as well as an attack on their revenues. We are not so ignorant, they said, as not to perceive the tendentiousness under the footnotes. "*History* disputeth not *Pro*, or *Con*; concludeth not what should be, or not be…This you have not observed, Master *Selden*, but made yourself a Party, which no *Historian* doth."[38] "[The] historical way," says Bacon, "[is] not wasting time, after the manner of critics, in praise and blame, but simply narrating the facts historically, with but slight intermixture of private judgment."[39] Selden answered the bishops that he had followed the way of Bacon. The facts spoke for themselves, once he had arranged them; to write them down as he had picked them up would have been "too studious [an] Affection of bare and sterile Antiquitie"—that is, worthless. But the bishops prevailed. Selden's brother in learning, King James, compelled him to retract.

While working on tithes, Selden buried, or rather drowned himself, in that investigation of the law of the sea from which he dredged up the doctrine that water could be owned as well as land. As we know, James did not like the conclusion and, going further than he had with Selden's history of tithes, prohibited the publication of *Mare clausum* altogether.[40] Fortunately James did not know the extent of Selden's deviancy. The great lawyer regarded the interpretation of Scripture as guesswork and predestination as unintelligible and challenged resurrection by directing that he be buried under ten feet of soil, a large block of marble, and a pile of bricks.[41]

Like Cotton, Selden sat in Howard seats in parliament, belonged to Arundel's academy of Italophile savants, and acted as an independent consultant at the highest level. He supplied Bacon with information for his history of Henry VII, catalogued Arundel's famous Greek marbles, helped Ussher calculate the eve of creation, and advised King James about the dating of the Nativity and the meaning of the number of the beast.[42]

Selden admired Sarpi's writings and practiced a similar historiography. He thus found himself in and out of favor with his sovereigns, who liked Sarpi's approach when directed at the papal, but not at the Stuart court.[43]

The researches of the legal historians easily exploded the notion of an ancient perfect balance of church, monarchy, and state. When could that have been? Before the dissolution? But then we were all Catholics and the pope had his finger on the balance. Since the dissolution? But in recent years we have seen *Magna carta* violated, church property destroyed or perverted, T&P illegally collected. There had never been an idyllic past any more than there had been a Brute, descended from Aeneas, who settled the British Isles. There were plenty of indigenous brutes, however, three kingdoms full of them according to their historiographer Camden. Here astrology came to the aid of history. The fiery trigon Aries, Leo, and Saggitarius in collaboration with Jupiter and Mars "maketh [the British] impatient of servitude, lovers of libertie, martiall and courageous." This flattering picture improves the description in Camden's source, Ptolemy's *Tetrabiblos*, which adds that northern people with close familiarity with Aries and Mars, such as Britons and Germans, tend to be fierce, headstrong, and bestial.[44] Camden discovered on his own that, when Saturn sits in Capricorn, plague invariably arrives in London, and that a certain eclipse (unspecified, so as to spare worry) is "'fatall to the Towne of Shrewsbury.'"[45]

The second project proposed to James, which frightened him less than the antiquaries', called for an "Academ Roial" modeled on Florence's Accademia della Crusca, which had charge of the literary affairs of Tuscany. Its moving spirit was Edmund Mary Bolton, a Catholic gentleman and minor poet whose friends included John Donne, Ben Jonson, and Inigo Jones. In 1617, Bolton approached Buckingham, a kinsman, with a plan of literary renewal that would cost only £200 a year. Buckingham supported it. James had wanted to set up "an academy for bettering the teaching of youth, and for the encouragement of men of art," but could not spare money from his hunting to do so. In 1622, he turned the project over to Charles. Nothing came of it. Two years later James took up the arts side of his academy in the form Bolton had proposed and went so far as to

concern himself with the design of the group's seal (himself on one side, Solomon on the other), the rights of precedence of its members, and other essential academic matters. Nothing more came of that either.[46]

Bolton divided the membership of his proposed academy into two classes: drones (consisting of "Tutelaries" like Knights of the Garter and "Auxiliaries" chosen from ordinary peers) and workers ("Essentials," leisured gentlemen at least 30 years of age). Many of Bolton's Essentials were Catholics or well disposed towards them: Ben Jonson, George Gage, Endymion Porter (Bolton's brother-in-law), George Fortescue, Tobie Matthew, Sir Thomas Aylesbury (a mathematician who invented a way to coin money and became master of the Mint), and that knight of miscellaneous learning, Sir Kenelm Digby, "the Pliny of the age for lying." Other prime candidates were Henry Wotton and three veterans of Camden's group, Cotton, Selden, and Spelman.[47]

The academy would serve (so Bolton told James) "for the universal embetterment of your people, for the more advantage of your kingly prerogative, certainly for your Majesty's greater comfort, and for the everlasting fresher glories of your name among us." Its duties included policing translations, especially of classical authors often mangled by hacks; drawing up expurgatory indexes of English books; overseeing the composition of a "spare and free authentic" celebratory history of England; and "keep[ing] a constant register of public facts."[48] Had James lived to endorse these activities, he almost certainly would not have paid for them. This much we can infer from the story of Chelsea College, established with royal backing in 1610.

Chelsea's purpose was to train controversialists to help James confute the "lyes, slanders, heresies, sects, idolatries, and blasphemies" of Pope Paul's army of seasoned Bellarmines. As its dowry it had enough timber from a royal forest to build an eighth of its fabric. Its first provost, Matthew Sutcliffe, Dean of Exeter, was a satisfactorily paranoid anti-Catholic. But, although Sutcliffe put his own resources into the college and several future bishops sharpened their teeth there, it did not pay its way and by 1616 was in serious financial trouble. James came to the rescue by ordering the bishops to do so. Most of the little that came in was consumed by

the cost of raising it. The college then diverged from royal policy by attacking Arminians as quasi-papists. Cromwell killed it. Not a stone now remains.[49]

While the Academ Roial was under lethargic consideration, the greatest projector of the time returned to James for support for what he called the Great Instauration, or root-and-branch renewal of the natural sciences. Francis Bacon had tried James just after the Gunpowder Plot, to no avail, although he had taken the trouble to write out a lengthy description and classification of the sciences needing renovation. This was the *Advancement of Learning* (1605), which coincided, unfortunately for Bacon, with the new king's launch of the projects that produced the King James Bible and Chelsea College. Even a rich divine-right king might have hesitated, however, over Bacon's plan to take over three public schools and three Oxbridge colleges.[50]

But who other than James could bring it about? "There hath not been since Christ's time any King or temporal Monarch, which has been so learned in all literature and erudition, divine and human." Not since Hermes has there been such a miracle: "the power and fortune of a king, the knowledge and illumination of a priest, and the learning and universality of a philosopher." James's rare conjunction of admirable traits must be celebrated by a marker as permanent as possible in this our world of flux and transition, by some "solid work, fixed memorial, and immortal monument." What better way to assure the quasi-immortality of the new Solomon than by directing the winds of learning, by preserving and improving knowledge?[51]

Bacon offered James three targets or "works of merit" in this line: libraries, universities, and scholars. Universities, with their privileges and endowments, provide quiet and privacy for the thinking man; libraries, shrines for the repose of the relics of learning; scholars, worthy subjects of reward. The works of merit of previous princes left the instruments of learning imperfect: the universities focus on the professions at the expense of the sciences natural, civil, and moral; scholars' salaries are too small and mean; and libraries, fixated on books, do not supply the

experimental apparatus essential for advancing knowledge. A useful set
of experiments costs money. In one of his striking strained analogies, Bacon
told James that inquiring into the kingdom of nature was like spying on
fellow rulers; "and therefore, as secretaries and spials of princes and states
bring in bills for intelligence, so you must allow the spials and intelligen-
cers of nature to bring in their bills, or else you will be ill advertised
[informed]."[52]

The advancement of learning is not a matter of money only. The work
also needs the guidance of a prince able to understand his investment, to
perceive where learning is deficient, and to engage competent people to
prosecute underdeveloped sciences. Bacon takes James on a "general and
faithful perambulation of learning, with an inquiry what parts thereof lie
fresh and waste, and not improved or cultivated by the industry of man."
In their long walk, which constitutes most of the *Advancement of Learning*,
Bacon notices the barrenness of the fields they pass, but does not stop
to improve them; "for it is one thing to set forth what ground lieth
unmanured, and another thing to correct ill husbandry in that which is
manured."[53] Not knowing how much manure he would be required to
hear or buy, and perhaps for other reasons as well, James declined to
patronize the Great Instauration.

After rising to Lord Chancellor, Bacon prepared a clearer diagnosis of
the illness of learning and its cure, a *Novum organum* (1620), a new method.
The cure was to begin with the compilation of the necessary data, or
"experimental natural histories." The effort demanded more manpower,
experiments, machines, and travel than appeared from the *Advancement of
Learning*. Bacon tried James again with the rhetoric he had employed unsuc-
cessfully in 1605. The Great Instauration was the sort of thing Solomon
would have done, if he had had a Bacon, and therefore a project worthy of
Your Majesty, "who resemble Salomon in so many things—in the gravity
of your judgments, in the peacefulness of your reign, in the largeness of
your heart, in the noble variety of the books you have composed."[54]

James liked the general idea as described in the preface to the Great
Instauration, but had not the patience to absorb the details.[55] In the end, Bacon

could only draw up a blueprint of a utopia located on an island in a distant sea. Solomon's House, the utopia's wellhead, employed dozens of savants arranged like bishops in hierarchical ranks to seek information, compile natural histories, do experiments, develop theories, and make medicines and machines. He died before he could specify how Solomon's House could be transported from its island to the Stuarts'. Arundel made a partial answer by providing in his will for room, board, and clothing for six Solomons who had the qualifications of being poor, honest, and unmarried. They would have a good supply of books "and convenient roomes to make all Distillations, phisickes, and Surgerie."[56] Their works, if any, are not recorded.

Had James supported the academies proposed to him, his Academ Roial would have anticipated the Académie francaise (1635); his Society of Antiquaries, the Académie des inscriptions (1663); and his Solomon's House, the Académie royale des sciences (1666). But he left his court without even the services of an astronomer, such as the emperor provided at Prague in Kepler and the Grand Duke of Tuscany at Florence in Galileo.[57]

Building

When fire destroyed his Banqueting Hall in 1618, James commissioned his Surveyor General to replace it with a modern building free from the discomforts of the shabby warren of Whitehall, a new fresh palace worthy to receive the Spanish princess he had set his heart on.[58] Jones decided on a freestanding Palladian town palace in the shape of a double cube (length 110 feet, height 55 feet); construction began in 1619 and ended three years later, ready for the princess who never came. Although Wotton condemned the Corinthian and Composite capitals on the facade as gaudy Catholic, most observers judged the Banqueting House a great success. "If all the Books of Architecture were lost, the true art of building might be retrieved from thence."[59] James had his portrait painted in front of a detailed representation of it (Figure 20).[60]

Jones's masterpiece received its finishing touch in 1635 with three huge ceiling paintings by Rubens. They celebrate good King James as a unifying

Figure 20 Paul van Somer, *James I of England*. The king is shown standing in a window of Whitehall with the almost finished Banqueting Hall in the background (1620).

Solomon who brought together the Crowns of England and Scotland; as an irenic Solomon who lavished Peace and Plenty on both; and, in the great oval centerpiece, as a dead Solomon who went to heaven in the company of Justice, Faith, and Religion. The paintings required a sacrifice beyond payment of £3,000 to the artist. Masques and plays could no longer be acted there because the smoke from the torches illuminating the performances might spoil the paintings.[61]

The coincidence of the start of Jones's great Palladian hall with the inauguration of the Mortlake tapestry works, and with Prince Charles's purchase of Raphael's cartoons for hangings depicting *The Acts of the Apostles*, suggests either a grand design or unusual luck. Several sovereigns, notably Christian IV and Henry IV, had set up or encouraged tapestry works in connection with major building projects. King James may have destined Mortlake products for new state apartments and for the Banqueting House, where Mortlake's *Acts of the Apostles* did hang on state occasions. Hiring the "Titian of tapestry" (our Cleyn) to decorate the Banqueting House of a king of England with tapestries designed for a pope of Rome, and engaging the Catholic Rubens to paint its ceiling with a celebration of the Protestant James, exemplified the religious–artistic miscegenation of the early Stuart courts.[62] Rubens's paintings, Jones's building, and the ghosts of Cleyn's tapestries make a powerful symbol for those who can read it. These were the last emblems of his reign that Charles saw before stepping out of the Banqueting House onto the scaffold, where he became a martyr to his father's teaching that he was "a little God to sit on his throne, and rule over other men."[63]

Queen Anna's Masques

The brave new Queen of Scotland, scarcely 16 years old, entered her uncomfortable capital of Edinburgh on May Day 1590, accompanied by 36 dames on horseback and an entourage of 200. The welcoming speeches, of which she could not have understood much, included one by Ceres, who addressed her primly in Latin, and another by Bacchus, who, more to the

taste of her new subjects, "[sat] upon a puncheon of wine, winking, and casting it by cups full upon the people."[64] These were not the manners of the German princes her parents had tried to imitate. Anna had some financial resources, however, which allowed her to improve her immediate surroundings; and she might have made an austere home for the muses in Scotland had James owned all the property he gave her.[65] In 1599 and again in 1601, she defied killjoy ministers by bringing in a traveling troupe of English actors. Perhaps the setting of *Hamlet* (published in 1602) with its many references to then recent Danish history owed something to the parentage of the Queen of Scotland.[66] Among her affronts to Calvinism, however, her encouragement of the theater paled against her covert conversion to Catholicism, which she underwent around 1600, despite her inaugural oath to "withstand and dispys all papisticall superstitiones, and quhatsumever ceremonies and rites contrair to the word of God." The move to England in 1603 gave Anna greater control of financial resources and a circle of aristocratic ladies who patronized the arts. By the time of her death she disposed of a considerable income: £24,000 a year from her jointure, £13,000 from duties on sugar and cloth, and something from licensing foreigners to fish in British waters.[67] Still she ended in debt. One reason for it, and the extravagance that made Bentivoglio doubt her piety, was the cost of her masques, her main contribution to English culture.[68]

These performances began with the queen and her ladies displayed, masked, in magnificent costumes on an elaborate stage. The cast proceeded to dance, by themselves and then with partners from the audience. All were mute: professional actors spoke and sang, and professional musicians played. Dancing was the centerpiece. The queen and her retinue spent much time in rehearsing, from two to five weeks, and much money on costumes, which might cost upwards of £300 each. Among the retinue wealthy enough to appear in several masques, the queen's favorite, Alethea Talbot, deserves mention: as Lady Arundel, she would be a lavish and knowledgeable patron of painters.[69]

The masques highlighted dancing for its mundane pleasures and, for those seeking symbols, for its cosmic mimicry. The stars and planets

dance to the music of the spheres, the elements continually change partners, sound is the fluttering of the air, and tides the choreography of the sea; only the solid earth stays put:

> Although some wits enrich'd with learning's skill
> Say heav'n stands firm, and that the earth doth fleet
> And swiftly turneth underneath their feet.

Either way, according to Sir John Davies, who wrote these words, the apparent motions of the stars invite us to dance, prove the nobility of dancing, and illustrate the concord of the universe.[70] Davies's interpretation of the universe as the domain of Terpsichore dates from 1596, when he enjoyed associations with Oxford and the London Society of Antiquaries.

The first of Anna's English masques, Samuel Daniel's *Vision of the Twelve Goddesses*, marked the high point in the play-filled Christmas season of 1603–4, when James, wishing to initiate his reign properly, entertained foreign ambassadors as well as his Scottish favorites and English courtiers. Invitations were scarce and prized: and, since not all ambassadors received them, the *Vision*, like all Anna's masques, had a political edge.[71] In her second play, Jonson's *Masque of Blackness* (January 1605), her company appeared blackened, as daughters of the god of the Niger, who wanted them whitewashed—a process that could be accomplished only under the scarce sun of Britannia. The audience shuddered to see their English roses blackened and disliked the play (Figure 21). Jonson and Jones redeemed themselves in their next try, *The Masque of Beauty* (January 1608), in which the nymphs, whitened and bejeweled, and four others wanting bleaching, returned to Britannia on a floating island. This piece of stage wizardry in the Italian style also carried an orchestra and figures representing the eight elements of feminine beauty, which prudence deters itemizing. No doubt the French ambassador was outraged that his Spanish counterpart received an invitation and he did not. He missed a good show. James liked it so much that he demanded encores and, despite its cost of £3,000, asked Anna to provide another masque for the following year.[72]

Figure 21 Inigo Jones, sketch of a participant in Jones's and Jonson's *Masque of Blackness* (1605).

For £5,000 she supplied *The Masque of the Queens*, which introduced the antimasque, a prelude or interlude intended by its quirkiness to bring out the sober beauty of the main action. Antimasques also offered opportunity for metaphorical political commentary with relative impunity. The antimasque of *Queens* centered on a smoke-filled pit from which emerged thirteen witches played by professional actors. The hag in charge introduces them—Ignorance, Suspicion, Credulity, Falsehood, Murmur, Malice, Impudence, Slander, Execution, Bitterness, Rage, and Mischief—who might have served as personifications of witch-hunters like King James. The witches boast storm powers, chant charms, and vanish with their Hell. In their place appears the House of Fame, whence twelve queens led by Bal-Anna ride forth in chariots, alight, and dance.[73]

Smoke-filled pits easily appeared when resin fell on an open flame and Hell's mouths and dragons' breath became pleasant and plausible with a little sal-ammoniac and brandy. Since torches and candles provided the illumination and reflectors multiplied the light, masques were literally smoke and mirrors.[74] The optical effects combined with loud music to drown out stage machinery and perfumed perspiring bodies completed the assault on the senses. On the mind, however, the beauty of the costumes, status of the performers, and veiled intent of the playwrights imposed a compelling three-dimensional hieroglyph; or so said Daniel, following Jonson and anticipating Bacon, who recommended hieroglyphs and parables in general, "because arguments cannot be made so perspicuous nor true examples so apt."[75] Appreciating a masque, putting together the hieroglyphs as symbol, allegory, myth, analogy, celebration, or protest, took some effort. The chief hieroglyph in Anna's performances is easily deciphered, however: women made the masque "the most developed courtly pastime and formal social occasion of the English Renaissance."[76]

For her son Henry's investiture as Prince of Wales in June 1610, Anna gave a masque written by Daniel, staged by Jones, and starring herself. Princess Elizabeth, acting in a masque for the first time, appeared as a Nymph of the Nile. Six months later it was Henry's turn, in *Oberon, the Faery Prince* (New Year's Day 1611), which he commissioned from Jonson

and Jones. *Oberon* opened with some satyrs playing on a boulder as they awaited the arrival of the faery prince and his company on a couch drawn by two white bears. Simultaneously musicians sang a hymn of praise and reassurance to King James: "[He] in his owne true Circle, still doth runne | And holds his course, as certayne as the sunne." The prince then led his followers in their own geometrical courses. A month later Anna gave her Jonsonian masque, *Love Freed from Ignorance and Folly*, which required Cupid, chained by the Sphinx, to solve a riddle to save himself and eleven beautiful maidens of the morning. The riddle: find a world without a world where everything is done by a fixed eye that moves and whose power rests on the mixture of contraries never previously joined. Cupid instantly answers "woman." Wrong. The Sphinx prepares to annihilate Love. Cupid tries again: "the King of Albion." Right. Love's recognition of the joint power of king and parliament vanquishes the evil Sphinx.[77]

The royals sat through many plays and masques, an average of twenty-five a year, most of them crammed into the holiday season between November and February. The sabbath presented no obstacle to these revels or to the abbreviation of costumes. "[Anna's] clothes were not so much below the knee but that we might see a woman had both feet and legs, which I [Dudley Carleton speaking] never knew before."[78] Submitting to these entertainments could be grueling. In February 1613, having just seen two long performances, James could not stomach a third. In March 1615, on his first visit to Cambridge, he sat through four successive evenings of theater, three of them in Latin. One was George Ruggle's *Ignoramus*, perhaps the most popular of academic comedies. James liked it so much he returned to Cambridge to see it again. Its fun depends largely on the broken Latin spoken by the lawyer Ambidexter Ignoramus and his clerk Dulman, who thus recommends the play:

> O Lector Friendlie ... tibi Wittum, tibi Jestaque plurima sellam
>
> Hic multum Frenchum, quo possis vincere Wenchum
> Hic est Latinum, quo possis sumere vinum.[79]

The tired plot employs a clever servant to prevent an old man (Ignoramus) from buying a young wife. Two fake priests accuse Ignoramus of diabolic possession for his unseemly lust and call out his devils by taking his legal terms to be their names. Ignoramus: if she married me she would have francum bancum. Priest: "Be gone, Francum Bancum." Ignoramus: She would also have Infangthief, Outfangthief, Tac, Toc, Tol, and Tem, which, by the way, she would have had if she had married John Bankes. Priest: "How many there are of them! Be gone all of you...Come forth you evil spirits, whether you be in his doublet, or his breeches, cloak, drawers, pen, wax, seal, inkhorn, indentures, parchments..."[80] James took great pleasure in the insults to the lawyers he blamed for the obstruction of his programs by parliament.

The lawyers railed at their treatment in Cambridge and composed many epigrams at the expense of scholars; but Gray's Inn's *Masque of Mountebanks*, performed before the king in 1618, struck instead at quack doctors.

> This powder doth preserve from fate
> This cures the Maleficiate
> Lost Maydenhead this doth restore
> And makes them Virgins as before.

The play also pokes fun at astrology. Physicians and surgeons relied on associations between zodiacal signs and body parts to determine times for bloodletting. The antihero of *Ignoramus* escapes gelding because the moon occupies the sign supervising the parts he would lose.[81] *Albumazar*, the only play in English James saw in Cambridge in 1615, involves such deep concepts of astrology that its resume must be put off pending further instruction. The same consideration applies to *Technogamia* (1617), a tedious play written and performed by scholars of Christ Church, Oxford, in the summer of 1621, which has in its favor some references to the Copernican system. Notice of Jonson's embroidery of Galileo's observations of the moon into the news that lunarians are humans covered with feathers need not be postponed, however, and is hereby given.[82]

Invitations to entertainments continued to have political significance. At a masque given by Prince Charles in January 1621, the ambassadors of

Tuscany, France, and Savoy being in attendance, and Charles and Buckingham competing in pirouettes, "the former Archbishop of Spalato, who daily advances in esteem and favour," stood near the king among a swarm of lords.[83] And it may be remembered that, soon after his arrival in England, George Conn was with the royal couple in Oxford at the performance of *Floating Island*.

Anna kept many musicians for her entertainments: a masque such as *Oberon* required around 60 instrumentalists and *Triumph of Peace*, the Inns' potlatch of 1634, employed perhaps 100 musicians of whom 40 were lutenists.[84] Many occasions besides masques needed singers. A refined evening with the queen might begin with an after-supper menu of French songs in her privy chamber before her closer friends withdrew to her bedchamber to hear "mr Lanier, excellently singinge & playinge on the lute."[85] Nicholas Lanier came from a family of Italian musicians close to the court; like them, he wrote music for masques and, like other artists with taste and connections, he improved the Stuart art scene by buying pictures abroad for patrons at home.[86]

Christian IV urged his sister to fill her palaces with art. She began modestly, with miniatures; her miniaturist, Isaac Oliver, led her to portraits, and on to landscapes and religious works, mainly by Dutch and Flemish artists.[87] Eventually she included the sorts of Italian paintings recommended by Wotton and collected by Somerset and Arundel. Since Italian (and Spanish) art often depicted scenes too close to popery or vice to recommend it to Puritans, and religious paintings had no place in their ways of worship, Catholics were more likely to appreciate it than Protestants. As we learned earlier from Prynne, strict Puritans would not risk even portraiture for fear of creating golden calves from prettified women.[88] Consequently many art agents were Catholics, and the great collections they helped to make during the reigns of the first Stuarts belonged to or were started by Catholics or Catholic sympathizers.[89]

Queen Anna stands high among them. Arundel qualifies twice or thrice: he acquired an interest in painting from his great-uncle, Lord John Lumley, a strong Catholic who spent time in prison for conspiracies until

released to cultivate his accumulations of books, buildings, and art; Lumley's large collection of paintings consisted overwhelmingly of portraits chosen rather for the sitter than for the painter. Lady Arundel, who began collecting with the help of Wotton and Jones, remained a Catholic after her husband's conversion. "The chief lady of the court and kingdom" by Venetian estimate, she returned from Italy, after seeing to a proper Catholic education for her children, with Van Dyck in tow.[90] Arundel's great rival as a collector before Charles entered the competition was the Duke of Buckingham, who, though "illiterate" according to Wotton, knew how to get what he wanted.[91] His closest female relatives, his wife and mother, were Catholics.

Prince Henry's Projects

Prince Henry's Puritanical streak and quick martial spirit, which made him the rallying point of English prudes and hawks, put him temperamentally and spiritually at odds with his father. But Henry cheerfully followed James's advice to abstain entirely from the works of Buchanan and, if free to do so, would have done the same to most literature. His interests ran to practical subjects, to the uses of arms and horses, techniques of building, geography and architecture, modern languages, applied mathematics. After 1610, under the influence of Arundel and perhaps Jones, the Prince developed an interest in art. Henry had very firm and sober opinions for a boy of 16 and courtiers aplenty to promote them.[92]

Our interest in Henry's short-lived initiatives and the men who served them lies in their likely impact on Charles, who idolized his elder brother. Two people in Henry's entourage would be particularly important for Charles: Jones, who kept under Charles the office of Surveyor he had acquired under James, and Arundel. Charles learned less directly but more substantively from the applied mathematicians whom Henry retained: an Italian and a French architect, Costantino de' Servi and Salomon de Caus, and two well-traveled English mathematicians, Edward

Wright and William Barlow. They tutored Henry for several years. Although he did not attain an expertise in mathematics unbecoming a prince, he no doubt fully understood its elements.[93] So did Charles.

Wright was an experienced navigator and champion of the Mercator projection, whose construction he simplified in a work, *Certaine Errors in Navigation* (1610), which he dedicated to Henry. The prince had a strong interest in exploration and colonization, and hence in navigation, and in mathematical instruments and mechanical automata like Drebbel's *perpetuum mobile* and Wright's clockwork celestial automaton.[94] That he cultivated an interest in astronomy may be inferred from his purchase of an expensive telescope and his request to the Florentine Resident, Ottaviano Lotti, for a copy of Galileo's *Sidereus nuncius*. Lotti complied and added a music book useful for masques by Galileo's father Vincenzo, and (a perceptive diplomat) a shipload of wine for King James.[95]

Henry never traveled abroad but surrounded himself with men who did. Coryate's *Crudities* (1611) gained its author appointment as court historiographer. Henry's chamberlain, comptroller, and chief tutor extended his vicarious Italian experience. He admired the spirit of Venice and would have fought for it against Rome had war come and James let him— an infatuation that left its trace in the Latin translation of Sarpi's *Trent* later made by Henry's chief tutor Adam Newton for the use of anti-Roman theologians.[96] Henry's precocious understanding of the value of spectaculars in promoting royalty also drew his attention to Italy. The ceremony by which Venice annually married the sea was a benchmark; but, for displays more applicable to the *terra firma* of England, Florence took the prize. Henry dispatched one of his Italian hands, Sir John Harington, the translator of Galileo's favorite piece of literature, Ariosto's *Orlando furioso*, to Florence to observe the blowout around the wedding of Galileo's student Cosimo II to Maria Maddelena of Austria in 1609. Henry probably had an eye to entertainments for his upcoming investiture as Prince of Wales and for his wedding, already under discussion, with an Italian princess.[97]

It was said that de' Servi's main job was to keep Henry in mind of things Florentine when thinking of marriage. He was something of a portraitist,

for he had studied with Santi di Tito, whose sitters included Galileo; and among de' Servi's few accomplishments in England was a portrait of Prince Henry.[98] De Caus was more engineer than courtier. He worked for Anna and Henry and then for Elizabeth, primarily as a designer of geometrical gardens; the beautiful example he made for Elizabeth at Heidelberg was one of the great losses she suffered when driven from the Electorate. While with Henry, de Caus completed a book on drawing and optics, *La Perspective avec les raison des ombres et miroirs* (1611), compiled from lessons he had given the prince, and designed all sorts of hydraulic machinery for Henry's palace at Richmond.[99]

When Henry began to express an interest in art, he received gifts from many sides, notably Giambologna sculptures from the Grand Duke of Tuscany. These lively statuettes seem to have made a strong impression on Charles as well as on his brother. Henry soon was buying paintings through Wotton, Carleton, and others, in such numbers that Jones had to build a small gallery for them.[100] Additional bespoke accommodation was needed for the many books Henry received as presents, by purchase, or through inheritance. The largest part of his library came from the childless Lord Lumley, whose collecting had privileged books on genealogy, history, antiquities, and natural science. Henry discarded law and theology and augmented the rest. The mathematician Wright was to have been Henry's librarian. But the books passed, as did the artworks, to Charles, who moved the center of interest to paintings.[101]

The Caroline Couple's Entertainments
Calculations

If he was indeed the good mathematician he was reputed to be, Charles would have been familiar with the military compass, a standard calculating instrument designed by Galileo and others for scaling up drawings or reckoning interest.[102] He no doubt understood the method of logarithms invented by his father's protégé John Napier as simplified by the same

Edward Wright who had made Mercator manageable; for Charles in his turn patronized a logarithmic inventor, Richard Delamain, a mathematics teacher with a gift for self-promotion. Delamain had his invention made in silver as a New Year's gift to Charles in 1630. The king accepted it and the dedication of Delamain's book, *Grammelogia* (1631), which described its construction and use.[103]

The instrument had log scales for sine and tangent as well as for the natural numbers, and so was useful in astronomy; and, as it also had proportional scales for integers, it could do the simpler problems treatable by Galileo's compass. The very first worked example in *Grammelogia* calculates interest at the 8 percent Charles typically paid. But the interest of the instrument for our story lies in the squabble it unleashed when William Oughtred, a mathematician in Arundel's circle, claimed credit for its invention. Since Delamain had studied with Oughtred, he very probably took the idea from him; and he certainly pinched the design of a second instrument, a pocket "horizontal quadrant" or handy astronomical calculator, from his teacher. This he reduced to practice and rushed to market, taking care again to give Charles a sample in silver.[104]

Oughtred called foul. Delamain was not only a thief but an ignoramus (he had taught him!), who probably did not know how the instruments worked and certainly did not bother to explain them. There is no reason to criticize me, Delamain protested, for not bothering my clientele with the theory of the instrument; the nobility and gentry had no time for "theoretical... demonstrations." They wanted to know how to survey their estates and to estimate the amounts of timber on their lands and wine in their casks; and for them Delamain's instructions sufficed. For Oughtred they were "onely the superficiall scumme and froth of Instrumentall trickes and practises." The exchange was not unprecedented. Competing for the then new (in 1619) Savilian chair in geometry in Oxford, the practical mathematician Edmund Gunter showed Savile his dexterity with instruments. "Said the grave Knight, 'Doe you call that reading Geometrie? This is shewing of tricks, man!'"[105]

Gunter did not get the job. He could not find the answer Delamain would give to Oughtred: go-betweens were needed to reduce difficult

concepts to art and deliver them to users without the "rigide Method and general Lawes [that] scarre men away."[106] Liking instrumental tricks and practices, Charles gave Delamain a patent on the circular slide rule, made him an engineer in the Office of Ordnance, and employed him as a tutor to the royal children. The king set great store by his engineer's silver quadrant. He carried it about his person until just before his execution. He then directed that it be given to his younger son, the future James II, who would need every help to find his way.[107]

Charles took a strong interest in architecture and liked to review the plans of Surveyor General Jones. Their grandest project, a magnificent new palace of Whitehall, turned out to be well beyond the royal means. A lesser project that succeeded deserves mention for its subtle combination of art, politics, and religion. This was the church of St Paul's, Covent Garden, said to be the first entirely new Protestant church built in England after the Reformation.[108] It still stands as the dominant structure in the piazza that Jones designed against the royal policy that forbade increasing the housing stock of London lest country aristocracy and gentry reside there with nothing to do between parliaments but plot and carouse. Despite this policy, Charles allowed development of Covent Garden with a square surrounded on two sides by townhouses that unwelcome newcomers, already a subject of comedy, soon occupied.[109]

The developer was the entrepreneurial fourth Earl of Bedford, who bought, for a fine or fee of £2,000, a license to build adjacent to the church he had constructed on his London estate at Laud's request. Charles insisted that the church have a portico. Being a frugal Calvinist, Bedford choked over the extra expense of the portico and asked Jones to build as cheaply as possible. Hence its chaste style, which did not suit Laud's ideas of the Lord's House. Nor did Jones's placement of the church on the west side of the piazza so that its entrance faced east, where the altar belonged. The archbishop was not amused. He ordered the entrance sealed and the altar placed against it.[110]

Addictions

Being indifferent to paintings and perhaps ignorant of their value, James had allowed the collections of Henry and Anna to pass intact to Charles.[111] The prince sharpened his appetite for art in competition with Buckingham, and both of them were energized by the acres of paintings in the galleries of Charles's prospective brother-in-law Philip IV. As king, Charles augmented his holdings inexpensively with presents from other sovereigns, like the King of Savoy, and ambitious courtiers such as Carleton, Cottington, and Porter.[112]

A great opportunity for more soon presented itself. The needy Duke of Gonzaga decided to sell his important collection. Daniel Nijs succeeded in buying it, much to his surprise. "In this business I feel I've had divine assistance, otherwise it would have been impossible to pull it off." He had managed to outmaneuver the Grand Duke of Tuscany, a rich Genoese consortium, and the citizens of Mantua. Divine assistance is not dependable, however. Many of the Gonzaga paintings degraded during shipment and Charles, declining to honor the agreed price, bankrupted Nijs. Charles delighted in his undamaged Gonzaga paintings, which, when added to what he had, made his collection one of the best in Europe, "the culminating point of Italian influence in England," the translation of "Italy (the greatest mother of Elegant Arts)" to Albion. As he rose to respected connoisseur in the art world, Charles sank to sinful spendthrift in the Puritan universe.[113]

Charles shared his Italianate sin with a few connoisseurs like Arundel. The degree of their intimacy and addiction may be gauged by the king's rushing to the earl's house to see the pictures he had brought back from his failed mission to Vienna in 1636. Conn was present at one of their discussions. Charles: I have learned of a miracle: the earl (Arundel) has given a Holbein to the Grand Duke (of Tuscany). Conn, who knew that it was impossible to extract anything from Arundel: the earl could perform the same miracle thirty times since he has thirty Holbeins. Arundel: I do not have the power. Conn: You have freedom of will. Arundel: "[I am] most willing to support that doctrine except in the matter of giving away

pictures." Conn diagnosed Arundel as too addicted to his collections to do much to help Catholics; all his conversation was about pictures, "while I am no good for these objects, unless to dust them."[114]

With Conn's help, Charles obtained several coveted pieces from Italy, most famously a bust of himself sculptured by Gian Lorenzo Bernini. This coup required the approval of Pope Urban; an art of the Vatican was the gift of Vatican art.[115] Urban gave his permission for Bernini to proceed with Charles's bust. That left the technical problem that the sculptor had never seen his subject. Van Dyck solved it by painting a triple portrait of Charles on the same canvas, two in profile and one face on. Bernini then worked his magic. The royal couple received the king's bust with rapture, and, when Conn returned to Italy, gave him a commission and drawings for a similar representation of the queen. It did not materialize. Charles's bust lasted longer than he did, but it also died violently, in the fire that destroyed Whitehall in 1698.[116]

The Barberini continued their seduction by art with works by Leonardo, Veronese, Correggio, Andrea del Sarto, and Guido Reni. They were circumspect: Henrietta Maria complained of one of their shipments that it contained no religious paintings. Nonetheless, the chapel Inigo Jones made for her in Somerset House opened with great fanfare in 1635 under pictures supplied by the pope.[117] He also sent her rosaries and a crucifix embossed with Barberini bees rendered in diamonds, "a priceless favor…my most precious possession."[118] The royal couple delighted to show their favorite paintings to Conn. Charles so forgot himself in exhibiting them that once he kept the glories of England, the Knights of the Garter, waiting while he dallied in his galleries with the pope's agent.[119] The king extended a similar familiarity to Conn's successor, whose residence he visited to see portraits of Urban and the cardinal nephew. Charles then remarked that he regarded the pope with "the esteem and respect that should prevail among all princes" and effusively praised the cardinal, who had been kind to important English travelers.[120]

It took money and taste, but not much imagination, to assemble a good collection of finished paintings. With a push from Lanier, Charles and his

emulators came also to value preparatory drawings. As Arundel's librarian Franciscus Junius put it, drawings allowed the collector to follow "the very thoughts of the studious Artificer, and how he did bestirre his judgment before he could resolve what to like and what to dislike." Perhaps Wotton had such drawings in mind when reaching the counterintuitive insight that it is almost harder to be a good critic than a good artist. The artist can change his mind as he proceeds; the critic, especially if a buyer, must conclude quickly and definitively; "the *working* part may be helped with *Deliberation* but the *Judging* must flow from an *extemporall habite*."[121]

Charles was a major patron as well as collector of art. "The most splendid of your Attainments [so Wotton wrote his sovereign], is your love of excellent Artificers and works." Most of these artificers were foreign. Francis Cleyn was the foremost if judged by expenditure on product, for his ongoing labors at Mortlake probably cost more than all the paintings and sculpture Charles commissioned from Van Dyck, Bernini, Daniel Mytens, Gerard Honthorst, Orazio Gentileschi, Orazio's daughter Artemesia, and Arundel's protégé Wenceslas Hollar. The only major Italian artist in Charles's employ, Gentileschi, acquired by Buckingham from the Dowager Queen of France in 1626, did more than paint: he probably acted as an intermediary between Spain and England as Rubens did and certainly sent the Vatican information about the Caroline court. The scant representation of resident Italian artists records their disinclination to live with rain and heretics. No doubt also they disliked Charles's bad habit of postponing payment and reducing prices. He cut a bill from Van Dyck for £1,295 for twenty-four pictures in half in 1638, although he then owed the painter £1,000 on the retainer he had not paid for five years.[122]

Foreign artists tended to live in ex-pat communities in districts of the city like Blackfriars that lay outside the jurisdiction of the Painters–Stainers Company.[123] Charles kept these guild-free painters busy painting his guilt-free person. Van Dyck outdid them all by portraying Charles bursting through an archway effortlessly controlling a huge horse, his adoring groom by his side, a baton of command in his hand (Figure 22). This persuasive depiction hung so as to give the impression that Charles

Figure 22 Antony van Dyck, *Charles I* (1633), commander of horses and men.

was riding into one of his galleries through its end wall. Other renditions by Van Dyck emphasize Charles's domestic virtues. As Wotton, who knew something about the political value of portraits, observed, Charles was made to appear a model of chastity and temperance (which he was), of steadiness of resolve (which he was not), and of "heroicall ingenuity" (which his foreign policy exemplified).[124] In these repetitive portraits Charles tried to achieve what ancient kings had done by multiplying their statues. As Wotton put it, "[the portraits] had a secret and strong Influence, even into the advancement of the Monarchie, by continuall representation of vertuous examples; so as in that point ART became a piece of State."[125]

Practicing his preaching, Wotton liked to hand out portraits of Sarpi copied from the one he had smuggled out of Italy. Known recipients were Nathaniel Brent, who, having accomplished the feat of publishing Sarpi's *Trent* in English within a year of the appearance of De Dominis's Italian edition, and having performed equally well in other projects of a political–religious character, had climbed to the wardenship of Merton College in Oxford. A late recipient of what Wotton called the "true picture of Padre Paolo the *Servita*, which was first taken by a painter whom I sent unto him from my house then neighbouring his monastery," was the Provost of King's College, Cambridge, Samuel Collins. His copy had a motto devised by Wotton: *Concilii Tridentini Eviscerator*, "The Eviscerator of the Council of Trent."[126] Just such a picture now hangs in the Upper Reading Room of Oxford's Bodleian Library (see Figure 7).

Masquerades

Court plays and masques offered another route by which royalty could exaggerate its merits. Charles and Henrietta Maria sat through the same yearly average of these hieroglyphs as had James and Anna and may have enjoyed them more, since the Caroline variety was both spunkier and more sycophantic, "more exotic and prodigiously expensive," than the Jacobean. Much of the difference was owing to Henrietta Maria. In her

first English theatrical season, 1625–6, she not only danced but also spoke; those not scandalized by her forwardness admired her recital, from memory, of hundreds of lines of poetry. The teenage queen must have been in good shape; she could rehearse for twelve hours before a performance lasting seven or eight. After one of these athletic feats Prynne announced his famous equation, "woman actors, notorious whores."[127]

To his iconic stature of chaste lover, model father, and alpha male, Charles added man of peace, to which he had a valid and compromising claim. Poverty and prudence advising against a war for international Protestantism, the court made the best of the situation and celebrated Charles as pacifier. The Banqueting House often served as auditorium, Inigo Jones as set designer, and Ben Jonson as skit writer. The final tableau usually referred to peace, which did not prevent Jones and Jonson from going to war; their collaboration ended with the masque given for Charles by William Cavendish in 1634, *Love's Welcome at Bolsover*, which parodies the king's Surveyor as Iniquio Vitruvio.[128]

The masques often conveyed their panegyric with the help of astronomical symbols and motifs. Representing the king as the sun was common coin, as we can read on one stamped to commemorate Charles's entrance into London in 1633, after his crowning in Scotland. *Sol rediens orbem, sic rex illuminat urbem*, "like the dawning sun the King illuminates the city."[129] A double portrait by Honthorst, *Apollo and Diana* (1628), makes the obvious connections between the sitters and the luminaries. The translation of the entire court into the Heavens, however, was something unusual. It happened in *Coelum britannicum*, "the most spectacular, elaborate and hyperbolic of the Caroline masques," written by Thomas Carew and staged by Inigo Jones in February 1633. Its premise: Olympian Jove looks down at the connubial faithfulness of the royal couple, feels ashamed, and resolves to clean up his act.[130]

Jove first purges the Heavens of every constellation representing his love affairs. The Bull and the Swan have to go, and the Bear, Dragon, Hydra, Centaur, and even the Virgin, compromised by lying between a Lion and a Scorpion. To accomplish the burdensome task, Jove appoints

an "Inquisition" taxed with removing all celestial improprieties and "all lustfull influences upon terrestrial bodies." Like Urban's Inquisition, Jove's is to "suppresse…all past, present, and future mention of those abjured heresies." Having thus arranged for the conversion of the home of the Gods into a "cloyster of Carthusians," Jove commands Mercury to make a "total eclipse of the eighth Sphere"—that is, to expel all the stars, an event, as Mercury rightly says, unforeseen by earth-bound prognosticators, "no, nor their great Master Ticho."[131]

Now the celestial regions must be refilled with asterisms more suited to them than the beasts just evicted. Personifications of the spirits that dominate human life put themselves forward. Mercury and the greatest nitpicker of the gods, Momus, examine each in turn: Plutus (Wealth), who claims to hold virtue by a golden chain and to have supplied Jove with the coins showered on Danae; Paenia (Poverty), who argues that her kingdom is far larger than Wealth's, and contains many poets and intellects; Hedone (Pleasure), who also excels Wealth, being the reason for acquiring riches; and so on. None passes scrutiny. The obvious solution arrives in personifications of the Genius of Britain and its three kingdoms, who emerge from a mountain on stage, and of Religion, Truth, Wisdom, Concord, Government, and Reputation, who descend on clouds. By adding to these the worthies of Britain, past and present, Mercury has enough virtuous candidates to replace the thousand stars listed by Ptolemy.[132] No member of "the eighth of our Coelestiall Mansions, commonly called the Starre-Chamber," is among the nominees. The requirement of virtue rules them out.[133]

The strikes at the high court of Star Chamber and the Inquisition aimed jointly at English censorship of the stage and Roman control of thought. Galileo's trial and sentencing took place between the performance and the printing of *Coelum britannicum*. That is not its only Italian reference. Carew took his plot from a dialogue, *Spaccio della bestia triomfante*, "Expulsion of the Triumphant Beast," which Giordano Bruno had published in 1584 during his stay in England. It is so thorough a compilation of Bruno's quirks and heresies that the Roman Inquisition featured it in its

summary of his trial. In Bruno's plot, Jove decides on reform because his "jaded strength and enervated manliness" disqualify him from repeating his former exploits. He orders Cupid to put on some clothes, Bacchus to give up debauchery except on Saturday nights, and Vulcan to stop working on holidays. He gets the gods to agree to the purge and, with the help of Momus and some input from Mercury, chooses the new celestial residents.[134]

Bruno's Jove substitutes Truth and Prudence for the Bear and the Dragon, which he sends to Britain. Wisdom and Law advance to the former seats of Cepheus and Boötes. Thus personifications of Good Things fill the Heavens: no king or courtier, as in Carew's adaptation, ascends so high. Jove leaves Corona Borealis in place as the crown of the champion who wipes out the Calvinists, a "stinking filth," whose souls Bruno condemns to spend 3,000 years migrating from one metempsychotic ass to another.[135] Carew's masquers who knew that his plot derived from Bruno might have shuddered at the thought of Jove's Roman-style Inquisition.[136] Charles would not have been among them. If we credit the report of a Catholic newsmonger, the king regarded the Inquisition as a useful tool for divine government, "it were to be wished that it were in all parts of Christendom to bridle mens tongues."[137]

Between the Bishops' Wars, Jones diverted the court with storms, mountains, cityscapes, heavenly spheres, populated clouds, and flying chariots. Like contrivances appear in the last court masque, William Davenant's *Salmacida spolia* (January 1640), in which, unusually, both the king and the queen performed. In the ancient story, a tavern-keeper by the sweet spring Salmacis civilized (some say emasculated) barbarians by serving them its waters; by strained analogy, Charles will conquer the idiots who oppose him by overcoming them with wisdom and patience. There is a nice astronomical image. "You that so wisely studious are | To measure and to trace each Starr," look where the true light is, down here, where the royal tavern keeper dwells. Lower your telescopes, "Levell your perspectives."[138] In an earlier masque, *Britannia triumphans* (1638), Davenant had directed king and courtiers by a more elaborate celestial metaphor.

Move then in such an order here
As if you each his governed planet were
And he moved first, to move you in each sphere.

The ranks of courtier dancers, inspired by "the wonders of his virtue," formed figures reminiscent of the constellations.[139]

Instruments were a common way of keeping astronomy in playgoers' minds. Among many humdrum examples of telescopes used to peer into ladies' closets, we have such marvels as Galileo's glass capable of firing a ship at night by concentrating moonbeams and the more remarkable lens that allowed a vision of God's throne.[140] A playwright needing a representation of genius might well choose an astronomer whose mind, instructed by his observations,

Has pierc't into the utmost of the Orbes
Can tell how … the Sphaeres are turned, and all their secrets
The motion and influence of the starres …
The causes of the winds, and what moves [!] the earth.[141]

This accomplished astronomer appears to have been a Copernican.

As the Personal Rule ran into trouble in Scotland, the Caroline masques promoted a picture of Camelot-in-being that increasingly diverged from reality. They insisted on the king's wisdom in governing and his divinely ordained prerogatives. Henrietta Maria's masques, *The Temple of Love* (1635) and *Luminalia* (1638), both by Davenant, portray her Catholicism and Charles's Anglicanism implausibly as two peas in an irenic pod.[142] Aurelian Townshend's *Albion's Triumph* (1637) stresses cultural refinement, especially in painting, which showcased the gap between the king's self-image and the condition of his realm. Charles's hazy distinction between fantasy and reality helped him to play the final part in his tragedy. An eyewitness to his execution thought that he "came out of the Banqueting House on the scaffold with the same unconcernedness and motion, that he usually had, when he entered it on a Masque-night."[143]

Although presented but once or twice to a small audience, the Caroline masques had a wide circulation by report and in print, and the repetition of their themes, almost as a liturgy, suggested the height to which king and country could aspire. By pointing to gaps between Whitehall and Camelot, panegyrics might encourage better behavior.[144] Strode's *Floating Island* (1636), reviewed earlier, is an example. It contains many apt jibes at favorite targets: monopolies, judges, the godly, Puritans, physicians, playwrights. Reversing direction, it attacks parliament and defends ship money. Before Charles–Prudentius temporarily sets aside his crown, he experienced efforts to blunt his prerogatives, reform his state, determine his expenditures, appoint his ministers, and refuse him supplies. Recognizing that the "Tumult, Lust, Debate, and Discontent" affecting his island might tempt foreign powers to attack it, he had collected ship money as the means to build a powerful defensive navy. Oh, "thou god on earth"! The island remains afloat. "Our scene which was but Fiction now is true | No King so much Prudentius as you."[145]

James Shirley's *Triumph of Peace* (3 February 1634), also mentioned earlier, struck at obscure inventions on which projectors hoped to obtain monopolies: a bridle that keeps a horse from tiring, a device for a day's walk under a river, a means of raising poultry on carrot scrapings. These projects are as idiotic as the quixotic knight and squire who, in the elaborate antimasque, attack a windmill.[146] Charles did not object to attacks on monopolies and other abuses provided they did not come too near to his. He thought Shirley's *Gamester* (February 1634), which digs at courtiers, one of the best plays he had ever seen. Since he suggested the plot, it must indicate his taste.

The main action revolves around a husband who tries to enlist his wife in his seduction of one of her kinswomen. She agrees but contrives to substitute for her relative in the dark room arranged for the tryst. As the hour of action approaches, the husband, who is as addicted to gambling as a courtier, is too deeply engaged to fulfill the seduction. He asks a fellow gamester to perform in his stead. The substitute reports blissful success, although the woman, contrary to expectation, was not a maid. The

husband perceives that he is a cuckold by (if possible) his own hand. Chaste Charles could not end the play there. The wife discloses the plot to the gamester, the gamester forbears, and the husband avoids the sin he desired to commit.[147] Virtue all around.

As Charles's rule weakened, playwrights grew bolder. William Habington's *Cleodora, Queen of Aragon* (1640) rails against the use of force to achieve agreement in Aragon's government as well as in marriage. The device of locating Caroline abuses in distant times and places recurs in John Denham's *The Sophy* (1642), which has the further interest of a fine telescopic metaphor. The venue is Turkey, the victim the ruler, the evil doers bad councilors.

> Alas, they shew him nothing
> But in the glasse of flatterie, if any thing
> May have a shew of glory, fame, or greatnesse
> 'Tis multiplied to an immense quantitie
> And strtech't even to Divinitie
> But if it tend to danger or dishonour
> They turn about the Perspective, and shew it
> So little, at such distance, so like nothing
> That he can scarce discerne it.[148]

5

HEAVENS ABOVE

The Theater of the World

Sense and common sense for once agree with philosophy and theology in placing the earth firmly at the center of whatever is. The stars wheel around the earth as their hub, at incredible speed, once a day; the moon and sun also circle the universal center, in a month and a year, for what else do day, month, and year signify? Less obviously, the wandering stars, whose exact gyrations concern only astronomers, also make their rounds, the inferior planets Mercury and Venus, which never appear far from the sun, in about a year, the superior ones Mars, Jupiter, and Saturn, which are not so bound, in two, twelve, and thirty years. Both sorts of planets differ from the sun and the moon, which in their yearly and monthly journey always move from west to east, counter to the daily motion of the fixed stars. The planets complicate matters by sometimes retrograding to the west. Their misbehavior challenged the picky astrologers and serious astronomers of Galileo's time.

Masque: Mathematical Astronomy

To account for the uneven and retrograde motion of the planets and for certain small irregularities in the behavior of the sun and moon, mathematical astronomers calculated as if the heavenly bodies rotated on systems of circles whose centers did not coincide with the center of the earth. It took painstaking study to master this ancient masque; the novice was advised to imitate Ptolemy night and day, "study him waking, dream of him sleeping."[1] Philosophers who desired something solider than hard

mathematical fictions embedded celestial bodies in crystalline spheres composed of an incorruptible "quintessence" not found on or near the earth. No material change could happen in the celestial region above the concave surface of the moon's sphere. Below it, in the region occupied by earth, water, air, and fire, everything is in flux, uncertainty, and confusion. Unfortunately, the philosophers' world did not have a place for the astronomers' masque: the inquiring mind might analyze the world mathematically or physically, but not both simultaneously.

Copernicus's alternative geometry, despite its counterintuitive assumption of a moving earth, had the important advantages of explaining why inferior planets stay close to the sun (the earth's orbit contains theirs) and superior ones do not (they enclose ours) and how retrogradations arise (another consequence of viewing planets from our moving platform). But Copernicus too had had to compound fictional circles in order to mimic the elliptical paths on which, unknown to him, the planets travel around the sun. It took a reagent more powerful than Copernican mathematics to dissolve the ancient adamantine quintessence. That was Tycho's mission. His measurements of parallax showed that passing comets traveled above the moon and, perhaps worse, that the new star that shone and vanished in Cassiopeia in 1572 had to be placed there too. The quintessence appeared to be fluid and flighty.

Tycho spread his ideas to Britain through books he gave to such prominent scholars as Dee and Buchanan. Although unequal to Buchanan in degrees of fame, he wrote in uncharacteristic modesty, he could claim equality in degrees of latitude. "For as Denmark sees the heavens roll by | Your Scotland later will regard them too."[2] Not quite! Where Tycho saw planets swimming in fluid heavens, Buchanan saw spinning crystalline spheres with embedded stars. Nor could Buchanan accept the positioning of comets and the nova of 1572 above the moon; for, as universal experience testified, the heavens do not change.[3] Nor does the earth turn, "as many ancient wizards did suspect." Nowadays, Buchanan told his royal student James, only people incurably ignorant could accept the tale of Copernicus or the deductions of Tycho.[4]

Ignorant meant ignorant of Aristotle's physics, which implied that an orbiting earth would fall to the universal center and a spinning one suffer perpetual winds. Where then are the winds? Scripture confirmed that the sun moves and not the earth, for had not Joshua, who was no fool, commanded it to stand still? Here Buchanan made common cause with Tycho, whose cosmology had no place for an earth that misbehaved physically and theologically. Yet, without the crystalline spheres, Tycho's planets and comets had no known reason to move in the formation he prescribed: revolving about the sun while the sun circled the stationary earth. Nonetheless, since this Tychonic formulation solved technical puzzles like retrogradation almost as naturally as Copernicus's without raising the physical or theological problems of a moving earth, many astronomers, particularly Jesuit experts, preferred it. James stuck with Buchanan's cosmology, "where everie planet has his owen repaire | and christall house."

Although he rejected Tycho's picture of the universe, James admired the observational work and feudal discipline of the island of Hven and the power they gave the astrologer. The king's admiration overflowed into three separate sonnets. One puts Tycho in command of the planets that govern base bodies, another advises those who would grasp the order, course, and influence of the planets to consult his methods, and the third mates him with the muse of astronomy.

> What foolish Phaeton dar'd was by Apollo done
> Who rul'd the fiery Horses of the Sunne
> More Tycho doth, hee rules the Starres above
> And is Urania's Favorite, and Love.[5]

Galileo was one of James's few informed contemporaries who did not share his high opinion of Tycho.

Tycho's observations and deductions were not the only conspicuous novelties that disfigured the traditional heavens before Galileo's telescopic discoveries in 1610. Another nova appeared in 1604 and also some comets, all of which by measurement from different places appeared to be at

different distances above the moon. That agreed with the earlier suggestion by Dee's protégé Thomas Digges that the fixed stars might be distributed in space. The most important innovator in astronomy between Tycho's measurements and Galileo's observations, or, perhaps, between the cosmologies of Adam and Newton, was Tycho's one-time computer Kepler. Thinking far outside the box, or, as he put it in a letter to King James, outside the barrel from which, as "Diogenes of Prague," he begged his living from the emperor Rudolf, Kepler chained Mars to an elliptical path not quite centered on the sun.[6] That was in 1609. The computational advantages of this geometry became clear in 1627, when Kepler published unprecedentedly accurate tables of planetary positions. The table's elaborate frontispiece presented the history of astronomy from the Greeks to Tycho by columns of increasing sophistication all supporting a vault flaunting a diagram of Tycho's system (Figure 23). He stands at the center of this little temple pointing at the diagram and asking "what if it's like this" (*quod si sic?*), to which Kepler silently answers, "it is not." Scenes from Tycho's island decorate the temple's base. The goddesses standing on its roof convey details about optics and other knowledge on which astronomy depends.[7]

The solidity of the temple is misleading. By replacing the fictitious circles of astronomy with the real orbits of planets, Kepler's ellipses underscored the lack of a foundation for the theater of the world. More than ever, the mathematical masque needed a physical stage.

Antimasque: Galileo's Song and Dance

Galileo printed only two items after his silencing by Pope Paul V before the *Dialogue* of 1632, both attacks on the Jesuits. The first, issued under the name of a student, dealt disingenuously with the destructive comet of 1618, and the second, the famous *Il saggiatore* (1623), "The Assayer," unfairly with a professor of mathematics at the Collegio Romano. Galileo's fellow lynxes saw *The Assayer* through the press and protected it with a dedication to Pope Urban. The new pope, who had written a few appreciative lines about the appearances of Jupiter and Saturn, "discovered | Learned

Figure 23 Johannes Kepler, *Tabulae rudolphinae* (1627), frontispiece.

Galileo, by your glass," enjoyed the *Assayer*'s hits against the Jesuits.[8] Galileo went to Rome to congratulate his fellow Florentine Barberini on becoming Rome's pope and came away from their several conversations believing that he had permission to reopen the discussion of world systems provided that he decided for neither. Urban did not think that any man-made astronomical system could be known or shown to be true and expected that Galileo's even-handed treatment would demonstrate the truth that there is no truth outside revelation. Rumor, which reached even unto England, more wisely expected something unexpected from "the novelty and freedom of [Galileo's] opinions."[9]

The immediate path to the *Dialogue* began after Urban's election with Galileo's draft answer to arguments against the Copernican system made by Francesco Ingoli, Secretary to the Congregation for the Propagation of the Faith, who earlier had drawn up the corrections to Copernicus's book mandated by the Congregation of the Index. Galileo's draft proposed reopening discussion about world systems in order to show that Catholic authorities did not prohibit the new astronomy on the basis of Ingoli's invalid arguments. Galileo sent the draft to Ciampoli, who asked Conn for advice. Conn delivered a favorable verdict, with which Pope Urban, informed by Ciampoli, concurred: "it was good to repress the audacity of such people [as Ingoli]."[10] Ciampoli asked Conn to teach young clerics how to philosophize about nature and asked Cesi to add him to the list of lynxes.[11]

Galileo met Conn in 1630 during a visit to Rome to discuss the printing of his *Dialogue*. They got along well. An anecdote told by Ciampoli suggests Conn's familiarity with Galileo's cranky concept of comets as optical illusions and other ideas. The context was a discussion about the nature of fire with Ciampoli and Sforza Pallavicino, a conscript in Ciampoli's teaching scheme. Unlike them, Conn did not suffer for his attachment to Galileo. Ciampoli fell from Urban's favor permanently during the turmoil over the *Dialogue*; Pallavicino was ostracized but eventually returned to Rome to join the Jesuits. When he came to edit Ciampoli's papers for publication he omitted all material relating to lynxes and suppressed the fiery

dialogue in which, in the sunny days before Galileo's condemnation, he had engaged with Conn. His superiors thought Pallavicino so good at rewriting history that they charged him to redo and refute Sarpi's *Council of Trent*.[12]

After some negotiation with the censors, Galileo's *Dialogue* saw the light nine years after Urban gave permission to reopen the Copernican question. Galileo's spokesmen Salviati and Sagredo devote the first day of their conversation to sapping the foundations of Aristotelian physics, weakly defended by Simplicio, on which the qualitative geocentric world picture rested. During the next two days they neutralize all physical arguments against the possibility of a spinning and revolving earth and brush away Simplicio's objections as scholastic cobwebs that catch people who cannot think mathematically. On the fourth day Salviati derives the diurnal tides from the two Copernican motions and traces their monthly and annual variations to the influence of the sun and moon. Sagredo declares that he has never heard anything so brilliant and persuasive. Simplicio cannot find an objection to it among his cobwebs but knows it must be wrong. He extricates himself and Galileo by recalling Urban's wise philosophy of science. The three exhausted colloquists then shake hands and go for a restorative ride in a gondola.

Although Galileo denied that he had intended to favor the Copernican side and offered to write a fifth day's discussion demolishing the strongest arguments he had put forth for it, the Inquisitors did not accept his offer. Instead, they "vehemently [strongly] suspected [him] of heresy" for having written a book defending a system that he knew to be contrary to Scripture. They forced him to abjure, required him to recite the penitential psalms once a week, and sentenced him to detention at a place of their choosing. The Supreme Inquisitor General was almost as despondent at this outcome as Galileo.

> God knows how much I grieved to see an Archimedes made so miserable by his own hand, for having decided to publish his new opinions on the motion of the earth against the true common interpretation of the Church. Opinions that brought him to the Holy Office in Rome...I tried to help his cause as much as I could.[13]

The conflicted Supreme Inquisitor was Bentivoglio.

The confiscation and prohibition of his masterwork vehemently depressed its author. His old friend Micanzio wrote to cheer him up. "One of your friends now in heaven wrote a History of the Council of Trent... Rome prohibited it...I have it in Italian, Latin, English, French: be assured that the same thing will happen with your *Dialogue*."[14] Within a year of this reassurance the Latin edition appeared. The translator was Matthias Bernegger, professor of history at the Gymnasium of Strasburg, a friend of Kepler and a reliable computer of horoscopes. Bernegger liked to stress the importance of mathematics for history: mathematics to master geography and chronology, and the astrology necessary for searching out causes. The complete historian must be able to include such cometary effects as the fogs of 1618, which depressed agriculture, impeded military operations, and brought on the Thirty Years War.[15]

Bernegger had studied in Italy and returned scorning Romanists but hopeful of Christian peace and concord under other auspices. He readily appreciated the polemical value of the *Dialogue* and its analogy to Sarpi's *Trent* and set out to do it justice. He had translated Galileo's booklet on the military compass, knew the style, and completed the translation in eighteen months. To it he added a passage from Polybius on the triumph of truth over error, an extract from Kepler's book on Mars, a Copernican pamphlet banned by the Index, and, as a measure to protect Galileo, a misleading account of how the material came into his hands.[16] Galileo's letter to Christina, which Bernegger had intended to include, appeared a year later.[17] Strasburg's Protestant theologians liked Bernegger's activities little more than the Inquisition did Galileo's. They condemned him for his liberal views and dangerous friends, hobnobbing with Jesuits, hoping for a reunion of the churches, and rejecting theological hairsplitting.[18]

The translations of the *Dialogue* and the *Letter to Christina* (printed in 800 and 500 copies, respectively) spread quickly around northern Europe. The translator of the *Letter*, Elie Diodati, also disseminated Sarpi's works. It was a family affair. Elie Diodati was the cousin of the Jean Diodati of Sarpi's circle who had translated the *Council of Trent* into French. The

Genevans supposed that Sarpi and Galileo combined would make a mighty ally in fighting Rome. Bernegger pointed to a higher purpose: Galileo and Sarpi proved the value of freedom of thought. From Alcinous, a follower of Plato, Bernegger took the admonition, "if you want to be a philosopher, you must have an open mind;" and from Seneca the advice, "among none more than among philosophers should impartial freedom prevail."[19] In the Latin of the learned, Galileo's *Dialogue*, like Sarpi's *Trent*, advertised what humanity could lose by the suppression of bold and innovative ideas.

Bernegger made an important change in the *Dialogue*'s frontispiece in addition to having the figures redrawn: he corrected the title to *Systema cosmicum*, which made it clear that the book was not an even-handed consideration of world pictures.[20] Its publication refreshed the reputation that Galileo had won beyond the Alps for his telescopic discoveries. Several copies of the *Systema* existed in Oxford by the time Cleyn painted his portrait of Bankes and Williams. With the help of a popularization published in Oxford in 1640 by a future bishop, John Wilkins, English scholars and virtuosi had almost enough information to recognize Cleyn's reference to Galileo.[21]

Galileo in England
Tentative Starts

Among the first Englishmen to notice the sun-centered system were sea-going mathematicians, and among them none went further than Thomas Harriot. After an Oxford education (BA, St Mary's Hall, 1580), he had the opportunity as mathematical consultant to Sir Walter Raleigh to test his theories in voyaging to, and mapping out, the ill-fated Roanoke settlement in Virginia. When Raleigh's star faded, Harriot found a patron in Henry Percy, the "wizard" ninth Earl of Northumberland, the father of Sir John Bankes's patron, the tenth earl. Harriot had a pension to do what he pleased while the Wizard Earl resided in the Tower for alleged involvement in the

Gunpowder Plot. During his sixteen years of detention, the wizard built up a large library and laboratory in the Tower and had the occasional company of Harriot and other mathematicians drawn by his books (he had works by Tycho, Kepler, Gilbert, Palladio), table (he lived well in prison), and conversation.[22]

Harriot used his freedom to make himself a telescope and observed, independently of Galileo, some lunar features and solar spots. But, as he missed the moon's mountains and Jupiter's satellites, he and the small group of virtuosos around him were flabbergasted by the revelations of *Sidereus nuncius*. "Methinks [one of them wrote] my diligent Galilaeus hath done more in his discoverie [our moon's mountains, the Milky-Way's stars, Jupiter's satellites] than Magellan in opening the straights to the South Seas."[23] Harriot did not circulate his important observations widely. Probably fewer people in England had access to, or could have profited from, his calculations than knew, or knew of, the manuscripts on the tides and scriptures that Galileo had composed to instruct the Roman Inquisition.

The earl pensioned two other Oxford mathematicians who, with Harriot, made up what playful contemporaries called his magi: Walter Warner (BA, 1579), who served as librarian and curator of instruments and left many unpublished tracts on mathematical subjects, and Robert Hues (BA, also 1579), who filled out the magi in 1615.[24] Like Harriot, Hues had studied at St Mary's Hall and went voyaging across the Atlantic, to Virginia and elsewhere. Concerned that his countrymen lacked the "reasonable competency of skill in Geometry and Astronomy" necessary to overtake the Spanish in exploration, he composed an excellent practical manual, a *Treatise on the Globes and their Use* (1594 and often reprinted), which would have been more useful still if he had not written it in Latin. Hues referred often to Copernicus for up-to-date values of parameters and defended him against the ignorant who judged "Copernicus his writings [to] deserve the spunge, and the Author himself the bastinado." As to world systems, however, Hues stayed with Ptolemy and "the Rapture of the first Movable."[25]

Hues's introduction to the spheres attracted the attention of a Dutch polymath, Johannes Isaacsz Pontanus, who enriched it with notes and

friendly nods to Copernicus, "that great restorer of astronomy," "that great Schollar, and second Ptolemy," "[that] never sufficiently commended man." These honorifica come from the first English edition of Hues's *Tractatus*, made in Oxford by a canon of Christ Church, Edmund Chilmead, and published in 1638 and 1639. It is very likely that young John Bankes studied this book while learning to use the globe in our picture. If so, he would have run across Pontanus's remark that astronomical systems are based on mathematical hypotheses made by men and not on immediate truths delivered by nature. "The office of these Hypotheses is only to show the measure of the apparent motion of the Heavenly bodies by circles and other figures."[26] Which is to say that there is no truth in the devices of mathematical astronomy apart from their predictions and that figures other than circles are admissible. Thus was a space cleared for Kepler at Oxford.

Two Oxford mavericks further enlarged the spectrum of cosmological inquiry. One was Nicholas Hill, who matriculated at St John's in 1587 and left the university on converting to Catholicism. He followed Bruno, whose transit through Oxford was not forgotten, into a Copernican, atomistic, eternal, infinite universe of many worlds. He dismissed the capital problem of the cosmologist, whether earth or sun stood at the center, as nonsensical: the universe, being infinite, has no middle. Still, the question of the earth's motion remained. Hill gave nineteen reasons in its favor, including the ocean tides and terrestrial magnetism, for which he offered half a dozen proofs. He set these ideas forth in his only book, *Philosophia epicurea democritiana theophrastica* (1601), whose title abundantly expresses his eclecticism. Jonson had fun with

> all those atomi ridiculous
> Whereof old Democrite and Hill Nicholas
> One said, the other swore, the world consists.[27]

The other maverick was "the greatest Monster that England produced," Thomas Lydiat, astronomer and chronologist, "the veryest Fool in the whole World." Lydiat did not earn these distinctions for his odd idea that the sun

might move in a curve different from a circle, but for his chronology. Since rival chronologists often addressed one another as if they were theologians or astrologers, neither Prince Henry, who engaged Lydiat as his cosmographer, nor Archbishop Ussher, who used his calculations, took the insults seriously. After Henry's death, Lydiat retired to a country vicarage, overspent his income, and went to prison until rescued by Laud and Ussher. His bad luck held so well, however, that he joined Galileo as emblematic of the harassed scholar.

> [Oh] mark what ills the scholar's life assail
> Toil, Envy, Want, the Garret, and the Jail
>
>
>
> If dreams yet flatter, once again attend
> Hear Lydiat's life and Galileo's end.[28]

The first professor of astronomy at Oxford was a Cambridge man, John Bainbridge, a working physician and astronomer who rose on the tail of the comet of 1618. In a pamphlet dedicated to James, he interpreted the comet as "a good omen for the new year and a symbol of the good astronomy yet to be established" (Figure 24)[29] Bainbridge was exact where he could be: from his telescopic observations he could place the comet 291,000 miles above the moon. And careful when he needed to be: "I can...scarcely refrain from the Samian Philosophy of Aristarchus [a forerunner of Copernicus] in the earth's motion;" but he feared backlash from vulgar folk, who included many of his patients, and so "reserve[d] these mysteries for a more learned language."[30]

While waiting he used the vulgar tongue vulgarly: "These...filthy and brutish swine...wallowing in the mire of voluptuous sensualitie, little regard the apparition of these new celestial signes...These Epicurean pigs in stead of sober Elegies grunt forth their wanton ditties." The pigs are astrologers who do not recognize comets as calls to repentance. The new *sidereus nuncius* (the comet) warns against "sumptuous and presumptuous apparell, with strange inconsistent fashions." We have grown effeminate. "Where are our muskets?" Are they not turned into tobacco pipes?

Figure 24 John Bainbridge, *The Late Comet* (1619), folding plate at end; the figures portray constellations, Serpens, Virgo, and so on.

"Where are our English Valour and Courage? Are they not with that out-landish weed vanished into smoke?"[31] And where is the information we require to prepare against the "equivocation, fraud, periurie, tracherie, assassinations, and murders" comets always bring? We need a patron for "these ravishing (and impoverishing) studies, by whose gracious bountie the most recondite mysteries of this abstruse and divine science shall at length be manifested."[32] Sir Henry Savile, the universal scholar who had worked on the King James Bible, heard and gave. He did not insist on a world system. Fifty years earlier, he had included the Copernican system in his college lectures with the odd justification that "it [is] all one to me in sitting at Dinner, whether my Table be brought to me, or I go to my Table, so I eat my meat."[33] His generous gift to Oxford of professorships in astronomy and geometry provided for a small library and some instruments, which very probably furnished the props for Cleyn's painting.

As Savilian professor, Bainbridge balanced new and old, teaching Tycho, Kepler, and Galileo, searching for Dee's manuscripts with the help of Ussher and Cotton, showing the use of the telescope, and calculating with logarithms, but also restoring ancient astronomical texts as acts of piety to their authors and of acknowledgment to Savile. He enriched the lives of his many students (undergraduates aiming at a master's degree had to hear the Savilian professors) with astrology as well as astronomy.[34] An astrology based on reason and experience, in contrast to the art of most practitioners, who built "a Babylonian tower on sand, nay, on cobwebs" (*arenas, imò et araneas*).[35] Correct astrology announced the death of King James in the spring before it occurred to those who understood what the presence of Saturn in the tail of the Lion signified: *obiit noster Regius ille Leo*, "our royal lion is dying."[36] Bainbridge taught his students that the best astronomical system was the Copernican and that astronomy must be learned at the telescope, "from the Heavens rather than from books."[37]

Bainbridge was at or near the center of several "networks of association," as Mordechai Feingold terms the informally connected students, fellows, and lecturers in and outside the universities who shared interests

in mathematics and natural science. The expertise of the participants ran from sampling the sweets of cosmology to doing time in the discipline of chronology. These subjects intersected with geography and astrology at the foundation of them all, astronomy. History, so necessary for those about to repeat it, could not see without its twin eyes of geography and chronology. Consequently, Laud as Chancellor of Oxford and his successor Bishop Juxton encouraged the study of astronomy and its allied subjects, as did heads of houses like Savile, Warden of Merton for thirty-six years until his death in 1621, and Abbot, Master of University College for thirteen years before his promotion to Archbishop of Canterbury. Students and fellows disputed about the motion of the earth and the existence of Lunarians. Contacts with influential fellow travelers outside the university, like Ussher and Selden, who drew on its expertise in astronomy for their chronology and history, and Bishop Andrewes, who read Bacon and Copernicus, helped further to diversify and enlighten the study of the mathematical sciences at Oxford.[38] Probably most people who spent a few years there had more up-to-date information about the motions and constitution of the heavens than the average university graduate does today.

Two well-known books published five years on either side of 1630 may indicate the scholarly environment into which Galileo's *Dialogue* first fell in England. The earlier writer, Ussher's protégé and later chaplain, Nathaniel Carpenter of Exeter Hall, preferred Tycho's system with a spinning earth to Copernicus's and ranted against "Popes and Dictatours [who] have taken it upon them an Universal authority to censure all which they never understood . . .To seeke for a determination of a Cosmographicall doubt in the Grammaticall resolution of two or three Hebrew words…were to neglect the kernell, and make a bouquet of the shells."[39] He must have had the banning of Copernican books in 1616 in mind. The second witness, Henry Gellibrand, professor of astronomy at Gresham College, London, had learned his subject from Savile and Bainbridge. He inclined towards "that admirable Copernican Hypothesis" embraced by all the best continental astronomers, but hesitated to declare

its truth; fearing, from the "imbecility of Mans apprehension," of falling into great absurdity. But an observation Gellibrand quoted in Italian from the *Dialogue* by that "most acute and learned mathematician," Galileo, almost convinced him.[40] His successor Samuel Foster adopted the Copernican system, while other pedagogues preferred to save physics and theology with Tycho or, less frequently, Ptolemy. But the direction of travel was clear: among students of astronomy, Galileo's would soon be the winning side.[41]

They would experience some friction along the way, of course, particularly from Puritan writers of the 1630s who relied on Scripture to rule out heliocentrism and on common sense to ridicule it. Henry Burton's strong, healthy "earthy brain" was immune to the "braine-sicke giddinesse" afflicting "Philosophicall Heretickes, or Hereticall Philosophers," or Copernicans. Bishop Christopher Wren, the father of the architect, deduced, correctly, that Joshua's stopping of the sun was among the greatest of miracles; from which he inferred, less reliably, that those who "raise[d] such a hellish suspition in vulgar minds" as the Copernican system accused God of asserting one thing in Scripture after having practiced another in Creation. It was also a miracle to Wren, though a lesser one, that people could still be found who followed crazy ideas that "the learned Tycho...hath by admirable and matchlesse instruments, and many years exact observations proved to bee no better than a dreame."[42]

The Cavendish Circle

Gellibrand was lucky to have a copy of the *Dialogue*. When Thomas Hobbes sought one in London in 1634 for his then current patrons, the Newcastle Cavendishes (cousins of his earlier patrons, the Devonshire Cavendishes), he discovered that none could be bought for love or money. He did better in Florence. In 1635, he visited Galileo in his villa prison and acquired several manuscripts, perhaps including Galileo's "Mechanica." Such a manuscript did reach the Cavendish seat at Welsbeck, where Robert Payne translated it.[43] Payne was an Oxford man (Christ Church)

with a "very witty searching brain" and amiable character, who joined the Cavendishes as chaplain after failing to secure a senior position in the university.[44] Eventually a copy of the *Dialogue*, a "booke that will do more to hurt [the Catholic] religion than all the books of Luther and Calvin, such opposition [do Papists] think that there is between their Religion, and naturall reason," came to light. A Cavendish hanger-on, a Dr Webbe, translated it.[45] When Galileo learned about the translation from Hobbes's visit, he thought that it could only do him harm in Italy.[46] He had trouble enough over his *Dialogue* without the English treating it as a sequel to Sarpi. He did not need to worry. Webbe's translation was never published, and Galileo's masterpiece seldom appeared in public discourse during King Charles's personal rule.

Webbe did not make his translation for the purpose Galileo feared if, as seems secure, he was that Joseph Webbe who owned a patent for teaching Latin without passing through grammar. The Webbe of painless Latin was a Catholic with degrees in medicine and philosophy from the universities of Padua and Bologna. The combination inspired a booklet on medical astrology that specifies, in a marvelously compact form, disease conditions aggravated by the stars and planets on every day in 1612.[47] Soon thereafter Webbs returned to England with his easy Latin, designed, according to a perceptive detector of popish traps, to turn Protestants into Catholics.[48]

Hobbes developed an admiration for Galileo just short of adulation.[49] This was Galileo the *physicus* who worried about the Copernican difficulty of the descent of separated bodies to a moving earth. "Striving with this difficulty," Galileo "opened to us the gate to universal physics"— that is, the theory of motion. During the trip that took him to Galileo's villa, Hobbes recognized that "the cause of all things is to be sought in the differences between their motions."[50] Working out the details with the help of Galileo's thought experiments took over twenty years.[51] About halfway along, Hobbes tried out his principles against an attempt by one of his more unusual friends, Thomas White, to create an embracing natural philosophy incorporating the discoveries of Galileo—the first such

philosophy, it is said, developed by an Englishman. White revolved around the Cavendish circle in an epicycle centered on Digby.[52]

As the brother of that Richard White who knew about tides and brought Galileo's work to England, Thomas White had a privileged insight into the methods and results of the "sublime Galileo," who (as Richard put it) had "overcome the tides below and penetrated the heavens above." "The eyes of all students, including mine, were on him."[53] Brother Thomas returned to England after ordination in Douai to combat Jesuit efforts to reconvert the kingdom.[54] In and out of England, he spiraled like another Sarpi toward some Protestant positions and promoted, under the alias of Blacklo, a plan to establish English bishops relatively free from Rome.[55] The first business of "Blacklo's cabal" was to try again to revise the Oath of Allegiance. Many lay English Catholics approved their version, as did seven theologians in Rome. The moment seemed propitious: Charles had relaxed the oath in 1639 to smooth recruitment of Catholics into his militias. Once again, however, the pope rejected compromise.[56]

White presented his eclectic natural philosophy, which paralleled his broad-church Catholicism, as a conversation among characters similar to those in Galileo's *Dialogue*: a knight whose visor has no eyeholes, a confident man of sense, and an overconfident man of science.[57] White's world resembled Bruno's, sun-centered and filled with extraterrestrial life; but it was also Christian, created in time and finite in space, and anti-Roman, full of unauthorized, reckless, and doubtful innovations. The Roman Index eventually banned all White's books.[58] Among his errors was a direct affront (so Hobbes) to "the greatest natural philosopher not only of our time but of all times."[59] The affront was a tidal theory worse than Galileo's. No matter. White's main objective was not to invent physics but to defeat extremism within Christendom and rampant skepticism inspired by the irrepressible spirit of innovation and the stultifying epistemology of voluntarism.[60]

In this noble battle White had the aid of the philosopher, pirate, and gentleman who constituted Sir Kenelm Digby. After participating in Charles's siege of the Infanta, Digby had enjoyed a career of seaway

robbery. His greatest exploit, the capture of a fleet of French merchantmen chaperoned by Venetian warships, earned him respectability and appointment as a commissioner of the Navy. Now and again Catholic (and permanently so from 1635), Digby worked with White, Conn, and Henrietta Maria to raise Catholic money for Charles's military adventures.[61] For this parliament imprisoned him in 1642, which gave him leisure to write down much of the philosophy he had developed with the help of White.[62]

Digby's *Two Treatises* (1644) move from description of an atomistic–mechanical material world to proof of the immortality of the incorporeal soul. This achievement, which attracted the favorable attention of Hobbes and Descartes, began with an unusual Oxford education. At Gloucester Hall (now Worcester College), "a notorious haunt of Papists," Digby had absorbed much from Thomas Allen, "the best astrologer of his time," also a fair alchemist, dedicated teacher, and compulsive collector. Allen conjured with papers and utensils he had acquired from John Dee and presented manuscripts to his friends Arundel, Bodley, Cotton, Selden, Ussher, and Digby to support their studies and enrich their polemics.[63] Bringing the diverse sciences he had from Allen and White together with the wide knowledge he had picked up as a pirate, administrator, traveler, and lover, Digby joined the fight against skepticism. He found his strongest weapon in "that miracle of our age," Galileo, who had discovered that true natural knowledge was discoverable. Why then did skeptics abound? The repulsiveness of traditional learning! "For what a misery it is, that the flower and best wittes of Christendom, which flocke to the universities, under pretence and upon hope of gaining knowledge, should be there deluded; and . . . be sent home againe . . . with a persuasion that in truth nothing can be knowne?"[64]

Copernican Bishop

John Wilkins, the son of an Oxford goldsmith, spent a decade at Oxford, studying and teaching, from 1627 to 1637. He learned religion and astronomy so well that he became bishop in both: a real bishop in the Church of England and an authoritative proselytizer for Galilean astronomy.[65] It was

Wilkins who brought the *Dialogue* into the public sphere in England. Although from a Puritan background, Wilkins acted with equal effectiveness as chaplain to Royalist and Parliamentarian, Calvinist and Arminian. During his last years at Oxford, he employed the leisure gained from refraining from polemics in writing two books, one, published in 1638, to show that the moon resembles the earth, and the other, published in 1640, to show that the earth is a planet. For both of them he drew heavily on Galileo and on Tommaso Campanella's *Defense of Galileo*. Drafted in 1616, published in 1622, and banned in 1623, Campanella's *Defense* reformulated Galileo's hermeneutics, endorsed the discoveries of *Sidereus nuncius*, and wrote off most philosophers as fools.[66] Wilkins supplemented this helpful resource with material from Kepler's account of moon men.[67]

The lunar market was booming in England when Wilkins printed his *Discovery of a World in the Moon*. The travelogue of Domingo Gonzales, the posthumous work of the then late Bishop of Hereford, Francis Godwin, was becoming a bestseller. Godwin had drawn his inspiration from "this our discovery age: In which our Gallilaeusses can by advantage of their Spectacles gaze the sun into spots, and descry mountains in the Moon." As Gonzales escaped from the magnetic attraction of the earth to enter that of the moon he noticed that the earth moved as Copernicus would have it. The Ptolemaic world evidently was "a very absurd conceit." "Philosophers and mathematicians…confesse the wilfulnesse of [your] owne blindnesse!"[68]

The reading public was prepared for Gonzales's trip if not for his cosmology by Kepler's posthumous dream (*Somnium* (1634)), describing astronomical observations made from the moon, and reprintings of Donne's *Ignatius his Conclave* (1635) and Harington's translation of *Orlando furioso* (1634). It also had before it an arresting report preserved in a dialogue by Lucian then newly rendered into English. Lucian detailed the flight of the cynical traveler Menippus to heaven to learn directly from the gods the truth about matters surprisingly contested among terrestrial philosophers, who knew nothing despite "the grimnesse of their countenances, the paleness of their complexion, and the profundidite of their beards." Observing the earth from the moon to which he ascended on

wings taken from an eagle and a vulture, Menippus saw that everything here below is absurd, peevish, paltry, petty, hypocritical, and futile.[69]

Wilkins's two popularizations can be considered as a single enterprise paralleling Galileo's *Dialogue*. *The Discovery of a World in the Moon*, corresponding to the *Dialogue*'s Day 1, destroys the Aristotelian universe. *A Discourse Concerning a New World* removes objections to a moving earth, as in Days 2 and 3. In his parallel to Day 1, Wilkins "insist[ed] on the observation of Galilaeus, the inventor of that Perspective, whereby we may discern the Heavens hard by us, whereby those things that others had formerly guest at, are manifested to the eye, and plainly discovered beyond exception or doubt," notably, mountains, valleys, and seas on the moon, and a fuzziness indicating an atmosphere.[70] Taking into account also that inconstant comets dwell above the moon, it followed, first, that there is no quintessence, no sphere of fire, no music of the spheres, and, secondly, that, since the moon has the same physical features as the earth, it may well be inhabited.[71]

Lunarians have a moon, which is the earth, and, being bound to their abode as we are to ours, believe themselves to be at rest. Although not much more could be deduced about these moon-dwellers, Wilkins reported, on Campanella's authority, that they are more intelligent than we are.[72] Therefore they know, if they have read our Bible, that it is not the place to look for answers to cosmological questions: "'tis besides the scope of the Holy Ghost whether in the new Testament or in the old, to reveale anything unto us concerning the secrets of Philosophy." And they know, if they read the book of nature, that it is "an indignity much mis-becoming a man who professes himselfe to be a Philosopher" to have recourse to super- or preternatural explanations of physical phenomena.[73]

Wilkins's widely read assimilation of the moon to the earth aroused a nodding Simplicio, Alexander Ross, a chaplain-at-a-distance to Charles I. Ross enjoyed the distinction of having written (in 1634) published, in 1634, the first treatise against Copernicus published in England. Relying on schoolboy Aristotelian physics and some scraps of Scripture, Ross

brought against the diurnal motion that ice could not form on a spinning earth since motion is the principle of heat and biblical stories about sundials would have no basis. "If the sun is stationary, how does the shadow move in a sundial? From the motion of the earth? If anyone can prove that, *Phyllida solus habebit*, "he will have Phyllis to himself." The allusion is to Virgil's third *Eclogue*, which promises Phyllis for an answer to the poser, "Where do flowers grow inscribed with the names of kings?"[74] Ross lived in the past. "[F]rom my youth I have been more conversant among the dead than the living."[75]

Wilkins's rebuttal to Ross ran, in its entirety, "Ha, ha, he."[76] Ross replied in the smoldering style of Prynne, who had lumped together "purblinde, squint-eyed Arminian Novellists" with the imbeciles who "sottishly enquire, whether the Sunne stands centred in one constant Climate, whiles the massy Earth wheeles around, because one brainsicke Copernicus out of the sublimitie of his quintessential transcendentall Speculations, has more senselessly than metaphysically, more ridiculously than singularly averred it."[77] Ross read Galileo's recantation as a willing escape from brainsickness. "[B]eing both ashamed, and sorry that he had been so long bewitched with so ridiculous an opinion; which was proved to him both by Cardinall *Bellarmine*, and by other grave and learned men...Galilei on his knees did abjure, execrate, and detest, both in word and in writ, his errour." How could he have fallen for so "false, absurd, and dangerous [an opinion], having neither truth, reason, sense, consent, antiquity, or universality to countenance it"? "Philosophical libertie"! Who needs it? "The world is pestered with too many opinions already." Ha, ha, he![78] But the laugh, and the world, was against him. Ross had to concede defeat in the fight against atheism, ignorance, profanity, unbelief, heresy, and the "dreams and fantastical whimsies" of freely philosophizing nuts.[79]

Wilkins went beyond Galileo in separating religious belief altogether from natural knowledge. It was wrong of Galileo, he said, to try to prove to his Grand Duchess that the stoppage of the sun and moon at Joshua's

command could be understood more readily in a Copernican than in a Ptolemaic universe.[80] Mixing Scripture with physics was to play the enemy's game. Wilkins adopted Galileo's refutations of objections to the earth's motions and affirmed them without invoking tides. Instead, he emphasized the convenience, proportion, and reasonableness of moving the tiny earth rather than the huge heavenly vault. The machinery required for that would be gargantuan, "altogether beyond the fancy of a poet or a madman." A cook does not roast his meat by carrying the fire around it. Placing the earth in the third orbit from the sun not only achieved the expected relation between meat and fire, but also brought all the periods and distances of the planets into line and gave a simple and natural explanation of the limited elongations of the inferior planets and the retrogradations of the superior ones.[81]

Wilkins's *Discourse* ends with an affirmation against the Bellarmines and Rosses who would constrain the study of astronomy. Properly undertaken, its study increases "the endowments of our Souls, the enlargement of our Reason." "The *demonstrations* of *Astronomy*, they are as infallible as truth." They prove God, enlarge our admiration of His omnipotence, confirm the truth of Scripture, show the pettiness of our preoccupations, and "may also stirre us up to behave ourselves."[82] From this uplifting exit, we can return profitably to the entrance to Wilkins's Galilean astronomy, the title page of the joint printing of 1640. It asserts without reservation that the moon is an earth and the earth a planet. Again there are three figures, but now, instead of Aristotle and Ptolemy, we have Galileo and Kepler, and not much of Kepler (Figure 25); they stand together, separated by the world system from its creator Copernicus, who now represents the ancients. He asks, as Tycho does in the frontispiece to Kepler's tables, "what if it is like this?" Galileo replies that he has the means of finding out, his new eyes, the telescope. Kepler wants more; he wants to know about the Lunarians invisible even through the best glasses: "would that [the glasses were] wings." The sun at the center claims to give light, heat, and, by its axial rotation, animation to everything.[83]

Figure 25 William Marshall, frontispiece to John Wilkins, *New World* (1640).

More Star Talk

Common Parlance

Many people acquired concepts for discussing the world picture through popular astrology as presented in general literature, almanacs, and the theater.[84] The works of the Reformers are not free from it. Melanchthon consulted astrology often, and yet not often enough: for, had he looked at his future son-in-law's ominous birth chart in good time, he would not have sacrificed his daughter to a ne'er-do-well. Like many believers, Melanchthon moved readily from the sun's production of the seasons and the moon's of the tides through cosmic regulation of the weather to planetary causes of lightning strikes and earthquakes.[85] Among worrisome heavenly signs were adverse conjunctions. A repetition in 1560 of the rendezvous of Mars and Saturn that had spoiled his son-in-law so frightened Melanchthon that he had his university, Wittenberg, stockpile food against the event.[86] Nothing happened, perhaps because he had used tables drawn up on Copernicus's system, in which he did not believe.[87]

Although Calvin took the trouble to write a little book against the "devilish superstition" of astrology, he did not doubt that all creatures are "subject to the order of heaven to draw from it some qualities." Oysters are plump and bones full of marrow when the moon is full or waning and physicians know to "ordeyne bloode lettings or drinks or pilles & other things in due time."[88] Although Calvin knew it was wrong, "vaine and unprofitable...[and] derogatynge from [God's] honour and diminishing his glorye," to attempt to predict the future, he did it.[89] The stars influence our characters, although not, as fake astrologers proclaim, at birth, but rather at the time of conception, "which for the most part is unknowen." It is secure, nonetheless, that the stars work on things that "concerneth the worlde and doth apperteine to the body."[90] What about comets? Again ambiguity: "I do not denye but that when God wyll stretch out his hande to execute some judgment to be remembered in the worlde, he wyll some tymes admonishe us by comets." Calvin exits this labyrinth with a

memorable parable. There is the same difference between wholesome and judicial astrology (prognostications about individuals) as there is between praising wine and recommending drunkenness.[91] Another church leader, King James, quite agreed, although he had nothing against drunkenness; he decisively rejected judicial astrology (in his *Daemonologie*) but accepted the study of celestial influences on the elements as a mathematical science.[92]

Bacon too decried judicial astrology while accepting astrological extrapolations from the sun's effects on earth. He deprecated the art as "so full of superstition that scarce anything sound can be discovered in it," and rejected horoscopes and houses as nonsense; yet he taught that great celestial cycles can have an effect on humanity at large and that stars can act on individuals via their humors. He looked forward to a "sane astrology" constructed from the aspects, culminations, distances, velocities, and characters of the planets; the colors, sizes, and twinkling of the stars; and systematic comparisons of historical disasters with accompanying configurations of the heavens. A sane astrology might well result from a physical astronomy that would abolish the eccentrics of the ancients, heal the divorce between things above and under the moon, and reveal "no slight knowledge of some motions of the lower world as yet undiscovered."[93] Constancy of species and variability of individuals might be consequences of the regularity of the fixed stars and the wanderings of the planets.[94]

Here are two lesser examples. In *Astrologomania* (1604, 1624), Dudley Carleton's combative Calvinist cousin George Carleton, Bishop of Chichester, rejected judicial astrology as neither mathematics nor natural philosophy. Aristotle did not allow it; Tertullian, Clement, and Lactantius condemned it; the devil invented it. Still, Carleton allowed that the stars regulate the weather, corrupt the air, and agitate the juices of animals and vegetables. "If Astrologie stayed it self in this, to foretell the natural Humours or their effects, which shall be in such Plants and Bodies as are somewhat governed by Planets; it might seem to have some likelihood."[95] Our Puritan guide John Geree demanded that astrologers be punished as wizards and sorcerers. Not because they were entirely wrong: The stars can

"worke on the temper, and on the Soule," pushing us to actions that "grace, education, civill Wisdome, a world of things may oversway." Astral forces can affect our bodies, but not our minds and moral judgments. Whatever truth astrology might contain, Englishmen must have nothing to do with it; for, according to Preacher Geree, its practices are popish. "Popish I call them, because under Popery such practices had allowance, and countenance."[96]

Although the popes had from time to time condemned astrology, usually they allowed the doctrine of St Thomas: *sapiens dominatur astris*, "the wise man rules over the stars." Celestial bodies work on ours and so affect our actions if we do not have the will or wisdom to oppose them. Sixtus V had prohibited the prediction even of inclinations in 1586; Clement VIII ignored the order; Urban VIII believed in inclining predictions.[97] Urban could boast a well-aspected sun as lord of his horoscope and he became pope as the sun moved into its domicile in the constellation Leo. No wonder he identified the sun's wellbeing with his! When astrologers hired by would-be popes exploited solar eclipses to foresee his demise, he took pains to save himself with the help of an astro-magician.

This expert was Campanella, who had perfected his instrumentalist astrology during the twenty-seven years he spent in prison for plotting against the state of Naples and other infractions. After release he went to Rome, arriving four years after his *Defense* of Galileo, and was again incarcerated. Urban plucked him forth to defend against eclipses. Together, in a darkened room, the pope and the jailbird set out lamps to represent the planets and luminaries in their normal courses, and incense, aromatic herbs, and music to indicate the harmonies of the universe. It worked. Earthly enemies of the pope and his magus then purloined and published the manuscript in which Campanella described their proceedings.[98] Urban was outraged by the public revelation of his credulity: which, however, reassured the faithful that they might entertain some belief in astrology.

Or, rather, should: "If there were no other, this were a sufficient errand for a mans being here below, to see and observe those goodly luminaries

above our heads, their places, their quantities, their motions." This teaching comes from a meditation on Psalm 8:3–4, "When I consider thy heavens, the work of thy fingers, the moon and the stars, which thou hast ordained | What is man, that thou are mindful of him, or the son of man, that thou visitest him?" The Lord's finger work includes the sun, "Monarch of dayes and yeares," the moon, "Mother of moneths, Lady of seas and moystures, a secret worker in bodily humours," and the twinkling stars, "as it were virgins with torches," which work on us too.[99] The author of this meditation worried how the earth stays in the middle of the cosmos so as to enjoy the full and even action of natural astrology. He has recourse to the fingers of God, whose hand he shows on his title page holding the earth by a string attached to the North Pole. Like a man wearing a belt and suspenders, the earth also floats on water.

> By this one argument, fond atheist see
> The Earth thou tread'st on shows a Deitie
> On such a liquid basis could it stand
> If not supported by a Pow'rfull hand?"[100]

As anyone could learn from Henry Peacham's *Compleat Gentleman* (1622), properly finished people knew astrology. Dante would have felt at home in Peacham's universe: a stationary earth, resting in the common center of the eleven spheres that turn the heavens and carry the planets, bakes evenly under astrological influences. For readers who wanted to know more, Peacham recommended consulting the books of John Dee for the art, and of "Clavius the Jesuite" and Copernicus for its astronomical underpinning. Unfortunately, he warned, the inquirer must first understand geometry.[101]

Elevated Discourse

Astrology is not always exact. That is not, however, a good reason to condemn it. The "*Mercurial Columbus…of this Noble Science*,"[102] George Wharton, made the case with the power of an Oxford education. Why pick on astrology? What geometer can square a circle? No doubt many

charlatans infest the field. So? We do not scrap politics because of Machiavelli, or the Catholic Church "because of [its] many Ravening *Wolves* and subtle *Foxes.*" Nor do we abolish the clergy, "because some Time-Buggering Changelings have…prefer'd their Worldly interests and carnal Ends of Pride, Vain-Glory, Strife, Covetousness, and desire of Preheminence above their Brethren, to the Truth and Peace of the Gospel."[103]

Should we not worry that the new astronomical systems negate the principles of the Art? By no means, says Sir Christopher Heydon, in what became the standard defense of judicial astrology in Stuart times. No matter the system, it was the same God who created the ravishing celestial bodies and, "in the richness of his infinite mercy, did also as well by his eternall providence foreordayne their ministry, as he does still sustaine the same as his next meanes, and instruments, for the ordinary government of this inferiour & elementary world." Multiplicity of systems gives the astrologer several ways to run calculations. That Ptolemy, Copernicus, and Tycho differ in their concepts of the order and motions of the planets does not matter.

> For whether any of their opinions be true, or whether they be false…the Astrologer careth not. For so that by any of these Hypotheses, he may come to the true place and motion of the starres, this varietie of opinions, whether such things be indeede, and in what order they be, is no impediment to the principles of Arte.

We need only to know the angles as obtained by mathematics and their effects as derived from experience.[104] Heydon could read Kepler on elliptical orbits with a critical eye and was among the first in England to study *Sidereus nuncius.* "I have read Galileus, and, to be short, do concur with him in opinion."[105]

Angular experience shows that shifts in planetary orbits, alteration of the sun's eccentricity, change in the obliquity of the ecliptic, and conjunctions of the superior planets have important consequences here below. Think only that, when Saturn's apogee drifted into Cancer, Mohammed arrived; and expect that, when it reaches the opposite sign, Capricorn, the

Muslim empire will begin to fall. Some tables put this event in 1630, others in 1728. The art is not perfect. But no one can deny that the shift of the apogee of Mars into Virgo in 1647 had its consequences: "A Dissolution of the English Monarchy, etc., [as] the whole World can witness."[106]

The eccentricity of the solar orbit does not change. Early modern astronomers thought it did, and astrologers tracked its consequences. Following Copernicus's spokesman Georg Joachim Rheticus, Wharton observed that the Roman Empire began, and Christ suffered, when the eccentricity hit a maximum; at its mean value, the Turkish empire rose, and, alas, persists, although the eccentricity has passed through a minimum. The change of the tilt of the earth's axis is another long-term cycle of immense but undetermined consequence, for which Wharton gives no examples. Evidently he had not read the *Faerie Queen*, where the change in obliquity, like the precession of the equinoxes, is the cause of universal disorder:

> So now all range, and do at random rove
> Out of their places farre away
> And all this world with them amisse do move
> And all his creatures from their course astray
> Till they arrive at their last ruinous decay.

On the effects of Wharton's fourth cause, however, superior planetary conjunctions, he gives good measure, as these are frequent enough to keep up with the follies and disasters of humankind.[107]

Conjunctions of Jupiter and Saturn occur every 20 years in such a way that for 200 years they remain within a "trigon," a set of zodiacal signs 120 degrees apart. Each of the four trigons is associated with one of the four terrestrial elements. In 800 years the conjunctions complete a full cycle of trigon visits. Unpleasant events occur at every change of trigon and particularly unpleasant ones at the renewal of a cycle. Transitions from the Watery to the Fiery are the most fateful. One such occurred in 1603, the year of James's accession. Campanella connected it with the nova of 1604, which occurred in the same neighborhood of Sagittarius, and predicted a change in religion. He was right to anticipate something profound. Counting

backwards by 800-year intervals, we arrive eventually near 4000 BCE and the deepest of profundities, Creation. When Jupiter and Saturn again renewed their meetings in the Fiery Trigon, something bad but unknown happened; the next renewal brought the Universal Deluge; and, subsequently, Moses and the Law, the birth of Rome and affliction of the Hebrews, Olympic games, Christ's mission and the Roman Empire, Charlemagne, and the Stuarts' age of trouble.[108] These specifications agreed well enough with those in Kepler's *Stella nova* (1606) to amount almost to a demonstration. His second conjunction, in 3200 BCE, advertised Enoch and banditry, cities, arts, tyrants; then Noah and the Deluge, Moses and the Law, Isaiah and the four monarchies, Christ and the reformation of the world. In our era, the seventh cycle, beginning in 800, coincided with Charlemagne and the Western and Saracen imperium, and the eighth, 1600, with Rudolf II and Kepler. The ninth, 2400, will be an age of people unknown, to whom, worse, we might not be known, "if indeed the world lasts so long."[109]

Wharton recognized moral as well as physical causes for the decline of states. He must have had the Stuarts in mind when writing them down: intemperance, lust, and effeminacy of princes; refusal to keep promises; corruption, unlawful fines and detentions, heavy taxation, disdain of advice. "When the Prince listens not to Wise and Faithful Councellors, Changes are imminent." The populace also has a part in ruining a state. When subjects become unwarlike, shake hands with infidelity, disobedience, and contumacy, and flout the law, things will go badly. "Where neither the laws nor Magistrates are held in Honour, then the Common-wealth cannot be safe or durable."[110] Astrologers do speak truly, sometimes.

"When beggars die, there are no comets seen. The heavens themselves blaze forth the death of princes."[111] Is there not ample evidence of the malevolence of comets? Nonsense, says the Earl of Northampton, "['Tis] plaine that neither Princes always dye when comets blaze, nor Comets always blaze when Princes dye." He was right. In 1612, a very bad year for great personages, an emperor, two queens, a pair of dukes, the Earl of Salisbury, and Prince Henry had all fallen "without any blazing star or other extraordinary sign." This last observation shows that

the connection between comets and potentates was never far from people's minds whether they believed it or not.[112] Northampton himself proves the rule.

Although he had written a big book against all sorts of prognostications, including astrology, which he ridiculed for claiming that planets exert physical influences on people ("A citizen of London might as well smell the perfumes of *Paris*"), Northampton could not bring himself to deprive the heavenly bodies of all influence here below. "Stars and Planets, by a certaine conformable heate or quality…[cause] the lower bodyes to draw their first beginning, both of their action and life."[113] Similarly, the eclectic Nicholas Hill had accepted some celestial portents such as eclipses as advertisements of illness (eclipses are diseases of the "eyes of the world") but rejected other signs as "the inventions of petty minds unworthy the magnanimity of a philosopher." Like many of their compatriots, Northampton and Hill accepted the contradictions of astrology as they did the relation between the royal prerogative and the liberties of the subject—an incipient opposition that could be maintained, and even made useful, if not driven to confrontation.[114]

The three comets of 1618 re-established whatever reputation blazing stars might have lost by their invisibility in 1612. The most brilliant of them announced the death of Queen Anna, the dethronement of Elizabeth and Frederick of Bohemia, and the Thirty Years War. It seemed aimed at James. His queen's death affected him deeply, temporarily.

> Thee to invite the great God sent a starre
> Whose Friends & kindred mighty princes are
>
> Thus she is chang'd not dead, noe good prince dyes
> But like the day-starre only sets to rise.

He soon began to suspect that the comet, "which though it bringe the World some news from fate | The letter is such as non can translate," might have a bright side.[115] After all, it did not kill him. Rather, by appearing in the constellation Libra, it seemed to endorse his balanced foreign policy. The ordinary Englishman preferred to suppose misfortune.

> Then let him dreame of famine, plague and warre
> And thinke the match with Spayne has rays'd this starre
> And let him thinke that I theyr Prince, and Mynion
> Will shortly change; or what is worse religion.

Archbishop Ussher agreed with the common man. The effects of the comet would be punishing and enduring: "the judgment that has begun [in Bohemia, in 1619] will end heavily upon us; and (if *all things deceive me not*) *it is even now marching toward us with a swift pace.*"[116] That was the general opinion. In one of the hundred or more contemporary tracts on the comets of 1618, we read that blazing stars herald such catastrophic events as "alterations of commonwealths and such slaughters as seldom are seene, with many more calamities, infinite and innumerable." A little consideration made clear why peers and princes were particularly exposed to their power: great people live "more delicately and intemperately than other[s]," and so suffer more readily from the corrupt air comets cause. "[S]o they…nourishing the cause of ill in themselves, being unpatient and not able to indure the working of medicinable receipts, quickly perish and miscarrie."[117] Comets announce the fate of the leisured classes.

Was that the reason that Wotton caught a cold watching them in 1618? He was then in Venice, where people were usually so intent on their business that they did not care about comets; but Wotton suspected that the obvious connection with the disturbances in Bohemia might arouse their languid interest. It certainly caused consternation in Rome, where Paul V lived "tormented by astrologers." And, as James foresaw, ordinary Englishmen noticed its bearing on the Spanish match.

> A starre did late appeare in Virgo's trayne
> The which from South to North did post awayne
> If England then be North and South be Spayne
> Brave Charles sitt fast, and look unto thy Wayne.[118]

These clever lines ("Charles's Wain" signifies the Big Dipper, a conquest, and a wagon) came from Richard Corbett, a longtime resident of Christ

Church, Oxford, where, he wrote in December 1618, all talk was about the comet.

> Physicians, Lawyers, Glovers in the Stall
> The Shopp-Keepers speak *Mathematiques*, all
>
>
>
> All weapons from the *Bodkin* to the *Pike*
> The Mason's Rule, the Taylor's Yard alike
> Take *Altitudes*; and th'early Fidling Knaves
> Of Fluites, and Hoe-Boyes, make them Iacob's-staves
> Lastly, of fingers glasses we contrive
> And every fist is made a Perspective.

What did it all mean? "O! tell us what to trust to, ere we wax | All stiffe and stupid with the Parallax."[119]

Among more professional observers of the great comet of 1618 were Galileo, Kepler, and a mathematician at the University of Leyden, Willibrord Snell, known to posterity as the discoverer of the law of optical refraction. Galileo worked out the dangerous theory that Conn defended, which, however, exonerated comets; for, as optical illusions, they could scarcely affect the weather. Kepler took the comet to be a real body moving rectilinearly above the moon and made explicit that its apparent path arose from the earth's rotation. Snell likewise located it in the former quintessence. Both saw it as a portent. Kepler associated it with the troubles in Bohemia and the death of his employer, the emperor Matthias. Snell saw a celestial conspiracy.

> What is most important to me is that Saturn was exposed to [the comet's] malign and adverse rays from its first risings, and that Saturn infected it with his evil qualities; consequently, from the glare of this comet I fear strong Saturnine effects. Which evils may Almighty God by his church and our prayers most mercifully avert, I implore on my knees: because only he can do it.[120]

Playful Argot

Virtually everyone who could read in early Stuart England would have known the argot of the almanacs that they consulted as often as the

Bible: meridian, equator, ecliptic, conjunction, opposition, aspect, zodiac.[121] Almanacs contained essential information for farmers, fishermen, physicians, and travelers, as well as predictions of the weather and consequences of eclipses and conjunctions. An authoritative estimate puts the number of editions of English almanacs in the seventeenth century at 2000, and the number of individual copies at three to four million. The authors of masques and plays could expect their audiences to know the lore and language of astrology to almanac level.[122]

It could be quite demanding. An almanac of 1642 predicts a cold spell at the autumnal equinox because "the *Barren* signe *Virgo* and *Mercure* Lord thereof, and the Moon are [then] ascending;" a very cold spell, because Saturn and Jupiter are in Pisces, in opposition to Virgo and retrograde, and "*Venus* likewise unfortunate in *Scorpio* in the 3. house, applying to the opposition of *Mars*, who is mounted in the cold and drie signe Taurus . . ." Convincing? William Cartwright of Christ Church, the author of a play King Charles saw and liked in Oxford in 1636, capitalized on this jargon in a later production, *The Siege, or Love's Convert*. A wooer recalls the instant he fell in love with his lady. "The sun in's Apogaeum, Moon in Libra | First Quartile, Minutes 23, 2 seconds." Lady:

What, your a Scholar?

.

I've vowed against all scholars.

Wooer:

I hate a scholar

.

That which I spoke now
I conn'd out of an Almanack.[123]

A few well-known passages from Shakespeare suggest the threshold level of astrological knowledge of Jacobean playgoers. "These late eclipses of the sun and moon portend no good to us" (*King Lear*); "Saturn and Venus this year in conjunction: what says the almanac to that?" (*Henry IV, Part 1*); "Shake the yoke of inauspicious stars" (*Romeo and Juliet*); "My mother compounded with my father under the dragon's tail, and my

nativity was under *Ursa major*; so that it follows I am rough and lecherous" (*King Lear*). "Madam, though Venus governs your desires I Saturn is dominator over mine" (*Titus Andronicus*). The exchange between Sir Toby and Sir Andrew in *Twelfth Night* requires greater knowledge of the zodiacal associations of the body than they possessed.

> "Were we not born under Taurus?"
> "Taurus! That's sides and heart"
> "No, Sir; it is legs and thighs."

They were drunk; it is the neck.

Rarely if ever does Shakespeare's star talk refer to up-to-date astronomy. A possibility:

> The heavens themselves, this planet, and this centre
> Observe degree, priority and place
>
> And therefore is the glorious planet Sol
> In noble eminence enthroned and sphered
> Adminst the other. (*Troilus and Cressida*)

Very likely, however, this text refers not to Copernican theory, but to the traditional scheme that centered the sun between the moon, Mercury, and Venus, on the one hand, and Mars, Jupiter, and Saturn on the other. The Sun-King stood at the center of the local ruling elite but not at the center of the visible universe. People who like metaphors might regard Copernicus's system as a promotion of the Sun-King to the real center of power, where Bellarmine fancied the pope stood.[124] Another candidate for a reference to contemporary, indeed, Galilean astronomy is Jupiter's appearance in *Cymbeline*. He descends from his heaven to banish four dancing ghosts and succor the hero born under his sign. Are the dancers Galileo's Medici stars and their banishment an expression of doubt about their existence? It is chronologically possible.[125]

The prattle of the ignorant practitioner in John Lyly's *Gallathea* (1592), who "can bring the twelve signs out of theyr Zodiackes, and hang them

up in Taverns," would be plain to everyone; the inference by Jonson's crooked alchemist that a horoscope with Mercury well placed in Libra advertised a "merchant [who] should trade with balance" required scarcely more knowledge; but the informed discourse of the doctor in John Fletcher's *The Bloody Brother* (1617, 1639), who calls upon technical concepts of Muslim astrology, might challenge an adept. "Look upon your Astrolabe [the doctor orders]; you'll find it | Four Almucanturies at least."[126] An almucanthar is a circle of altitude projected onto a tympan of an astrolabe; *quid clarius?*

Stargazer in Philip Massinger's *The City Madam* (1632) drivels more learned nonsense (perhaps borrowed from Ben Jonson) than Fletcher's doctor.[127] Stargazer has the job of finding signs showing that the young ladies who employ him will dominate their marriages. He calculates: "Venus in the West-angle, the house of marriage, the seventh house, in *Trine* of *Mars*, in conjunction of *Luna*, and *Mars* Almuthen, or Lord of the Horoscope . . ." A lady interrupts: "The Angel's language, I am ravish't. Forward." Stargazer starts again:

> This is infallible. Saturn out of all dignities in his detriment and fall, combust [close to the sun]: and Venus [now] in the South-angle elevated above him, Ladie of both their nativities…in a sign commanding, and he dejected… argue, fortel, and declare rule, preheminence, and absolute sovereignty in women.[128]

These ladies were not the sort who, we are told, flocked to astrologers to locate lost teaspoons and new husbands, but feminists using the weapons of their time to advertise their rights.[129]

Fletcher and Massinger did not overlook the theatrical potential of the new astronomy. The villain in *The Bloody Brother* describes great sights seen in a powerful glass. "All these now done by Mathematicks | Without which there's no science, no truth." A menacing doctrine! In a lighter vein, Marcelia in Massinger's *Duke of Milan*, written around 1623, dismisses the insinuation that her husband does not love her as more implausible than the Copernican system.

If you would'st worke
On my credulitie. Tell me rather
That the Earth moves, The Sunne, and the Starres stand still
The Ocean keeps nor Floods, nor Ebbes.[130]

Students at Cambridge used astrology to advantage in the play, *Albumazar*, they performed before King James in 1614. They pinched it without acknowledgment from Galileo's Italian rival in the invention of the telescope, Giambattista della Porta. The original version opens with Albumazar and his associates itemizing the crooks who flourished in Naples, whom the Cantabridgians recast into merchants, lawyers, and other respectable persons, "the learned only excepted." After brief consideration they cancelled the exception:

> [The scholar] steales one author from another
> This Poet is that Poet's Plagiary
> And he a thirds, till they all end in *Homer*.

Albumazar: "And *Homer* filch't all from an Egyptian Prestresse | The World's a Theater of theft." Albumazar's main contribution is to deceive people into believing that one of the play's protagonists died in shipwreck.

> I wander twixt the Poles
> And heav'nly hinges, 'mongst excentricals
> Centers, concentricks, circles, and epicycles
> To hunt out an aspect for your buinesse.

After much calculation, the desired result:

> Drown'd in the sea stone dead: for *radix directionis*
> In the sixt house; and the waning moon by Capricorne
> Hee's dead, hee's dead.[131]

Albumazar had an engine to catch "such Planets as have lurk't | Foure thousand yeares under the protection of *Jupiter* and *Sol*." What is it?

Sir, 'tis a perspicill, th' best under heaven
With this I've read a copy of that small *Iliade*
That in a wall-nut shell was desk't, as plainly
Twelve miles off, as you see *Pauls* from Highgate.

The thing works by "refraction | Opticke and strange;" no closet with windows can escape its prying eye. What have we here? Ah, Rome.

I see the Pope, his Card'nals and his mule
The English Colledge and the Jesuits
And what they wrote and doe.[132]

For any auditors who did not recognize this parody of *Sidereus nuncius*, Albumazar points to "the bunch of planets new found out | Hanging at th'end of my best Perspicill." These he proposes to send to "Galileo in Padua."[133]

All sorts of changes could be worked on Galileo's glass. Jonson's *Staple of News* (1625) reports the discovery of one in Galileo's study capable of firing a ship at sea by moonshine. Jonson's alchemist had a perspective that could spy out potential gulls and ways to fleece them. Davenant bettered even that feat. "[In] Opticks...the Moderns are become so skilled | They dream of seeing to the Maker's Throne."[134] Playwrights conjured with spheres as well as glasses. A wandering sphere represented a disturbed mind; the lunar sphere, eclipsed without earth glow, deceit; familiarity with the heavenly spheres, wisdom. The mountebank in Shackerly Marmion's *A Fine Companion* is certified a sage because he "Can tell how...the Spheres are turned, and all their secrets."[135] And so on.

King James's surfeit of academic plays included *Technogamia*, performed for him in Oxford in 1621. Its characters personify the seven liberal arts plus medicine and magic. Astronomia, the heroine, is seriously ill, poor thing, as she had died once already, "her brain...turned to jelly from the constant turning in her head." The magician proposes a consultation. "[T]here's one *Galilaeus* an exquisite Mathematician, an Italian: whom I came very lately acquainted with, by admirable lucke; and he has promised

to help me to a glasse, by which I shall see all things as perfectly represented in Astronomia's house, as if I were there." Astronomia grows stronger with the help not of Magus, but of Geometricus. A figure suggestive of King James confirms the couplings geometry and astronomy, history and poetry, rhetoric and grammar, and music and melancholy, and offers them the salutary but unexpected advice not to use tobacco.[136]

James did not like *Technogamia* any more than he did tobacco or oysters. He thought it tedious, as indeed it is; but it has the merit of showing that the English had associated Copernican ideas with Galileo's discoveries about the time the Inquisition ordered the earth to stand still and Galileo to shut up. Technogamia's wheeze that the spinning earth turns astronomers' brains to jelly recurs in Prynne and Ross and lesser writers. It was also applied to the stomach. Describing a rough crossing of the Channel, James Howell, the glass merchant who helped Charles in Madrid, wrote that he "began to incline to Copernicus his opinion which hath got such a sway lately in the World, viz., that the Earth, as well as the rest of her Fellow-Elements, is in perpetual Motion." Howell associated the new noise about Copernicus with telescopes and Lunarians.[137]

Political Metaphor

When Charles entered Edinburgh in 1633 for his belated coronation, he passed through an arch at the east end of town decorated with a portion of the heavens showing his zodiacal sign, Virgo, in the ascendant. Planetary gods competed to improve him. Saturn pledged support for big projects; Jupiter handed over his thunderbolts; the sun offered empire without end.[138] A year earlier, the audience at the inauguration of the Lord Mayor of London had heard similar play between the zodiacal signs and the City's twelve chief companies.[139] It was not play when Strafford said to the crowd eagerly awaiting his execution: "It should appear from your concourse and gazing aspects that I am now the onely prodigious Meteor toward which you direct your wandering eyes. Meteors are the infallible Antecedents of tragicall events...I am become my own prodigy."[140]

A most apt metaphor, commented the king, for, "while moving in so high a sphere and with so vigorous a luster, he must needs, as the sun, raise many envious exhalations which, condensed by a popular odium, were capable to cast a cloud upon the brightest merit and integrity." Charles's execution excited a more veiled imagery:

> Let all things move within their orbs; suppose
> The inferior lights should labor to depose
> The Prince of light, and drive him from his throne
>
> Consider then, would not the stars let fall
> Too great an influence, the sun too small
> On humane bodies? Oh may they remain
> In their own Region, then would Sol again
> Enjoy his just prerogatives.[141]

The effort to impeach Buckingham in 1626 brought forth an extended analogy to the world system so admired that it was republished during the first year of the Civil War. Its author, Sir Dudley Digges, had family connections to the heavens. He was the son of Thomas Digges, who had scattered the stars in three dimensions, and the ward of Thomas's friend and tutor John Dee, who opened his mind to further mysteries. Dudley Digges demonstrated his command of the elements of astronomy in a tract on the size of the earth intended to promote searches for a northwest passage to the Orient; inspired by the same muse as Delamain, he admired the learned who "could reduce their studie in histories the Mathematickes or the like from speculation to practice for the...honourable service of their country."[142] Digges reduced his analogy as follows.

"The solid body of incorporate Earth and Seas" represents the husbandry and commercial activities of the Commons; the "firmament of fixed stars," the Lords; the planets, the great officers of state; the "pure element of fire, the most religious, pious Clergy;" the air, "the reverend Judges, Magistrates, and Ministers of Law and Justice." The attribution of wandering stars to high politicians, fiery elements to pious clergy, and hot

air to lawyers was autobiographical; Digges had rejected a career in court, church, and bench because of their luxury, hypocrisy, and "money getting." All elements of the state, laudable or not, receive their "heat, and life, & Light, from our glorious sun"—that is, King James. Unfortunately, his "powerfull beames of…grace and favour," being so very strong, have "draw[n] forth from the bowels of this earth an exhalation that…shine[s] out like a starre." An evil star.

> If such an imperfect Meteor appear like that in the last age in the Chair of Cassiopeia [Tycho's nova of 1572] amongst the fixed starres, where Aristotle and the old Philosophers conceaved there is no place for such corruptions; then as the learned Mathematicians were troubled to observe the irregular motions, the prodigious magnitude, the ominous prognostics of the Meteor, so the commons when they see a blazing starre, in course so exorbitant in the affairs of the Common-wealth, cannot but look upon it, and for want of prospectives [Galilean glasses], commend the nearer examination thereof to your Lordships, who may behold it at a better distance, such a prodigious Commet the Commons apprehend the Duke of Buckingham to be.[143]

Here indeed was learning working! Working itself into rhetoric bordering on sedition! The inference that the solar Stuarts were the suns that raised the rank exhalation that was Buckingham from commoner to lord earned the "very affable and courteous" Digges a stay in the Fleet prison.[144] William Davenant's famous heroic poem *Gondibert*, written in 1648–9, has a place here. It describes "Optick Tubes" and other instruments belonging to Solomon's House that are as useful for withering human conceit as for exploring the universe. The sedentary life does not suit the earth or its inhabitants. "As if 'twere great and stately to stand still | Whilst other Orbes dance on…" Which, decoded, signifies that inaction results in evil, in particular, in bad government, "for the virtuous are often preach'd into retirement." Contrary to nature, whose ceaseless motion makes life and preserves it, the indolent men of talent and probity allow the wicked to gain authority.[145] The wicked of Davenant's time drove him into exile and the arms of the Catholic Church.

Another applied cosmologist was Robert Greville, second Lord Brooke, who, in 1640, tried to prove that Truth is one. The apparent radical multiplicity of things arises from the unreliable testimony of the senses. The senses of sight, touch, and sound tell us that the earth does not move—we see the heavens rotate, feel ourselves at rest, and do not hear "such a black Cant as [the earth's] heavy rowlings would rumble forth" if it spun—"yet if we believe our new Masters, sense has done what sense will doe, misguided our reason." These Masters were Copernicus, Kepler, and Galileo. Suspect your senses, seize in your soul the truth that apparently disparate things are but one, but do not think too much (Greville was a militant Puritan). "It is often seene, a working head is like an over-hot liver, burneth up the heart, and so ruineth both."[146]

It required a strong head and heart to face the consequences of modern astronomy. One of Ussher's correspondents put the challenge in a striking metaphor: the immensity of Copernicus's universe (as inferred from failure to detect a stellar parallax) exposed the immensity of our hubris in thinking ourselves "the only Creatures of Excellency for whom all these things were made." "So might a Spider, nested in the Roof of the Grand Seignior's Seraglio, say of herself, All that magnificent and stately structure, set out with Gold and Silver, and embellish'd with all Antiquity and Mosaick Work, was only built to hang up her Webs and Toys to take Flies." The telescope shows us to be insects "many degrees below nothing." The individual's salvation is to know his true situation by "chaste observations…[and] undeniable Demonstrations" (an echo of Galileo's mantra, "sensory experience and necessary demonstrations") and thence rise slowly to Heaven.[147]

According to the Cambridge Platonist Henry More, the Copernican theory and its confirmation by Galileo's observations can help people who doubt the immortality of their souls on the evidence of their senses. "But wiser he that on reason relies | Then stupid sense low-sunken into dirt." Sense says the world is Ptolemaic and imagines nothing else; reason says the earth is a planet and explodes the physical arguments against it.

These and like phansies do so stronlgly tye
The slower mind to ancient Ptolomee
That shameful madnesse 'twere for to deny
So plain a truth as they deem that to be.[148]

The Copernican attack on the authority of the senses opened the way to other truths blocked by immediate sense experience. The prospect was scary: in the foreground, freedom to philosophize; in the middle ground, tolerance; and in the distance, the collapse of religion and the state.

There is no hiding from the consequences of innovation. Selden: "'Starry Messengers'…have taught us about new stars…Once the use of the telescope has been transmitted, we ourselves perceive the very same things as these Messengers." We must apply the same principle to "oriental doctrine, whence the whole of Christianity arose."[149] Galileo himself has shown the way by observing that the Roman liturgy hid a hint of Copernican doctrine.

> For in the Ambrosian hymn for the Fourth Day, that of the creation of the luminaries, the breviary reads: "Most Holy God of Heaven | Who colors the shining center [*centrum*] of the heavenly vault [*poli*] with fiery splendor, enriching it with befitting light | Who on the Fourth Day fixed the flaming wheel [*rotam*] of the sun | Governs the ways of the moon and the wide courses of the stars." Unless *centrum* & *polus* & *rota* are taken here in an altogether different sense…than customary in physics, mathematics, theology, and elsewhere, a rotating sun seems to be placed in the world's center in the public forms of the church's liturgy.[150]

This was indeed the message that Galileo insinuated at the end of his hermeneutical letter to Christina, and the mixing of physics with Scripture for which Wilkins later criticized him.

Pope Urban removed the difficulties Galileo signaled by rewriting the breviary. For the phrase, "shining center of the heavenly vault," Urban put "shining regions of the world;" and he praised God for "kindling the wheel of the sun" rather than for fixing or setting it. Urban's revision of the Roman Breviary, published in 1631, could hardly arrest the cause for which he would soon condemn Galileo. As Selden observed, outside the Roman battle zone the Copernican theory was "flourishing well enough, and did flourish [among the Pythagoreans], and, in my opinion will

flourish...[although] it turns the machinery and the system of the natural world upside down."[151]

The reader ignorant of astronomy and her sister sciences will miss much in the discourse of Stuart times. "It will be unto you a great disgrace," warned the author of a popular text on the celestial globe, "not to be cunning in these things." If cunning, you can appreciate such complicated metaphors as the title page of *Saturni ephemerides* (1633) by the hagiographer of that "Angell in the pulpit," Lancelot Andrewes.[152] The title appears between two columns made up of books (Figure 26). The left-hand column is in the light under a celestial globe; the lintel above it features a rising sun and a naked lady, "Historia." The right-hand column of books, under a terrestrial globe, is largely in shadow; its lintel has a setting sun and a woman, "Chronologia," who regards Historia through a telescope. In explanation:

> The COLUMNS both are crown'd with eyther SPHERE
> To show CHRONOLOGY and HISTORY beare
> No other CULMEN then the double ART
> ASTRONOMY, GEOGRAPHY impart.

Here the telescope appears as a double symbol, as a stand-in for astronomy and as an instrument of investigation. "By OPTICK SKILL pull farre HISTORY | Neerer;" while History, "Ne're so farre distant, yet CHRONOLOGIE | Will have a PERSPICILL to find her out."[153] Therefore acknowledge this truth, "The chiefe light and Eye of *History* is *Chronology*, and the very Load-star, which directeth a man out of the Sea of *History*, into the wished for Heaven of his Reading." Study astronomy. You will see more clearly where the world has been, how it now spins, and where it is headed. Unless you are "so dull, stupid, or ignorant [to] understand not the singular Benefits which accrew to Mankind from Histories," study astronomy.[154]

Besides being a help to history, a corrective to hubris, and an ally in political discourse, astronomical instruments and metaphors may prefigure salvation. Deep inside the *Emblemes* of Francis Quarles, first published in 1635 and often reprinted, Flesh and Spirit are busy with a telescope. Spirit directs it to Christ sitting on a rainbow giving Final Judgment (Figure 27).

Figure 26 Intimacy of history and chronology, from Henry Isaacson's *Ephemerides saturni* (1633).

Oh that they were wise, then they would understand this; they would consider their latter end. Deuteron: 32 · I Payne scul.

Figure 27 Flesh and Spirit vying over a telescope, from Francis Quarles, *Emblemes* (1635), 180.

She sees Flesh's enemy, "Grim Death, standing at the glasse's end." And worse:

> I see a Brimstone Sea of boyling Fire
> And Fiends, with knotted whips of flaming Wyre
> Tort'ring poore sools, that gnash their teeth, in vaine
> And gnaw their flame-tormented tongues, for paine.

Flesh tells Spirit to cheer up and offers her a prism in which she can see the world in rainbow colors. But Spirit is not one of the Foolosophers who challenged the reality of things seen through Galileo's glass. She sticks to her telescope as the instrument of truth; the rainbow that counts is Christ's judgment seat. "Foresight of future torment is the way | To baulk those ills which present joyes bewray."[155]

6

MEDICINE AND MELANCHOLY

Dr Williams

The road of life that Maurice Williams raced down sure-footedly began in London and led through Oxford to the service of the most powerful men in Britain. Born like Charles I with the century, he matriculated at St John's, Oxford, in 1616, the year in which Galileo campaigned for Copernicus, De Dominis fled to England, and John Bankes began practice in London. Three years later, possessed of a bachelor's degree, Williams became a fellow of Oriel, and, after another three years, a Master of Arts. He gained sufficient recognition to contribute a few Latin verses to Oxford's book of condolences on the death of the irreplaceable pacific King James, "the nurse of peace...now Mars alone blazes in the Heavens." Heaven in fact had been "unfeeling and harmful;" witness Buckingham's war of pique against Spain and the ongoing hostilities that had driven the new king's sister into exile.[1] The world was crammed with danger. Nonetheless, Williams found the courage to leave Oxford for Padua. Three years later, in 1628, he returned to England as a medical doctor and to Oriel as a Fellow.

In Italy, Williams had ventured beyond Galileo's old university to visit the great cities of Tuscany and the Papal States, Florence, Pisa, Bologna, and Rome. He contemplated the "crooked" towers in Pisa and Bologna—not as backdrops for falling bodies, since the myth of Galileo and the Leaning Tower had not been invented yet—but rather as puzzles in mechanical stability. What kept them from being falling bodies? Williams worked out that their figures contained the vertical through their centers

of gravity, "otherwise they or anie other bodie would fall." In Rome he inquired into the inundations of the Tiber, their extent and causes, and questioned how they depended on ocean tides. Later he included these among many other questions about the physical world in a manuscript now in the British Library. In this unexploited work, he ordered his questions under the nineteen inquiries into gravity and levity posed by Bacon as exemplars of proper scientific investigation.[2] Williams had made a close study of the *Novum organum* (1620) soon after its publication. He gave his copy, unfortunately not annotated, to the library of St John's.[3]

In 1628, the year in which Williams returned from Italy, Harvey published his controversial theory of the circulation of the blood, which, as Hobbes remarked, reworked physiology in the image of Copernican and Galilean astronomy.[4] Williams defended Harvey's heart-centered microcosm against traditionalists who rejected it out of hand, Cartesians who wanted to modify it, and Italians who claimed it for Sarpi. But it did not suit Williams's Baconian style to endorse Harvey without reservation. "I like al progresses in learning which the received placits of others have too much hindered … Give mee an emancipated spirit and judgment, not tied to the professor of one chair. Let me examine things in the balance of my own reason, and of experience joine issue with it." Should this prayer be answered, and reason join harmoniously with experience, a cautious philosopher might allow himself to reach a conclusion, though not establish an article of faith. "We can assure ourselves of nothing but appearances." To go further would admit a vicious circle. We would become "advocates in our own cause, in making ourselves judges of nature above others: The sphere of our activitie cannot bound others: except a natural Storie could be soe grounded as to have the gift of Infallibilitie."[5]

This formulation comes from a course of lectures Williams gave at the Royal College of Physicians, probably in 1648, during his stint as Anatomy Reader there. Their empirical approach almost certainly dates from his first acquaintance with Bacon's writings and the epistemology he encountered at the Paduan school of medicine. He ends his qualified defense of Harvey with an assertion and metaphor worthy of, and perhaps taken

from, Galileo. "If I have judged of anie thing not visible here in the booke of nature, it was by natural induction and necessarie inference. Yet therein I have done as painters doe in perspective, who not being able to represent on a plaine al the divers faces of a solid body, choose one of the principal to set to the light, and shadow the rest. And it was because my weaknesse could do no otherwise."[6]

In 1633, after a few years of successful practice in London, the learned and diligent Williams became a protégé of the risk-prone ministers Laud, promoted that year to Archbishop of Canterbury, and Wentworth, appointed the previous year as Lord Deputy of Ireland.[7] Laud's tenure as President of Saint John's coincided with the future doctor's undergraduate years there; "he was bred some years under mee [Laud wrote Wentworth]; And I know him to be a very good Schollar, soe I promise you shall fynd him a very honest, and a good natured man." He will doctor you or, if you prefer, help you to doctor yourself; he is not doctrinaire. One of Williams's authoritative colleagues, Sir Simon Baskerville, a royal physician, also recommended him. Wentworth needed good medical advice, for he had chronic gout and his health was a matter of state. "I doubt not that [Williams] will give your Lordship every contentment. He hath given me thankes, as if he found himself better in your Lordship's acceptation, because he came recommended by me, and I assure myself that he will make all good that I have said in his behalf."[8]

Wentworth apparently suffered from the "knotted and stony [type of gout that] refuseth medical helps." Laud delved deep into his small stock of humor to tease Wentworth about it. "I shall wish the gout may continue in your knee [so the Archbishop] till you be better minded to honour Jesus with it." The unbending Lord Deputy refused to genuflect. Earlier Laud had suggested a remedy of the sort for which Wentworth, although then only a year or two in office, had already made himself notorious. "Use your Power in both Houses, make an Act of [the Irish] Parliament against [gout]."[9] Almost from the start of his regime in Ireland, Wentworth was never well for long; treating his insomnia, migraine, fatigue, and gout gave Doctor Williams ongoing employment.

Wentworth trusted his physician with more than doctoring. He had Williams elected to the Irish Parliament as its member for Asheaton, county Limerick.[10] The good doctor pursued a good policy. He asked Wentworth to commission him to hunt out usurpers of lands intended to support hospitals and lazar houses, to recover the lands, and to return them to their intended use—in return for a lease on them, at half value for sixty years, to cover expenses.[11] It is no sin to help oneself while helping others. Williams also helped John Bramhall, another of Laud's protégés who came over with Wentworth in 1633, and, coincidentally, a good friend of Sir John Bankes. A fervent Arminian soon to be consecrated Bishop of Derry, Bramhall took strong measures to rescue the Protestant Church in Ireland from its poverty and to combat resurgent Catholicism directed by priests who had swarmed into the country during James's wooing of Spain.[12] Bramhall was effective. In three or four years he increased the income of the Crown by over £30,000, tried to impose the Thirty-Nine Articles on the Church of Ireland, and drove two Scottish ministers with 140 followers to New England.[13]

For his miscellaneous service, Wentworth knighted Williams. The elevation surprised Laud, for whom doctoring and politicking were not enough for knighting. Wentworth explained that Williams received the honor not for serving in Ireland but for wooing in England, "for our women say here, 'a wife will be sooner gotten if she may be made a lady.'" The lucky lady, Jane Mawhood, was a relation of a fellow physician, Sir Matthew Lister, formerly doctor to Queen Anna and then to Henrietta Maria. The connection proved important. When Wentworth had no further need of him, Williams would enter the queen's service.[14] Laud had already introduced him at court "to kiss the King's Hand, and more kindness than that, he desired not of me."[15] Williams could make his own way through an open door. We learn further from Laud's heavy humor that Williams inclined toward modern medicine. "As for the distemper you talk of that marriage may prove, and neither Galen nor Hippocrates able to cure...'tis not impossible that your Dr Williams...may be able to do that in a Paracelsian way."[16] Perhaps Laud had Jonson's alchemist in mind, "a rare physician...| An excellent Paracelsian!"[17]

We will not go far wrong in placing Williams among the enlightened physicians who made use of the London *Pharmacopoeia* of 1618, which included the chemical drugs of Paracelsus. Issued by the Royal College of Physicians at the urging of James's primary physician Théodore de Mayerne, it contained a wealth of materials that might have helped King James. Still drinking to excess in "quality, quantity, frequency, time, and order," the divine monarch "laugh[ed] at medicine" but not at his gout. How then cure it? Not by walking in the dew, as suggested by Laud, or by the new chemical therapies, which lacked the cachet of tried-and-false ones. Mayerne fell back on the old recipe of scrapings from an unburied human skull mixed with white wine and taken at the full moon. His prescription of medicines and cosmetics for Henrietta Maria, compounded of puppy dogs, worms, and bats, further demonstrates his unusual flexibility.[18]

Since gout continues to plague the human race, specification of another of Mayerne's remedies may be a public service. Vomiting and purging are the key. Take a little *mercurius dulcis* (calomel, still employed in homeopathic medicine) or, better, a concoction of cassis, turpentine, and rhubarb followed by a dose of vitriolated tartar and a broth of stinging nettles. Better yet, regular consumption of pills made of Spanish liquors, the stones of mollusks, and the powder of human bones "of the same parts as those that are affected" will keep the disease at bay. If you do not take your pills and continue to ache, you should not dose yourself with opiates. Consult a doctor. "Otherwise a Medicine is as a Sword in the hand of a Mad man."[19] Remember what the Italians say: "I was well, I would be better, I took Physic and died."[20]

Williams returned to Ireland in the summer of 1638 with his new wife and 500 ounces of silver plate. Wentworth reported the event in the misogynist mode introduced by the jolly archbishop. "We shall see what Course he follows, be it Galen, Hippocrates, Paracelsus, or a Dozen of the Doctors more," but if she behaved like others Wentworth knew, "she would become 'the shame of Physicians'...too hard for them all." "The more fits she hath," returned the man of God, "the less fit she shall be for him."[21] We assume that Lady Williams fit well into the diverting company

that Wentworth had brought over from England, which included the implausible, magnificent, singular John Ogilby.

Ogilby had come from somewhere (he did not know where) in Scotland, the son of an improvident father. By selling pins he earned enough by the age of 11 or 12 to buy a lottery ticket. He won, extracted his father from debtors' prison, and apprenticed himself to a dancing master. He soon bought out his time and set up for himself. After landing badly from a high-flying pirouette when showing off in an anti-masque at Buckingham's house, he gave up performing in favor of teaching privileged children like Wentworth's. The Lord Deputy, who was fond of plays and masques, assigned Ogilby the charge of arranging for them; which he did so well that Wentworth suggested that he set up a theater in Dublin. Its start stuttered when Archbishop Ussher shut it down in 1636 during Wentworth's absence in London; but it reopened at the deputy's return and ran with moderate success until 1640, with James Shirley as resident playwright. Irish rebels soon accomplished what the Irish Archbishop could not and, in 1641, burnt it to the ground. Ogilby fled to England, suffered shipwreck, and limped, destitute, to Cambridge, where Shirley and other friends helped him to study Latin. Soon he thought he knew enough to publish his own translation of Virgil (1649).[22] He went on to Aesop and to collaboration with Francis Cleyn.

The Doctor's Masters
The Lord Deputy

Wentworth accomplished wonders in Ireland. On his arrival in 1633, he had faced a population split into irreconcilable groups, of which the dispossessed native Catholics and large Protestant landowners presented the gravest problems. The most rapacious "New English" land grabbers had not spared holdings intended for the support of their own ministers, churches, and government. Wentworth clawed back land and income, acquired custom farms, subdued pirates, and bullied settlers.[23] His efforts

to convert natives into good English agriculturists, allow them justice in court, and give them access to education did not agree with the ideas of economy and charity entertained by the New English. They charged Wentworth with going native, nurturing Catholicism, and acting the tyrant. To counter the influence of his enemies at court, Wentworth relied principally on Laud and Bankes. He also had the backing of Arundel until he reprimanded the earl for searching for faulty deeds, trying to throw ancient owners out of their estates, and violating the "promised and princely protection and grace of his Majesty."[24]

To reinvigorate the Church, improve royal finances, relieve the peasants, and challenge land grants, Wentworth packed his Privy Council and the Irish Parliament with loyalists like Williams, raised and trained an obedient Irish army, and had the English Navy repress piracy in Irish seas. Trade flourished, with Spain especially. With the help of William Bedell, once Wotton's chaplain and Sarpi's instructor, and now an Irish bishop, Wentworth improved the education of the clergy and instituted services in the Anglican style. Here he ran up against Ussher, whom he admired for his learning and character, but not for his intolerant Calvinism. Once when dining at the archbishop's palace (Ussher lived well despite his dour religion), Wentworth chided him for its magnificence. "I shall live to want necessities," was the reply. The Lord Deputy: "You must [then] live a long time." The archbishop, who was twelve years Wentworth's senior, answered with a chilling prophecy: "I shall live to close your eyes."[25] And so it would be.

Wentworth based his policy in Ireland on having what Charles never did in England or Scotland: the means of carrying it out. The Irish debt on his arrival was £76,000, the annual deficit £20,000. Wentworth moved swiftly to diminish the one and eliminate the other via subsidies granted by his packed parliament. Increasing trade raised profits on customs farming by two-thirds in three years. Wentworth tried to establish new industries, such as linen weaving, and wanted to develop a tapestry works. For this he made inquiries at Mortlake, but nothing came of it.[26] While serving the Crown Wentworth did not neglect himself. Already a rich

man on arrival—his goods and attendants traveled in thirty coaches—his total annual income after his purchases in the custom farms, land (some 59,000 acres), and monopolies (alum, tobacco) amounted to around £23,000.[27] That added envy to other motives for bringing him down.

Wentworth went to England in 1636 to conduct business connected with his estates and, more urgently, to neutralize charges against him originating in Ireland. His speech detailing his accomplishments won over the Privy Council and Charles declared his deputy's dealing with parliaments a pattern for his own. Wentworth doubted his inconstant master's capacity to follow it or to sustain his post as keystone of an arch supported by royal prerogatives on one side and parliamentary privileges on the other.[28] In the trappings of power, however, in which Charles excelled, Wentworth sedulously copied him. He spent some time "vandycking"—that is, glorifying himself via portraits by Van Dyck. He commissioned three such, of himself, after imperial portraits by Titian. He conducted his court with Carolinian pomp, established a personal guard, ordered and oversaw improvements in Dublin Castle ("Without offense to Mr Jones…I take myself to be a very pretty Architect"), and, as in Williams's case, exercised royal authority in conferring knighthood. A damaging charge against him at his trial in 1641 was "[having] traitorously assumed to himself royall power."[29]

Charles realized that he had no chance of success in his wars with Scotland without "the relentless, overwhelming Wentworth." Illness prevented the savior's immediate attendance, but when the Lord Deputy dragged himself to London in September 1639 he was confident and belligerent. He offered a loan of £20,000; other members of the Privy Council subscribed, and £200,000 was thus raised by Christmas. Believing that he could cow an English parliament as he had the Irish, Wentworth urged Charles to summon one. Reluctantly Charles agreed and, more enthusiastically, satisfied Wentworth's wish to be an earl. That was on 12 January 1640.[30]

The new Earl of Strafford, now Lord Lieutenant, returned to Ireland in March 1640 and immediately raised £180,000 from its parliament to prepare an army of 9,000 men for shipment to Scotland in May. Since it had no Puritan soldiers and many Catholic officers, English Protestants

reasonably inferred that it was directed against them.[31] Strafford rushed back to England in April despite the advice of physicians, who thought him unfit to travel, and of mariners, who knew the sea was not safe for it. Desperately ill, he rallied to enter the Lords on 23 April, a week after parliament had convened. The Crown had opened the session by demanding immediate subsidies to meet the Scottish emergency. The Commons turned as usual to airing grievances: religion, Laud, T&P, ship money, monopolies, forest enlargements, the Privy Council, bishops, judges. On 4 May, Strafford edged it back to the king's business with a call for eight subsidies in lieu of ship money. The Commons did not comply, and Charles dissolved it the next day after an existence of three weeks.

Strafford then tried to raise money from Spain. No luck. The queen and Secretary Windebank appealed to Rome. Urban replied that he would be happy to help a Catholic King of England. Bankes harried sheriffs behind in collecting ship money and prepared, on Charles's orders, the Commissions of Array that required the nobles of the land and their servants to attend the king at their expense. The Privy Council discussed debasing the currency. With £20,000 in hand, a promise of another £20,000 a year from the bishops, and the loan begun in the Privy Council that reached £250,000 on 15 May, Charles went to war against Scotland in June.[32]

On the day of the dissolution of the "Short Parliament," Charles called a meeting of the Privy Council's Committee for Scottish Affairs, at which Strafford gave some oracular advice: "You have an Army in Ireland you may employ here to reduce this kingdom." The ambiguity of "here" and "this kingdom" when taken out of context would be fatal to the earl.[33] Instead Charles fielded another ragtag army, again met with defeat, and again summoned his Lord Lieutenant, who, once more, was detained by illness. Williams accompanied him to England and saw at first hand the diseases racking the kingdom. He was in attendance when his patient, imprisoned in the Tower, prepared to fight for his life before the Lords. Strafford's condition was so desperate that Williams consulted Mayerne.[34] Bankes too tried to help as an ex officio member of

the committee to examine Strafford.[35] But neither medicine nor the law could save their friend.

Williams returned to Ireland before his patron's execution and did not see what many rushed to witness (Figure 28).[36] He could not bear it. He was one of the few who shared the feeling of Strafford's confidential agent George Radcliffe: "I lost in his death...such a friend as never man within the compass of my knowledge had." How could such a friend, so great a man, so loyal, effective, and generous a public servant despite his rough ways and driving ambition, come to such an end? Williams's reaction to the execution opens room to speculate about his religion. One of his doctor friends wrote of him: "Because of his lofty mind he would not ascribe [Strafford's] miserable, sorrowful, and pernicious fate to God." Evidently Williams was no Calvinist.[37] A stronger clue to his religiosity might lie in the final lines of his poem on the death of King James. "He is always to be honoured as the director [*caput*] of the world, the priest and the altar."[38] This suggests the Arminianism of Laud and Bramhall. Although he had been Wentworth's man in the Irish Parliament and had engaged in the same enterprise as Bramhall, who fell (although not to his death) along with Strafford, Williams succeeded in avoiding the fates of his patrons and colleagues.[39] In this he resembled Bankes.

One of Williams's colleagues was Hugh Cressy, a fellow of Merton, who served as Wentworth's chaplain. Cressy could neither stand nor understand the challenge of "ignorant Presbyterians" to the monarchy. The threat that they and their anti-episcopal fellow Puritans and Calvinists mounted was the more terrifying because not of their making; they merely capitalized on a "fateful concatenation of a world of dispositions and circumstances...so strange that no humane prudence could have seen or suspected them." The root cause seemed clear enough, however: King Charles had tolerated a religion that allowed people to think for themselves. The only possible cure was a firm dogma interpreted by authorized theologians. Cressy fled to the Continent, submitted to Rome, and joined the Benedictines.[40] Thus did Strafford's associates distribute themselves according to character and

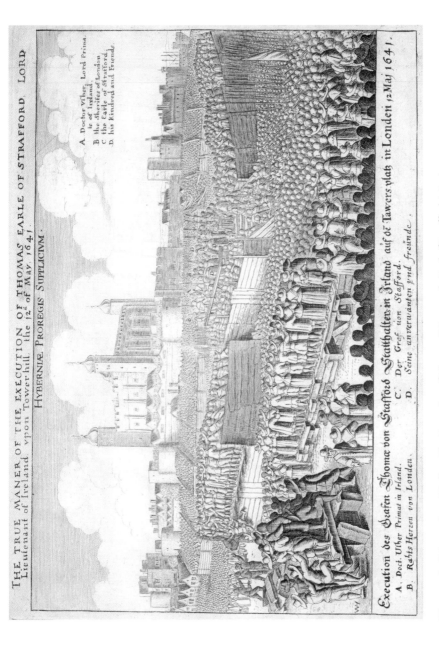

Figure 28 Wenceslaus Hollar, *The Execution of Thomas Wentworth, Earl of Strafford* (1641).

opportunity, Ogilby to literature, Williams to medicine, and Cressy to monasticism.

The Lord Chancellor

Williams knew that a good doctor cannot be a strict Calvinist. If he believed, as a Turk or a Stoic, that God had decreed everything, he would be a charlatan to claim to cure disease or extend life. Fatalistic patients, who conceive that because God has decided when each person dies they need not take care of their health, commit a sin worse than quackery, for they "seeme to tempt God to a miracle for their preservation." A good doctor recognizes that God's decrees are conditional: we cannot have more days than God numbered, but, through poor diet, intemperance, and bad medicine, we may well have fewer.[41] A good way to cut down the allotted span of life is to follow Bacon's advice for prolonging it.

Bacon advocated an annual condensation of the vital spirits for a fortnight at the end of May with strong opiates as cleansers. That opiates condense spirits, and that the condensation is beneficial, followed from physiological theories that Williams condemned as dreamy speculation: "this nobleman's opiates lulled him asleep." Among the condensing drugs Bacon recommended were poppy juice, "a kind of herb called 'coffee'," and tobacco, "the use [of which] has immensely increased in our time." Thus Bacon. Williams: tobacco is dangerous, opiates more so. The philosopher: "the Turks find opium, even in large quantities, innocent and cordial." The doctor: it gives them the indulgent idea of a paradise of "feast[ing] in pleasant grenes with wine and women." Opiates can help in violent diseases, but not in preserving health, and they can kill.[42]

Bacon was no prude. He recommended a "seasonable use of sexual intercourse, lest the spirits grow too full," and if this therapy should go awry, an emaciating diet against venereal diseases. A spare diet is good for the aged too, whether they are diseased or not, and should be followed every two years to procure renewal of the elderly body, "like the casting of skins of serpents." To which the philosopher added that frequent purging

was more likely to procure longevity than exercise, and that his remedies were safe and effective. "It would scarce be believed with how much care and choice they have been examined."[43] Williams:

> [your prescriptions] savor too much of that magistralitie which in others you condemn...[It] is to assume to your selfe the empire in nature and physike, authoritatively to have that required which you never yet experienced; nay, to introduce it against the continued experience of others; which makes against your selfe in the practises of reason you require in others.[44]

Several of Bacon's absurdities concerned the Irish. They are long-lived, he said, because they had a habit of standing naked before their fires, "and rubbing and as it were pickling themselves with old salt butter." Or because they wore clothes rubbed with saffron. Bacon deduced from these practices that anointing the skin with oil, "either of olives or sweet almonds," is the best means of prolonging life. The Irish had perfected this ancient after-bath remedy by skipping the bath, on the ground that oil excludes the cold in winter and retains the spirits in summer. Williams knew something about the Irish and about perspiration. It is silly, he wrote, to block the body's natural means of removing waste. "Shal I make my selfe sicke because I have a physician nere"?[45]

The philosopher: never take a cold drink on an empty stomach. "[T]he first draught at supper of wine, beer, or whatever drink a man uses [should] be taken hot." The doctor: "Tepide water inclines men to vomit." The point is not that drink taken before dinner should be warm, but that it be wine. Wine in moderation is a good thing, according to Williams, for women as well as men. The jury is out on artificially cold beverages, however. Some Jews died in Sicily from cooling their drink in snow; but a Japanese embassy entertained by Pope Paul V in 1615 grew healthy and fat on ices. In his judicious way, Williams condemned very cold drinks and simultaneously gave effective methods for chilling wine and water.[46]

He added a good laugh at doctors who taught that the proper volumes of the bodily humors—blood, phlegm, black and yellow bile—are as 18:6:2:1, numbers for which this much can be said, $18 = 2(1+2+6)$ and

27 = 18 + (1+2+6). (In Greek numerology, 18 and 27 have powerful properties.) Still, mathematics is meaningless in medicine. People differ from one another, and an individual requires different things from time to time. Take frogs, for example. Williams advised that they were suitable food only for fools "whose ful feeding and wanton stomacks crave unusual things." And yet, when he inadvertently ate some when traveling in France, they did him no harm.[47] And if they had, the remedy would have been neither harsh nor mathematical if it was Williams's usual medicine for "a mellencholy humor in the stomacke that hart burnes"—namely "[a] good store of smale beer and a good quantitie of salett oyle." This recipe is of particular interest, as it comes from notes on medical recipes that Inigo Jones inscribed in the flyleaves of his copy of Palladio's *Architectura*.[48] It appears that Williams knew Jones and that they probably had friends in common. One possible mutual friend, like them in royal employment, was Cleyn, who may thus have known Williams before he painted him.

Although he pontificated about many things, Bacon was content to leave "particular topics" for others to examine. To assist them he supplied a model set of questions concerning that capital subject of natural philosophy, gravity, and levity. Williams set himself to fill in this template. The task probably occupied him for several years before he wrote out his answers in the clean copy preserved in the British Library. Bacon would not have liked the answers. They followed an authority Bacon did not prize: Galileo.

Williams's approach mingled independence, optimism, and caution. He begins his investigation of falling bodies, in which he was able to quote from Galileo's last work on the subject, published in 1638, with an unexpected prayer: "Give me an emancipated spirit, and judgement, not tied to the profession of one chaire, nor in vassallage to a sect. Let me examine things in the ballance of my reason." And a promise: "If my reason and experiment of the thing joine…Ile conclude I have satisfied my selfe so I suspend my assent noe longer."[49] Williams was jealous of his assent and withheld it in the grand speculation in which Galileo so fully and fatefully committed his. He acknowledged that tradition gave good reasons for supposing the earth to be at the center of the universe and the sun to circle

around it; and that Galileo gave good reasons for supposing the opposite. Not only did he prove that Venus revolves around the sun; he also argued persuasively that Scripture does not rule out the Copernican model. "[But] be it one, bee it t'other that is true (as I thinke neither is reallie) tis al one to mee, soe the apparent motions be exactly calculated by either hypothesis."[50]

Williams hesitated because neither system explained how the planets stay in their orbits. He accepted that exact observation of the course of comets had exploded the ancient system of crystalline shells, which made no sense anyway. The mechanical structure it required would need constant oiling "to supple and grease the axle tree, least by the swift motions al be set on fire."[51] As for the epicycles and eccentrics that expedited calculations in both the old and the new systems, "how they subsist in nature is very questionable." Judging no theory satisfactory, Williams began with common sense, took specific gravity as his guide, and provisionally placed the earth at the hub of the universe. What then supports the planets?

That question returned Williams to the nature of heavy and light. Rarity and tenuity, which are specific-gravity translations of "light," extend to the stars. There is no limit to levity: recent over-exact estimates made the relative density of space and water 1 to 1,553,304,682. Perhaps interesting, certainly useless. Williams preferred gravity and such practical problems as the separation or mixing of wine and water and the retardation of moving objects by resisting media. He approved Galileo's experiments with falling, floating, and projected bodies, motion in a vacuum, beating of pendulums, and flights of artillery shells. He knew Galileo's *Dialogue*, from which he excerpted some philosophy and the information that an object falling freely under Galileo's rule for an hour would traverse 17,280 miles.[52] Williams once had the opportunity to ask the son of Solomon the Galilean question, which of two lead weights, one ten times the other, would fall more swiftly? King Charles replied unhesitatingly, as if he had designed the universe or had studied in Padua, that they would fall together.[53]

We are no further with the question, what holds the planets up? Following Bacon's method, Williams collected phenomena that might be relevant. His

up-to-date examples included the Jesuit Niccolò Cabeo's feat of suspending a magnetized needle between two lodestones for as long as it took to recite four verses in hexameters. Electricity might also be at work, for, as Cabeo and another Jesuit, Athanasius Kircher, had shown, emanations from electrified objects can overcome gravity. Are these the forces that balance the gravity of the planets? They might well be made strong enough in the vast interplanetary spaces if, as Cabeo surmised, here on earth magnetism was once mighty enough to suspend Mohammed's coffin.[54]

Williams withheld judgment about the Copernican system and the circulation of the blood because both pictures lacked essential details. Copernicus did not have the physics needed to run the planets and Harvey could not exhibit the connections between the arteries and the veins needed to return blood to the heart from the extremities. Since Williams believed that future discoveries would advance astronomy and anatomy, he did not doubt that skeptical doctors in the future would be able to assent where he had had to hesitate. In time we will know if the purpose of drawing air into the lungs is to warm or cool the body; whether any creatures can live without respiration; and whether, as some Aristotelians held, goats breathe through their ears.[55]

Williams allowed himself to assent to the proposition that the heart is the "fountaine of native heat." That suggested the classical analogy, which Williams drew from Philolaus the Pythagorean, between the sun in the macrocosm and the heart in the microcosm. Although Williams could not "place fire in the middle of the universe as the center of nature" or identify this fire with solar heat, he accepted that the heart's power and empire did indeed make it function as the body's sun. Therefore, Harvey might well be right. Further judicious inquiries will tell: for the proper way to investigate the body is "to expresse Mechanicallie what is done within us." Perhaps we are no more than manikins, assemblies of wheels put in motion by the heart's heat.

[A] fire placed by some new Prometheus in a hart from whence the arteries and veins branch might diffuse some spirituous vapores; and steame out

its hot parts on one side; and on the other side sucke up matter for it, to nourish it self out of the adjacent parts soe passing and returning forge as wel a perpetual motion in art as in nature.[56]

A speculation wilder than a moon man: a man machine! Williams did think for himself.

Where would the soul dwell in a man who is not a machine? The question did not fall in the domain of doctors of the body, who held that "nature makes things either for necessitie or because 'tis better soe," but of doctors of divinity. Williams did not think much of their methods. "Religious mysteries have heretofore bin veyled for a more awful regard to be had of them." This remark introduces a lecture by Williams on the male reproductive system, whose "naturals soe too might be kept from sight; or the speaker of them covered (as anciently the orators were, when they spoke of Love)." In both cases, public interest and noble minds are best served by anatomy, openness, and naturalization. As a cure for inability to see pudenda for what they are, without mystification or cover up, Williams suggested doing as "the chast Roman matrones who meeting naked men, conceived them only to be statues."[57]

Royal Doctors

The practice of a royal physician-in-ordinary could be exciting. Suspicious Puritans saw political murder in the sudden death of young healthy Henry, Prince of Wales. Perhaps his doctors, suborned by Catholics who feared he would reverse James's Spanish policy did him in. Or perhaps Mayerne, who was the chief of the attending doctors, made a mistake by bleeding the prince against the advice of the others.[58] To defeat the repetition of such charges, Mayerne drew up a protocol for treating royal persons: all the attending physicians must agree in writing to the actions taken; the medicines prescribed must be prepared by the royal apothecary; and no one other than the physicians should administer anything to the patient. Mayerne gave these instructions to James's five other

physicians-in-ordinary when he left England in 1624 for a brief visit to the Continent. He added that James was increasingly prone to the deep depression that he had suffered after the deaths of Prince Henry and Queen Anne. James fell ill during Mayerne's absence. The doctors agreed that he suffered from a tertian fever that did not threaten his life.[59]

Mayerne's colleagues continued to follow his protocol as James's condition worsened. Then Buckingham broke the rule against unauthorized physicking. With his mother's help, he administered a plaster and a cordial to the dying king. Did it matter? The doctors could detect no sign of poison when they opened the body, only blood "wonderfully corrupted with melancholy." Nonetheless conspiracy theorists returned to their earlier insight, although with reversed political polarity: this time the royal person was removed because of fear he might return to a pro-Spanish policy and readmit Gondomar to England. Charles's first parliament examined the charges and decided that Buckingham was at least guilty of an act "[of] transcendent presumption and of dangerous consequence."[60] We know the next step. Charles dismissed parliament and forfeited the grant he needed.

The most famous of royal physicians, William Harvey, had known James almost from the beginning of his reign in England, for Harvey's father-in-law was one of the physicians James brought with him from Scotland. In 1618, around the time Harvey began to lecture publicly on the circulation of the blood, James made him an extraordinary physician royal.[61] Ten years later, Harvey renewed the connection by dedicating the definitive exposition of the theory, *De motu cordis*, to Charles. The dedication plays on the usual parallels among heart, king, and sun. The heart is the sovereign power of animals, "the sun of their microcosm," the king the foundation of his kingdom, "the sun of the world around him." Since a monarch acts, sometimes, according to his heart, he should know how his heart acts; contemplating together "the prime mover of the body of man, and the emblem of [his] own sovereign power."[62] Two years later Charles appointed Harvey one of his physicians in ordinary at the attractive retainer of £300 a year.[63]

Harvey's duties extended to accompanying royal relatives and royal emissaries abroad. From 1630 to 1632 he toured the Continent with Charles's 18-year-old cousin, the Duke of Lennox. It was not a pleasant trip. War had so ravaged the countryside that Harvey could scarcely find a healthy animal to anatomize. In compensation, he had fresh carcasses in abundance whenever he traveled with Charles on royal hunts. In 1636, Harvey was again abroad, keeping Arundel healthy on his hopeless mission to Prague to negotiate a restoration of the Palatinate. Harvey took the occasion to debate with doctors who doubted his theories and to revisit Italy, which he had not seen since earning his medical degree in Padua in 1602.

On the outward journey Arundel picked up an artist to illustrate his progress from Cologne to Prague. This was Wenceslas Hollar, who recommended himself to Arundel not only as a meticulous draftsman but also as a Catholic or proto-Catholic and, what was unusual for an artist, as a gentleman, for he was a son of a knight of the empire.[64] Hollar specialized in designing and engraving street scenes and townscapes, almost always of a peaceful character, even when drawn in the midst of the devastation through which Arundel passed. An account left by one of the earl's party describes burnt and pillaged villages, starved peasants "found dead with grasse in their mouths," gallows with corpses still dangling from them, and a village reduced to coals on which Arundel had his supper cooked. None of this, apart from some peculiarly bloodless executions, did Hollar depict. He returned to England with Arundel to make engravings of items in the earl's picture collection. He again had the opportunity of recording grisly events, such as the torture of the Puritan triumvirs and the execution of Strafford, and again rendered them as if viewed by a robot.[65] His tranquility and exactness made him a good collaborator. When Civil War released Hollar from his copying and Cleyn from his tapestries, they worked together on book illustrations.[66] Hollar could have told Cleyn something about the frontispiece of Galileo's *Dialogue* in the edition shown in our painting, for he had worked with its designer.

Harvey made his side trip to Italy in order to buy paintings for Charles.[67] His shopping was not successful. Having traveled to Italy through a

plague zone, he spent most of his vacation in quarantine tantalizingly close to Venice. When liberated, he went to Rome, where he enjoyed a warm welcome from Cardinal Barberini and a dinner with congenial colleagues at the English College.[68] Perhaps the Jesuits put on a play for him, as they often did for distinguished travelers; he and Arundel sat through several during their excursion to Prague. One of these, staged by students at the Jesuit college there, deserves resurrection for its high compliment and poor prophecy. Neptune has taken Peace to England to escape the wars in Germany, while Ceres, Bacchus, and Apollo bewail their fates under Mars's dominion on the Continent. Neptune discloses that he has also given "the Imperiall government of the sea" to King Charles and that the other gods should apply to him to restore peace to the world. Mercury observes that they need not trouble themselves: Charles's envoy Arundel would soon arrange for Peace's return. That did not happen. Like Harvey, Arundel returned to England with his mission unaccomplished.[69]

Although Charles enjoyed good health, he had at least eighteen doctors, five surgeons, and four apothecaries, who were also available to Henrietta Maria, for whom, in addition, he maintained a midwife and three French physicians.[70] By 1641, Harvey had reached the top of this heap of health-givers as the chief of three physicians designated for "the person of his Ma[jes]tie." The others were Matthew Lister, who had a good record of polishing off Stuarts, having assisted at the deathbeds of Henry, Anna, and James, and Mayerne, who, when relinquishing the primacy to Harvey, gave him the friendly counsel to "take care not to be alone."[71] Among the colorful colleagues on whom Harvey could call for concerted action after Charles set up in Oxford late in 1642 were Edward Greaves, trained at Padua and Leyden, whose brother, John Greaves, was the Savilian professor of astronomy; Walter Charleton, brought up in the new astronomy at Oxford by John Wilkins; and, as reinforcement, a living link to John Dee of Mortlake.[72]

The link was Dee's son Arthur, as good an astrologer as his father and a better alchemist, and formerly physician to Queen Anna. After her death, James dispatched Dee to Russia to answer the Tsar's request for a competent

doctor. Dee got along with his employer but not with some employees of the English Muscovy Company, one of whom, it is said, he tried to murder, most incompetently, with a knife and poison. The charge did not bother King Charles, who invited Dee back to England in 1633, "preferring our deare Father's servants, to the attention of our owne person and our children…and to take away any suspicion that a gentleman of Doctor Dee's merits by his long absence from our presence, should be forgotten by us." Mayerne advised Dee against accepting the royal offer. Long experience had shown him that serving impoverished princes like Charles was slavery. In Russia, he told Dee, you have an exalted position; in England you would be the junior among seven royal physicians, and an irritant to the mob of doctors hoping for similar preferment. Dee decided to enter Charles's service; it left him time for alchemy.[73]

Royal doctors were usually fellows of the Royal College of Physicians, established under Henry VIII with a monopoly to grant licenses to practice medicine in and around London. Fellows of the college examined candidates *viva voce* in Latin to check their ability to consult the dead if not to cure the living. Passing might not result in a license, however, since the college restricted the number of physicians competing within its jurisdiction. Nor did a degree in medicine from a good university, foreign or domestic, guarantee a pass. For example, in 1606 the college refused a Cambridge graduate, Thomas Bonham, a license after testing his Latin; he practiced anyway; the college, acting within powers delegated from the royal prerogative, fined him, and, after additional infractions, jailed him. The episode became a test case: Bonham went to Common Pleas, which found for him by declaring unlawful the college's powers to act as prosecutor, judge, and jury in cases involving its own monopoly. The court held further that the college should not be testing Latinity but detecting quackery; and that even there it did not deserve a monopoly, since any well-educated university graduate knew enough about medicine to expose a charlatan.[74]

Even a royal physician might have trouble obtaining a license. Thus Arthur Dee, who took his degree at Basle, may never have had one, and Mayerne waited until 1616, five years after his arrival in England, for

election to a fellowship. He then entered cheerfully into the spirit of monopoly, joining with others to free apothecaries from the Grocers' Company and charter them under the supervision of the college. The supervision, which extended to the standardization of drugs in the London *Pharmacopoeia* of 1618, tightened in 1624, when a servant used a poison bought from an apothecary to cure all the ills of his master. The college continued to divide and conquer by promoting divorce of the distillers from the apothecaries. Mayerne and another royal doctor, Thomas Candeman, who, though an MD from Padua, had had trouble obtaining his license to practice in London, were the moving spirits in procuring the divorce.[75]

The recusant Candeman entered the queen's service in 1626. One of his jobs was to write certificates of illness to procure the release of sick Catholics from jail. Another was to run a still, a line of work that interested Mayerne as chemist and boozer. Together the royal doctors obtained the patent, mentioned earlier, on a means of obtaining alcohol and vinegar from cider, perry, and, improbably, buckwheat, and led the agitation for the creation of a Company of Distillers of which Mayerne would be Founder, Candeman Master, and the College Overseer. To meet the new company's need for a parallel to the apothecaries' *Pharmacopoeia*, the Founder and Master received a charter from Charles (via Attorney General Bankes) to compile a manual of potable drink. They assembled recipes and avouched, after swallowing hard, their safety and reliability.[76] Naturally they died, though not immediately. Mayerne passed out in 1655. Candeman had gone in 1651, as a senior fellow (an "elect") of the college. His place went to Maurice Williams.[77]

Melancholy

Disease of the Age

Melancholy suffuses our painting, most conspicuously in the pasty face, uncommitted gaze, and listlessness of young John Bankes. The boy was ill. We can infer as much from the sympathetic expression of Dr Williams

in the picture and from the special diet served to John at Oriel.[78] We can also guess that his general complaint was melancholy, the disease of the age, from which, in one form or another, everyone suffered at least occasionally. Medically speaking it arose from either a passing putrefaction of the black bile present, along with the other humors blood, phlegm, and choler, in all of us; or from an innate predominance of the melancholic humor over its companions. Both types could be treated medically, but the second sort, being imposed by nature, could not be cured. That was not altogether bad. Although innate melancholy, if strong enough, caused madness, it might, if muted, produce scholars, statesmen, artists, indeed, according to an opinion long attributed to Aristotle, everyone who has accomplished anything notable.[79] It was said, in explanation of his murder of Buckingham, that John Felton was "a melancholy man much given to reading."[80]

Levels of melancholy parallel degrees of drunkenness: loquacious, eloquent, bold, amorous, reckless, insolent, frenzied, catatonic. During the amorous stage, the wine bibber is "induced to kiss those whom, owing to their appearance or age, no sober person would kiss." Just so, nothing is safe from lovesick melancholics, "who are particularly inclined to sexual intercourse."[81] We may suppose that most Oxford undergraduates suffered from this affliction and that it raged around Christ Church, from which the Doctor of Melancholy, Robert Burton, issued five editions of his *Anatomy* each ending with useful recommendations for deadening lust. And these were not the only handbooks available. The petty canon of Christ Church, Edmund Chilmead, who turned Hues's tract on the globes into English, translated a French treatise that suggested remedies for concupiscence within the reach of the poorest sufferer: bleed your right arm, swallow a little hemlock, bathe your privates in vinegar, take cold baths, go barefoot; drink only water, eat lettuce, coarse bread, lemons; avoid pine nuts, meat, artichokes, carrots, parsnips, ginger, onions, oysters, chestnuts; exercise, study, pray, fast; sleep not on your back or on a soft bed; have nothing to do with plays, masques, or music.[82] If all this does not work, get yourself whipped, have a friend insult your inamorata, and, if all else fails, sleep with her, if you can get your tutor to

agree. To prevent the uneducated from discovering this last resort, Chilmead put the details into Latin.[83]

A disposition to melancholy could be assessed before any symptoms appeared. It was written in the sufferer's stars, not so indelibly as to exclude doctoring, for, as we know, *sapiens dominatur astris* and diseases known to be untreatable brought no fees. The prime celestial agent for melancholy was Saturn, who could signal both the deleterious disease and the touch of genius. As a physical agent he was cold and dry, owing to his distance from the nurturing seats of warmth and moisture, the sun and moon, and he conferred these elemental qualities on native melancholics. But again, because he occupied the highest heaven, between Jupiter and the stars, he could impose genius when he figured favorably in birth charts.[84]

Among the few facts about John Bankes junior that have come down to us are the date, time, and place of his birth. His horoscope, newly cast using the most reliable early modern rules, shows that he must have been, or thought he was, a grand melancholic of the gifted type (Figure 29). Saturn occupies the ascendant, rising just before John's birth, while Mercury

Figure 29 J. L. Heilbron, John Bankes's birth chart.

approaches culmination, shedding his ambiguous rays from the mid-heaven and the sign of Gemini, wherein he has special powers. Mars and Venus are conjoined in Leo in the eleventh house, that of friendship. In short, any apprentice astrologer could see that young John Bankes was a son of Saturn and Mercury and therefore wise, shrewd, thoughtful, prudent, inventive, curious, emulous, covetous, and prone to love melancholy.[85]

Chief among the authorities who influenced English melancholic thought was Marsilio Ficino, who interpreted Plato, Hermes Trismegistus, and other ancient sages at the Platonic Academy in Florence in the later fifteenth century. Like John Bankes junior, Ficino had Saturn in his ascendant and, being scholarly and ambitious, celebrated the cerebral aspects of the Saturnine personality. But Ficino kept in mind the proverb, *sub Saturno nati aut optimi aut pessimi*, "Saturn's natives are the best or the worst," and proposed pleasant treatments against the lapse of genius into mystery, magic, superstition, despair, hallucination, and madness. The pasty bookworm should exercise, diet, listen to music, go for a massage, make talismans that concentrate beneficent rays.[86] The most famous of all depictions of melancholy derives many of its emblems from Ficino's therapies, if, as experts assert, the magic square in Dürer's *Melancholia I* is a talisman to collect the rays of Jupiter (Figure 30). More obviously, the symbols of hard thought and geometrical tools in Dürer's print come from Saturn's cupboard. Dürer made the mathematical element more prominent than Ficino had, thus fusing the paraphernalia of the god of melancholy with those of the muse Geometria (or sometimes Urania), as depicted, to pick a relevant example, in Cleyn's *Seven Liberal Arts* (Figure 31).[87]

The connection between Saturn, melancholy, and the mathematical sciences appears to perfection in the *Melancholia* of Jacques II de Gheyn (Figure 32), whose work Cleyn knew well. The Saturn figure sits on a generalized terrestrial globe with his back to a dramatic scene of mountains, stars, and a crescent moon. He looks not at nature but gazes listlessly toward its model, a small celestial globe, which he cannot see to measure because his cloak obscures the zodiacal sign at which he appears to aim his calipers. Will he shake off his black mood and investigate the cosmos

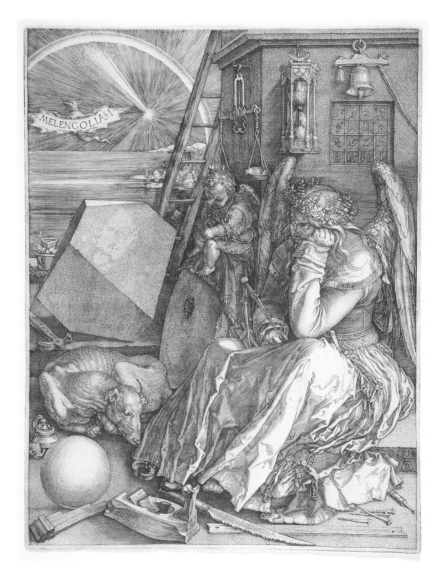

Figure 30 Albrecht Dürer, *Melencolia I* (1514).

or remain stagnant in unprofitable thought? Will he be another *sidereus nuncius* or a terrestrial nincompoop? The writing gives a hint but no certainty: *Atra, animaeque, animique, lues aterrima, bilis | Saepe premit vires ingenii, & genii,* "melancholy, the blackest plague of mind and soul | often overcomes the powers of talent and genius."[88]

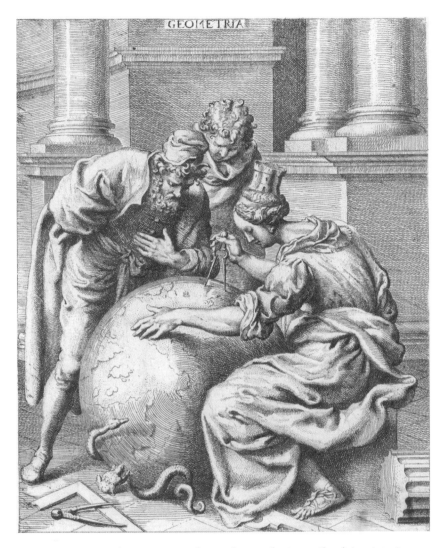

Figure 31 Francis Cleyn, *Geometry*, from Cleyn's *The Seven Liberal Arts* (1646).

Its Doctor

Robert Burton died within a fortnight of the time he had calculated from his geniture. Meanwhile he lived with the knowledge that Saturn was the lord of his birth chart, the source of his mathematics and melancholy. Long experience taught him the pain and perplexity of the gifted sick scholar oscillating between joy and misery, a predicament he set forth in

Figure 32 Jacques II de Gheyn, *Melancholia*, from Gheyn's *The Four Temperaments* (1596/7).

affecting doggerel at the beginning of his *Anatomy*. First the pleasure of idling with his thoughts and books in sweet solitude:

> I'll not change life with any king
> I ravisht am: can the world bring
> More joy than still to laugh and smile
> In pleasant toys time to beguile?
> Do not, O do not trouble me
> So sweet content I feel and see
> All my joys to this are folly
> None so divine as melancholy.

Then the distress of confronting stale ideas, loneliness, and despair:

> I'll change my state with any wretch
> Thou canst from gaol or dunghill fetch
> My pain's past cure, another hell
> I may not in this torment dwell!
> Now desperate I hate my life
> Lend me a halter or a knife
> All my griefs to this are jolly
> Naught so damn'd as melancholy.[89]

Burton began the second and later editions of his *Anatomy* with folly. "Folly, melancholy, madness are but one disease." Democritus of old, supposed deranged by his fellow citizens, proved his sanity to Hippocrates by laughing at the ridiculous scrapes and stupidities of the human race. Were he alive today, in the 1620s, he would guffaw until he collapsed over papal claims, religious wars, lawyers, litigants, and place seekers ("parasites' parasites"), and, by far the worst, unworthy sycophants promoted over "Scholar[s forced to] crouch and creep to an illiterate peasant for a meal's meat."[90] The world is topsy-turvy. "Every silly fellow can square a circle, make perpetual motions, find the philosopher's stone, interpret Apocalypses, make new theories, a new system of the world," while idiots, tyrants, and children reign, and lawyers and doctors proliferate. Not a missed stroke! "[I]t is a manifest sign of a distempered, melancholy state."[91] We have come to this pass because we are lazy, idle, indolent; "we

live solely by tippling-inns and ale-houses," leave menial work to foreigners, fill the countryside with beggars, are governed by imbeciles.[92]

Where shall we find anyone fit to govern? Kings are either anxious and miserable or, if cheerful, irrational. Great men incline to hair-brained schemes; scholars and philosophers to "absurd tenets, prodigies, paradoxes." But then, as Aristotle has it, nothing valuable can be accomplished without a little madness. Let us therefore not despair, for everyone is mad. As evidence whereof, Burton cites an episode from Ariosto's *Orlando furioso* in which Orlando's cousin Astolfo flies to the moon to recover the great knight's wits. There they were, since everything lost on earth ends up on the moon. Great was Astolfo's surprise, however, to stumble over his own wits: he had not noticed that he had lost any. With a little further searching, he discovered large parts of the brains of his fellow half-witted paladins. Galileo, whose power of invention and physical suffering made him an exemplary melancholic, loved the story of Astolfo, which applies to theologians as well as to warriors.[93]

In his despondent moments, Burton thought no one crazier than his fellow scholars, "silly fools, idiots, asses," for giving up everything for knowledge that the rest of the world despised. Most students, seeing how little profit there is in mathematics and philosophy, go into law, medicine, and divinity, swelling the professions with incompetents who make their way among mountebanks and fools; although, to quote the world's opinion again, divinity is contemptible, the law mere wrangling, physicians loathsome, philosophers madmen, schoolmasters drudges. And university dons, Burton's colleagues? They are at the root of the problem. They teach the idiots who enter the professions; they prostitute themselves for fees and "huckstering the word of God."[94] But then, the problems the dons agitate when left to themselves are unprofitable, like the details of astrology and the conundrums of theology—"what fruitless questions about the Trinity, resurrection, election, predestination, reprobation, hell-fire, etc., how many still to be saved, damned!" It is better not to ruin mind and body with the asinine questions of deep study. Strive instead for healthy ignorance, like Americans.[95]

Nonetheless, the cultivated melancholic mind is a wonderful inventor. Just look at Dürer's *Melancholia*, "proud, soft, sottish, or half mad…and yet of a deep reach, excellent apprehension, judicious, wise, and witty." Look to the work of painters, mechanics, and mathematicians. Our greatest challenge is to promote fruitful melancholy. Burton advises diet, good air, exercise, avoidance of all refined products of the "science of cooking," idleness of body or mind, solitude, and "those two main plagues and common dotages of human kind," wine and women. Unfortunately, the delight of a gentle melancholy promoted by abstinence and exercise often turns bitter. It may end in an untreatable depression. Does the wretched incurable have the right to end his life? The ancients approved it, for euthanasia and to escape dishonor; Christian women committed suicide to avoid something worse than death; but the Gospels and the church condemn it. Still, acute, incurable melancholy is a desperate and ghastly affliction. Let us not judge.[96]

Burton deals in detail with two kinds of melancholy that grew luxuriantly in the celibate society of university fellows; one had to do with sex, the other with religion, with "impertinent, needless, idle, and vain ceremonies," gross superstition, "incredible madness and folly," blind zeal, "the worst of all plagues." They have something in common: like love, "superstition makes wise men beasts and fools."[97] But religious fanatics are worse than erotomaniacs. Christmas, adoration, exorcism, indulgences expose the Catholic Church as ridiculous, and Jesuits show it to be dangerous; which, as to stupidity and menace, Puritans equal by their refusal to fast, kneel at communion, or hear music in church; or to allow sports, holidays, bishops, degrees, and universities. Do you require a more persuasive example of doctrinal stupidity? The well-known case of the Jew who fell into a privy on a Saturday should do. None of his co-religionists could fish him out, it being the Sabbath; nor could any Christian on the Sunday; wherefore he died.[98] Toleration is not the way to handle such crackpots: they belong in Bedlam.[99]

More serious religious melancholy surrenders to fear and reaches the depths of the soul. The sufferer feels "a privation of joy, hope, trust,

confidence…the heart is grieved, the conscience wounded, the mind eclipsed with black fumes arising from these perpetual terrors." "Fear of God's judgment and hell-fire drives men to desperation." The usual remedies—long fasts, endless meditation, fear of the afterlife—only worsen the condition. "But the greatest harm of all comes from those thundery ministers" who damn everything, "and so rent, and tear and wound men's consciences, that they are almost mad."[100] The devastating result: "'Tis an epitome of hell." Mental torture often prompts suicide, which, again, Burton does not condemn provided the victim has tried the efficacy of exercise, diet, and abstinence from wine, worry, and women.[101]

Burton works down to love melancholy from the general operations of the universe, from the sympathies and antipathies among animate creatures and the transformations of the four elements, from the attractions implied by gravity and levity, magnetism, and the desires that inspire the sun, moon, and stars to circle around their centers. *Amor mundum fecit*, "love made the world." Men love all sorts of things, gaming, hunting, fame, riches, women, as their temperaments and their stars drive them. Scholars love their books and one another, *mulus mulum scabit*, "as one mule scratches his fellow." If we could only love one another! Alas, we are nasty animals, "our whole life is a perpetual combat, a conflict, a set battle, a snarling fit." Our charity is only vainglory, our philanthropy a bid for salvation.[102]

Love between the sexes derives from the high motives that formed communities. Unfortunately, it has descended into "burning lust, a disease, frenzy, madness, hell," into "that feral melancholy which crucifies the soul" and vexes the body with gout, arthritis, cramps, convulsions, and pox. No doubt, Burton conceded, faithful conjugal love is a treasure; but burning lust after marriage is a disease, a "heroical melancholy" endemic among the parasitic class, the "young, fortunate, rich, high-fed, idle."[103] They cannot help it. "Wine is strong [saith Esedra], kings are strong, but a woman strongest." A beautiful woman, with her paints and perfumes, is a lodestone to undergraduates, and others too. They lose their appetite, cannot sleep, blush, leave their books. Their mistresses

become their *primum mobile*, "they are very slaves, drudges for the time, fools, dizzards, atrabiliarii."[104]

And yet love can put courage in cowards, civility in clowns, mercy in the wicked, religion in unbelievers, subtlety, wit, and elegance in boors. The love-struck fool might learn to sing, dance, play an instrument, write, rhyme. That would be a good thing. "Why are Italians to this day so good poets and painters? Because every man of fashion amongst them has his mistress."[105] *Verbum sapienti*. If you do not want to dabble in plays, poetry, songs, masques, then fast ("a friend of virginity"), abstain from wine, eat lemons and lettuce, travel, slander your beloved, dispraise her looks, take another paramour.[106] As a last resort, you may marry, but not until you have examined your prize minutely, unclothed, from top to toe, in all her moods. For marriage is like to be a bondage, and children mean poverty. Thomas More and Francis Bacon, in their distinctive utopias, offer the same advice, although Bacon recommends that third parties perform the inspection. But better not to marry. Follow the advice of Cardinal Bellarmine, who kept the fair sex at bay with his diet of garlic and water: *melius est scortari et uri quam de voto coelibatus ad nuptias transire*, "it is better for a vowed celibate to go to a whore and be burnt than to marry."[107]

This is not Burton's final word, however. A scholar is not a monk. Perhaps then he should wed? No, if she takes him from his books and ruins his peace. Yes, if, like the wives of Pliny and Cicero, she holds a candle while he reads and writes. Burton ends his long book where he began it, praising and lamenting his situation. "Nothing gives more comfort than solitariness, no solitariness like this thing of a single life." Yet... "God send us all good wives, every man his wish in this kind, and me mine!"[108]

Its world

Halfway through his indecisive review of love melancholy, Burton asks whether dancing is a filthy delight or an honest pastime. He finds for pastime by exploiting the latest news about the universe in extension of an old conceit about cosmic dancing. The sun and moon dance around the earth,

the planets around the sun (the Tychonic system), 33 planetoids around the sun (a Jesuitical account of sunspots), four stars around Jupiter (Galileo's great discovery), and two around Saturn (a misinterpretation of its rings).[109] As to the steps and figures of the dance, Burton admitted uncertainty. That suited his method of give-and-take perfectly. In his opening message, Democritus Junior (as he calls himself) warns his reader not to expect from him "some prodigious tenet, or paradox of the earth's motion, of infinite worlds...in an infinite waste," as Democritus Senior had taught.[110]

That did not keep Burton from discussing the puzzles of the world system, like the cause of the tides, whether from the moon, "as the vulgar hold," or from the earth's motion, "which Galileus, in the fourth dialogue of his System of the World, so eagerly approves and firmly demonstrates;" or (two alternatives rarely satisfied Burton) from the winds, "as some will."[111] Burton prized Galileo for his melancholic brilliance: not only was he a good example himself of the madness of humankind, his observations made clear the cause of our folly. "[I]f it be so that the earth is a moon, then we are also giddy, vertiginous, and lunatic."[112] Among the craziest of us all are the crackpots raised up by Galileo and Copernicus, who have spun "insolent and bold attempts, prodigious paradoxes, and inferences....out of their own Daedalian heads." "[T]he earth is tossed in a blanket amongst them."[113]

The tossing itself was enough to make a melancholic. Those atrabilious weathervanes, the poets, sang what every thinking man knew. John Donne, a self-diagnosed melancholic ("It is my *thoughtfulnesse*, was I not made to *thinke*?"), recognized the senescence of mind and matter.

> [F]reely men confesse that this world's spent
> When in the Planets and Firmament
> They seek so many new...

Yes, the world is exhausted, the seasons more irregular, the sun fainter, human life shorter, than they used to be; the heavens mutate, "new species of wormes, flies, and sicknesses" spawn here below.[114] Also new ideas. William Drummond, sometime poet laureate of Scotland, put the blame

where it belonged: the spinning out of novelties. "Sciences by the diverse Motions of the Globe of the Braine of Man, are become Opiniones, nay Errores, and leave the Imagination in a thousand Labyrinthes." New philosophy moves the earth, strews stars through the ether, puts comets beyond the planets, puts spots on the sun. Where can our spinning heads rest? Where find the least certainty? We do not even know why grass is green and not red. Astronomers may claim to see clearly through their telescopes, but ordinary melancholics see only "Alchemie, vaine Perspective, and decaying Shadowes."[115] Incoherence in the cosmos could only aggravate the disease of the poor melancholics whose black bile enticed them to its study.

Not much poetic imagination was needed to feel depressed by the immense empty space assumed by Copernican astronomers. Suppose with Burton that if the earth is a planet like the moon, and Jupiter and its satellites like the earth, all the bodies in the solar system except the sun should be inhabited. Even if we find these suppositious creatures socially acceptable, we must expect, in keeping with the principle of plenitude, that the ethereal spaces will harbor some unfriendly spirits. Perhaps the stars are suns circled by planets with plentiful accommodation for devils. Do not think that the vast distance to these stars, which Burton reckoned at 170 million miles in a Ptolemaic universe, provides security. A spirit or devil dwelling among the stars could be here in only 65 years (*recte* 194) traveling at 100 miles an hour. More woe to the melancholy![116] And if Copernicus was right, the stars must be at least 170 times 170 million miles distant and have a circumference no smaller than the earth's orbit around the sun. A tenement for an all but infinite plague of demons! The choice of world systems involved problems more difficult than geometry. Balancing the pluses and the minuses, Burton inclined toward Tycho's arrangement but with a rotating earth so as to remove the absurdity of the heavens' turning at a tangential velocity of 44 million miles an hour. Reaching a definitive conclusion lay outside Burton's psychological reach, however, and, he may well have thought, beyond the united intelligence of humankind.[117]

Burton had many books on astronomy and astrology in his personal library and diligently took notes from such authorities as Dee, whose

special sigil, or hieroglyphic monad, he drew on the title pages of some of his books. He carefully cast the nativity of an individual born at 8:44 in the morning of 8 February 1577, at a latitude of 52°30′, that is, of himself, only to confirm, as we know, that the stars announced his austere, sullen, churlish, fearful, solitary, scholarly character. This unhappy geniture may be found on his tombstone in Christ Church together with an epitaph he composed, *Paucis notus, paucioribus ignotus, hic jacet Democritus Junior, cui vitam dedit et mortem, Melancholia,* "here lies Democritus Junior, known to few [as a person], unknown to fewer [as an author], to whom Melancholy gave both life and death."[118]

We must not conclude that melancholics have no fun. In 1606 Burton wrote a play in Latin, *Philosophaster,* revised it in 1615, and staged it at Christ Church two years later. It features Polupragmaticus, a fake academic as cynical as a Jesuit; Pantometer, a measurer of all things, a quack mathematician; Pantomagus, an all-round magician, alchemist, and physician, also a quack; Theanus, a false theologian; Pedanus, a social-climbing grammarian; and Antonius, a freshman corrupted by them all. They assemble to create a new university at the call and cost of the Duke of Andalusia. We learn from Polupragmaticus how to advance in a university: "deceive, boast, & pretend." Counterfeit, plagiarize, dedicate your book to a numbskull, attack an authority, found a new sect. "Dost thou know some silly paradox? Rub up one that's been rejected, or create a new one – earth is shifting, moon and stars are inhabited, & matters of that sort."[119] Antonius enters, stricken with love-melancholy, and sighs, "I know not where to turn me, so am I rack't, miserable, and tortured." His beloved, a harlot, has too great a liking for students; "they give of aught they have, and make love beyond all bounds." They are much better than friars and monks, the experienced Pantomagnus declares, for women having trouble becoming pregnant.[120]

Two true scholars, Polumathes, who knows everything, and Philobiblos, who knows books, arrive at the new university and flush out the charlatans. Philobiblos to Polupragmaticus: "Hast thou beheld old Oxford?" "Aye . . . but I cannot recall having seen any wise men living there." Polumathes, to

a new Master of arts: "What thinketh thou of the new star – is it sublunary, or of the Heavens?" What about Tycho's system? What do you think of Magini's proposal of a universe with eleven heavens, "[w]herein, belike, he offendeth against first principles of mathematics: optics on the one hand, philosophy on t'other. What, then, shall we believe? To what conclusions have you come?" Theanus, the fake theologian, answers for the fake Master of arts: "What's above is naught to us." The play ends with the exposure, branding, and banishment of the philosophasters, and the closing down of all unnecessary taverns. Sir John Bankes tried to realize half of this academic utopia by imposing a warrant for licensing only three pubs in Oxford, "for the preventing the disorders of youth there."[121] He did not succeed.

A Cambridge don peering at Oxford through an "optick glasse" spied many absurdities among the claims of the merry sons of Saturn there. Students working day and night, melancholics meandering from rapturous contemplation to hellish purgatory, scholars elevated because Saturn stands high in the heavens—nonsense all. No doubt, however, Oxonians belonged to Saturn. The plodding progress of the furthest planet in every world system perfectly represented the working habits and scientific attainments of Oxford men.[122]

7

THE PAINTER

Cosmopolitan

Francis Cleyn was so versatile an artist and so little an egoist that the high reputation he enjoyed in his time did not long survive him. Another Titian in the seventeenth century, but a "dull and derivative" eclectic in the twentieth, at best weakly and vaguely imitative of Rubens.[1] The disparagement may result from lack of an adequate account of his wide-ranging work and the destruction of the buildings his paintings, tapestries, and interior designs adorned. Most of his extant output consists of designs for etchings and engravings. Here again his reputation has tumbled. In the seventeenth and eighteenth centuries he was an inventive storyteller who raised the standard of allegorical depiction by an order of magnitude. "He was very eminent for his Invention, and made several Designs, that were extraordinary fine, for Painters, Gravers, Sculptors, etc."[2] In the twentieth century he dropped to an uninspired mechanic, "totally without grace," skilled only in clutter and confusion, "show[ing] no evidence of his considerable experience as a painter and designer."[3]

A revaluation is in progress, however, and Cleyn as illustrator is climbing back toward the height he once shared with Hollar.[4] "Although not an artist of great distinction, he played an important role in introducing more up-to-date and sophisticated motifs into the vocabulary of Caroline decoration."[5] More recently, an eminent authority has praised Cleyn for his "exuberant creativity," "magnificent imagination," and "cornucopia of delights."[6] His allusive style and impressionistic line drawings reminded another modern connoisseur of the mannerist etchings of Parmigianino,

another artist whose reputation has fluttered. Arundel thought very highly of Parmigianino. Galileo judged him to be the best representative of the worst trends in Italian art.[7]

Franz Klein (our Francis Cleyn) was born in 1582 in the prosperous old Hanse city of Rostock. Of his state and education nothing certain is known; but if, as lexicographers suppose, his father worked as a goldsmith, he would have been raised in reasonable comfort and in surroundings preparatory for his multifarious career. A goldsmith's son might learn not only the use of tools but also the attitudes of a skilled artisan. Cleyn was to cooperate easily with others without claiming the precedence his accomplishments merited. One of his friends remarked that he was worthy of "admiracon and encouragement, not onely for the excellency of the work, but for the exemplar, vertues, and indefatigable industry of the workman."[8]

The earliest piece by Cleyn now known is a drawing in brown ink and a little color depicting the story of Acteon. As it dates from his time in Rostock, he must have been young when he drew it. Its size and clumsy composition suggest that it came from an *album amicorum* (the sort of witty academic autograph book that got Wotton into trouble); if it did, Cleyn may have studied at the University of Rostock or known people there, and later evidence also suggests that he had more education than an artisan's.[9] The drawing shows five oddly posed adipose nymphs standing in a shallow bath made of dressed stone incongruously let into a grotto in a hillock. They do not seem to be alarmed at the sight of a man growing the ears and antlers of a stag as he approaches them. However unsatisfactory the drawing, it advertises the inventiveness for which Cleyn would be known. The action continues in the background where Acteon, now completely transformed into a stag by Diana for gazing at her naked nymphs, is ripped to pieces by his dogs.[10] When directed to composing narratives, Cleyn's vigorous imagination would win him his fleeting reputation as "the greatest storyteller in English art."[11]

Cleyn continued his training at the center of painting in northern Europe, the cosmopolitan Netherlands, where he encountered Pieter

Isaacsz, who entered the service of Christian IV not long after the king had returned from his first bibulous visit to England. The palaces and furnishings Christian saw there had fired his competitive spirit. He wanted pictures in quantity, Dutch and Flemish pictures, for the walls of Rosenborg, the palace then being built in Copenhagen. The emissary he sent to the Low Countries bought an acre of paintings, good and bad, sometimes with the advice of Isaacsz, who knew the Danish as well as the Dutch scene. He was born in Denmark, the son of an official who collected tolls from ships passing through the Danish Sound, and inherited the post on his father's death in 1617. To help slake the demands of the royal walls in Copenhagen, Isaacsz would accept as tolls any good Dutch paintings the ships might be carrying.[12]

Alternatively, Christian could buy painters. Cleyn, recruited by Isaacsz, was at work in Denmark by 1611. He thereby acquired a rich and powerful patron, settled close to home (Copenhagen lies 100 miles from Rostock by sea), and took the first step on the journey that would end in England. His course ran through Italy. Like Jacobean collectors, Christian was beginning to appreciate modern Italian painting. Thinking it safer to dispatch a solid Protestant to Italy for finishing than to import a finished Italian, inevitably a knave, Christian sent Cleyn to brave the dangers, and learn the arts, of the peninsula. That took some four years between 1612 and 1617. In Sarpi's Venice, Francesco Clennio met and impressed Wotton; in Paul V's Rome, he mastered the art of grotesque.[13]

Grotesque developed in Italy during the sixteenth century from examples exposed in 1480 during excavation of Nero's infamously extravagant *Domus aurea*. Cleyn met it as wall decoration consisting of ill-assorted objects, animals, and zoomorphs cleverly and incongruously attached by ropes, vines, acanthus leaves, and strapwork. He would later put them in his tapestries, decorative panels, and prints, tying together human and mythological figures, birds of all species, satyrs, centaurs, pergolas, fountains, birdcages, tripods, lamps, candelabras, cornucopias, altars, garlands, a sphinx here, a triton there, putti playing, monkeys swinging, acrobats climbing. The form demanded a wild imagination and

controlled technique and also, because grotesques usually appeared in surrounds and borders, a feel for symmetry and geometry.[14] And also a grasp of the subject matter thus framed. The art theorist Lomazzo defined grotesque as "a secondary language, a gloss on the central discourse," a sort of anti-masque.[15]

A clutch of drawings Cleyn made in Italy and Denmark is preserved in Copenhagen. Some of these seem playful: a shield displaying three inverted violins made for a Dutch family, for example, and a sleeping woman apparently exhausted from the attentions of a satyr. Another drawing makes a story from a collector's visit to a curio shop: he studies the stock while shopkeepers reckon the cost in time and money. The clutch includes items on religious themes, among them a nice torso of Christ and a curious unsigned version of Eve handing the apple to Adam. These items have their modern admirers. The organizers of the Council of Europe's showcase of the age of Christian IV, mounted in 1988, chose the Satyr, the Collector, and the Shield as representative of the royal treasures.[16]

When in Italy Cleyn probably made use of the *laissez-passer* accorded itinerant artists to acquire objects and information of interest to their patrons. If he did, he had much to relay. There was the new hard line Rome had drawn in 1616 through philosophical speculation by banning and indexing Copernican books. That would have interested Christian, who eventually emulated his father's support of Tycho by building an observatory, the Rundetaarn, for Tycho's former assistant Christian Longomontanus. Another hard line would have been of even greater interest to him. Apparently undaunted by the failure of the Venetian interdict, Pope Paul had ambitions to reinvigorate his predecessor's plan to return northern Europe to the Catholic camp. It was not a promising project. Christian had prohibited Catholics from holding public office or private property in Denmark, and in 1617, when he celebrated the centennial of Luther's rebellion, he could declare his kingdom doctrinally pure.[17] Nonetheless, Rome tried again. The hermetic seal remained tight, however. Christian had no Catholic problem, although he sometimes found it useful to pretend that he did.[18]

Cleyn returned to Demark in the year of Luther's centennial to join Isaacsz and a few Dutch and Danish painters in decorating Rosenborg.[19] Since many of the group's paintings do not bear signatures and many others have been lost, Cleyn's total contribution to the improvement of the palace cannot be determined. But, since he had learned to paint anything anywhere, on surfaces of any shape, ceilings, walls, corbels, pendentives, or lunettes, whether serious pictures, indifferent ornamentation, or grotesques, his contribution during his seven or eight years in Copenhagen must have been considerable. Four large paintings for the ceiling of the Great Hall at Rosenborg, authoritatively attributed to Cleyn, have survived. All date from 1619 or 1620.[20] They now decorate the ballroom at Kronborg in Elsinore, the putative home of Hamlet. Together with paintings by Isaacsz and other members of the Rosenborg group, they fill one long wall of a huge whitewashed room otherwise almost empty of ornament.[21] In Cleyn's time a series of forty elaborate tapestries devoted to the doings of 100 kings of Denmark covered the wall.[22]

The Rosenborg paintings presented three series of seven: planets, liberal arts, and ages of man. Some say that in its details the series refers to the rendition of the ages by Longomontanus, who came under the mysterious power of 7 at the University of Rostock, to which he migrated after Christian drove Tycho from Hven.[23] The university's badge and emblem was "7" in recollection of the 7 sets of 7 doors, streets, gates, wharves, turrets, bells, and linden trees the city boasted. Longomontanus eventually obtained a professorship in the University of Copenhagen, where he worked out tables that made the Tychonic system useful and lobbied for building the Rundetaarn. He also squared the circle, justified astrology, fit the world's history into the time allowed by Scripture, and accomplished many other impossible things. An English mathematician who tried to straighten him out received an answer couched in the reasoned language of mathematical discourse: "stupidus, stolidus, cani similis, temerarius, petulans juvenis."[24] Possibly Longomontanus's confident account of the seven ages of the world and their astrological connection with the planets and liberal arts influenced the Rosenborg depictions

of the ages of man. Cleyn had the task of illustrating the first two stages, infancy and boyhood.

"[F]irst the infant muling and puking in his nurse's arms."[25] Cleyn (or perhaps Pieter Isaacsz, to whom it is sometimes credited) preferred to place the baby in its mother's arms and to show a sedate baptism in a Venetian scene modeled on a painting by Tintoretto. In its Danish rendition, an addition to the right has an open arch through which the viewer sees the baptism of Christ (Figure 33), an addition that contrasts the mysterious power of the sacrament with the first helpless stage of life.[26]

> And then the whining schoolboy with his satchel
> And shiny morning face, creeping like snail
> Unwillingly to school.

One of the two paintings Cleyn devoted to the whining schoolboy illustrates the snail's pace of reluctant children clinging to their mothers before starting to climb the steep stairs to the temple of learning (Figure 34). One clings also to a pretzel. Boys already on the steps linger for a last look at liberty on their long, arduous, tranquil climb. The temple stands under a clear sky, while clouds form over a fortified castle on a hill in the background.

The second schoolboy painting, which belonged to the series on the seven liberal arts, shows the interior of a temple, or rather, a factory of grammar (Figure 35). Here the space–time sequence is reversed. The frieze in the apse behind the young teacher on the left shows boys at play. In the middle ground, four young scholars, attentive to a book and the teacher's stick, express a persuasive mixture of puzzlement, effort, and understanding. They also display the knobby knees that seem to be one of Cleyn's trademarks. In the foreground, older boys work at harder texts, while the youngest among them performs before a master whose kindly face balances his raised stick. The master looks inquiringly at and beyond the boy at a proof of his gentle pedagogy, a broken switch lying on the stairs. Behind the group, on a plinth between fluted pillars, the school's library is attractively if inconveniently placed. The few connoisseurs of

Figure 33 Francis Cleyn and/or Pieter Isaacsz, *Baptism* (c.1620).

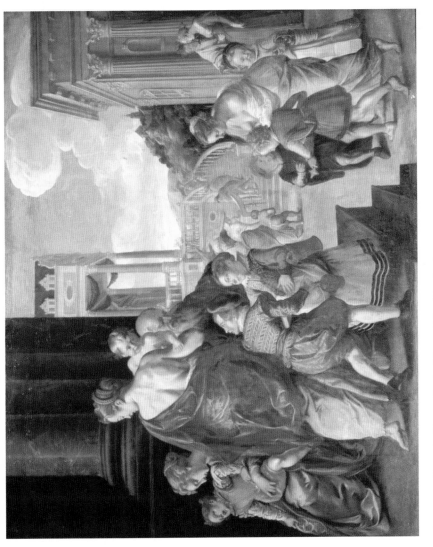

Figure 34 Francis Cleyn, *On the Way to School* (c.1620).

Figure 35 Francis Cleyn, *Interior of a Boys' School* (c.1620).

Cleyn's Danish paintings rate it his best both for composition and for execution.[27] The double portrait of young John Bankes and his tutor refers to a higher level of education, the quadrivium, represented by the liberal and melancholic art of astronomy.

> And then the lover
> Sighing like a furnace, with a woeful ballad
> Made to his Mistriss' eyebrow.

The third Rosenborg painting, *A Wedding* (Figure 36), has the interest that one of Cleyn's schoolboys has escaped into the scene (the head on the far right), that it shows mastery in handling action in several planes, and that the positioning of its three central figures echoes Albrecht Dürer's *Betrothal of the Virgin*.[28] Rubens painted a similar arrangement for Marie de' Medici. The painting has a pronounced Venetian character and a surprisingly Catholic flavor for a commission from a Lutheran king.[29] In the fourth and most unusual of the Cleyn paintings the lady from the *Wedding* witnesses a great display of fireworks over Castel Sant'Angelo in Rome in the company of a gentleman in a turban who does not resemble her husband (Figure 37). The display terrifies almost everyone in the scene—notably, the little black boy, the dog, and the little girl and her mother; only the richly dressed people appear calm. The menacing castle in the background adds to the distress of the spectators, who know that it houses the papal dungeons. Although fireworks might entertain people educated enough to recognize them as artificial and harmless, they could awe and intimidate others. Hence the picture has been construed as a criticism of the display of papal power.[30] In other renditions of the time the Castel Sant'Angelo resembles a squat fire-breathing toad.[31]

Cleyn must have seen at least one of these displays, since they occurred twice a year, on the feast days of Saints Peter and Paul. The fireworks began by burning barrels of tar. Thousands of rockets then leapt into the night sky to shower sprays or *girondele* of shooting stars, torches, dragons, and other intimations of the fires of Hell. They might more readily have

Figure 36 Francis Cleyn, *A Wedding* (c.1620).

Figure 37 Francis Cleyn, *Fireworks at Castel Sant'Angelo, Rome, 1619.*

reminded onlookers of the horrors of war. Large-scale fireworks became court fare in Italy during the sixteenth century as underemployed gunners sought new markets for their talents.[32] Fireworks therefore belong to the fourth age, when a man becomes

> a soldier, full of strange oaths, and bearded like the pard
> Jealous in honour, sudden and quick in quarrel
> Seeking the bubble reputation.

Christian and James delighted in fireworks.

Other pieces by Cleyn survive in situ at Rosenborg. Most of them decorate Christian IV's study: characteristic whimsical grotesques in the embrasures and, in the corners, a little mythology, depictions of Minerva and Juno, of Helen's abduction to Troy and Aeneas' flight from its ruins. The Trojan scenes recur in Cleyn's etchings for Ogilby's edition of Virgil's works. On the ceiling of the study is a copy, perhaps made under Cleyn's supervision, of a scene from Ariosto's *Orlando furioso*. This is a more curious choice for a cabinet of reason than Helen's abduction, since it depicts Orlando's unfaithful girlfriend Angelica in the sort of situation that drove him mad. Galileo made use of the same scene in his *Dialogue* in reference to the maddening problem of the tides.[33] The paintings at Rosenborg and Kronborg by no means represent the full spectrum of Cleyn's work in Denmark. He had the reputation there of a portrait painter, established by his persuasive depiction of his employer (Figure 38). The eyes tell of Christian best qualities, the slight curl of his lip of his worst; a portrait more subtle and insightful than Isaacz's contemporary painting of the same subject in the same pose. A knobby knee in an extant likeness of Christian's son suggests that it too may be Cleyn's. Few if any other Danish portraits by him survive. His portraits in England had a similar fate, apart from the Kingston-Lacy painting, one other, and some rough preliminary sketches.[34]

Whether or not Cleyn's Danish paintings have the quality of "silent poetry," of a "presentation from the soul," as his most knowledgeable modern critic reckons, they attracted the attention of the English ambassador.[35] He was Robert Anstruther, a Scot whose father had served King

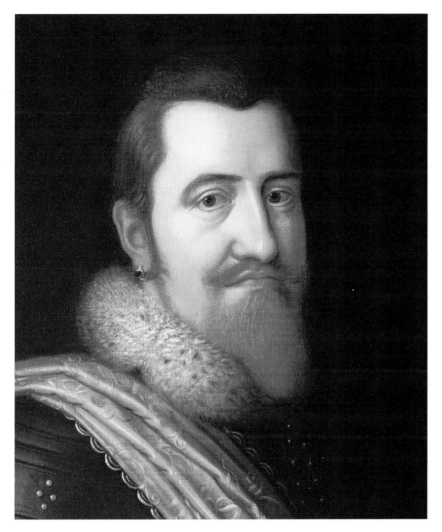

Figure 38 Francis Cleyn, *Christian IV* (*c.*1620).

James, literally served, as the Royal Carver. Anstruther was closer to King Christian even than a carver, as he had been bred in the Danish court and negotiated for as well as with the Danes. The timing of his recommendation of Cleyn to James is intriguing: the mid-1620s, the years in which James was borrowing heavily from Christian and simultaneously trying to enlist him in military action in the Palatinate. Anstruther carried one

installment of interest on the existing loan (£6,000!) to Denmark in 1620 and returned to negotiate another for £30,000 in 1621. Dickering came to a head in 1623 when the emperor transferred the Electoral dignity of the Palatinate from the ousted Frederick to the Duke of Bavaria.[36] Anstruther prepared to return to Denmark to render another interest payment and to discuss Christian's intervention in Germany, for which he required 30,000 men and £180,000 a year.[37]

On his first visit to England in 1623, Cleyn had immediate access to James. Did he bring information about the great matter of the Palatinate? As we know, itinerant artists often served as government agents; Cleyn had a bad example close to home in his Danish–Dutch colleague Isaacsz, who spied continuously for Sweden.[38] Anstruther delayed his trip to Denmark, commissioned at the end of 1623, until the middle of 1624, perhaps because Cleyn had conveyed whatever he had to report to Christian. Cleyn certainly carried at least one such message. It was from King James. It asks that Cleyn, "who has occasion to go over there may have leave to return." The phrasing is suggestive. The ostensible reason for Cleyn's travel to England was not to gather intelligence, however, but to assist in preparations to receive the unrealized Infanta.[39] When he came back to England in 1625, he worked with Inigo Jones on a triumphal arch to welcome the substitute queen, Henrietta Maria. He also designed a new Great Seal for Charles, for which his inventiveness suggested six possibilities.[40] Then came the call to Mortlake.

The tapestry works had been in operation since 1619, when Francis Crane brought over enough Flemish weavers to run eighteen looms. The government of the Spanish Netherlands had regarded tapestry production as prestigious and profitable, even at the standard output of one square yard of standard stuff per weaver per month, and had tried to keep the weavers at home.[41] Crane needed the help of the English agent in Brussels to secure his workers and the approval the Archbishop of Canterbury to guarantee them freedom of worship. The Dutch Reformed Church of London facilitated the business by agreeing to set up a branch in Mortlake. The arrangement worked well under Archbishop Abbot but

faltered under Laud, who rated Dutch Calvinists as no better than Puritans. The Dutch Church outlasted Laud, however, and helped Mortlake survive the Civil War with its orders.[42] Cleyn attended the Anglican church of St Mary, in whose font five of his six children were baptized between 1625 and 1632.[43]

The Mortlake factory occupied a three-story building with a footprint of 1,000 square feet and employed a workforce of 140 or more. Cleyn had a house across the street from the works. Memory of the former proprietor Dee also dwelt in the neighborhood. Many of the locals had known him (he died in 1608) and could point out his house and the garden gate where Queen Elizabeth had once stopped to converse with him. Dee also talked with angels. His conversations with one of them reached print in 1659. The book has a frontispiece by Cleyn on which Dee appears as the last of six "illuminati" running from Mohammed to Paracelsus (see Figure 6).[44] The other five had worked through private revelation, whereas, to the benefit of mankind, the more discursive Dee had preserved his instructions for posterity in the unknown angelic language in which he received it.

Englishman

The early productions of Crane's weavers were uninspired copies of earlier designs made for his chief clients, Charles and Buckingham, while they dallied in Spain.[45] During a respite there, Charles bought the set of scratched and patched cartoons for *The Acts of the Apostles* that Raphael had made for hangings to cover the nakedness of the lower reaches of the Sistine Chapel. Cleyn copied and accommodated them for production. His main apparent qualification was his expertise in grotesque. Purchasers of tapestries typically commissioned distinctive borders bearing their crests and other decorations, which sat well in the elaborate bric-a-brac that Cleyn so readily invented. An excellent example is the festoon of fish and putti around Raphael's rendition of the miraculous catch in the Sea of Galilee, where Christ told his disciples they would be fishers of men (Luke 5:4–10) (Figure 39).[46] Tapestries made from Cleyn's copy came on

Figure 39 Francis Cleyn, *The Miraculous Draught of Fishes*, tapestry after Raphael. (1630s).

the market in the 1630s.[47] The success of his borders, quite superior to earlier ones, gained him ongoing employment at a salary of £100 a year. He became a citizen. His salary in 1637, £200, acknowledged his merit, as it equaled the pension promised, but not paid, to Van Dyck.[48] Cleyn's artistry at Mortlake also put him on a par with Van Dyck, who had worked on tapestry design under Rubens. Some critics impressed by great names have mistakenly assigned some of Cleyn's best designs to Rubens's student.[49]

Cleyn enjoyed so high a salary because tapestries were more expensive and, in the cold, more useful, than paintings.[50] Queen Anna had worried that Princess Elizabeth would have to live in a drafty palace in Heidelberg, "without enough tapestry to cover the bare walls." Elizabeth showed her suitor what her mother expected by embellishing the rooms in which she received him with new tapestries, and Anna made sure that the hall built for the wedding feast boasted many valuable hangings, some borrowed for the occasion. Frederick did not need the hints. The collection of the palatine Elector, built up over a century and more, contained 500 pieces. Still, a wedding gift of sixteen tapestries from the Dutch States General was welcome.[51] As an indication of their comparative cost, Charles owed Crane £6,000 for tapestries in 1625, and £12,500 in 1629; whereas he had paid only £300 for the Raphael cartoons and spent less on a full-length portrait by Van Dyck. Charles repaid Crane in part with an estate of 500 acres, on which, with the help of Jones and Cleyn, a Palladian villa rose, no doubt warmed within by hangings from Mortlake.[52]

During the reign of Crane and Cleyn, tapestries made in England rivaled the best in Europe in their artistry, and surpassed them in their main ingredient, the finest, native-grown, Cotswold wool. Their excellence, according to French experts, consisted not only in richness of borders and colors, and quality of wool, but also in the weavers' attention to detail. One of them specialized in faces and another in carnations, "modeling them with three tones of pink merging with one another."[53] As a mark of special favor, Charles would give a foreign ambassador a suite of Mortlake tapestries as a parting gift—thus, to the French ambassador in 1630, six hangings, to the Spanish, in 1631, the same, each set valued at £3,000. The

standard gift for departing ambassadors was silver plate nominally worth £800, but usually clipped to no more than £600 by the frugal Master of the Jewels.[54] One of Conn's assignments in England was to acquire a set of the Acts of the Apostles for his patron Cardinal Barberini.[55]

The earliest set of tapestries that Cleyn designed portrayed the story of *Love and Folly* in five pieces. Only drawings survive. If, as supposed, they date from the time of Charles's wedding in 1625, their elegant representation of a blind cupid guided by Folly made an excellent symbol, or forecast, of his later relationship with Henrietta Maria.[56] The main Mortlake output to Cleyn's original designs before the Civil War comprised three sets: *The Five Senses* and *Hero and Leander* in the 1620s, and *Noble Horses*, completed in the mid-1630s.[57] Of the three, Cleyn's friend Norgate preferred the mythological, for good reason:

> These six rare peeces of the story of Hero and Leander, all within excellent Landscape of Sestos, and Abydos, the Hellespont, Temple of Venus, etc. which by him done in water colours to the Life, were wrought in rich Tapestry, in silk and gold, with bordures and Compartments in Chiar oscuro of the same hand alluding to the story.

Lyme Park, a National Trust Property in Cheshire, has the first three pieces (*Meeting in the Temple, First Swim, Arrival at Hero's Tower*); the Victoria and Albert Museum in London the last (*The Death of Leander*).[58] The tale of Hero, a priestess of Aphrodite in Sestus, and Leander, a lad from Abydos who swam the Dardanelles to visit her at night, does not end well. One evening the light she lit to guide him failed; he drowned; and she threw herself from her tower into the sea, the pair thus making an unhappy emblem of the four elements, "Both robbed of air, we both lie in one ground | Both whom one fire had burnt, one water drowned."[59] A modern critic judges the series to be "a rather clumsy echo of Paolo Veronese," an assessment in disagreement with that of contemporaries who praised Cleyn's "excellent designes for thos rare Tapestry works, wrought at Moretlake."[60] Certainly Cleyn's handling of the first meeting of the lovers at *The Temple of Venus* (Figure 40) successfully conveys pity as

Figure 40 Francis Cleyn, *Meeting at the Temple*, tapestry from the series *Hero and Leander* (1630s).

well as expectation, as in the double portrait at Kingston Lacy, and his scenes of Leander in the water have the verisimilitude of the swimming manual he consulted.

The story was popular. King James had written himself into it in a poem he composed during the storm he braved to fetch his Danish princess. Charles liked it too, especially as told by Christopher Marlowe and set to music, in 1628, by Lanier. Naturally so popular and saccharine a subject invited parody. Ben Jonson fell to it. He replaced Leander by a fuller's son, Hero by a hussy, the Hellespont by the Thames, and Venus' temple by a puddle. There they met:

> Now as he is beating, to make the Dye take the fuller
> Who chances to come by, but Fair Hero, in a Sculler
> And seeing Leander's naked Leg, and goodly Calf
> Cast at him from the Boat a Sheeps Eye and a half."

Here is Marlowe's version of their meeting:

> He kneel'd, but unto her devoutly prayed
> Chast Hero to herself thus softly said
> "Were I the saint hee worships, I would heare him"
> And, as shee spake those words, came somewhat nere him.[61]

For inspiration for his other series, Cleyn turned to Aesop (the borders of *The Senses*) and Ovid (the subject matter of *Noble Horses*).[62] *The Senses*, "the most magnificent products of the [Mortlake] workshop at its height," survives in England only in a single set, at Haddon Hall in Derbyshire.[63] Charles probably commissioned it, as the bottom border displays four crossed scepters under the optimistic slogan *sceptra favent artes*, "royal rule favors the arts." The overall design is arresting: against a creamy background filled with animals symbolic of the senses and elaborate grotesques, sit, centered, the ladies of the senses, done in a red chiaroscuro highlighted with gold thread. Roundels on the vertical borders depict scenes from Aesop.

Cleyn followed a Renaissance innovation, stimulated perhaps by the publication of Aristotle's *De sensu*, of representing the senses by female figures. The animals traditionally associated with the senses (lynx or eagle with sight, mole or deer with hearing, vulture or dog with smell, monkey with taste, and spider or tortoise with touch) either disappear or share the stage with the ladies. Cleyn avoided the obvious cliché of replacing the animals with cavaliers better suited to help the personifications indulge their senses.[64] In his rendition, each lady holds an object able to excite her special sense and has *angellini* in attendance who extend the possibilities. Thus *Sight* (*visus*) admires herself in a mirror while her putti hold up a pair of spectacles and peer through a telescope—this last by then being an old association, occurring as early as 1616, in José de Ribera's cycle of the senses.[65]

After *Vision* comes, in the Aristotelian order, *Hearing* (*auditus*), whom Cleyn pictured strumming a lute that charms animals while a pair of *angellini* try to play bagpipes; *Smell* (*odor*), busy only with the sweet scent of flowers; *Taste* (*gustus*), eating fruit from a bulging bowl as her *angellini* empty cornucopias; and *Touch* (*tactus*), submitting to a bird's peck and resting her foot on a traditional tortoise as her *angellini* prick themselves with thorns. The same company reappear in a set of etchings Cleyn did for less exalted patrons when Civil War reduced work at Mortlake (Figure 41ab).[66] There may be more in *The Senses* than meets the eye if they relate to the Aristotelian ranking as moralized in the Renaissance. Aristotle had privileged sight and hearing for their superior ability to instruct intelligent animals like philosophers. Smelling, tasting, and touching, which inform by direct contact, necessarily bring in less information. Thus the hierarchy identified sight with Platonic, and touch with ordinary lust.[67]

Cleyn's work at Mortlake included cartoons made from paintings by other artists—for example, Titian's *Supper at Emmaus* and Van Dyck's portrait of himself and Endymion Porter, both of which exist as tapestries, at St Johns College, Oxford, and at Knole House (National Trust) in Kent, respectively. Other Cleyn cartoons scaled up depictions of satyrs and puttini by Polidoro da Caravaggio that became popular during the

Figure 41a Francis Cleyn, *Quinque sensuum* (1646), Title Page, *Vision*, and *Hearing*.

Figure 41b Francis Cleyn, *Quinque sensuum* (1646), *Smell, Taste,* and *Touch.*

reign of the great satyr Charles II. What were perhaps Cleyn's last designs produced at Mortlake, *The Hunters' Chase*, commemorated the favorite illiberal pastime of the early Stuarts. One surviving piece, *The Evening Entertainment*, has Cleyn's usual multiplicity of activity: in the foreground, an elaborately dressed couple dance on uneven ground accompanied by three musicians and a torch bearer; in the background, a woman prepares to bowl down ninepins so close she can hardly miss them, while another woman helps a hunter overcome by the good cheer at the hunters' dinner.[68]

There is no complete set of *Noble Horses* anywhere in Britain. The sole surviving member now known certainly to have come from Mortlake shows Perseus rescuing Andromeda (Figure 42). Its vigor and liveliness suggest the appeal the entire set would have had for a first-class cavalier and connoisseur.[69] Such a person was William Cavendish, with whose circle of philosophers we are acquainted. His other main interests were horsemanship, which produced magnificent stables and riding schools at Welbeck and Bolsover, and womanizing, which left some traces in paintings done for the Bolsover folly.[70] Of this latter pastime his indulgent philosophical second wife, Margaret, Duchess of Newcastle, wrote: "I know him not addicted to any manner of Vice except that he has been a great lover and admirer of the Female Sex; which, whether it be so great a crime as to condemn him for it, I'le leave to the judgment of young gallants and beautiful ladies."[71]

Cavendish also had a taste for art awakened when he accompanied Wotton to Turin when the ambassador tried to negotiate marriage between Savoy and England. Young Cavendish took to the Italian style and returned to Welbeck with some pictures.[72] It may well be that Cavendish commissioned some paintings from Cleyn for Bolsover during the early 1630s: an old account credits him with decorating several rooms, and a more recent one repeats it.[73] Cavendish would have needed good fast-working artists like Cleyn to make Welbeck and Bolsover fit to receive the king and queen as they made their way from London to Edinburgh in 1633 and 1635.[74]

Figure 42 Francis Cleyn, *Perseus and Andromeda*, tapestry, from the series *The Horses* (1630s).

William welcomed guests at the folly, or "Little Castle," at Bolsover in an anteroom that challenged them with ingenious pictorial messages encoded in lunettes above the wall paneling. The messages are consistent with Cleyn's wit and style. One depicts a fisherman and his wife selling their wares; another, a red-faced warrior and his girlfriend; a third, a lecherous mature man proffering jewels to a bare-breasted young woman; and, on the fourth wall, a sea and a temple without a human figure. No doubt a puzzle! As a hint to a solution, William stood in front of the empty scene, thereby completing what an astute viewer might identify as representations of the four humors. The fishmongers stand for the watery or phlegmatic humor; the worked-up soldier, the choleric; the display of exchangeable

goods, the melancholic; and William, hale and hearty, the sanguine.[75] The unexpected presence of the open book and celestial globe in the reception room of the half-dressed lady exposes her as a courtesan of Venetian attainments (Figure 43). These props also suggest the broad scientific interests of the Cavendish circle, which willingly studied everything from moons to mites with the help of Galileo's "multiplying glasses."[76]

If Cleyn did not paint at Bolsover, it was not because he disdained painting houses. He often moonlighted as an interior decorator. He helped Jones with Henrietta Maria's establishment at Somerset House, the most sensitive and difficult parts of it, her closet and her chapel. Of the closet we know that the ceiling boasted "a faire skie," sunnier than the real one, and personifications of art, architecture, painting, music, and poetry, and also a wall frieze in the grotesque style, "all done by [Cleyn's] own invention, *con studio, diligenza, e amore*."[77] (Wotton informs us that diligenza, studio, and amore designated an ascending scale of workmanship.[78]) As for the chapel, it was a perfect mix of art and politics. Its beauty surprised the chief of the queen's Capuchins. "The architect, who is one of those Puritans, or rather people without religion, worked unwillingly, however with the help of God [and Cleyn!] ... this building has been completed, and is more beautiful, larger and grander than one could have hoped for."[79] It is said that when Francis Windebank saw it, he declared himself openly a non-Roman Catholic.[80] Somerset House and Jones's chapel perished toward the end of the eighteenth century to make way for today's Somerset House.

The best documented of Cleyn's surviving decorative work in stately homes is in Ham House, a villa close to Mortlake. He painted there during the 1630s for its owner, William Murray, who had been Charles I's whipping boy. Against the odds—a whipping boy received the punishments earned by the prince he served—William and Charles became good friends. William was with Charles in Madrid and returned, like the prince, enthusiastic about Titian. A nice copy of Titian's rendition of Acteon approaching the nymphs decorates the stairway in Ham House. Cleyn did not handle this conspicuous and seductive subject of his youth but rather decorated the more intimate and sedate space of Murray's study or "Green

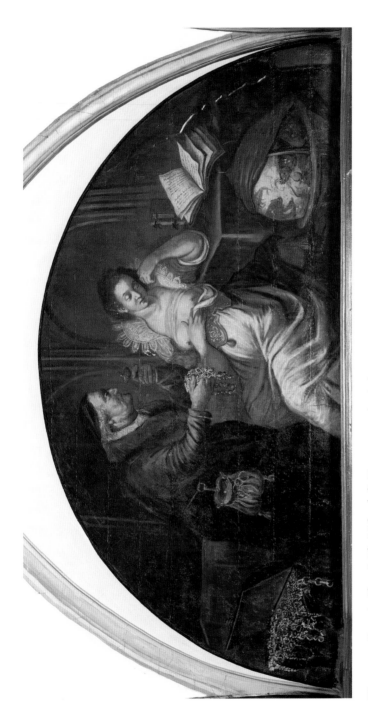

Figure 43 Francis Cleyn?, *The Melancholic Temperament* (c.1635).

Closet." He made use of the same pictures by Polidoro da Caravaggio that he had adapted to tapestry, and the same technique he used for his cartoons, to improve the closet's coves. It is likely that he did much more, probably a part of a drawing room, a balustrade, over-doors and overmantels, other bits in an Italianate manner, and some chairs. He may have supervised the entire project.[81]

Cleyn the decorator was soon in demand among people with big houses needing embellishment. He worked in Holland House, Wimbledon House, Carew House (Parson's Green), and Stoke Park, Crane's country seat in Northampton.[82] Perhaps he worked at Corfe Castle. Bankes knew about Cleyn and Mortlake by the time he was improving his Dorset home, if not earlier. For, in 1638, two years after he had bought Corfe, he drew up the contract by which Charles acquired the Mortlake operations and responsibility for the salaries of Cleyn and the rest of the staff, £250 for Cleyn and his assistant ("the painter and his man"), and £2,000 for six Flemish weavers and their supplies.[83] The weavers agreed to provide, *con diligenza*, 250 ells of tapestry at £2⅝ each; *con studio*, 200 at £3¼; and *con amore*, 150 at £4¼, give or take sixpence.[84] Although no evidence supports (or negates) the conjecture, Sir John might have obtained the help of the all-around artist Cleyn in redecorating Corfe Castle *con amore*.

Book Illustrator

"The mother of every ingenious concept," as we learn from the ex-Jesuit Emanuele Tesauro, as persuasive as a preacher as he was undisciplined as a priest, is *argutezza*, or wittiness: "in so far as a work is not animated by wit, it is dead." Tesauro showed his wit, and his connection with his times, by aiming what he called "the telescope of Aristotle"—that is, the principles of rhetoric, at the arts. In the case of painting, *argutezza* appears primarily in the choice of apt symbols, like those on the frontispiece of *Il cannochiale aristotelico* (Figure 44).[85] We see Lady Rhetoric ill-advisedly looking though a telescope pointed at the sun and supported at one end by a bearded figure

Figure 44 Emanuele Tesauro, *Cannochiale aristotelico* (1664), frontispiece.

named Aristotle. Around Rhetoric are symbols of the arts and some dis-used implements of war. Opposite her another lady paints in the difficult and witty style of anamorphosis, in which the image can only be unscram-bled by looking from a special point of view; here, by reflection in the cone, the viewer reads "omnis in unum," the whole grasped as one, the economical essence of wit. The banner at the top of the telescope reads *Egregio in corpore*, which all good rhetoricians would have recognized as a compaction of Horace, *Egregio inspersos reprehendas corpore naevos*, "you find fault with scattered blemishes on an otherwise spotless body," referring at the same time to the solar spots detected by Galileo and the subtlety of rhetorical inference.[86] The blemish that caused Tesauro's break with the Jesuits is worth recording. He and a confrère had disputed in print over whether the Emperor Augustus' rising sign was Virgo or Capricorn.

Invention required more than draftsmanship, more even than clever-ness: it also required learning of the sort, if not the degree, that painters' patrons shared. Renaissance and early modern handbooks of art recom-mend that painters acquire a fund of general knowledge, "as learned as possible in all the liberal arts," and, especially, geometry.[87] Cleyn had at his disposal a repertoire of standard symbols and examples of their success-ful deployment, and also a miscellany of learning picked up in his wide travels. And, if he was the "D. Clenius" (the Latin form of his name) con-nected with Isleworth in Middlesex (which is close to Mortlake) in 1639, he had some connection with the circle around Selden and Cotton. In any case, he devised a coat of arms for Selden to decorate the printing of a Renaissance manuscript on heraldry Selden owned. The shield features swans, which, as Selden's friend Spelman explained, referred not only to singers and persons with long necks, but also, which would suit Selden better, brilliant minds.[88]

Sandys and Ovid

When frontispieces and illustrated title pages first came to England around 1550, they were straightforward indications of a book's subject; by

Cleyn's time, many had become so elaborate as to require explanations themselves.[89] Cleyn made his literary debut as the designer of very intricate frontispieces for one of the great coffee-table books of his time, a translation of Ovid's *Metamorphoses* published in 1632, the same year as Galileo's *Dialogue*. The translator was George Sandys, brother of that Edwin Sandys whose pacific *Relation* (1605) had impressed Wotton and Sarpi and whose performance in parliament had irritated King James. George Sandys transmuted the family back into favor by dedicating his work to King Charles with a witty invocation of the ancient gods and a play with stars worthy of Galileo.

> Those old Heroes with their Heroines
> Who spangled all the firmament with Signes
> Shut out succeeding worthies; scarce could spare
> A little roome for *Berenices* Haire.

Latecomers like Caesar had to be content with a comet. No matter, the rising sun wipes them out, "Their lights prov'd erring Fiers, their influence vaine I And nothing but their empty names remaine." No such fate awaited divine and humble Charles, no association with planets shining by reflected light or stars extinguished by the sun, but rather a reserved and deserved heavenly throne.[90]

Like his brother Edwin, George Sandys was Oxford educated, well traveled, and uncommonly tolerant. His first important literary work, his *Relation* (1615) of a trip to Jerusalem, elaborates the distinction his brother drew between indifferent and core religious beliefs. In the Holy City, surrounded by Turks who had no interest in their adiaphora, the many Christian confessions, including Roman Catholics, got along well enough; in Jerusalem, their differences paled before their common commitment to Christ. Understood as an expansive military power, however, the Roman Church was no better than the Turks. At home, the Sandys brothers championed a mixed constitution of prerogatives and liberties and remained partisans of parliament until financial interests moved them kingward. Edwin Sandys supported Charles and Buckingham in

their anti-Spanish policy, and George became a gentleman of Charles's Privy Chamber. Their ways to these positions ran through the Virginia Company.[91]

As a director of the company, Edwin wanted war with Spain to open trade in the New World. George's politics went hawkish around the same time, during a stint as resident treasurer of the Virginia colony. In 1622, a year after his arrival, the Indians massacred the colonists. That overstretched his tolerance, and he metamorphosed into a leader of reprisal raids. He spent the little leisure his office left him with Ovid, the ancient world's authority on transformations, and returned to England to see his full translation of the poet's *Metamorphoses* through the press. Then he exchanged the dangers of America for those of Charles's Privy Chamber without, however, diminishing his regard for parliament, in which three of his brothers and his cousin Dudley Digges served. With the Personal Rule, he had no sympathy. He regarded it as a move toward despotism and made some futile efforts to arrest it.[92]

Meanwhile he was busy with a new edition of the *Metamorphoses* enriched by notes raked in from all antiquity and illustrations, one for each book, depicting the major stories it contained. This last task called for skill at storytelling. Sandys called on Cleyn for sixteen compact frontispieces—one for the volume as a whole and one for each book—to complement his 13,210 lines of economical poetry.[93] Sandys praised Cleyn's drawings as so many illustrations of the adage, *ut poesis pictura*, poetry is like painting, or vice versa.

> I have contracted the substance of every Booke into as many Figures (by the hand of a rare Workman, and as rarely performed, if our judgment may be led by theirs, who are Masters among us in their Facultie) since there is between Poetry and Picture so great a congruitie...Both daughters of the Imagination, both busied in the imitation of nature, or transcending it for the better with equall Libertie.[94]

Cleyn's frontispiece to Sandy's work presents personifications of four elements (Jove and Juno with salamander and peacock above, Ceres and

Neptune with cornucopia and trident below), from which, we read, "everything is made" in accordance "with love and wisdom." As witnesses to this truth, Cleyn added figures of Venus and Minerva: "Fire, Aire, Earth, Water, all Opposites | That strive in Chaos, powerfull Love unites." At the bottom a shield displays a metamorphosis under the learned tag, *Affixit humo divinae particulam aurae*, which, in its Horatian context, signifies that a body loaded down with the sins of the past carries the mind with it, and so "fixes to the ground a bit of divine substance."[95] Sandys explains the connection: Minerva has stocked our minds with all the heroic virtues needed for fame and glory. "But who foresake that faire *Intelligence* | To follow *Passion*, and voluptuous *Sense*," these "themselves deform...and are held for beasts."[96]

A good example of Cleyn's storytelling is his frontispiece to Ovid's third book (Figure 45). We meet Acteon again, also naked Diana, and a representative nymph and dog, all squeezed into the lower left corner. To Acteon's right, Narcissus gazes lovingly into a reflecting pool, and, in counterpoint, the hideous dragon slain by Cadmus shuffles off its mortal coil. Cadmus sights Minerva, who, in contrast to Diana, is clothed and armed; she advises him to sow the dragon's teeth, from which, once planted, armed men sprout up fighting, like newborn hyenas. In fast-track evolution, the winners of this infantile combat become Cadmus's close companions. Above the fighters, two episodes from the life of Bacchus continue the unpleasantness. The lady in the burning palace is his mother, thus suffering for her wish to enjoy Jove's favors in as ardent a manner as Juno. She is pregnant with Bacchus, whom, as everyone knows, Jove removed, sewed into his thigh, and carried to term. In the second episode, a ship picks up young Bacchus, wandering precociously tipsy along the shore. Where does he want to go? "Wine-growing Naxos." The crew tries to row off in another direction. Ivy fouls their oars and stays the ship, and the terrified men, some turned to fish, jump into the sea. To the left of the dragon-seed warriors Cleyn depicts the seer Tiresias engaged in the research necessary to answer the question raised by Jove and Juno, whether male or female gets the greater pleasure from intercourse.

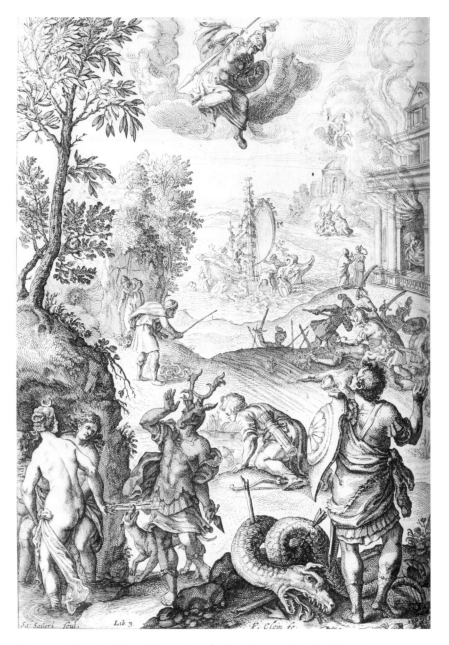

Figure 45 Francis Cleyn, illustration for Sandys' *Ovid*, book III (1632).

Teresias found that by uncoiling certain snakes he could change sex. Having thus acquired both male and female experience (not shown), he decided for Jove's contention that females have more fun. Galen had arrived at the same conclusion by reason: the advantage goes to females as compensation for the pain of childbirth.[97]

Cleyn's familiarity with Ovid may have inspired the subjects of *Noble Horses*. The vivid *Perseus and Andromeda* has the same sea monster as his illustration for book IV of *Metamorphoses*—which correctly has Perseus flying to the maiden's rescue on his own wings, strapped to his ankles, not on a flying horse. And we have the same "Andromeda, freed from her chaines | The cause and recompense of all his paines." The story of Niobe inspired a scene of vigorous but useless galloping. Niobe had claimed precedence over the mother of Apollo and Diana, in both status and beauty, and boasted of being mother to seven strong sons and seven lovely daughters. To punish her effrontery, the gods slew her sons as they tried to evade the divine arrows, and then the daughters as they watched their brothers fall. One of the horses and riders from Cleyn's illustration to Ovid's sixth book made it into his tapestry. Since both stories tell of punishment for impudence and arrogance, they had some relevance to the Caroline court. Andromeda's mother's excessive vanity caused many evils; to cure them, the gentle gods required the sacrifice of Andromeda; being innocent, however, the girl escaped. But Niobe, having only herself to blame, suffered cruelly and was turned into a weeping stone. Sandys lets Niobe draw the moral:

> Who proudly reigns in Princely towers
> Nor feare the easy-changing powers
> But too much trust their happy state
> My change behold: for never fate
> Produc't a greater Monument
> Of slippery height, and pride's descent.[98]

A subtler Ovidian omen advertises the sad outcome in the first of Cleyn's tapestries on Hero and Leander: two kingfishers seen above the

water between Hero's tower and the temple in which the lovers meet. These birds reminded the well-read of the fate of King Ceyx and his wife, Alcyone, whom the "compassionate gods" turned to birds after drowning the king and encouraging his queen to drown herself. The passages describing the storm at sea that killed Ceyx are among the most riveting in Sandys's translation. Cleyn did not include the storm in his illustration for book XI of the *Metamorphoses*, but only the birds that it indirectly bred. Although Ovid does not say so, the myth, like Niobe's, describes chastisement for hubris. The royal pair, who in their devotion to one another outdid Charles and Henrietta Maria, had the bad habit of referring to themselves as Zeus and Hera. The real Zeus, annoyed at their lèse-majesté, threw a thunderbolt at the ship carrying Ceyx. Hera took further revenge by informing Alcyone of the event, and so inspired her suicide. In contrition and partial compensation, the gods turned the faithful pair into kingfishers, which, as Sandys informs us, breed only when there is no wind or storm, "on halcyon days."[99]

It would be wrong to leave Ovid without a word about Pythagoras, whose life and opinions occupy most of the last book of *Metamorphoses*. Cleyn begins his presentation of the details with a transformation of black into white (Figure 46, lower left corner). Hercules accomplished this feat, now commonplace among politicians, to rescue one Mycilus, whom he had chosen to found the city of Croton. Mycilus' fellow citizens tried to condemn him to death for leaving home, but Hercules transformed the black balls they cast into white. Near his new town, Mycilus discovered another émigré, the Samian Pythagoras, depicted lecturing (Figure 46, bottom right). He is preaching metempsychosis and its implication vegetarianism (you would not want to eat an ox who might be your late brother). To exemplify the transmigration of souls, Pythagoras reels off many credible metamorphoses, several of which Cleyn illustrated. One is the tree grown from Romulus' spear, which flourishes above Pythagoras. The active middle ground depicts the story of Hippolytus, who, being unable to control his horses when they sighted an ocean-going bull, was dragged by his chariot and ground into a thousand unrecognizable pieces.

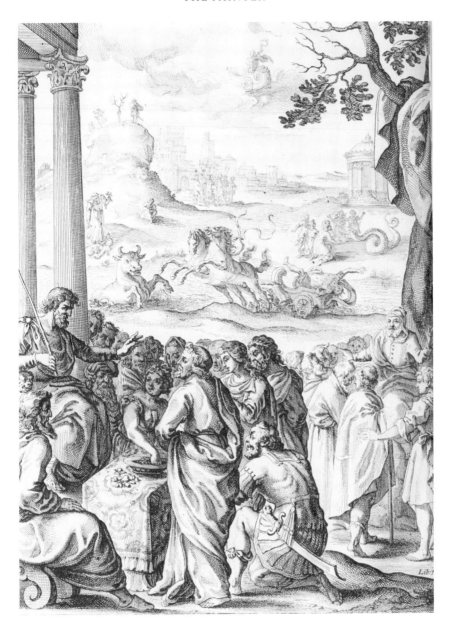

Figure 46 Francis Cleyn, illustration for Sandys' *Ovid*, book XV (1632).

Nonetheless the great doctor Aesculapius, Apollo's son, put him back together, and Diana transformed him into a lesser god. The serpent beneath the temple in the upper right is an incarnation of Apollo, come to reinvigorate his cult. In the sky above, Cleyn shows the transformation of Julius Caesar into a comet.

One reason Ovid gives for Caesar's elevation was his conquest of Britain. To this Sandys remarks that the conquered were in fact the gainers, "having got thereby civility and letters, for a hardly won, nor a long detained domination."[100] Indeed, no polity, no religion, nothing, long endures. "What was before, is not, what was not is | All in a moment change from that to this." Earth rarifies to water, water to air, and air to fire, which, on condensing, returns to air, to water, and to earth. And so it is with humans.

> *Helen* cry'd
> When shee beheld her wrinkles in her Glasse
> And asks herselfe, why she twice ravisht was.

On further reflection, Ovid discovered an exception to the change and tribulation here below.

> For, where-so-ere the Roman Eagles spread
> Their conquering wings, I shall of all be read
> And if we Poets true presages give
> I, in my fame eternally shall live.[101]

Cleyn and Sandys strove to keep this hope alive.

One way to do so was to update the poet's cosmology. Ovid had believed the heavens incorruptible; "late observations have proved the contrary." The moon is just a big rock, "[as] discovered by Galileo's Glasses." Parallax has driven comets above the moon, violating "the virgin purity of *Aristotle*'s quintessence." Despite their great distance, they act on us, indirectly, by drying the air, and on Sandys, by giving him material on which to expatiate. He touches on Caesar's comet, which

brings him to Caesar's calendar, and then to Gregory's; he piles on factoids like another Bacon, to whom he awards "the Crowne of the modernes." The story of Phaeton inspires an explanation of the ecliptic, the seasonal change of daylight, the duration of dawn and twilight, and the habits of Venus, who is as changeable as the moon, "as found out by the new perspectives." "The new refiners of astronomy" put a soul in the sun and the sun in the center, whence it directs the planets. Many more stars exist than the 1,143 visible to the naked eye, "as appears [again] by Galileo's Glasses."[102] And so on. Readers of Sandys's coffee-table Ovid could glimpse an eclectic semi-modern cosmology against a familiar ancient literary background. Among those who could do so in presentation copies of the press run of 820 were Kenelm Digby, Ben Jonson, King Charles, and "Mr Clen."[103]

Varia

When, in 1635, John Selden finally issued at Charles's command the account and proof of British dominion over local waters stifled by James, it went abroad without a frontispiece. This lack was supplied in its English translation of 1652, issued by order of parliament, for which Cleyn created a fine depiction of Britannia sitting splendidly isolated in mid-ocean on a large rock marked *Angliae respublica* (Figure 47). The rock also supports symbols of the three Britannic countries (formerly kingdoms) now united under parliament and also their discarded arms, crowns, and scepters. A vigorous Neptune arrives from the right drawn on a shell by two horses, literally plowing the sea, underlining Selden's fundamental claim that water can be owned like land. Neptune hopes for an alliance with the Commonwealth.

> Of Thee (Great STATE) the God of Waves
> In equal wrongs, assistance crave's, defend thyself and me
> For if o're Seas there be no sway, My Godhead clear is taen away, the Sceptre pluckt from thee.

If "little Venice" can dominate its gulf, should Britannia not rule the seas?

Figure 47 Francis Cleyn, frontispiece for Selden's *Of the Dominion...of the Sea* (1652).

A few years before devising this piece for parliament, Cleyn had contributed one for a collection of poems in memory of the Huntingdon heir, Henry Lord Hastings, who, despite the attendance of "The wise-powerful MAYERN, (who can give | As much as Mortality can receive)," died of smallpox at the age of 19, on the eve of his wedding. Cleyn's image shows the nine muses weeping around the shroud that disguises the object of their tears. Urania with her globe stands disconsolate to the right. An anonymous poet with the intriguing initials "J.B." contributed the suggestive verse:

> Blush, ye Pretenders to Astrologie
> That tell us stories out of Ptolemie
> Kepler, with others; what shall be this year
> Th'effects of Saturn joyn'd with Jupiter
> But could not tell us that our *Sun* should set
> To rise no more within this Sphere.[104]

Under the shroud we are no doubt to understand the martyred king, who could not be mourned publicly. "Cease thou to weep; for he and angels sing | Hallelujah in Heav'n, with Charles our king."[105] The astronomy of *Lachrymae musarum* included a notable invocation by a young poet calling not on immortal gods, as might have been expected, but on dead astronomers. "Come learned *Ptolemy*, and trial make | If thou this Hero's Altitude canst take." Come Tycho, "take [up your] *Astrolabe*, and seek out here | What new star"t was did gild our Hemisphere."[106]

We must suppose that the collaboration with Sandys sharpened, if it did not awaken, Cleyn's awareness of contemporary issues in cosmology and geography. Pertinent images occur in the globes in Cleyn's depictions of the seven liberal arts, a series issued in 1645 by Thomas Rowlett and Robert Peake, perhaps the first English commercial publishers to risk issuing prints intended for art lovers. To reduce the risk and to have something Italianate to appeal to connoisseurs, they engaged Cleyn to do a set based on his tapestries depicting the five senses as well as a series on the hackneyed seven arts. These engravings, by Cleyn and William Faithorne, are rated much superior to earlier British prints.[107]

Figure 48a Francis Cleyn, *Astronomy* from *Septem artes liberales* (1645).

Among the liberal arts Astronomy has the first claim on our attention. She
is a winged creature depicted leaning against a celestial globe while gesturing
at the stars with a surprisingly sleek telescope (Figure 48a). Near her feet are
her usual utensils, dividers for angular measure, a pocket sundial, armillary
sphere, quadrant. Her bearded companion is her student, recently graduated
from instruction by her sister, Geometry, who has taught him the use of

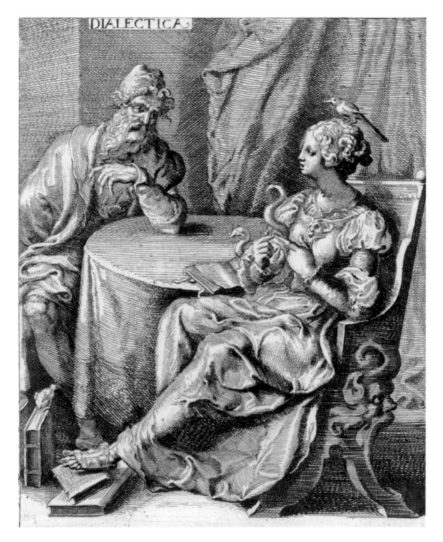

Figure 48b Francis Cleyn, *Dialectics* from *Septem artes liberales* (1645).

dividers on a terrestrial globe (see Figure 31). The features of this globe, like the lines of reference on its celestial counterpart, would not be much use for navigation. Geometry wears a castle in her hair, to indicate her utility in fortification, and dwells among pedestals and pillars, to suggest her prowess in architecture. And what of the snake under the globe? Perhaps it is a relative of the snakelike creature dear to Dialectica, which, having slithered into the

sphere of geometry, which allows no doubtful arguments, is duly squashed (Figure 48b). Or, perhaps, as Sandys explained the association, the snake represented to antiquity the heliacal motion of the sun.[108]

Cleyn's reputation as a designer of prints won him commissions for teaching materials—models of ancient gods, grotesque patterns, and the sports of the little boys and *angellini* incontinently distributed on the canvases and tapestries of the time. These materials must have been consumed by use, as copies are rare.[109] One Cleynigkeit in the British Museum deserves attention. It features Justice, Minerva, and flying putti bringing a laurel wreath to Hercules. The globe, compasses, book, and what may be a telescope at Hercules' feet suggest that he and Cleyn have been studying astronomy.[110] The same props recur in the portrait of Bankes and Williams.

Cleyn's major work around 1650 was illustrating all the fables of Aesop. The commission came from John Ogilby. Although Cleyn followed the tradition of continental Aesops by adapting the classic realistic depictions of Marcus Gheeraerts the Elder, he added some telling details to go with Ogilby's clever and innovative adaptations of the stories to contemporary events.[111] The very first of Cleyn's eighty-one illustrations captures Aesop's character as tradition has it: dull, physically deformed, and yet, when exposing human foibles through vignettes about animals, brilliant.[112] Davenant had a place for it in his version of Solomon's House, among the books on moral philosophy.

> Esop with these stands high, and they below
> His pleasant wisdome mocks their gravitie
> Who Vertue like a tedious Matron show
> He dresses Nature to invite the Eie.[113]

Cleyn's dressing of the opening fable, "The Jewel and the Cock," sneaks a topical reference from Ogilby's text into Gheeraerts design. The story is familiar: the cock pecks about on his dung heap and finds to his great disappointment an inedible precious stone: what has great value for us means nothing to a bird.

Ogilby squeezes more from this story than its trite moral by identifying the jewel with learning and the fowl with people who ignorantly

Figure 49 Francis Cleyn, *Of the Frogs Desiring a King*, in Ogilby, *Aesop* (1651), fable XII.

prefer the evident attraction of a full belly to the usual side effect of study, "a head stuft with melancholic vapours." And so Ogilby's moral:

> Voluptuous Men Philosophie despise
> Down with all Learning the Arm'd Soldier cryes
> On Glaeb, and Cattell, greedy Farmers look
> And Merchants only prize their Counting Book.

Cleyn emphasized the moral by placing a schoolhouse behind the cock and jewel. We see pupils at desks and books on shelves, as in Cleyn's paintings in Kronborg.[114] Ogilby understood the power of the image. As he put it in his limp verse:

> Examples are best Precepts; And a Tale
> Adorn'd with Sculpture better may prevaile
> To make Men lesser Beasts, than all the store
> Of tedious volumes, vext the world before.[115]

Among the lesser beasts that act like men are frogs. A pond-full of them, enjoying untrammeled liberty, decided they needed a god and applied to Jupiter for one. He gave them a log. King Log made a big splash at his entry, but then disappointed his subjects by behaving woodenly. The frogs requested a replacement. Jupiter gave them energetic King Stork, whose favorite activity was eating them. They now begged for the return of old King Log, but Jupiter would not indulge them further. Ogilby did not have far to seek for a lesson:

> No government can th'unsetled Vulgar please
> Whom change delight's, think quiet a disease
> Now Anarchie and Armies they maintain
> And wearied, are for King and Lords again.[116]

Cleyn's accompanying figure (Figure 49) shows a vicious stork (parliament) feeding off ignorant frogs (the mob) who try to find safety on old King Log (the past) while an unsympathetic Jupiter (innovation) looks on.

8

THE SETTING

The Parties

Oriel College's Buttery Books, which record charges for food and drink, show that young John Bankes arrived in June 1643, a month before his matriculation on 10 July 1643, and continued in residence through 1644, including the summer. Entries for him cease in the fall term of 1644–5, covering, in all, six terms and a week. As a fellow of Oriel, Maurice Williams ran up buttery bills throughout the same period and left the college five weeks after John did, although he remained on its books into 1646. Perhaps John withdrew late in 1644 to be with his father, who by then was seriously ill. Williams may also have attended Sir John, who died on 28 December 1644.[1] Our picture probably dates from the period when Bankes and Williams resided together at Oriel.

John Bankes's Oxford offered much to inquisitive minds unaffected by stench and overcrowding. The town and university had to accommodate the royal court, cavaliers, hangers-on, a large garrison, and the means of making war. Magdalen College hosted workshops and an artillery park, Christ Church a cannon foundry, New College a powder magazine, and the Schools storehouses: uniforms in Music and Astronomy, grain in Logic, and (someone still had a sense of humor) Corn and Cheese in Law.[2] Charles and his immediate entourage occupied Christ Church; Henrietta Maria and hers, the Warden's accommodation at Merton; the queen thus replacing Nathaniel Brent, who, having served Laud slavishly, had judged it expedient to throw in his lot with parliament. At Oriel, located between the colleges occupied by the royal couple, the Executive Committee of the

Privy Council, to which Sir John Bankes belonged, held its meetings. The king and queen held theirs too, through a special passage erected through the gardens of the intervening colleges. In June 1643, Charles invited, and in December ordered, parliament to assemble in Oxford. The loyalists who obeyed amounted to 83 lords and 175 commoners.[3]

In all, some 3,000 "strangers" served and protected the court, ran the military enterprises, established a mint to coin silver plate extracted from the colleges, and catered, victualed, and fortified the town, an increase in population of over 30 percent. Good accommodation became scarce, overcrowding inescapable; soldiers were quartered on citizens, ladies on colleges, aristocrats on grocers. Sir Richard and Lady Fanshaw can stand for them all. The family fled from its fine apartments to "a baker's house on an obscure street…a very bad bed in a garret…one dish of meat, and that not the best ordered." The Fanshaws had no money or spare clothes. They spent their time looking out of their window at "the sad spectacle of war, sometimes plague, sometimes sickness of other kinds." Their daughter did better. Mistress Fanshaw obtained lodgings at Trinity College. Perhaps, like her friend who lived at Balliol, she employed a lutenist to alert admiring collegians to her comings and goings.[4]

The city's filthy streets and rivers brimming with animal carcasses combined with close living to invite the scourges witnessed by Lady Fanshaw. In summer of 1643, an epidemic of typhus imported by soldiers hit Oxford. Rats multiplied in the grain stores, and citizens died by the score. The City ordered the bailiffs to remove the pigs from the streets. Physicians recommended eating garlic, which might have helped by discouraging intimacy. Was the outbreak the plague? No, no, said the royal doctor Edward Greaves, that is enemy propaganda: we are dealing with a malignant fever. Has God sent it directly to punish our sins? No, God works through secondary causes, which we can combat. Are the stars the cause? No. Look rather to dirty streets, bad beer, filthy dishware, and the unwholesome army. Besides cleanliness, good air, mild purges, spare diets, and soporifics, cordials, and other ancient remedies can alleviate symptoms. The greatest danger is to fall into melancholy. Therefore, Greaves advised:

"Be Cheerful and Pleasant, as far as the disease will give leave, avoid all sad thoughts, and sudden passions of the mind, especially Anger, which addes fire to the [fever's] Heat, inflames the Blood, and Spirits, and at length, sets the whole Fabrick in Combustion."[5]

And yet, for those with good health, insensitive noses, and strong stomachs, Oxford during the first years of the Civil War, when the Royalists had reason to think they might prevail, was an exciting place, full of soldiers, gallants, men of action, ladies, spies, schemers, crooks, and prostitutes. Students had a broad real-life education under Oxford's dreamy spires. They came in contact with cavaliers occupying rooms in their colleges and with soldiers with whom they worked on fortifications, thereby becoming, according to an eyewitness, "much debauched."[6]

Oriel fared better than most of the colleges. In 1643, only nineteen strangers appear on its books, including a lady. The king's demand in January that all colleges send their silver plate to the new mint weighed less heavily on Oriel, which surrendered £82, than on All Souls (£253) and Magdalen (£296). Further to the war effort, Oriel probably accommodated the editorial office of *Mercurius aulicus*, a weekly news and propaganda sheet, begun in January by Peter Heylyn, the author of *Mikrokosmos* and Laud's collaborator in hounding Prynne.[7] The hound and hare changed places with Laud's fall and Prynne's rise; found "delinquent by Parliament," Heylyn retired to Oxford, where, in the capacity of a royal chaplain, he practiced as a spin doctor.[8] He soon hived off his *Mercurius* to another of Laud's protégés, John Birkenhead, and occupied himself rewriting history. He concluded that the archbishop's "martyrdom" (which had yet to take place) was the forerunner and herald of all subsequent troubles. Troubles aplenty there were already, owing, according to the yet-to-be-martyred Laud, to Charles's sacrifice of Strafford. "[Knowing] not how to be, or to be made, great," the king acquiesced in the murder of his minister and released the forces that would destroy him.[9]

One who tried to make Charles great was Henrietta Maria. While abroad pawning jewels to purchase the stuff of war, she urged her husband to concede nothing to his enemies. Her return to England in February 1643

showed the iron of her constitution. She landed her supplies at a village in Yorkshire closely pursued by five ships commanded by rebels. They parked offshore and amused themselves at night by shelling her lodgings. She scrambled out of bed. The fusillade continued. "I was on foot some distance from the village and got shelter in a ditch. But before I could reach it the balls sang merrily over our heads and a sergeant was killed twenty paces from me."[10] The tough queen proceeded to York, where she stopped for the winter. In the spring, as she prepared to travel to Oxford with her 150 carriages of arms and ammunition, parliament impeached her for high treason. Her arrival in Charles's new capital in July was perhaps the high point of the war for the Royalists. The king sallied out to meet her with a cavalcade of lords, officers, and servants. The royal reunion moved the sensitive soul of *Mercurius aulicus*: "Cursed will they be (and so find themselves by this time) who forced so tedious a separation of these sacred bodies, whose soules are so entirely linkt in divine affection."[11]

The University Orator, William Strode, who in happier days had entertained her with *The Floating Island*, welcomed her back to Oxford with prose more purple than *Mercurius*'s.

> Most Gratious and Glorious Queene...[your] Absence, so barbarously forc'd with danger, so bitterly perused with Calumnies, so patiently born, in leaving that Company out of pure love which you most Lov'd, in sequestering your selfe from the Armes of Your Royall Husband to furnish His Hands with Strength, to send him the sinewes of Mars for the Venus-like Brests which you carried hence, such an absence, after perills by Sea and Land, now turn'd to a powerfull Returne, calls us out of ourselves; our Spirits beyond our Eyes, our Hearts before our Tongues, to greet your most desired Presence; which, in beholding Your Picture, we longed for, and in beholding Your Person, we are ready to dye for...[12]

Strode's extravagance ends a book of welcome-home poems to which young Bankes and his tutor contributed Latin verses. Bankes: "O Queen, we celebrate the indomitable ardor of your love!" We know that you once fearlessly exposed yourself to Charles, when he was confined to bed suffering from a disease that turned him an "unbecoming shade of scarlet." You

have performed heroically again, heedless of personal safety, in running the risks, dangers, perils, of wind and wave, land and sea, and armed enemies. "Fearing nothing, Maria triumphs." Williams: "six glasses [of wine] to dry Charles, two-thirds to each of the children [*Carolidi*], nine to Henrietta!" With wine there must be verses. "We take pleasure in amiable [*facili*] Charles, while we sing of Maria." From these hints, we guess that Bankes and Williams agreed with those who regarded the queen as determined and uncompromising, and the king as indecisive and uxorious.[13] Their poems suggest the familiarity of neighbors, who could refer to the complexion of the king and order bumpers for the queen, rather than the distance of subject from sovereign. She knew both of them, Bankes as the son and heir of her husband's top lawyer, Williams as one of her own physicians.

The campaigning season of 1643 left military matters much as they were at the end of 1642. During the summer of 1644, however, the Royalist position declined along with the number of students at the university. Rebel forces were closing in. Charles fled in June across the Cotswolds to Worcester. Henrietta Maria had withdrawn in April to Exeter, ill and pregnant, attended by Mayerne and Lister. According to the spin doctors at *Mercurius aulicus*, "Her Majestie made choice to enjoy the present peace and quiet of [the West], rather than Oxford, where she was in the middest of H.M.'s Armies, which afforded security but too much noyse and businesse." She gave birth to a daughter in mid-June and left for France on 13 July, not to return before her son had succeeded his martyred father.[14]

The peculiar situation in Oxford bred some tolerance. The pamphlets of Sir John Spelman (son of the antiquary Henry Spelman), who would have been Secretary of State had camp fever not carried him off in 1643, hinted how tolerance might fit the fuzzy concept of mixed monarchy. A frontispiece designed by Sir John's father, drawn by Marshall, and used for Thomas Fuller's *The Holy State* (1642), represents the guiding idea. As in Strafford's concept of government, the king is the keystone of an arch resting on the twin pillars of church (whose plinth is Holy Scripture) and

state (whose plinth is Common Law). Inclining on the arch supported by the sacred writings, naked Truth tans under an emblem of the sun; her clothed opposite number, Justice, carries a sword and scales.[15]

Spelman explained that laws bind kings, but in a peculiar way, "in Honour, in Conscience between God and them." The fuzzy state can survive and prosper only if the people, when suffering under ill-intentioned leaders, do not force confrontation. King Charles's cause did not pit the royal prerogative against the subject's liberty, "but libertie [against] *Ochlocracie* [mob rule], the established protestant Religion [against] scisme and heresie." Most judges, divines, and lawyers, "the visible major part of those Seminaries of Learning the Universities, and the Inns of Court," and educated people in general favor the king and the mixed constitution of the state.[16] He was their sovereign, and yet he was not. He could make no laws without parliament. Although head of the true Protestant church, he could not refuse his protection to his loyal Catholic subjects. The great question was "whether learning, Law, the flower of the Nobility, the best and choyce of the commonality" could manage to muddle through.[17] Charles might have led such a coalition had he practiced the advice he offered his successor: allow religious dissent in matters only probable; keep the middle way, listen to many, yield in small things; enforce civil justice and the laws of the kingdom; show no "aversion or dislike of parliaments;" and beware of covert innovators who mask their "thirst after novelties…with the name of reformations." And, while granting what should be granted to an obedient and grateful people, preserve what should be preserved of the majesty and prerogative of a king.[18] Not an easy program!

Within the *Holy State* illustrated by Spelman's frontispiece Fuller described the sorts of citizens needed to maintain a moderate, balanced, forbearing Christian polity. Our protagonists are among them. The healthy state needs "the general artist," that is, young John Bankes, who "moderately studieth [mathematics] to his great contentment," but does not allow it to "jostle out other arts." He entertains but does not believe in judicial astrology. He must know history, without which "a mans soul is

purblind," but cannot unless he first master chronology, without which "history is at best a heap of tales." And he must be acquainted with the universe, through a smattering of cosmography. If the general artist were also a true gentleman, as was young Bankes, he would be as studious at the university "as if he intended Learning for his profession."[19] He would not copy the "pretender to learning," who looks over books in Greek only when people are looking over his shoulder; nor the true scholar, awkward, unsophisticated, and melancholic, "his minde [being] somewhat too much taken up with his mind."[20]

Another necessary citizen, the good judge, exemplified by Sir John Bankes, is patient, attentive, upright, merciful, and above bribery. Where justified, he decides fairly in suits against the sovereign. Kings may not at first like this independence, but they will come to "see with the eyes of their Judges, and at last will break those false spectacles which (in point of Law) shall be found to have deceived them." Had Charles only listened to Bankes! But why should he? "He is a mortall God...He holds his Crown immediately from the God of Heaven." The good king should be pious, loving, generous, just, and merciful, and also humble, like Charles, who disliked being praised. "His Royall virtues are too great to be told, are too great to be conceal'd." Fuller's description of the good physician fit Williams better than his sketch of the ideal sovereign did Charles. A good physician does not diagnose on the basis of one vial of urine, or experiment on his patients with new or exotic drugs, or hide from them their approaching deaths.[21]

Charles did not need Fuller's exhortation to accept the obligation to protect all his loyal subjects, including Catholics. He had to shield them, among other reasons because he could not wage war without them. They had succored him when he was destitute at York and continued to supply him at Oxford. About a third of the gentry families in the county were Catholic. Their distant chief, Pope Urban, sympathized with their king's cause, although, as he wrote with undiplomatic realism, all the treasure in Castel Sant'Angelo would not recover the crown Charles had lost by his concessions in Scotland. Still, if Charles indicated his intention to rejoin

the old religion . . .[22] Charles refused this stale impossible condition. But, while publicly declaring his faith in and support of "the true reformed Protestant Religion, as it stood in its beauty in the happy daies of Queen Elizabeth," he allowed Catholics to attend mass openly in Oxford. There may have been many of them, for Laud had warned that Jesuits were at work in the university helped by the holy water at the Blue Boar, the Mitre Inn (reputed to be a recusant hangout), and other pubs in town owned by Catholics.[23] This was very different from the situation Henrietta Maria had experienced during her previous stay in London.

> Imagine how I feel to see power wrested from the King, Catholics perse-cuted, priests hanged, our servants fleeing for their lives for having tried to serve the King…It seems that God wants to afflict both of us…but my afflictions are greater, for the suffering of religion is above everything.[24]

The relatively tolerant Oxford of 1643 harbored representatives of many of the sects and religions that Andrew Ross lovingly disparaged in a cata-logue he published in 1642. Heading the list, "the worst of all Creatures," was the Atheist, followed immediately by the Papist, who "acknowledges no High Power but the Pope." The half-Papist Arminian came next (leav-ing aside Jews), lusting after a hierarchical clergy, "Altars, Cushions, Wax-Candles…with many other superfluous Ceremonies." Ross did not overlook Libertines, "so overcome with the flesh they cannot pray;" Communists, who enjoy wives and other things in common; Anabaptists, Waiverers, and Time-Servers, with no fixed church; Canonists, who want, and Lutherans, who do not want, bishops; Separatists, who rightly decry bishops but wrongly admit lay elders; Brownists or Quakers; and Puritans, "the most commendable," who long to follow the Scottish kirk.[25]

Ross left for last Rattle-Heads and Round-Heads, equally misguided, who were already at loggerheads. The Rattlers are "haire-brain'd, spittle-witted coxcombes with no time for law or religion"—that is, Cavaliers, "[who] regard nothing but to make mischief, build castles in the Ayre, hatch Stratagems, invent Projects." The Rounders, though desiring orderly

performance of church services, "yet they are the chief Ring-Leaders to all tumultuous disorders, they call the *Common Prayer* Porridge, and they will allow no doctrine for good, nor any Minister a quiet audience, without he preach absolute damnation." The catalogue ends with its pious compiler "Praying to God the Author of true peace | That truth may flourish and dissension cease."[26]

For six months or so after Bankes had joined his king at York, he worked for truth and against dissension. He remained *persona grata* to parliament, which asked that he be kept in his place as Chief Justice. After the failure of the last efforts toward peace, however, he subscribed liberally to Charles's cause and, in the spring of 1643, addressing a Grand Jury in Salisbury, accused Essex and other parliamentary commanders of high treason. Parliament responded by ordering his impeachment and the forfeiture of his property. A parliamentary force besieged his castle. Lady Bankes commanded the defenses of the upper ward with a force consisting of her daughters, maidservants, and five soldiers. The siege lasted six weeks before the Roundheads withdrew with more than 100 casualties. Sir John was then able to rejoin his heroic mate and create their fourteenth child, who entered upon the miseries of this world in June 1644. The following July parliament repeated its order depriving the Bankeses of their property and charged Sir John with high treason for giving judgment the previous December against its generals. It was a devastating blow to so faithful a public servant, to a man of whom contemporaries said, as Tacitus did of Rome's great general and architect Agrippa: "There was this very rare about him, his affability did not lessen his authority, nor his severity diminish his love." He had done his best. But he failed, as did all other wise and well-meaning councilors, to bring the king to agree to a compromise long enough to effect it.[27]

The distress Bankes felt at his treatment by parliament and his inability to prevent or blunt the oncoming disaster might well have hastened his death. He was buried in Christ Church, where he could continue to witness Charles's ineptitude. His epitaph reads, after a recital of his various

offices, "Peritam integritatem fidem | Egregie praestetit," "he stood far above others in knowledge, integrity, and honesty." For once an honest monument! After all his work and service, he died land poor. Besides Corfe Castle, he had property in London and elsewhere, but a recorded income at death of only £1,263.[28] He left various benefactions, a portrait of himself in the robes of Chief Justice (see Figure 16), and an admonition to his son John. "My eldest sonne must be contented to follow his studyes until he attaine the age of 24 yeares and to spend his time at the universitie, Innes of court, or travail, and when he enters upon his estate he is to be helpful to his brothers and sisters."[29] John would choose travel.

He could not return home. Toward the end of 1645, regiments of Cromwell's New Model Army tried their luck at Corfe. They put their artillery in the village church, stored their powder in organ pipes, made missiles from the lead roof, and fashioned shirts from surplices. Despite these pious preparations, Lady Mary's troop held out again. On 7 February 1646, a passing detachment of Royalists relieved the siege. Nine days later, betrayed by one of the officers left there, an inglorious Colonel Pitman, the castle fell. Perhaps he would not have acted so if Lady Bankes had been there. She had left her castle, perhaps soon after Sir John's death, in order to improve her position in compounding for her estates, which she did with the help of her co-trustee of young John's inheritance, the Mr Green to whom Sir John had described his increasingly difficult relations with the king. Since Lady Mary was in or around London with her unmarried daughters from July 1645 until March 1646, she was spared the sight of her neighbors stealing her furniture and Corfe's conquerors demolishing her home.[30] Neither she nor her sons could recover its valuable paintings or tapestries, although its library, which included some of Noy's books, survived for a time. By Act of Parliament, it went intact to Sir John Maynard, an eminent lawyer and parliamentarian who served on the committees that condemned Strafford and Laud. Maynard became a Royalist champion in good time and had the opportunity to restore the books to Bankes's heirs, but few have made their way to the library at Kingston Lacy.[31]

The Audience

John Greaves

Astronomy in Oxford had a tinge of the exotic about it. The astronomer Bainbridge taught himself Arabic to be able to read his Muslim predecessors directly, lest he be "hoodwinked" by Arabists who knew no astronomy. He found it hard going, he told Ussher, "but the great hopes I have in that happy Arabia to find most precious Stones...do overcome all difficulties."[32] As part of his program to encourage the study of mathematics and Eastern languages at Oxford, Laud commissioned a former fellow of Merton, John Greaves, who would succeed Bainbridge as Savilian professor, to hunt up Arabic manuscripts for him in the Middle East. Greaves intended also to measure the latitudes of eastern cities. For this enterprise he had the support of another powerful bishop, Laud's protégé William Juxon, risen to Bishop of London and Lord Treasurer of England. Juxon knew that such work as Greaves proposed was much desired "by the best astronomers, especially Ticho Brahe and Kepler...as tending to the advancement of that science."[33]

In 1631, after graduation from Balliol (1621) and further improvement under the Savilian professors, Greaves became professor of mathematics at Gresham College, London, with the support of Bainbridge, Brent, and Abbot. He soon gained leave to study in Padua. He went on to Rome, where he ran into Harvey at the English College, and had serious talk with the Jesuit polymath Athanasius Kircher (on magnetism), Cardinal Bentivoglio (on foreign travel), the Barberinis' librarian Lucas Holstein (editions of Copernicus), and Galileo's disciple Gasparo Berti (the sights of Rome). Greaves's easy travel in Italy suggests an easygoing religion, if not crypto-Catholicism.[34] His commission from Laud to live and collect among Muslims further evidences his courage and tolerance.

Greaves's most splendid acquisition on his trip to Arabia was a copy of Ptolemy's *Almagest* stolen for him from the library in the Seraglio in Istanbul, "the fairest book [he wrote] that I have ever seen." What other

fair things did he see or hear there? Enough to add some particulars to a book about the seraglio composed by Ottaviano Bon, an intimate of Sarpi's circle, who served as the Venetian agent in Istanbul between 1604 and 1608. Bon's book describes the exotic life of the seraglio diplomatically, with an occasional titillating detail. Item: the "young, lusty, and lascivious wenches" of the harem had a taste for cucumbers, which were never served them whole, "to deprive them of the means of playing the wanton."[35] Greaves's version of Bon and other results of his exotic travel made him an unusually alluring professor of mathematics.

As a travel writer Greaves tended more toward arithmetic than ethnology. He reports of his visit to Santa Croce in Florence that its holy relics include a nail of the true cross (weight, a shilling and sixpence), and two thorns from Christ's crown (length, 2 inches). About St Peters and the Pantheon in Rome he records little more than their linear dimensions. But he was able to work out the length of an ancient Roman foot, which he reported in a book dedicated to Selden, and the exact size of the pyramids.[36] In Venice he admired the glassworks—not for giving beautiful ware to the world, but for providing good lenses for Galileo. No more than two such lenses existed, the professor of mathematics in Siena told Greaves, after neither of them had managed to see more than one of Jupiter's satellites through the telescope they had to hand.[37] The instrument Greaves had brought with him sufficed, however, to measure the latitudes of Constantinople, Rhodes, and Alexandria to a new degree of accuracy. He published these data, with due criticism of his predecessors, via a letter to his friend Ussher.[38]

For much of his journey to the east, where he spent over a year between stays in Italy, Greaves had the company of the first incumbent of Laud's chair of Arabic, Edward Pococke. After returning to his professorship at Gresham College in 1640, Greaves visited Pococke and other colleagues in Oxford from time to time, and so was on the spot when Bainbridge died. He "immediately" succeeded to the Savilian chair, "either because of the pure faith [he] reposed in the King or because of greater expertise in universal mathematics."[39] He was entirely at home, almost literally, for,

besides the society of his cronies Harvey, Pococke, and Ussher, he had the company of his brothers Edward (the royal physician), who had studied at Padua, and Thomas (a Fellow of Corpus Christi), who had learned Arabic from Pococke and translated a portion of the Qur'an. There is good reason to think that Maurice Williams made part of the company of physicians, mathematicians, and orientalists around Greaves and his brothers, and that young John Bankes was one of Greaves's students.[40] Certainly Sir John Bankes knew the merit of the new professor. He was on the committee that elected Greaves.[41]

Like many sevententh-century mathematicians, including Galileo, Greaves had an interest in finding longitude at sea. He preferred a method using our moon rather than Galileo's scheme of exploiting Jupiter's.[42] Unlike Galileo, he had experience in long voyages and allowed himself a sneer at idle "persons of quality" who looked down on navigators and other practical folk. Among such idle persons could be found fools who still opposed the Gregorian reform of the calendar because a pope had brought it forth. Greaves proposed to eliminate the calendrical discrepancy between Britain and Europe by making ten successive leap years ordinary ones. His advice did not prevail; Britain remained Julian until 1752. It would be wrong to say that Greaves's applied chronology had no positive outcome, however, for it helped Ussher to discover when Adam lived.[43]

Doctors of Body and Soul

When William Cavendish was called to court in 1638 to instruct the future Charles II in horsemanship, perhaps with Hobbes's "Considerations touching the facility or difficulty of the motions of a horse" in his saddlebag, the Cavendish's mathematician, Robert Payne, arrived in Oxford, perhaps clasping his copy of Galileo's *Systema cosmicum*. Payne's official post was chaplain of Christ's Church and soon also royal chaplain, thus becoming a colleague at-a-distance of Alexander Ross, the scourge of novelty-mongers.[44] Payne found himself thoroughly at home with the sort of science flourishing at Oxford around 1640, which produced,

among other curiosities, a disputation at Queen's in 1638 on ocean tides and lunar life.[45]

Payne's fellow chaplain Chilmead had just published his translation of Hues's *Tractatus* and was turning his attention to music. In the manner of Williams, he developed his ideas in a critique, or "Examination," of questions posed by Bacon. His most penetrating analysis answered the question, why the sound of a bell depends on how it is struck, via an extraordinary analogy to the Copernican system. A bell has the ability to vibrate in different ways simultaneously, "which [modes] are to be conceaved to stand with the [fundamental] Primigeniall Motion, as the Copernicans, in their Sphericall doctrine, conceave the Earth, to make 365 circles in the Diurnall Motion, while it is finishing One Annual Course about the Sun." Chilmead left this magnificent simile in manuscript lest it and other bits of his "Examination" offend the growing band of Baconians in Oxford, "so over-ruling is the name of Ld Verulam."[46] The fans of Bacon, "our English Aristotle," had raised their standard at the university in 1640, in an amusing frontispiece to the English edition of *De augmentis* (see Figure 60).[47]

Many learned Royalists took up or continued residence in Oxford while Charles held court there. Physicians abounded. There were Dr Thomas Clayton, the Regius Professor of Medicine, an enthusiastic Royalist who trained companies of scholars for military service; Mayerne, attendant on Henrietta Maria, pregnant again after the joyful reunion of the royal couple in the summer of 1643; Williams, attendant on young John Bankes; and the score or more of fresh MDs created in 1642–3 by royal order, some of them deserving, like Walter Charleton, but others with few qualification beyond being gentlemen. This batch process exceeded the normal output of Oxford MDs by a factor of ten, creating a light Royalist counterweight to the London College of Physicians, which had a preference for parliament.[48] Sir John Bankes knew some of the doctors of Oxford as he had had to clear up legal questions about Clayton's royal professorship.[49]

Several of Oxford's many doctors collaborated with Harvey, who moved to Merton as Warden in 1645. He owed this preferment to

Greaves, who had consulted him on the pressing problem of breathing in pyramids, and, as Merton's Sub-Warden, had petitioned Charles to deprive the absentee rebel Brent of the wardenship. The wheel of fortune continued to spin, however, and Brent, returning in 1648 as President of the parliamentary committee appointed to review the university, turned out the brothers Greaves.[50] The charges against John Greaves were alienating college property for the king's use, being overly familiar with the queen's confessors, and causing the ejection of Brent. Anticipating that he would be removed, Greaves resigned in favor of Seth Ward, a former student of Oughtred, an informed and reliable Copernican.[51] Ward became a close colleague of Wilkins, Galileo's first English popularizer, who, having married Cromwell's sister, returned to Oxford in 1648 as Warden of Wadham. According to Ward, writing in 1654 but referring to a pre-existing condition, no one at Oxford able to understand astronomy was Ptolemaic, most being Copernicans "of the elliptical way."[52]

Several doctors of divinity and their friends in and around Oxford would have been able to recognize the Galilean reference in Cleyn's painting. They included King Charles's chaplain and Prince Charles's tutor, Bishop Brian Duppa, formerly Dean of Christ Church and Vice Chancellor under Laud, and Duppa's friend Justinian Isham, a future fellow of the Royal Society. Isham joined Charles in Oxford just after Edgehill and befriended young John Bankes, perhaps through Williams, whose interests in Baconian philosophy he shared. Duppa's disciple and Bankes's protégé Jasper Mayne often visited Oxford from his benefice in nearby Cassington.[53] Nor can we forget the disputatious Peter Heylyn, who returned to his *Mikrokosmos* after whitewashing Laud. Aristotle might have written the account of the world system in the early editions of *Mikrokosmos*. In the new version, retitled *Cosmographie*, Heylyn silently acknowledged modern astronomy by saying nothing about the earth's place in the universe. "For though Truth be the best Mistress that a man can serve...yet it is well observed withall, that if a man follow her too close at the heels, she may chance to kick out his teeth."[54]

Men of Great Tew

Among those who migrated to Oxford with the king was Lucius Cary, Viscount Falkland, of the near-by village of Great Tew. During the 1630s he had kept open house in the village for a circle of philosophers, divines, and poets, and had opposed key Crown policies. He had refused to pay ship money, which he blamed on evil councilors, and led the Long Parliament's attack on the judges by whom "a most excellent Prince hath been most infinitely abused...telling him he might do what he pleased." And he was one of the spears who headed the prosecution of Strafford in the Lords. Nonetheless Charles made him a Secretary of State. That was in January 1642. Falkland did not want the job but yielded to pressure from his intimate friend Edward Hyde, the future Lord Clarendon, who was acting as Charles's mole in parliament. Falkland and Hyde were with the king at York in June. There they made common cause with Bankes to nudge the king toward compromise; but, although they had greater access than the Chief Justice, they had no better luck. Their moderate views, in religion as well as in politics, were not opportunistic: they had a reasoned position characteristic of the men of Great Tew.

Falkland had developed his tolerance, improbably, in Ireland, where his father had governed, unsuccessfully, as Lord Deputy in the 1620s. Cary (as he then was) graduated from Trinity College, Dublin, fluent in Latin and French and aware that Catholics and Protestants could live together if they tried. He experienced standard prejudice in his immediate family: his maternal grandfather disinherited his mother for becoming a Catholic (and for other reasons too), and his unsuccessful father almost disinherited him for marrying a penniless girl. After death removed the grandfather and old Lord Falkland, the well-to-do new Lord Falkland and his loving and learned and no longer penniless wife began to draw out their intellectual circle. But religion continued to split the family. Falkland had charge of two of his younger brothers, to bring up as Protestants. His incorrigible mother kidnapped them and sent them to France to be raised as Catholics. They became Benedictines, as did four of their sisters.[55]

"All men of eminent parts and faculties in Oxford" belonged to, or sympathized with, the teachings of Tew; or so Hyde in retrospect defined the reasonable people at the university. Falkland's circle included the enlightened from many walks of life, some of whom we know: Galileo's translator Robert Payne, Charles's intimate Endymion Porter, and Cleyn's patron George Sandys.[56] Sandys's "graver Muse [had] from her long Dreames awaken[ed]"—that is, by the late 1630s he had switched from translating the *Metamorphoses* of Ovid to paraphrasing the *Psalms* of David. ("The Lord my Shepheard, me his Sheep | Will from consuming Famine keep.") As psalmist, David inspires; as king, exemplifies. Sandys took David to be exemplary, because he submitted to the law; and it troubled him, as it did most others at Tew, to see Charles increasingly deviate from this standard.[57]

Tew's political message appears more plainly in the lengthy poem Falkland contributed to Sandys's *Paraphrase*. It begins praising the author's earlier writings for "Teaching the frailty of Human things | How soone great Kingdoms fall, much sooner Kings," and ends criticizing those who would criticize Sandys for mixing eloquence and things divine. "[A]s the Church with Ornaments is Fraught | Why may not That be too, which There is Taught?" But this line too was decoration: Falkland's main point was tolerance, not ornament. Like Saint Paul, "Who Iudais'd with Iewes, was All to All," the church must be open to different approaches to the same fundamental beliefs.[58] Falkland made all this clearer and longer a year later in his *Of the Infallibilitie of the Church of Rome* (1637), which argues that, as no religion possesses the full truth, it is absurd and dangerous to quarrel over adiaphora.

Tew's tolerance followed in the tradition that George Sandys's elder brother Edwin had set out in the evenhanded survey of the state of Europe around 1600 with which this story began. The leading men of Tew thought that the Anglican Church was the most reasonable of the Christian communions around which partnership with non-Roman Catholics of France and Italy might be arranged. They disliked clericalism, distrusted Laud, and disdained Presbyterian forms. Hoping to reconcile political as well as religious factions, they remained Royalists though disheartened by the

Personal Rule.[59] As we know, Hyde and Falkland entered Charles's service when the Long Parliament was intransigently expropriating his prerogative. They thus were bound in government with at least one Oxford man of "eminent parts and faculties" who shared their worldview: Sir John Bankes.

Great Tew occasionally indulged in fun and science. For fun it had its member John Earle's bestseller *Microcosmographie* (1628+) with its weak caricatures of lawyers, doctors, divines, scholars, and antiquaries. Thus, of the young gentleman at the university, "[o]f all things hee endureth not to be mistaken for a Scholler." Having succeeded in countering this mistake, the young man proceeds to the Inns of Court, "where he studies to forget, what he learned before."[60] Great Tew's science was more sophisticated. It linked to Oxford through Payne at Christ Church and Gilbert Sheldon, the Warden of All Souls, who had shocked the university as a bachelor of divinity by denying that the pope was anti-Christ. A mind so large also had room for mathematics. So did Hyde's. His library preserved the manuscripts of Harriot given him by his father-in-law, Sir Thomas Aylesbury, one-time acolyte of the Wizard Earl of Northumberland, and, at the time of our painting, Master of the Mint converting the silver plate of Oxford into coin of the tottering realm. Perhaps more pertinently, Hyde urged "observation and experience," as exemplified by Bacon, as the way to advance natural knowledge.[61] It is said that the men of Tew looked to the laws of mechanics for guidance in their analyses of politics and religion. And, if they also looked into the copy of Galileo's *Dialogue* owned by George Morley, a member of their circle and, like his good friend Payne a canon of Christ Church, they would have seen its famous frontispiece in the original version by della Bella.[62]

Morley's *Galileo* is now in Winchester cathedral, whose bishop he became during the Restoration. He succeeded Duppa, translated from Salisbury in 1660, a move that made him Prelate of the Knights of the Garter and the donor of another notable artifact. He gave the Knights' mother church, St George's Chapel in Windsor Castle, "the picture of Christ and the Twelve at Supper" recorded as a modern piece in the

chapel's inventory of 1672; a painting of the same subject now hangs in the Parish Church of St John the Baptist in Windsor. The parish advertises it as a national treasure, which it may be, and as a Cleyn, which may be doubted. The inventory also mentions a hanging given by Duppa with "the pictures of Christ and His disciples at Supper;" thus the national treasure may be a copy or model of a Mortlake tapestry, whence the ascription to Cleyn may have arisen.[63] A welcome advertisement in any case!

To continue with the fates of Tew's veterans under Charles II: Earle became Bishop of Salisbury; Sheldon, Archbishop of Canterbury; and Hyde, Lord Clarendon and Lord Chancellor. Falkland did not reach the Restoration. "Melancholy" brought on by the intolerance, rigidity, violence, and inhumanity of the Civil War, or, as Aubrey has it, by the death of his mistress, drove him to court death. During a battle in 1643 he sought a spot where enemy bullets filled the air and galloped straight toward it.[64]

Starry Messengers

The stars were never far from the battlefield during the first years of the Civil War. Our astrological docent, George Wharton, set up his shop in Oxford after fighting for the king at Edgehill. His learning as a chronologist recommended him to the university's historians and mathematicians, while his mathematics and predictions made him welcome to the military. In Oxford he worked in the ordnance office under Sir John Heydon, a second-generation astrologer, son of the Elizabethan adept and defender of astrology, Sir Christopher Heydon. Elias Ashmole, another of Sir John's amateur artillerymen, took up astrology under his influence and reissued an epitome of old Sir Christopher's unanswerable defense of it previously blocked by "the error or rather malice of the clergy." John Aubrey, who matriculated in May 1642, likewise fell in with Sir John and became an addict. The examples of Wharton and Heydon were reassuring. Apparently honest practitioners existed among the "divers Illiterate Professors (and Women are of the Number) who even make Astrologie the bawd and Pander to all manner of Iniquity, prostituting chaste Urania to be abus'd by every adulterate Interest."[65]

Wharton's prognostications were more uplifting than correct. For example, he advertised on the shaky basis of the positions of the moon and Mars when Charles marched his army south in May 1645 that the rebellious capital would soon fall. "Believe it (*London*) thy Miseries approach, they are…not to be diverted unless thou seasonably crave Pardon of God for being Nurse to this present *Rebellion*, and speedily submit to the Princes Mercy." The *cor Leonis* was rising, the sun auspiciously surrounded by Jupiter and Venus and clear of menacing aspects from Saturn and Mars. So what? "These are undeniable Testimonies of the *Honour* and *Safety* of the Famous *University and City of Oxford*."[66] Alas, Wharton had overlooked the approaching conjunction of Saturn and Mars on 12 June 1646, from which some "barking mongrel" (astrologers addressed one another as if they were mathematicians or theologians) had predicted, correctly, that Oxford would soon surrender. Wharton: the barking mongrel had not taken into account the recurrence of that dire conjunction on 28 June 1648, "[which] will be assuredly fatal to London."[67]

London's astrologers knew better. A typical tract warned of "the great eclipse of the sun, or *Charles his waine*, over-clouded by the evill influences of the Moon ['the destructive perswasions of his Queen'], malignancie of ill-aspected planets [his '*Cabinett* Counsell'], and the constellation of retrograde and irregular stars ['the Popish faction']."[68] But, although the prognostication was correct, it lacked the persuasive argot of an accomplished practitioner like William Lilly, the first authority in the realm, widely read, generally respected, and too often right. He was self-taught and initially restricted his practice to the usual questions about marriage, health, travel, and business. His first major work, *England's Prophetical Merline* (1644), begins with an analysis of the opposition of Jupiter and Saturn on 15 February 1643, which he found, retrospectively, to have announced the troubles of the kingdom. The trouble was evident much earlier to informed people. Ptolemy knew that the effects of major comets could extend for a generation and more; as late as 1644 the comet of 1618, then the last seen in Europe, still afflicted England and most of the Continent. Considering also the badly aspected solar eclipse of 1639 and the bizarre

grand conjunction of 1642–3, which "preposterously and irregularly" occurred in the wrong Triplicity, Lilly could only conclude that things would go badly for Charles.[69]

Several old prophecies also announced the doom of the Stuarts. Here is a clear one, which Lilly learned from a priest in the last years of King James: "Mars, Puer, Alecto, Virgo, Volpes, Leo, Nulus," which, interpreted, signified Henry VIII (warrior), Edward VI (boy), Mary (fury), Elizabeth (virgin), James (fox), Charles (lion, for ruling without parliament), No One. A similar prophecy, recorded in 1588, ran "When Hempe is sponne, England's done," which ditty, unveiled, signifies that after Henry, Edward, Mary and Philip, and Elizabeth, a Scottish king would undo England.[70] Right again. But, however persuasive such prophecies, they were only footnotes to messages from the stars.

Lilly deduced his judgments from "pa[s]t and present configurations of the heavenly bodyes, expectant effects of Comets and blazing Starres, influence and operation of greater and lesser Conjunctions of Superior Planets, famous Eclipses both *Solar* and *Lunar*, Annual congresses, [and] the remaining effects of prodigious Meteors." To foretell the fate of rulers, however, he had to inquire into "the removal of the Aphelion of the Superior bodies out of one [trigon] signe into another, by which alone, high and deepe Knowledge is derived to the Sonnes of Art concerning the fate and period of Monarchies and Kingdomes."[71] As for that particular monarchy that reigned in the British Isles, a deeper sign than a passing conjunction declared its doom. As the great astrologer Girolamo Cardano had observed, England fell under the dominion of Mars. It was "a Rebellious and Unluckie Nation," destined for civil strife.[72] Knowing all this, Lilly forecast a parliamentary victory for the very day on which the royal army suffered a crushing defeat in the Battle of Naseby.[73] And this in the teeth of Wharton's prophecy of victory against London!

Professional disagreement and mutual vituperation did not prevent stargazers from gathering in an informal guild. They met annually in a Society of Astrologers for conviviality and mutual encouragement. At its conclave of 1649, it listened to a minister of the Church of England, Robert

Gell, confirm that God governs the world through angels and stars. As interpreters of starry messages, astrologers ranked almost with angels; "almost" because sometimes astrologers miss or misinterpret the news. Gell gave a bizarre example. At the time of the nova of 1572, a hill in Herefordshire gamboled over 400 yards before coming to rest. (There was such a landslip at Marcley Hill in February 1571.) Now, when Israel crossed the Red Sea, "[t]he mountains skipped like rams, the hills like young sheep;" the astrologers ought to have coupled the bounding hill with the nova and announced a new age in religion.[74] Gell's clerical colleagues did not think much of his hermeneutics, denounced him for defending conjurors and advocating tolerance, but (such is the power of the stars) failed to turn him out of his rich London parish.[75]

Lilly and Wharton lived to save one another from peril. With impeccable professional courtesy, Lilly helped extract Wharton from imprisonment by parliament in 1650, which service Wharton, who received knighthood from Charles II, reciprocated in 1660–1. Lilly further demonstrated his professionalism by advising the first Charles confidentially while demonstrating his doom publicly. Lilly recommended days on which Charles should attempt his escapes from Hampton Court in 1647 and the Isle of Wight in 1648. Had Charles heeded Lilly the second time, he might have succeeded.[76] Instead he followed his own star, which portended for him personally what, according to King James, Tycho's nova signified for us all. "By this starre great Tycho did contend | To show that the World was coming to an end."[77]

The Portrait

Soon after John Bankes junior had matriculated at Oriel, parliamentary forces under their Captain General, the Earl of Essex, established a forward post in the village of Wheatley, almost within sight of Oxford. Cavalry skirmishing went on for days while the defenders knocked down houses to open a line of fire for their artillery stationed at Magdalen Bridge. Judging that his forces could not take or even blockade fortified

Oxford, Essex retreated to a position from which he hoped to intercept the queen's munitions convoy. Prince Rupert thought the situation ripe for an evening's entertainment at rebel expense. He sallied forth across Magdalen Bridge at 4:00 p.m. on 17 June, savaged a few rebel outposts before dawn, and drew units of Essex's army into battle around 9:00 in the morning. After a hard fight in which John Hampden, the veteran of the cold war against ship money, was fatally wounded, Rupert could declare victory and return to Oxford in time for a late lunch. Report of the wounding of his old enemy Hampden struck a chord in Charles's concert of civility. He sent Hampden a minister and offered to add a doctor; but Hampden had need only of the minister.[78]

The high probability of dying from disease or wounds suffered in sallies caused cavaliers who wished to leave their likeness to posterity to have their portraits painted. Several accomplished artists set up in Oxford, drawn by business opportunity and the hope, perhaps, of filling the top slot vacated by Van Dyck's death in 1641. One of these adventurers was Hollar, by then attached to the court as drawing master to the Prince of Wales. Although portraiture was not his line, he drew a few royals, including Henrietta Maria and Prince Rupert, and, what was of greater value, Oxford itself, as it appeared in 1643 (Figure 50). He soon dropped from the competition, however, to go to his patron Arundel, who had not returned from his conveyance of the Queen and Princess Mary to the Continent.[79] The legacy of Van Dyck fell to Cleyn's only known student besides his own children. This anomaly, William Dobson, had worked for an alert lady in Mortlake who noticed that he could draw. She recommended him to Cleyn, who taught him technique enough to enter the king's household as instructor in painting to the princesses Mary and Anne, and, perhaps, to join in decorating Ham House. From his master, Dobson learned what one authority depreciates as a "ponderous," another as a "somewhat pedestrian version of the international mannerist style," which, tradition has it, was improved by some exercise in the studio of Van Dyck.[80] Dobson then set up for himself in London, where he made his name as a portraitist with his arresting

Figure 50. Wenceslaus Hollar, *Oxforde* (c.1643)

depiction of Endymion Porter (Figure 51). Late in 1642, while still in his early thirties, he went to Oxford.

The evidence of Cleyn's influence on Dobson lies in symbolic figures and reliefs in some of Dobson's portraits and especially in an early canvas, *The Four Kings of France*, a satirical rendition of Charles IX, Henris III and IV, and François II, in which two crowned dogs wearing collars reading "Cathol[ic]" and "Hugu[enot]" fight over the prostrate body of France, the

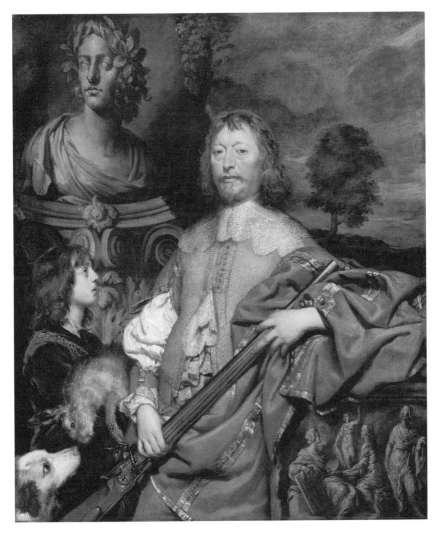

Figure 51 William Dobson, *Endymion Porter* (c.1643).

whole contained within a border recalling Cleyn's tapestries. This complicated conceit arose from the brain of Sir Charles Cotterell, the royal Master of Ceremonies, to illustrate a history of the French civil wars that King Charles, facing one himself, wanted translated. Dobson portrayed Cotterell along with himself and Lanier in a picture said to show the "resoluteness, weariness and stress of a beleaguered existence," or, perhaps, music, painting, and literature coping with their wartime situations. The painter is the only one courageous or curious or impudent enough to direct his gaze at the viewer.[81]

Dobson's first commissions at Oxford included Prince Rupert. Thereafter lesser aristocrats, mainly officers of the king, sought him out. He portrayed them, even the bravest, in appropriate melancholy, apprehensive, anxious, even anguished.[82] He tried to place in his portraits symbols indicative of the client, appealing to a taste downplayed during Van Dyck's dominance, but quite in keeping with Cleyn's narratives; and, although the press of people demanding his attention caused him to cut corners, he escaped the censure that Norgate directed at Van Dyck for a similar fault. "Vandike...[in Italy] was neat, exact, and curious in all his drawings, but since his coming here, in all his later drawings was never judicious, never exact." With his quick talent, vigorous poses, and Venetian colors, Dobson became the new star, "the English Tintoret," in the expert opinion of his sovereign.[83] Demand increased. To help meet it Dobson took an assistant and may have called on, or joined forces with, his former instructor Cleyn. He had a studio on the High Street near St Mary's and, it seems, lodging in St John's; as a painter patronized by the king, Dobson could find accommodation in crowded Oxford.[84]

Despite his reputation as a portraitist in Denmark, Cleyn's work for great people in England had centered on painting their houses rather than their persons. However, an album of his drawings that has recently come to light shows that he continued to sketch portraits. It contains several well-drawn heads, including those of Henrietta Maria and the young woman who became the Hero of his tapestries.[85] When he returned to formal portrait painting in Oxford, it was not for long; only two examples,

both owned by the National Trust, are known. One is of Williams and Bankes, the other, once attributed to Dobson, is of Sir John Crump Dutton, who had a large estate at Sherborne some 20 miles west of Oxford.

Sir John was a crotchety rich lawyer who had not been keen on the king. He had opposed forced loans, refused ship money, and served in the Long Parliament. Nevertheless, he went, or, as he later asserted, was taken by force, to wartime Oxford, given an honorary degree, and made a colonel in the Royal Army. This commission cost him £5,200 when he later had to compound with parliament for his estates (worth £60,000); he remained nimble enough, however, to ingratiate himself with Cromwell and support the Commonwealth. His portrait, hanging in the lodge he built at Sherborne, is similar in palette to the Kingston-Lacy picture, but without the deep melancholy; it exhibits a confidant, quizzical sitter, knowing his place in the world and not discontent with it (Figure 52).[86] Why did Dutton choose Cleyn? Perhaps at Sir John Bankes's suggestion. The lawyers knew, or knew of, one another. Attorney General Bankes had assisted the House of Lords when it heard a petition against Dutton arising from a family quarrel.[87]

Cleyn's painting of young Bankes and Williams has a naturalness that might have recommended it even to Prynne and his fellow pious logicians who reckoned that portraiture belonged to the genre of cosmetics. To them the deceit practiced by women who painted their faces and dyed their hair differed negligibly from the counterfeiting of cavaliers on canvas. Portraiture misleads by the cunning use of light and shadow, foreshortening and perspective; it turns daubs into icons. To ascribe reality to such fakery is to make a meal of a still life. Yes, no doubt, replied such connoisseurs as Norgate and Wotton, cozening is indeed the point of painting: a good picture gives pleasure to the extent that it deceives, its truth being in proportion to its falsity (Norgate); indeed, it is an "*Artificial Miracle*," which can work miracles itself by prompting viewers to recognize the truth in caricature (Wotton).[88] The picture of Sarpi Wotton distributed might serve as an example; the serene face marred by an assassin's attempt illustrated both the evils of popery and the fortitude needed to

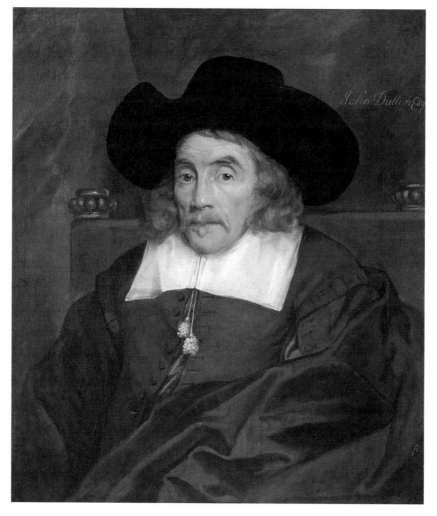

Figure 52 Francis Cleyn, *John Dutton* (*c.*1643).

overcome them—a message, if not a medium, entirely acceptable to Prynne's faction.

Another reason for the pious to distrust pictures was their connection with the stage. Masques, declared Jones, downgrading Jonson, are "nothing else but pictures with light and motion."[89] A tragedy with a strong plot, said Aristotle, is like a well-conceived painting, *ut pictura poesis*. With deceitful colors applied *con amore*, portraitists can "catch the lovely graces,

witty smilings, & sullen glances which passe sodainly like lightning" across the faces of their sitters and can claim a place on Parnassus along-side epic poets. Like poets, painters must bring out the universal in the individual, which, if successful, must involve some distortion. Prynne was right, a portrait is a selective caricature, and therefore deceitful; but wrong in condemning the result as necessarily untruthful. Skillful por-traitists reveal character economically, indeed, with the discipline of the most spare and retrograde Puritan. For good painters, again like poets (and also politicians), should not complicate their counterfeits with gim-micks; the multiplication of novelties in portraiture, as of neologisms in literature, shows not power to improve, but inability to master, an art.[90]

Cleyn's portraits observe this sophisticated naturalism. Williams is convincing as a healthy sober man of middle age, perceptive, reliable, and sympathetically attentive to young John, whom he is trying to interest in the wider world represented by the carefully chosen items on the table. John is depicted more subtly. No doubt he is a perfect rendition of a listless adolescent, apparently indifferent to his studies and more interested in striking a fashionable melancholic pose with his splendid dark clothes and the awkward, if not impossible, posture of his left hand, a device Cleyn may have taken from Isaacsz or Van Dyck (see Figure 1).[91] But the boy's melan-choly may also be of the genuine intellectual kind, as indicated by the approach of his right hand toward the table, his outsized head, and averted gaze. Is he suffering from the effort of thought? Is he sick, proud, miserable?

Williams may be recognized as a physician by his jewelry, if, as appears, his ring is of topaz, a gemstone reputed for its curative properties, and his ruff tie is of turquoise, known to promote healing. The objects on the table of cosmology are perhaps not entirely what they seem. The item that might be taken for a rolled-up nautical chart is a telescope with draw-tubes. Surviving examples usually have a tooled leather covering or other decoration of the main body of the instrument; Cleyn's version without decoration, perhaps a German or English model, improves the confusion of nautical chart and perspective glass.[92] It does not resemble the conven-tional representation in his series on the *Five Senses* or the *Seven Liberal Arts*.

The telescope in the liberal art "Astronomy" (see Figure 48) resembles the flute in "Music," both being slender cylindrical wands; that in "Sight" (see Figure 41), aimed by a putto at grotesque work, is slightly more realistic; but, in contrast to the model in our picture, both belong to Cleyn's world of make-believe. As we know, the telescope, alias perspective, prospective, or Galilean glass, had many meanings; and, although here its fundamental note might be a metaphor for travel or instrument of investigation, its overtones—clarity of vision, perception of truth, guide to life—would have been heard by educated viewers of Cleyn's picture.

The telescope and its companions, the globe and books, do not have the sort of claim to reality as do the items carefully rendered in *The Linder Gallery* and many other contemporary depictions of studios and Kunstkammern.[93] In contrast, the vagueness of the props in Cleyn's double portrait enhances the real-life story of Williams and Bankes. The telescope can be mistaken for a rolled-up chart; the compass, though rendered delicately, may be for measuring or drawing; the books have no titles; and the globe has no features definite enough to fix a destination, although the portion of the globe facing the viewer suggests the North Atlantic as depicted in English maps of the 1630s.[94] Sir John Bankes was familiar with this geography, from charters and grants he had drawn up when Attorney General, and so perhaps was Cleyn, from his association with the former Virginia Company's former treasurer Sandys. If the landmass facing the viewer is North America, the brass pointer at the globe's pole would indicate Europe as the likely destination of young Bankes's travels.

A famous painting by Van Dyck of Lord and Lady Arundel sitting by a large globe (Figure 53) suggests another possibility. Arundel is pointing toward the island of Madagascar, whose colonization the Arundels were promoting. Endymion Porter had urged Charles to send an expedition to this tropical paradise under the direction of Prince Rupert (then, in 1637, only 17) to remove the French and Portuguese, and in 1639 the Arundels, as usual needing ready money and worried about possible enforcement of the recusancy laws against them, obtained royal approval to make the attempt. The earl contemplated going himself. So did Davenant: "I wish'd

Figure 53 Antony Van Dyck, *Thomas Howard, Earl of Arundel, and his Wife Lady Alethea Talbot*. The couple are caught considering a trip to Madagascar (c.1649).

my Soule had brought my body here | Not as a poet, but as a Pioneer." In Davenant's poem, the pioneers led by "the first true Monarch of the Golden Isle"—that is, Prince Rupert—destroy an unidentified enemy to open Madagascar to the English.[95]

That was poetry. In prose nothing happened until 1643, when a disaffected former employee of the East India Company, a surgeon named Walter Hamond who had visited Madagascar in 1630, advertised that the island groaned with gold and gems and boasted a soil so fruitful and water so plentiful that the "sluggish and slothful" natives lived off them without planting or sowing. Among their other merits was ignorance of navigation, which had almost ruined England with drunkenness from Germany, fashion from France, insolence from Spain, Machiavellianism from Italy, and pox from America. Hamond's short account ends with the allurement that its women went naked, which at first "made our eyes unchast." After a week the gallants could gaze where they pleased without quickening their pulse, "as we behold ordinarily our Cattell," and had discovered that "the dresse of women, allures more than their nakednesse." Inspired into rare agreement, parliament and king both authorized an expedition, which sailed, with 145 people, early in 1643. The adventure proved a disaster, as anyone who had read Heylyn's *Mikrokosmos* would have foretold. "The people are treacherous and inhospitable," he had written, ignorant, without religion or a calendar, "onely laudable … [in] restraining themselves to one wife."[96] The British expedition came to grief owing to fever, hunger, malaria, and the natives' "barbarous shriekings, which they term singing."[97] News of the disaster would have scuttled any plan Sir John might have had to enroll his son in Arundel's project to colonize Madagascar.

The compass John Bankes holds so listlessly, as if reluctant to measure the distance to Madagascar or Newfoundland or somewhere else he did not want to go, seems to be a pair of single-handed dividers convertible into a drawing compass. Although the basic design goes back to the sixteenth century if not earlier, no exemplar has come to light.[98] Presumably Bankes would use it in his studies, if he devoted his Saturnine energy to them. Mindful of Wotton's observation, "[e]very Nature is not a fit stock

to graft a Scholar on," we should think that Williams wanted not to make a mathematician or an astronomer of young Bankes, but only to have him learn cosmography to the extent Peacham and Fuller recommended for a gentleman of average capacity.[99] If, however, the imperturbable boy was a true melancholic intellectual, he had easy access to a complete education in the mathematical sciences. John Greaves lived at Merton across the street from Bankes's rooms at Oriel.[100] Since Greaves had every reason to serve Sir John Bankes, to whom, as an elector, he owed his chair, we might reasonably conjecture that he did instruct young Bankes, and that the telescope, globe, and the Galilean book in Cleyn's painting came from the cabinet of the Savilian professors. It had everything needed: Savile's library, globes and telescopes, and a copy of the Latin translation of the *Dialogue*, the *Systema cosmicum*, in the first edition of 1635.[101]

Several colleges also had copies of the *Dialogue*. Payne gave his to Christ's Church in 1642. The Bodleian has copies associated with Savile and Selden. Those now at Queen's and St John's, acquired in the 1650s, might have belonged to members there in the 1640s. Balliol, Greaves's college, has a copy of the *Dialogo* of 1632 bound together, most appropriately, with Sarpi's posthumous *Historia della Sacra Inquisitione*.[102] Another would have been present if anyone at Oxford bought the copy or copies offered for sale in London in 1639.[103] A reprinting of the *Systema* in Leyden in 1641 brought more copies, five of which would now be on deposit if one had not been stolen from Christ's Church in the 1990s. The publisher of the reprint of 1641 misstated its content and purpose in a blurb that deserves preservation as unusually nonsensical: by returning the sun to its rightful place, Galileo's *Systema* defeated the ancients and suppressed quarrels among astronomers.[104] The only unidentified item among the props is the heavy book holding the *Dialogue* open. A guess at its identity will be made in due course.

Having the props and the people, Sir John had only to procure a painter. He could not commission his own portraitist, Gilbert Jackson, who had died soon after finishing his lifeless image of the Chief Justice.[105] Perhaps Sir John invited Cleyn, whose work at Mortlake he knew, to work in Oxford; perhaps he found him there, in Dobson's studio. Cleyn was ready

for the work and eager to give of his best. His income had plummeted with the idling of the tapestry works and he still had children to educate. Three wanted to become artists. They were to make modest reputations, the girl, Penelope, as a miniaturist and the boys, Francis and John, as draftsmen. Evelyn saw pen drawings the sons made after the famous Raphael cartoons copied by their father, "where, in fraternal emulation, they have done such work, as was never yet exceeded by mortal man, either of the former, or the present age."[106] Nothing securely attributable to either of the sons seems to have survived.

Cleyn drew young Bankes seated on the chair on which Dutton had sat, the same sort of chair that Rubens and Van Dyck had used for some of their portraits.[107] The posture thus imposed challenged the painter's ability to depict the character of a melancholy sitter in the manner prescribed by Italian authorities. According to Alberti, "a sad person stands with his forces and feelings as if dulled, holding himself feebly and tiredly on his pallid and poorly sustained members." Lomazzo arrives at the same place (a melancholic should be rendered as pensive, sorrowful, and heavy) after reviewing eleven delineable passions of the mind and bodily expressions of humoral imbalances. But Lomazzo concedes that slavish adherence to these rules does not produce a great work of art; which "cannot be attained unto, by the mere practice of painting, but by the earnest studie of Philosophie."[108] Lomazzo was an authority worthy of attention, another Aristotle in the opinion of his English translator, for the depth and extent of his "most absolute body of the [rules of the] Arte."[109] Cleyn knew the rules. It was by combining them with an "earnest studie of Philosophie" that he was able to portray a heavy melancholic young man, "holding himself feebly and tiredly" in a chair.

Not only must a theorist be tinctured with philosophy to make an excellent picture, but its viewers, like the painter, must also be "filled with a great variety of learning." This was the opinion of Arundel's librarian Junius, who continues, "without this purifying of our wit, enriching of our memory, enabling of our judgment, inlaying of our conceit," we will never be able to get beyond evaluation of coloring and draftsmanship. An amateur properly

prepared can judge a painting as accurately as its creator.[110] Wotton had considered the matter. "An excellent Piece of Painting," he said, becomes "an *Artificiall Miracle*" when viewed "philosophically."[111] Viewing is hard work. "The Expressions are the Touchstone of the Painters Understanding…But there is much Sense requir'd in the Spectator to perceive, as in the Painter to perform them."[112] Would not a philosophical critic have thought Cleyn's rendition of tutor and pupil, with its economical evocation of their mood and bond, superior to Jan Lievens's sumptuous presentation of King Charles's nephew, Charles Louis, and his tutor (Figure 54)? Submerged

Figure 54 Jan Lievens, *Prince Charles Louis and his Tutor* (1631).

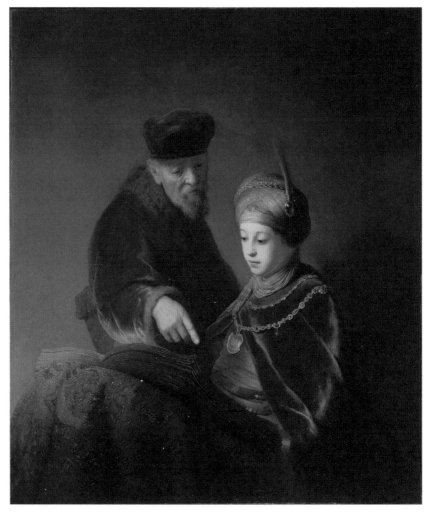

Figure 55 Gerrit Dou?, *Prince Rupert? and his Tutor (c.1630)*.

under his elaborate drapery and placed before the huge book he is supposed to be studying, Charles Louis looks appropriately despondent, and there is no rapport between him and his tutor, whom we may suppose the chief cause of his discomfort.[113] SOMEONE in Rembrandt's studio handled the same subject more gently in a portrait, perhaps of Charles Louis's brother Rupert: the tutor is not so overbearing, the book is smaller, and the boy regards it intelligently. In neither case is the book identifiable (Figure 55).[114]

Viewers of Cleyn's mysterious masterpiece did not need to know much about the sitters, or even recognize them, to philosophize about the painting. The power of a portrait is not in the identity of the sitter, who, if not uncommonly famous or infamous, is soon forgotten. The poet Abraham Cowley, who was in Oxford about the time Cleyn painted our picture, noticed the frenzied portrait painting of cavaliers and the fleeting interest in their identity. "The man who did this picture draw | Will swear next day my face he never saw."[115] Put in a little puzzle like a reference to Galileo, however, and your portrait of an unknown boy might live for hundreds of years.

9

THE IMAGE

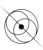

The society in which the Bankes family lived and worked was constantly exposed to old star lore and new astronomy through almanacs, plays, literature, handbooks, and political and religious discourse. The better instructed must have known enough to recognize the allusion to Galileo in Cleyn's painting. What did it mean to them? Galileo's way of exploring answers to difficult questions, by way of dialogue among quasi-fictitious characters, suggests a route to an answer. We shall have a dialogue. As in Galileo's, the characters will take positions they would have assumed in life: Dr Williams (MW) resembles the omniscient Salviati and John Bankes (JB) the sharp-witted, commonsensical Sagredo. Francis Cleyn (FC), like Simplicio, is a gentle, composite figure, but of master artists, not of slavish philosophers. There is a fourth interlocutor, offstage but never far away, whose ideas direct most of the conversation: Galileo himself in his *Dialogue*, Sir John Bankes in ours. Also, as in a Galilean dialogue, we must have digressions.

The conversation takes place in Gray's Inn, in the rooms of John's brother Ralph, who is studying law. Cleyn's painting has probably hung there since its completion a decade earlier. The Bankes family had chambers even after Sir John's death; he had enrolled his eldest sons in Gray's Inn during their childhood to encourage them to study law after terms at Oxford or Cambridge.[1] At the time of our dialogue, John is a confident, wealthy young man, transformed by travel from the feckless youth we knew. He had gone to France in 1645, improved his knowledge of French in Paris, and soon set off for Italy. On his way he fell in with a Dutch jurist who stretched his mind with the grotesque claim that the university of

Leyden, with its Scaliger, Grotius, and infamous Arminius, was more distinguished than the much older Oxford of Bainbridge and Greaves.[2]

Threading his way between the two Italys of the guidebooks, between "the Nurse of Policy, Learning, Musique, Architecture, and Limning" and the gymnasium of vice, epicurizing, whoring, poisoning, sodomizing, and atheism, further broadened him. If he acted on his guidebook's report that a traveler is "accounted little lesse than a foole, who is not melancholy once a day," he might have passed for an intellectual.[3] In any case, he took on enough of the continental to practice the bad habit, censured by the guidebooks, of acting the foreigner on his return. Or so we infer from a note that "Giovanni Bankes" addressed to his acquaintance from Oxford days, Justinian Isham, "tra i boschi ameni a campo Elisée di Richemont."[4]

Cleyn had substituted graphic for tapestry design as his main work after completing our painting. He moved to London, to the parish of Covent Garden, where he remains, buried in Inigo Jones's oddly oriented church. He stayed busy making hundreds of drawings for coffee-table books for Ogilby, the limping dancing master who translated Aesop and Virgil into limp verse. A few of the drawings from which the engravers worked survive. An exemplary one shows poor doomed infatuated Dido leading Aeneas to their cave to escape the downpour that interrupts their hunt, while in the background the monster Rumor, covered in mouths and ears, her head in the clouds, wings open, stands ready to spread the lovers' doings far and wide (Figure 56).

The Mortlake works had scraped by with a few commissions for old sets until Cromwell took an interest in tapestries and Cleyn could return to making cartoons. The themes appointed, the *Story of Abraham* and the *Triumphs of Caesar*, suited the Protector's mix of religion and militarism.[5] By a rare agreement between king and parliament, Cleyn kept tools and designs from Mortlake in his London studio, where they joined paintings by Titian, Tintoretto, and Van Dyck. There were excellent copies of other masterworks, including the Raphael cartoons, all done by Cleyn's two sons.[6] To his great sorrow and the world's loss, both died young, leaving, as his last artistic offspring, his daughter Penelope, who gained some reputation as a miniaturist.[7] Cleyn gave some of his select collection,

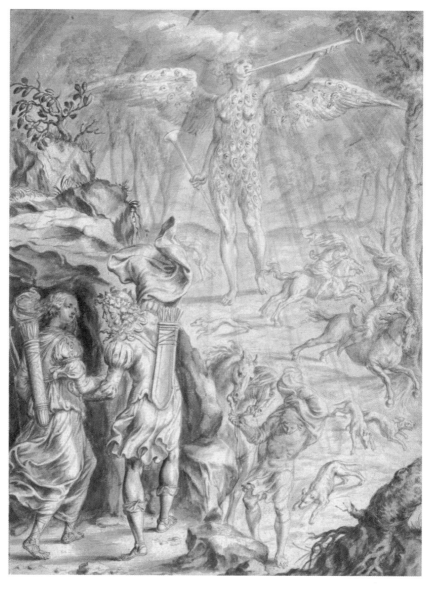

Figure 56 Francis Cleyn, *Dido, Aeneas, and Rumor (c.1654)*.

regrettably identified only as "draughts and pieces of paintings of sundry excellent masters," to John Tradescant for preservation, along with gifts from King Charles, the Duke of Buckingham, Laud, Wotton, Digby, and the Countess of Arundel, in his famous Ark.[8]

The third of our interlocutors, Maurice Williams, had risen in the medical world since leaving Oxford. In 1651, he became an "elect," or senior member, of the College of Physicians. He had made his peace with parliament, which sent him and two other physicians to Ireland in 1652 on urgent unspecified business. He had property there to dispose of, evidently not extensive, for which he compounded with parliament for £20. If he paid this ransom at the same rate as the Bankeses, the property would have been worth £400 to £500. So far the historical record extends.

At John Bankes's request, Williams arrived at Gray's Inn before Cleyn for a consultation about some medical advice John had received when taking the waters at Bath.[9] Their exchanges showed something of the doctor's erudition, discernment, and humor. The advice in question had to do with the difficult question, still with us, of what and how much to drink in England. Could one domesticate the behavior described in the adage Bankes had recorded in his travel diary, perhaps enviously, *Qui bue si garde sobre se rend italien*, "if you can drink and stay sober you make yourself an Italian"? His doctor in Bath, Tobias Venner, had reassured him: do not drink water unless your stomach is preternaturally hot and dry. Drink beer or, better, wine, as it strengthens natural heat, helps digestion, combats flatulence, and "taketh away the sadnesse, and other hurts of melancholy." Of course, Dr Venner advised, no one should drink immoderately except kings and great officers of state. Children under 14, youths under 25, and men under 35 should be abstemious, temperate, and careful, respectively; but over 35 you can drink wine as you please, for "it mightily strengtheneth all the powers and faculties of the body," especially in people in the later period of old age—that is, over 60.[10] A wise physician! There remained the question whether wine should be consumed hot, cold, or tepid.

JB. As you know, Sir Maurice, I suffer from a melancholy stomach and learned from Venner that cold was bad for it. He says that the omniscient Lord Chancellor Bacon recommended that we should

warm our stomachs with a hot drink before dining even in midsummer. Bacon proved the danger of excessive cold very dramatically if it is true that he died at Lord Arundel's house after trying to stuff a chicken with snow.[11]

MW. Bacon did not die from stuffing snow into a chicken but from swallowing medicines he prescribed for himself.[12] Incidentally, the custom of drinking wine before the meal is at least as old as Tiberius. As for cold drinks, unnaturally cooled by snow or ice, they are a damaging luxury. But I've seen Florentines put ice in wine and the Sienese keep wine jars in cold water, on the advice of no less a man than Girolamo Mercurio, who doctored Galileo.[13] Mixing wine with cold water, however, can produce excellent results. When the Nymphs washed Bacchus they used cold water. Symbolic, no doubt. Plutarch advises watering wine by harmonic proportions: 3 parts water to 2 of wine (a fifth, musically speaking) for the merriest; the octave (2:1) for the staid; and the product of the two (3:1) for the abstemious. Here is another curiosity from Plutarch for you. After the ancients forbade women to drink wine they invented kissing to discover infractions.[14]

JB. Venner says that a ratio of 2 or even 3 parts of water to 1 of wine is suitable for southerners, but 1 to 1 is the recipe for England, and 0 to 1 for men of your age. He says nothing about kissing but urges frequent cleaning of the teeth and avoidance of radishes, which might be intended as a preparation for it.[15]

MW. Excellent advice, all of it, but enough of it. Let's prepare for our talk by looking over Cleyn's illustrations for Sandys's *Ovid*. They are very clever, attractive in themselves and a great temptation to play at *sortes virgilianae*. We need only open the book at random. Well, well, here is an augury, Cleyn's depiction of bugonia, that queer old practice of growing bees from the carcasses of slaughtered cattle (Figure 57). Bees! No doubt we shall have sweet conversation as we buzz about our portrait. There is Aristaeus, who invented or perfected the practice; Cleyn has him appear a little perplexed by his

Figure 57 Francis Cleyn, *Bugonia*, from Virgil's *Georgics*, book IV, in John Olgilby, *Virgil* (1654).

success.[16] It reminds me of the conclave that elected Urban VIII when I was in Italy. Barberini and his bees emerged from it over the bodies of several cardinals who died of heat or old age during their long burial in the Vatican. Ah, here is Mr Cleyn.

FC. I apologize, gentlemen, for my tardiness. The fields are wet and though I picked my way carefully I got moist in the nth degree, as old John Dee might have said. He made algibberish out of everything.[17] It is a beautiful place, Gray's Inn, but a little isolated. Yes, thank you, a cup of sherris-sack, just the thing for a cold stomach.

JB. Well, here is the painting. What do you think of it?

FC. It needs cleaning. The London smoke ruins everything even in these outskirts. But I'm glad to see that the Galileo emblem still stands out clearly.

JB. That comes to the heart of the question quickly enough. How did you think to put it there?

Gaps

FC. It wasn't my idea. Dr Greaves brought it to me. He said that I should take care to put it in the painting, but not paint in it, which I suppose was a mathematician's joke. I knew the book. I had looked at a copy here in London quite carefully, to study the design of its frontispiece, an art in which I can claim a professional interest. It is one of the most brilliant frontispieces I know, maybe the most brilliant. Just the spacing of the figures is stupendous! It is so singular, it is instantly recognizable—only by people who know the book, of course. The brilliance is, I say, in the spacing: the figures evidently are engaged in friendly conversation, but one of them just as clearly opposes the other two and is somehow the strongest. And that is shown just by the spacing and the attitudes. Brilliant! And to think that della Bella was only 20 when he conceived it.

MW. It is a very clever design. He did something similar for a book in my field by the chief physician to the Grand Duke of Tuscany, Giovanni Nardi. Della Bella needed tact as well as talent to do both jobs at the same time. Nardi rated his fellow courtier Galileo an

arrogant thieving novelty hunter for pinching the idea of the telescope from della Porta and the idiocy of a moving earth from Pythagoras. Della Bella's frontispiece to Nardi's book, which is about milk, plays with three figures separated two to one as in the *Dialogue* (Figure 58): two sick rustics offer Aesculapius what seems to be wine and burnt offerings to effect a cure; he points to a statue of a woman from whose breasts milk is pouring into a pool. Milk not wine is nature's food.[18]

FC. Both drawings use the convention of a stage or portal where allegorical figures advertise the nature of the entertainment or instruction discoverable within.[19] For the *Dialogue*, della Bella turned the stage into a strand on which his three figures talk under a curtain carrying the title and raised to reveal a harbor (see Figure 3).

MW. And on the strand, for the cognoscenti, are strewn some arrows and cannon balls from Galileo's experiments.

FC. I should correct myself: the figures do not talk. Their stance conveys their meaning. Compare Marshall's frontispiece to Wilkins' book, where each person says something about his position (see Figure 25); in my opinion, a picture should tell its own story without reliance on written clues. In Marshall's frontispiece to our late king's ghostly testament, *Eikon basilike* (1649) (Figure 59), the suffering sovereign talks to himself. "Caeli specto beatam et aeternam," "Mundi calco splendidam et gravem," "Christi tracto asperam et levem." Even a rock speaks ("immota triumphans") and also a tree ("crescit sub pondere virtus")![20] And the frontispiece he did for Mr Quarles's *Fons lachrymarum*! Five people talking! I remember a badly drawn King Charles bending over a woman and saying something like, "look at the face, behold mine."[21] Really!

JB. But perhaps you carried your principle too far, Mr Cleyn, in omitting the author and title of Galileo's book from the impression of it in our painting.

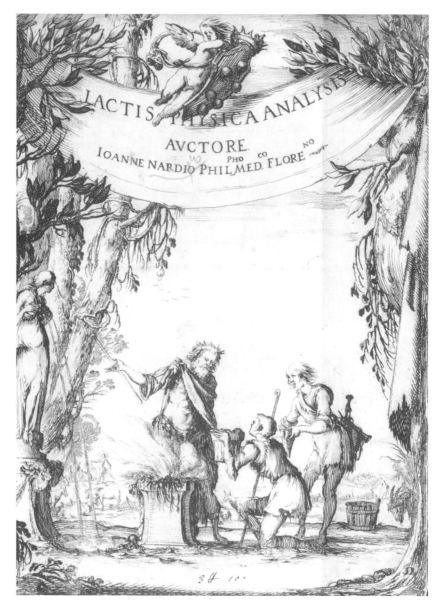

Figure 58 Stefano della Bella, frontispiece to Giovanni Nardi, *Lacta physica analysis* (1634).

Figure 59 William Marshall, frontispiece to *Eikon basilike* (1649).

FC. But does that not make the question why that particular book, once identified, is there, all the more worthy of investigation? Only people who had seen it before and knew the circumstances of your family, Mr Bankes, could interpret it.

MW. We shall go there in just a minute Mr Cleyn. First I want to say a good word for Marshall's art. He can be quite witty. I'll give you two examples. One is his adaptation of the title page of a favorite book of mine, Bacon's *Novum organum*, to suit a recent edition of the *Advancement of Learning*. The original presents the Pillars of Hercules as the gateway to discovery, or the proscenium to the theater of the new world, under

347

a slogan taken from the prophet Daniel, *Multi pertransibunt et augebitur scientia,* "many will pass through and knowledge will be increased."[22] In Marshall's version, the pillars consist of columns of books surmounted by obelisks, one reading "Oxonium," the other, "Cantabridgia" (Figure 60). Oxford's obelisk stands on Bacon's most important works and a pedestal marked "Science" advertising tough subjects such as history, philosophy, and poetry, all acquired by reason; Cambridge's obelisk stands on Bacon's slighter works and its pedestal, marked Philosophy, advertises its humanizing, natural, and divine divisions, acquired with the help of God. A terrestrial globe (the visible world) and the sun shine over practical Oxford, an empty sphere (the intellectual world) and a moon dominate lunatic Cambridge; and two owls holding torches illuminate the name of the printer and his employer, the University of Oxford.[23]

FC. I admit, there is something clever in that.

MW. The second piece I have in mind is the befuddling frontispiece to George Wither's *Collection of Emblems.* Although he had no idea what most of them meant, that did not stop him, or anyone else, "Who many times, before this Taske is ended | Must pick out Moralls, where none was intended."[24] Let us keep this salutary warning in mind!

JB. I suppose that Galileo must have had a hand in della Bella's drawing for the *Dialogue.*

FC. He had some training at the famous art school in Florence, the Accademia del Disegno. And you can see in the extraordinary drawings of the surface of the moon in *Sidereus nuncius* that he knew about foreshortening and other tricks of the trade.

MW. Also, it is hard to credit that the young della Bella knew enough about Galileo's work to put in the arrows and weights on the ground or the reference to the ships and the wharf.

FC. No doubt, Sir Maurice, but I feel confident that the soul of the drawing came from della Bella. As an artist he was well acquainted

Figure 60 William Marshall, frontispiece to Francis Bacon, *Advancement of Science* (1640).

with what I call the three-body problem: how to represent a triplet of people of unequal rank on the same canvas, say two saints and the Virgin or two laymen and a saint. There are very pertinent examples in Venetian painting that Galileo might have seen during the many years he spent in Padua. They are by a very famous trio of artists (there is not much space between them!) who sometimes worked together, Giorgione, Titian, and Sebastiano del Piombo.[25]

MW. What were the trio's solutions to the three-body problem?

FC. From Titian I have in mind a painting you probably know. Van Dyck made a copy of it in Venice and later it hung in the king's gallery. It celebrates a victory over the Turks by a Venetian fleet led by a bishop, Jacopo Pesaro, who was put in charge by Pope Alexander VI. The picture shows the pope presenting the kneeling bishop to St Peter seated on a throne. Between the saint and the prelates is an eloquent space expressing the difference in merit between them. Titian uses this space to depict a part of the fleet on its way to engage the Turks.

MW. The gap of merit is well observed, Mr Cleyn. Now that you have me thinking in gaps, am I not right in recalling that you put two of them in your tapestry *The Miraculous Draught of Fishes*, between Christ and Peter and between Peter and the other apostles (see Figure 39)?

FC. Well observed, Sir Maurice! The gap of merit in the painting by Sebastiano I am thinking of is a window through which the viewer sees a distant landscape. St Catherine and St John the Baptist make a group on one side of the window, the Virgin holding the child a single figure on the other. The third picture, by Giorgione and Sebastiano, offers an interesting variation. It depicts three philosophers. Since they enjoy the same level of being, no gaps occur between them; instead, the artists have individuated them by props and attitudes. One, a youth holding a T-square and drawing compasses, sits with his back to the other two, a tall man in oriental garb and an old man holding a paper covered with strange figures. What

it all signifies no one knows for sure; for me it is enough to know it has no gaps of merit.

MW. There are dozens of interpretations each more fanciful than the next: the Magi; Aristotle, Averroes, and Virgil; Archimedes, Ptolemy, and Pythagoras; Aristotle, Averroes, and Regiomontanus; Moses, Averroes, and a Christian; Plato, Aristotle, and Alexander the Great.[26]

JB. Too bad that chronology rules out Galileo's trio Aristotle, Ptolemy, and Copernicus. If I understand you correctly, Mr Cleyn, the separation between Aristotle and Ptolemy, taken together, and Copernicus taken alone in della Bella's description is to be read as a gap of merit.

FC. That's it, and that is not all. Della Bella drew Copernicus as an old man resembling Galileo: the gap thus separates ordinary mortals from the sublime mathematician–philosopher of the Grand Duke of Tuscany. The editors of the Latin edition missed this subtlety and had the frontispiece redrawn, using the standard representation of Copernicus as a clean-shaven young man. The redrawing of the frontispiece by van der Heyden, which is based on Copernicus's self-portrait, thus destroys what was almost certainly the original intent, to show Galileo with a gap of merit.

JB. What you say, Mr Cleyn, fits well with the habit of astronomers of depicting themselves on their frontispieces as the latest adept of their science. So, if I remember correctly, Philipp Lansbergen places himself in his *Tables of Celestial Motions* after Aristarchus, Hipparchus, Ptolemy, Albetagnius, and Tycho. To make clear that Lansbergen stands for Copernicus, he put in a sun-centered zodiac between his effigy and Tycho's around which the earth revolves as if it were a roulette ball (Figure 61).[27]

FC. Since I've gone this far, I'll confide another of my reasons for considering della Bella's rendition a play on threesomes. When I was in Denmark I worked on a program of the seven ages of man developed by Tycho's disciple Longomontanus. From him I learned that no

Figure 61 Frontispiece to Philipp Lansbergen, *Tabulae motuum coelestium* (1632).

respectable astronomer believed in the old earth-centered system anymore, but that many accepted Tycho's system rather than Copernicus'. Where is Tycho in Galileo's *Dialogue*? Certainly not in the frontispiece, where he would have made up an awkward quartet both symbolically and graphically. The frontispiece puts a gap of merit between the ancients and Copernicus by omitting the major modern challenger to the world system Galileo championed.

JB. I recall that in Kepler's allegory of the history of astronomy, contained in his wonderful frontispiece to the tables he calculated using Tycho's data, there are no gaps of merit, just equal spaces, between the representations of the major contributors to astronomical knowledge including Tycho (see Figure 23). Of course, and rightly, Kepler put himself in the series [seated, in the left-hand panel of the base of the gazebo]. Galileo did indeed load the dice in omitting Tycho from the inventors of world systems. But to return to our main question, which is not a gap in merit but in knowledge, who asked Greaves to bring Galileo's book for inclusion in our painting?

MW. Greaves cannot tell us since he died last year here in London. The parliamentary visitors to Oxford headed by that hothead Nathaniel Brent had ejected him from his professorship. That was not fair, but Brent was strong against monarchy. I think his sympathy with the Republic of Venice and his intimate familiarity with Sarpi's *Trent*, which, as you may know, he translated into English, colored his mind. I was called in when Greaves took ill. He was incurably melancholic over his forced separation from Oxford. His appointment as Savilian Professor was the fulfillment of his dreams. He was just 50. But I can answer your question, John. I asked Greaves for the book after a conversation with your father, who wanted a symbol personal to you and, by an appropriate reference to the troubles of the time, also to him.

JB. So the question becomes why he decided to refer to Galileo. No doubt he had several reasons. He seldom did anything if he could think of only one reason in its favor. He was a great lawyer.

MW. One reason is obvious. Since you and I were then studying astronomy and reading the *Sidereus nuncius,* a reference to Galileo in a picture painted on your leaving the university would have commemorated your studies and interests. That would have been an ordinary gesture.

JB. And it would also have commemorated Galileo, who died the year before I went up. Father would have had that in mind too. He admired Galileo for several reasons. He knew a lot about mechanical devices from his upbringing in Cumberland and from evaluating proposals for monopolies when he was Attorney General. He could appreciate Galileo's work in transforming the Dutch spyglass into a practical instrument for military and commercial purposes. And for searching the heavens. Father took an interest in astronomy, not least because it supplied nice images for his legal arguments; he invented a complicated one when defending ship money that may have helped him win his case. He understood that Galileo had discovered something new about the size and complexity of the world and respected him for his courage in proclaiming it.

MW. What then did Sir John make of Pope Urban's condemnation of Galileo?

JB. It gave him a problem. As a law-and-order judge, Father did not criticize Urban for disciplining Galileo in so far as he had violated an edict or injunction properly drawn up and served: but as a fair-minded man, he could not excuse Urban for exacting an unusual penalty, keeping Galileo under house arrest for so many years and then harrowing him beyond the grave.

FC. Do popes claim jurisdiction in the afterlife? No wonder our recusants are so intractable!

JB. No, I meant that Urban refused to allow the Florentines to give Galileo a suitable monument, or even a decent burial, because he had been "vehemently suspected of heresy." He deserves a monument as

great as Michelangelo's, or perhaps he should share it if it is true that he inherited Michelangelo's soul.

MW. Urban had exercised a similar after-death authority over Sarpi. The Venetian Senate wanted to raise a monument to him. Urban told their ambassador that it would be inappropriate to honor a man excommunicated by a pope. The senate did not think the matter important enough to go to battle with Rome and acquiesced, no doubt expecting to put up a proper statue one day. Anyway, Galileo and Sarpi created their own monuments. Sarpi's *Trent*, which Sir Henry Wotton rated the best book on the subject ever written in Italian, ranks with Galileo's *Dialogue*, which has a fair claim to being the greatest literary product of the Italian Renaissance.[28]

JB. I know Sarpi's book, not as Italian literature but as English propaganda. Father bought a copy of the 1640 edition of Brent's translation. I cannot say that I have read it, but he did, all the way through. He liked to read the wittiest attacks on the papal establishment aloud, so I absorbed some of it. Curious that Urban reunited Galileo and Sarpi in that great gap in afterlife, Limbo!

[Not until 1892 did the Venetian government think it expedient to raise a monument to Sarpi against continuing objections from Rome. Like the monument to Bruno, erected in the Campo de' Fiori in Rome in 1889, Sarpi's bigger-than-life statue stands at the scene of his suffering, the foot of the bridge where the assassination attempt on him occurred. Appropriate anti-church speeches accompanied its unveiling. Galileo got his monument 155 years earlier—a proof that physics is less dangerous than history—opposite Michelangelo's in Santa Croce. He came minus a few body parts removed by souvenir seekers. Sarpi's remains wandered further than Galileo's, in and out of monastery, church, library, and private home, and may probably be as widely distributed as fragments of the true cross.[29]]

JB. I should add about my father's interest in Galileo's case that he very much approved of John Milton's use of it in his pamphlet on the censorship of the press, which has some pompous Greek title, *Areopagitica* I think…

FC. What does it mean?

MW. It refers to an oration by an ancient Greek urging a return to government by aristocracy rather than by democracy, which he thought had failed. The title suggests the argument favored by all sides in our political debates: the way to mend is to return to the past. Thus Milton's title, which suggests renovation, goes against his evocation of Galileo, the champion of innovation.

JB. Milton's essay was one of the last things my father was able to read. Although he sharply prosecuted people whose writings he considered seditious, he did not like the practice of censorship before publication, especially of matters having little or nothing to do with the royal prerogative. I remember his reading to me in Oxford Milton's powerful image of "the famous Galileo, grown old a prisoner of the Inquisition, for thinking in astronomy otherwise than the Franciscan and Dominican licensors thought."[30] My father must have taken Galileo as a symbol of legitimate questioning suppressed by improperly exercised authority.

Ambiguities

MW. Can it be that simple, John? If your father judged that Galileo's behavior was seditious, then, as you said a minute ago, he would have thought punishment in order; Urban's fault, if any, was its severity. Galileo may have suffered more than strict justice required, but that does not make him "a symbol of legitimate questioning."

JB. Galileo was an ambiguous figure for my father. As you say, he disapproved of Galileo's disobedience to the order issued to him by his

legitimate prince, Paul V, and the prince's agent, Cardinal Bellarmine, to keep silent about world pictures. Father distinguished Galileo's behavior from Sarpi's. He admired Sarpi without reservation; in doing his best to undermine the Roman establishment, he was following the order of his prince, the doge.

MW. But Sir John opposed the Crown in parliament and tried to change the king's mind when Chief Justice. This was not quite doing his duty as you say he saw it.

JB. Well, yes. The answer is tied up with the larger question of his ambivalence over Galileo. Like many open-minded men of his generation, he was content to leave politics and religion fuzzy. He recognized that the claims of royal prerogatives, parliamentary privileges, and the liberties of the people were fundamentally incompatible. When everyone forbore, the peace for which King James and King Charles were lauded stumbled on. The same sort of unstable equilibrium existed between the Arminian church and the Calvinists. Unfortunately, Laud had too weak a mind to be able to keep things fuzzy.

MW. That is why when confrontation loomed each side insisted that it was merely trying to return to an earlier state of exemplary balance. That imaginary state, ill defined, obscured by time, was a perfect subject for fuzzy thinking.

JB. A good illustration of the importance of forbearance is the religious behavior of the Stuart queens. Anna did not parade her Catholicism and King James did not make an issue of it. Henrietta Maria constantly flaunted hers and so helped to destroy her husband. During his pursuit of the Spanish match, James may have thought that his son would have no more trouble with a Catholic wife than he had.

FC. Shall we add foreign policy and astrology to the list of items saved by fuzzy logic? Maybe King Charles's foreign policy was not transparent enough to be fuzzy. The situation is clearer in astrology. I can believe that the sun and moon influence the growth of lettuce but not

that the planets determine what I put in my salad. It is hard to know where to draw the line.

JB. I am tempted to suggest an analogy between della Bella's frontis-piece, with its suggestive blurred figures, and the hardline version of van der Heyden. Della Bella's version aligned with my father's political philosophy, which was to avoid hard confrontations. He knew that the Roman establishment had made a big mistake in meeting Galileo's challenge with its own hard line. The pope had a choice: he did not have to regard Galileo's conduct as a sort of sedition. Certainly, the Roman establishment erred in invoking Scripture against him. Father agreed with Sarpi that the popes had the bad habit of ascribing their misuse of authority to the dictates of God.

MW. Let me try to summarize what you have said, John, about your father's attitude toward Galileo. As a lawyer and a judge worried about a nascent rebellion, he saw Galileo's case as one of sedition; as an Englishman of the muddle-through school, he tried to dissuade people who insisted on challenging the fuzzy logic that underlay stable gov-ernment in church and state; but, as an educated, just, and honest man, he thought that Galileo acted correctly, even bravely, in revealing what he had found that was useful to humankind and innocuous to true religion. That is the ambiguity, and the value, of Galileo's image to thoughtful people.

JB. I would add that my father did not find muddling attractive. In points of law and treasury receipts he could be painfully exact. He did not like the dissimulation muddling entailed, even though his hero Sarpi and Sir Maurice's hero Bacon recommended the practice. Father would have liked to argue in constitutional questions like his friends Selden and Cotton; but he saw that he might be more effective after the removal of Buckingham by blunting rather than sharpening oppos-ition. Also, despite its remoteness and draftiness, he preferred Corfe Castle to the Tower.

MW. Politics is the art of the possible. Despite his occasional fulminations, King James understood this and avoided confrontation with humans by hunting animals. King Charles, Archbishop Laud, and my lamented patron the Earl of Strafford did not understand this; hence they left this world without their heads, while the English Solomon died intact in bed, perhaps, as it was rumored, with a helping hand from his dear Buckingham.

FC. It seems to me that Sir John Bankes might have exploited Galileo's image more effectively and without the least fuzziness as confirmation of Sarpi's exposure of the power grabs of the Roman church. What a convenient club to beat popes with! I wonder that our divines have not made greater use of it.

JB. Galileo was condemned in 1633, just when King Charles's personal rule was stabilizing and his Catholic problem easing. I suppose that he did not want his prelates to undercut his policy toward Rome by pointing the lesson of Galileo's continuing detention. And very probably the king regarded the disciplinary acts of the pope within his domains as legitimate if mistaken.

FC. Yes, King Charles and Pope Urban were then on friendly terms. I do not like to claim too much for my profession, but art more than politics was the reason of their mutual amiability.

JB. To say nothing of the influence of the queen and the papal agent Conn, who, to top the list of unlikely coincidences, was a friend and supporter of Galileo. My father had several conversations with Conn. He was a very witty and pleasant man and quite open about the ways of the court of Rome. So too was Bentivoglio, with whom Professor Greaves spent some time touring Rome. Their accounts almost make you feel sorry for people caught between their respect and friendship for Galileo and their obligation to their church and pope.

MW. However, ministers opposed to King Charles's flirtation with the pope and to Laud's vision of the church would have had no scruples

against brandishing what we may call the Club of Galileo against Romanism. But here again we confront an unexpected limit. Blockheads like Ross, who would apply Scripture to quash all innovation, would rather destroy Galileo than exploit him.

JB. The implication, Sir Maurice, that people in the Protestant center are more likely to wield the Club of Galileo than those on the extremes is borne out in a book Bishop Duppa mentioned to me—I got to know him through Isham at Oxford. It is a verbose rambling around Proverbs 20:27: "The spirit of man is the candle of the Lord, searching all the inward parts of the Belly." The author was a Platonist, so he ignored the bit about the belly and interpreted the candle as human reason. He then castigated Rome for blowing out the candles. "[I]f a *Galilaeus* should but present the world with a handful of new demonstrations, though never so warily, and submissively, if he shall frame, and contrive a glasse for the discovery of more lights; all the reward he must expect from *Rome*, is, to rot in an Inquisition, for such unlicensed inventions, for such virtuous undertakings."[31] To tie things off, I should say that Bishop Duppa liked to use the telescope as a metaphor for reliable investigation.[32]

MW. I accept Galileo as a symbol of legitimate inquiry suppressed by improper exercise of authority. But, while I acknowledge the depth and importance of Galileo's contributions to knowledge, I blame him for setting back the cause of science with his insistence that he was right and all who disagreed with him wrong. The arrogance that infuses his writings runs exactly counter to the more tentative and sounder approach Bacon advocated. Galileo's bullishness made it impossible for Catholic astronomers to debate freely about world systems.

JB. Sir Maurice, do you really question that the sun stands still in the center, and the planets, including the earth, circle around it?

MW. Yes, I do question it, although I think Copernicus' system in Kepler's version is far better than Ptolemy's or Tycho's. Maybe the world is not the sort of thing that has a center, either because it is

infinite or because it has many centers equivalent to our sun. The arguments about world systems with which Galileo entertained us miss the great question. His *Dialogue* is one of the greatest books to come from Italy, but it is as much Ariosto as Copernicus.

JB. I see that in your deep way, Sir Maurice, you approach the position of suspended belief occupied by such odd bedfellows as skeptics and voluntarists.

MW. With a big difference: I consider the rational investigation of the natural world to be an obligation of human beings. Skeptics and voluntarists shirk this duty as, I regret, almost everyone else does. And this is very odd. It takes far less intellectual effort to master the intricacies of modern astronomy than to explain away the discrepancies in the Bible.

JB. Even astrologers, or some of them, do not care to decide whether the earth moves or the sun. I read in the reprint of Christopher Heydon's defense of astrology that, since only the aspects count, it is not necessary to bother about the real layout of the planets. And I recall reading in Carpenter's *Geography* that Sir Henry Saville once indicated his indifference to the question of world systems with the strange analogy that it was all the same to him whether, in sitting down to dinner, he went to his table or his table came to him. Nonetheless, his cook had roasted his dinner by rotating the meat over the fire, not by running with the fire around the meat.

MW. That is almost as peculiar an analogy as Viscount Conway's argument that to move the gross earth among the light stars is as reasonable as requiring old fat people at a feast to dance while the young and vigorous sit still.[33] He had not given the question his full attention. Most people, even educated ones, do not care whether the earth spins or not; they would take an interest only if it spun fast enough to throw them off. If they penetrated far enough into the *Dialogue*, they would perhaps be reassured by Galileo's faulty proof that this could never happen.

FC. May I suggest, Sir Maurice, that people who manage to change things believe more strongly than they can demonstrate? They are the ones who make a difference, the Raphaels, Michelangelos, Sarpis, Galileos. People who withhold their assent, however correct their arguments, do not get their ideas into other people's heads. Debilitating skepticism is as much a hazard of learning as debilitating omniscience. Both positions are frozen for fear of error.

JB. The omniscient Selden did not miss your point, Mr Cleyn. He argues in one of his books, there are so many, I don't know which, that error honestly admitted can be a mighty source of advance. Galileo might be as great a source of fruitful error as of demonstrated truth. Already the Jesuits are bettering his measurements, and Gassendi and Descartes are trying to improve and extend his physics to apply to a Copernican world.

MW. By choosing the *Dialogue* as his text, Sir John separated himself from people who cry wolf at every suggestion of change and think that innovating is a prime qualification for a place in Hell. And yet, although we cannot admire those divines who rejected the Gregorian calendar on the ground that every alteration is for the worse, we cannot overlook that even improvements in the material conditions of our lives may have adverse unintended consequences.

JB. My father promoted devices and practices that he deemed likely to "improve man's estate," as Bacon put it, like the prolific inventions of the Moravian van Berg. He certainly understood the hazards. He championed the drainage of the fens, knowing that it threatened the ruin of the fen-dwellers, and he received some blame for it. We must have innovations and we must guard against them. Galileo is an inspiration and a warning.

FC. It is the human condition. Galileo can symbolize legitimate questioning necessary for science, as Mr Bankes observed, or, as Pope Urban thought, disobedient meddling subversive of religion; or, as we seem to agree, perpetual struggle between innovation and conservation.

JB. I remember that the first Copernican book you had me read, Sir Maurice, Wilkins's *New Planet*, has at its first proposition something like, "That the seeming Novelty and Singularity of this opinion, can be no sufficient reason to prove it erroneous."[34]

MW. If we are to believe what John Barclay wrote in his *Mirrour* of European minds, the English have the peculiarity of holding on to any law or custom, no matter how ridiculous, provided it is ancient, and yet in cosmology are willing to follow the strangest modern opinions, for which, of course, he takes the idea of a moving earth as exemplary.[35]

FC. Who was Barclay?

MW. A very popular French–Scottish writer trained by the Jesuits and pensioned by King James. According to his informed cosmopolitan opinion, it is almost impossible to make Englishmen accept anything new; and, in the rare cases that they do, they pick the craziest.

Multivalence

FC. What you say reminds me of what King Charles said when he came to see your portrait.

JB. A royal review? You never told us that.

FC. Well, I thought that he just came by to see whether I might be competent enough to paint his portrait. He considered many options after Van Dyck died. He was familiar with practical mathematics and emblems and even with my inventions on the borders of tapestries and recognized the Galilean frontispiece.[36] Perhaps he was a closet Galilean. If I heard him correctly, he muttered, "Galileo could stand for me." What do you suppose he meant?

JB. I would have thought that the king would identify himself with the rightful ruler (the pope) and Galileo with the upstart Parliament. Galileo was guilty of something like sedition for having defended the

Copernican theory after it was judged contrary to Scripture, and King Charles, not to mention Star Chamber and my father, punished even trivial acts or statements they deemed challenges to the royal prerogative. Remember the case of the royal fool?

MW. Yes, and furthermore the late king and the late pope had many things in common through being sovereigns by divine right. That implied conflict, since the pope's sovereignty extended in principle over all Christian kings. Still, there is a natural camaraderie among absolute rulers appointed by God when they are not at war with one another. It would seem unnatural for the king to see a reference to himself in the frontispiece to a book considered anathema by the pope.

JB. How then do you explain the royal remark that Mr Cleyn says he heard?

MW. Urban was then ruling absolutely in Rome and King Charles was fighting for the right to rule in any manner against a parliament led by people he condemned as traitors. They usurped his authority just as, in our Protestant teachings, the popes had usurped and corrupted the true Catholic Church. Parliament had become the pope and he, the king, a Galileo, trying desperately to persuade the usurpers to accept the naked truth he saw so clearly. In his days of power, Charles might well have seen parliament's challenge to his right to rule as a parallel to Galileo's challenge to scriptural authority over physics. With his subsequent change in fortune, Charles could see his and Galileo's struggles as similar: Galileo trying to set the sun in the center, where it in fact belongs, and Charles striving to return to the center, where he thought he belonged.

JB. Bravo, Sir Maurice! It makes sense. During the heyday of personal rule, when the king enjoyed good relations with his court, managed religious dissent at home, and remained at peace abroad, he could identify with his fellow connoisseur and brother in divine right, the pope. When, however, his ill-advised war against the Scots forced him

to face the reality that God unaccountably had given him the right to rule as he wished without the income to do so, he had a choice between conceding to the Scots or surrendering to parliament. He mismanaged things so badly as to be obliged to do both. When he muttered to Mr Cleyn about Galileo, he regarded himself as an embattled witness to the truth and perhaps foresaw his martyrdom.

FC. Yes, that must be the point, I remember that he said something like, "man cannot be blamable to God or man who seriously endeavors to see the best reason of things and faithfully follows what he takes for reason."[37]

MW. Or, as Mr Quarles put it, the king's opponents endeavored "To banish wisdom, that at last they may | Make all the world, as ignorant as they."[38] That fits the Galileo case rather well. There is something else the king might have seen in the reference to Galileo: an unintended accusation against himself for his part in a process resembling the Inquisition's proceeding against Galileo. I have in mind the mock trial of Lord Strafford, which ended in judicial murder. By signing the extra-legal bill of attainder, the king allowed the execution of a faithful servant. Similarly, Urban, by agreeing to or overlooking irregular procedures of the Inquisition, sentenced his old friend Galileo to perpetual house arrest. I suspect that history will judge the king and the pope harshly for these acts.

JB. I think we must add another reason. Probably the main cause for the destruction of the Stuart monarchy was religious strife, particularly between Puritans and Catholics. As we all know, the king would not enforce the laws against recusants against the wishes of his queen and his Catholic peers and advisers, and perhaps also because he did not want to; he disliked the Puritans, as he made clear by allowing the barbaric mutilation of those pious crackpots, Bastwick, Burton, and Prynne. There is good reason to think that, if left to himself, he would have countenanced Catholics who acknowledged his supremacy in everything but spiritual matters. In two words, he had nothing against Catholics who opposed the temporal claims of the popes and were willing to say so by subscribing to the Oath of Allegiance.

MW. And, of course, the very best examples of anti-Roman Catholics were the group around Paolo Sarpi. It makes sense to see Galileo as a distinguished representative of good Catholics, tolerable Catholics, able to make contributions to culture of the first order and acceptable within a Protestant state as fellow Christians once they foreswore allegiance to the pope. Would that have been your father's view, John?

JB. Indeed. He saw that accommodation along these lines would be possible if only the pope would allow English Catholics to take the Oath of Allegiance or if parliament would decide not to require it. But Urban again drew a hard line and remained as inflexible as Paul V had been. So, although my father thought that Catholicism is a valid Christian religion, as, I think, King Charles and Archbishop Laud did, he regarded Roman Catholicism as a dangerous foreign power.

MW. Which returns us to our main question. Galileo's *Dialogue* was condemned because the Roman Inquisition, following the advice of Roman theologians and philosophers, decided that it conflicted with passages in the Bible interpreted in their literal sense. Galileo had argued that the Bible has no authority over the matters of interest to him, which, he claimed, were to be decided solely by sensory experience and reasoned inference. Here you have a formal contradiction of authorities over questions that had not only not been resolved by the inspired writers of Scripture but had not even occurred to them; whereas anyone could look into them, and perhaps answer them, by the methods advocated by Galileo. These were the methods I put young John here to study in the book by Wilkins...

FC. I know it, that book with the bumbling buffoonery of a title page...

MW ...at just the time that the brilliant Dr Harvey, the intrepid author of the unsettling theory of the circulation of the blood, was investigating the development of chick eggs. All sorts of other freethinking took place in wartime Oxford, some of which perhaps offended clear reason and good taste, but free and unmolested by irrelevant objections from slavish divines. Galileo is the pre-eminent example of the loss

humankind would suffer from the suppression of unauthorized opinions. And I am sure that Oxford freethinkers, or anyway those whose freedom had not made them ignorant, would have recognized this symbolic meaning of the *Dialogue* in our picture.

FC. I do not doubt that Galileo can stand as a symbol for any of these things, or for all of them, and also for himself, as a man most worthy of praise. But, with all respect, I must say that you may be missing the big picture by focusing on Galileo's troubles. If we look on Galileo as the heir to the genius of Michelangelo, the *Dialogue* is a sublime product of the bravura, self-confidence, and profound culture of Renaissance Italy. Galileo knew art and poetry and could invent more cleverly than the devil. Already *Sidereus nuncius* showed him to be a new Columbus if not a new Michelangelo, and even better than Columbus, in the proportion that heaven excels earth, and peaceful exploration armed conquest.[39] Sir Henry Wotton regarded *Sidereus nuncius* as the single most notable invention ever made anywhere, and, for its bravura, pure Florentine. Or so I remember his telling me.[40] And the *Dialogue* is even richer in invention and *arditezza*. The book could stand for all good literature in all respectable subjects.

MW. Galileo not only gave the measure of human capacity by his example, but also, by his method, showed how greater heights might be attained. For this he makes a better emblem than my Lord Bacon, who preached the possibility of progress but did not recognize that Galileo was in its van.

Abstractions

MW. The problem for Bacon was that Galileo dealt in mathematical abstractions from physical phenomena. For Bacon, a successful physics had to be fuzzy: the mathematician's compulsion to order everything by number fatally collides with all the "Idols" as Bacon called the obstacles that block our way to reliable knowledge.[41]

JB. If I remember correctly, the obstacles derive from general human traits, like lusting after simplicity (Idol of the Tribe); from individual idiosyncracies, like requiring exactness in all things (Idol of the Cave); for love of grand theories (Idol of the Theater); and for want of apt words (Idol of the Market Place). Did I get that right, Sir Maurice?

MW. Yes, indeed. And, to break the hold of those Idols, he recommended fitting philosophers with lead boots, to prevent speculative flights. Galileo plumped for the opposite extreme: true philosophers are like eagles, and every effort should be made to abet their flight. There were not many. Galileo could think of only one eagle beside himself: Kepler. Most other philosophers flock together like starlings and foul the ground beneath them.

JB. And yet Galileo insisted when criticizing Aristotelian physics that the only reliable natural knowledge comes from "sensory experience and necessary deduction," not from mathematical abstractions. How, good doctor, are we to heal the fracture between these views?

MW. You must begin with the assumption that nature is inherently mathematical, or, as Galileo put it, that the book of nature is written in geometrical language. I suppose he meant that the goal of physics is a mathematical description of observed phenomena, as in planetary astronomy. This was a very bold program, indeed, his boldest. There was (and still is!) no convincing reason to think that a mathematical physics is possible or even desirable, no matter what Descartes says.

FC. Why should a mathematical physics have been a bold idea if a mathematical astronomy had existed since the Greeks, and maybe earlier?

MW. A good question, Mr Cleyn! It is because the astronomer is at liberty to invent geometrical constructions, like circles moving perpetually on circles, or around empty points, that have no real existence: all that is required is that the fictitious geometrical motions describe the choreography of the planets closely enough that you know where to look for them. It is clear that such a mathematical

astronomy is possible, since we have one, or rather several, Tycho's and Copernicus' being the best. Experience shows their utility. We use our knowledge of the motions of the stars for navigation and, if you believe in astrology by aspect alone, to forecast using a false system, as Sir Christopher Heydon allowed, and as Mr Lilly does, sometimes successfully.

FC. So why can we not be confident that a mathematical physics is possible and practical?

MW. For two reasons. Experience does not suggest that motions that occur beneath the moon are regular enough to be describable mathematically: you need only to consider the weather to be persuaded of the impossibility of any such description. It does not seem likely that we will ever prognosticate it reliably. Do you think that mathematicians will be able to predict the occurrence of volcanic eruptions, earthquakes, thunder and lightning, as they now do eclipses?

JB. I remember reading in Aristotle's *Physics* that its subject is not events that take place by strict rule, but those that happen "for the most part." That implies that a mathematical physics is impossible. And Aristotle may well be right: Galileo's arguments to the contrary cover a very limited domain and in fact do not agree perfectly with his own experiments.

MW. The second reason to doubt the possibility is that we are not free to invent every fiction we find convenient to account for the behavior of objects around us. We have ideas about matter, cause, time, space, and so on that mathematical fictions should not violate. One of the most important consequences of the sun-centered system is to force people who believe in it to develop a physics that allows the earth— "the heavy sluggish earth," as anti-Copernicans put it—to move around the sun. A theory adequate to the job would join the earth and the heavens, and physics and astronomy, in new ways. The only such theory that existed before our time is astrology.

JB. Does that mean that there is less fiction in physics than in astronomy? And, consequently, that, in trying to mathematize physics, Galileo labored under greater constraints than Ptolemy?

MW. Exactly. Galileo tried to escape the problem by avoiding forces and causes whenever he could. He wanted to reduce the amount of physics required by letting geometry do most of the work. That is the modern spirit, according to Galileo's great admirer Hobbes, who says somewhere that "most of what distinguishes today's world from primitive times is owing to geometry." On this reckoning, Galileo's theory of the tides is postmodern. He has the oceans respond to the two Copernican motions of the earth, the daily spin and the annual circuit, without any physical connection between the earth and the moon. I doubt that that is the way to success. What does Virgil say? *Felix qui potuit rerum cognoscere causas*, which might be rendered for present purposes "whoever would succeed in physics should ascertain the causes of things."[42]

JB. Galileo's famous account of the ballistic trajectory, the path described by a cannon ball, suffers from, or profits by, the same trick. He again obtains his answer by combining motions—the constant straight-line velocity of the ball along its original direction of flight and its accelerated fall to the ground—without discussing causes. That allows him to omit the cause that makes the real path very different from the perfect parabola he calculated. This is the resistance of the air to objects moving rapidly through it.

FC. To get persuasive results, Galileo had to abstract the object of study, say the flight of a cannon ball, from the confusing details that obscure it. Just so the portrait painter must ignore the humdrum and ordinary circumstances of his sitters to bring out their characters.

JB. The artist and the mathematician have to solve a similar problem. They both deal in caricature, and a good caricature can reveal much more than an image full of detail that is hard to grasp.

FC. Perhaps Van Dyck's projections of King Charles as a mighty man among his people and as a wise governor and faithful husband parallel Galileo's cannon balls that fly without hindrance. Both representations contain some truth, but not all of it. I would place Van Dyck's portrait of Bentivoglio (see Figure 9), perhaps his best, certainly one of his most famous, in the same class: we see the heart and soul of the man, and his gentleness, but not the bodily strength that enabled him to sustain long marches during the wars in the Low Countries.

JB. We see what we are looking for and disregard the rest of the world. Your double portrait, Mr Cleyn, is a compelling depiction of a listless melancholy young man and a sympathetic doctor.

FC. You were a compelling model, Mr Bankes. You were very melancholy, in both the Galenic and the Aristotelian senses. Your appearance confirmed the medical diagnosis and your interest in astronomy, represented by Galileo's book, was in line with the pastimes of the children of Saturn. I painted you as I saw you and as Sir Maurice seemed to see you. You were sick and suffering, as was the monarchy; despite the sage advice of Greaves's brother the doctor, melancholy stalked Oxford. We were horrified to think that neither you nor the monarchy had long to live. But while there's life there's hope. The globe and chart-like telescope in the picture referred to this hope; doctors of melancholy prescribed travel as a preeminent cure.

JB. Your portrayal satisfies all of Sir Henry Wotton's tests of a good rendition—"the *Story*…rightly *represented*, the *Figures* in true *action*, the *Persons* suited to their severall *qualities*, the *affections proper* and *strong*."[43] And your rendition of the frontispiece is a perfect example of expressive caricature, for with a few strokes you recover its essence and leave the knowledgeable viewer the task of supplying the details. That is just where Galileo's parabolic trajectory left artillerymen.

MW. As long as we are flying high on the wings of analogy, I submit that the masques that delighted our sovereigns and their courtiers have something of the same nature. Certainly they were caricatures! They

are stocked with ideal types that everyone recognized as Platonic and hoped might prompt great persons to emulation. Just as the abstractions of mathematical physics may allow some control of nature, the abstractions of character in a masque may modify behavior of individuals. It may be a great discovery that masques and mathematics have something in common, but I will not press it.

JB. Sir Henry's little book on architecture teaches that too great accuracy in rendering a scene or person can be as bad as poor drawing. He says that there are some *"Artificers so prodigiously exquisite"* they are just too good. In trying for truth they privilege naturalness over gracefulness.[44] Exactness can diminish that "free disposition...which doth animate Beautie where it is, and supplie it where it is not."[45] Galileo says the same thing in the *Saggiatore*.

FC. I agree with him entirely. The artist cannot simultaneously render a scene or a person with complete accuracy, with every wart and speck of dust, and also portray true essences or characters. They are what you may call "complementary values." You cannot express both perfectly at the same time and by maximizing one of them, you will ruin the other. You must smudge a bit to come close to evoking the desired emotional response. Again we meet the double blunt edge of fuzziness. Clarity is the enemy of truth; emotional response can be dangerous...I wonder what Sir Henry would have thought of my picture.

MW. You will turn us into necromancers, Mr Cleyn! But perhaps we can work out an answer from common knowledge about the man and a few details I learned from Lord Strafford.[46] Sir Henry would have given high marks to the handling of complementary values. You, John, are shown melancholic, but whether from illness of the body, as suggested by your pasty face, or of the soul, as suggested by your mathematical studies, or, most likely, both, or whether from being adolescent, is left to the viewer to resolve. I am depicted as a worried man; but whether as a tutor and doctor for both forms of your ailment, or as a distressed witness to the collapse of government and the judicial

murder of Strafford, or as both, may be debated. The compass, globe, telescope, and book are each rendered with the degree of exactness appropriate to its function: thus the compass is presented in the greatest detail, to suggest costly mathematical instruments and a knowledge of their use; the globe only generically, to suggest travel in general; the telescope, with sufficient features to suggest an up-to-date model; and the book—that Sir Henry would have liked particularly—evoked with only the brushstrokes needed to identify it.

FC. Very brilliant Sir Maurice. But perhaps the painting is so impressionistic because I never finished it. There was a great rush, as you remember. It was a difficult time. And then, how do you know when a painting is finished? Leonardo worked on some of his for a lifetime, while Rubens and Van Dyck knocked theirs off like suits of clothes. But you did not finish with Sir Henry's evaluation of the painting. What would he have made of the reference to Galileo?

MW. He would have understood it as he and his friend Donne did *Sidereus nuncius*, as a threat and a promise, an ambiguous comet, a herald of a great upheaval.

JB. It appears from some stray remarks in the *Elements* that Sir Henry did not live in Galileo's world. He takes as a theorem that heavy bodies fall to the center of the universe and praises Aristotle, from whom he learned it, as "our greatest Master among the sonnes of nature." Sir Henry worked a curious reference to Tycho into his epitome of architecture. It should amuse you, Mr Cleyn. Sir Henry allowed a limited use of grotesques but had no time for grottoes. If you have one on your grounds, he advised, convert it into an underground observatory, "whereof mention is made among the curious provisions of *Tycho Braghe the Danish Ptolemie*." Sir Henry took Tycho, not Copernicus or Galileo, as the prince of modern astronomy.[47] To finish with Sir Henry, I suppose, given his attachment to Sarpi and the Venetians, he also would have understood the reference to Galileo as an indictment of

the Roman Catholic Church, which showed its true colors by insisting that the world system must conform with a few obscure or metaphorical passages in a text written two millennia before the invention of the telescope.

FC. My good sitters, I have learned much that surprises me, and used as I am to thinking in symbols, I cannot absorb any more today. Also, it is getting dark, and I must be going. The law might be observed in Gray's Inn, but not invariably between it and Covent Garden.

MW. And we—I think that I can speak for Mr Bankes too—have learned many things from you. But before we part, please bring our conversation to a conclusion by telling us what you had in mind when designing the painting.

FC. My designs usually tell a story. So, Mr Bankes, when Sir Maurice asked me to put Galileo's book in the painting, I thought how it might be done so as to indicate the esoteric nature of the studies you were then pursuing so avidly. That meant avoiding anything so trivial as presenting the book spine forward with its title and author clearly inscribed on it; and anyway I wanted it open, as a closed book suggests a closed mind or finished subject. A good example of what I wanted to avoid is Zubarán's stupendous portrait of Diego Deza, Archbishop of Seville and Grand Inquisitor of Spain. Deza, looking very severe and elegant, sits at a table on which rest four closed volumes of theology (Figure 62). A marvelous depiction of a refined bigot! The uninformed viewer would have no idea that Deza had been the main champion of Columbus at the court of Ferdinand and Isabella. I wanted to tell a more complete story of my sitters.

MW. And so you exhibited Galileo's *Systema* as an open book to signify an ongoing inquiry, and omitted its title so as to suggest the esoteric nature of the subject, since only people who had had the book in their hands would have been able to recognize it in your sketchy figures.

FC. Also, I thought that della Bella's design, of which you know I am a great admirer, would stick in the mind of anyone who saw it. I posed

Figure 62 Francisco de Zubarán, *Fray Diego Deza* (1630).

you, Sir Maurice, with your right hand on the globe, which, together with your empathetic gaze, suggests Mr Bankes's opportunity to explore the great world beyond Oxford; which Mr Bankes does not seem to want to do, as he gestures listlessly toward the globe and looks over the telescope toward the open book. I apologize for botching your left hand, Mr Bankes, I would have fixed it if I had had time to revise.

JB. No apology needed, Mr Cleyn. It is true that I was more strongly drawn to astronomy and cosmology than probably was fitting for the heir of a great landed lawyer. I remember that telescope, which Professor Greaves showed me how to use. I suppose you put it under the globe, Mr Cleyn, to emphasize its application to travel. I took one with me when I went to Europe and found it very useful for seeing towns and travelers at a distance and paintings high up in churches.

FC. You give me too much credit, Mr Bankes. I put the telescope there to draw attention to it and the book, which incorporates and interprets the great discoveries Galileo made with it.

MW. Still, I suspect, we have not got to the essence of the painting. For example, what is the other book? I cannot believe that it is there just as a paperweight. You do not waste opportunities like that, Mr Cleyn.

FC. Sir John handed me the book and asked me to put its title on the spine. Its omission was one of the casualties of haste. But I did scratch the title on it so that I would not forget it when I came to fix up Mr Bankes's hand and other details. I think that you can just make out a few letters despite the need for cleaning.

JB. Yes, I see an "H" and an "i" followed a little further on by what looks like a "t". Is it "History"?

FC. Yes. I took it as a clever opposition to the Galileo: the closed book of history holding open a dramatic portrayal of present discovery. Which also points to future improvement through reasoned dialogue among people of good will. The past is the necessary foundation of the advance of humankind, but not a dictator of direction or scope.

JB. That is very likely, Mr Cleyn. But, as Sir John usually had more reasons than one for his actions and had too strong a sense of symmetry to pair a particular volume indicative of the future with an unidentified general history, the closed book must have been something special. I am morally certain that it is the Corfe Castle copy of

Sarpi's *Trent*. It certainly has the right girth! Nothing could have been more appropriate. Or more eloquent of my father's last judgment on the affairs of church and state he had seen and suffered.

MW. He suffered from trying to do his duty to both prerogative and privilege, from struggling to reconcile his deep loyalties to the king and the Common Law. The conflict could easily bring on a fatal attack of melancholy.

JB. Galileo's book might represent Sir John's last thoughts about this enduring problem. He came to see that Galileo's brave defiance of an unjust order of legitimate authority was a responsible, not a seditious act, and that peaceful dissent is compatible with stable government.

MW. That seems a plausible explanation of the hieroglyph as far as Sir John was concerned with it. But he did not make the painting. What was on your mind, Mr Cleyn, when you joined us with your subtle evocation of Galileo?

FC. Sir Maurice, for me Galileo represents the highest attainments possible for unaided human reason energized by curiosity and ambition; and you two melancholy gentlemen (please forgive me!) the perfect embodiment of doubt and lethargy. Will Mr Bankes continue stupefied by traditional teachings or wake up, seize the instruments, and add a few more pages to the open book of knowledge? Or will he shun the light and sink into that disabling melancholy that Mr Burton described so powerfully?

JB. Am I right in thinking that you placed us so as to indicate a gap of merit between real melancholics and a virtual Galileo?

FC. Yes, Mr Bankes, but I placed within the gap the means by which you and posterity could not only close it but advance far beyond the level of Galileo. These are the instruments of exploration and discovery, which I represented by those now essential to navigation. For, as Sir Francis Bacon assures us through his wonderful image of the ship passing through the Pillars of Hercules with its invocation of the prophet Daniel, "many will pass through, and knowledge will be increased."

JB. I suspect that there is much more that you might tell us about the picture. You are famous for telling several stories at once.

FC. Well, there is a little something more about the way I portrayed Galileo's *Dialogue*. Is the symbol or motto of your university not an open book?

MW. It is indeed, Mr Cleyn, and what is written on it is *Dominus illuminatio mea*. Your artistry is uncannily subtle if you intended to suggest the profound association I now perceive between the Oxford slogan and Galileo's book.

FC. I am not very clever, Sir Maurice. Tell me what I have done.

MW. *Dominus illuminatio mea* are the first words of Psalm 27. The first of its six verses express optimism, confidence in the future, full faith in God's protection: "Though an host should camp against me, my heart shall not fear: though war should rise against me, in this I will be confident." The next six verses are pessimistic. The psalmist no longer takes God's protection for granted: "Hide not they face far from me...Deliver me not over unto the will of mine enemies." The psalmist does not choose between these attitudes, but advises: "Wait on the Lord: be of good courage, and he shall strengthen thine heart; wait, I say, on the Lord."

JB. Wait not upon the Lord, but depend upon yourself, is not the message of the psalm, but the only reasonable reply that experience suggests to it. Despite all the recent persuasive evidence to the contrary, let us read our portrait as Mr Cleyn suggests. In a passage that scandalized bigots and naysayers, Galileo boldly proclaimed that we can understand some propositions as well as God Almighty and can apply their truths to improving our circumstances. To be sure, God knows many more propositions than we do, and, in our fallen state and current confusion, the few we can grasp with absolute certainty are mathematical. "But with regard to those few [propositions] which the human intellect does understand, I [Galileo] believe that its knowledge equals the Divine in objective certainty, for here it succeeds in understanding necessity, beyond which there can be no greater sureness."[48]

Our interlocutors did not have much reason for optimism. Cromwell and his Commonwealth were in the ascendant. Any journeyman stargazer could predict from the conjunction of seven planets in Pisces scheduled for September 1656 that much worse was in store. Just such an assembly had happened the year before the Universal Deluge. The astrologer John Gadbury, who was not always wrong, could therefore most confidently

Figure 63 Peter Lely, *Ralph Bankes* (c.1660).

predict that "the *Politician* will plague us with subtle and treacherous devices; the men in power with hard Taxes; the *Countryman* with want of Grain, the *Soldier* with wars and strifes."[49]

John Bankes died of one of the maladies on offer in that dire year. Another two years and Cleyn and Williams too were gone. They missed the revival of fortune that came with the dispersal of the planets and the return, in 1660, of the Stuarts. Their picture did better. During the Restoration, Ralph Bankes reacquired many of the family's assets, including knighthood, by which Charles II acknowledged the sacrifices of Chief Justice Bankes. Sir Ralph was able to commission a splendid villa at Kingston Lacy by Roger Pratt, who designed in the style of Inigo Jones, and a portrait of himself by Peter Lely, who depicted him as an aesthetic version of his melancholic brother John (Figure 63). Among the lavish furnishings of Kingston Lacy were many fine paintings appropriate for display above the main mantelpiece. Ralph chose the double portrait of his brother and Maurice Williams for this honor.

In the inventory that specifies the portrait's location, the painter's name is given as "Decline." It was an ominous slip. As Galileo remarked when naming Jupiter's moons the Medici stars, man-made monuments all perish in the end and glory has a short shelf life. "For such is the condition of the human mind that...all memories easily escape from it."[50] Remodeling and forgetfulness have removed Cleyn's picture from its original conspicuous place. As it fell in fortune it rose in obscurity. It now occupies a remote spot in a dark corridor at the top of the house, where it can still be seen if staff are available to open the upper stories to visitors.

POSTSCRIPT

Cleyn's painting is perhaps the first to make use of Galileo as a symbol. The intent was subtle: the preceding analysis, which cannot reasonably be faulted for skirting possibilities, has not established just what Cleyn or Bankes or Williams understood by it. Not until the nineteenth century did painters and sculptors exploit Galileo in ways that left no doubt about their intent.

Perhaps the most powerful of these imaginings originated in Jean Antoine Laurent's drawing of 1822, which shows the hero chained in a dungeon contemplating a diagram he has scratched on the wall. The drawing immediately became an emblem for the opposition against a resurgent Catholic Church for control of public instruction in France. An equally fanciful depiction, best known from Joseph-Nicolas Robert-Fleury's rendition of 1847, gives us Galileo before the Inquisition, rising from his knees muttering "still it moves," *Eppure si muove*, "after begging pardon from a conclave of imbeciles for having discovered the truth."[1] Robert-Fleury's fancy remains in use, suitably tweaked. The American Academy of Arts and Sciences used it to set the tone of *Daedalus* for fall 2018, which is devoted to "the challenge of getting courts to recognize and accept sound science."[2]

With the French contribution to Galilean imagery *Eppure si muove* became the watchword of those convinced that no human force could stay "the movement of ideas in the life of a nation and the course of humanity any more than [it could stop the motion] of the earth and stars around the sun."[3] Galileo was the exemplar of this truth: his ideas moved worlds and eventually overcame the force that would stifle them. He was both the progenitor of modernity and its martyr. As progenitor he had

some collaborators, Italians, of course, among them Sarpi, for Italy is the cradle of innovation and civilization.[4] The Municipality of Paris recognized these claims and, in celebration, proposed to build an international pantheon in which Galileo, the "founder of science" and "hero and martyr of scientific freedom," would have been the Prometheus. But building is more expensive than talking, and the proposal died of poverty.[5] And also, perhaps, from the discovery of a defect in Galileo's patent of martyrdom.

In 1870, a hero of the Risorgimento, who was also a physicist and a historian, Silvestro Gherardi, published most of the surviving documents from Galileo's trial. They were a disappointment. They showed that Galileo had not been subjected to torture and had not confronted his persecutors in the manner of a martyr. That confirmed the view of David Brewster, a physicist and biographer of Newton, who had complained a generation earlier that the martyr had not allowed himself to be murdered. The reviewer of a French play about Galileo, staged in 1867, embroidered this uncharitable complaint: "never had a man a better chance to be a hero, to prove that science too had a moral force to die for. Galileo missed his opportunity. He is the first of too many scientists for whom vast knowledge and novel discoveries sum to a deplorable moral skepticism."[6] With Galileo's unexpected delivery from torture and demotion from martyr to milksop, the Church acted to redeem its stolen lamb. It allowed that Galileo had proved himself to be a believing and obedient Catholic by abjuring his errors when ordered to do so by benevolent priests better informed than he.[7]

The struggle between church and state for the soul of Galileo was particularly intense in his hometown. An early skirmish took place in 1839, when the Congress of Italian Scientists held its inaugural meeting in Pisa. The delegates attended the unveiling of a statue of Galileo at the university and visited places in the city associated with him, notably the Piazza dei Miracoli with its cathedral and Leaning Tower. The connection of the great discoverer with the structures of the Church was made portable in a medal coined for the congress by the City of Pisa and given to every participant. It has Galileo in profile on one side and the tower and cathedral on the other.[8] We may count this a draw.

When the congress met again in Pisa, in 1864, on the third centennial of Galileo's birth, some of its members, encouraged by the progress of unification, proposed to promote Galileo to apostle of all Italy and move his statue from the university to the burial ground within the Square of Miracles. The university demurred, unwilling to lose its statue to the enemy. Church authorities also refused, seeing a perversion of religious rites in the scientists' pilgrimages to Galilean shrines, in their Te Deum of "thanks to Providence for giving such a discoverer of truth to Pisa, to Italy, and to the world," and, not least offensive, in their retrograde rhetoric extolling Galileo as "an exemplary martyr."[9] The statue of 1839 would remain in the university, now not just to encourage scholarly pursuits, but to give students "faith in the unity of the common fatherland." Placards scattered through the university announced that *Eppure si muove* is "today the cry of Italy and the civilized world."[10]

Galileo's admirers objected to having to enter the university to profit from viewing him. They set up many committees to raise money and to negotiate a public secular space for a statue to their saint, and always were stymied by fights over possession of the saint's image. A socialist newspaper calling itself *Eppure si muove* took up the battle; it folded after one issue, in 1897. An organization invoking Galileo's name brought 15,000 anarchists onto the streets in 1901.[11] The Church came forward, in the plausible person of an astronomer, Pietro Maffi, who was also the Cardinal Archbishop of Pisa. By 1922, Maffi had raised enough cash to erect a statue in the Piazza dei Miracoli and offered to do so; Galileo would stand looking at the cathedral and Leaning Tower from a pedestal with appropriate references to the discoveries he made there. The Catholic press welcomed the offer; the municipal government opposed it. Such monuments should be paid for by the public, said its representatives, not by an individual, and should not reside in an ecclesiastical space.[12] A century later, a big bronze Galileo at last came to stand, though only temporarily, in the city center. In welcoming him, the official responsible for culture in Pisa, Andrea Buscemi, underlined that what had secured the long-postponed homecoming was the bottom line, domestic and foreign. "The object is to

overcome the typical Pisan paradox regarding the figure of Galileo: a 'brand' that has never been exploited fully notwithstanding that the city of Pisa produced him and that he can also be a tourist attraction."[13]

Meanwhile Rome continued to wrestle with the legacy it had created in 1633. To go back no further, Galileo's ghost stalked sessions of Vatican II devoted to bringing the Church into the intellectual and cultural neighborhood of the twentieth century. Modern-minded delegates with a wary eye to the past warned that mishandling the writings of Teilhard de Chardin, or the results of the higher criticism, or the use of contraception might precipitate another Galileo event.[14] The time was right for rehabilitation. Galileo would be 400 years old in 1964. Scientists called on the pope, Paul VI, to seize the occasion. The pope responded weakly and perhaps disingenuously by releasing the biography commissioned by the Vatican to commemorate the 300th anniversary of Galileo's death. This major work had been in the custody of the Society of Jesus for over twenty years. Its author, an erudite priest named Pio Paschini, had blamed the Jesuits for Galileo's troubles. When Paschini's biography appeared in 1964 as the Vatican's concession to Galilean pressure, it had been censored more severely than Copernicus's dangerous *De revolutionibus*.[15]

In an attempt at a definitive resolution, Pope John Paul II put in motion a full examination of the theological, philosophical, scientific, and historical context of Galileo's trial and condemnation. As an earnest of the Church's good intentions, he mentioned the publication of Paschini's bowdlerized biography. A steering committee containing several disposable octogenarians set up subcommittees to pursue the investigation. Death and lethargy stultified the project for almost a decade. At John Paul's request, the president of the Pontifical Council for Culture, Cardinal Paul Poupard, pulled its pieces into a conclusion following a line developed by one of the project's productive collaborators, Walter Brandmüller, a German Jesuit. The conclusion: the affair was an unfortunate no-fault collision between misunderstandings of the natures of natural science and of Scripture. The misunderstandings were not what the ordinary mind might suppose. According to Brandmüller and Poupard, it was Galileo

who had grasped the correct principles of biblical hermeneutics and the Inquisition's theologians who knew what it took to establish a scientific theory. Galileo could not draw an unanswerable proof of the Copernican system from his observations and deductions, and the theologians could not find one against it in Scripture and Aristotle.[16] John Paul accepted this surprising contrivance in 1992.

This was to put Galileo on the level of the theologians who condemned him. There are signs that he might rise higher, even unto official sainthood. Holy relics exist in the form of body parts and the cracked lens with which, when not cracked, Galileo made his greatest discoveries, all preserved in reliquaries at the Museo Galileo in Florence. His right forefinger is the most popular exhibit in the museum. The martyr recently came within an ace of taking up residence in the Vatican itself, as a statue in the palace gardens that was to be erected in time for the 400th anniversary of the publication of *Sidereus nuncius*. But no. Pope Benedict XVI reacted to charges that he condoned the Church's actions against Galileo by substituting for the statue a promise to review the no-fault decision of 1992.[17]

Eppure si muove! Not long ago a big bronze statue, promoted by Antonino Zichichi, a physicist close to the Vatican, reached the basilica of Santa Maria degli Angeli in Rome. It came from China through the good offices of a Nobel laureate in physics, T. D. Lee, who, as artist, designed the statue, and, as President of the China Center of Advanced Science and Technology, found the money for it. The message of the "Divine Man," as the statue's pedestal introduces Galileo, had spread further than the gospel of Christ. According to the Chinese ambassador, his countrymen never would have heard of Italy had it not been for the man "who discovered the cosmos."[18]

Although Galileo's image has been harnessed most often in connection with the Roman Catholic Church, it has not lacked exploiters in fringe contexts. For example, August Comte placed Galileo in the pantheon of positivist paladins for his destruction of the metaphysical phase of intellectual development.[19] As a paladin, Galileo had the defect referred to earlier of being unwilling to die for his worldview. Ernest Renan found a clever way to paper over the problem. He distinguished between martyrs

who die for their cause because they are not sure it will prevail without their sacrifice and heroes like Galileo, who preserve themselves because they know their cause will win.[20]

A more sinister use of the hero suggested itself to the Nazis. In his bestseller, *Galileo und die Inquisition* (1938), Ludwig Bieberbach drew a parallel between Pope Pius XI's condemnation of Nazi racial policy in 1937 and the Church's banning of Galileo's work some 300 years earlier; which, he said, was just what Germans should expect from a church that still prohibited Kant's *Critique of Pure Reason* and Ranke's *History of the Popes*. But the truth will out. Galileo's case shows that papal condemnation virtually guarantees the correctness of the ideas condemned. Does it not follow that Catholic strictures prove Nazi dogma? There is more. During his visit to Mussolini in 1938, Hitler praised Italy for having given "the world the great inventor and scientist Galileo." Piping the theme further, the Nazis made Galileo and Kepler symbols of the Axis alliance, an "intellectual brotherhood in arms" against the forces of reaction in religion and science. Just as Galileo had destroyed the cobwebbed science of Aristotle, so the champions of Deutsche Physik broke the mystical Jewish physics of Einstein's relativity.[21]

Contrarily, some Creationists blame Galileo for his part in creating the myth that the Bible is inimical to science. Galileo brought his troubles on himself, forfeited the support of the Jesuits by his arrogance and conceit, and insisted on the truth of a system that was no more than a supposition. "[S]cience and faith, for complex reasons, were almost driven into opposition for the first time because of one man's insistence that a working hypothesis was a proven fact." Following this unreasonable man, scientists have become ever more confident in their unproven ideas and have set up impostors to enforce the orthodoxy of evolution, which is no better than a working hypothesis.[22] And, perhaps worse, Galileo's hermeneutics, which has imposed itself on many interpreters of the Bible, has precisely the wrong polarity. It teaches that the passages in Scripture in conflict with natural science must not be taken literally, whereas the correct approach requires that "the book of nature must never take precedence

over the Book of Scripture when it comes to understanding the origin of things."[23] The depreciation of Galileo's character on which these defenders of Creationism drew comes from Arthur Koestler's quasi-history of cosmology, *The Sleepwalkers*, published in 1959. The image of a strident, arrogant, and uncompromising Galileo appears also in the several versions of Berthold Brecht's famous play and, with dishonesty added to complete the subversion of his character, in the historical writings of the philosopher Paul Feyerabend.

Despite all attacks on Galileo's person, the inventors of commercial advertisements thought and think of him as an asset. Countless products have carried his image, some appropriately, as the inventor of the telescope, such as Bausch and Lomb optics and Argus cameras; and as the man who rushed to modernity, such as Pirelli tires and Shell Oil. The food industry cannot get enough of him: Cinzano, Vermouth, brandy, and salami, all happily chosen, for Galileo knew his meat and drink; but also chocolates, coca cola, and meat extract, from which he probably would have abstained. Perhaps the most apt of the slogans that went with these images runs "Bitter Compari is a delicious reality."[24] The counterintuitive may be the truth.

There is still another Galileo available for exploitation: the humanist. Galileo loved music and literature. He could play the lute at a professional level and quote voluminously from the Italian classical poets, Dante, Petrarca, Ariosto, and Tasso. His training in drawing helped him to interpret the lunar features he observed as mountains and valleys, and sunspots as revolving blotches on the solar surface. The image of a creative humanist–scientist, of an exemplary bonding of the arts and sciences, may be in the offing. As Aristotle observed, in one of his few pronouncements that no one questions, the road from Athens to Sparta also runs from Sparta to Athens. May the image of Galileo the humanist–scientist inspire humanists who know no science and scientists disdainful of the humanities to widen their horizons!

GLOSSARY OF NAMES

The following list includes protagonists of the first and second level and a few tertiary actors who appear at widely different places in the text or whose names might occasion confusion. Transcendental people, such as Adam, Plato, Hippocrates, Luther, Calvin, Shakespeare, Satan, and God, are considered sufficiently notorious not to require further specification.

The Lords appear under their family names: Arundel, Northampton, Suffolk, under Howard; Buckingham under Villiers; Clarendon under Hyde; Devonshire and Newcastle under Cavendish; Essex under Devereux; Falkland under Cary; Northumberland under Percy; Portland under Weston; Russell under Bedford; Salisbury under Cecil; Saye and Sele under Fiennes; Somerset under Carr; Strafford under Wentworth.

ABBOT, George (1562–1633). Calvinist Archbishop of Canterbury, 1611; helped publish Sarpi's *Trent*.

AESCULAPIUS, son of Apollo, god of medicine.

ALBERT VII, Archduke of Austria (1559–1621). Co-ruler of the Spanish Netherlands, 1598–1621.

ALBUMAZAR (Abu Ma'shar), Muslim astrologer (787–886). Comedy performed at Cambridge in 1615.

ALLEN, Thomas (1540?–1632). Mathematician and antiquarian, fellow of Catholicizing Gloucester Hall.

ANDREWES, Lancelot (1555–1626). Leader of the Arminian sympathizers in the Church of England; preacher admired by James I and Sir John Bankes; ended career as Bishop of Winchester.

ANNA OF DENMARK, Queen of England (1574–1619). Sister of Christian IV, King of Denmark.

ANSTRUTHER, Sir Robert (1578–1644/5?). Diplomatic agent for James I and Christian IV; patron of Cleyn.

ARMINIUS, Jacobus (1550–1609). Eponymous advocate of an anti-Calvinist theology.

ASHMOLE, Elias (1617–92). Antiquary, royalist, alchemist, and astrologer.

AYLESBURY, Sir Thomas (1576–1657). Surveyor of the Navy 1628, Master of the Mint 1635.

BACON, Sir Francis (1561–1626). Chancellor of England, lawgiver to science.

BAINBRIDGE, John (1582–1643). Physician and astronomer, Savilian Professor of Astronomy.

BANKES, Sir John (1589–1644). Parliamentarian, Attorney General, Chief Justice of Common Pleas.

BANKES, John junior (1626–56). Son and heir of Sir John Bankes, the young man in Cleyn's painting.

BANKES (née Hawtrey), Lady Mary (?–1661). Wife of Sir John Bankes, defender of Corfe Castle.

BANKES, Sir Ralph (1631–77). Lawyer, younger brother and heir of John Bankes junior.

BARBERINI, Francesco (1597–1679). Nephew of Pope Urban VIII, Cardinal Protector of England.

BARLOW, William (1544–1625). Mathematician, clergyman, tutor, and chaplain to Henry, Prince of Wales.

BASTWICK, John (1595?–1654). Medical doctor from Padua, zealous convert to Puritanism.

BEDELL, William (1572–1642). Wotton's chaplain in Venice, friend of Sarpi; later Bishop of Kilmore.

BELLARMINE, Saint Robert (1542–1621). Jesuit, Cardinal, and hardened controversialist.

BENTIVOGLIO, Guido (1579–1644). Student of Galileo and Cardinal Inquisitor against him.

BERNEGGER, Matthias (1582–1640). Professor of history in Strasbourg, translator of Galileo's *Dialogue*.

BLACKWELL, George (1547–1612). Vatican's "Archpriest" who combatted the Jesuits in England.

BODLEY, Sir Thomas (1545–1613). Founder of the University Library at Oxford, "the Bodleian."

BRAHE, Tycho (1546–1601). Prince of pre-telescopic astronomers, author of a well-regarded earth-centered cosmology alternative to Ptolemy's.

BRENT, Nathaniel (1573–1652). Translator of Sarpi's *Trent*, lieutenant of Laud, Warden of Merton College.

BRUNO, Giordano (1548–1600). Dominican, Hermetic philosopher, Copernican, playwright.

BUCHANAN, George (1506–82). Scottish scholar, one-time Catholic, tutor to James VI.

BURTON, Henry (1578–1647/8). Clerk to Prince Henry; strict Puritan, mutilated with Bastwick and Prynne.

BURTON, Robert (1577–1640). "Democritus Junior," author of the classic *The Anatomy of Melancholy*.

CAESAR, Sir Julius (1557/8–1636). Judge in the Admiralty Court; Chancellor of the Exchequer 1606–14.

CAMDEN, William (1551–1623). Animator of the Society of Antiquaries under Elizabeth and James.

CAMPANELLA, Tommaso (1568–1639). Defender of Galileo and astrological magician to Urban VIII.

CARLETON, Sir Dudley (1574–1632). Succeeded Wotton in Venice and abetted De Dominis's flight.

CARLETON, George (1557/8–1628). Relative of Dudley Carleton, eventually Bishop of Chichester.

CARLO EMANUELE I, Duke of Savoy (1580–1630). Attempted a marriage alliance with England.

CARPENTER, Nathanael (1589–c.1628). Influential cosmographer who favored Tycho's system.

CARR, Frances, Countess of Somerset (1590–1632). Daughter of Thomas Howard, Earl of Suffolk.

CARR, Robert, 1st Earl of Somerset (1587–1645). Favorite of James I, found guilty of murder.

CARY, Lucius, 2nd Viscount Falkland (1609/10–43). Opposed Crown over ship money, yet joined government as Secretary of State in 1642; center of the literary circle of Great Tew.

CAVENDISH, William, 1st Duke of Newcastle (1592–1676). Center of the "Cavendish circle," equestrian.

CAVENDISH, William, 2nd Earl of Devonshire (1590–1628). Tutored by Hobbes; friend of Micanzio.

CECIL, Robert, 1st Earl of Salisbury (1563–1612). James I's first main minister.

CESI, Federico Angelo (1585–1630). Founder of the Accademia dei Lincei.

CHARLES I, King of England, Scotland, and Ireland (1600–49). Reigned 1625–49.

CHARLES-LOUIS, Elector Palatine (1617–80). Nephew of Charles I, favored Parliament in Civil War.

CHARLETON, Walter (1619–1707). Oxford educated (Under Wilkins); antiquarian and physician.

CHILMEAD, Edmund (1610–54). Oxford scholar and translator; Burton's colleague at Christ's Church.

CHRISTIAN IV, King of Denmark and Norway (1577–1648). Brother-in-law to James VI and I.

CHRISTINA OF LORRAINE, Grand Duchess of Tuscany (1565–1637). Pious addressee of an open letter from Galileo arguing that in natural knowledge human science trumps scripture.

CIAMPOLI, Giovanni (1589–1643). Vatican operative, pupil and friend of Galileo and Conn.

CLAVIUS, Christoph (1538–1612). Senior mathematician at the Jesuits' university in Rome.

CLEMENT VIII Aldobrandini (1536–1605), pope (1592–1605). Moderate, succeeded by the scrappy Paul V.

CLEYN, Francis (d. 1658). Taspestry designer and jack of all artistic trades.

COKE, Sir Edward (1552–1634). Champion of the common law and lawyers, rival of Francis Bacon.

CONN, George (?–1640). A Catholic Scot, papal representative in England, friend of Galileo.

COPERNICUS, Nicolaus (1473–1543). Author of *De revolutionibus coelum coelestium* (1543).

CORYATE, Thomas (1577–1617). English travel writer who published his experiences as *Crudities*.

COTTINGTON, Francis (1579?–1652). Old Spanish hand; secretary to Charles I when Prince of Wales; Chancellor of the Exchequer; ended a Catholic in Spain.

COTTON, Sir Robert (1570/1–1631). Pupil of Camden; MP; antiquarian with extensive library.

CRANE, Sir Francis (1579–1636). Close to Charles I; established the Mortlake tapestry works.

DANIEL, Samuel (1562–1619). Playwright often used by Queen Anna for her masques.

DAVENANT, Sir William (1606–68). Playwright favored by the Caroline court.

DE CAUS, Salomon (1576–1626). Huguenot engineer and architect, attached to the court of Prince Henry.

DE DOMINIS, Marc'Antonio (1560–1624). Catholic Archbishop of Split before fleeing to England.

DEE, ARTHUR (1579–1651). Son of John Dee, alchemist, royal physician.

DEE, JOHN (1527–1608/9). Mathematician and astrologer with a large library and laboratory at Mortlake.

DELAMAIN, Richard, the elder (d. *c*.1644). Instrument-maker and teacher patronized by Charles I.

DELLA BELLA, Stefano (1610–64). Designer of the inspired frontispiece to Galileo's *Dialogue*.

DEMOCRITUS (*c*.460–*c*.370 BCE). Scoffer at human folly; Robert Burton took the name Democritus Junior.

DE' SERVI, Costantino (1554–1622). Florentine painter and architect attached to the court of Prince Henry.

DEVEREUX, Robert, 2nd Earl of Essex (1565–1601). Over-reaching disobedient one-time favorite of Queen Elizabeth, disgraced for military inaction in Ireland, failed rebel.

DEVEREUX, Robert, 3rd Earl of Essex (1591–1646). Head of Royalist then of parliamentary forces.

D'EWES, Sir Simonds (1602–50). Antiquarian, diarist, anti-Royalist parliamentarian.

DIGBY, Sir Kenelm (1603–65). Studied with Thomas Allen; courtier, pirate, natural philosopher.

DIGGES, Sir Dudley (1582/3–1639). Son of mathematician Thomas Digges; Oxford-educated opposition MP.

DIGGES, Thomas (*c*.1546–95). Mathematician, father of Dudley Digges; studied with John Dee.

DIODATI, Élie (1576–1661). Calvinist lawyer instrumental in disseminating Galileo's and Sarpi's works.

DIODATI, Jean (1576–1649). Calvinist theologian, member of Sarpi's group in Venice.

DOBSON, William (1611–46). Portraitist taught by Cleyn and encouraged by Van Dyck.

DONNE, John (1572–1631). Poet, friend of Wotton, author of sensitive reactions to Galileo's astronomy.

DREBBEL, Cornelius (1572–1633). Dutch inventor, creator of a perpetual motion clock and tidal simulator.

DUPPA, Brian (1588–1662). Taught by Andrewes, promoted by Laud; tutor to the future Charles II.

DUTTON, John Crump (1594–1657). Wealthy lawyer; opposed Puritans and ship money; painted by Cleyn.

EARLE, John (c.1600–65). Oxford-educated sometime poet, member of Great Tew circle.

ELIOT, Sir John (1592–1632). Parliamentary leader; protégé then adversary of Buckingham; died in prison.

ELIZABETH I (1533–1603), Queen of England and Ireland (1558). Last of the Tudor monarchs.

FELTON, John (c.1595–1628). Assassin of Buckingham unhealthily given to reading.

FIENNES, William, 1st Viscount Saye and Sele (1582–1662). Godly Protestant; moderate MP; correspondent of Sir John Bankes.

FINCH, John, Baron Finch of Fordwich (1584–1660). Attorney General 1626, Speaker of the Commons 1628, Chief Justice of Common Pleas 1634, Lord Keeper 1639.

FORTESCUE, George (1578–1659). Present at the Roman College during Galileo's visit in 1611.

FREDERICK V, Elector Palatine (1596–1632). Protestant leader, brother-in-law of Charles I.

FULLER, Thomas (1608). Royalist clergyman, church historian; his *Pisgah-sight of Palestine* (1650) illustrated by Cleyn; his *Worthies of England* (1662) a popular character book.

GAGE, George (c.1582–1638). English Catholic employed in the Spanish match, art connoisseur, friend of Tobie Matthew; not the priest George Gage (c.1602–52), against whom Prynne inveighed.

GALEN OF PERGAMON (129–c.210). The Ptolemy of medicine.

GALILEI, Galileo (1564–1642). Florentine one-time friend of Urban VIII; brilliant innovator in physics; discoverer of new worlds; author of *Dialogue on the Two Chief World Systems* (1632).

GELLIBRAND, Henry (1597–1637). Student of Savile and Bainbridge, almost won to Copernicus by Galileo.

GEREE, JOHN (1599/1600–49). Oxford-educated author of *Character of a Puritan*.

GODWIN, Francis (1562–1633). Bishop of Hereford; wrote a popular account of a voyage to the moon.

GREAVES, Sir Edward (1608–80). Studied medicine at Padua and Leyden; Reader in Physic in Oxford.

GREAVES, John (1602–52). Brother of Edward Greaves and Savilian professor of astronomy.

GREEN, Giles (fl. 1621–48). Confidant of Sir John Bankes, MP for Corfe Castle.

HALL, Joseph (1574–1656). Bishop of Norwich, known for religious writings and mild satires.

HAMPDEN, John (1594–1643). Opponent of ship money and episcopy; strong parliament man.

HARINGTON, John (1560–1612). Elizabethan courtier, translator of Ariosto, epigrammist.

HARRIOT, Thomas (1560–1621). Mathematician, astronomer, surveyor of Virginia.

HARVEY, William (1578–1657). Studied at Padua; royal physician, discoverer of blood circulation.

HATTON, Sir Christopher (1540–91). Chancellor to Elizabeth I, owner of Corfe Castle.

HATTON, Lady Elizabeth (1578–1646). Wife of Sir William Hatton and then of Edward Coke; close friend of Queen Anna; sold Corfe Castle to Sir John Bankes.

HEATH, Sir Robert (1575–1649). Protégé of Buckingham; Attorney General 1625.

HECKSTETTERS. Family of Cumberland miners into which Sir John Bankes's sister married; his brother-in-law David Heckstetter was a fellow of Queen's, Sir John's Oxford college.

HENRIETTA MARIA of France, Queen of England, Scotland, and Ireland (1609–69). Married Charles I in 1625; her Catholicism and belief in the rights of kings helped destroy her husband.

HENRY, Prince of Wales (1594–1612). Eldest son of James VI & I and Anna of Denmark; militant Protestant and major art collector.

HENRY IV, King of France (1553–1610). Converted from Protestantism; relatively tolerant of Huguenots; father of Henrietta Maria by his queen, Marie de' Medici.

HEYDON, Sir Christopher (1561–1623). Author of the authoritative *Defence of judiciall astrologie* (1603).

HEYDON, Sir John (1588–1653). Son of Sir Christopher Heydon, likewise a mathematician, soldier, and astrologer.

HEYLYN, Peter (1599–1662). Oxford-trained royalist polemicist and theologian; author of *Microcosmos*.

HILL, Nicholas (1570–*c*.1610). Eclectic philosopher associated with the Wizard Earl of Northumberland.

HOBBES, Thomas (1588–1679). Political philosopher, would-be mathematician, tutor to both William Cavendishes (of Devonshire and Newcastle), met and admired Galileo.

HOLLAR, Wenceslaus (1607–1677). Bohemian artist brought to England by Arundel, worked with Clyne.

HOLLES, Denzil, 1st baron Holles (1599–1680). Boyhood friend of Charles I but a strong parliamentarian.

HOWARD, Alethea (née Talbot), Lady Arundel (1585–1654). Wife of Thomas Howard, 14th Earl of Arundel.

HOWARD, Henry, 1st Earl of Northampton (1540–1614). Senior member of the Howard family rehabilitated by James I; succeeded Salisbury as Treasury Lord, 1612; wrote against astrology.

HOWARD, Thomas, 1st Earl of Suffolk (1561–1626). Half-brother of Northampton, Lord Treasurer 1614–18; cashiered for peculation; uncle of Thomas Howard, Earl of Arundel; father of Frances Carr.

HOWARD, Thomas, 14th Earl of Arundel (1586–1646). Catholic converted to Church of England; in and out of favor with the Crown; an extravagant and knowledgeable collector of art.

HOWARD, Lord William (1563–1640). Half-brother to Northampton and Suffolk; patron of John Bankes.

HOWELL, James (1594?–1666). Linguist, travel writer, glass merchant, courtier.

HYDE, Edward, 1st Earl of Clarendon (1609–74). A lawyer close to Selden, Jonson, Falkland, and Laud; opposed ship money and other royal exactions but eventually joined with the king.

IGNATIUS OF LOYOLA, St (1491–1556). Founder of the Society of Jesus (the Jesuits).

ISAACSZ, Pieter (1569–1625). Danish–Dutch painter, recruited Cleyn into the service of Christian IV.

ISHAM, Sir Justinian (1611–75). Protégé of Bishop Duppa, friend of John Bankes junior.

JAMES VI, King of Scotland and James I, King of England and Ireland (1566–1625).

JONES, Inigo (1573–1652). Imported Italian architectural practice into England; staged masques for Queens Anna and Henrietta Maria.

JONSON, Ben (1572–1637). Prolific poet and playwright; put on masques in collaboration with Inigo Jones.

JUNIUS, Franciscus (1591–1677). Dutch pastor who entered Arundel's service as tutor and librarian.

JUXON, William (1582–1663). Bishop of London and Lord Treasurer under Charles I.

KEPLER, Johannes (1571–1630). Wild but exact astronomer, friendly competitor of Galileo.

LAUD, William (1573–1645). Arminian Archbishop of Canterbury, 1633; patron of Maurice Williams.

LILLY, William (1602–81). Self-taught astrologer helpful to parliament during the Civil War.

LISTER, Sir Matthew (1571–1656). Educated at Oxford and Basel; royal physician under several reigns.

LITTLETON, Sir Edward (1589–1645), 1st baron. Moved from opposition MP to Solicitor General 1634; Lord Keeper after Sir John Finch.

LOMAZZO, Giovanni Paolo (1538–92). Authoritative theorist of art.

LONGOMONTANUS, Christian Sørenson (1562–1647). Assistant to Tycho Brahe on Hven, professor at the University of Copenhagen.

LOUIS XIII, King of France (1601–43). Uncooperative brother-in-law of Charles I.

LUMLEY, John, 1st Baron (1533–1609). Catholic whose books and paintings passed to Prince Henry.

LYDIAT, Thomas (1572–1646). Chronologist and cosmologist in the service of Prince Henry.

MARIA ANNA, Infanta of Spain (1606–46). Prospective bride of Prince Charles, later Queen of Hungary.

MARSHALL, William (fl. 1617–49). Designer–engraver of many poor quality and some witty title pages.

MATTHEW, Tobie (1546–1628). Vice Chancellor of Oxford, godly Archbishop of York, father of the apostate Tobie Matthew (1577–1655), a Catholic priest in and out of favor with James I.

MAYERNE, Sir Théodore Turquet de (1573–1655). Genevan Huguenot physician trained in Europe, migrated to England in 1610, became doctor to James I and Charles I.

MAYNE, Jasper (1604–72). Poet, converted from a Catholic family, patronized by Duppa and Bankes.

MEDICI, Cosimo II de', Grand Duke of Tuscany (1590–1621). One-time student of Galileo.

MEDICI, Marie de', Queen of France (1575–1642). Mother of Charles I's queen, Henrietta Maria.

MELANCHTHON, Philip (1497–1560). Luther's collaborator, "preceptor of Germany," addicted to astrology.

MICANZIO, Fra Fulgenzio (1570–1654). Italian monk, close associate of Sarpi and friend of Wotton.

MILTON, John (1608–74). Peerless poet and a polemicist for Parliament; used Galileo against Rome.

MODENA, Leone (1571–1648). Venetian Rabbi whom Coryat tried to convert; a friend of Wotton.

MONTAGU, Richard (1577–1641). Stout defender of the church of England; Bishop of Worcester 1628.

MYTENS, Daniel (1590–1647/8). Dutch portrait painter active in London; clientele included royalty.

NEILE, Richard (1562–1640). Professional bishop (six dioceses, lastly York); patron of Laud.

NIJS, Daniel (1572–1647). Flemish merchant in Venice, art dealer and go-between Wotton and Sarpi.

NORGATE, Edward (1581–1650). Miniature painter, musician, good friend, and admirer of Cleyn.

NOY(E), William (1577–1634). Opposition MP from 1603; Attorney General 1631–34; chief deviser of ship money and deafforestation.

OGILBY, John (1600–76). Dancing master turned scholar and publisher, patron of Cleyn.

OLIVER, Isaac (c.1565–1617). Miniaturist, artist, and adviser on art to Queen Anna.

OUGHTRED, William (1575–1660). Mathematician in Arundel's circle; disdained Delamain.

PALLADIO, Andrea (1508–80). Italian architect active in Venice whose work influenced Inigo Jones.

PARACELSUS, Theophrastus Bombastus von Hohenheim (1493/4–1541). Anti-Galenic physician.

PAUL V BORGHESE (1550–1621). Tridentine pope, precipitated the Venetian interdict, approved edict against Copernican teachings, excommunicated Sarpi.

PAYNE, Robert (1596–1651). Oxford man, cleric, and natural philosopher in Cavendish circle.

PEACHAM, Henry (1578–c.1644). Authority on what made a complete gentleman.

PERCY, Algernon, 10th Earl of Northumberland (1602–68). Lord Admiral who went over to Parliament.

PERCY, Henry, 9th Earl of Northumberland (1564–1632). The "Wizard Earl," patron of Hariot and others.

PHILIP IV, King of Spain (1605–65). Brother of Prince Charles's inamorata Maria Anna.

PORTER, Endymion (1587–1649). Old Spanish hand, finished courtier, intimate of Charles I.

PRYNNE, William (1600–69). Oxford educated lawyer, uncontrollable Puritan writer.

PTOLEMY, Claudius (c.100–c.170). Author of the standard texts on earth-centered astronomy and astrology.

PYM, John (1584–1643). Anti-Catholic, anti-Royalist leader of the Long Parliament; protégé of the Earl of Bedford, close to John Hampden.

QUARLES, Francis (1592–1644). Royalist poet, anti-Arminian and anti-Catholic, yet took his most successful work, *Emblemes* (1635) from Jesuit sources; father of John Quarles (1624/5–65).

ROBINSON, Henry (1551/2–1616). Bishop of Carlisle; collaborated with Lord William Howard in policing the Scottish borders; placed his brother Giles as Vicar of Sir John Bankes's parish church.

ROSS, Alexander (1591–1654). A chaplain of Charles I, aggressive and ignorant opponent of new ideas.

RUBENS, Peter Paul (1577–1640). Among his paintings, decoration of the ceiling of Inigo Jones's Banqueting House; among his other activities, diplomatic negotiations between England and Spain.

RUPERT, Prince of the Rhine, Duke of Cumberland (1619–82). Nephew of Charles I, vigorous cavalier.

RUSSELL, Francis, 4th earl of Bedford (1587–1641). Developed Covent Garden and other London properties; for a time, the leader of compromise in the early Long Parliament.

SAGREDO, Gianfrancesco (1571–1620). Galileo's Venetian friend made a character in the *Dialogue*.

SALVIATI, Filippo (1583–1614). Galileo's Florentine friend made his spokesman in the *Dialogue*.

SANDYS, Edwin (1519?–88). Combative moderate Puritan Archbishop of York, zealous anti-Catholic; father of Sir Edwin Sandys (1561–1629), opposition MP and director of the Virginia Company.

SANDYS, George (1578–1644). Brother of Sir Edwin Sandys; translator of Ovid and patron of Cleyn.

SARMIENTO DE ACUÑA, Diego, Conde de Gondomar (1567–1626). Spanish ambassador to England, 1613–22.

SARPI, Fra Paolo (1552–1623). Defender of Venice, Protestant sympathizer, author of the *History of the Council of Trent* and other works highly critical of the papacy and court of Rome.

SAVILE, Henry (1549–1622). Mathematician and classicist, founder of the Oxford Savilian professorships.

SCHOPPE, Kaspar (1576–1649). Catholic convert and polemicist, Vatican hanger-on close to the Lincei.

SELDEN, John (1584–1654). Learned lawyer, influential MP, friend of Jonson, Cotton, Arundel.

SHIRLEY, James (1596–1666). Playwright, author of *Triumph of Peace*; with Williams in Ireland.

SIMPLICIO. The literal follower of Aristotle in Galileo's *Dialogue*.

SIR POLITIC WOULD-BE. Absurd character in Jonson's *Volpone* (1605/6) who apes Venetian ways.

SPELMAN, Sir Henry (1562–1641). Antiquarian friend of Camden, Cotton, and Selden.

SPELMAN, Sir John (1594–1643). Son of Henry Spelman; defender of the Crown and Church of England.

STUART, Elizabeth (1596–1662). Daughter of James I and wife of Frederick V; "Elizabeth of Bohemia."

TYMME, Thomas (?–1620). Clergyman, alchemist, Ptolemaic pedagogue.

URBAN VIII BARBERINI, Pope (1568–1644). Man of letters; condemned Galileo, though once his friend.

USSHER, James (1581–1656). Archbishop and chronologist, learned and superstitious primate of Ireland.

VAN DYCK, Sir Antony (1599–1641). The leading portraitist of Caroline England.

VENNER, Tobias (1577–1660). Medical doctor, treated John Bankes junior at Bath.

VILLIERS, George, 1st Duke of Buckingham (1592–1628). Favorite of kings James and Charles.

VIRGIL (70–19 BCE). Author of *Eclogues*, *Georgics*, and the *Aeneid*, all illustrated by Cleyn for Ogilby.

VORSTIUS, Conrad (1569–1622). Follower of Arminius persecuted by King James.

WARNER, Walter (c.1563–1643). Mathematician associated with the Wizard Earl.

WEBBE, Joseph (fl. 1610–40). Medical doctor from Padua, invented a royal road to Latin, translated the *Dialogue*.

WENTWORTH, Thomas, 1st Earl of Strafford (1593–1640). Lord Lieutenant of Ireland, patron of Williams.

WESTON, Richard, 1st Earl of Portland (1577–1635). Lord Treasurer 1628–35, patron of Sir John Bankes.

WHARTON, Sir George (1617–81). Astrologer mistaken in predicting royalist victories.

WHITE, Richard (1590–1682). English Catholic student of Galileo; brother of Thomas White.

WHITE, Thomas, alias Blacklo (1592/3–1676). Planned a Catholic England independent of Rome.

WILKINS, John (1614–72). First popularizer of Galileo's teachings at Oxford; ended Bishop of Chester.

WINDEBANK, Sir Francis (1582–1646). Pro-Spanish Catholicizing secretary to Charles I from 1632.

WILLIAMS, Maurice (1600–58). Physician to Strafford, Henrietta Maria, and young John Bankes.

WOTTON, Sir Henry (1568–1639). Ambassador to Venice, close to Sarpi circle; connoisseur of Italian art.

WRIGHT, Edward (1561–1615). Mathematician and cartographer in service of Prince Henry.

WOODFORD, Robert (1606–54). Puritan country lawyer, admirer of the triumvir martyrs.

NOTES

The following abbreviations are used:

AS	*Annals of Science*
BJHS	*British Journal for the History of Science*
BPB	Bodleian Library, Oxford, Sir John Bankes Papers
CSPD	*Calendar of State Papers, Domestic*
CSPV	*Calendar of State Papers, Venice*
CSP Ireland	*Calendar of State Papers, Ireland*
CWASS	Cumberland and Westmorland Antiquarian and Archaeological Society
D-BKL	Dorset History Centre, Dorchester, Bankes Papers
DNB	*Dictionary of National Biography*
DSB	*Dictionary of Scientific Biography*
HG	J. L. Heilbron, *Galileo* (Oxford: Oxford University Press, 2010)
HLQ	*Huntington Library Quarterly*
IMSS	Istituto e Museo di Storia della Scienza
JHI	*Journal of the History of Ideas*
JWCI	*Journal of the Warburg and Courtauld Institutes*
OG	Galileo Galilei, *Opere*, ed. Antonio Favaro et al., 20 vols (Florence: G. Barbèra, 1890–1909)
RCHM	Royal Commission on Historical Manuscripts (Historical Manuscripts Commission)
SC	*Seventeenth Century*
SL	L. G. Smith, *The Life and Letters of Sir Henry Wotton*, 2 vols (Oxford: Oxford University Press, 1907)

Prologue

1. Bacon, *Advancement* (1605), bk 2, para. 170, in *Philosophical Works* (1905), 121, and in *Advancement* (1954), 136.
2. Bacon, *Novum organum* (1620), bk 1. aph. 59, and *De augmentis* (1623), VI.1, in *Philosophical Works* (1905), 269, 521–2, resp.; Snider, *Origin* (1994), 49–51.
3. Simonutti, in Meroi and Pogliano, *Immagini* (2001), 87.
4. Yarker, in Moore, *Paxton Treasure* (2018), 238–9.
5. Brian Twyne, "Ad Galileum," in Anon., *Justa funebria* (1613), 115.
6. *HG* 221, 258, 302–3.

7. Cf. Sprang, *Fountaine* (2008), 1–2, 22–4, 29, 38.
8. Lomazzo, *Tracte*, trans. Haydock (1598), 12–20.
9. Quoted from Baker, in Darby, *Historical Geography* (1936), 387.
10. Conan Doyle, *Study in Scarlet*, 1.2, in *Holmes* (n.d.), i. 10; Burton, *Anatomy* (2001), pt 1, p. 38.
11. Peacham, *Gentleman* (1622), 57.

Chapter 1

1. Pastor, *Popes*, xxiv (1933), 55, 58–60, 103–30, 237–58.
2. Budé, *Vie* (1869), 60–1; Selden, *Table Talk* (1856), 143 (quote).
3. Sandys, *Relation* (1605), 7–12; Rabb, *Gentleman* (1998), 24–36; Cozzi, *Rivista storica italiana*, 79 (1967), 1089, 1104–6; Ellison, *Sandys* (2002), 32–5.
4. Waterworth, *Canons* (1889), 151, 277–8.
5. Pastor, *Popes*, xxiv (1933), 269–79 (1.2 million); Cattabiani, *Breve storia* (1999), 121 (3 million); Palumbo, *Giubileo* (1999), 35–41.
6. Cattabiani, *Breve storia* (1999), 118–25.
7. Fosi, *Convertire* (2011), 57–61, 83, 107–11, 118.
8. Fosi, in Marcocci and Aranha (eds), *Spaces* (2014), 157, 160–2, 168–70; Williams, *Venerable College* (2008), 39.
9. Wotton to Salisbury, 5 September 1608, in *SL* i. 434; Matthew and Calthorp, *Life* (1907), 95–106, 117. Matthew's description of the excellences of Florence dates from 1608; his ordination to 1614; for his personal contact with Galileo, Matthew to Bacon, 4 April 1619 (Bacon, *Works* (1857–74), xiv. 35–6).
10. Kodera, in Neuber and Zittel (eds), *Copernicus* (2015), 236–47; Omodeo, *Copernicus* (2014), 40 (quote).
11. Scaramelli to Doge and Senate, 27 August 1603, and Francesco Vendramin, Venetian ambassador to Rome, to same, 6 December 1603, *CSPV, 1603–7*, 85–6, 117–18.
12. *Merchant of Venice* (1596–7), III.iii.26–31.
13. Howell, *Survay* (1651), 4–7; Wills, *Venice* (2001), 95–134.
14. Howell, *Survay* (1651), epigraph.
15. *Volpone* (1605–6), II.i.35–6, III.iv.84–5 (quote), IV.i.50–2; McPherson, *Shakespeare* (1990), 28–9, 33, 39–43, 91–2, 94, 107–16.
16. De Mas, *Sovranità* (1975), 26–7, 44, 91–5.
17. Pastor, *Popes*, xxv (1937), 8, 14, 36–7, 41, 45–50; for Sarpi on the Pope, *HG*, 220, and Cavendish, *Horae* (1620), 397, 400–3; Kainulainen, *Sarpi* (2014), 4–6, 9.
18. *SL* i. 55–6.
19. Rabb, *Gentleman* (1998), 39, 44; Cozzi, *Rivista storica italiana*, 79 (1967), 1113–20; Dorian, *Diodatis* (1950), 99; Garcia, *Rivista storica italiana*, 114 (2002), 1004, 1007–9, 1012; De Mas, *Sovranità* (1975), 118–19.
20. Burnet, *Life* (1685), 9, 11, 53, 66; Rev. 13:6, 18.
21. Wotton to Salisbury, 12 October, 1 November, 21 December 1609, in *SL* i. 406–8.

22. Wotton to Salisbury, 13 September 1607, in *SL* i. 399; on distribution of the portrait, *SL* ii. 478–9.
23. De Rubertis, *Civiltà moderna* (1939), 383–7; Budé, *Vie* (1869), 53–4, 66, 71–2.
24. Budé, *Vie* (1869), 81.
25. Sarpi, *Historie* (1640), 4. Cf. Bolton, in Haslewood, *Ancient Essays* (1811), ii. 224–5.
26. Wotton to Salisbury, 13 September 1606, in *SL* i. 399, with reference to Sarpi.
27. Cozzi, *Rivista storica italiana*, 68 (1956), 572, 575–7, 598–600; Levi, *Athenaeum*, 3689 (9 July 1898), 66–7).
28. Gabrieli, *English Miscellany*, 8 (1957), 197; Gelder, in Keblusek and Noldus (eds), *Double Agents* (2011), 111–12; Anderson, "Art Dealing" (2010), 21, 25, 29, 32, 127–31.
29. Cozzi, *Rivista storica italiana*, 68 (1956), 578–82, 586, 602–7 (letters from Abbot to Brent, between 21 June and 24 September 1618).
30. Wotton to James I, 30 July 1616, in *SL* ii. 100; Gabrieli, *English Miscellany*, 8 (1957), 226; Micanzio to William Cavendish, 24 February 1617 and 12 January 1618, in Add. MS 11309 (BL), fos 4–5, 16.
31. Patterson, *James* (1997), 223–4, 229–30; Akrigg, *Pageant* (1963), 308–9; Sommerville, in Peck (ed.), *Mental World* (1991), 58–9, 286.
32. James VI & I, *De triplici nodo* (1607), in *Political Writings* (2006), 85–6, 90–5, 101, 116, 121, 124, 128–30.
33. Patterson, *James* (1997), 85–8, 92–5, 97 (quote).
34. Patterson, *James* (1997), 98–9; Wilson, *HLQ* 8 (1944), 42, 45–8.
35. Samuel Ward to James Ussher, 25 September 1622, in Parr, *Life* (1686), 82, and Belligni, *Auctoritas* (2003), 182–98.
36. Abbott to Sir Thomas Roe, 20 December 1622, in Lievsay, *Phoenix* (1973), 33, 57–61.
37. *SL* i. 149–50; ii. 110, 120, 252.
38. Wotton to Sir George Calvert (Secretary of State), 6/16 March 1621/2, in *SL* ii. 229; Micanzio to Cavendish, 24 February 1622, in Ferrini (ed.), *Lettere* (1987), 157; cf. Gabrieli, *English Miscellany*, 8 (1957), 228–9; Sarpi, in Belligni, in Pin (ed.), *Ripensando* (2006), 105–8.
39. Patterson, *James* (1997), 220, 231, 234–7, 241–5.
40. Wotton to Calvert, 2/12 December 1622, in *SL* ii. 252; Newland, *Life* (1859), 5–6; Patterson, *James* (1997), 251–4.
41. Micanzio to Cavendish, 27 and 6 May, resp., in Ferrini (ed.), *Lettere* (1987), 180, 164–5; cf. Gabrieli, *English Miscellany*, 8 (1957), 230–1.
42. Redondi, *Heretic* (1987), 107–18.
43. Cf. Belligni, in Pin (ed.), *Ripensando* (2006), 151.
44. Brent, in Sarpi, *Historie* (1620), "Epistle dedicatorie."
45. Cf. Burke, in Pin (ed.), *Ripensando* (2006), 106–8.
46. Sarpi, *Historie* (1620), 216, 195 (quote), 168, 45, resp.
47. Infelise, in Pin (ed.), *Ripensando* (2006), 520–1; Fernbach et al. (eds), *Private Libraries* (1992), *passim*; Lievsay, *Phoenix* (1973), 76–85, 121–56; Chambers, *Transactions of the Cambridge Bibliographical Society*, 5 (1970), under "Andrewes;" Lawlor, *Proceedings of*

the Royal Irish Academy, 6 (1901), *passim*. Both bishops also had copies of De Dominis's *Republica ecclesiastica*.

48. Sharpe, *Reading* (2000), 79, 123, 300 (on Drake); Heylyn, *Mikrokosmos* (1636⁷), 297–8.

49. Bouwsma, *Venice* (1968), 623.

50. Sarpi, *Quarrels* (1626), 117–18, 175–6, 184–6, 238; Potter, in Sarpi, *Quarrels* (1626), fo. ¶¶1ʳ.

51. Jonson, *The Entertainment at Britain's Bourse* [1609], in *Works* (2012), iii. 357–72. Jonson, *The Alchemist* [1610], III.iv.87–99, in *Works* (2012), iii. 644, describes another marvelous perspective.

52. Bentivoglio, *Memorie* (1864), i. 103, and letter to Scipione Borghese, 2 April 1609, in Sluiter, *Journal for the History of Astronomy*, 28 (1997), 225–6, 229–32; J. Beaulieu to W. Trumbill, 5 August 1607, in RCHM, *Downshire MSS* (1924), ii. 31; Selvelli and Molaro, in Pigatto and Zanini (eds), *Astronomy* (2010), 198.

53. Hall, *Discovery* [1609] (1937), 79, 87–8.

54. De Dominis, *De radiis visus* (1611); Pigatto, in Pigatto and Zanini (eds), *Astronomy* (2010), 40–8.

55. Wotton to Salisbury, 13 March 1610, in *SL* i. 486–7.

56. Letters to William Trumbull, English agent in Brussels, from Lyonnel Wake, Antwerp, 4 and 10 February 1609/10, and Captain Bruz, London, 14 February 1609/10, in RCHM, *Report*, 2 (1938), 228–9, 239; and from John Finet, 14 February 1611/12, in RCHM, *Report*, 2 (1938), 238–9.

57. Belisario Vinta (Florentine secretary of state) to Orso d'Elci (Madrid), 23 May, and Lotti to Vinta, 23 June 1610, in *OG* x. 356, 377.

58. Thomas Lucy III, "Divers difficile Questions," in BL, Sloane MS 682, fos 46–8.

59. John Wedderburn, *Confutatio* (1610), in *OG* iii/1. 151, 178; Kepler to Galileo, December 1610, in *OG* x. 507; Favaro, *Amici* (1983), ii. 980–4; Benedetti, *Quaderni per la storia dell'Università di Padova*, 4 (1971), 154–5.

60. Paolo Gualdo to Galileo, 10 February 1611, in *OG* xi. 43.

61. Foley, *English College* (1880), 255; Fortescue, *Feriae* (1630), 122–59, Mitford, *Gentleman's Magazine*, 182 (1847), 382–4.

62. Fortescue to Galileo, 15 October 1629, and reply, February 1630, in *OG* xiv. 47, 88; Favaro, *Amici* (1983), iii. 1137n.

63. Fortescue, *History* (1880), 436–8, 441.

64. Fortescue, *Feriae* (1630), 141.

65. Jonson, *Love Freed from Ignorance and Folly* (1611), in *Works* (2012), iii. 751–62, I.i.159–60.

66. Donne, *Ignatius* (1611), 6, 14, 18–22.

67. Donne, *Ignatius* (1611), 24–30, 41, 59, 65–8, 76–7, 90, 93, 98–100.

68. Donne, *Ignatius* (1611), 113, 117–18, 127, 131–2, 136. Loyola was canonized a decade later (in 1622) by Pope Gregory XV. Cf. Reeves, *News* (2014), 26, 43–4, 51–5.

69. Nicolson, *Science* (1962), 49–54; Coffin, *Donne* (1937), 83–4, 121–2, 132–7; Hassell, *Modern Philology*, 68 (1971), 330–5.

70. *DNB*, s.v. "Lombard."

71. *Tempest*, V.i. For Shakespeare on tides, Clark, *Shakespeare* (1929), 211.

72. De Mas, *Sovranità* (1975), 31–5, 69–70, 165.

73. *HG*, 197–8.

74. Bacon, "Descriptio globi" (*c.*1612), in Bacon, *Philosophical Studies* (1996), 157, 165; cf. "Thema coeli" (1612–13?), in Bacon, *Philosophical Studies* (1996), 175, 193.

75. Bacon, "De fluxu et refluxu maris," in *Works* (1857–74), v. 443–58, at 450, and *Advancement of Learning*, in *Works* (1857–74), viii. 488; Rossi, in Maccagni, *Saggi* (1972), 260–8.

76. Favaro, *Amici* (1983), ii. 991–4; Spedding, *Account* (1878), ii. 373; Bacon, *Works* (1857–74), xiv. 36–7.

77. Bacon, *Novum organon* (1620), bk 2, aph. 36 (observation) and aph. 46 (against Galileo), in Bacon, *New Organon* (1960), 191–2, 227. At least four copies of Galileo's "On the Tides" are extant in England; Feingold, in Galluzzi, *Novità* (1983), 415–16, and Hall, in McMullin, *Galileo* (1967), 413 n. 9.

78. Wotton to Bacon, Vienna, 19? December 1620, OS, in *SL* ii. 204–5; Kepler to M. Bernegger, 29 August 1620, in *SL* ii. 205n.; Micanzio to Cavendish, 10 September and 10 December 1621, in Ferrini (ed.), *Lettere* (1987), 140, 146; cf. Gabrieli, *English Miscellany*, 8 (1957), 213.

79. Rees, *Revue internationale de philosophie*, 159/4 (1986), 412, 414 (from Bacon, *Works* (1857–74), iv. 370).

80. Micanzio to Cavendish, 1624, in Ferrini (ed.), *Lettere* (1987), 263; cf. Gabriele, *English Miscellany*, 8 (1957), 216.

81. Micanzio to Cavendish, 31 March and 17 June 1616, 24 February 1617, in Ferrini (ed.), *Lettere* (1987), 54–5, 57, 62–3; cf. Gabrieli, *English Miscellany*, 8 (1957), 203–8; Bacon, "Of Unity in Religion" and "Of Superstition," in "Essays," in *Philosophical Works* (1905), 755–6, 738–9.

82. De Mas, *Sovranità* (1975), 157–8, 164–5, 168–71, 175–6.

83. Gabrieli, *English Miscellany*, 8 (1957), 209–10; De Mas, *Sovranità* (1975), 174–9.

84. Jonson, *Works* (2012), iv. 188; Coryate, *Coryate's Venice* (1989), 20, 43–4, 47, 60–6; according to Chaney and Wilks, *Grand Tour* (2014), 193, the rescuer was Wotton's secretary.

85. Roth, in Jewish Historical Society of England, *Transactions*, 11 (1924–7), 207, 213–15, 222, referring to Modena, *History* (1650); McReynolds, in Howard and McBurney (eds), *Image* (2014), 123n8.

86. Warneke, *Images* (1995), 105–7, 130–5, 171, 176–7; Cavendish, *Horae* (1620), 390; Hall, *Quo vadis* (1617).

87. Cavendish, *Horae* (1620), 408–17; Peckard, *Memoirs* (1790), 57–61; Penrose, *Travelers* (1942), 16–18.

88. Walton, *Lives* (1888), 91–7; *SL* i. 40–2; Brocard, *Alarm* (1679), 2–3, 10–12.

89. *SL* i. 19–26, 42–5; *CSPV*, 1603–7, 81–3.

90. *SL* i. 8–26, 34–8; Wotton to Lord Zouche, 8 May 1592, in *SL* i. 274 (quote).

91. *HG* 90.

92. *SL* ii. 364.

93. Bacon, "Of Simulation and Dissimulation," in "Essays," in *Philosophical Works* (1905), 741–2; Jonson, *Volpone*, IV.i.16–17, 22–3.

94. Rothman, *Pursuit* (2017), 148–51 (Kepler); Galileo, *Dialogue* (1953), 131, 162, 211, 265.
95. Parker, as quoted by Ord, *SC* 22/1 (2007), 4; *SL* ii. 434, 300–1; Ord, in Betteridge, *Borders* (2007), 163–6.
96. Wotton, *Survey* (1938), 24.
97. *Volpone*, II.i, 9–10.
98. Quoted in Ord, *SC* 22/1 (2007), 18.
99. O'Callaghan, in Wilks (ed.), *Prince Henry* (2007), 90–3; Ord, *Travel* (2008), 125–7.
100. Mathew, *Age* (1951), 247, 256.
101. Peacock, in Sharpe and Lake (eds), *Culture* (1993), 201–2, citing Peacham, *Graphice* (2012), 10–14; Gent, *Picture* (1981), 7–8, 17–18.
102. Gent, *Picture* (1981), 6–14, 27, 77; Levy, *JWCI* 37 (1974), 180–4; Burton, *Anatomy*, II.2.4, (2001), 86–8.
103. Brotton, *Sale* (2006), 39; Chaney, *Evolution* (1998), 205–8; Winton-Ely, *Eighteenth-Century Life*, 28/1 (2004), 139; Ord, in Betteridge (ed.), *Borders* (2007), 148–51, 156–7.
104. Wotton to Sir Edmund Bacon, 16 June 1614, in *SL* ii. 40; Hervey, *Life* (1921), 76–8.
105. Robinson, *Dukes* (1995), 101–2, 107–9; Fletcher, *Apollo*, 144 (August 1996), 64; Wilson, *Lanier* (1994), 204; Norgate, *Miniatura* (1919), pp. ix–x; Chaney and Wilks, *Grand Tour* (2014), 191. The gondola is noted in *CSPD*, 1623–25, 81.
106. Peacock, in Sharpe and Lake (eds), *Culture* (1993), 206–7, 212, 215–19; Braunmuller, in Peck (ed.), *Mental World* (1991), 232–3; Wilks, *Journal of the History of Collections*, 1/2 (1989), 168–74; Anderson, "Art Dealing" (2010), 50–5.
107. Chaney and Wilks, *Grand Tour* (2014), 232; Anderson, in Howard and McBurney (eds), *Image* (2014), 124–35.
108. *SL* ii. 194–201; Harris with Savage, *Architectural Books* (1990), 499–500.
109. Wotton, *Elements* (1624), 41–2; Kruft, *History* (1994), 231–2; Myers, *Literature* (2013), 51–62.
110. Cavendish, *Horae* (1620), 383–4; Gent, *Picture* (1981), 14–17, 69–86.
111. Jones, *On Palladio* (1970), i. 9, 12, 46; ii, bks I, 36, 50, and IV, 29; Wilks, *Court Historian*, 12/2 (2007), 164, 166. Jones went to Denmark, perhaps not for the first time, with a mission to convey the Garter to Christian (Wilks, *Court Historian*, 12/2 (2007), 157–8).
112. Chaney and Wilks, *Grand Tour* (2014), 60.
113. Jones, *On Palladio* (1970), i. 1, and ii, first flyleaf; Serlio, *Architecture* (1611), I.1, fo.1.1r, II.3, fo. 2.5r.
114. Orgel and Strong, *Jones* (1973), i. 7, 18; Lewcock, *Davenant* (2008), 46–9.
115. Limon, *Masque* (1990), 56–8, 69, 72, 75.
116. Peacock, *Designs* (1995), 84–5, 91, 96, 104–7, 181, 269, 305.

Chapter 2

1. Bentivoglio, *Memorie* (1864), i. 26–30, 79, 82; Bentivoglio to Francesco Bivero (a Dominican in Brussels), 10 April 1616, in Bentivoglio, *Collection* (1764), 69.
2. Bentivoglio, *Relationi* (1630), i. 205–9.

3. Bentivoglio, *Relationi* (1630), i. 209–12; Loomie, *HLQ* 34 (1970–1), 303–5. Gardiner, *Government* (1877), ii. 235, estimates that Catholics amounted to a twentieth of the population of England.

4. Bentivoglio, *Relationi* (1630), i. 210–15; Patterson, *James* (1997), 77–84.

5. Earle, *Microcosmographie* (1638[7]), no. 13 (quote); Walsham, *Church Papists* (1993), 11–12, 76–7, 80.

6. Bentivoglio, *Relationi* (1630), i. 216–18.

7. Questier, *English Historical Review*, 123 (2008), 1134–6, 1141, 1149–50, 1156, and *Newsletters* (2005), 9–15. The Venetian ambassadors kept track of James's vacillations, e.g., *CSPV, 1603–7*, 138, 166 (11 March and 7 July 1604), lenient; 232, 270 (30 March and 14 September 1605), hesitant; 279–80, 321, 323 (12 October 1605, 24 February and 10 March 1606), severe.

8. McCullough, *Sermons* (1998), 6, 103, 105, 117–20, 125.

9. James VI & I, *Basilikon doron* (1603), 41–2; Croft, *James* (2003), 155, 158–9; Cozzi, *Rivista storica italiana*, 79 (1967), 1110.

10. McCullough, *Sermons* (1998), 107–12.

11. Kepler, in *Werke* (1937–98), xii. 30–5; Rothman, *Pursuit* (2017), 90.

12. White, in Fincham, *Church* (1993), 219–22.

13. Quoted in Hill, *Bench* (1988), 264, 212.

14. Sir John Harrington, in Akrigg, *Pageant* (1962), 80 (quote), 82; Roberts, *Entertainment* (1606), 10; Anon. (1606), 20, 28.

15. Heiberg, *Christian 4* (2006), 120; Summerson, *Jones* (2000), 6–7; Gotch, *Jones* (1928), 26–8.

16. Anon. (1606), 9 (quote); Giovani Carlo Scaramelli to Doge and Senate, 24 April, 28 May, 12 and 19 June 1603, and Piero Duodo and Nicolo Molin to same, 11 December 1603 (quote), in *CSPV, 1603–7*, 11, 40–2, 47, 52, 122.

17. Scaramelli to Doge and Senate, 24 April, 8 May, 30 July (quote) 1603, and Molin to same, 1 December 1604, in *CSPV, 1603–7*, 11, 20, 70, 195.

18. *SL* i. 81–4; Ord, *SC* 22/1 (2007), 8–10.

19. Wotton to Salisbury, 1 September 1606, in *SL* i. 360.

20. Lockhart, *Denmark* (1996), 78; Heiberg, *Christian 4* (2006), 152–6.

21. Bentivoglio, *Memorie* (1864), i. 26–30, 79, 82; Bentivoglio to Francesco Bivero, 10 April 1616, in Bentivoglio, *Collection* (1764), 69.

22. Bentivoglio, *Relationi* (1630), i. 227–332.

23. Laud and Buckeridge, "Epistle Dedicatory," in Andrewes, *XCVI. Sermons* (1631), fos A3–A5; Andrewes, *Morall Law* (1642), esp. 253–6, 373–4, for Andrewes's early Puritanism.

24. Andrewes, *Selected Sermons* (2005), 179–90, 191 (quote); Mitchell, *Pulpit Oratory* (1932), 148–66.

25. Andrewes, *Selected Sermons* (2005), 153–4, 156–60, 193–7; *CSPV, 1603–7*, 327 (23 March 1606).

26. Andrewes, *Selected Sermons* (2005), 198–202.

27. Mocket, *God* (1615), 20–4, 63–9, 75–5, 84–7.

28. James VI & I, *Declaration* (1612), 6, 21, 29–32; Shriver, *English Historical Review*, 85 (1970), 455, 462, 460 (quotes), 454–8.

29. De Mas, *Sovranità* (1975), 41, 52–4, 59, 65, 70–3.

30. Bellany and Cogswell, *Murder* (2015), 93–103; Anthony, *Medicinae chymicae . . . assertio* (1610), 46–8; Debus, *Paracelsians* (1965), 142–3.

31. Milton, *Delegation* (2005), pp. xxii–xxxv, xlii, xlvii–liii; White, in Fincham (ed.), *Church* (1993), 225; Fincham and Lake, in Fincham (ed.), *Church* (1993), 31.

32. Montagu, *Gagg* (1624), fo. +2ᵛ, 108, 144–5; Tyacke, in Duke and Tamse (eds), *Church* (1981), 100; Milton, in Fincham (ed.), *Church* (1993), 200, 208–9.

33. Andrewes, *Selected Sermons* (2005), 232, 235, 242.

34. McCullough, in Andrewes, *Selected Sermons* (2005), pp. xxvi–xxx; Lake, in Peck (ed.), *Mental World* (1991), 113–19; Milton, in Ashbee (ed.), *Lawes* (1998), 73–4.

35. McCullough, *Sermons* (1998), 155–6, 161, 163.

36. Laud and Buckeridge, in Andrewes, *XCVI. Sermons* (1631), fos A3ᵛ, A5ʳ.

37. Isaacson, *Narration* [1650] (1817), 3–4; Lossky, *Andrewes* (1991), 11–12.

38. Foley, *English College* (1880), 356–7.

39. Eeles, *Parish Church* (1953), 58–61; Bouch, *Prelates* (1948), 244–7.

40. Fincham, *Prelate* (1990), 86, 180, 256–7.

41. Eeles, *Parish Church* (1953), 47; Collingwood, CWASS, *Transactions*, 10 (1910), 379; Crosthwaite, CWASS, *Transactions*, 2 (1876), 228–31.

42. Crosthwaite, *Life* (1873), 3, 7, 24; Prest, *Diary* (1991), 99; Bott, *Keswick* (1994), 185; Crosthwaite, CWASS, *Transactions*, 2 (1876), 226–7, 232, following Camden, and 6 (1883), 344–6; Esser, in Panayi (ed.), *Germans* (1996), 22–6.

43. Brathwaite, *English Gentleman* (1631²), 126.

44. Hutchins, *History* (1973), iii. 239; Bott, *Keswick* (1994), 18–21.

45. Magrath, *Queen's College* (1921), i. 206–24.

46. Jonson, *Everyman out of his Humour* (1599), in *Works* (2012), i. 249–420, dedication, quoted in Green, *Inns* (1931), 2–3; see also 11–17, 57–8, 80–96; Prest, *Inns* (1972), 230–2; Levack, *Civil Lawyers* (1973), 9–10, reports the 90% restriction to gentlemen.

47. Prest, *Inns* (1972), 47–8, 52–5, 64–5; Fletcher, *Pension Book* (1901), 293, 308, 311, 313–17; Charles's Lenten tantrum occurred on 18 March 1633.

48. Green, *Inns* (1931), 43–4, 49–50.

49. *Biographia Britannica* (1747–66), i. 471 (first quote); Clarendon, *History* (1849), ii. 137 (second quote).

50. Baker, *Readers* (2000), 259, 275, 329, 506, 525.

51. Fletcher, *Pension Book* (1901), 215; Ornsby, *Selection* (1878), 114–16, 209, 259, app. xxxv; the estimate converts the 11-shilling fees for copying, advising, filing, etc., to 5 shillings an hour.

52. Matthew, in Woodruff (ed.), *Belloc* (1942), 117–18, 122–3, 130; *Victoria History. Cumberland* (1901–5), ii. 283–5; Scot, *Lay of the Last Minstrel* (1805), VI.vi, xix, xxiii, xxiv, xxvi, and V.v.82–5 (quote). Mathew, *Age* (1951), 245–58, takes Lord William as his example of the early Stuart antiquary.

53. Reinmuth, *Recusant History*, 12 (1973–4), 226, 228, 232–3.

54. Harrington, 1615, quoted in McCullough, *Sermons* (1998), p. v.

55. McCullough, *Sermons* (1998), 126, 195; Morrissey, *Politics* (2011), 25, 38–9; D-BKL/ H/A/77.

56. Bankes to Laud, in Laud, *Works* (1847–60), iv. 115; Laud to Bankes, Laud, *Works* (1847–60), vi. 74, and letters of 11 November and 3 December 1634, 14 July 1637 and 1 July 1635, in Laud, *Further Correspondence* (2018), 104, 106, 173–4 (first quote), 139 (second quote).

57. Hall, *Sermon* (1642), fo. A2v; Bankes, *Story* (1853), 76–9; Kerling, London and Middlesex Archaeological Society, *Transations*, 22/3 (1970), 3.

58. Sibbes, *Soule's Conflict* (1635), fos A2v, A5r; Dever, *Sibbes* (2000), 66–70, 73, 82–3, 86–90; Adlington, in Archer (ed.), *Worlds* (2011), 54, 57–8.

59. Lloyd, *Memoires* (1668), 586 (s.v. "Bankes"). Cf. Prest, *Inns* (1972), 213.

60. *SL* i. 125; Loomie, *HLQ* 34 (1970–1), 308; Hervey, *Life* (1921), 155.

61. Pagnini, *Constantino* (2006), 134–5, 141–5, 147–9.

62. Antonio Foscarini, Venetian ambassador to England, to Doge and Senate, 30 November 1612, *CSPV, 1610–13*, 453–4.

63. Crinò, in Chaney and Ritchie (eds), *Oxford* (1984), 107–13; Watson and Avery, *Burlington Magazine*, 115 (1973), 494–502; *SL* i. 114–16, 119–22, 131–2.

64. Thrush, in Clucas and Davies (eds), *Crisis* (2003), 25–31; Barroll, *Anna* (2001), 153–6, 171.

65. Glarbo, *Afhandlinger* (1956), 50–80.

66. Nichols, *Progresses* (1828), ii. 69n., quoting a contemporary source (Pegge's *Curialia*, pt 4, p. 63); Heiberg, *Christian 4* (2006), 227, 230; Williams, *Anne* (1970), 178–9.

67. Akrigg, *Pageant* (1962), 321–8; *CSPV, 1621–3*, 550–1, and *1623–5*, 208.

68. Glabro, *Afhandlinger* (1956), 50–80; Murdoch, *Britain* (2000), 42, 48.

69. Croft, *James* (2003), 84–5, 113; Hill, in Keblusek and Noldus (eds), *Double Agents* (2011), 41; Chaney, *Evolution* (1998), 209–10; Barnes, in Howarth (ed.), *Art* (1993), 1, 4–7.

70. Huxley, *Porter* (1959), 25, 30–1, 53–4, 72, 75, 81.

71. Redworth, *Prince* (2003), 65–9.

72. Baldwin, *Chapel* (1990), 100, 236; Matthew and Calthorp, *Life* (1907), 193–7, 213–15, 220; Redworth, *Prince* (2003), 69–71, 134–7.

73. Brotton and McGrath, *Journal of the History of Collections*, 20 (2008), 1, and Brotton, in Samson (ed.), *Spanish Match* (2006), 19–24.

74. Akrigg, *Pageant* (1962), 222.

75. Huxley, *Porter* (1959), 95, 100–1, 117.

76. Huxley, *Porter* (1959), 110.

77. McCullough, *Sermons* (1998), 183–5, 195, 196 (quote, from the preacher Daniel Price), 197–9, 204–6.

78. Crinò, in Crinò, *Fatti* (1957), 55–6; Matthew and Calthorp, *Life* (1907), 141–3, 148–50, 155.

79. Baldwin, *Chapel* (1990), 129; Petersson, *Digby* (1956), 29, 57, 264–74; Moshenska, *Stain* (2016), 80–3, 111–12; Bacon, *Sylva sylvarum* (1627), 264–5, in Bynum, *Journal of the History of Medicine*, 21 (1966), 9.

80. Ruigh, *Parliament* (1971), 308.

81. Micanzio to Cavendish, 27 December 1619, and 5 June, 29 October 1620, in Ferrini (ed.), *Lettere* (1987), 99, 113, 121; Gabrieli, *English Miscellany*, 8 (1957), 195–250, and De Mas, *Sovranità* (1975), 215–59, also review this correspondence.

82. Micanzio to Cavendish, 10 September 1621, 5 February 1622, in Ferrini (ed.), *Lettere* (1987), 144, 148 (quote).

83. Micanzio to Cavendish, 19 August 1622, 26 May and 8 June 1623, in Ferrini (ed.), *Lettere* (1987), 199–200, 234 (quote), 237.

84. Sarpi to Dohna, 20 May 1609, in Benzoni, *Archivio veneto*, 98 (1967), 22; Lievsay, in Bluhm, *Essays* (1965), 112–15; Belligni, in Pin (ed.), *Ripensando* (2006), 140; Cogswell, in Cust and Hughes (eds), *Conflict* (1989), 107–9.

85. Micanzio to Cavendish, 3 June, 21 October, 2 November, and 9 December 1622, 30 June and 13 July 1623, in Ferrini (ed.), *Lettere* (1987), 182–3, 208, 212, 217–18, 242, 245; *CSPV*, 1621–3, 493–4.

86. Micanzio to Cavendish, 24 February, 6, 13, 20, 27 May 1622, in Ferrini (ed.), *Lettere* (1987), 157, 170–1, 175, 178.

87. Micanzio to Cavendish, 12 March 1621, in Ferrini (ed.), *Lettere* (1987), 180.

88. Micanzio to Cavendish, 2 August, 27 October 1623, in Ferrini (ed.), *Lettere* (1987), 248–9, 255.

89. Micanzio to Cavendish, 21 February, 24 April 1620, and 28 September 1618, in Ferrini (ed.), *Lettere* (1987), 80 (quote), 101 (quote), 110.

90. Ranier Zen, *CSPV*, 1621–3, 493–4.

91. Middleton and William Rowley, *The World Tost at Tennis* (1620), in Middleton, *Works* (2010), 1416 (ll. 163–8).

92. Thus 3000, in Hogg, in Hogg (ed.), *Jacobean Drama* (1995), 291–5; Limon, *Dangerous Matter* (1986), 102–18.

93. Bold, in Middleton, *Game* (1929), 11, 17–20; quotes from *Game*, II.ii, pp. 71–2 (slightly varied in Middleton, *Works* (2010), 1848–9, ll.13–14, 48–52); Heineman, in Mulgrave and Shewring (eds), *Theatre* (1993), 242–8; Limon, *Dangerous Matter* (1986), 6–7, 98–129.

94. Croft, *James* (2003), 106–9; McCullough, *Sermons* (1998), 139–41, 209.

95. Gardiner, *England* (1875), i. 13 (quote), 21–6, 30–3; Alexander, *Weston* (1975), 51–2; Croft, *James* (2003), 123–5; Berkowitz, *Selden* (1988), 86–9.

96. Gardiner, *History* (1893–4), i. 39–42, 69, 82–3.

97. Gardiner, *England* (1875), i. 161–2.

98. Lando, in *CSPV*, 1621–3, 450–3.

99. Gardiner, *England* (1875), ii. 14, 75, 84, 88–91.

100. White, in Fincham (ed.), *Church* (1993), 225–9; Fincham and Lake, in Fincham (ed.), *Church* (1993), 37–40; Tyacke, in Fincham (ed.), *Church* (1993), 62, 66–9.

101. Gardiner, *Government* (1877), i. 35–8 (quote, 37), 56, 65, 87.

102. Gardiner, *Government* (1877), i. 166, 292–5, 305; ii. 207–9, 214, 222, 276–7; Laud to Brent, 9 September 1635, in Laud, *Further Correspondence* (2018), 131–2.

103. Gardiner, *Government* (1877), ii. 252–8, 253; Steele, *Plays* (1968), 259–60 (quote); Elliott et al. (eds), *Records*, xvii.1 (2004), 519–64.

104. Strode, *Floating Island* (1655), II.iv, IV.xiii, V.vi.
105. Questier, *Newsletters* (2005), 288–9.
106. Gardiner, *Government* (1877), ii. 24–8, 35–9; Jones, *HLQ* 40 (1977), 215–16.
107. Prynne, *Pleasant Purge* (1642), fo. A4r, pp. 100–1.
108. Prynne, *Love-Lockes* (1628), fo. a3, p. 2, and fo. a2, resp.
109. Hill, *Bench* (1988), 263, re Sir Julius Caesar.
110. Prynne, *Healths-Sicknesse* (1628), ¶¶ 2v, 5r.
111. According to Aubrey, *Lives* (2018), i. 270.
112. Burton [and Prynne], *Tragedie* [1626] (1642), fo. A3r and pp. 28, 1, 29 (quotes); fos A4v–B1r, on Bellarmine.
113. Burton, *For God* (1636), fo. B1r (quote).
114. Gardiner, *Fall* (1882), i. 4–5.
115. Cf. Sharpe, *Personal Rule* (1992), 758–65; Wedgwood, *Wentworth* (2000), 236–7 (quote); Howell, *Collection* (1816), iii, col. 745; Sanderson, *Compleat History* (1658), 218–19.
116. Wedgwood, *Wentworth* (2000), 237; Woodford, *Diary* (2012), 377, for 26 November 1640.
117. Geree, *Character* (1646), 1–6.
118. Thomas, Lord Coventry, to Assize Judges, July 1635, in Howell, *Collection* (1816), iii, cols 831–2; cf. Questier, *Newsletters* (2005), 278.
119. Prynne, *Popish Royal Favourite* (1643), 15–16, 19.
120. Sanderson, *Compleat History* (1658), 219–20.
121. Albion, *Charles I* (1935), 193–200; Anon., *A Refutation* (1681), re Cottington; Havran, *Catholics* (1962), 51–2, 55, 59.
122. Leyburn to Biddulph, 19 July 1633, and "Short Instruction" (1635), in Questier, *Newslettters* (2005), 192, 246–7.
123. Laud, *Works* (1847–60), iii. 219; iv. 332.
124. Sitwell, *Recusant History*, 5 (1960), 136–41, 145–7, 162–6; Davidson, "Catholicism" (1970), 655.
125. Anon., *Nuntioes* (1643), 4–5, 8–13.
126. Albion, *Charles I* (1935), 172–5, 179–87; Birrell, "Introduction," in Berington (ed.), *Memoirs* (1970).
127. Kraus, *Staatssekretariat* (1964), 30, 85, 138–40, 148.
128. Conn, *Vita* (1624), fos †3v–†6v, cited in Favino, *Bruniana e Campanelliana*, 3/2 (1997), 269; Allacci, *Apes* (1633), 126–7, largely following Dempster, *Historia* (1627), 170–2.
129. Conn, *Assertionum catholicarum* (1629), fos +1, +4r, and pp. 154, 157.
130. Schreiber, *Carlisle* (1984), 81–7; Mathew, *Age* (1951), 57–9.
131. Nicius, *Pinacotheca* (1643), 132–3; Lutz, *Kardinal* (1971), 406–7; Albion, *Charles I* (1935), 118–44.
132. Questier, *Newsletters* (2005), 52, 90–1, 108, 130–1, 151–5, 161–2, 166–7, 206, 225 (correspondence of January–February 1632 to 1 July 1634); Villani, in Visceglia (ed.), *Papato* (2013), 314–16.
133. *SL* i. 100–7; James to Salisbury, September 1609, in James VI & I, *Letters* (1984), 312–13; Jaitner, in Schoppe, *Philoteca* (2004), i.1. 78–9, 102; Schoppe, in Schoppe,

Philoteca (2004), i.1. 580, 599–601; Sells, *Paradise* (1964), 65–6. "Starving turncoat" and "mud-caked quack" are Wotton's compliments, as quoted in Reeves, *News* (2014), 144.

134. Schoppe, "Catalogus virorum doctorum," in Schoppe, *Philoteca* (2004), i.2. 617–27; Bentivoglio to Conn, December 1639, in Ciampoli, *Lettere* (1676), pt 1, 71.

135. HG 257–8, 300–8; D'Addio, *Scioppio* (1962), 20–8, 171–5, 244–6.

136. Ciampoli, *Poesia* (1626), 4, 30.

137. Conn to Barberini, 16 September 1636, in Ranke, *History* (1875), v. 453.

138. Leyburn to Edward Bennett, 3 September 1636, in Questier, *Newsletters* (2005), 287–90; Hervey, *Life* (1921), 326–7.

139. Huxley, *Porter* (1959), 163–5; Laud to Charles I, 16 November 1637, in Laud, *Works* (1847–60), vii. 382.

140. Huxley, *Porter* (1959), 235–7; Selden, *Table Talk* (1856), 137. If we are to believe Aubrey, *Lives* (2018), i. 400–1, Selden was an expert in seduction.

141. Gardiner, *Government* (1877), ii. 235–6.

142. Conn to Barberini, 12 March 1637, in Ranke, *History* (1875), v. 456.

143. Questier, *Newsletters* (2005), 295, 302–3, 305, 317, 321 (letters of November 1636 to 15 March 1638); Conn to Barberini, 17 September 1638, quoted by Worsley, *Cavalier* (2007), 136.

144. Conn to Barberini, 16 September 1636, in Ranke, *History* (1875), v. 453.

145. Meyer, *American Historical Review*, 19 (1913), 22; Albion, *Charles I* (1935), 189; Havran, *Catholics* (1962), 148–9; Cropper, "Introduction," in Cropper (ed.), *Diplomacy* (2000).

146. Solinas, in Cropper et al. (eds), *Documentary* (1992), 236–7, 257n.

147. Donaldson, *Prayer Book* (1954), 44 (quote), 49–53, 62–70, 73–7; McCullough, *Sermons* (1998), 127–8.

148. Gardiner, *Government* (1877), i. 323–4, 328–9, 333–4, 338–9, 343–61.

149. Gardiner, *Fall* (1882), i. 101, 109–10, 127–30, 137–8, 144 (quote), 168–9, 177–8.

150. Gardiner, *Fall* (1882), i. 149–50, 228–9; Alexander, *Weston* (1975), 178. An army of 30,000 men cost about £7,800 a month (Alexander, *Weston* (1975), 190).

151. Gardiner, *Fall* (1882), i. 194–5; Murdoch, *Britain* (2000), 90–1, 94, 98–103, 109, 115.

152. Gardiner, *Fall* (1882), i. 233–5, 238, 241.

153. Gardiner, *Fall* (1882), i. 251–5.

154. Gardiner, *Fall* (1882), i. 308, 315–16, 326, 331, 345–56, 360–1, 382–3, 391–8; Wedgwood, *Wentworth* (2000), 271, 273, 276–82, 288–9.

155. Laud, *Works* (1847–60), iv. 465–6, 469 (from a reprinting of *Romes Master-peece* with protestations by Laud).

156. Laud, *Works* (1847–60), vii. 397n.

157. Prynne, *Romes Master-peece* (1643), 2–7, 15–24; Gardiner, *Fall* (1882), i. 23.

158. Prynne, *Romes Master-peece* (1643), 19.

159. Laud, *Works* (1847–60), iv. 477, on notes on letter from Boswell of 15 October 1640.

160. Prynne, *Romes Master-peece* (1643), 19; Woodford, *Diary* (2012), 306, 358 (16 May 1639, 17 May 1640).

161. Laud to Joseph Hall, 14 January 1639, in Laud, *Works* (1847–60), vi. 577–8; iv. 308–9, 333, 346.
162. Ellison, *Sandys* (2002), 183, quoting Smuts, *Court Culture* (1987), 226.
163. Prynne, *Romes Master-peece* (1643), 27, 29, 33–6. In *Popish Royal Favourite* (1643), Prynne itemizes "papists" released from prison or fines by Charles.
164. Prynne, *Hidden Workes* (1645), fo. a1–a2ʳ; cf. Sanderson, *Compleat History* (1658), 360, and Laud, *Works* (1847–60), iv. 496–501.
165. Giblin, *Irish Ecclesiastical Record*, 85 (1956), 393–8, 403–4.
166. Gardiner, *Fall* (1882), i. 295, and *History* (1893–4), ix. 219, 227–8, 243–4, 288–9, 323, 363, 375; Hervey, *Life* (1921), 424, 427, 429.
167. Gardiner, *History* (1893–4), ix. 354, 401, 411–12.
168. Gardiner, *History* (1893–4), ix. 403–4, quoting Rossetti; Finlayson, *Historians* (1983), 105–7.

Chapter 3

1. Alexander, *Weston* (1975), 68, 70; Wallace, *Sandys* (1940), 26, 32, 40–3, 48, 56, 65–6, 70, 86–7.
2. Hill, *Bench* (1988), 142, 159, 164–71, 189; Croft, *James* (2003), 63–5, 78–9, 93; Clucas, in Clucas and Davies (eds), *Crisis* (2003), 182–3.
3. Jones, *Politics* (1971), 156; Wotton to Edmund Bacon, 8 June 1614, in *SL* ii. 37; Alexander, *Weston* (1975), 22–3.
4. James VI & I, *Political Writings* (1994), 250, 261, 268 (text of 1622). Cf. Croft, *James* (2003), 113–15; Alexander, *Weston* (1975), 17–22.
5. Cf. Finlayson, *Historians* (1983), 86, 92, 94; Foster, *Lords* (1983), 33–5.
6. James to Salisbury, September 1609, in James VI & I, *Letters* (1984), 270 (quote); Robinson, *Dukes* (1995), 80–96; Andersson, *Howard* (2009), 136–7.
7. Croft, *James* (2003), 90–1, 97, 101–3.
8. Hervey, *Life* (1921), 105, 113 (quote), 185, 191–2, 222–4, 236–7; Sharpe, in Sharpe (ed.), *Faction* (1985), 12–19.
9. Barroll, *Anna* (2001), 133, 144–8; Sharpe, in Sharpe (ed.), *Faction* (1985), 37–9.
10. *Victoria History. Wiltshire*, v (1957), 121.
11. Ruigh, *Parliament* (1971), 39–42, 165–70, 233, 239–40, 362.
12. Ruigh, *Parliament* (1971), 261, 288, 310, 341–3, 349, 354, 358–61.
13. Ruigh, *Parliament* (1971), 55, 220, 226, 229, 234.
14. Thrush and Ferris, *House* (2010), iii. 125–6.
15. Gardiner, *England* (1875), i. 273–5, 283–4, 294–5; Alexander, *Weston* (1975), 80–8; Lockhart, *Denmark* (1996), 93–8, 110–29; Ruigh, *Parliament* (1971), 382–3.
16. Gardiner, *England* (1875), i. 342–4, 353–4, 362; ii. 92, 97, 111–12, 156–64.
17. Laud, *Works* (1847–60), i. 84 (quote), 100.
18. Gardiner, *England* (1875), ii. 15–16, 39, 66, 69; Sharpe, in Sharpe (ed.), *Faction* (1985), 232–4; Hervey, *Life* (1921), 243–8, 251–5.
19. Foster, *Lords* (1983), 28–9.

20. Speeches of 3 June and 21 March 1626, resp., in Bidwell and Jansson, *Proceedings* (1991–6), iii. 354, 360; ii. 331; cf. iii. 204, 212, and Thrush and Ferris, *House* (2010), iii. 127.

21. Alexander, *Weston* (1975), 96–105; Berkowitz, *Selden* (1988), 111–13, 116, 119, 121 (quote, from Simmonds d'Ewes).

22. D'Ewes, *Autobiography* (1845), i. 120; ii. 124.

23. Popofsky, *Historian*, 41 (1979), 258–60, 263–5; Berkowitz, *Selden* (1988), 96, 126–34.

24. Berkowitz, *Selden* (1988), 94–9, 148–9, 159, 173, 189–91, 269, 279; Alexander, *Weston* (1975), 111–15.

25. Murdoch, *Britain* (2000), 72–4, 202–17; Lockhart, *Denmark* (1996), 147–50, 192–206; Gardiner, *England* (1875), i. 340–1.

26. Johnson et al., *Proceedings* (1977–83), ii. 363–4, 375; iii. 157; iv. 298, 373–468 *passim*, esp. 430–1, 438.

27. Guy, *Historical Journal*, 25 (1982), 296–300, 307–10, as modified by Kishlansky, *Historical Journal*, 42 (1999), 54, 76–82.

28. Johnson et al., *Proceedings* (1977–83), ii. 481–2; iii. 150; Thrush and Ferris, *House* (2010), iii. 127.

29. Thrush and Ferris, *House* (2010), iii. 201, 207, 210, 214, 226; quote, from John Eliot, 204–5; Alexander, *Weston* (1975), 118.

30. Heilbron, in Shumaker (ed.), *Dee* (1978), 15.

31. Gardiner, *England* (1875), ii. 251, 260–1, 295 (quoting John Pym).

32. Berkowitz, *Selden* (1988), 175 (quote), 188, 189 (quote), 190–2; Popofsky, *Historian*, 41 (1979), 266–8, 271–4.

33. Berkowitz, *Selden* (1988), 204–8, 231, 262, 273, 278, 280–1, 286–7, 305–10, 314–15; Alexander, *Weston* (1975), 121–4.

34. Gardiner, *England* (1875), ii. 191, 270–3, 330, 336–42, 348–55; Cogswell, *Historical Journal*, 49 (2006), 361–3, 368–74, 377; Holston, *English Literary History*, 59 (1992), 524–5.

35. Alexander, *Weston* (1975), 5–7, 13–17, 43–4, 56, 168–9, 180–1, 195, 199, 210, 219; Gardiner, *England* (1875), ii. 120, 122, 316, and *Government* (1877), ii. 91.

36. Gardiner, *England* (1875), ii. 230, and *Government* (1877), i. 52–3, 58–9, 85–8, 94–5, 99, 120–2, 153; Alexander, *Weston* (1975), 106–8, 129–30, 133–44.

37. Popofsky, *Past and Present*, 126 (1990), 54, 61–7, 68 (quote from a member), 69–72; Berkowitz, *Selden* (1988), 202–3.

38. Gardiner, *Government* (1877), i. 126–9; Alexander, *Weston* (1975), 152–3, 157; Thompson, in Sharpe (ed.), *Faction* (1985), 248–74; Jones, *Politics* (1971), 71; Terry, *Life* (1936), 175–7.

39. Jones, *Politics* (1971), 169–70 (quotes); Berkowitz, *Selden* (1988), 231 ("malevolent vipers"), 232, 243.

40. Berkowitz, *Selden* (1988), 245, 251–2, 258–9, 262–5, 275, 279, 283–90.

41. Aylmer, *King's Servants* (1961), 26–32; Cuddy, in Cruckshanks (ed.), *Courts* (2000), 66–71, 76; Huxley, *Porter* (1959), 125.

42. Gardiner, *Government* (1877), i. 177–8; Alexander, *Weston* (1975), 67–8, 159–61; Huxley, *Porter* (1959), 196.

43. Alexander, *Weston* (1975), 174; Mendle, *Dangerous Positions* (1985), 172–4; Sharpe, in Sharpe (ed.), *Faction* (1985), 42.

44. Cust, in Merritt (ed.), *Political World* (1996), 73–9; Jones, *Politics* (1971), 92. A list of cases Bankes pursued as attorney to the Prince of Wales is in BPB 57/14.

45. Privy Council, *Acts, 1626, June–December*, 234–7, and *Acts, 1629 May–1630 May*, 236–7; *CSPD, 1634–5*, 196, 206, 221. Havran, *Courtier* (1973), 116, gives Henrietta's outlay over two years as £89,378 against an income of £18,166.

46. Foster, *Alumni oxonienses* (1891–2), i. 67; Foss, *Judges* (1848–64), 251–4; Kopperman, *Heath* (1989), 242–4 (first quote); *The World Tost in Tennis*, in Middleton, *Works* (2010), 1129, ll. 28–30 (second quote); G. Garrard to Thomas Wentworth, 1635, in Bankes, *Story* (1853), 54 (third quote); Thomas Egerton, first baron Ellesmere, served Elizabeth and James. On Finch and the queen, Terry, *Life* (1936), 106, 134, 153, 183.

47. Bacon, in Jones, *Politics* (1971), 37; Johnston, *Life* (1837), i. 211–12.

48. Cliffe, *World* (1999), 198–9.

49. Hawtrey, *History* (1903), i. 42, 67, 86–9; Waterhouse, *Burlington Magazine*, 102 (1960), 122; Montagu, in Chaney and Mack (eds), *England* (1990), 271–82; Mitchell, *Kingston Lacy* (1994), 10, 61; Little, *History Today*, 65 (2015), 11–12.

50. Anon. (1908), 78.

51. Bankes, *Story* (1853), 33; *Encyclopedia Britannica* (1911), s.v. "Cinque Ports."

52. Heywood, *Notes* (n.d.); Bennett, RHMC, *Report*, 8 (1881), 208b.

53. Hutchins, *History* (1973), iii. 236–7; "A note on the goods of Sʳ John Bankes which were taken away from Corfe Castle," in "Autograph Letters," vol. 1 (D-BKL).

54. Russell, *Fall* (1991), 39–41, 506n.; Bennett, RCHM, *Report*, 8 (1881), 208a; Bankes, speeches to the serjeants, in D-BKL/H/A/31–5, esp. 35.

55. Howell, *Collection* (1816), iii, cols 714–15, 718, 727–45; D-BKL/H/A/29 contains Bankes's outline of the trial.

56. Gardiner, *Government* (1977), ii. 180, 192, 201, 313; Quintrell, *SC* 3 (1988), 159–60, 166; Havran, *Recusant History*, 5 (1959), 252 n. 19.

57. Sharpe, *Personal Rule* (1992), 719–20.

58. Clarendon, quoted in Howell, *Collection* (1816), iii, cols 827–8.

59. Howell, *Collection* (1816), iii, cols 870–1, 875–6, 880–4, 898.

60. Howell, *Collection* (1816), iii, col. 1078.

61. Howell, *Collection* (1816), iii, cols 1015–17, 1023 (quote); *CSPD, 1634–5*, 161–2, 234; Jones, *HLQ* 40 (1977), 211–12; Judson, *Crisis* (1949), 130–1, 136, 139–40; Bankes to Laud, 23 January 1636, D-BKL/H/Q/44/1–10.

62. Howell, *Collection* (1816), iii, cols 1024–5, 1045–7, 1060.

63. Howell, *Collection* (1816), iii, cols 1004–5.

64. Howell, *Collection* (1816), iii, col. 1083.

65. Howell, *Collection* (1816), iii, cols 1088–9, 1146; cf. Copernicus, *De revolutionibus*, 1.10.

66. Macaulay, *Essays* (n.d.), 189–93.

67. D'Ewes, *Autobiography* (1845), ii. 133; Francesco Zonca to the Doge and Senate, 8 January 1638, in *CSPV, 1636–9*, 353.

68. Gardiner, *Fall* (1882), i. 70–7, 86–91.

69. Ash, *Draining* (2017), 184–200, 206; BPB 50/13.

70. Judson, *Crisis* (1949), 108.

71. BPB 44/63–9.

72. Gardiner, *Government* (1977), ii. 75, 81–3, 166–72, 183; Jones, *HLQ* 40 (1977), 201 (quote), 207–8; Alexander, *Weston* (1975), 204–5; Aubrey, *Lives* (1898), ii. 98; (2018), i. 571–2, ii. 1516, on Noy's practical joking.

73. Sharpe, *Personal Rule* (1992), 90, 104, 126–7; BPB 47/240.

74. Gardiner, *Government* (1877), i. 208–11, 216–17, 221, 231, 236–9, 248–52.

75. Gardiner, *Government* (1877), ii. 51, 57, 65–8, 79–80, 85–7, 93, 97–8, 102–3, 195–6, 199–201, 266–70; Hervey, *Life* (1921), 357, 368, 370, 377, 392.

76. Gardiner, *Government* (1877), ii. 68, 260–5; Wedgwood, *Wentworth* (2000), 217; Quintrell, *SC* 3 (1988), 171–4.

77. BPB 5/45, 5/46, 55/14, 55/20, 50/25 (Philip Warwick to Bankes, 10 June 1638), 43/58 (£12,000 and £2,400 to Charles's nephews, the Elector palatine and Prince Rupert, resp., 23 June 1637), 43/94 (£4,000 increase to Elizabeth, 4 April 1638). The picture given by Sharpe, *Personal Rule* (1992), 129–30, for 1640/1 may be too rosy, for example, in making anticipations £330,000 less than Bankes did.

78. BPB 43/22, 51/36, 49/6; Aylmer, *King's Servants* (1961), 177–8, 201, 210, 212; Fissel, *Bishops' War* (1994), 127.

79. Price, *Patents* (1913), 34–5, 135–41, 83–4, 90, 96, 115–18.

80. Price, *Patents* (1913), 50–4.

81. BPB 46/*passim*, 55/62; Price, *Patents* (1913), 63.

82. BPB 11/67, 11 and 13 March 1635/6.

83. BPB 11/*passim*; 43/*passim* and 46/*passim* (drainage), 55/62 (sewers). Cf. Sharpe, *Personal Rule* (1992), 121, 253–6.

84. Powell, *Depopulation* (1636), fos A2v–A3r.

85. Monson to Bankes, 19 July 1637, D-BKL/H/A/23.

86. BPB 41/29, 27 March 1635.

87. BPB 52/6, 67/9 (2 January 1636/7), 67/12, 52/20 (14 June 1638), 57/1–2, 57/7.

88. BPB 57/9–11, 16, 21.

89. BPB 11/45, 27 May 1640; 55/94, 8 October 1638 (granted); 17/10, 1 December 1634.

90. Huxley, *Porter* (1959), 199–218.

91. BPB 17/29, 8 November 1634 (the yeoman); 17/40, 17/49, 17/68; 17/41, 31 July 1635 (the recusant).

92. Huxley, *Porter* (1959), 197.

93. Havran, *Recusant History*, 5 (1959), 248–50; Price, *Patents* (1913), 39–42.

94. Price, *Patents* (1913), 73–80, 119–22 (£43,000), 229–30, 235–6.

95. Gardiner, *Fall* (1882), i. 70–7, 86–91; Ashton, *City* (1979), 142.

96. BPB 38/8, 1 March 1638/9; Croft, *Historical Journal*, 30/3 (1987), 525, 537–8; Ashton, *City* (1979), 19–23, 86–93 (currants); BPB 51/33, 31 May 1635, and 17/37, 18 June 1638; 47/14, 2 July 1637.

97. BPB 16/8, 16/35; 41/37, 23 May 1632, and 2 February 1634/5 (Digby).

98. BPB 11/28, 13 February 1635/6; 12/20, 12/23; Mayerne and Cademan, *Distiller* (1639), 1–4, 11.

99. Cf. Peck, *Court Patronage* (1993), 139–45, 210–19.

100. Ashton, *City* (1979), 107–8, 118, 124–5, 129–30, 139–40, 148, 152, 199, 208–9.

101. Ashton, *City* (1979), 75–82; Fissel, *Bishops' War* (1994), 103–4.

102. BPB 44/2; *CSPD, 1635*, p. 31.

103. BPB 44/1; *CSPD, 1637*, p. 50.

104. Holdsworth, *History* (1923–72), v. 208–11; viii. 339–40, 407; Knowles, *HLQ* 69 (2006), 164.

105. BPB 44/5, 44/12AB, 44/46; *CSPD, 1639*, p. 70. Cf. Geree, *Character* (1646), 4, on Puritan resistance.

106. Havran, *Catholics* (1962), 129 ("caterpillar"); BPB 41/53, 3 June 1639; 18/24, 65/18, 42/30 (Archie the Fool = Archibald Alexander), March 1637/8.

107. Mayne, *Citye* (1639), I.v, II.1, II.iii, IV.vii, V.ix, V.vii.

108. Clarendon, *History* (1849), i. 295; Kopperman, *Heath* (1989), 80–6, 95–103, and 24 (quote, from a courtier's letter of 14 February 1637); Little, *History Today*, 65 (2015), 12.

109. Ogilvie, *King's Government* (1978), 79–87; Bennett, RCHM, *Report*, 8 (1881), 230a.

110. Baker, *Order* (1984), 6–7, 85–6, 188.

111. Bankes, "Speech," [1640], D-BKL/H/A/9, and "Sermons," D-BKL/H/A77.

112. Jones, *Politics* (1971), 20, 29, 139, 199–207, 208 (quote).

113. Weldon, *Court* (1651), 195–6, 206; Warburton, *Memoirs* (1849), i. 275–6; D'Ewes, *Journal* (1923), i. 241 (11 January), and 90 (1 December 1640); Terry, *Life* (1936), 468–71.

114. Foster, *Lords* (1983), 83–6; D'Ewes, *Journal* (1923), i. 18n., 260, 283, 292, 366 (Bankes as messenger in 1640); Thrush and Ferris, *House* (2020), iii. 126 (Northumberland as client).

115. Wentworth to Bankes, 28 April 1639, and 24 December 1638, resp., D-BKL/H/Q/45.

116. Adamson, *Noble Revolt* (2007), 157, 298.

117. Gardiner, *Fall* (1882), ii. 66–77, 96, 113, 152, 171–4, 187–92.

118. Gardiner, *Fall* (1882), ii. 24, 36, 379–80.

119. Gardiner, *Fall* (1882), ii. 192–3, 218.

120. Adamson, *Noble Revolt* (2007), 288–91, 294, 299, 303; Gardiner, *Fall* (1882), ii. 166, 171, 181.

121. Gardiner, *Fall* (1882), ii. 237, 242, 289–96, 375.

122. Gardiner, *Fall* (1882), ii. 255–60; Adamson, *Noble Revolt* (2007), 336–7, 345, 349–51, 355–7, 360–4, 372–82, 388–91, 408–9, 413–16.

123. Gardiner, *Fall* (1882), ii. 303–8, 317, 320–5.

124. Gardiner, *Fall* (1882), ii. 383–97, 404–8.

125. Malcolm (ed.), *Sovereignty* (1999), i. 148–50, 153.

126. Malcolm (ed.), *Sovereignty* (1999), i. 157–62, 168–9.

127. Mendle, *Dangerous Positions* (1985), 128–33, 136–7, 147–54, 175–6, 182–3, 213–14n.

128. Parker, *Discourse* (1641), 24–5.

129. Gardiner, *Fall* (1882), ii. 427, 438–9, 448–9; Hervey, *Life* (1921), 431, 434.

130. Havran, *Catholics* (1962), 156–7; Gardiner, *Fall* (1882), ii. 439, 456, 458–9.

131. Selden, *Table Talk* (1856), 79.

132. Porter to Edward Nicholas, 7 September 1641, in Huxley, *Porter* (1959), 263.

133. *CSPD, 1640–1*, 439, 441; Wedgwood, *Kings War* (1991), 82–7; Braddick, *God's Fury* (2009), 189–91; Gardiner, *Fall* (1882), ii. 450, 453–4, 477.

134. Murdoch, *Britain* (2000), 122–7.

135. Foster, *Lords* (1983), 70–80; RCHM, *Report*, 5 (1876), 178b. Bankes's summons is dated 4 May 1642; Bennett, RCHM, *Report*, 8 (1881), 209b.

136. Clarendon, *History* (1849), ii. 137 (quote); Bankes, *Story* (1853), 115, 118–21; Kopperman, *Heath* (1989), 285.

137. Banks to Northumberland, 16 May, and to Lord Saye and to Holles, 18 May 1642, in Bennett, RCHM, *Report*, 8 (1881), 211b–212a.

138. Bankes, *Story* (1853), 134–5, corrected from the manuscript in "Autograph Letters," D-BKL.

139. Coke, as quoted by Foster, *Lords* (1983), 81.

140. Letter to Green in "Autograph Letters," vol. 1, fo. 57, D-BKL; *A True List* (1641), under "Isle of Purbeck," D-BKL; Hutchins, *History* (1973), iii. 240–1; Russell, *Fall* (1991), 472.

141. Bankes to Lord [Francis] Willoughby (then illegally mustering troops for Parliament), 8 June 1642, in Bennett, RCHM, *Report*, 8 (1881), 212b.

142. Fissel, *Bishops' War* (1994), 152; Coward, *Stuart Age* (1994), 204; Braddick, *God's Fury* (2009), 192, 210–12.

143. Andrews, *His Majesties Resolution* (1642).

144. Letters of Northumberland and Holles, in "Autograph Letters," vol. 1, fos 17, 25, D-BKL; Bankes, *Story* (1853), 122–6.

145. Braddick, *God's Fury* (2009), 186–8; Woods, *Prelude* (1980), 90, 115 (quote); Bankes to Lord Saye, 11 July 1642, in Smith, *Constitutional Royalism* (1994), 97–8, 113–14; Andrews, *His Majesties Resolution* (1642), fo. A4.

146. Warburton, *Memoirs* (1849), i. 269–70.

147. Saye to Bankes, 8 June 1642, D-BKL/H/Q/44/20–30, and Northumberland to Bankes, 14 June 1642, "Autograph Letters," vol. 1, fo. 19, D-BKL.

148. Wharton to Bankes, 14 June and 13 July 1642, "Autograph Letters", D-BKL; Bankes, *Story* (1853), 132–3; Wedgwood, *King's War* (1958), 100–7.

149. Warburton, *Memoirs* (1849), i. 279–80; Bankes, *Story* (1853), 136–7; Northumberland to Bankes, 29 June 1642, "Autograph Letters," vol. 1, fo. 21, D-BKL.

150. Northumberland to Bankes, 29 June 1642, "Autograph Letters," vol. 1, fo. 21, D-BKL; Bankes to Lord Saye, 11 July 1642, in Bennett, RCHM, *Report*, 8 (1881), 212b; Endymion Porter to Bankes, 16 July 1642, in Bankes, *Story* (1853), 149. The new propositions were probably those brought by Lord Holland on 15 July.

151. Gardiner, *Fall* (1882), ii. 485–6.

152. Charles I to Bankes, Oxford, 12[/22] January 1642[/43], "Autograph Letters," vol. 1, D-BKL; Emberton, *Civil War* (1997), 53.

Chapter 4

1. Craig, *Papers* (1828), 12–13, 37; Riis, *Relations* (1988), i. 263–4.
2. Dreyer, *Tycho* (1963), 203–4; Norlind, *Tycho* (1951), 103–4.
3. Quoted from Norlind, *Tycho* (1951), 103.
4. James VI & I, *Basilikon doron* (1603²), in *Political Writings* (1994), 44 (first quote), and *Daemonologie* (1603), 13 (second).
5. Croft, *James* (2003), 133–4.
6. Arrowood, *Powers* (1949), 37–8, 50, 56, 81–3; McFarlane, *Buchanan* (1981), 382, 397–8, 399, 414–15, 426, 430–1.
7. Arrowood, *Powers* (1949), 11–12, 15–16; Conn, *De duplici statu* (1627), 12, 39, 142.
8. Ilsøe, *Historisk tidsskrift*, 2 (1960), 577–84, 591–8.
9. Kepler to James, 1607, in Kepler, *Werke* (1937–98), xvi. 103–4, and to Harriot, 2 October 1606, xv. 149–50; dedication to *Harmonice mundi* (1619), in *Werke*, vi. 10–12. Cf. Westman, *Copernican Question* (2011), 404–11.
10. Kepler, *Harmony* (1997), 3–5, 255–79, esp. 273–5; Rothman, *Pursuit* (2017), 18–21, 25, 91; Patterson, *James* (1997), 125–6; Mosley, in Christianson et al. (eds), *Tycho Brahe* (2002), 77, 80–2
11. Janacek, *Belief* (2011), 16–22, 25, 30, 32, 41–2.
12. Tymme, *Dialogue* (1612), 60–2.
13. Tymme, *Dialogue* (1612), 58–9. "Since Aristotle cannot comprehend the sea, let the sea comprehend Aristotle."
14. Tymme, *Dialogue* (1612), 59–63.
15. Colie, *HLQ* 18 (1955), 253–4.
16. Antonini to Galileo, 4 and 11 February 1612, in *OG* xi. 269–70, 275–6; Middleton, *History* (1966), 14–21.
17. Helbing, *Galilaeana*, 5 (2008), 26–31; Heilbron, *Quaderni storici*, 150 (2015), 875–7.
18. James VI & I, *Daemonologie* (1603), 45–7.
19. Summers, *Geography* (1958), 216, quoting a contemporary report, and Scott, *Demonology* (1970), 299–304; Borman, *Witches* (2014), 31–8.
20. James VI & I, *Daemonologie* (1603), [80]; Larner, in Smith (ed.), *Reign* (1973), 80–1; Croft, *James* (2003), 26–7, 172; Notestein, *History* (1968), 137–45; *Macbeth* (1606), I.iii, IV.1.
21. Bentivoglio to Ferdinando de Boischot in London, 15 April 1614, in RCHM, *Downshire MSS* (1924), iv. 366; Bentivoglio had just ordered the University of Louvain to ban a book on sorcery.
22. Davenant, *Gondibert* (1651), 10.
23. Bellany and Cogswell, *Murder* (2015), 36–8; Tracy, *Preparation* (1540), fos Bi^v, Bii^v, Ciii^r, Dvi^v, Jvii^v; Ussher to S. Ward, Cambridge, 30 June 1626, in Parr, *Life* (1686), 344–5; Trevor-Roper, *Catholics* (1987), 135, 139, 156–61.
24. Aubrey, *Lives* (2018), i. 115; Evans, *History* (1956), 6–13; Jayne and Johnson (eds), *Lumley Library* (1956), 5–8; Trevor-Roper, *Catholics* (1987), 133, 155.
25. Evans, *History* (1956), 17–18.

26. Blundeville, *True Order* (1574), fos Hivv; Di, Diiv–Diiir; Eivv (last quotes); Thompson, *History* (1942), i. 626.
27. Bacon, *De augmentis* (1623), II.4, in *Philosophical Works* (1905), 431.
28. Cotton, *Short View* (1627), 40–4.
29. Gardiner, *England* (1875), ii. 55–7, Sejanus invoked against Buckingham; Sharpe, *Cottton* (1979), 80–2, 187, 243; Clucas, in Clucas and Davies (eds), *Crisis* (2003), 178–86; Patterson, *Censorship* (1984), 49–58.
30. Sharpe, *Cotton* (1979), 76, 197, 200, 205; Worden, in Sharpe and Lake (eds), *Culture* (1993), 67–9, 76–9.
31. Sharpe, *Cotton* (1979), 99–100, 128–9, 197, 205, 209, 211, 230–1.
32. Jones, *Politics* (1971), 94; Kopperman, *Heath* (1989), 79.
33. Jones, *Politics* (1971), 113, 175–6; Wilson, in Davies, *Studies* (1957), 458–67; Foster, *Lords* (1983), 139, 142–7; Ogilvie, *King's Government* (1978), 80–1, 84; Hill, *Bench* (1988), 226.
34. Sharpe, *Cotton* (1979), 122–4, 131–3, 145, 158–60, 169–70, 177, 214; Peck, *Northampton* (1982), 114–15; Ruigh, *Parliament* (1971), 227, 285.
35. Johnson et al., *Proceedings* (1977–83), ii. 515 (17 April 1628).
36. Parry, *Trophies* (1995), 97, 101–5; Selden, *Tithes* (1618), fos c4, d1, and pp. 63, 123, 142–50, 285–6.
37. Selden, *Tithes* (1618), fo. a2^{r-v}; Parry, *Trophies* (1995), 118–19, 122–3.
38. Montagu, *Diatribe* (1621), 16–17; Rosenblatt, *Selden* (2006), 3; Berkowitz, *Selden* (1988), 99, 319.
39. Tillesley, *Animadversions* (1619), fos ¶4v–a1r; Bacon, *De augmentis* (1623), II.4, in *Philosophical Works* (1905), 431.
40. Nedham (trans.), in Selden, *Dominion* (1652), fo. (a)1v, and pp. 138–40, on "thalassometry."
41. Selden, *Table Talk* (1856), 21, 96, 103; Parry, *Trophies* (1995), 129.
42. Rowse, *Portraits* (1993), 130, 144.
43. Sharpe (ed.), *Faction* (1985), 239–43; Feingold, in Galluzzi (ed.), *Novità* (1983), 419; Parry, *Trophies* (1995), 125–7.
44. Camden, *Remaines* [1605] (1657), 9; Ptolemy, *Tetrabiblos*, II.3, trans Robbins, 133, 135.
45. Aubrey, *Lives* (2018), i. 395.
46. James to Charles, 25 June 1622, in *CSPD, 1619–23*, 411–12.
47. Portal, British Academy, *Proceedings* (1915–16), 192–203; *DSB*, s.v. "Aylesbury" and "Twyne."
48. Hunter, *Archaeologia*, 32 (1847), 148, 141.
49. Anon., *Declaration* (1645), 3 (quote), 4, 8; *DNB*, s.v. "Sutcliffe."
50. Rossi, *Bacon* (1968), 23–5.
51. Bacon, *Advancement* (1954), 1–4.
52. Bacon, *Advancement* (1954), 62–3, 65.
53. Bacon, *Advancement* (1954), 67–8.
54. Bacon, *Great Instauration*, "Epistle Dedicatory," in Bacon, *New Organon* (1960), 6.
55. Crowther, *Bacon* (1960), 304–5.

56. Hervey, *Life* (1921), 460.

57. Cf. Sprang, *Fountaine* (2008), 123; Johnston, *AS* 48 (1991), 343.

58. Hervey, *Life* (1921), 72–4; Harris et al., *King's Arcadia* (1973), 55; White, *Van Dyck* (1995), 16.

59. John Evelyn, quoted by Chaney and Wilks, *Grand Tour* (2014), 61; Hart, *Jones* (2011), 142–4, 204–8.

60. Scott, *Portrait* (2010), 72–3.

61. Newman, in Sharpe and Lake (eds), *Culture* (1993), 231, 235–41.

62. Palme, *Triumph* (1956), 3–5, 27–8, 271–4, 278; Huxley, *Porter* (1959), 101–3.

63. James VI & I, *Basilikon doron* (1599¹), quoted by Strong, *Van Dyck* (1972), 89.

64. Craig, *Papers* (1828), 39–41; Ilsøe, *Historisk tidsskrift*, 2 (1960), 576.

65. Riis, *Relations* (1988), i. 265, 270–6.

66. Langberg, *Dansesalen* (1985), 109–10, 113, 116–18.

67. Riis, *Relations* (1988), i. 130–2, 275, 281–2; Craig, *Papers* (1828), 54 (quote); Williams, *Anne* (1970), 110–12, 185.

68. Barroll, *Anna* (2001), 15–16, 35, 73; Croft, *James* (2003), 54–5; McManus, *Women* (2002), 66, 102.

69. Barroll, *Anna* (2001), 54–9, 61, 68; Hervey, *Life* (1921), 42, 44; Ravelhofer, *Masque* (2006), 75.

70. Davies, *Orchestra* [1596], in Davies, *Works* (1773), 143–4, 149–55, 177 (§§ 17, 19, 35, 38–41, 43, 49–50, 51 (quote), 60, 80, 110).

71. Barroll, *Anna* (2001), 74–5, 78, 86–7, 90–4; Steele, *Plays* (1968), 134–8; *CSPV, 1603–7*, 201, 212–13; Shohet, *Masques* (2010), 23–5.

72. Williams, *Anne* (1970), 125, 129; Barroll, *Anna* (2001), 111; Steele, *Plays* (1968), 142, 158; Brock, *Companion* (1983), 10, 173–4.

73. Williams, *Anne* (1970), 129–32; Steele, *Plays* (1968), 160–1; Brock, *Companion* (1983), 174–5.

74. Butterworth, *Theatre* (1998), 38–40, 55, 62, 82, 87–9.

75. Daniel, *Vision* (1604), fo. A4ʳ; Orgel and Strong, *Jones* (1973), i. 3, 9–11; Lewcock, *Davenant* (2008), 30–1, 35–8; Jonson, in Crawforth, in Adams and Cox (eds), *Diplomacy* (2011), 147; Bacon, *De augmentis* II.xiii, in *Works* (1857–74), iv. 317.

76. Barroll, in Bevington and Holbrook (eds), *Politics* (1998), 124–8, and Bevington and Holbrook (eds), *Politics* (1998), 4 (quote).

77. Jonson, [*Works*] (1925 52), vii. 353 (ll. 352–3); Steele, *Plays* (1968), 165–6; Brock, *Companion* (1983), 157–8; Strong, *Henry* (2000), 104–6, 122, 126.

78. Law, *Hampton Court* (1891–1903), ii. 20, 27 (quote); statistics compiled from entries in Steele, *Plays* (1968), *passim*.

79. Steele, *Plays* (1968), 178–9; Schmitz, in Hogg (ed.), *Jacobean Drama* (1995), 219, 225; Ruggle, *Ignoramus* (1996), "In laudem ignorami" (O friendly reader . . . I'll sell you wit and many jests | . . . | Here is much French, with which to win a Wench | Here is Latin, in which to guzzle wine."

80. Ruggle, *Ignoramus* (1996), "Second Prologue," I.2, I.5, II.3, II.6, III.8, IV.11 (pp. 12, 19, 27, 49–50, 75, 114).

81. Steele, *Plays* (1968), 201–2; Anon., *Mountebank's Mask* ([1618]; 1994), 112–13, 118, 122 (quote); Ruggle, *Ignoramus* (1996), II.8, p. 56; Tucker, *Renaissance Quarterly*, 30 (1977), 341, 349–50.

82. Steele, *Plays* (1968), 203, 210, 212; Jonson, *News from the New World Discovered in the Moon* (1620), in *Works* (2012), v. 431–44.

83. Steele, *Plays* (1968), 203, 206–7 (quote, from the Florentine ambassador), 219, 226.

84. Lindley, in Bevington and Holbrook (eds), *Politics* (1998), 275–6.

85. Steele, *Plays* (1968), 198, 204; Wilson, *Lanier* (1904), 35, 49; Lindley, in Bevington and Holbrook (eds), *Politics* (1998), 275, 285–6; Ravelhofer, *Masque* (2006), 76.

86. Wilson, *Lanier* (1904), 5, 32, 61–2, 67.

87. Wilks, *Journal of the History of Collections*, 9 (1997), 42–4.

88. Prynne, *Love-Lockes* (1628), 2.

89. Cf. Stone, *Past and Present* (November 1959), 93; Aston, in Gent (ed.), *Classicism* (1995), 181–2, 189–91; Thomas, in Gent (ed.), *Classicism* (1995), 224–7; Chaney, *Country Life*, 184/40 (4 October 1990), 148.

90. Hill, in Keblusek and Noldus (eds), *Double Agents* (2011), 52–3; Hervey, *Life* (1921), 141 ("chief lady"); White, *Van Dyck* (1995), 6, 9; Akrigg, *Pageant* (1963), 272–6; Cust, *Walpole Society*, 6 (1918), 18, *et passim*.

91. Wotton, *A Parallel* (1641), 173, quoted from Portal, British Academy, *Proceedings* (1915–16), 190.

92. James VI & I, *Basilikon doron* (1603), 92; Strong, *Henry* (2000), 8–9, 48, 54.

93. Strong, *Henry* (2000), 29–31, 38–41, 53, 136–7, 161, 165.

94. Wilks, *Court Culture* (1988), i. 118–19, 121–2, 201–3; ii, fig. 33; Cormack, in Moran (ed.), *Patronage* (1991), 75.

95. Strong, *Henry* (2000), 157; *DSB*, s.v. "Wright, Edward;" Wilks, *Court Culture* (1988), i. 119; Pagnini, *Costantino* (2006), 118–27.

96. Binns, *Culture* (1990), 265.

97. Strong, *Henry* (2000), 13–17, 24–7, 59–61, 101; Wilks, *Prince Henry* (2007), 90–2; Muir, *American Historical Review*, 84 (1979), 23, 36–7, 49–50; Pagnini, *Costantino* (2006), 62–4, 97–9.

98. Wilks, *Court Historian*, 6 (2001), 59–64; Molaro, *Journal of Astronomical History and Heritage*, 19 (2016), 255–63.

99. Strong, *Henry* (2000), 73–8; Marr, in Wilks, *Prince Henry* (2007), 212–14; Muir, *American Historical Review*, 84 (1979), 41–2.

100. Strong, *Henry* (2000), 88–9, 142–3; Watson and Avery, *Burl. mag.*, 115 (1973), 494, 498, 501; Hervey, *Life* (1921), 62–3.

101. Strong, *Henry* (2000), 154–5; Jayne and Johnson (eds), *Lumley Library* (1956), 14–20; Wilks, *Court Culture* (1988), i. 162–3, 195–8, 218.

102. Pickel, *Charles I* (1936), 18, citing Lilly, *True History* (1715), 3; Huxley, *Porter* (1959), 167, citing *CSPV*, 1621–3, 452.

103. Pumfrey and Dawbarn, *History of Science*, 42 (2004), 167.

104. Delamain, *Grammelogia* (1631), front matter, fo. A3r; "To the reader," fos ()12, ()3v; "Of the projecting … circles," fo. **3r; "Patent," fo. E.1r; Turner, IMSS *Annali*, 6/2

(1981), 104, 110–14; Wallis, *Transactions of the Cambridge Bibliographical* Society, 4/5 (1968), 373–6. For the complicated bibliography of *Grammelogia*, Bryden, Cambridge Bibliographical Society, *Transactions*, 6/3 (1974), 158–63.

105. Aubrey, *Lives* (2018), i. 265; Sprang, *Fountaine* (2008), 143–6; Turner, *AS* 30 (1973), 52–61, 62 (quote from Oughtred); Cajori, *Oughtred* (1916), 47–8, 89–91.

106. Delamain, *Grammelogia* (1631), "To the reader [bis]," fos A1ᵛ–A4ᵛ, A7ᵛ–A8ᵛ, B3ᵛ–B4ʳ; Hill, *BJHS*, 31 (1998), 257–60, 272–3.

107. *DNB*, s.v. "Delamain, Richard;" *CSPD*, 1631–3, 556–7 (patent, 4 March 1633).

108. Summerson, *Castle* (1990), 43–52, 94–6.

109. Butler, *Theatre* (1984), 118–19, 147–8, 152; Sanders, *Caroline Drama* (1999), 50–2; Brome, *Weeding* (1997), esp. II.1, IV; Southcot to Biddulph, 8 February 1633, in Questier, *Newsletters* (2005), 150.

110. Duggan, *Architectural History*, 43 (2000), 141–2, 149–54; Anderson, *Jones* (2007), 202–5, 210–11; Worsley, *Jones* (2007), 128–32, 135, 157–60, 173–4.

111. Wilks, *Journal of the History of Collections*, 9 (1997), 32–4.

112. Brown, *Kings* (1995), 4; Nijs to Endymion Porter, 12 May 1628, in Luzio, *Galleria* (1913), 155, 68–80; Huxley, *Porter* (1959), 180–1; Osborne, *SC* 22/1 (2007), 33–4.

113. Quotes from, resp., Meyer, *American Historical Review*, 19 (1913), 13, and Wotton, *Panegyrick* (1649), 105–6; Huxley, *Porter* (1959), 149; Anderson, "Art Dealing" (2010), 4–6, 157–8, 169–72, 179, 191–3.

114. Conn to Francesco Barberini, January–February 1637, in Hervey, *Life* (1921), 399.

115. Wolfe, in Burke and Bury (eds), *Art* (2008), 115–16.

116. Albion, *Charles I* (1935), 387–400; Barnes, in Howarth (ed.), *Art* (1993), 8; Hearn, in Hearn (ed.), *Van Dyck* (2009), 11–12; Stewart, in Onori et al., *Barberini* (eds) (2007), 619; Solinas in Cropper et al. (eds), *Documentary* (1992), 258.

117. White, *Henrietta Maria* (2006), 90–1; Havran, *Catholics* (1962), 143–6; Oy-Marra, in Cropper (ed.), *Diplomacy* (2000), 178–9; Meyer, *American Historical Review*, 19 (1913), 2.

118. Baillon, *Henriette-Marie* (1877), 137; Scarisbrick, *Country Life*, 184/40 (4 October 1990), 136.

119. Laud to Windebank, 23 September 1638, in Laud, *Works* (1847–60), vi. 540; Conn to Barberini, 23 February 1637, in Hervey, *Life* (1921), 399; Delbeke, in Burke and Bury (eds), *Art* (2008), 232.

120. Havran, *Catholics* (1962), 143–6; Sharpe, in Starkey (ed.), *English Court* (1987), 241–3.

121. Wood, in Baker et al. (eds), *Collecting* (2003), 85, 87; Peacock, in Sharpe and Lake (eds), *Culture* (1993), 206–7; Junius, *Painting* (1638), 270–1; Wotton, *Elements* (1624), 115.

122. Wilson, *Lanier* (1994), 101–3, 169; Huxley, *Porter* (1959), 185–6, on prices; Finaldi and Wood, in Christiansen and Mann (eds), *Gentileschi* (2001), 225–30; Sharpe, *Image Wars* (2010), 192; Lutz, *Kardinal* (1971), 95–7, on intermediaries.

123. Howarth (ed.), *Art and Patronage* (1993), 39–40.

124. Wotton, *Panegyrick* (1649), 68–71, 92 (quote), 100–1; cf. Millar, editorial comment, in Millar (ed.), *Tercentary* (1951), 5–6.

125. Wotton, *Elements* (1624), 106–7.

126. Wotton to Collins, 17 January 1638, in *SL* ii. 371, 373.

127. Steele, *Plays* (1968), 231, 234–5, 243–4; Gardiner, *England* (1875), ii. 100; Russell, *Origins* (1973), 179–83; Pickel, *Charles I* (1936), 165, 128–57; Lewalski, in Bevington and Holbrook (eds), *Politics* (1998), 296 ("more exotic").

128. Strong, *Van Dyck* (1972), 70–4, 77, 83–4; Gordon, *JWCI* 12 (1949), 152–3; Brown, *SC* 9 (1994), 157–65; Jonson, *Works* (2012), vi. 659–96.

129. Sharpe, *Image Wars* (2010), 218–19; Lewalski, in Bevington and Holbrook (eds), *Politics* (1998), 304–5 (quote). Henrietta-Maria appears as the sun in *Luminalia* (1638), in Britland, *Drama* (2006), 9.

130. Millar, *Burlington Magazine*, 96 (February 1954), 36–7; Butler, in Mulgrave and Shewring (eds), *Theatre* (1993), 141.

131. Carew, *Coelum* (1634), 2–3, 7, 9, 12.

132. Carew, *Coelum* (1634), 16–31.

133. Carew, *Coelum* (1634), 13–14.

134. Imerti, in Bruno, *Expulsion* (1964), 7–11, 21; see also 91, 94–5, 115–16. Cf. Kogan, *Hieroglyphic King* (1986), 183, 191, and Adamson, in Sharpe and Lake (eds), *Culture* (1993), 171–2.

135. Bruno, *Expulsion* (1964), 121–7, 235–40, 249–51, 255–7.

136. Heylyn, *Mikrokosmos* (1639[8]), 51 (as in edition of 1636[7]).

137. John Southcot to Peter Biddulph (Rome), 26 April 1633, in Questier, *Newsletters* (2005), 176.

138. Davenant, *Salmacida spolia* (1639 [1640]), fos B4[r], C1[v], D1[v], D2r[v]; Ravelhofer, *Masque* (2006), 87–90, 95.

139. Quoted in Ravelhofer, *Masque* (2006), 102–3 (ll. 558–60, 554); Sandys, editorial comments, in Ovid, *Metam.* (1632), 206–9, 701–2.

140. Sprang, *Fountaine* (2008), 98, 107, 392–3.

141. Marmion, *Companion* (1633), IV.iii and V.ii (fos H1[r], I3[v]).

142. Britland, *Drama* (2006), 9, 146, 176–91, and Butler, *Stuart court* (2008), 335–57, 375–6; Howarth, in Howarth (ed.), *Art* (1993), 68, 73–86.

143. Kogan, *Hieroglyphic King* (1986), 135, 219, 228, 270 (quote).

144. Butler, in Mulgrave and Shewring (eds), *Theatre* (1993), 119–20, 124–6, 131, 140, and in Sharpe and Lake (eds), *Culture* (1993), 92.

145. Strode, *Floating Island* (1636), IV.iii, III.ii, V.viii, V.x, Epilogue.

146. Shirley, *Triumph* (1634), 3, 7–8, 11; cf. Butler, *Theatre* (1984), 173.

147. Shirley, *The Gamester* (1637); Steele, *Plays* (1968), 247, 252–4.

148. Butler, *Theatre* (1984), 58–9, 62–3, 68–70, 73, 79–80 (quote).

Chapter 5

1. Chamber, *Encomium* (1601), 41.

2. Tycho to Buchanan, 1574, in Naiden, *Sphaera* (1952), 57.

3. Buchanan, *Sphaera*, 2.144–9, 612–15, in *Opera omnia* (1725).

4. Buchanan, *Sphaera*, 1.316–18, 325–8, from an anonymous early seventeenth-century translation, in Schuler, *Studies in Philology*, 75/5 (1978), 129.

5. James VI & I, *Poems* (1955–8), ii. 100–1 (quotes); Anon., *Learned: Tyco Brahae* (1632), dedication; cf. Christianson, *Tycho's Island* (2000), 140–1.

6. Gilbert, *De magnete* [1600] (1958), 322, 327, 341; Westman, *Copernican Question* (2011), 407, fig. 77.

7. Gattei, in Albrecht et al. (eds), *Tintenfass* (2014), 335–61.

8. Urban's *Adulatio perniciosa* ("Perilous Flattery" in the translation by Gattei, *Life* (2019), 305), in Galileo, *Opere* (1656), i. fo. +5r (Gettei, ll. 11–12); in another verse in the same poem (Gettei, ll. 35–6), Urban mentions Galileo's observation of sunspots.

9. William Boswell to provost of King's College, Cambridge, 3 October 1628, in RCHM, *Report*, 1 (1870), 68.

10. Guiducci to Galileo, 8 November 1624, in OG xiii. 226.

11. Favino, *Ciampoli* (2015), 93, 96, 99; Gabrieli, *Contributi* (1989), i. 464 (10 December 1625); HG 261–3.

12. HG 285–6, 304–5, 321; Favino, *Bruniana e Campanelliana*, 3/2 (1997), 268–9.

13. Bentivoglio, *Memorie* (1864), i. 103–4.

14. Letter of 5 August 1634, OG xvi. 120.

15. Bünger, *Bernegger* (1893), 20–1, 62, 67–71, 77, 93–4.

16. Nonnoi, *Saggi* (2000), 195, 203–6; Bernegger to Caspar Hofmann, Altdorf, 21 July 1638, in Reifferscheid, *Briefe* (1889), 573–4, 936; Garcia, *Bulletin de la Société de l'histoire du Protestantisme français*, 146 (2000), 311–18; Patterson, *James* (1997), 149–51.

17. Galileo, *Nova-antiqua* (1636); Nonnoi, *Saggi* (2000), 211–18; Garcia, *Bulletin de la Société de l'histoire du Protestantisme français*, 146 (2000), 317–18, 320, 324–32.

18. Bünger, *Bernegger* (1893), 81–2, 122–4, 206, 277.

19. Garcia, *Bruniana & Campanelliana*, 10 (2003), 46–7, 51–5.

20. Cf. Nonnoi, *Saggi* (2000), 85–8, 92–5.

21. Cf. Feingold, in Galluzzi, *Novità* (1983), 416; Nonnoi, *Saggi* (2000), 187–90; Galileo, OG xiv. 399–401, 422.

22. Batho, *Library*, 15 (1960), 255–7.

23. Sir William Lower to Harriot, 21 June 1610, quoted by Roche, *Archives internationales d'histoire des sciences*, 32 (1982), 11–12.

24. Shirley, *Ambix*, 4 (1949), 56–9, 63–4; Batho, *Library*, 15 (1960), 247–8.

25. Markham, "Introduction," in Hues, *Tractatus* (1889), pp. xxv–xxviii, xxxvi–xl, and index entry "Copernicus."

26. Pontanus, in Hues, *Tractatus* (1639), quotes on pp. 24, 145–6, 4, resp., the middle two from Scaliger.

27. Hill, *Philosophia* (1619^2), 122, 156–8; Trevor-Roper, *Catholics* (1987), 5, 10–12, 29–31; McColley, *AS* 4 (1939), 391, 396–7, 404n. (citing an epigram of 1619); Massa, *JHI* 38 (1977), 228, 230, 235, 238–9. For brief mention of other early British Copernicans, Drake, in McMullin (ed.), *Galileo* (1967), 417–24, and Omodeo, *Copernicus* (2014), 37–43.

28. Plot, *Natural History* (1705), 228; Lydiat, *Praelectio* (1605), 59, 61–5, 68–72; Johnson, *Vanity* (1749), 14 (the verse). "Monster" and "Fool" are Scaliger's epithets.

29. Bainbridge, *Description* (1619), dedication ("Foelix novi anni auspicium | et | D: Astronomiae tandem instaurandae symbolum;" Smith, *Vitae* (1707), 5–6.

30. Bainbridge, *Description* (1619), 5–6 (Aristarchus), 12, 14, 19, 22.

31. Bainbridge to Hanniball Baskerville (his patient), 15 January 1622, and 14 December and 3 February 1627, in Bodleian Library, MS Rawl. Letters, 41.5 (formerly Add. MS 14923).

32. Bainbridge, *Description* (1619), 28–9, 31–9, 41–2.

33. Hallowes, Halifax Antiquarian Society, *Transactions* (1962), 84; Carpenter, *Geography* (1625), 143 (quote); *DNB*, s.v. "Savile."

34. Sharpe, *Cotton* (1979), 70; Tyacke, in Pennington and Thomas (eds), *Puritans* (1978), 76–8; Curtis, *Oxford* (1959), 231; Smith, *Vitae* (1707), 7–9, 12–13; Bainbridge, *Procli sphaera* (1620), dedication.

35. Bainbridge, "Antiprognosticon" (1623), Bodleian, Add. MS A380, fo. 201v; the date appears from fo. 199v.

36. Bainbridge, in Oxford University, *Oxoniensis academiae parentalia* (1625), fo. K1r.

37. Bainbridge, "De stella Veneris" (c.1630), Bodleian, Add. MS A380, fos 205v–206r, 208r (quote).

38. Feingold, *Apprenticeship* (1984), 56–7, 60, 67–8, 103, 117–19, 125, 190–2.

39. Carpenter, *Geography* (1625), 75–6, 111–13, 93–4 (quote); cf. Carpenter, *Philosophia* (1622), 271–99, and Feingold in Galluzzi (ed.), *Novità* (1983), 412–13, 417–20.

40. Gellibrand, *Discourse* (1635), 20–2; the observation, which was spurious, suggested that the latitude of a given place changes slowly in time. Gellibrand transcribed exactly from Galileo's *Dialogo* (1632), in OG vii. 471.

41. Russell, in Dobrzycki, *Reception* (1972), 214, 217–21; Sellers, *Journal for the History of Astronomy*, 37/4 (2006), 412–14.

42. These and other examples from Feingold, in Poole (ed.), *Wilkins* (2017), 9–16.

43. Galileo to Micanzio, 1 December 1635, OG xvi. 355; correspondence among Walter Warner, Robert Payne, John Pell, and Charles Cavendish, 1634–36, 1641, 1644, in Halliwell, *Collection* (1841), 68, 72–7; Hobbes to Cavendish, 15/25 August 1635, in Hobbes, *Correspondence* (1994), i. 28–9.

44. Feingold, in North and Roche (eds), *Essays* (1985), 266–72, 274–5 (the high opinion of Payne's brain); Jonson, quoted in Brown, *SC* 9/2 (1994), 166–7; Jacquot, *AS* 8 (1952), 17–21; Payne to Cavendish, 22 March 1631, BL, Add. MS 70499, fo. 151, signs himself "Your Lordship's most oblig'd and devoted Chapleine." Payne's translation of Galileo is preserved in BL, Harley MS 6796, fos 317–30; Galileo to Micanzio, 1 December 1635, OG xvi. 355.

45. Hobbes to Wm Cavendish, 26 January/5 February 1634, in Hobbes, *Correspondence* (1994), i. 19 (quote). A copy of the original *Dialogo* was offered for sale in London in 1639; Martin, *Catalogus* (1639), 69.

46. Letter of 1 December 1635, in OG xvi. 355; T. Salusbury to Giovanni Buonamici, 16 August 1636, cited by Favaro, *Rivista delle biblioteche*, 18–19 (1889), 88, mentions a finished translation.

47. Webbe, *Minae* (1612), 105–7; Salmon, *Study* (1988), 16, 22–31; Malcolm, in Hobbes, *Correspondence* (1994), i. 20 n. 10.

48. A "Catalogue of . . . Popish Physicians," quoted in Salmon, in Salmon, *Study* (1988), 16, from John Gee, *The Foot out of the Snare: With a Detection of Sundry Late Practices and Impostures of the Priests* (1624).

49. Aubrey, *Lives* (1898), i. 366.

50. Hobbes, *Elements of Philosophy* (1656), in *English Works* (1962), i, pp. viii–ix (first quote), and as quoted by Jesseph, *Perspectives in Science*, 12/2 (2004), 195; Gargani, *Hobbes* (1971), 19–20, referring to *Short Tract on First Principles* (c.1630). Cf. Goldsmith, *Hobbes' Science* (1966), 242.

51. Gargani, *Hobbes* (1971), 55–8.

52. Clucas, *SC* 9/2 (1994), 252–3, 256–7.

53. Quoted by Favaro, *Amici* (1983), ii. 990, from R. White, *Hemispherium dissectum* (1648).

54. Bradley, in Carter (ed.), *Renaissance to the Counter Reformation* (1965), 349, 357–8.

55. Bradley, in Carter (ed.), *Renaissance to the Counter Reformation* (1965), 351–4, 361, 366; Henry, *BJHS* 15 (1982), 223–9.

56. Clancy, *Archivum historicum Societatis Jesu*, 40 (1971), 69–79, 86–8; Tutino, *Thomas White* (2008), 5–6.

57. White, *De mundo dialogi tres* (1642), as summarized by Jacquot and Jones, in Hobbes, *Critique* (1973), 47–53.

58. Southgate, *Covetous* (1993), 9–10, 15–16, 32, 95–100; Tutino, *Thomas White* (2008), 31–5.

59. Hobbes, *Critique* (1973), 178 ("Galilaeus, non modò nostri, sed omnium saeculorum philosophus maximus"); chs 16–17 (on the tides); Jacquot, *Notes and Records*, 9 (1952), 189; Hobbes, *Thomas White* (1976), 170–91, 253–4.

60. Cf. Southgate, *History of European Ideas*, 18 (1994), 53, 57.

61. Petersson, *Digby* (1956), 83–4, 89–91, 98–9, 120, 140; Moshenska, *Stain* (2016), 141–4.

62. Petersson, *Digby* (1956), 21, 152, 158, 162, 180, 214–20.

63. Petersson, *Digby* (1956), 188–9; Foster, *Downside Review*, 100 (1982), 123 (first quote), 125–30; Aubrey, *Lives* (2018), i. 303 (second quote); Watson, in Parkes and Watson (eds), *Scribes* (1978), 288–90, 301; Foster, *Oxoniensia*, 46 (1981), 109–12; Donaldson, *Bodleian Library Record*, 8 (1967–72), 253–4, 257.

64. Digby, *Two Treatises* (1644), "Preface," fo. O5r, 70, 83–4.

65. Shapiro, *Wilkins* (1969), 13–25, 55; "Life of the Author," in Wilkins, *Works* (1708), fo. A2r.

66. Campanella, *Defense* (1994), 62–110; McColley, *AS* 4 (1939), 152–67.

67. Nonnoi, *Saggi* (2000), 71–6.

68. Godwin, *Man in the Moone* (1937), 2 ("discovery age"), 18–22, 23 ("philosophers"), 33.

69. Rahn, in Neuber and Zittel (eds), *Copernicus* (2015), 158, 163–4; Cressy, *American Historical Review*, 111 (2006), 966–7; Hicks, *Dialogues of Lucian* (1634), 11–22, 12 (quote); Henderson, in Poole (ed.), *Wilkins* (2017), 133–45.

70. Wilkins, *Discovery* (1638), 85–6 (quote), 95–142.

71. Wilkins, *Discovery* (1638), 44, 50–1, 54–9, 88–94.

72. Wilkins, *Discovery* (1638), 143–66, 112, 193–5.

73. Wilkins, *Discovery* (1638), 36 (quote), 38–9, 174–5 (quote).

74. Ross, *Commentum* (1634), 10, 16–17, 33, 62 (quote); McColley, *AS* 3 (1938), 156–62; Dix, *Classical Philology*, 90/3 (1995), 256–8; Drake, in McMullin (ed.), *Galileo* (1967), 422.

75. Quoted from Ross, *History of the World* (1652), 83, by Allan, *SC* 16/1 (2001), 83; Ross issued his challenge specifically to Nathanael Carpenter.

76. Wilkins, *Discourse* (1640), 148–9.

77. Prynne, *Perpetuities of a Regenerate Man's Estate* (1627), quoted by Kirby, *Prynne* (1931), 12.

78. Ross, *New Planet* (1646), 1–2, 9.

79. Ross, *Leviathan* (1653), fo. A4v.

80. *HG* 204, 212. Cf. Nonnoi, *Saggi* (2000), 56–70, 79–81; McColley, *AS* 3 (1938), 168–72, 183; Deason, in Mckee and Armstrong (eds), *Probing* (1989), 327–34.

81. Wilkins, *Discourse* (1640), 169–75, 194–5 (quote), 203–6, 226–32.

82. Wilkins, *Discourse* (1640), 236–7, 241–3.

83. Cf. Nonnoi, *Saggi* (2000), 105–111. The frontispiece does not appear in either printing of the *Discovery* in 1638; McColley, *AS* 1 (1936), 330–4.

84. Cf. Nicolson, *AS* 4 (1939), 2–3, 8, 16–17; Camden, *Isis*, 19/1 (1933), 26–31, 37–42.

85. Wharton, *Works* (1683), 322.

86. Montgomery, *Ambix*, 11 (1963), 68–9; Manschreck, *Melanchthon* (1941), 103–5.

87. Wohlwill, *Mitteilungen zur Geschichte der Medizin und Naturwissenschaften*, iii (1904), 263–7.

88. Calvin, *Admonicion* (1561), fos A5–6, fo. A8v.

89. Calvin, *Admonicion* (1561), fos B3v, C3, C6r (quote).

90. Calvin, *Admonicion* (1561), fos B1v, B2v–B3r, B4v.

91. Calvin, *Admonicion* (1561), fos D8r, D1v–D2r, resp. Cf. Probes, *Westminster Theological Journal*, 37/1 (1974), 32–3.

92. James VI & I, *Daemonologie* (1603), 13.

93. Bacon, *De augmentis* (1623), III.4, in Bacon, *Philosophical Works* (1905), 462, 464.

94. Bacon, *De augmentis* (1623), II.13, in Bacon, *Philosophical Works* (1905), 445.

95. Carleton, *Astrologomania* (1624), "Epistle dedicatory" (by Thomas Vicars, Carleton's chaplain), 4–8, 9 (quote), 57–60, 70–2.

96. Geree, *Astrologo-mastix* (1646), 17–19 (quote).

97. Baldini, in Fragnito (ed.), *Church* (2001), 90–1, 96–7.

98. *HG* 253–4, 287–90; Shank, in McMullin (ed.), *Church* (2005), 74–7.

99. Hodson, *Divine Cosmographer* (1640), 49–51, 149.

100. Hodson, *Divine Cosmographer* (1640), opp. title page.

101. Peacham, *Gentleman* (1634), 58–9, 71–2.

102. Gadbury, editorial comment, in Wharton, *Works* (1683), fos A6v, a3v–a4r.

103. Wharton, *Works* (1683), 44–5.

104. Heydon, *Defense* (1603), fo. ¶3r, and pp. 370–1, 386.

105. Feingold, *Apprenticeship* (1984), 133, 140; Camden to Heydon, 6 July 1610, in Camden, *Epistolae* (1691), 128–30.

106. Wharton, *Works* (1683), 128, 131. Eade, *Forgotten Sky* (1984), 4–103, gives a good overview of the intricate astrology of the period.

107. Wharton, *Works* (1683), 131; Spencer, *Faerie Queene* [1596], V, Proem, stanzas 5–7; (1977), 528.
108. Ernst, in Galluzzi (ed.), *Novità* (1983), 259–61; Wharton, *Works* (1683), 132–6.
109. Kepler, *Werke* (1937–98), i. 183.
110. Wharton, *Works* (1683), 138–40.
111. *Julius Ceasar*, II.ii.
112. Howard, *Defensative* (1620), fo. 74v; Chamberlain to Carleton, 26 November 1612, in Chamberlain, *Letters* (1965), 225 (letter 155).
113. Howard, *Defensative* (1620), fos 57v, 56v, 53^{r-v}, 98r, resp.; James to Cecil, October 1605, in James VI & I, *Letters* (1984), 265–6.
114. Hill, *Philosophia* (1619^2), 131–2; cf. Andersson, *Howard* (2009), 136–9; Peck, *Northampton* (1982), 101–21.
115. James VI & I, *Poems* (1955–8), ii. 175, 172, resp.
116. Ussher to unknown, 1619, in Parr, *Life* (1686), 71.
117. Nausea, *Treatise* (1618), fos C3v, D1r, E2r; Urbánek, in Christianson et al. (eds), *Tycho Brahe* (2002), 282–3 (100 tracts).
118. Wotton to Sir Robert Norton, 27 November 1618, in *SL* i. 270; Corbett, *Poems* (1955), 65 (quote).
119. Corbett, *Poems* (1955), 64–5; Bennett and Trevor-Roper, in Corbett, *Poems* (1955), pp. xii–xiii, xviii, xxiv.
120. Kepler, *De cometis libelli tres* (1619), in *Werke* (1937–98), viii. 131–262, on 257–60; *HG* 218–19, 233–8, 253–9, 260; Snell, *Descriptio* (1619), 36–8, 67 (quote).
121. Cf. Rusche, *English Historical Review*, 80 (1965), 322.
122. Cf. Sondheim, *JWCI* 2/3 (1939), 245, 250–4; Camden, *Isis*, 19/1 (1933), 69–73; Bosanquet, *Library*, 10 (1930), 365.
123. Naworth, *Prognostication* (1642), "Of Autumne;" Cartwright, in Cartwright, *Comedies* (1651), 150 (IV.ii); Steele, *Plays* (1968), 262.
124. Cf. Clark, *Shakespeare* (1929), 31, 51, 78–86, 130–3; Hutchinson, in Curry (ed.), *Astrology* (1987), 95, 99, 104–8.
125. *Cymbeline* (1610), V.iv, stage directions, and ll. 107–8.
126. Lyly, *Gallethea* [1592], fo. E1v; (1998), 30; Jonson, *Alchemist* (1610), I.iii.54–7; Fletcher, *Bloody Brother* (1639), fos G2v, G(bis)4, IV.ii.
127. Leech, *Fletcher Plays* (1962), 90; Edwards and Gibson, editorial comment, in Massinger, *Plays* (1976), iv. 5.
128. Massinger, *City Madam* (1632), II.ii, in Massinger, *Plays* (1976), iv. 44–5. Cf. Eade, *Forgotten Sky* (1984), 197–200.
129. Melton, *Astrologaster* (1620), 5–6.
130. Massinger, *Duke of Milan*, II.i, in Massinger, *Plays* (1976), i. 248 (ll. 354–6).
131. Tomkis, *Albumazar* (1615), I.i, I.v, fos B1, C4r; Della Porta, *Lo astrologo* (1606), I.i.
132. Tomkis, *Albumazar* (1615), I.iii, fo. B4.
133. Tomkis, *Albumazar* (1615), I.v, fo. C1v.
134. Jonson, "Staple" (1625), in Jonson, [*The Works*] (1925–52), vi. 329, and "Alchemist" (1610), III.iv.87–97; Davenant, *Gondibert* (1651), II.xvii, III.iii.55, in Gladisch (ed.), *Gondibert* (1971), 168, 266.

135. Middleton and Rowley, *World Tost in a Blanket* (1620), fo. F1r, in Middleton, *Works* (2010), 1428 (ll. 794–7), on deceit; Marmion, *Companion* (1633), IV.iii, V.ii (fos H1r, I3v).

136. Holiday, *Technogamia* [1618] (1630), fos G1–M3r, K3r (Galileo), O2v–O3r.

137. Howell to his brother, 1 April 1618 or 1619, in Howell, *Epistolae* (1890), i. 25–6 (quote), 531; ii. 705, 786–7.

138. Anon., *Entertainment* (1633), 16–22.

139. Heywood, *London's Fountaine* (1632), fos C1v–C2r.

140. Strafford, quoted in Lilly, *Collection* (1645), 49. Strafford, *Last Speeches* (1641), has no such statement, but an admission of flying too close to the sun (pp. 4–5).

141. Charles I, *Eikon* [1649], ed. Knachel (1966), 7; Quarles, "Englands Complaint," in his *Fons lachrymarum* (1648), 24–5.

142. D. Digges, *Circumference* (1612), and (with T. Digges) *Paradoxes* (1604), 78 (quote); T. Digges, *Alae* (1573), "Praefatio;" Aubrey, *Lives* (1898), i. 237–8, and (2018), i. 736.

143. Digges, *Speech* (1643), 4–6, and *Paradoxes* (1604), 78.

144. Bellany and Cogswell, *Murder* (2015), 236–7, 249, 402–3; Prest, *Diary* (1991), 107.

145. Davenant, *Gondibert* (1651), II.v.16, II.v.20, in Gladisch (ed.), *Gondibert* (1971), 168–9.

146. Greville, *Nature of Truth* (1641), 103–6, 63.

147. William Gilbert, Dublin, to Ussher, 11 December 1638, in Parr, *Life* (1686), 492–4; HG 203, 211–12.

148. More, *Platonicall poem* (1642), verses 1.4, 1.33–4, 3.69.

149. Selden to Francis Taylor, 25 June 1646, in Toomer, *Selden* (2009), ii. 846.

150. Selden, *De synedriis* (1650–5), 532–3.

151. Galileo, "Lettera" (1615), in Galileo, *Scienza* (2009), 83; Selden, *De synedriis* (1650–5), 533. The points at issue disappear in John Henry Newman's translation used in the *Roman Breviary* (1879), ii. 160: "O Lord, who throned in the holy height | Through plains of ether didst diffuse | The dazzling beams of light | In soft transparent hues || Who didst, on the fourth day, in heaven | Light the fierce cresset of the sun | And the meek moon of even | And stars that wildly ran."

152. Isaacson, *Narration* (1817), 21.

153. Isaacson, *Ephemerides* (1633), "Explanation" of the frontispiece.

154. Isaacson, *Ephemerides* (1633), fos A3r, A4.

155. Quarles, *Emblemes* (1635), 180–1 (to avoid those evils that passing pleasure exposes).

Chapter 6

1. Oxford Univ., *Oxoniensis academiae parentalia* (1625), fo. H2r.

2. BL, Sloane MS 70, fos 66r, 53v; Bacon, "De gravi et levi," in *De augmentiis* (1623), V.3, in *Works* (1857–74), i. 631–9; Bacon, *Philosophical Works* (1905), 512–14.

3. "Ex dono MW," shelf mark Gamma 4.4; Hegarty, *Biographical Register* (2011), 486–7.

4. Hobbes, *De corpore*, quoted in Gargani, *Hobbes* (1971), 3.

5. Sloane MS 95, fos 198 (last quote), 201v–202r (first quote), 203r.

6. Sloane MS 95, fo. 210r; on Galileo's criteria of "sensory experience and necessary demonstration," *HG* 173, 204.

7. Munk, *Roll*, 1 (1878), 206: "sedulus literatus elegansque medicus."

8. Laud to Wentworth, 4 December 1633 and 13 January 1633/4, in Laud, *Further Correspondence* (2018), 85, and *Works* (1847), 7, 56, resp.

9. Laud to Wentworth, 12 May 1635, in Laud, *Works* (1847–60), vii. 132, and 4 March 1634, in Strafford, *Letters* (1739), i. 375; Mayerne, *Councels* (1677), 74–5 (on stony gout); Wedgwood, *Wentworth* (2000), 166, 204.

10. Kearney, *Strafford* (1959), 47, 196, 241. Williams attended the parliament held in Dublin in July 1634; *CSP Ireland*, 2 (1901), 65.

11. Williams to Wentworth, n.d., Sloane MS 2681, fo. 268.

12. Kearney, *Strafford* (1959), 104–10; Bramhall, *Works* (1842–5), i, pp. v, lxxix–lxxxii; Cunningham, *Ussher* (2007), 27–8, 35–6, 48–57; Bankes to Bramhall, 30 March 1639, in Huntington Library, Hastings Papers.

13. Bramhall, *Works* (1642–5), i, pp. vii–viii; Kearney, *Strafford* (1959), 123–4, 264–8; Cunningham, *Ussher* (2007), 31.

14. Laud to Wentworth, 22 June 1638, in Laud, *Works* (1847–60), vii. 449; Henrietta Maria to Wentworth, 2 July 1638, in Strafford, *Letters* (1739), ii. 178–9.

15. Laud to Wentworth, 14 May 1638, in Laud, *Works* (1847–60), vi. 527, and Strafford, *Letters* (1739), ii. 171.

16. Laud to Wentworth, 22 June 1638, in Laud, *Works* (1847–60), vii. 449.

17. Jonson, *Alchemist*, II.iii.229–30.

18. Trevor-Roper, *Physician* (2006), 53, 151–4, 197, 203–8, 270–1 (quotes), 272–5, 324, 386; Laud to Wentworth, 29 December 1638, in Laud, *Works* (1847–60), vi. 558.

19. Mayerne, *Gout* (1676), 10–11, 14, 37–9, 71 (quote), 48 ("the raspings of a human Skull unburyed"), and *Councels* (1677), 74–5 (turpentine, etc.).

20. Howell to Porter, 20 January 1647, in Howell, *Epistolae* (1890), 536.

21. Wentworth to Laud, 7 August 1638, in Strafford, *Letters* (1739), ii. 194, and reply, 10 September 1638, ii. 212; *CSP Ireland*, 2 (1901), 193.

22. Schuchard, *Ogilby* (1973), 22–4, 44, 50; Van Eerde, *Ogilby* (1976), 18–23; Eames, New York Public Library, *Bulletin*, 65 (1961), 78–84; Clark, *Irish Stage* (1955), 27, 31–2, 39; Nason, *Shirley* (1915), 93, 97–8, 153; Forsythe, *Relations* (1914), 26–7; Stevenson, *Review of English Studies*, 20 (1944), 20–2.

23. Wedgwood, *Wentworth* (2000), 128–30, 202, 212.

24. Hervey, *Life* (1921), 305, 349–51; Wedgwood, *Wentworth* (2000), 170 (quote), 158, 185–8, 214.

25. Gardiner, *Government* (1877), ii. 113, 121–34, 142–4; Wedgwood, *Wentworth* (2000), 150, 176–7, 226–7.

26. Wedgwood, *Wentworth* (2000), 138, 194–5, 212, 226; Howarth, *British Library Journal*, 20/2 (1994), 151–4.

27. Wedgwood, *Wentworth* (2000), 126, 223, 233.

28. Gardiner, *Government* (1877), i. 40–1, 168, 176, 187, 194, 277; Wedgwood, *Wentworth* (2000), 148.

29. Shaw, *Historical Journal*, 49 (2006), 338–1, 342, 351 (first quote), 352, 354, 355 (second quote).

30. Gardiner, *Government* (1877), ii. 73; Wedgwood, *Wentworth* (2000), 265, 267, 269.

31. Gardiner, *Fall* (1882), i. 278–83, 291–2, 306.

32. Gardiner, *Fall* (1882), i. 308, 315–16, 326, 331, 345–56, 360–1, 382–3, 391–8; Wedgwood, *Wentworth* (2000), 271, 273, 276–82, 288–9.

33. Gardiner, *Fall* (1882), i. 360–2, 364 (quote); Wedgwood, *Wentworth* (2000), 287–8.

34. Trevor-Roper, *Physician* (2006), 305, 412 n. 3.

35. D'Ewes, *Journal* (1923), 260, 283, 292.

36. John More to Williams, 25 May 1641, Sloane MS 2681, fo. 265, mentioning "the mournfull newes of the death of our noble Lorde" and the financial burden of the debt to the Scots.

37. Radcliffe, quoted in Wedgwood, *Wentworth* (2000), 397; Munk, *Roll*, i (1878), 206.

38. Williams, in Oxford Univ., *Oxoniensis academiae parentalia* (1625), fo. H2v; Cook, in Grell and Cunningham (eds), *Religio medici* (1996), 102, speculates about Williams's religion.

39. Kearney, *Strafford* (1959), 192–6; Cunningham, *Ussher* (2007), 32–3.

40. Trevor-Roper, *Catholics* (1987), 184–5; Cressy, *Exomologesis* (1647), 8–10 (first quote), 11, 289–92, 296 (second quote), 300.

41. Williams, Sloane MS 113, fos 3r–4, 5r (quote), 7r, 18v.

42. Bacon, "History," in *Works* (1857–74), v. 269–72; Williams, Sloane MS 113, fos 9v–10r, 19v (quote), 20–24r.

43. Bacon, "History," in *Works* (1857–74), v. 277, 310.

44. Williams, Sloane MS 113, fo. 33.

45. Bacon, "History," in *Works* (1857–74), v. 285–7; Williams, Sloane MS 113, fos 39v–42v.

46. Bacon, "History," in *Works* (1857–74), v. 294; Williams, Sloane MS 113, fos 111r, 114v, 117–21.

47. Williams, Sloane MS 113, fos 6v–7r, 105.

48. Allsopp, *Jones* (1970), i. 71.

49. Williams, Sloane MS 70, fo. 2v; fos 24r, 25v, 46v for references to Galileo's *Discorsi* (1638).

50. Williams, Sloane MS 70, fos 6v, 7r, 9v (quote), 63, 64v, 65.

51. Williams, Sloane MS 70, fos 30r, 73r.

52. Williams, Sloane MS 70, fos 74r, 80r, 81r. The value of the acceleration under gravity, 13 ft/sec, agrees with the number Galileo gives, in *Dialogue* (1953), 223–4, 480.

53. Williams, Sloane MS 70, fos 21v–22r (Charles on free fall), 24–5, 39, 41, 44r, 46–7.

54. Williams, Sloane MS 70, fos 67v–69. On the work of Cabeo (1629), Kircher (1641), and Gilbert (1600), see Heilbron, *Electricity* (1979), 174–85.

55. Sloane MS 95, fos 185r, 186r, 187r, 205v–206r, 209v.

56. Sloane MS 95, fos 188r, 205r, 207r (quotes).

57. Sloane MS 95, fo. 171r.

58. Bellany and Cogswell, *Murder* (2015), 30–7, 212.

59. Trevor-Roper, *Physician* (2006), 174–5; Nance, *Turquet* (2001), 179; Keynes, *Harvey* (1978), 138–40, 144–7.

60. Bellany and Cogswell, *Murder* (2015), 144, 183, 191, 214–19, 229, 238, 262.

61. Bellany and Cogswell, *Murder* (2015), 215–19; Franklin, in Harvey, *Circulation* (1958), pp. xvi, xxi.

62. Harvey, *Disquisition* [1628], trans. Willis (1952), 267.

63. Toynbee and Young, *Strangers* (1973), 214–15.

64. Van Eerde, *Hollar* (1970), 12–14, 17; Godfrey, *Hollar* (1994), 20.

65. Crowne, *True Relation* (1637), 5, 8 (quote), 9–11, 18–19, 38; Godfrey, *Hollar* (1994), 61; Pav, *Art Bulletin*, 55/1 (1973), 94–6.

66. Robinson, *Dukes* (1995), 103, 105, 111; Kratochvíl, *Hollar's Journey* (1965), 12–14; Gilman, *Arundel Circle* (2002), 130.

67. *DNB*, s.v. "Harvey;" Trevor-Roper, in Howarth (ed.), *Art* (1993), 267, and *Physician* (2006), 236–7, 245–9, 256, 262–4, 273–4.

68. Keynes, *Harvey* (1978), 245–57, 261.

69. Crowne, *True Relation* (1637), 32–7, 67–70.

70. Furdell, *Royal Doctors* (2001), 119; Cook, *Decline* (1986), 281–2.

71. Toynbee and Young, *Strangers* (1973), 214–15; Nance, *Turquet* (2001), 184 (letter of 1636).

72. Furdell, *Royal Doctors* (2001), 112, 121–2; Westfall, *Science and religion* (1958), 118–20.

73. Letters to Dee from Charles I, 24 December 1633, and Mayerne, 18 January 1634, in Appleby, *Ambix*, 26 (1979), 6, 9; Appleby, *Ambix*, 24 (1977), 99–100; Appleby, *Slavonic and East European Review*, 57 (1979), 54–5; Camden, *Isis*, 19:1 (1933), 51; Trevor-Roper, *Physician* (2006), 321.

74. Cook, *American Journal of Legal History*, 29 (1985), 314–20.

75. Cook, *Social History of Medicine*, 2 (1989), 12–16, 19–22, 28.

76. BPB 11/28, 12/20, 12/23; Mayerne and Candeman, *Distiller* (1639), 1–4, 11; Cook, *Social History of Medicine*, 2 (1989), 22.

77. Vigne, Royal College of Physicians, *Journal*, 20/3 (1986), 222–3.

78. Oriel, Buttery Books, under date.

79. ps-Aristotle, *Problemata*, xxx.1, 953a10–13, in Aristotle, *Complete Works* (1984), ii. 1498–9. Cf. Klibansky et al., *Saturn* (1964), 16–41; Gowland, *Worlds* (2006), 88–96; and Dixon, *Dark Side* (2013), 115–17, 120, 123 (artists).

80. Quoted in Moshenska, *Stain* (2016), 314, without reference.

81. ps.-Aristotle, *Problemata*, xxx.1, 953b15–16, p. 1499, and iv.30, 880a30, in *Complete Works* (1984), ii. 1358, resp.

82. Ferrand, *Treatise* (1640), 222–33, 238–48, 256, 262, 266–7.

83. Ferrand, *Treatise* (1640), 255–8, 278–9; Beecher and Ciavolella, in Ferrand, *Treatise* (1990), 9–11, 15–16, 126–7, 205.

84. Klibansky et al., *Saturn* (1964), 137–59, 247–54.

85. Ptolemy, *Tetrabiblos* (1964), §3.13, pp. 333, 341, 359–61.

86. Klibansky et al., *Saturn* (1964), 254–5, 259–70; Babb, *Elizabethan Malady* (1951), 30–2, 62–5; Drew, *Melancholy* (2013), 20–1.

87. Klibansky et al., *Saturn* (1964), 315–35.

88. Klibansky et al., *Saturn* (1964), 399.
89. Burton, *Anatomy* (2001), "The author's Abstract of Melancholy."
90. Burton, *Anatomy* (2001), "Democritus Junior to the Reader," i. 39 (quote), 54, 56, 67 (quote).
91. Burton, *Anatomy* (2001), i. 73, 81–3.
92. Burton, *Anatomy* (2001), i. 90, 92–3.
93. Burton, *Anatomy* (2001), i. 110–11, 115–20; *HG* 22–3, 192–3.
94. Burton, *Anatomy* (2001), i. 278, 303, 305, 309–10, 323, 328–9.
95. Burton, *Anatomy* (2001), i. 366.
96. Burton, *Anatomy* (2001), i. 392, 254; 225, 227, 234, 243, 246–7, 291, 439.
97. Burton, *Anatomy* (2001), iii. 311–13, 319, 346; 347, 351.
98. Burton, *Anatomy* (2001), iii. 367; 370, 375.
99. Burton, *Anatomy* (2001), iii. 379.
100. Burton, *Anatomy* (2001), iii. 394–400.
101. Burton, *Anatomy* (2001), iii. 404, 408; 411–12, 419–21, 429–32.
102. Burton, *Anatomy* (2001), iii. 15–16, 222–3, 34–6.
103. Burton, *Anatomy* (2001), iii. 40, 49–50 (first quote), 53–7, 62 (second quote); cf. Dixon, *Dark side* (2013), 59–61.
104. Burton, *Anatomy* (2001), iii. 69 (1 Esdras 3:10–12, who has truth trump women), 87, 91, 96, 146, 153 (quote).
105. Burton, *Anatomy* (2001), iii. 172–3, 177, 179, 183 (quote).
106. Burton, *Anatomy* (2001), iii. 189, 191–3, 201.
107. Burton, *Anatomy* (2001), iii. 213, 219, 221, 228, 245 (quote); Weinberger, in Price (ed.), *Bacon's* New Atlantis (2002), 109–10.
108. Burton, *Anatomy* (2001), iii. 248–9, 253 (first quote), 255 (second quote).
109. Burton, *Anatomy* (2001), iii. 117, 119–20.
110. Burton, *Anatomy* (2001), i. 15.
111. Burton, *Anatomy* (2001), ii. 36, citing Carpenter, *Geography* (1625), II.6.
112. Burton, *Anatomy* (2001), i. 78 (quote); ii. 47, 50–5; iii. 33, 120.
113. Burton, *Anatomy* (2001), ii. 56–7.
114. Quoted by Trevor, *Poetics* (2004), 92 (first quote), and Williamson, *Journal of English Literary History*, 2 (1935), 140–1, 143.
115. Drummond, *Flowers* (1623), 154–5.
116. Burton, *Anatomy* (2001), i. 189–90, 200–1; ii. 54–5.
117. Burton, *Anatomy* (2001), ii. 52–5. Cf. Simon, *Burton* (1964), 237–8, 244, 246, and Barlow, *JHI* 34 (1973), 297–300.
118. Burton, *Anatomy* (2001), i. 18, 397–8; O'Connell, *Burton* (1986), 17–18, 32; Bamborough, *Review of English Studies*, 32 (1981), 267–72, 275, 278; Vicari, in Brückmann, *Colloquy* (1978), 99–103; *Notes and Queries*, 227 (1982), 415–16.
119. Burton, *Philosophaster* (1931), 5, 7–9, 27, 145.
120. Burton, *Philosophaster* (1931), 101, 103, 167, 111.
121. Burton, *Philosophaster* (1931), 53, 81, 221; BPB 55/102. Giovanni Alfonso Magini, professor of mathematics at Bologna, was a rival of Galileo.
122. Walkington, *Optick Glasse* (1639), fo. ¶2ʳ, pp. 125, 128–31, 139–40.

Chapter 7

1. Woodward, *Drawings* (1951), 22; Croft-Murray, *Decorative Painting* (1962–70), i.1. 38–9.
2. Strutt, *Dict.* (1785–6), i. 202; Buckeridge, in Piles, *Art* (1744), 362 (quote).
3. Hodnett, *Aesop* (1979), 8–10, 51–3, and *Five Centuries* (1988), 56.
4. Griffiths, *Print* (1998), 105, 119–23; Howarth, *Art and Patronage* (1993), 58–9, and *Master Drawings*, 49/4 (2011), 462, 472–3.
5. Stainton and White, *Drawing* (1987), 70.
6. Howarth, *Master Drawings*, 49/4 (2011), 469–70, 473.
7. Kolb, *Apollo*, 144 (August 1966), 57–60; *HG* 19.
8. Norgate, *Miniatura* (1919), 62–3.
9. Kaufmann, *Drawings* (1982), 16, 66–7.
10. "Diana and Acteon," from Geissler, *Zeichnung* (1979–80), i, no. 29.
11. Howarth, *Master Drawings*, 49/4 (2011), 473, 436; Croft-Murray et al., *Catalogue* (1960), i.1. 286.
12. Heiberg, *Leids kunsthistorisch jaarboek*, 2 (1983), 11–12, 15; Noldus, in Keblusek and Noldus (eds), *Double Agents* (2011), 188.
13. Beckett, *Kristian IV* (1937), 48.
14. Morel, *Grotesques* (1997), 24–8; Boro et al., *Rabisch* (1998), 154–5, 158–61.
15. Lomazzo, quoted by Peacock, *Designs* (1995), 249.
16. Statens Museum for Konst, TP 503, nos 17, 3, 9, 15, and 12, resp.; Heiberg (ed.), *Christian IV* (1988), 110–12. The Geissler Collection at the Getty Research Center has several prints of Cleyn's drawings from his Danish period dealing mainly with mythological and religious themes.
17. Pastor, *Popes* (1891–1953), xxvi. 231–47; Pieper, *Propaganda* (1886), 2–6; Lockhart, *Denmark 1513–1600* (2007), 173–9.
18. Lockhart, *Denmark* (1996), 99–100, 108–10, 119–20; Pastor, *Popes* (1891–53), xxvii. 153–4; Pieper, *Propaganda* (1886), 9.
19. Friis, *Samlinger* (1872–8), 30, 35.
20. Roding, in Noldus and Roding (eds) *Isaacsz.* (2007), 189–94; Friis, *Samlinger* (1872–8), 36; Heiberg (ed.), *Christian IV* (1988), 77–9.
21. Reindel, *King's Tapestries* (n.d.), 24, has a good illustration.
22. Langberg, *Dansesalen* (1985), 31–2, 35, 43–4.
23. Meir Stein's discovery, *Billedverden* (1987), 21–55, endorsed by Roding, in Noldus and Roding (eds), *Isaacsz* (2007), 196–7, 235–6. The pertinent work of Longomontanus, *Disputatio tertia de tempore trium praecipuarum epocharum . . . cui accedit contemplatio de septem aetatibus mundi* (Copenhagen, 1629), was published after the completion of the ceiling; Moesgaard, in Dobrzycki (ed.), *Reception* (1972), 126–34.
24. John Pell to William Cavendish, 8/18 February 1644/5, in BL, Harley MS 6796, fos 195–6: "a stupid, dull, dog-like, rash, imprudent youth."
25. *As You Like It*, II.7.
26. Stein, *Billedverden* (1987), 40–1.

27. Beckett, *Kristian IV* (1937), 52, and "Painter" (1936), 12; Stein, *Billedverden* (1987), 27, 29, 38, 42.

28. Roding, in Noldus and Roding (eds), *Isaacsz* (2011), 189–90; Panofsky, *Dürer* (1971), 102–3, and plate 143; Beckett, *Kristian IV* (1937), 49–50.

29. Stein, *Kronborg* (1989), 24, and *Billedverden* (1987), 46.

30. Roding, in Noldus and Roding (eds), *Isaacsz* (2011), 193.

31. Piccininni, in Cavazza, *Fuochi* (1982), 84, 90–2.

32. Werrett, *Fireworks* (2010), 13–45.

33. Skovgaard, *Architecture* (1973), 72; Stein, *Leids kunsthistorisch jaarboek*, 2 (1983), 127–30; Ariosto, *Orlando furioso*, 19.36; *HG* 259–60.

34. Howarth, *Master Drawings*, 49/4 (2011), 460–1; Rasmussen, in Noldus and Roding, *Isaacsz* (2007), 140–1; Beckett, *Christian IV* (1937), 58 (picture on 56), on Prince Christian.

35. Stein, *Billedverden* (1897), 143.

36. *CSPD, 1619–23*, 131, 213, 437; Murdoch, *Britain* (2000), 38–40, 53, 57–8, 61, 64; Stuart, *Correspondence* (2015), i. 455–6.

37. *CSPD, 1623–5*, 130, 152, 165; Gardiner, *England* (1875), i. 83, 134–46; Heiberg, *Christian 4* (2006), 261–5, 269; Murdoch, *Cairn*, 1 (1997), 53–4; Ruigh, *Parliament* (1971), 29, 39, 248.

38. Noldus, in Cools and Keblusek (eds), *Humble Servant* (2006), 60–3; Keblusek, in Keblusek and Noldus (eds), *Double Agents* (2011), 151, 154–5, 159.

39. *CSPD, 1623–5*, 14 (12 July 1623, re Cleyn), 224, 247; cf. Fuller, *Worthies* (1811), ii. 354.

40. Thornton and Tomlin, *National Trust Studies* (1980), 23; Howarth, *Master Drawings*, 49/4 (2011), 443.

41. Hefford, in Campbell (ed.), *Tapestry* (2007), 171; Roding et al., *Artists* (2003), 46, 51–2; Campbell, in Campbell (ed.), *Tapestry* (2007), 3–5, 112–19.

42. Grell, *Dutch Calvinists* (1989), 82, 226–8; Lindeboom, *Austin Friars* (1950), 108–9; Hefford, in Campbell (ed.), *Tapestry* (2007), 182; Howarth, *British Library Journal*, 20/2 (1994), 149, 159.

43. Anderson, *Short Account* (1894), 12.

44. Casaubon, *Relation* (1659); Anderson, *History* (1886), 28, 31–2; Anon., *Burlington Magazine*, 110/778 (January 1968), 43.

45. *Exhibition of English Tapestries* (1951), 3–8; Hefford, Centre international d'études des textiles anciens, *Bulletin*, 76 (1999), 91–2, 95, 97–100.

46. Howarth, *Master Drawings*, 49/4 (2011), 435, 454, 469; Hefford, in Campbell (ed.), *Tapestry* (2007), 187–8; Watson, *Burlington Magazine*, 85 (1944), 227; Wyld, in Royal Academy, *Charles I* (2018), 190–203, illustrates the set.

47. Shearman, *Cartoons* (1972), 147; Fermor and Derbyshire, *Burlington Magazine*, 140/1141 (1998), 236–50. Another copy, made on a reduced scale by Cleyn's sons between 1640 and 1646, is in the Ashmolean Museum, Oxford.

48. Walpole, *Works* (1798), iv. 200–2; Campbell, in Campbell and Cleland (eds), *Tapestry* (2010), 8, 10, showing, p. 9, *The Miraculous Draft of Fishes*; Wood, *Simiolus*, 28/3 (2000–1), 117; Howarth, *British Library Journal*, 20/2 (1994), 155–7; Long,

Miniaturists (1929), 72–3. The original cartoons (seven of the ten scenes Raphael designed), depicted in Millar (ed.), *Italian drawings* (1965), plates 33–42, now reside in the Victoria and Albert Museum in London; for inferior borders, made from the original cartoons, White and Shearman, *Art Bulletin*, 40 (1958), plates 14, 15.

49. Martin, *Apollo*, 113 (1981), 91–2; Turner, *Tate Papers*, 17 (2012), §§2–4, 6; Hefford, *Country Life*, 184/40 (4 October 1990), 135.

50. Peck, *Consuming Splendour* (2005), 80–3; Hefford, in Delmarcel (ed.), *Weavers* (2002), 49–61, and in Campbell (ed.), *Tapestry* (2007), 171, 175–6, 179; Chauvette and De Chalup, *Etude* (1928), 8–13.

51. Hubach, in Campbell and Cleland (eds), *Tapestry* (2010), 104–7.

52. Martin, *Apollo*, 113 (1981), 93–5; *CSPD*, 1639–40, 243; BPB 16/14; *CSPD*, 1637–8, 173.

53. Chauvette and De Chalup, *Etude* (1928), 27.

54. Loomie, *Ceremonies* (1987), 27–30, 37–8, 86, 100, 221, 303.

55. Howarth, *British Library Journal*, 20/2 (1994), 157–8.

56. Howarth, *Master Drawings*, 49/4 (2011), 442–3, fig. 11: *Folly Leading Cupid through the World*.

57. Hefford, in Campbell (ed.), *Tapestry* (2007), 173.

58. Norgate, *Miniatura* (1919), 63–4; picture of *Meeting at the Temple*, in Hefford, in Campbell (ed.), *Tapestry* (2007), 191–3, and of Leander swimming, in Heiberg (ed.), *Christian IV* (1988), 118.

59. Donne, *Poems* (1986), 149.

60. Whinney and Millar, *English Art* (1957), 127–8; Sanderson, *Graphice* (1658), 20.

61. Jonson, *Bartholomew Fayre*, V.iiii; Marlowe, *Works* (1981), ii. 436 (ll. 177–80), text of 1598; Mulherron and Wyld, *National Trust Historic Houses and Collections Annual* (2011), 20–5.

62. Mulherron and Wyld, *Apollo*, 175 (March 2012), 127; Hefford, *National and Art Collections Fund Review*, 86 (1990), 100.

63. Wyld, contributor's comment, in Rowell, *Ham House* (2013), 182.

64. Ferino-Pagden, *Cinque sensi* (1996), 18–20, 106–11, 116–19, 228–35; Vinge, *Five Senses* (1975), 15–20.

65. Ferino-Pagden, *Cinque sensi* (1996), 144–5; Vinge, *Five Senses* (1975), 54–5.

66. Cleyn, *Quinque sensuum descriptio* (1646).

67. Ferino-Pagden, *Cinque sensi* (1996); Mulherron and Wyld, *Apollo*, 175 (March 2012), 122–8; Aristotle, *De anima*, 422^b17–423^a20, 424^b23-4, and *De sensu*, 436^b17–437^a15, in Aristotle, *Complete Works* (1984), i. 672–3, 675, 693–4.

68. Hefford, in Campbell (ed.), *Tapestry* (2007), 175, 181–2.

69. Hefford, *National and Art Collections Fund Review*, 86 (1990), 99; Faulkner, *Bolsover* (1975), 15–16. The set of *The Hunter's Chase*, to which Cleyn contributed four designs, would also have appealed to William, but they date from the war years. Hefford, in Campbell (ed.), *Tapestry* (2007), 181–2; Dulac-Rooryck, *Revue du Louvre*, 33 (1983), nos 5–6.

70. Worsley, *Cavalier* (2007), 81–3.

71. Cavendish, *Life* (1667), 149–50.

72. Worsley, *Cavalier* (2007), 48.

73. Walpole, *Works* (1798), iii. 252; Croft-Murray et al., *Catalogue* (1960), i.1. 284, and *Decorative Painting* (1962–70), i. 211.

74. Cavendish, *Life* (1667), 140; Pegge, *Sketch* (1785), 17–18, 21.

75. Worsley, *Cavalier* (2007), 102–3, and plate 10; the Witt Library, London, attributes the lunette paintings to Cleyn, giving "Palmer AA50/109656-7" as source. Klibansky et al., *Saturn* (1964), plate 140, show a spitting image of the lecher.

76. Jonson, *The New Inn*, I.i.29, quoted by Worsley, *Cavalier* (2007), 84.

77. Norgate, *Miniatura* (1919), 64.

78. Wotton, *Elements* (1624), 85.

79. Lees-Milne, *Age* (1953), 86–9, quoting from a letter to Rome of 17 September 1636.

80. Wilks, in Coward (ed.), *Companion* (2009), 196, 198.

81. Thornton and Tomlin, *National Trust Studies* (1980), 21–5; Newberry, *International Journal of Museum Management and Curatorship*, 5/4 (1986), 357; Rowell, *Apollo*, 143 (1996), 19, and editorial comment, in Rowell, *Ham House* (2013), 14–15, 19–20, 67–8, 79–80, 146, and Wyld, contributor's comment, pp. 186–7.

82. Martin, *Apollo*, 113 (February 1981), 92; Sanderson, *Graphice* (1658), 24; Croft-Murray, *Decorative Painting* (1962–70), i. 196–7.

83. BPB 16/11, 16/12, 16/14, 37/7, 50/25; *CSPD*, 1637, 13 April 1637, 567, providing £280 and an assistant. Other pertinent financial arrangements are mentioned in BPB 16/39, 16/42, 16/44.

84. BPB 37/7, 50/25; Howarth, *British Library Journal*, 20/2 (1994), 158–9.

85. Tesauro, *Cannochiale* (1664), 1–3; Zanardi, *Archivum historicum Societatis Jesu*, 47 (1978), 43–4, 48, 54–8, 65–9, 79–80 n. 244.

86. Cf. Llasera, *Représentations* (1999), 72–3, 63.

87. Alberti, *On Painting* (1966), 89–91; Lee, *Ut pictura* (1967), 41–5.

88. John Morris to Johannes de Laet, 27 February 1639, in Bekkers, *Correspondence* (1970), 29; Upton, *De studio* (1654), fo. A2^{r-v}; Spelman, *Aspilogia* (1654), 132.

89. Johnson, *Catalogue* (1934), pp. vii–viii.

90. Ovid, *Metamorphosis* (1970), 4–5.

91. Ellison, *Sandys* (2002), 1–2, 7, 16–25, 49–50, 57–62, 68–77.

92. Ellison, *Sandys* (2002), 126–30, 137–9, 161–5; Davis, *Sandys* (1955), 198–9, 283–5, and Bibliographical Society of America, *Papers*, 35 (1941), 258–63, 271–3.

93. Bush, in Ovid, *Metamorphosis* (1970), pp. vii–xii; Davis, Bibliographical Society of America, *Papers*, 35 (1941), 263–6. Ovid had required 11,995 lines; that Sandys could match his laconic Latin in corresponding English couplets within 10% was itself an achievement. Rubin, *Ovid's* Metamorphoses (1985), 2–4, 14–15.

94. Sandys, in Ovid, *Metamorphosis* (1632), "To the reader."

95. Ovid, *Metamorphosis* (1970), frontispiece and p. 3 ("Minde of the Frontispiece);" Limon, in Peck, *Mental World* (1991), 214, 221, 223.

96. Sandys, in *Metamorphosis* (1970), "Minde of the Frontispiece," 2.

97. Ferrand, *Treatise* (1990), 525–7.

98. Ovid, *Metamorphosis* (1970), 170, 192, 219, 264, 292.

99. Ovid, *Metamorphosis* (1970), 496, 508–17, 533–4.
100. Ovid, *Metamorphosis* (1970), 714.
101. Ovid, *Metamorphosis* (1970), 672–3, 691.
102. Sandys, in Ovid, *Metamorphosis* (1632), 48, 50, 53–7, 108–9, 720–1.
103. Davis, *Library*, 3 (1948), 193 n. 4, 198–9, and *Sandys* (1955), 205.
104. J. Hall, in Brome (ed.), *Lachrymae* (1649), 46; "J.B.," in Brome (ed.), *Lachrymae* (1649), 50; Steggle, *Brome* (2004), 184–5; McWilliams, *Yearbook of English Studies*, 33 (2003), 273–5.
105. Edward Standish, in Brome (ed.), *Lachrymae* (1649), 70–1; Gearin-Tosh, *Essays and Studies*, 34 (1981), 107–13.
106. Dreyden, in Brome (ed.), *Lachrymae* (1649), 89–90.
107. Griffiths, *Print* (1998), 20.
108. Sandys, editorial comment, in Ovid, *Metamorphosis* (1632), 219, 449.
109. *Variae deorum ethnicorum effigies* (1654); *Varii zophorii animalium* (1645); *Propaegnion, sive puerorum ludentium shemata varia* (1651, 1658), according to Croft-Murray et al., *Catalogue* (1960), i.1. 284. Cleyn designed but did not engrave these series. The British Museum, London, has the *Effigies*, the Statens Museum for Konst, Copenhagen, the *Zophorii*.
110. British Museum, Inv. 1874.8.8.21 (L.B.1), and 1881.6.11.232, in Croft-Murray, *Catalogue* (1960), i.2, plate 99, and i.1. 285–6.
111. Hodnett, *Barlow* (1978), 70–3; *Aesop* (1979), 51–2, 31–41; *Five Centuries* (1988), 32, 56; Acheson, *Journal for Early Modern Cultural Studies*, 9/2 (2009), 30; Patterson, *Fables* (1991), 83–94.
112. Cf. Lewis, *English Fable* (1996), 71–9.
113. Davenant, *Gondibert* (1651), ii.5.9; in Gladisch (ed.), *Gondibert* (1971), 177.
114. Ogilby, *Aesop* (1651), bk 1, p. 2; the redrawn figure for the second edition (1668) omits the schoolhouse and misses the point of the moral.
115. Quoted by Acheson, *Journal for Early Modern Cultural Studies*, 9/2 (2009), 29.
116. "Of the Frogs Desiring a King," fable XII, in Ogilby, *Aesop* (1651), 36; Kishlansky, in Amussen and Kishlansky (eds), *Culture* (1995), 347–52.

Chapter 8

1. Oriel College, Buttery Books, 1643–5; Shadwell, *Registrum* (1893–1902), i. 248, 250. Sir John may have lived with a son-in-law outside Oxford when ill but returned to Oriel to die; Hamper, editorial comment, in Dugdale, *Life* (1827), 76.
2. Barratt, *Cavalier* (2015), 86, 93–4; Varley, *Siege* (1932), 25, 65–7.
3. Varley, *Siege* (1932), 30–1, 47–8, 57–61.
4. Varley, *Supplement* (1935), 9–10; Toynbee and Young, *Strangers* (1973), 10–12, 20; Barratt, *Cavalier* (2015), 39, 46, 82; Fanshaw, *Memoirs* (1907), 24–5 (quotes).
5. Greaves, *Morbus epidemicus* (1643), 1, 6, 8–9, 13–22, 23 (quote); Barratt, *Cavalier* (2015), 117–19; Varley, *Siege* (1932), 96–8, and *Supplement* (1935), 15.
6. Barratt, *Cavalier* (2015), 74, 87 (quote, from Anthony Wood); Toynbee and Young, *Strangers* (1973), 32.

7. Varley, *Siege* (1932), 30–1, 36–41, and *Mercurius* (1948), pp. vii, ix–xi.

8. Milton, *Polemic* (2007), 23–6, 106, 113–15, 122–5.

9. Milton, *Polemic* (2007), 107, 127–9.

10. The queen to the king, 23 February 1643, in Haldane, *Portraits* (2017), 12.

11. Varley, *Mercurius* (1948), 42–3.

12. Dugdale, *Life* (1827), 47, 50; William Strode, in Oxford University, *Musarum oxoniensum ΕΠΙΒΑΤΗΡΙΑ* (1643), fos D2ᵛ–D3ʳ.

13. Williams and Bankes, in *Musarum oxoniensum ΕΠΙΒΑΤΗΡΙΑ* (1643), fos Aa1ᵛ–Aa2ᵛ, B2ᵛ–B3ʳ, resp.; Bate, *Narrative* (1652), 39; Baillon, *Henriette-Marie* (1877), 201–2; White, *Henrietta Maria* (2006), ch. 5.

14. Varley, *Siege* (1932), 8–11, 26–8, 122–4, and *Mercurius* (1948), 73 (quote).

15. Parry, *Trophies* (1995), 157–9, 169–70; Gibson, in H. Spelman, *Works* (1727), fo. b1ʳ; Fox, *Scholarship* (1956), 666–7, 71–2.

16. J. Spelman, *Considerations* (1642), 22, and *View* (1642), fo. E4, resp.

17. J. Spelman, *Case* (1643), 24, and *Protestants Account* (1642), 45, resp.

18. Charles I, *Eikon* (1649), ed. Knachel (1966), 76, 91, 94, 162–4, 168.

19. Fuller, *Holy State* (1642), 74–5, 150; Walten, in Fuller, *Holy State* (1938), 15–16, 26, 32, and Houghton, *Formation* (1938), 17–37, 155–68.

20. Earle, *Microcosmographie* (1638), §§33, 66.

21. Fuller, *Holy State* (1642), 53–4, 273, 353–4.

22. Albion, *Charles I* (1935), 349–66; Sanderson, *Compleat History* (1658), 702.

23. Foster, *Oxoniensia*, 46 (1981), 116–18; Davidson, "Catholicism" (1970), 666–7, 669–70; Laud, *Works* (1847–60), v.1, 184, 215, 269.

24. *Victoria History. Oxford*, iv (1979), 410–11; Meyer, *American Historical Review*, 19 (1913), 25–6; letters of 18/8 August 1641 and 23 June 1642 to her sister, in Henriette-Marie, *Lettres* (1881), 58, 61.

25. Ross, *Lotterie* (1642), fos A2ʳ–A3ᵛ.

26. Ross, *Lotterie* (1642), A4ᵛ.

27. RCHM, *Report*, 6 (1877), 19; Clarendon, *History* (1849), ii. 131–3, 137, 589 = bk 5, 203–5, 209, bk 6, 396; Hawtrey, *History* (1903), i. 43, 48, 50; Johnston, *Life* (1837), ii. 204–14; Lloyd, *Memoires* (1668), 586 (*Illi quod est rarissimum, nec facilitas authoritatem, nec severitas amorem diminuit*).

28. Foss, *Judges* (1848–64), iii. 251–4; *Victoria History. Middlesex*, iii (1961), 100, 342; De Groot, *English Historical Revue*, 117/474 (2002), 1221.

29. Bankes, "Will," 24 September 1642, D-BKL/B/A/1/1; Rous, *Diary* (1866), 129 (property in Norfolk).

30. Bankes, *Story* (1853), 59–60; Bennett, *Historical Dictionary* (2000), 33–4; *Victoria History. Dorset*, ii (1908), 150–61; Heywood, *Notes*; Little, *History Today*, 65/2 (2015), 14–16. Norsworthy, *Cornhill Magazine*, 150 (1934), 66–81, presents a lively version of the story.

31. RCHM, *Report*, 6 (1877), 182; D'Ewes, *Journal* (1923), 109n.; Hutchins, *History* (1973), ii. 241.

32. Bainbridge to Ussher, 3 October 1626, in Parr, *Life* (1686), 370–1. Bainbridge calculated eclipses for Ussher.

33. Quoted by Tyacke, in Pennington and Thomas (eds), *Puritans* (1978), 84.

34. Shalev, in Hamilton, *Republic* (2005), 85–7, 91, 94–7, and in *JHI* 63 (2002), 575.

35. Greaves, *Description* (1650), 59; Rice, *Modern Language Notes*, 43/7 (1928), 451–2; Dursteler, *Mediterranean Historical Review*, 16/2 (2001), 9–10, 25; Goodwin, in Bon, *Seraglio* (1996), 13–16; Bentivoglio to Paolo Guardo, 21 January 1612 and 12 December 1618, in Bentivoglio, *Collection* (1764), 37, 121.

36. Greaves, *Pyramidographie* (1646), and *Discourse* (1647), 40–1.

37. Birch, in Greaves, *Miscellaneous Works* (1737), i, pp. ii–vi; Greaves, *Miscellaneous Works* 1737), ii. 480; Smith, *Vitae* (1707), 8–9.

38. Greaves, *Miscellaneous Works* (1737), ii. 364–71; Greaves to Ussher, 19 September 1644, in Parr, *Life* (1686), 509.

39. Smith, *Vitae* (1707), 15. Bainbridge died on 3 November, Greaves was in place on the 14th.

40. Birch, in Greaves, *Miscellaneous Works* (1737), i, pp. lviii, lxx–lxxi; Lawlor, *Proceedings of the Royal Irish Academy*, 6 (1901), 262.

41. *CSPD*, 1641–3, 14 November 1643, 496–502; Greaves, *Miscellaneous Works* (1737), ii. 168.

42. Greaves, *Miscellaneous Works* (1737), ii. 390–2.

43. Greaves, *Miscellaneous Works* (1737), ii. 379–83 (navigation), 375–8 (calendrics); Greaves to Ussher, 19 September 1644, *Miscellaneous Works* (1737), ii. 451–4.

44. Feingold, in North and Roche (eds), *Essays* (1985), 275–6, and *Apprenticeship* (1984), *passim*.

45. Feingold, in Galluzzi (ed.), *Novità* (1983), 417–18.

46. Quoted in Feingold and Gouk, *AS* 40 (1983), 145–50.

47. "Our English Aristotle": Wilkins, *Mercury* (1641), 10.

48. Trevor-Roper, *Physician* (2006), 360–1; Birken, *Journal of British Studies*, 23/1 (1983), 49, 55–6.

49. Laud to Bankes, 1 January 1635, in Laud, *Further Correspondence* (2018), 139.

50. Keynes, *Harvey* (1978), 301–2, 309–12; Robb-Smith, *Oxford School Medical Gazette*, 12 (1957), 72–6; Munk, *Roll*, i. (1878), 277–9 (E. Greaves); *DNB*, s.v. Brent; Greaves, *Pyramidographia* (1646), in *Miscellaneous Works* (1737), i. 136–7n.

51. Birch, in Greaves, *Miscellaneous Works* (1737), i, pp. xxviii–xxix; Aubrey, *Lives* (1898), ii. 284–5; (2018), i. 272; ii. 1125.

52. Ward, *Vindiciae* (1654), 390.

53. Abell, *Reports and Transactions of the Devonshire Asssociation*, 57 (1925), 259–60.

54. *DNB*, s.v. Heylyn; Heylyn, *Mikrokosmos* (1639), 14–15, and *Cosmographie* (1652), 1–18, 22–3, fo. A5v (quote); Tyacke, in Pennington and Thomas (eds), *Puritans* (1978), 92–3.

55. Lewalski, *Writing Women* (1993), 184–90.

56. Weber, *Lucius Cary* (1940), ch. 4; Malcolm, *Historical Journal*, 24 (1981), 317–18; Trevor-Roper, *Catholics* (1987), 188, quoting Hyde.

57. Sandys, *Paraphrase* (1636), "To the King," and p. 25; Weber, *Lucius Cary* (1940), 215–19, 245; Wedgwood, *Wentworth* (2000), 365–6; Hayward, *SC* 2 (1987), 20.

58. Cf. Ellison, *Sandys* (2002), 185–96, 202, 212.
59. Trevor-Roper, *Catholics* (1987), 176–7, 188–97, 208, 220, 227–8.
60. Earle, *Microcosmographie* (1638), §41.
61. Quoted by Trevor-Roper, *Catholics* (1987), 212, from Bodleian, MS Clar. 126, nos 22, 59; praise for Bacon, nos 27–32.
62. Mathew, *Age* (1951), 232, 235, 239; Hayward, *SC* 2 (1987), 32–4, 41–2.
63. Bond, *Inventories* (1947), 246, 248. The parish church sells a postcard of the recently cleaned painting.
64. Aubrey, *Lives* (2018), i. 296–8.
65. Heydon, *Discourse* (1650), fo. A4; Curry, *Prophecy* (1989), 35, 37 (second quote, from Ashmole, *Theatrum chemicum* (1652), 453); Powell, *Aubrey* (1964), 50; Frank, Royal Society of London, *Notes and Records*, 27 (1973), 199–200.
66. Wharton, *Works* (1683), 217, 221–2, 216–17 (text of 1645).
67. Wharton, *Works* (1683), 269 (text of 1647).
68. *Great Eclipse* (August 1644), title page.
69. Geneva, *Astrology* (1995), 183–4, 195, 207, 211, 216, 222, 229 (quote); Parker, *Familiar* (1975), 89, 95–100.
70. Lilly, *Collection* (1645), fo. A3v, pp. 3–5, 33–4, 45. The Hempe ditty was current when Bacon was a boy; Bacon, "Essays," in *Philosophical Works* (1905), 780 ("On Prophecy").
71. Lilly, *Collection* (1645), fo. A3.
72. Quoted in Gregory, *Posthuma* (1649), 299.
73. Parker, *Familiar* (1975), 134, 139–40; Geneva, *Astrology* (1995), 100.
74. Gell, *Stella nova* (1649), 19, 25–6; Ps. 114: 4.
75. *DNB*, s.v. "Gell."
76. Rusche, *English Historical Review*, 80 (1965), 331, 333; Parker, *Familiar* (1975), 149–51; Curry, *Prophecy* (1989), 28–9.
77. Brahe, *Learned: Tico Brahae* (1632), "Preface."
78. Barratt, *Cavalier* (2015), 100–18; Varley, *Siege* (1932), 81, and *Supplement* (1935), 10.
79. Van Eerde, *Hollar* (1970), 23, 28–9; Sprinzels, *Hollar* (1938), 15, 46.
80. Piles, *Art* (1744), 377; Rogers, *Dobson* (1983), 10–16 ("somewhat pedestrian"); Whinney and Millar, *English Art* (1957), 85 ("ponderous"); Rudolf, in Cropper (ed.), *Diplomacy* (2000), 209–12; Baker, *Lely* (1912), i. 91–101.
81. Millar, *Burlington Magazine*, 90 (1948), 98; Wilks, in Coward (ed.), *Companion* (2009), 199–200 (quote). The history was A. C. Davila, *Istoria delle guerre civili di Francia* (1630); Rogers, *Dobson* (1983), 72–4, 88–9; Baker, *Lely* (1912), i. 96; Wilson, *Lanier* (1994), 200–1.
82. Whinney and Millar, *English Art* (1957), 85–6.
83. Rogers, *Dobson* (1983), 18; Norgate, *Miniatura* (1919), 83; Walpole, *Works* (1798), ii. 351 (Charles on Dobson); Millar, *Tercentenary* (1951), 6.
84. Haldane, *Portraits* (2017), 11, 58–9.
85. Howarth, *Master Drawings*, 49/4 (2011), 438–9, 452, 461, 463, 466 (figs 4, 26, 49, 55, 59).

86. *DNB*, s.v. Dutton; Morgan, *Memoirs* (1899), 103–4, 114–15, 123, 149–50.

87. Morgan, *Memoirs* (1899), 111–12.

88. Gent, *Picture* (1981), 35, 39, 43–4, 60, quoting Norgate, *Miniatura* (1919), and Wotton, *Elements* (1624), 80, 83.

89. Gent, *Picture* (1981), 57.

90. Peacock, in Sharpe and Lake (eds), *Culture* (1993), 207–8 (garbling Aristotle, *Poetics*, 1450b1–2 (*Compete Works* (1984), ii. 2321)), 218–21; Bate, *Mysteries* (1635), 147 (quote); Lee, *Ut pictura* (1967), 9, 13, 18.

91. Haldane, *Portraits* (2017), 44; Noldus and Roding (eds), *Isaacsz* (2007), 271 ("Portrait of a Man with a Boy").

92. Examples in Museo di storia della scienza, *Catalogo* (1991), 73–5, and Van Helden, IMSS, *Catalogue* (1999), 24, 66–8; Powell, *Art History*, 39/2 (2016), 283–7, on telescopes in paintings.

93. Gorman and Marr, *Burlington Magazine*, 149/1247 (2007), 87–8; Gorman et al., *Mysterious Masterpiece* (2010), 50–123; Marr, *Between Raphael and Galileo* (2011), 199–214.

94. McCoy, *Edge* (2012), 71, fig. 6.1.

95. *CSPD, 1639*, 543; Howarth, *Lord Arundel* (1985), 167–8; Gilman, *Arundel Circle* (2002), 23, 29–30, 147–57; Hervey, *Life* (1921), 416–24; Davenant, *Madagascar* (1638), 16, 18 (quote).

96. Hamond, *Paradox* (1640), fos A2, B2, C1; Heylyn, *Mikrokosmos* (1639), 762; Wright, *JHI* 4 (1943), 113, 117.

97. Ogilby, *Africa* (1670), 677, 692–3.

98. See the sixteenth-century examples in Museo di storia della scienza, *Catalogo* (1991), 17.

99. Wotton, *Survey* (1938), 20.

100. Peacham, *Gentleman* (1634), 56–7; *CSPD, 1641–3*, 498 (14 November 1643).

101. *Catalogi librorum* (1697), 307; cf. p. 302, on gifts of instruments to the collection from Greaves and his brother Thomas; Aubrey, *Lives* (2018), i. 266.

102. Hobbes, *Correspondence* (1994), 875, records Payne's donation; Tyacke, in Pennington and Thomas (eds), *Puritans* (1978), 89.

103. Martin, *Catalogus* (1639).

104. A. Huguetan, editorial comment, in Galileo, *Systema* (1641), fo. *3.

105. Grove, *Apollo*, 123 (May 1986), 304.

106. Evelyn, *Sculptura* (1662), 111–12; Williamson, *Miniatures* (1898), 35; Watson, *Burlington Magazine*, 85 (1944), 226–7.

107. e.g., Rubens, *Sara Breyll* and *Rogier Clarisse*, and Van Dyck, *A Lady* (all at the Palace of the Legion of Honor, San Francisco), and Van Dyck, *Agostino Pallavicini* (Getty Center, Los Angeles).

108. Alberti, *On Painting* (1966), 77; Lomazzo, *Tracte* (1598), 2.2, 2.5–2.7, 2.9, trans. Haydock, 10, 12–20, 21 (quote), 25; Blunt, *Artistic Theory* (1940), 140–59.

109. Haydock, editorial comment, in Lomazzo, *Tracte* (1598), ¶iiiv.

110. Junius, *Painting* (1638), 172–3, 341, 353.

111. Wotton, *Elements* (1624), 61, 84–7.

112. Piles, *Art* (1706), 31.

113. Lievens, *Prince Charles Louis of the Palatinate with his Tutor Wolrad von Plessen* (Getty Center).

114. Dou's portrait, *Prince Rupert of the Palatinate and his Tutor in Historical Dress* (c.1631), is also at the Getty Center.

115. Quoted by Pace, *SC* 2 (1987), 179 (Junius' *Painting*, 1638), and *Word and Image*, 2/1 (1986), 4 (Cowley's *The Mistress*, 1647).

Chapter 9

1. Foster, *Register* (1889), 192–3; Cowper, *Prospect* (1985), 24, 30; Headlam, *Inns* (1909), 153–7; Hill, *Bench* (1988), 101. Francis Bacon and his brothers offer a parallel case of early admission and retention of the father's rooms at the Inn; Jardine and Stewart, *Hostage* (1999), 69–71.

2. "Mr John Bankes's observations on his travels," Kingston Lacy, Dorset.

3. Howell, *Instructions* (1869), 41–2; Raymond, *Itinerary* (1648), A11v–A12; Moshenska, *Stain* (2016), 62.

4. Raymond, *Itinerary* (1648), fo. A9r, and Howell, *Instructions* (1869), 42, 63–5, resp.; Bacon, "Of Travel," in "Essays," in *Philosophical Works* (1905), 756–7 (n.d.), 74; Duppa (to whom Bankes applied in quest of Isham) to Isham, 20 January 1652, in Isham, *Correspondence* (1955), 52. "Affectation . . . is a general fault amongst English Travellers, which is both displeasing and ridiculous." Earl of Essex to his cousin, 4 January 1596, in Fisher, *Instructions* (1633), 48–9, 55 (quote), 59–60.

5. Thomson, *Tapestry* (1973), 294–7; Hefford, in Murdoch (ed.), *Boughton House* (1992), 101, 104; Wyld, in Moore, *Paston Treasure* (2018), 386–7.

6. Richard Symmonds recorded the content of Cleyn's studio in 1652; Baker, *Lely* (1912), ii. 183; Millar, *Inventories* (1972), p. xx, and *Doort's catalogue* (1960), 171.

7. Walpole, *Works* (1798), iii. 252; Long, *Miniaturists* (1929), 72–3; Brown, *Catalogue* (1982), 61–2, figs 107–13.

8. The items, unfortunately not identified, survive in the founding collection of Oxford's Ashmolean Museum; Tradescant, *Musaeum* (1656), fos N2–N4, and p. 40 (quote).

9. Venner, *Via* (1638), 13; Aikin, *Biographical Memoirs* (1780), 281.

10. Venner, *Via* (1638), 10–11, 23–5.

11. Aubrey, *Lives* (2018), i. 210–11 (story from Hobbes); Jardine and Stewart, *Hostage* (1999), 502–4.

12. Jardine and Stewart, *Hostage* (1999), 505–11.

13. BL, Sloane MS 113, 110v, 114v, 117.

14. BL, Sloane MS 113, fos 120, 121r.

15. Venner, *Via* (1638), 32–3, 93, 132–4.

16. Virgil describes the technique in the Fourth Georgic; cf. Wallace, *Renaissance Quarterly*, 56 (2003), 377–82; Ovid, *Metamorphoses*, trans. Sandys (1632), 676.

Sampson managed the same trick with a lion, with disastrous consequences; Judges 14:5–9.

17. Dee, *Preface* (1570), fos iii^r–iiii^v.

18. Nardi, *Lactis physica analysis* (1634); De Vesme, *Della Bella: Text* (1971), 141, and *Plates*, 191; Ciancio, *Galilaeana*, 15 (2018), 85–7.

19. Corbett and Lightbrown, *Frontispiece* (1979), 6–9, 45.

20. How much of the posthumous *Eikon*, Charles wrote is disputed. Several versions of the frontispiece exist; Madan, *New Bibliography* (1950), 126–33, 175–87; Knachel, in Charles I, *Eikon* (1966), pp. xxi-xxxii. The Latin tags read: "I look at the blessed and eternal [things] of heaven," "I kick the showy and heavy [things] of the world," "I practice the hard and light [way] of Christ," "unmoved victorious," "valor increases when opposed."

21. "Aspice vultus, ecce meos;" Quarles, *Fons lachrymarum* (1648).

22. Burnett, *Title Page* (1998), 8, 20–3; Daniel 12:4.

23. Bacon, *Advancement*, ed. Wats (1640); Rosenthal, *JWCI* 34 (1971), 206–15.

24. Wither, *Collection* [1635], "A Proposition to this Frontispiece."

25. For the pictures Cleyn is about to describe, see Royal Academy of Arts, *In the Age of Giorgione* (2016), 27–8, 110–13.

26. Williams thus anticipated Meller, in Palluchini (ed.), *Giorgione* (1981), i. 228, 241–6, Wischnitzer-Bernstein, *Gazette des beaux arts*, 27 (1945), 198, 205–7, 210, and Cohen, *Gazette des beaux arts*, 126 (1995), 54–61.

27. Philipp Lansbergen, *Tabulae motuum coelestium* (1632); for other examples John Bankes may have known, Metze, *Entwicklung* (2004), 97–108; Gattei, in Albrecht et al. (eds), *Tintenfass* (2014), 341–2, 350; Remmert, *Widmung* (2005), 156–78.

28. SL ii. 486.

29. Tonini, in Pin (ed.), *Ripensando* (2006), 715–20; Kainulainen, *Sarpi* (2014), 18; Gattei, in Beretta et al. (eds), *Relics* (2016), 68–9, 79–84, 89–90.

30. Milton, *Areopagitica* (1644), in *Major Works* (2003), 258–9; cf. Shea, *Galilaeana*, 13 (2016), 7, 11, 15–16, 20–2.

31. Culverwell, *Discourse* (1652), pt 1, "Introduction," and pp. 155, 157, 159–60 (quote). Cf. Giudice, in Bucciantini et al. (eds), *Caso* (2011), 285.

32. Culverwell, "Spiritual Optics," in Culverwell, *Discourse* (1652), pt 2, p. 195; Duppa to Isham, 10 September 1650, in Isham, *Correspondence* (1955), 17–18: "If I have not answered your expectations [for advice about behavior] in this return, condemn me not for it, for without Galilaeo's glasses I cannot see spots on the moon."

33. Duppa to Isham, 22 July 1651, in Conway, *Letters* (1992), 34: "for the Earth a heavy dull grosse body to move and the heaven and Starres who are light to stand still is as if a Prince should upon a festivall day appoint all the old and fat men and women to dance and all the younger men and women of sixteen and twenty to sit still."

34. John had the quote down pat; Wilkins, *Discourse* (1640), fo. aa6^r; Wilkins says much the same in his opening to *New World* (1640), 1–2.

35. Barclay, *Mirrour* (1631), i. 117–18.

36. Sharpe, *Image Wars* (2010), 193, quoting Van der Doort.
37. Cleyn may have remembered this from Charles I, *Eikon* [1649], ed. Knachel (1966), 27.
38. Quarles, *Fons lachrymarum* (1648), 10–11.
39. Cf. Battistini, *Annali d'italianistica*, 10 (1992), 117–18, 125–6, 129–30.
40. Wotton to Earl of Salisbury, 13 March 1610, in *SL* i. 486–7: "the strangest piece of news . . . ever yet received from any part of the world."
41. Cf. Jaclobeanu, in Neuber and Zittel (eds), *Copernicus* (2015), 67–70, 79–80.
42. Hobbes, *De cive* (1647), fo. *4ᵛ; Rothman, *Pursuit* (2017), 216–21; Virgil, *Georgics*, 2.490, "happy was he who could know the causes of things."
43. Wotton, *Elements* (1624), 100.
44. Wotton, *Elements* (1624), 90, 95.
45. Hart, *Jones* (2011), 139–42; Wotton, *Elements* (1624), 51, 85–6.
46. Wotton to Wentworth, 8 April 1628, in *SL* ii. 306–7.
47. *SL* ii. 347; Wotton, *Elements* (1624), 47, 109, 113.
48. Galileo, *Dialogue* (1953), 103.
49. Gadbury, *Coelestis legatus* (1656), fo. A2ʳ (quote), 12–15, 26, 41 (quote).
50. Galileo, *Sidereus nuncius* [1610], trans. van Helden (1989), 29.

Postscripts

1. De Vergette, in Bucciantini et al. (eds), *Caso* (2011), 438–40, 443, 450, 454 (quote).
2. *Daedalus*, 197/4 (2018), title page.
3. Guillaume Libri, *Histoire des sciences mathématiques en Italie* (1838), quoted in Bucciantini, in Bucciantini et al. (eds), *Caso* (2011), 356.
4. Sergi, *Nuova antologia*, 35 (1900), 212.
5. Sergi, *Nuova antologia*, 35 (1900), 217–20.
6. Redondi, *Nuncius*, 9/1 (1994), 96–100, 108–9 (quote), 111–13. The play: François Ponsard, *Galilée* (1867).
7. Ferrone, in Bucciantini et al. (eds), *Caso* (2011), 336; Torrini, *Galilaeana*, 7 (2010), 63–4, 67–70; Cavagnini, *Galilaeana*, 13 (2016), 111–12.
8. Tognoni, "*Naturamque*" (2013), 41, 53, plate 7.
9. Tognoni, in Coppini and Tosi (eds), *Sapienza* (2004), 168.
10. Tognoni, *Galilaeana*, 1 (2004), 216, 218, 221–2, 226, quoting mainly the address of the rector; Micheli, in Galluzzi, Micheli, et al., *Galileo* (1988), 180, on the Te Deum and placards.
11. Tognoni, in Coppini and Tosi (eds), *Sapienza* (2004), 171–8.
12. Cavagnini, *Galilaeana*, 13 (2016), 115–20, 129–30.
13. *Pisa Today*, 8 February 2020, "Cronaca."
14. Melloni, in Bucciantini et al. (eds), *Caso* (2011), 463, 468–72, 476.
15. Melloni, in Bucciantini et al. (eds), *Caso* (2011), 475–8, 482.
16. *HG* 363–5.
17. *Catholic News Agency*, 6 May 2008, *TimesOnline News*, 3 April 2008, and *Scotsman*, 29 January 2008.

18. *Comunicato stampa*, 186, 28 April 2010, <santamariadegliangeliroma.it> (accessed 30 April 2010).

19. Quoted by Redondi, *Nuncius*, 9/1 (1994), 73–4.

20. Savorelli, *Galilaeana*, 7 (2010), 32, 37–8.

21. Remmert, *Science in Context*, 14 (2001), 343, 346–54.

22. Schirrmacher, *Legends* (2001), 8–30, following Custance, *Science and Faith* (1978), 152–6.

23. Davis and Chmielowski, *Brill's Series in Church History*, 30 (2008), 461–2.

24. Tognoni, *Galileo* (2014), 56 (quote), 126, 128, 148–59.

WORKS CITED

This list does not include standard reference sources like the *Dictionary of National Biography* (DNB), which are cited in the notes only when quoted directly or for other special reason. Also items that exist in many editions, such as the Bible and the plays of Jonson and Shakespeare, are usually not cited to any particular one, but given by chapter and verse, or act and scene. Other items not listed are books mentioned in the text but not cited in the notes; sporadic comments (as opposed to introductions) by editors; and brief descriptions of artworks in catalogues. In the last two cases, the authors of the comments and descriptions are credited in the notes.

Manuscripts

Bodleian Library, Oxford
 Add. MS A380
 Add. MSS 14923 = MS Rawlinson Letters 41
 Sir John Bankes Papers (cited as BPB)
British Library, London
 Add. MSS 11309, 46925, 70499–70503 (Cavendish papers)
 Harley MSS 6320 (Joseph Webbe's translation of Galileo's *Dialogo*), 6796
 Sloane MS 70 (Maurice Williams, "A survey of the motion of bodies")
 Sloane MS 95 (Williams, [Lectures on anatomy])
 Sloane MS 113 (Williams, "Prolongation of life" and "Use…of cold drinke")
 Sloane MSS 682, 2052, 2681
Dorset History Centre, Dorchester
 The Bankes Papers (cited as D-BKL)
Getty Research Center, Los Angeles
 Heinrich Geissler Collection
Huntington Library, San Marino, California
 Hastings Papers
Kingston Lacy, Dorset
 John Bankes, Jr, diary and other papers
Oriel College, Oxford
 Buttery Books
Statens Museum for Kunst, Copenhagen
 TP 503 (Cleyn material)

Printed Material

Abell, E. T. "A Note on Jasper Mayne," *Reports and Transactions of the Devonshire Asssociation*, 57 (1925), 257–65.

Acheson, Catherine, "The Picture of Nature: Seventeenth-Century English Aesop's Fables," *Journal for Early Modern Cultural Studies*, 9/2 (2009), 25–50.

Adams, Robyn, and Rosanna Cox (eds), *Diplomacy and Early Modern Culture* (Basingstoke: Palgrave, 2011).

Adamson, John S. A., "Chivalry and Political Culture in Caroline England," in Sharpe and Lake (eds), *Culture* (1993), 161–97.

Adamson, John S. A., *The Noble Revolt: The Overthrow of Charles I* (London: Phoenix, 2007).

Adlington, Hugh, "Gospel, Law, and *ars praedicandi* at the Inns of Court, *c.*1570–*c.*1640," in Archer (ed.), *Worlds* (2011), 51–74.

Aikin, John, *Biographical Memoirs of Medicine in Great Britain* (London: J. Johnson, 1780).

Akrigg, G. P. V., *Jacobean Pageant: The Court of King James I* (Cambridge, MA: Harvard University Press, 1962).

Alberti, Leon Battista, *On Painting*, trans. John R. Spencer (New Haven, CT: Yale University Press, 1966).

Albion, Gordon, *Charles I and the Court of Rome: A Study in 17th Century Diplomacy* (London: Burns, Oates & Washbourne, 1935).

Albrecht, Andrea, et al. (eds), *Tintenfass und Teleskop: Galileo Galilei im Schnittpunkt wissenschaftlicher, litterarischer und visueller Kulturen im 17. Jahrhundert* (Berlin: De Gruyter, 2014).

Alexander, Michael van Cleve, *Charles I's Lord Treasurer, Sir Richard Weston, Earl of Portland* (Chapel Hill, NC: University of North Carolina Press, 1975).

Allacci, Leone, *Apes urbanae* (Rome: L. Grignanus, 1633).

Allan, David, "'An Ancient Sage Philosopher': Alexander Ross and the Defense of Philosophy," *SC* 16/1 (2001), 68–94.

Allsopp, Bruce (ed.), *Inigo Jones on Palladio*, 2 vols (Newcastle on Tyne: Oriel Press, 1970).

Anderson, Christine Marie, "Art Dealing and Collecting in Venice: The Multifaceted Career of Daniel Nys (1572–1647)," D.Phil. thesis, Oxford, 2010.

Anderson, Christy, *Inigo Jones and the Classical Tradition* (Cambridge: Cambridge University Press, 2007).

Anderson, Christy, "The Learned Art of Architecture: Henry Wotton's Elements of Architecture," in Howard and McBurney (eds), *Image* (2014), 124–35.

Anderson, John Eustace, *A History of the Parish of Mortlake* (London: T. Laurie, 1886).

Anderson, John Eustace, *A Short Account of the Tapestry Works, Mortlake* (Richmond: R. W. Simpson, 1894).

Andersson, Daniel C., *Lord Henry Howard (1540–1614): An Elizabethan Life* (Cambridge: Brewer, 2009).

Andrewes, Lancelot, *XCVI. Sermons…Published by His Majesties Special Command*, ed. John Buckeridge and William Laud (London: R. Badger, 1631).

Andrewes, Lancelot, *The Morall Law Expounded* (London: A. Cooke for M. Sparke et al., 1642).

Andrewes, Lancelot, *Selected Sermons and Lectures*, ed. Peter E. McCullough (Oxford: Oxford University Press, 2005).

Andrews, Thomas, *His Majesties Resolution Concerning the Setting up of his Standard... Also Sir John Bankes his Perswasion, for His Majesties Return to London, His Majesties Consent at the First, but Afterwards His Refusal* (London: I. Thompson and A. Coe, 1642).

Anon., *The King of Denmarkes Welcome: Containing his Arivall, Abode, and Entertainement, both in the Citie and Other Places* (London: E. Allde, 1606).

Anon., *Justa funebria Ptolemaei oxoniensis Thomas Bodleii equitis aurati celebrata...1613* (Oxford: J. Barnes, 1613).

Anon., *The Mountebank's Mask* ([1618]; Cambridge: Chadwyck-Healy, 1994).

Anon., *Learned: Tico Brahae his Astronomical Conjecture, of the New and Much Admired [Star] which Appered in the Year 1572* (London: B. Alsop, etc., 1632).

Anon., *The Entertainment of the High and Mighty Charles King of Great Britaine, France, and Ireland, into his Auncient and Royall City of Edinburgh* (Edinburgh: J. Wreittoun, 1633).

Anon., *The Popes Nuntioes or, The Negotiation of Seignior Panzani, Seignior Con, &c. Resident here in England with the Queen* (London: R. Bostock, 1643).

Anon., *A Brief Declaration of the Reason that Moved King James... to Erect a College of Divines, and Other Learned Men at Chelsea* (London: E. P. for N. Bourne, 1645).

Anon., *A Refutation of a False and Impious Aspersion Cast on the Late Lord Cottingham by the Writer of the Popish Currant* (London: s.n., 1681).

Anon., "Some Althams of Mark Hall in the Seventeenth Century," *Essex Review*, 17 (1908), 74–87.

Anon., "The Magical Speculum of Dr Dee (British Museum)," *Burlington Magazine*, 110/778 (January 1968), 42–3.

Anon., "Propositions extraites des *Dialogues* de Galilei entre quelques autres, où il se trouve quelques difficultés" [n.d.], in Mersenne, *Correspondance* (1945–88), v. 603–14.

Anthony, Francis, *Medicinae chymicae, et veri potabilis auri assertio* (Cambridge: C. Legge, 1610).

Appleby, John H., "Arthur Dee and Johannes Bánfi Hunyades," *Ambix*, 24 (1977), 96–109.

Appleby, John H., "Some of Arthur Dee's Associations before Visiting Russia Clarified, Including Two Letters from Sir Theodore Mayerne," *Ambix*, 26 (1979), 1–15.

Appleby, John H., "Dr Arthur Dee, Merchant and Litigant," *Slavonic and East European Review*, 57 (1979), 32–55.

Archer, Elizabeth Jane (ed.), *The Intellectual and Cultural Worlds of the Early Modern Inns of Court* (Manchester: Manchester University Press, 2011).

Aristotle, *Complete Works*, 2 vols (Princeton: Princeton University Press, 1984).

Arrowood, Charles Flinn, *The Powers of the Crown in Scotland. Being a Translation... of George Buchanan's "De jure regni apud scotos,"* (Austin: University of Texas Press, 1949).

Ash, Eric H., *The Draining of the Fens* (Baltimore: Johns Hopkins University Press, 2017).

Ashton, Robert, *The City and the Court 1603–1643* (Cambridge: Cambridge University Press, 1979).

Aston, Margaret, "Gods, Saints and Reformers: Portraiture and Protestant England," in Gent (ed.), *Classicism* (1995), 181–220.

Aubrey, John, *Brief Lives, Chiefly of Contemporaries*, ed. Andrew Clark, 2 vols (Oxford: Oxford University Press, 1898).

Aubrey, John, *Brief Lives, with an Apparatus for the Lives of our English Mathematical Writers*, ed. Kate Bennett, 2 vols (Oxford: Oxford University Press, 2018).

Avery, Charles (ed.), *Studies in European Sculpture* (London: Christie's, 1981).

Aylmer, G. E., *The King's Servants: The Civil Service of Charles I, 1625–1642* (New York: Columbia University Press, 1961).

Babb, Lawrence, *The Elizabethan Malady: A Study of Melancholia in English Literature from 1780 to 1642* (East Lansing: Michigan State College Press, 1951).

Bacon, Francis, *Saggi morali . . .con un'altro suo trattato Della sapienza degli antichi*, ed. Tobie Matthew (London: J. Bill, 1618; Florence: P. Cecconcelli, 1619; Venice: P. Dusinelli, 1619).

Bacon, Francis, *New Organon* [1620], trans. F. H. Anderson (Indianapolis: Bobbs-Merrill, 1960).

Bacon, Francis, *Of the Advancement and Proficiencie of Learning*, ed. Gilbert Wats (Oxford: L. Lichfield, 1640); ed. G. W. Kitchim (London: Dent, 1954).

Bacon, Francis, *The Works*, ed. James Spedding et al., 14 vols (London: Longmans et al., 1857–74).

Bacon, Francis, *The Philosophical Works...Reprinted from the...[Edition] of Ellis and Spedding*, ed. J. M. Robertson (London: Routledge, 1905).

Bacon, Francis, "History of Life and Death [Historia vitae et mortis]," in *Works* (1857–74), v. 213–335.

Bacon, Francis, "The Essays, or Counsels, Civil and Moral," in Bacon, *Philosophical Works* (1905), 785–807.

Bacon, Francis, *Philosophical Studies c.1611–c.1619*, ed. Graham Rees, Oxford Francis Bacon, 6 (Oxford: Oxford University Press, 1996).

Baillon, le comte de, *Henriette-Marie de France, Reine d'Angleterre* (Paris: Didier, 1877).

Bainbridge, John, *An Astronomical Description of the Late Comet...with Certaine Morall Prognosticks or Applications Drawn from the Comets Motion and Irradiation amongst the Celestial Hieroglyphics. By Vigilant and Diligent Observations* (London: J. Parker, 1619).

Bainbridge, John, *ΠΡΟΚΛΟΥ ΣΦΑΙΡΑ ΠΤΟΛΕΜΑΙΟΥ ΠΕΡΙ ΥΠΟΘΕΣΕΩΝ ΠΛΑΝΩΜΕΝΩΝ Procli sphaera, Ptolomaei de Hypothesibus planetarum liber singularis nunc primum in lucem editus* (London: W. Jones, 1620).

Baker, C. H. Collins, *Lely and the Stuart Portrait Painters: A Study of English Portraiture before and after Van Dyck*, 2 vols (London: P. L. Warner, 1912).

Baker, John Hamilton, *The Order of Serjeants at Law: A Chronicle of Creations, with Related Texts and a Historical Introduction*, Supplemental series, vol. 5 (London: Selden Society, 1984).

Baker, John Hamilton, *Readers and Readings in the Inns of Court and Chancery* (London: Selden Society, 2000).

Baker, J. N. L. "England in the Seventeenth Century," in Darby (ed.), *Historical Geography* (1936), 387–443.

Baldini, Ugo, "The Roman Inquisition's Condemnation of Astrology," in Gigiola Fragnito (ed.), *Church, Censorship and Culture in Early Modern Italy* (Cambridge: Cambridge University Press, 2001), 79–110.

Baldwin, David, *The Chapel Royal, Ancient and Modern* (London: Duckworth, 1990).

Bamborough, J. B., "Robert Burton's Astrological Notebook," *Review of English Studies,* 32 (1981), 267–85.

Bankes, George, *The Story of Corfe Castle and of Many who have Lived there* (London: John Murray, 1853).

Bankes, Viola, *A Dorset Heritage: The Story of Kingston Lacy* (London: Richards, 1953).

Barlow, Richard G., "Infinite Worlds: Robert Burton's Cosmic Voyage," *JHI* 34 (1973), 291–302.

Barnes, Susan, "Van Dyck and George Gage," in Howarth (ed.), *Art* (1993), 1–11.

Barratt, John, *Cavalier Capital: Oxford in the English Civil War 1642–1646* (Solihull: Helion, 2015).

Barclay, John, *The Mirrour of Mindes, or, Barclay's Icon animorum* [1614], trans. T.M. (London: J. Norton for T. Walkley, 1631).

Barroll, Leeds, "Inventing the Stuart Masque," in Bevington and Holbrook (eds), *Politics* (1998), 121–43.

Barroll, Leeds, *Anna of Denmark, Queen of England: A Cultural Biography* (Philadelphia: University of Pennsylvania Press, 2001).

Bate, George, *A Compendious Narrative of the Late Troubles in England* (London: s.n., 1652).

Bate, John, *The Mysteries of Nature and Art* ([1634]; London: T. Harper for R. Mabb, 1635^2).

Batho, G. R., "The Library of the Wizard Earl, Henry Percy, 9th Earl of Northumberland (1564-1632)," *Library,* 15 (1960), 246–61.

Battistini, Andrea, "'Cedat Columbus' e 'Vincisti Galilaee': Due esploratori a confronto nel immaginario barocco," *Annali d'Italianistica,* 10 (1992), 116–32.

Baudi de Vesme, Alexandre, *Le Peintre-graveur italien* (Milan: Hoepli, 1906).

Beckett, Francis, "The Painter Franz Cleyn in Denmark," *Académie royale des sciences et des lettres de Danemark, Section des lettres, Mémoires,* ser. 7, vol. 5/2 (1936).

Beckett, Francis, *Kristian IV og malerkunsten* (Copenhagen: Munksgaard, 1937).

Beecher, Donald, and Massimo Ciavolella, "Jacques Ferrand and the Tradition of Erotic Melancholy in Western Culture," in Ferrand, *Treatise* (1990), 1–202.

Bekkers, J. A. F. (ed.), *Correspondence of John Morris with Johannes de Laet (1634–1649)* (Assen: Van Gorcum, 1970).

Bellany, Alastair, and Thomas Cogswell, *The Murder of James I* (New Haven, CT: Yale University Press, 2015).

Belligni, Eleanora, *Auctoritas et potestas: Marcantonio De Dominis fra l'Inquisizione e Giacomo I* (Milan: FancoAngeli, 2003).

Belligni, Eleanora, "Paolo Sarpi, Marcantonio De Dominis e i latitudinari della prima generazione," in Pin (ed.), *Ripensando* (2006), 137–52.

Benedetti, Francesca Zen, "La laurea in medicina di Giovanni Wedderburn," *Quaderni per la storia dell'Università di Padova,* 4 (1971), 153–7.

Bennet, J. A., "The MSS of Ralph Bankes, Esq., of Kingston Lacy, Dorset," RCHM, *Report*, 8 (1881), 208–13.

Bennett, J. A. W., and Hugh Trevor-Roper, "Introduction," in Corbett, *Poems* (1955), pp. xi–lxv.

Bennett, Martyn, *Historical Dictionary of the British and Irish Civil Wars, 1637–1660* (London: Scarecrow, 2000).

Bentivoglio, Guido, *Relationi*, 2 vols in 1 (Cologne: s.n., 1630).

Bentivoglio, Guido, *A Collection of Letters Written by Cardinal Bentivoglio…during his Nunciatures in France and Flanders* (London: P. Vaillant, 1764).

Bentivoglio, Guido, *Memorie*, ed. Carlo Morbio (Milan: G. Daelli, 1864).

Benzoni, Gino, "Giovanni Francesco Biondi: Un avventuroso dalmata del '600," *Archivio veneto*, 98/115 (1967), 19–37.

Berington, Joseph (ed.), *The Memoirs of Gregorio Panzani: Giving an Account of his Agency in England, in the Years 1634, 1635, 1636* ([1793]; Farnborough: Gregg, 1970).

Berkowitz, David Sandler, *John Selden's Formative Years: Politics and Society in Early Seventeenth-Century England* (Washington: Folger Shakespeare Library, 1988).

Bevington, David, and Peter Holbrook, "Introduction," in Bevington and Holbrook (eds), *Politics* (1998), 1–19.

Bevington, David, and Peter Holbrook (eds), *The Politics of the Stuart Court Masque* (Cambridge: Cambridge University Press, 1998).

Bidwell, William B., and Maija Jansson (eds), *Proceedings in Parliament, 1626*, 4 vols (New Haven, CT: Yale University Press, 1991–6).

Binns, James, *Intellectual Culture in Elizabethan and Jacobean England: The Latin Writings of the Age* (Leeds: Francis Cairns, 1990).

Biographia Britannica, 6 vols (London: W. Innys et al., 1747–66).

Birch, Thomas, "An Account of the Life and Writings of Mr John Greaves," in John Greaves, *Miscellaneous Works* (1737), i, pp. i–lxxii.

Birken, W. J., "The Royal College of Physicians of London and its Support of the Parliamentary Cause in the English Civil War," *Journal of British Studies*, 23/1 (1983), 47–62.

Birrell, T. A., "Introduction," in Berington (ed.), *Memoirs* (1970), no pagination.

Blundeville, Thomas, *The True Order and Method of Wryting and Reading Hystories* (London: W. Serres, 1574). (A translation of Francesco Patrizzi, *Della historia dieci dialoghi* (Venice, 1560).)

Blunt, Anthony, *Artistic Theory in Italy 1450–1600* (Oxford: Oxford University Press, 1940).

Bold, R. C., "Introduction," in Middleton, *Game* (1929), 1–43.

Bolton, Edmund, "*Hypercritica, or, A Rule of Judgment for Writing, or Reading our History's* [1622]," in Joseph Haslewood (ed.), *Ancient Critical Essays upon English Poets and Poetry*, 2 vols (London: R. Triphook, 1811–15), ii. 221–54.

Bon, Ottaviano, *The Sultan's Seraglio: An Intimate Portrait of Life at the Ottoman Court*, ed. Godfrey Goodwin (London: Saqi, 1996).

Bond, Maurice (ed.), *The Inventories of St George's Chapel Windsor Castle 1384–1667* (Windsor: Olney, 1947).

Borman, Tracy, *Witches: James I and the English Witch Hunts* (London: Vintage, 2014).

Boro, Giulio, et al., *Rabisch: Il grottesco nell'arte del cinquecento* (Milan: Skira, 1998).

Bosanquet, Eustace F., "English Seventeenth-Century Almanacs," *Library*, 10 (1930), 361–97.

Bott, George, *Keswick: The Story of a Lake District Town* (Carlisle: Cumbria County Library, 1994).

Bouch, C. M. L., *Prelates and People of the Lake Counties: A History of the Diocese of Carlisle, 1133–1933* (Kendal: T. Wilson, 1948).

Bouwsma, William, *Venice and the Defense of Republican Liberty* (Berkeley and Los Angeles: University of California Press, 1968).

Braddick, Michael, *God's Fury, England's Fire: A New History of the English Civil Wars* (London: Penguin, 2009).

Bradley, Robert I., "Blacklo and the Counter-Reformation: An Inquiry into the Strange Death of Catholic England," in Charles H. Carter (ed.), *From the Renaissance to the Counter Reformation* (London: J. Cape, 1965), 348–70.

Brahe, Tycho, *Learned Tico Brahae His Astronomicall Conjecture of the New and Much Admired * which Appeared in the Year 1572* (London: M. Sparks, 1632).

Bramhall, John, *The Works*, ed. A. W. Hadden, 5 vols (Oxford: J. H. Parker, 1842–5).

Brathwaite, Richard, *The English Gentleman* (London: F. Kyngston, 1631²).

Braunmuller, A. R., "Robert Carr, Earl of Somerset, as Collector and Patron," in Peck (ed.), *Mental World* (1991), 230–50.

Britland, Karen, *Drama at the Courts of Queen Henrietta Maria* (Cambridge: Cambridge University Press, 2006).

Brocard, Francis, *His Alarm to all Protestant Princes: With a Discovery of Popish Plots and Conspiracies, after his Conversion from Popery to the Protestant Religion* ([c.1603]; London: T.S. for William Rogers, 1679).

Brock, Dewey Heyward, *A Ben Jonson Companion* (Bloomington: University of Indiana Press, 1983).

Brome, Richard (ed.), *Lachrymae musarum: The Tears of the Muses Expressed in Elegies* (London: T. Newcombe, 1649).

Brome, Richard, *The Weeding of the Covent-Garden* ([1632, 1658]; Cambridge: Chadwyck-Healey, 1997).

Brotton, Jerry, *The Sale of the Late King's Goods: Charles I and his Art Collection* (London: Macmillan, 2006).

Brotton, Jerry, "Buying the Renaissance: Prince Charles's Art Purchases in Madrid, 1623," in Alexander Samson (ed.), *The Spanish Match: Prince Charles's Journey to Madrid, 1623* (Aldershot: Ashgate, 2006), 9–26.

Brotton, Jerry, and D. McGrath, "The Spanish Acquisition of King Charles I's Art Collection," *Journal of the History of Collections*, 20 (2008), 1–16.

Brown, Cedric C., "Courtesies of Place and Arts of Diplomacy in Ben Jonson's Last Two Entertainments for Royalty," *SC* 9/2 (1994), 147–71.

Brown, David Blaney, *Catalogue of the Collection of Drawings in the Ashmolean Museum*, iv. *The Earlier British Drawings* (Oxford: Oxford University Press, 1982).

Brown, Jonathan, *Kings and Connoisseurs: Collecting Art in Seventeenth Century Europe* (Princeton: Princeton University Press, 1995).

Bruno, Giordano, *The Expulsion of the Triumphant Beast*, trans. A. D. Imerti (New Brunswick: Rutgers University Press, 1964).

Bryden, D. J., "A Patchery and Confusion of Disjointed Styles: Richard Delamain's 'Grammelogia' of 1631/2," Cambridge Bibliographical Society, *Transactions*, 6/9 (1974), 158–66.

Bucciantini, Massimo, "Galileo e le passioni del Risorgimento," in Bucciantini et al. (eds), *Caso* (2011), 347–66.

Bucciantini, Massimo, et al. (eds), *Il caso di Galileo: Una rilettura storica, filosofica, teologica* (Florence: Olschki, 2011).

Buchanan, George, *Opera omnia*, 2 vols (Leyden: J. A. Langerak, 1725).

[Buckeridge, B.], "An Essay towards an English School of Painters," in Piles, *Art* (1744), 354–430.

Budé, Eugène de, *Vie de Jean Diodati, théologien genevois, 1576–1649* (Lausanne: Bridel, 1869).

Bünger, Carl, *Matthias Bernegger, ein Bild aus dem geistigen Leben Strassburgs zur Zeit des dreissigjährigen Krieges* (Strasbourg: Trübner, 1893).

Burke, Jill, and Michael Bury (eds), *Art and Identity in Early Modern Rome* (Aldershot: Ashgate, 2008).

Burke, Peter, "Sarpi storico," in Pin (ed.), *Ripensando* (2006), 103–9.

Burnet, Gilbert, *The Life of William Bedell, D.D., Bishop of Kilmore in Ireland* (London: Southby, 1685).

Burnett, David, *The Engraved Title Page of Bacon's "Instauratio magna,"* Durham Thomas Harriot Seminar, Occasional Papers, no. 27 (Durham: University of Durham Press, 1998).

Burton, Henry, *A Divine Tragedie Lately Acted, or, A Collection of Sundrie Memorable Examples of Gods Judgment upon Sabbath-Breakers* ([1626]; London: J. Wright & T. Bates, 1642).

Burton, Henry, *For God and the King: The Summe of Two Sermons Preached on the Fifth of November Last* ([London: F. Kingston], 1636).

Burton, Robert, *The Anatomy of Melancholy* [1621], ed. Holbrook Jackson, 3 vols in 1 (New York: New York Review of Books, 2001).

Burton, Robert, *Philosophaster, with an English Translation of the Same together with his Other Minor Writings in Prose and Verse*, trans. Paul Jordan Smith (Stanford: Stanford University Press, 1931).

Bush, Douglas, "Foreword," in Ovid, *Metamorphosis* (1970), pp. vii–xiii.

Butler, Martin, *Theatre and Crisis, 1632–1642* (Cambridge: Cambridge University Press, 1984).

Butler, Martin, "Reform or Reverence? The Politics of the Caroline Masque," in Mulgrave and Shewring (eds), *Theatre* (1993), 118–56.

Butler, Martin, "Ben Jonson and the Limits of Courtly Panegyric," in Sharpe and Lake (eds), *Culture* (1993), 91–115.

Butler, Martin, *The Stuart Court Masque and Political Culture* (Cambridge: Cambridge University Press, 2008).

Butterworth, Philip, *Theatre of Fire: Special Effects in the Early English and Scottish Theatre* (London: Society for Theatre Research, 1998).

Bynum, William, "The Weapon Salve in Seventeenth-Century English Drama," *Journal of the History of Medicine*, 21 (1966), 8–23.

Cajori, Florian, *William Oughtred, a Great Seventeenth Century Teacher of Mathematics* (Berkeley and Los Angeles: University of California Press, 1916).

Calvin, John, *An Admonicion against Astrology Iudiciall and Other Curiosities, that Raigne now in the World* (London: R. Hall, 1561).

Camden, Carroll, Jr, "Astrology in Shakespeare's Day," *Isis*, 19/1 (1933), 26–73.

Camden, William, *Remaines, Concerning Britaine: But Especially England, and the Inhabitants thereof* [1605, 1614, 1623], ed. John Philipot (London: S. Waterson and R. Clavell, 1657).

Camden, William, *Epistolae*, ed. Thomas Smith (London: R. Chiswell, 1691).

Campanella, Tommaso, *A Defense of Galileo the Mathematician from Florence* [1622], trans. Richard Blackwell (Notre Dame: University of Notre Dame Press, 1994).

Campbell, Thomas P. "A Consideration of the Career and Work of Francis Clein" (MA thesis, Courtauld Institute of Art, London, 1987).

Campbell, Thomas P., "Introduction: The Golden Age of Flemish Tapestry Weaving," in Campbell (ed.), *Tapestry* (2007), 3–15.

Campbell, Thomas P., "Stately Splendor," in Campbell (ed.), *Tapestry* (2007), 107–21.

Campbell, Thomas P. (ed.), *Tapestry in the Baroque: Threads of Splendour* (New York: Metropolitan Museum of Art; New Haven, CT: Yale University Press, 2007).

Campbell, Thomas P., "An Introduction to the Exhibition," in Campbell and Cleland (eds), *Tapestry* (2010), 2–17.

Campbell, Thomas P., and Elizabeth A. H. Cleland (eds), *Tapestry in the Baroque: New Aspects of Production and Patronage* (New York: Metropolitan Museum of Art; New Haven, CT: Yale University Press, 2010).

Capp, Bernard, *Astrology and the Popular Press: English Almanacs 1500–1800* (London: Faber and Faber, 1979).

Carew, Thomas, *Coelum britannicum: A Masque at White-Hall, in the Banqueting House 18 February 1633* [i.e., 1634] (London: for T. Walkleg, 1634); also in Orgel and Strong, *Jones* (1973), ii. 570–80.

Carleton, George, ΑΣΤΡΟΛΟΓΟΜΑΝΙΑ [Astrologomania]: *The Madnesse of Astrologers, or, An Examination of Sir Christopher Heydon's Booke, Intituled* A Defense of Judiciarie Astrology, ed. Thomas Vicars (London: W. Jaggard for W. Turner, 1624).

Carpenter, Nathanael, *Philosophia libera, triplici exercitationum decade proposita: In qua adversus huius temporis philosophos, dogmata quaedam nova discuntiuntur* (Oxford: Oxford University Press, 1622).

Carpenter, Nathanael, *Geography Delineated forth in Two Books: Containing the Sphericall and Tropicall Parts thereof* (Oxford: H. Cripps, 1625, 1635).

Cartwright, William, *The Siege: or Love's Convert*, in Cartwright, *Comedies, Tragicomedies, with Other Poems* (London: H. Moseley, 1651), 91–180.

Casaubon, Meric (ed.), *A True and Faithful Relation of what Passed for Many Years between Dr John Dee and Some Spirits* (London: T. Garthwait, 1659).

Catalogi librorum manuscriptorum Angliae et Hibernicae (Oxford: Sheldonian, 1697).

Cattabiani, Alfredo, *Breve storia dei Giubilei (1300–2000)* (Milan: Bompiani, 1999).

Cavagnini, Giovanni, "Dimenticare l'Inquisizione: Pisa, il cardinale Maffi, e un monumento mancato a Galileo (1922)," *Galilaeana*, 13 (2016), 111–30.

Cavazzi, Lucia, *"Fuochi d'allegrezza" a Roma dal cinquecento all'ottocento* (Rome: Quasar, 1982).

Cavendish, Margaret, Duchess of Newcastle, *The Life of the Thrice Noble, High and Puissant Prince William Cavendishe* (London: A. Maxwell, 1667).

Cavendish, William, *Horae subsecivae: Observations and Discourses* (London: for E. Blount, 1620).

Chamber, John, *Astronomiae encomium* (London: J. Harison, 1601).

Chamberlain, John, *The Chamberlain Letters: A Selection… Concerning Life in England from 1597 to 1626*, ed. Elizabeth M. Thomson (New York: Putnam, 1965).

Chambers, J. D. C., "A Catalogue of the Library of Bishop Lancelot Andrewes," *Transactions of the Cambridge Bibliographical Society*, 5 (1970), 99–212.

Chaney, Edward, *The Grand Tour and the Great Rebellion: Richard Lassels and the "Voyage of Italy" in the Seventeenth Century* (Geneva: Slatkine, 1985).

Chaney, Edward, "Pilgrims to Pictures," *Country Life*, 184/40 (4 October 1990), 146–9.

Chaney, Edward, *The Evolution of the Grand Tour: Anglo-Italian Cultural Relations since the Renaissance* (London: Frank Cass, 1998).

Chaney, Edward, and Peter Mack (eds), *England and the Continental Renaissance* (Woodridge: Boydell, 1990).

Chaney, Edward, and Timothy Wilks, *The Jacobean Grand Tour: Early Stuart Travellers in Europe* (London: I. B. Tauris, 2014).

Chapman, Allan. "'A world in the moon': John Wilkins and his Lunar Voyage of 1640," *Royal Astronomical Society, Quarterly Journal*, 32 (1991), 121–32.

Charles I, King of England, and John Gauden. *Eikon basilike: The Portrait of His Sacred Majesty in his Solitude and Sufferings* [1649], ed. Philip A. Knachel (Ithaca, NY: Cornell University Press, 1966).

Charleton, Walter, *The Immortality of the Soul, Demonstrated by the Light of Nature* (London: W. Wilson for H. Herringman, 1657).

Chauvette, T. S., and H. de Chalup, *Etude illustrée sur la Manufacture royale angloise de tapisseries établie à Mortlake au xviie siècle* (Bordeaux: Delbrel, 1928).

Chippindale, Christopher, *Stonehenge Complete* (Ithaca, NY: Cornell University Press, 1987).

Christianson, John Robert, *On Tycho's Island: Tycho Brahe and his Assistants, 1570–1601* (Cambridge: Cambridge University Press, 2000).

Christianson, John Robert, et al. (eds), *Tycho Brahe and Prague: Crossroads of European Science* (Frankfurt/M: H. Deutsch, 2002).

Ciampoli, Giovanni Battista, *Poesia in lode dell'inchiostro: Dedicata al Signor Giorgio Coneo* (Rome: G. Mascardi, 1626).

Ciampoli, Giovanni Battista, *Lettere*, ed. Alessandro Pozzobonelli (Venice: Per i Curti, 1676).

Ciancio, Luca, "'An Amphitheatre Built on Toothpicks': Galileo, Nardi and the Hypothesis of Central Fire," *Galilaeana*, 15 (2018), 83–113.

Clancy, Thomas H. "The Jesuits and the Independents," *Archivum historicum Societatis Jesu*, 40 (1971), 67–89.

Clarendon, Edward Hyde, Earl of, *The History of the Rebellion and Civil Wars in England*, ed. William Warburton, 7 vols (Oxford: Oxford University Press, 1849).

Clark, Cumberland, *Shakespeare and Science* (Birmingham: Cornish Brothers, 1929).

Clark, William Smith. *The Early Irish Stage: The Beginnings to 1720* (Oxford: Oxford University Press, 1955).

Clarke, Adrian, "The Government of Wentworth, 1632–40," in T. W. Moody et al. (eds), *A New History of Ireland*, iii. *Early Modern Ireland 1534–1691* (Oxford: Oxford University Press, 1976), 243–69.

Cleyn, Francis, *Septem liberales artes* (London: T. Rowlett, 1645).

Cleyn, Francis, *Quinque sensuum descriptio: In eo picturae genere quod (Grottesche) vocant Italici* (London: T. Hill, 1646).

Cliffe, J. T., *The World of the Country House in Seventeenth-Century England* (New Haven, CT: Yale University Press, 1999).

Clucas, Stephen, "The Atomism of the Cavendish Circle: A Reappraisal," *SC* 9/2 (1994), 247–73.

Clucas, Stephen, "Robert Cotton's *A Short View of the Life of Henry the Third*, and its Presentation in 1614," in Clucas and Davies (eds), *Crisis* (2003), 177–89.

Clucas, Stephen, and Rosalind Davis (eds), *The Crisis of 1614 and the Addled Parliament* (Aldershot: Ashgate, 2003).

Coffin, Charles M., *John Donne and the New Philosophy* (New York: Columbia University Press, 1937).

Cogswell, Thomas, "England and the Spanish Match," in Richard Cust and Ann Hughes (eds), *Conflict in Early Stuart England* (London: Longman, 1989), 107–33.

Cogswell, Thomas, "John Felton, Popular Political Culture, and the Assassination of the Duke of Buckingham," *Historical Journal*, 49/2 (2006), 357–85.

Cohen, Simona, "A New Perspective on Giorgione's Three Philosophers," *Gazette des beaux arts*, 126 (1995), 53–64.

Colie, Rosalie L., "Cornelis Drebbel and Salomon de Caus: Jacobean Models for Salomon's House," *HLQ* 18 (1955), 245–60.

Collingwood, W. G., "Germans at Coniston in the Seventeenth Century," *CWASS, Transactions*, 10 (1910), 369–74.

Conan Doyle, Arthur, *The Complete Sherlock Holmes*, 2 vols (New York: Doubleday, n.d.).

Condé, Henri II de Bourbon, prince de, *Voyage... en Italie* (Paris: T. Quinet, 1634).

Conn, George, *Vita Mariae Stuartae* (Rome: J. P. Gellius, 1624).

Conn, George, *De duplici statu religionis apud scotos libri duo* (Rome: Typis Vaticanis, 1627).

Conn, George, *Assertionum catholicarum libri tres* (Rome: Haeredes B. Zannetti, 1629).

Conway, Anne, *The Conway Letters: The Correspondence of Anne, Viscountess Conway, Henry More and their Friends, 1642–1684*, ed. Marjorie H. Nicholson and Sarah Hutton (Oxford: Oxford University Press, 1992).

Cook, Harold J., "'Against common right and reason': The College of Physicians against Dr Thomas Bonham," *American Journal of Legal History*, 29 (1985), 301–22.

Cook, Harold J., *The Decline of the Old Medieval Regime in Stuart London* (Ithaca, NY: Cornell University Press, 1986).

Cook, Harold J., "Policing the Health of London: The College of Physicians and the Early Stuart Monarchy," *Social History of Medicine*, 2 (1989), 1–34.

Cook, Harold J., "Institutional Structures and Personal Belief in the London College of Physicians," in Grell and Cunningham (eds), *Religio medici* (1996), 91–114.

Cools, Hans, and Marika Keblusek (eds), *Your Humble Servant: Agents in Early Modern Europe* (Hilversum: Verloren, 2006).

Copernicus, Nicolaus, *De revolutionibus orbium coelesium* (Nuremberg: J. Petreius, 1543).

Corbett, Margery, and Ronald Lightbown, *The Comely Frontispiece: The Emblematic Title Page in England 1550–1650* (London: Routledge & Kegan Paul, 1979).

Corbett, Richard, *The Poems*, ed. J. A. W. Bennett and H. R. Trevor-Roper (Oxford: Oxford University Press, 1955).

Cormack, Leslie G. "Twisting the Lion's Tail: Practice and Theory at the Court of Henry Prince of Wales," in Bruce T. Moran (ed.), *Patronage and Institutions: Science, Technology and Medicine at the European Court 1500–1750* (Woodbridge: Boydell, 1991), 67–84.

Coryate, Thomas, *Coryate's Venice: Thomas Coryate's Description of the City Taken from Coryate's Crudities* (London: Beeches Press, 1989).

Cotton, Robert, *A Short View of the Long Life and Raigne of Henry the Third* (London: J. Okes, 1627).

Coward, Barry, *The Stuart Age: England 1603–1714* (London: Longman, 1994²).

Cowper, Francis, *A Prospect of Gray's Inn* (London: Graya, 1985²).

Cozzi, Gaetano, "Fra Paolo Sarpi, l'anglicanesimo e la *Historia del Concilio Tridentino*," *Rivista storica italiana*, 68 (1956), 559–619.

Cozzi, Gaetano, "Sir Edwin Sandys e la *Relazione dello stato della religione*," *Rivista storica italiana*, 79 (1967), 1096–121.

Craig, J. T. G., *Papers Relative to the Marriage of King James the Sixth of Scotland, with the Princess Anna of Denmark* (Edinburgh: s.n., 1828).

Craigie, James, "Introduction," in James VI & I, *Poems*, i (1955), pp. xi–civ.

Crawforth, Hannah J., "Court Hieroglyphics: The Idea of the Cypher in Ben Jonson's Masques," in Adams and Cox (eds), *Diplomacy* (2011), 138–54.

Cressy, David, "Early Modern Space Travel and the English Man in the Moon," *American Historical Review*, 111 (2006), 961–82.

Cressy, Hugh, *Exomologesis, or, A Faithful Narration of the Occasion and Motives of the Conversion unto Catholique Unity of Hugh-Paulin de Cressy* (Paris: s.n., 1647).

Crinò, Anna Maria, *Fatti e figure del seicento anglo-toscano* (Florence: Olschki, 1957).

Crinò, Anna Maria, "Two Medici–Stuart Marriage Proposals and an Early Seicento Solution to the Irish Problem," in Edward Chaney and Neil Ritchie (eds), *Oxford, China, and Italy* (London: Thames and Hudson, 1984), 107–15.

Croft, Pauline, "Light on Bate's Case," *Historical Journal*, 30/3 (1987), 523–39.

Croft, Pauline, *King James* (Basingstoke: Palgrave, 2003).

Croft-Murray, Edward, *Decorative Painting in England 1537–1837*, 2 vols (London: Country Life, 1962–70).

Croft-Murray, Edward, Paul Hulton, et al., *Catalogue of British Drawings*, i. *XVI and XVII Centuries* (London: British Museum, 1960).

Cropper, Elizabeth (ed.), *The Diplomacy of Art: Artistic Creation and Politics in Seicento Italy* (Milan: Nuova Alfa, 2000).

Crosthwaite, J. Fisher, *Life and Times of Sir John Bankes, Attorney-General and Lord Chief-Justice of the Common Pleas in the Reign of Charles I* (Keswick: R. Bailey, 1873).

Crosthwaite, J. Fisher, "The Crosthwaite Registers," CWASS, *Transactions*, 2 (1876), 225–41.

Crosthwaite, J. Fisher, "The Colony of German Miners at Keswick," CWASS, *Transactions*, 6 (1883), 344–54.

Crowne, William, *A True Relation of the Remarkable Places and Passages Observed in the Travels of Thomas Lord Howard Earle of Arundel* (London: F. Kingston, 1637).

Crowther, J. G., *Francis Bacon: The First Statesman of Science* (London: Cresset, 1960).

Cruickshanks, Eveline (ed.), *The Stuart Courts* (Stroud: Sutton, 2000).

Cuddy, Neil, "Reinventing a Monarchy: The Changing Structure and Political Function of the Stuart Court," in Cruickshanks (ed.), *Courts* (2000), 59–85.

Culverwell, Nathanael, *An Elegant and Learned Discourse of the Light of Nature* (London: T.R. & E.M. for J. Rothwell, 1652).

Cunningham, Jack, *James Ussher and John Bramhall* (Aldershot: Ashgate, 2007).

Curry, Patrick, *Prophecy and Power: Astrology in Early Modern England* (Princeton: Princeton University Press, 1989).

Curtis, H. M., *Oxford and Cambridge in Transition, 1558–1642* (Oxford: Oxford University Press, 1959).

Cust, Lionel, "The Lumley Inventories," *Walpole Society*, 6 (1918), 15–35.

Cust, Richard, "Wentworth's 'Change of Sides' in the 1620s," in Merritt (ed.), *Political World* (1996), 63–80.

Custance, Arthur C., *Science and Faith*, Doorway Papers, 8 (Grand Rapids: Zondervan, 1978).

D'Addio, Mario, *Il pensiero politico di Gaspare Scioppio* (Milan: Giuffrè, 1962).

Daniel, Samuel, *The Vision of the 12. Goddesses Presented . . . by the Queenes Most Excellent Maiestie and her Ladies* (London: T.C. for S. Waterson, 1604).

Darby, H. C. (ed.), *An Historical Geography of England before AD 1800* (Cambridge: Cambridge University Press, 1936).

Davenant, William, *Madagascar; with Other Poems* (London: T. Walkly, 1638).

Davenant, William, *Salmacida spolia* (London: T.H. for Thomas Walkley, 1639 [1640]).

Davenant, William, *Gondibert, an Heroick Poem* (London: T. Newcomb for J. Holden, 1651).

Davidson, Alan, "Roman Catholicism in Oxfordshire, c.1580–1640," Ph.D. thesis, University of Bristol, 1970. MS. Top. Oxon. d.602 (Bodleian).

Davies, John, *Orchestra, or A Poem Expressing the Antiquity and Excellence of Dancing* [1596], in Davies, *The Poetical Works* (London: T. Davies, 1773), 137–89.

Davis, Edward B., and Elizabeth Chmielewski, "Galileo and the Garden of Eden: Historical Reflections on Creationist Hermeneutics," *Brill's Series in Church History*, 30 (2008), 437–64.

Davis, Richard Beale, "Early Editions of George Sandys' 'Ovid': The Circumstances of Production," Bibliographical Society of America, *Papers*, 35 (1941), 255–76.

Davis, Richard Beale, "George Sandys v. William Stansby: The 1632 Edition of Ovid's *Metamorphosis*," *Library*, 3 (December 1948), 193–212. (The Bibliographical Society, *Transactions*.)

Davis, Richard Beale, *George Sandys, Poet Adventurer* (London: Bodley Head, 1955).

Deason, Barry G., "John Wilkins and Galileo: Copernicanism and Biblical Interpretation in the Protestant and Catholic Traditions," in E. A. McKee and B. G. Armstrong (eds), *Probing the Reformed Tradition* (Louisville, KY: Westminster/John Knox, 1989), 313–38.

Debus, Allen G., *The English Paracelsians* (London: Oldbourne, 1965).

De Dominis, Marc Antonio, *De radiis visus et lucis in vitris perspectivis et iride tractatus…In quo inter alia ostenditur ratio instrumenti cuiusdam ad clarò videndum* (Venice: T. Baglionus, 1611).

Dee, John, *The Mathematical Preface to the Elements of Geometrie of Euclid of Magara* (1570), ed. Allen G. Debus (New York: Science History, 1975).

De Groot, Jerome, "Space, Patronage, Procedure: The Court at Oxford, 1642–46," *English Historical Revue*, 117/474 (2002), 1204–27.

Delamain, Richard, *Grammelogia, or, the Mathematical Ring* (London: J. Haviland and T. Cotes, 1631).

Delamain, Richard, *The Making, Description, and Use of a Small Portable Instrument for the Pocket…Called a Horizontal Quadrant* (London: T. Cotes for R. Hawkins, 1632).

Delbeke, Maarten, "Individual and Institutional Identity: Galleries of Barberini Projects," in Burke and Bury (eds), *Art* (2008), 231–46.

Della Porta, Giambattista, *Lo astrologo* (Venice: P. Ciera, 1606).

De Mas, Enrico, *Sovranità politica e unità cristiana nel seicento anglo-veneto* (Ravenna: Longo, 1975).

Dempster, Thomas, *Historia ecclesiastica gentis scotorum* (Bologna: Typ. N. Theobaldini, 1627).

De Rubertis, Achille, "Nuovi documenti su Fra Paolo Sarpi e Fulgenzio Micanzio," *Civiltà moderna*, 11 (1939), 382–400.

Dever, Mark, *Richard Sibbes: Puritanism and Calvinism in Late Elizabethan and Early Stuart England* (Macon, GA: Mercer University Press, 2000).

De Vergette, Françoise, "Triomphe d'un Galilée martyrisé par l'Eglise dans l'art français du xixe siècle," in Bucciantini et al. (eds), *Caso* (2011), 435–60.

De Vesme, Alexandre, *Stefano della Bella. Catalogue raisonné*, 2 vols (New York: Collins, 1971).

D'Ewes, Simonds, *Autobiography and Correspondence…during the Reigns of James I and Charles I*, 2 vols (London: R. Bentley, 1845).

D'Ewes, Simonds, *Journal: From the Beginning of the Long Parliament to the Opening of the Trial of the Earl of Strafford*, ed. Wallace Notenstein (New Haven, CT: Yale University Press, 1923).

D'Ewes, Simonds, *Journal: From the First Recess of the Long Parliament to the Withdrawal of King Charles from London*, ed. W.H. Coates (New Haven, CT: Yale University Press, 1942).

Digby, Kenelm, *Two Treatises: In the One of which, the Nature of Bodies; in the Other, the Nature of Mans Soule; Is Looked into* (Paris: G. Blaizot, 1644).

Digges, Dudley, *Of the Circumference of the Earth, or, A Treatise on the North-[West] Passage* (London: W.W. for J. Barnes, 1612).

Digges, Dudley, *A Speech Delivered in Parliament* (London: J. Doe, 1643).

Digges, Dudley, and Thomas Digges, *Four Paradoxes, or Politique Discourses* (London: H. Lowdes for C. Knight, 1604).

Digges, Thomas, *Alae seu scalae mathematicae* (London: T. Marsh, 1573).

Dix, T. Kieth, "Virgil in the Grynean Grove: Two Riddles in the Third Eclogue," *Classical Philology*, 90/3 (1995), 256–62.

Dixon, Laurinda S., *The Dark Side of Genius: The Melancholic Persona in art, ca. 1500–1700* (University Park, PA: Pennsylvania State University Press, 2013).

Dobrzycki, Jerzy (ed.), *The Reception of Copernicus' Heliocentric Theory* (Dordrecht: Reidel, 1972).

Donaldson, Alan, "Catholics and Bodley," *Bodleian Library Record*, 8 (1967–72), 252–7.

Donaldson, Gordon, *The Making of the Scottish Prayer Book of 1637* (Edinburgh: Edinburgh University Press, 1954).

Donne, John, *Ignatius his Conclave: or, The Enthronization of Loyola in Hell* (London: N. Oakes for R. Moore, 1611).

Donne, John, *The Complete English Poems*, ed. A. J. Smith (Harmondsworth: Penguin, 1986).

Dorian, Donald Clayton, *The English Diodatis* (New Brunswick: Rutgers University Press, 1950).

Drake, Stillman, "Galileo in English Literature of the Seventeenth Century," in McMullin (ed.), *Galileo* (1967), 415–31.

Drew, Daniel, *The Melancholy Assemblage: Affect and Epistemology in the English Renaissance* (New York: Fordham University Press, 2013).

Dreyer, J. L. E., *Tycho Brahe: A Picture of Scientific Life and Work in the Sixteenth Century* ([1890]; New York: Dover, 1963).

Dring, Thomas, *A Catalogue of The Lords, Knights, and Gentlemen that have Compounded for their Estates* (London: T. Dring, 1655).

Drummond, William, *Flowers of Sion* (Edinburgh: Heirs of A. Hart, 1623).

Dugdale, William, *The Life, Diary, and Correspondence*, ed. William Hamper (London: Harding, Lepard, 1827).

Duggan, Dianne, "'London the Ring, Covent Garden the Jewell of that Ring:' New Light on Covent Garden," *Architectural History*, 43 (2000), 140–61.

Dulac-Rooryck, Isabelle, "Trois teintures de la Manufacturie royale anglaise de tapisseries établie à Mortlake au xviie siècle, au Musée de Brive," *Revue du Louvre*, 33 (1983), nos 5–6.

Dursteler, E. R., "The Bailo in Constantinople: Crisis and Career in Venice's Early Modern Diplomatic Corps," *Mediterranean Historical Review*, 16/2 (2001), 1–30.

Eade, John Christopher, *The Forgotten Sky: A Guide to Astrology in English literature* (Oxford: Oxford University Press, 1984).

Eames, Miriam, "John Ogilby and his Aesop," New York Public Library, *Bulletin*, 65 (1961), 78–86.

Earle, John, *Microcosmographie, or, A Peeece of the World Discovered in Essayes and Characters* ([1628]; London: J. L. for A. Crook, 1638⁷).

Eeles, Francis Carolus, *The Parish Church of St Kentigern, Crosthwaite* (Carlisle: C. Thurmam, 1953).

Ekserdjian, David, "Further Sources for Francis Cleyn," *Master Drawings*, 50 (2012), 259–61.

Elliott, John R., et al. (eds), *Records of Early English Drama*, xvii (London: British Library, 2004).

Ellison, James, *George Sandys: Travel, Colonisation, and Tolerance in the Seventeenth Century* (Woodbridge: Brewer, 2002).

Emberton, Wilfrid, *The English Civil War Day by Day* (Stroud: Sutton, 1997).

Ernst, Germana, "Aspetti dell'astrologia e della profezia in Galileo e Campanella," in Galluzzi (ed.), *Novità* (1983), 255–66.

Esser, Raingard. "Germans in Early Modern Britain," in Panikos Panayi (ed.), *Germans in Britain since 1500* (London: Hambledon, 1996), 17–27.

Evans, Joan, *A History of the Society of Antiquaries* (Oxford: Oxford University Press, 1956).

Evelyn, John, *Sculptura, or the History and Art of Chalcography and Engraving on Copper* (London: J. Cottrell, 1662).

Evelyn, John, *Memoirs Illustrative of the Life and Writings…Comprising his Diary, from the Year 1641 to 1705–06, and a Selection of his Familiar Letters* (London: A. Murray & Sons, 1871).

Evelyn, John, *The Letterbooks*, ed. D. D. C. Chambers and David Galbraith, 2 vols (Toronto: University of Toronto Press, 2014).

Exhibition of English Tapestries (Birmingham: s.n., 1951).

Fanshaw, Ann, *Memoirs* (New York: John Lane, 1907).

Faulkner, P. A., *Bolsover Castle, Derbyshire* (London: HMSO, 1975).

Favaro, Antonio, "Rarità bibliografiche galileiane. III. Sopra una traduzione inglese di alcune opere di Galileo," *Rivista delle biblioteche*, 18–19 (1889), 86–91.

Favaro, Antonio, *Amici e corrispondenti di Galileo*, 3 vols (Florence: Salimbeni, 1983).

Favino, Federica, "A proposito dell'atomismo di Galileo: Da una lettera di Tommaso Campanella ad uno scritto di Giovanni Ciampoli," *Bruniana e Campanelliana*, 3/2 (1997), 265–81.

Favino, Federica, *La filosofia naturale di Giovanni Ciampoli* (Florence: Olschki, 2015).

Feingold, Mordechai, "Galileo in England," in Galluzzi (ed.), *Novità* (1983), 411–20.

Feingold, Mordechai, *The Mathematicians' Apprenticeship: Science, Universities and Societies in England 1560–1640* (Cambridge: Cambridge University Press, 1984).

Feingold, Mordechai, "A Friend of Hobbes and an Early Translator of Galileo: Robert Payne of Oxford," in J. D. North and J. J. Roche (eds), *The Light of Nature: Essays in the*

History and Philosophy of Science Presented to A. C. Crombie (The Hague: Nijhoff, 1985), 265–80.

Feingold, Mordechai, "John Selden and the Nature of Seventeenth-Century Science," in R. T. Bienvenu and Mordechai Feingold (eds), *In the Presence of the Past: Essays in Honour of Frank Manuel* (Dordrecht: Kluwer, 1991), 55–78.

Feingold, Mordechai, "The Young Wilkins and the Debate over Copernicanism," in Poole (ed.), *Wilkins* (2017), 3–34.

Feingold, Mordechai, and Penelope M. Gouk, "An Early Critic of Bacon's *Sylva sylvarum*: Edmund Chilmead's Treatise on Sound," *AS* 40 (1983), 139–57.

Ferino-Pagden, Silvia (ed.), *I cinque sensi nell'arte: Immagini del sentire* (Milan: Leonardo Arte, 1996).

Fermor, Sharon, and Alan Derbyshire, "The Raphael Cartoons Reexamined," *Burlington Magazine*, 140/1141 (April 1998), 236–50.

Fernbach, R. J., et al. (eds), *Private Libraries in Renaissance England: A Collection and Catalogue of Early Stuart Book-Lists*, 9 vols (Binghampton: Medieval and Renaissance Texts and Studies, 1992–2017).

Ferrand, Jacques, *ΕΡΩΤΟΜΑΝΙΑ, or A Treatise Discoursing of the Essence, Causes, Symptomes, Prognosticks, and Cure of Love, or Erotique Melancholy* ([1623]; Oxford: L. Lichfield, 1640).

Ferrand, Jacques, *A Treatise on Lovesickness*, ed. Donald Beecher and Massimo Ciavolella (Syracuse: Syracuse University Press, 1990).

Ferrini, Roberto (ed.), *Fra Fulgenzio Micanzio, O.S.M. Lettere a William Cavendish (1615–1628)*, Scrinium historiale, 15 (Rome: Istituto storico O.S.M., 1987).

Ferrone, Vincenzo, "L'illuminismo e il caso Galileo: Breve storia di un problema mal posto," in Bucciantini et al. (eds), *Caso* (2011), 335–43.

Finaldi, Gabriele (ed.), *Orazio Gentileschi at the Court of Charles I*. London: National Gallery, 1999.

Finaldi, Gabriele, and Jeremy Wood, "Orazio Gentileschi at the Court of Charles I," in Keith Christiansen and Judith W. Mann (eds), *Orazio and Artemesia Gentileschi* (New Haven, CT: Yale University Press, 2001), 222–46.

Fincham, Kenneth, *Prelate as Pastor: The Episcopate of James I* (Oxford: Oxford University Press, 1990).

Fincham, Kenneth (ed.), *The Early Stuart Church, 1603–1642* (Stanford: Stanford University Press, 1993).

Fincham, Kenneth, and Peter Lake, "The Ecclesiastical Policies of James I and Charles I," in Fincham (ed.), *Church* (1993), 23–49.

Finlayson, Michael G., *Historians, Puritanism, and the English Revolution: The Religious Factor in English Politics before and after the Interregnum* (Toronto: University of Toronto Press, 1983).

Fisher, Benjamin (ed.), *Profitable Instructions for Travellers* (London: B. Fisher, 1633).

Fissel, Mark Charles, *The Bishops' War: Charles I's Campaigns against Scotland, 1638–40* (Cambridge: Cambridge University Press, 1994).

Fletcher, Jennifer, "The Arundels in the Veneto," *Apollo*, 144 (August 1996), 63–9.

Fletcher, John, *The Bloody Brother* (London: R. Bishop, 1639).

Fletcher, Reginald J. (ed.), *The Pension Book of Gray's Inn (Records of the Honourable Society)* *1569–1669* (London: Chiswick Press, 1901).

Foley, Henry (ed.), *The English College in Rome*, Records of the English Province of the Society of Jesus, 6 (London: Burns and Oates, 1880).

Forsythe, Robert S., *The Relations of Shirley's Plays to the Elizabethan Drama* (New York: Columbia University Press, 1914).

Fortescue, George, *Feriae academicae* (Douai: M. Wyon, 1630).

Fortescue, Thomas, *A History of the Family of Fortescue* (London: Ellis and White, 1880²).

Fosi, Irene, *Convertire lo straniero: Forestiere e Inquisizione a Roma in età moderna* (Rome: Viella, 2011).

Fosi, Irene, "The Hospital as a Space of Conversion: Roman Examples from the Seventeenth Century," in Giuseppe Marcocci and Paolo Aranha (eds), *Spaces and Conversion in Global Perspective* (Leyden: Brill, 2014), 154–74.

Foss, Edward, *The Judges of England*, 9 vols (London: Longman et al., 1848–64).

Foster, Elizabeth Read, "Petitions and the Petition of Right," *Journal of Brtish Studies*, 14 (1974), 21–45.

Foster, Elizabeth Read, *The House of Lords, 1603–1649* (Chapel Hill, NC: University of North Carolina Press, 1983).

Foster, Joseph, *The Register of Admissions to Gray's Inn, 1521–1889* (London: Hansard, 1889).

Foster, Joseph (ed.), *Alumni oxonienses: The Members of the University of Oxford, 1500–1714*, 4 vols (Oxford: Parker, 1891–2).

Foster, Michael, "Thomas Allen (1540–1632), Gloucester Hall and the Survival of Catholicism in Post-Reformation Oxford," *Oxoniensia*, 46 (1981), 99–128.

Foster, Michael, "Thomas Allen, Gloucester Hall, and the Bodleian Library," *Downside Review*, 100 (1982), 116–37.

Fox, Levi (ed.), *English Historical Scholarship in the 16th and 17th Centuries* (Oxford: Oxford University Press, 1956).

Frank, Robert G., "John Aubrey, John Lydall, and Science at Commonwealth Oxford," Royal Society of London, *Notes and Records*, 27 (1973), 193–217.

Franklin, Kenneth J., "Biographical," in William Harvey, *The Circulation of the Blood* [1628], trans. K. J. Franklin (Oxford: Blackwell, 1958), pp. xv–xxiii.

Friis, Frederik Reinholdt, *Samlinger til dansk bygnings- og kunsthistorie* (Copenhagen: Gyldendal, 1872–8).

Frith, John, *Vox piscis: or, The Book-Fish: Contayning Three Treatises which were Found in the Belly of a Codfish in Cambridge Market* (London: H. Lownes et al., 1626).

Fuller, Thomas, *The Holy State* (Cambridge: R. Daniel for John Williams, 1642).

Fuller, Thomas, *A Pisgah-Sight of Palestine and the Confines Thereof: With the History of the Old and New Testament Acted Thereon* (London: J.F. for John Williams, 1650).

Fuller, Thomas, *The History of the Worthies of England* ([1662]; 2 vols, London: F. C. and J. Rivington, 1811).

Fuller, Thomas, *The Holy State and the Profane State*, ed. Maximilian Graff Walten, 2 vols (New York: Columbia University Press, 1938).

Furdell, Elizabeth Lane, *The Royal Doctors 1485–1714: Medical Personnel at the Tudor and Stuart Courts* (Rochester: University of Rochester Press, 2001).

Gabrieli, Giuseppe, *Contributi alla storia della Accademia dei lincei*, 2 vols (Rome: Accademia nazionale dei lincei, 1989).

Gabrieli, Vittorio, "Bacone, la Riforma e Roma nella versione Hobbesiana d'un carteggio di Fulgenzio Micanzio," *English Miscellany*, 8 (1957), 195–250.

Gadbury, John, *Coelestis legatus: or The Coelstial Ambassadour. Astrologically Predicting the Grand Catastrophe that is Probable to Befall most of the Kingdomes and Countries of Europe* (London: E.B. for John Allen, 1656).

Galilei, Galileo, *Sidereus nuncius* [1610], trans. Albert van Helden (Chicago: University of Chicago Press, 1989).

Galilei, Galileo, "Lettera a Cristina di Lorena" [1615], in Galileo, *Scienza e religione*, ed. Massimo Bucciantini and Michele Camerota (Rome: Donzelli, 2009), 35–84.

Galilei, Galileo, *Dialogo sopra i due massime sistemi del mondo* (Florence: Landini, 1632).

Galilei, Galileo, *Systema cosmicum/Dialogus de systemate mundi* (Strasbourg: Elzevir, 1635; repr. Leyden: A. Huguetan, 1641; London: T. Dicas, 1663).

Galilei, Galileo, *Nova-antiqua sanctissimorum patrum, & probatorum theologorum doctrina, de Sacrae Scripturae testimoniis, in conclusionibus mere naturalibus, quae sensatâ experimentiâ, & necessariis demonstrationibus evinci possunt, temere non usurpandis* (Strasbourg: Elzevir, 1636).

Galilei, Galileo, *Opere*, ed. Carlo Manolessi, 2 vols (Bologna: Del Dozza, 1656).

Galilei, Galileo, *Opere*, ed. Antonio Favaro et al., 20 vols (Florence: G. Barbèra, 1890–1909). (Cited as OG.)

Galilei, Galileo, *Dialogue Concerning the Two Chief World Systems* [1632], trans. Stillman Drake (Berkeley and Los Angeles: University of California Press, 1953).

Galluzzi, Paolo (ed.), *Novità celesti e crisi del sapere* (Florence: IMSS, 1983). (IMSS, *Annali*, 1983: Supplemento.)

Galluzzi, Paolo, Gianni Micheli, et al., *Galileo: La sensata esperienza* (Milan: Banca Toscana, 1988).

Garcia, Stéphane, "L'édition strasbourgeoise du *Systema cosmicum* (1635–1636), dernier combat copernicien de Galilée," *Bulletin de la Société de l'histoire du Protestantisme français*, 146 (2000), 307–23.

Garcia, Stéphane, "Ginevra, fulcro della diffusione dell'opera di fra Paolo Sarpi nella prima metà del xvii secolo," *Rivista storica italiana*, 114 (2002), 1003–18.

Garcia, Stéphane, "L'Image de Galilée, ou le trajectoire symbolique du portrait de 1635," *Bruniana & Campanelliana*, 10 (2003), 45–59.

Gardiner, Samuel R., *England under the Duke of Buckingham and Charles I*, 2 vols (London: Longmans Green, 1875).

Gardiner, Samuel R., *The Personal Government of Charles I: A History of England from the Assassination of the Duke of Buckingham to the Declaration of the Judges on Ship-Money, 1628–37*, 2 vols (London: Longmans Green, 1877).

Gardiner, Samuel R., *The Fall of the Monarchy of Charles I, 1637–1649*, 2 vols (London: Longmans Green, 1882).

Gardiner, Samuel R., *History of England from the Accession of James I to the Outbreak of the Civil War 1603–1642*, new edn, 10 vols (London: Longmans Green, 1893–4).

Gargani, Aldo G., *Hobbes e la scienza* (Florence: Olschki, 1971).

Gassendi, Pierre, *Abrégé de la philosophie de Gassendi* [1684], ed. François Bernier, 7 vols (Paris: Fayard, 1992).

Gattei, Stefano, "On Tycho's Shoulders, with Vesalius' Eyes: Speaking Images in the Engraved Frontispiece of Kepler's *Tabulae Rudolphinae*," in Albrecht et al. (eds), *Tintenfass* (2014), 337–68.

Gattei, Stefano, "From Banned Mortal Remains to the Worshipped Relic of a Martyr of Science," in Marco Beretta et al. (eds), *Savant Relics: Brains and Remains of Scientists* (Sagamore Beach, MA: Science History Publications, 2016), 67–92.

Gattei, Stefano, *On the Life of Galileo* (Princeton: Princeton University Press, 2019).

Gearin-Tosh, Michael, "Marvell's 'Upon the Death of the Lord Hastings,'" *Essays and Studies Collected for the English Association*, 34 (1981), 105–22.

Geissler, Heinrich, *Zeichnung in Deutschland: Deutsche Zeichner, 1540–1640. Ausstellung… Katalog*, 2 vols (Stuttgart: Staatsgalerie, 1979–80).

Gelder, Maartje van, "Acquiring Artistic Expertise: The Agent Daniel Nijs and his Contacts with Artists in Venice," in Keblusek and Noldus (eds), *Double Agents* (2011), 111–23.

Gell, Robert, *Stella nova: A New Starre, Leading Wise Men unto Christ* (London: S. Satterthwaite, 1649).

Gellibrand, Henry, *A Discourse Mathematical on the Variation of the Magnetical Needle: Together with its Admirable Dimunition Lately Discovered* (London: W. Jones, 1635).

Geneva, Ann, *Astrology and the Seventeenth-Century Mind: William Lilly and the Language of the Stars* (Manchester: Manchester University Press, 1995).

Gent, Lucy, *Picture and Poetry 1560–1620: Relations between Literature and the Visual Arts in the English Renaissance* (Leamington Spa: J. Hall, 1981).

Gent, Lucy (ed.), *Albion's Classicism: The Visual Arts in Britain, 1550–1660* (New Haven, CT: Yale University Press, 1995).

Geree, John, *Astrologo-Matrix, or A Discovery of the Vanity and Iniquity of Judiciall Astrology* (London: M. Simmons for J. Bartlett, 1646).

Geree, John, *The Character of an Old English Puritan, or Non-Conformist* (London: W. Wilson for C. Meredith, 1646).

Giblin, Cathaldus, "Aegidius Chaissy O.F.M. and James Ussher, Protestant Archbishop of Armagh," *Irish Ecclesiastical Record*, 85 (1956), 393–405.

Gibson, Edmund, "Life of Sir Henry Spelman," in Spelman, *Works* (1727), fos a1–c1.

Gilbert, John T., *History of the Irish Confederation and the War in Ireland*, iii. *1643–1644* (Dublin: M. H. Gill, 1885).

Gilbert, William, *De magnete* [1600], trans. P. Fleury Mottelay (New York: Dover, 1958).

Gilman, Ernest B., *Recollecting the Arundel Circle: Discovering the Past, Recovering the Future* (New York: Peter Lang, 2002).

Giudice, Franco, "Echi del caso Galileo nell'Inghilterra del xvii secolo," in Bucciantini et al. (eds), *Caso* (2011), 277–87.

Glarbo, Henny, "Om den dansk-engelske forbindelse i Christian IV's og Jakob I's tid," Øststifternes historisk-topografiske selskab, *Fra arkiv og museum*, 2/2 (1943), 49–80.

Glabro, Henny, *Danske in England: Tre afhandlinger* (Copenhagen: Munksgaard, 1956).

Gladisch, D. F. (ed.), *Sir William Davenant's Gondibert* (Oxford: Oxford University Press, 1971).

Godfrey, Richard T., *Wenceslaus Hollar, a Bohemian Artist in England* (New Haven, CT: Yale University Press, 1994).

Godwin, Francis, *The Man in the Moone and Nuncius inanimatus* [1638, 1629], ed. Grant McColley (Northampton, MA: Smith College, 1937).

Goldsmith, M. M., *Hobbes' Science of Politics* (New York: Columbia University Press, 1966).

Goodwin, Godfrey, "Introduction," in Bon, *Seraglio* (1996), 11–19.

Gordon, D. J., "Poet and Architect: The Intellectual Setting of the Quarrel between Ben Jonson and Inigo Jones," *JWCI* 12 (1949), 152–78.

Gorman, Michael John, et al., *A Mysterious Masterpiece: The World of the Linder Gallery* (Florence: Mandragora, 2010).

Gorman, Michael John, and Alexander Marr, "Others See it Otherwise": *Disegno* and *pictura* in a Flemish Picture Gallery Interior," *Burlington Magazine*, 149/1247 (2007), 85–91.

Gotch, J. Alfred, *Inigo Jones* (London: Methuen, 1928).

Gowland, Angus, *The Worlds of Renaissance Melancholy: Robert Burton in Context* (Cambridge: Cambridge University Press, 2006).

The Great Eclipse of the Sun (London: s.n., 1644).

Greaves, Edward, *Morbus epidemicus anni 1643: or, The New Disease with the Causes, Remedies, etc.* (Oxford: L. Lichfield, 1643).

Greaves, John, *Pyramidographia: or, A Description of the Pyramids of Egypt* (London: G. Badger, 1646).

Greaves, John, *A Discourse of the Romane Foot and Denarius: From whence, as from Two Principles, the Measure and Weights Used by the Ancients, may be Deduced* (London: W. Lee, 1647).

Greaves, John, *A Description of the Grand Signor's Seraglio, or Turkish Emperours Court* (London: Martin and Ridley, 1650).

Greaves, John, *Miscellaneous Works*, ed. Thomas Birch, 2 vols (London: J. Hughes et al., 1737).

Green, A. Wigfall, *The Inns of Court and Early English Drama* (New Haven, CT: Yale University Press, 1931).

Gregory, John. *Gregorii posthuma, or, Certain Learned Tracts Written by John Gregory, M.A., and Chaplain of Christ-Church in Oxford* (London: Z. Sadler, 1649).

Grell, Ole Peter, *Dutch Calvinists in Early Stuart London. The Dutch Church in Austin Friars 1603–1642* (Leyden: Brill, 1989).

Grell, Ole Peter, and Andrew Cunningham (eds), *Religio medici: Medicine and Religion in Seventeenth Century England* (Aldershot: Scolar, 1996).

Greville, Robert, Lord Brooke, *The Nature of Truth: Its Unity and Unison with the Soule* (London: R. Bishop, 1641).

Griffiths, Antony, *The Print in Stuart Britain 1603–1689* (London: British Museum, 1998).

Grove, St John, "The Bankes Collection at Kingston Lacy," *Apollo*, 123 (May 1986), 302–12.

Guy, J. A., "The Origins of the Petition of Right Reconsidered," *Historical Journal*, 25/2 (1982), 289–312.

Haldane, Angus, *Portraits of the English Civil Wars* (London: Unicorn, 2017).

Hall, Joseph, "Quo vadis? A Just Censure of Travel, as it is Commonly Undertaken by Gentlemen of this Nation" [1617], in *The Works of Joseph Hall*, 12 vols (Oxford: Talboys, 1837–9), xii. 101–32.

Hall, Joseph, *The Discovery of a New World* [1609] (*Mundus alter et idem* [1605]), ed. Huntington Brown (Cambridge, MA: Harvard University Press, 1937).

Hall, Marie Boas, "Galileo's Influence on Seventeenth-Century English Scientists," in McMullin (ed.), *Galileo* (1967), 405–14.

Hall, William, *A Sermon Preached at St Bartholomews the Lesse in London, on the xxvii. Day of March 1642* (London: T. Badger for S. Brown, 1642).

Halliwell, James Orchard, *A Collection of Letters Illustrative of the Progress of Science in England from the Reign of Queen Elizabeth to that of Charles the First* (London: Taylor, 1841).

Hallowes, D. M., "Henry Briggs, Mathematician," Halifax Antiquarian Society, *Transactions* (1962), 79–92.

Hamond, Walter, *A Paradox: Proving, that the Inhabitants of the Isle Called Madagascar, or St Lawrence (in Temporall Things) are the Happiest People in the World* (London: N. Butler, 1640).

Harris, Eileen, with Nicholas Savage, *British Architectural Books and Writers, 1556–1785* (Cambridge: Cambridge University Press, 1990).

Harris, John, Stephen Orgel, and Roy Strong, *The King's Arcadia: Inigo Jones and the Stuart Court* (London: Arts Council of Great Britain, 1973).

Hart, Vaughan, *Inigo Jones: The Architect of Kings* (New Haven, CT: Yale University Press, 2011).

Harvey, Mary, "Hobbes and Descartes in the Light of the Correspondence between Sir Charles Cavendish and Dr John Pell," *Osiris* 10 (1952), 657–90.

Harvey, William, *An Anatomical Disquisition on the Motion of the Heart and Blood of Animals* [1628], trans. Robert Willis, in R. M. Hutchins et al. (eds), *Great Books of the Western World*, xxviii (Chicago: University of Chicago Press, 1952), 267–328.

Hassell, R. C., Jr, "Donne's 'Ignatius his Conclave' and the New Astronomy," *Modern Philology*, 68 (1971), 329–37.

Havran, Martin J., "Sources for Recusant History among the Bankes Papers in the Bodleian," *Recusant History*, 5 (1959), 246–55.

Havran, Martin J., *The Catholics in Caroline England* (Stanford: Stanford University Press, 1962).

Havran, Martin J., *Caroline Courtier: The Life of Lord Cottington* (London: Macmillan, 1973).

Hawtrey, Florence Molesworth, *The History of the Hawtrey Family*, 2 vols (London: G. Allen, 1903).

Hayward, J. C., "New Directions in Studies of the Falkland Circle," *SC* 2 (1987), 19–48.

Headlam, Cecil, *The Inns of Court* (London: A. and C. Black, 1909).

Hearn, Karen, "Van Dyck, the Royal Image and the Caroline Court," in Hearn (ed.), *Van Dyck* (2009), 10–13.

Hearn, Karen (ed.), *Van Dyck in Britain* (London: Tate Publishing, 2009).

Hearn, Karen, "'Picture Drawer, Born in Antwerp': Migrant Artists in Jacobean London," in Tarnya Cooper et al. (eds), *Painting in Britain 1500–1630: Production, Influence and Patronage* (Oxford: Oxford University Press, 2015), 278–87.

Hefford, Wendy, "Cleyn's Noble Horses," *National and Art Collections Fund Review*, 86 (1990), 97–102.

Hefford, Wendy, "Prince behind the Scenes: The Founding of the Mortlake Manufactury," *Country Life*, 184/40 (4 October 1990), 132–5.

Hefford, Wendy, "Ralph Montagu's Tapestries," in Tessa Murdoch (ed.), *Boughton House: The English Versailles* (London: Faber and Faber, 1992), 96–107.

Hefford, Wendy, "The Duke of Buckingham's Mortlake Tapestries of 1623," Centre international d'études des textiles anciens, *Bulletin*, 76 (1999), 91–103.

Hefford, Wendy, "Flemish Tapestry Weavers in England, 1550–1775," in Guy Delmarcel (ed.), *Flemish Tapestry Weavers Abroad: Emigration and the Founding of the Manufactures in Europe* (Louvain: Louvain University Press, 2002), 43–61.

Hefford, Wendy, "The Mortlake Manufacture, 1619–1649," in Campbell (ed.), *Tapestry* (2007), 171–201.

Hegarty, Andrew, *A Biographical Register of St John's College, Oxford 1555–1660* (Oxford: Boydell, 2011).

Heiberg, Steffen, "Art and Politics. Christian IV's Dutch and Flemish Painters," *Leids kunsthistorisch jaarboek*, 2 (1983), 7–24.

Heiberg, Steffen, *Christian 4: En europæisk statsmand* (Copenhagen: Gyldendal, 2006).

Heiberg, Steffen (ed.), *Christian IV and Europe: The 19th Council of Europe Exhibition, Denmark 1988* (Copenhagen: Foundation for Christian IV Year 1988, [1988]).

Heilbron J. L., "Introductory Essay," in Wayne Shumaker (ed.), *John Dee on Astronomy: Propaedeumata aphoristica* (Berkeley and Los Angeles: University of California Press, 1978), 1–99.

Heilbron J. L., *Electricity in the 17th and 18th Centuries* (Berkeley and Los Angeles: University of California Press, 1979).

Heilbron J. L., *Galileo* (Oxford: Oxford University Press, 2010). (Cited as *HG*.)

Heilbron J. L., "Galileo and the Tides," *Quaderni storici*, 150 (2015), 873–84.

Heinemann, Margot, "Drama and Opinion in the 1620s: Middleton and Massinger," in Mulgrave and Shewring (eds), *Theatre* (1993), 237–65.

Helbing, Mario O., "Spogliature attinenti alla tecnologia nel *Dialogo sopra i due massimi sistemi del mondo*," *Galilaeana*, 5 (2008), 17–32.

Henderson, Felicity, "Taking the Moon Seriously: John Wilkins's *Discovery of the World in the Moone* (1638) and *Discourse Concerning a New World and Another Planet* (1640)," in Poole (ed.), *Wilkins* (2017), 129–57.

Henriette-Marie de France, *Lettres... à sa soeur Christine Duchesse de Savoie*, ed. Hermann Ferrerò (Rome: Bocca, 1881).

Henry, John, "Atomism and Eschatology: Catholicism and Natural Philosophy in the Interregnum," *BJHS* 15 (1982), 211–39.

Hervey, Mary, *The Life, Correspondence and Collections of Thomas Howard, Earl of Arundel* (Cambridge: Cambridge University Press, 1921).

Heydon, Christopher, *A Defense of Judiciall Astrologie* (London: J. Legat, 1603).

Heydon, Christopher, *An Astrological Discourse with Mathematical Demonstrations Proving the Powerful Influence of the Planets and Fixed Stars upon Elementary Bodies* (London: J. Macock for N. Brooks, 1650).

Heylyn, Peter, *Mikrokosmos: A Little Description of the Great World* (Oxford: W. Turner, 1636[7], 1639[8]).

Heylyn, Peter, *Cosmographie in Four Books: Containing the Chorographie and History of the Whole World* (London: H. Sile, 1652).

Heywood, Louise, *Notes* [on St Edward's, Corfe Castle] (Corfe Castle: St Edwards, n.d.).

Heywood, Thomas, *Londini artium & scientiarum scaturiga: or, Londons Fountaine of Arts and Sciences* (London: N. Okes, 1632).

Hicks, Francis, *Certain Select Dialogues of Lucian: Together with his True Historie* (Oxford: W. Turner, 1634).

Hill, Katherine, '"Jugglers or Schollers?' Negotiating the Role of a Mathematical Practitioner," *BJHS* 31 (1998), 253–74.

Hill, L. M., *Bench and Bureaucracy: The Public Career of Sir Julius Caesar, 1580–1636* (Cambridge: J. Clarke, 1988).

Hill, Nicolaus, *Philosophia epicurea, democratiana, theophrastica* (Geneva: Fabriana, 1619[2]).

Hill, Robert, "Art and Patronage: Sir Henry Wotton and the Venetian Embassy, 1604–1624," in Keblusek and Noldus (eds), *Double Agents* (2011), 27–58.

Hobbes, Thomas, *De cive* (Amsterdam: Elzevir, 1647).

Hobbes, Thomas, *The English Works*, ed. William Molesworth [1839–45], 11 vols (Aalen: Scientia, 1962).

Hobbes, Thomas, *Critique du* De mundo *de Thomas White* [1642], ed. Jean Jacquot and Harold W. Jones (Paris: Vrin, 1973).

Hobbes, Thomas, *Thomas White's* De mundo *examined*, trans. Harold W. Jones (London: Bradford University Press, 1976).

Hobbes, Thomas, *The Correspondence*, ed. Noel Malcolm, 2 vols (Oxford: Oxford University Press, 1994).

Hodnett, Edward, *Francis Barlow, First Master of English Book Illustration* (Berkeley and Los Angeles: University of California Press, 1978).

Hodnett, Edward, *Aesop in England: The Transmission of Motifs in Seventeenth-Century Illustrations of Aesop's Fables* (Charlottesville: University Press of Virginia, 1979).

Hodnett, Edward, *Five Centuries of English Book Illustration* (Aldershot: Scolar Press, 1988).

Hodson, William, *The Divine Cosmographer, or, A Briefe Survey of the Whole World* (Cambridge: R. Daniel, 1640).

Hogg, James, "An Ephemeral Hit: Thomas Middleton's *A Game at Chess*," in Hogg (ed.), *Jacobean Comedy* (1995), 285–318.

Hogg, James (ed.), *Jacobean Drama as Social Criticism* (Salzburg: Mellen, 1995).

Holdsworth, William S., *A History of English Law*, 17 vols (Boston: Little Brown, 1923–72).

Holiday, Barten, ΤΕΧΝΟΓΑΜΙΑ [*Technogamia*]: *or, The Marriages of the Arts. A Comedie* ([1618]; London: J. Haviland for R. Meighen, 1630).

Holston, James, "'God Bless thee, Little David!' John Felton and his Allies," *English Literary History*, 59/3 (1992), 513–52.

Houghton, Walter E., Jr, *The Formation of Thomas Fuller's Holy and Profane States* (Cambridge, MA: Harvard University Press, 1938).

Howard, Deborah, and Henrietta McBurney (eds), *The Image of Venice: Fialetti's View and Sir Henry Wotton* (London: Paul Holberton, 2014).

Howard, Henry, Earl of Northampton, *A Defensative against the Poyson of Supposed Prophecies* (London: W. Iaggard, 1620).

Howarth, David, *Lord Arundel and his Circle* (New Haven, CT: Yale University Press, 1985).

Howarth, David, "The Politics of Inigo Jones," in Howarth (ed.), *Art and Patronage* (1993), 68–89.

Howarth, David (ed.), *Art and Patronage in the Caroline Courts: Essays in Honor of Sir Oliver Millar* (Cambridge: Cambridge University Press, 1993).

Howarth, David, "William Trumbull and Art Collecting in Jacobean England," *British Library Journal*, 20/2 (1994), 140–63.

Howarth, David, *Images of Rule: Art and Politics in the English Renaissance, 1485–1649* (Berkeley and Los Angeles: University of California Press, 1997).

Howarth, David, "The Southampton Album: A Newly Discovered Collection of Drawings by Francis Cleyn the Elder and his Associates," *Master Drawings*, 49/4 (2011), 435–78.

Howell, James, *Instructions for Forreine Travell Shweing by what Cours, and in what Compasse of Time, One May Take an Exact Survey of the Kingdomes and States of Christendom* (London: T.B. for H. Mosley, 1642; repr. London: English Reprints, 1869).

Howell, James, *S.PQ.V. A Survay of the Signorie of Venice…with A Cohortation to all Christian Princes to Resent her Dangerous Condition at Present* (London: R. Lowndes, 1651).

Howell, James, *Epistolae ho-elianae of James Howell: The Familiar Letters*, ed. Joseph Jacobs (London: D. Nutt, 1890).

Howell, T. B. (comp.), *A Complete Collection of State Trials…to the Year 1783*, 21 vols (London: Hansard, 1816).

Hubach, Hanns, "Tales from the Tapestry Collection of Elector Frederick V and Elizabeth Stuart, the Winter King and Queen," in Campbell and Cleland (eds), *Tapestry* (2010), 104–33.

Hues, Robert, *Tractatus de globis et eorum usu* [1594], trans. Edmund Chilmead [1639], ed. C. R. Markham (London: Hakluyt Society, 1889).

Hunter, Joseph, "An Account of the Scheme for Erecting a Royal Academy in England in the Reign of King James I," *Archaeologia*, 32 (1847), 132–49.

Hunter, Michael, *Boyle: Between God and Science* (New Haven, CT: Yale University Press, 2009.

Hutchins, John, *The History and Antiquities of the County of Dorset*, 3rd edn, 4 vols, ed. W. Shipp and J.W. Hodson ([1861–74]; repr., Wakefield: EP Publishing, 1973).

Hutchinson, Keith, "Towards a Political Iconology of the Copernican Revolution," in Patrick Curry (ed.), *Astrology, Science and Society* (Woodbridge: Boydell, 1987), 95–141.

Huxley, Gervas, *Endymion Porter: The Life of a Courtier, 1587–1649* (London: Chatto and Windus, 1959).

Ilg, Ulrike, "Stefano della Bella and Melchior Lorck: The Practical Use of an Artist's Model Book," *Master Drawings*, 41/1 (2003), 30–43.

Ilsøe, Harald, "Gesandskaber som kulturformidlende factor: Forbindelser mellem Danmark og England-Skotland o. 1580–1607," *Historisk tidsskrift*, 2 (1960), 574–600.

Imerti, Arthur D., "Introduction," in Bruno, *Expulsion* (1964), 3–65.

Infelise, Marco, "Ricerche sulla fortuna editoriale di Paolo Sarpi (1619–1799)," in Pin (ed.), *Ripensando* (2006), 519–46.

Isaacson, Henry, *Saturni ephemerides, sive Tabula historico-chronologica* (London: B.A. and A.T. for H. Seile and H. Robinson, 1633).

Isaacson, Henry, *An Exact Narration of the Life and Death of the Reverend and Learned Prelate, and Painfull Devine, Lancelot Andrewes* ([1650]; London: J. Strafford; repr., n.p.: S. Hodgson, 1817).

Isham, Gyles (ed.), *The Correspondence of Bishop Brian Duppa and Sir Justinian Isham, 1650–1660* (Lampert Hall, Northants: Record Society, 1955).

Jaclobeanu, Dana, "A Natural History of the Heavens: Francis Bacon's Anti-Copernicanism," in Neuber and Zittel (eds), *Copernicus* (2015), 64–87.

Jacquot, Jean, "Notes on an Unpublished Work of Thomas Hobbes," Royal Society of London, *Notes and Records*, 9/3 (1952), 188–95.

Jacquot, Jean, "Sir Charles Cavendish and his Learned Friends," *AS* 8 (1952), 13–27.

Jacquot, Jean, and Harold W. Jones, "Introduction," in Hobbes, *Critique* (1973), 9–102.

Jaitner, Klaus, "Einleitung," in Schoppe, *Philoteca* (2004), i.1. 1–229.

James VI and I of Scotland and England, ΒΑΣΙΛΙΚΟΝ ΔΟΡΟΝ [Basilikon doron], or His Maiesties Instructions to his Dearest Sonne, Henry the Prince (Edinburgh: R. Waldegrave, 1509¹; 1603²).

James VI and I of Scotland and England, *Daemonologie, in Forme of a Dialogue* ([1597]; London: A. Hatfield for R. Waldgrave, 1603).

James VI and I of Scotland and England, *De triplici nodo, triplex cuneus: or, An Apologie for the Oath of Allegiance* [1607], in *Political Writings* (1994), 85–131.

James VI and I of Scotland and England, *His Majesties Declaration Concerning his Proceedings with the States General…in the Cause of D. Conradus Vorstius* (London: R. Baxter, 1612).

James VI and I of Scotland and England, *The Poems*, ed. James Craigie, 2 vols (Edinburgh: W. Blackwood, 1955–8).

James VI and I of Scotland and England, *Letters*, ed. G. P. V. Akrigg (Berkeley and Los Angeles: University of California Press, 1984).

James VI and I of Scotland and England, *Political Writings*, ed. J. P. Sommerville (Cambridge: Cambridge University Press, 1994).

Janacek, Bruce, *Alchemical Belief: Occultism in the Religious Culture of Early Modern England* (University Park, PA: Pennsylvania State University Press, 2011).

Jardine, Lisa, and Alan Stewart, *Hostage to Fortune: The Troubled Life of Francis Bacon* (New York: Hill and Wang, 1999).

Jayne, Sears Reynolds, and F. R. Johnson (eds), *The Lumley Library: The Catalogue of 1609* (London: British Library, 1956).

Jesseph, Douglas M., "Galileo, Hobbes, and the Book of Nature," *Perspectives in Science*, 12/2 (2004), 191–211.

Johnson, Alfred Forbes, *A Catalogue of Engraved and Etched English Title Pages down to the Death of William Faithorne, 1691* (Oxford: Oxford University Press, 1934).

Johnson, R. C., et al., *Proceedings in Parliament, 1628*, 6 vols (New Haven, CT: Yale University Press, 1977–83).

Johnson, Samuel, *The Vanity of Human Wishes* (London: R. Dodsley, 1749).

Johnston, Cuthbert William, *Life of Sir Edward Coke*, 2 vols (London: H. Cuthbert, 1837).

Johnston, Steve, "Mathematical Practitioners and Instruments in Elizabethan England," *AS* 48 (1991), 319–44.

Jones, Inigo, *On Palladio: Being the Notes by Inigo Jones in [his] Copy of* I quattro libri dell'architectura *di Andrea Palladio*, ed. Bruce Alsop, 2 vols (Newcastle upon Tyne: Oriel, 1970).

Jones, W. J., *Politics and the Bench: The Judges and the Origins of the English Civil War* (London: George Allen and Unwin, 1971).

Jones, W. J., "'The Grand Gamaliel of the Law': Mr Attorney Noye," *HLQ* 40 (1977), 197–226.

Jonson, Ben, [*The Works*], ed. C. H. Herford et al., 11 vols (Oxford: Oxford University Press, 1925–52).

Jonson, Ben. *The Works*, ed. D. M. Bevington et al., 7 vols (Cambridge: Cambridge University Press, 2012).

Judson, Margaret Atwood, *The Crisis of the Constitution: An Essay in Constitutional and Political Thought in England 1603–1645* (New Brunswick: Rutgers University Press, 1949).

Junius, Franciscus, *The Painting of the Ancients* (London: R. Hodgkinsonne, 1638).

Kainulainen, Jaska, *Paolo Sarpi: A Servant of God and State* (Leyden: Brill, 2014).

Kargon, Robert, *Atomism in England from Hariot to Newton* (Baltimore: Johns Hopkins University Press, 1966).

Kaufmann, Thomas D., *Drawings from the Holy Roman Empire, 1540–1680: A Selection from North American Collections* (Princeton: Princeton University Press, 1982).

Kearney, Hugh F., *Strafford in Ireland 1633–41: A Study in Absolutism* (Manchester: University of Manchester Press, 1959).

Keblusek, Marika, "Cultural and Political Brokerings in Seventeenth-Century England. The Case of Balthazar Gerbier," in Roding et al., *Artists* (2003), 73–82.

Keblusek, Marika, "The Pretext of Pictures: Artists as Cultural and Political Agents," in Keblusek and Noldus (eds), *Double Agents* (2011), 147–59.

Keblusek, Marika, and Badeloch Vera Noldus (eds), *Double Agents: Cultural and Political Brokerage in Early Modern Europe* (Leiden: Brill, 2011).

Kepler, Johannes, *Gesammelte Werke*, ed. Max Caspar et al., 22 vols (Munich: Beck, 1937–98).

Kepler, Johannes, *The Harmony of the World* [1619], trans. A. J. Aiton et al. (Philadelphia: American Philosophical Society, 1997).

Kerling, Nellie J., "A Seventeenth Century Hospital Matron: Margaret Blague," London and Middlesex Archeololgical Society, *Transactions*, 22/3 (1970), 30–6.

Keynes, Geoffrey, *The Life of William Harvey* (Oxford: Oxford University Press, 1978).

Kirby, Ethan Williams, *William Prynne: A Study in Puritanism* (Cambridge, MA: Harvard University Press, 1931).

Kishlansky, Mark, "Turning Frogs into Princes: Aesop's *Fables* and the Political Culture of Early Modern England," in Susan D. Amussen and M.A. Kishlansky (eds), *Political Culture and Cultural Politics in Early Modern England* (Manchester: Manchester University Press, 1995), 338–60.

Kishlansky, Mark, "Tyranny Denied: Charles I, Attorney General Heath, and the Five Knights' Case," *Historical Journal*, 42/1 (1999), 53–83.

Klemm, David, *Von der Schönheit der Linie: Stefano della Bella als Zeichner* (Hamburg: M. Imhof, 2013).

Klibansky, Roland, Erwin Panofsky, and Fritz Saxl, *Saturn and Melancholy: Studies in the History of Natural Philosophy, Religion, and Art* (New York: Basic Books, 1964).

Knachel, Philip A. (ed.), *Eikon basilike: The Pourtraiture of his Sacred Majesty in his Solitudes and Sufferings* (Ithaca, NY: Cornell University Press, 1960).

Knowles, James, "Songs of Lesser Alloy: Jonson's Gypsies Metamorphosed and the Circulation of Manuscript Libels," *HLQ* 69/1 (2006), 153–76.

Kodera, Sergius, "Timid Mathematician vs. Daring Explorers of the Infinite Cosmos: Giordano Bruno, Literary Self-Fashioning and *De revolutionibus orbium coelestium*," in Neuber and Zittel (eds), *Copernicus* (2015), 229–50.

Kogan, Stephen, *The Hieroglyphic King: Wisdom and Idolatry in the Seventeenth-Century Masque* (London: Associated University Press, 1986).

Kolb, Arianne Faber, "The Arundels' Printmakers," *Apollo*, 144 (August 1996), 57–62.

Kopperman, Paul E., *Sir Robert Heath, 1575–1649: Window on an Age* (London: Royal Historical Society, 1989).

Kratochvíl, Miloš, *Hollar's Journey on the Rhine* (Prague: Artia, 1965).

Kraus, Andreas, *Das päpstliche Staatssekretariat unter Urban VIII* (Rome: Herder, 1964).

Kruft, Hanno-Walter, *A History of Architectural Theory* (Princeton: Princeton University Press, 1994).

Lake, Peter, "Lancelot Andrewes, John Buckeridge, and Avant-Garde Conformity at the Court of James I," in Peck (ed.), *Mental World* (1991), 113–33.

Lando, Girolamo, "Relation of England, 21 September 1622." *CSPV, 1621–3*, 423–59.

Langberg, Harald, *Dansesalen på Kronborg* (Copenhagen: Langbergs Forlag, 1985).

Larner, Christina, "James VI and I and Witchcraft," in A. G. R. Smith (ed.), *The Reign of James VI and I* (London: Macmillan, 1973), 74–90.

Laud, William, *The Works*, 7 vols (Oxford: J. H. Parker, 1847–60).

Laud, William, *The Further Correspondence*, ed. Kenneth Fincham (Martlesham: Boydell, 2018).

Law, Ernest, *The History of Hampton Court*, 3 vols (London: Bell, 1891–1903).

Lawlor, H. J., "Primate Ussher's Library before 1641," *Proceedings of the Royal Irish Academy*, 6 (1901), 216–64.

Lee, Rensselaer W., *Ut pictura poesis: The Humanistic Theory of Painting* (New York: Norton, 1967).

Leech, Clifford, *The John Fletcher Plays* (Cambridge, MA: Harvard University Press, 1962).

Lees-Milne, James, *The Age of Inigo Jones* (London: Batsford, 1953).

Levack, Brian P., *The Civil Lawyers in England 1603–1641: A Political Study* (Oxford: Oxford University Press, 1973).

Levi, Eugenia, "King James I and Fra Paolo Sarpi in the Year 1612," *Athenaeum*, 3689 (9 July 1898), 66–7.

Levy, F. J., "Henry Peacham and the Art of Drawing," *JWCI* 37 (1974), 174–90.

Lewalski, Barbara K., *Writing Women in Jacobean England* (Cambridge, MA: Harvard University Press, 1993).

Lewalski, Barbara K., "Milton's *Comus* and the Politics of Masquing," in Bevington and Holbrook (eds), *Politics* (1998), 296–320.

Lewcock, Dawn, *Sir William Davenant, the Court Masque, and the English Seventeenth-Century Scenic Stage* (Amherst: Cambrian, 2008).

Lewis, Jayne Elizabeth, *The English Fable: Aesop and Literary Culture, 1651–1740* (Cambridge: Cambridge University Press, 1996).

Lievsay, John L., "Paolo Sarpi's Appraisal of James I," in Heinz Bluhm (ed.), *Essays in History and Literature* (Chicago: Newberry Library, 1965), 109–17.

Lievsay, John L., *Venetian Phoenix: Paolo Sarpi and Some of his English Friends (1606–1700)* (Lawrence, KS: University Press of Kansas, 1973).

Lilly, William, *A Collection of Ancient and Moderne Prophesies concerning these Present Times, with Observations thereon* (London: J. Partridge and H. Blunden, 1645).

Lilly, William, *True History of King James the First, and King Charles the First* (London: J. Roberts, 1715).

Limon, Jerzy, *Dangerous Matter: English Drama and Politics 1623/4* (Cambridge: Cambridge University Press, 1986).

Limon, Jerzy, *The Masque of Stuart Culture* (Newark: University of Delaware Press, 1990).

Limon, Jerzy, "The Masque of the Stuart Court," in Peck (ed.), *Mental World* (1991), 209–29.

Lindeboom, Johannes, *Austin Friars: History of the Dutch Reformed Church in London, 1550–1950* (The Hague: Nijhoff, 1950).

Lindley, David, "The Politics of Music and the Masque," in Bevington and Holbrook (eds), *Politics* (1998), 273–95.

Linden, Stanton J. "Robert Burton's Sigil and John Dee," *Notes and Queries*, 227 (1982), 415–16.

Lister, Susan Madocks, "'Trumperies Brought from Rome': Barberini Gifts to the Stuart Court in 1635," in Cropper (ed.), *Diplomacy* (2000), 151–75.

Little, Patrick, "Lady Bankes Defends Corfe Castle," *History Today*, 65/2 (2015), 10–16.

Llasera, Margaret, *Représentations scientifiques et images poétiques en Angleterre au xviie siècle: À la recherche de l'invisible* (Paris: CNRS, 1999).

Lloyd, David, *Memoires of the Lives of…those Noble, Revered, and Excellent Personages, that Suffered…for the Protestant Religion, and the Great Principle thereof, Allegiance to their Soveraigne* (London: J Wright, 1668).

Lockhart, Paul Douglas, *Denmark in the Thirty Years' War, 1618–1648* (London: Associated University Presses, 1996).

Lockhart, Paul Douglas, *Denmark 1513–1660: The Rise and Decline of a Renaissance Monarchy* (Oxford: Oxford University Press, 2007).

Lomazzo, Giovanni Paolo, *A Tracte Containing the Arts of Curious Paintinge Carvinge Buildinge*, trans. Richard Haydock (Oxford: J. Barnes, 1598).

Long, Basil, *British Miniaturists* (London: G. Bles, 1929).

Loomie, Albert J., "King James's Catholic Consort," *HLQ* 34 (1970–1), 303–16.

Loomie, Albert J. (ed.), *Ceremonies of Charles I: The Notebooks of John Finet, 1628–1641* (New York: Fordham University Press, 1987).

Lossky, Nicholas, *Lancelot Andrewes: The Preacher (1555–1626)* (Oxford: Oxford University Press, 1991).

Lutz, Georg, *Kardinal Giovanni Francesco Guidi di Bagno: Politik und Religion im Zeitalter Richelieus und Urbans VIII* (Tübingen: Niemeyer, 1971).

Luzio, Alessandro, *La galleria di Gonzaga venduta all'Inghilterra nel 1627–28* (Milan: L. F. Cogliati, 1913).

Lydiat, Thomas, *Praelectio astronomica de natura coeli & conditionibus elementorum* (London: J. Bill, 1605).

Lyly, John, *Gallathea* ([1592]; Oxford: Oxford University Press, 1998).

Macaulay, Thomas Babington, *Historical Essays* (London: Collins, n.d.).

McColley, Grant, "The Second Edition of the 'Discovery of a World in the Moon,'" *AS* 1 (1936), 330–4.

McColley, Grant, "The Ross–Wilkins Controversy," *AS* 3 (1938), 153–89.

McColley, Grant, "The Debt of Bishop John Wilkins to the *Apologia pro Galileo* of Tommaso Campanella," *AS* 4 (1939), 150–68.

McColley, Grant, "Nicholas Hill and the *Philosophica epicurea*," *AS* 4 (1939–40), 390–405.

McCoy, Roger, *On the Edge: Mapping North America's coasts* (Oxford: Oxford University Press, 2012).

McCullough, Peter E., *Sermons at Court: Politics and Religion in Elizabethan and Jacobean Preaching* (Cambridge: Cambridge University Press, 1998).

McCullough, Peter E., "Introduction," in Andrewes, *Selected Sermons* (2005), pp. xi–lvii.

McFarlane, Ian D., *Buchanan* (London: Duckworth, 1981).

McManus, Clare, *Women on the Renaissance Stage: Anna of Denmark and Female Masquing in the Stuart Court (1590–1619)* (Manchester: Manchester University Press, 2002).

McMullin, Ernan (ed.), *Galileo, Man of Science* (New York: Basic Books, 1967).

McMullin, Ernan (ed.), *The Church and Galileo* (Notre Dame: Notre Dame University Press, 2005).

McPherson, David C., *Shakespeare, Jonson, and the Myth of Venice* (Newark: University of Delaware Press, 1990).

McReynolds, Daniel, "Lying Abroad for the Good of the Country: Sir Henry Wotton and Venice in the Age of the Interdict," in Howard and McBurney (eds), *Image* (2014), 114–23.

McWilliams, John, "'A Storm of Lamentations Writ': *Lachrymae musarum* and Royalist Culture after the Civil War," *Yearbook of English Studies*, 33 (2003), 273–89.

Madan, Francis F., *A New Bibliography of the Eikon Basilike* (Oxford: Oxford University Press, 1950).

Magrath, John Richard, *The Queen's College*, 2 vols (Oxford: Oxford University Press, 1921).

Malcolm, Joyce Lee (ed.), *The Struggle for Sovereignty: Seventeenth-Century English Political Tracts*, 2 vols in 1 (Indianapolis: Liberty Fund, 1999).

Malcolm, Noel, "Hobbes, Sandys, and the Virginia Company," *Historical Journal*, 24 (1981), 297–322.

Malcolm, Noel, and Jacqueline Stedall, *John Pell (1611–1685) and his Correspondence with Sir Charles Cavendish: The Mental World of an Early Modern Mathematician* (Oxford: Oxford University Press, 2005).

Manschreck, Clyde L., *Melanchthon, the Great Reformer* (New York: Columbia University Press, 1941).

Markham, C. R., "Introduction," in Hues, *Tractatus* (1889), pp. xi–l.

Marlowe, Christopher, *The Works*, ed. Francis Bower, 2 vols (Cambridge: Cambridge University Press, 1981).

Marmion, Shackerly, *A Fine Companion* (London: A. Matthewes for R. Meighen, 1633).

Marr, Alexander, "'A Duche Graver Sent for': Cornelis Boel, Salomon de Caus, and the Production of *La Perspective avec les raisons des ombres et miroirs*," in Wilks (ed.), *Prince Henry* (2007), 212–38.

Marr, Alexander, *Between Raphael and Galileo: Mutio Oddi and the Mathematical Culture of Late Renaissance Italy* (Chicago: University of Chicago Press, 2011).

Martin, Laurence, "Sir Francis Crane, Director of the Mortlake Tapestry Manufactory and Chancellor of the Order of the Garter," *Apollo*, 113 (February 1981), 90–6.

Martin, Robert, *Catalogus librorum ex praecipuis emporis selectorum* (London: T. Harper, 1639).

Massa, Daniel, "Giordano Bruno's Ideas in Seventeenth-Century England," *JHI* 38 (1977), 227–42.

Massar, Phyllis Dearborn, *Presenting Stefano della Bella, Seventeenth-Century Printmaker* (New York: Metropolitan Musum of Art, 1971).

Massinger, Philip, *Plays and Poems*, ed. Philip Edwards and Colin Gibson, 5 vols (Oxford: Oxford University Press, 1976).

Mathew, David, *The Age of Charles I* (London: Eyre & Spottiswoode, 1951).

Matthew, Arnold Harris, and Annette Calthorp, *The Life of Sir Tobie Matthew, Bacon's alter ego* (London: E. Matthews, 1907).

Matthew, David, "The Library at Naworth," in Douglas Woodruff (ed.), *For Hilaire Belloc: Essays in Honour of his 72nd Birthday* (London: Sheed and Ward, 1942), 117–30.

Mayerne, Theodore Turquet de, *A Treatise of the Gout* (London: D. Newman, 1676).

Mayerne, Theodore Turquet de, *Medicinal Councels or Advices* (London: N. Pander, 1677).

Mayerne, Theodore Turquet de, *Pictoria, sculptoria & quae subaltenarum atrium*, ed. M. Faidutti and C. Versini (Lyons: Audin, 1977).

Mayerne, Theodore Turquet de, and Thomas Candeman (eds), *The Distiller of London* (London: R. Bishop, 1639).

Mayne, Jasper, *The Citye Match* (Oxford: L. Lichfield, 1639).

Meller, Peter, "I tre filosofi di Giorgione," in Rudolfo Palluchini (ed.), *Giorgione e l'umanesimo veneziano*, 2 vols (Florence: Olschki, 1981), i. 227–47.

Melloni, Alberto, "Galileo al Vaticano II: Storia d'una citazione della sua ombra," in Bucciantini et al. (eds), *Caso* (2011), 461–90.

Melton, John, *Astrologaster, or, The Figure-Caster* (London: B. Alsop for E. Blackmore, 1620).

Mendle, Michael, *Dangerous Positions: Mixed Government, the Estates of the Realm, and the Making of the Answer to the xix Propositions* (University, AL: University of Alabama Press, 1985).

Merritt, J. F. (ed.), *The Political World of Thomas Wentworth, Earl of Strafford, 1621–1641* (Cambridge: Cambridge University Press, 1996).

Mersenne, Marin, *Correspondance*, ed. Cornélis de Waard et al., 17 vols (Paris: PUF, 1945–88).

Metze, Gudula, *Die Entwicklung der Copernicus-Porträts vom 16. Jahrhundert bis zum 18. Jahrhundert* (Munich: Ph.D. thesis, University of Munich, 2004).

Meyer, Arnold Oskar, "Charles I. and Rome," *American Historical Review*, 19 (1913), 13–26.

Michele, Gianni, "L'idea di Galileo nella cultura italiana del XVI al XIX secolo," in Galluzzi, Micheli, et al., *Galileo* (1988), 163–87.

Middleton, Thomas, *A Game at Chesse* [1625], ed. R. C. Bold (Cambridge: Cambridge University Press, 1929).

Middleton, Thomas, *The Collected Works*, ed. Gary Taylor et al. (Oxford: Oxford University Press, 2010).

Middleton, W. E. K., *A History of the Thermometer* (Baltimore: Johns Hopkins University Press, 1966).

Millar, Oliver, "A Subject Painting by William Dobson," *Burlington Magazine*, 90 (1948), 97–9.

Millar, Oliver (ed.), *Tercentenary of the Battle of Worcester: Exhibition of Paintings from 1642 to 1651* (Worcester: City Art Gallery, 1951).

Millar, Oliver, "Charles I, Honthorst and Van Dyck," *Burlington Magazine*, 96 (February 1954), 36–42.

Millar, Oliver, *Abraham van der Doort's Catalogue of the Collections of Charles I*, Walpole Society, 37 (Glasgow: R. Maclehose, 1960).

Millar, Oliver (ed.), *Italian Drawings and Paintings in the Queen's Collection* (London: Waterlow & Sons, 1965).

Millar, Oliver, *The Inventories and Valuations of the King's Goods, 1649–1651*, Walpole Society, 43 (Glasgow: R. Maclehose, 1972).

Milton, Anthony, "The Church of England, Rome and the True Church: The Demise of a Jacobean Consensus," in Fincham (ed.), *Church* (1993), 187–210.

Milton, Anthony, "'That Sacred Oratory': Religion and the Chapel Royal during the Personal Rule of Charles I," in Andrew Ashbee (ed.), *William Lawes (1602–1645)* (Aldershot: Ashgate, 1998), 69–96.

Milton, Anthony, *The British Delegation and the Synod of Dort (1618–19)* (Woodbridge: Boydell, 2005).

Milton, Anthony, *Laudian and Royalist Polemic in Seventeenth-Century England: The Career and Writings of Peter Heylyn* (Manchester: Manchester University Press, 2007).

Milton, John, *The Major Works* (Oxford: Oxford University Press, 2003).

Mitchell, Anthony, *Kingston Lacy* (London: National Trust, 1994).

Mitchell, W. Fraser, *English Pulpit Oratory from Andrewes to Tillotson* (London: SPCK, 1932).

Mitford, J., "Retrospective Review: *Feriae academicae*," *Gentleman's Magazine*, 182 (1847), 382–4.

Mocket, Richard, *God and the King: or, a Dialogue Shewing that our Soveraigne Lord King James, Being Immediate under God within his Dominions, Doth Rightfully Claime whatsoever Is Required by the Oath of Allegiance* (London: By His Majesties Command, 1615).

Modena, Leone, *The History of the Rites, Customes, and Manner of Life, of the Present Jews throughout the World*, trans. Edmund Chilmead (London: J. Martin and J. Ridley, 1650).

Moesgaard, Kristian Peder, "How Copernicanism Took Root in Denmark and Norway," in Dobrzycki (ed.), *Reception* (1972), 117–51.

Molaro, Paolo, "On the Lost Portrait of Galileo by the Tuscan Painter Santi di Tito," *Journal of Astronomical History and Heritage*, 19 (2016), 255–63.

Montagu, Jennifer, "Altham as a Hermit," in Chaney and Mack (eds), *England* (1990), 271–82.

Montagu, Richard, *Diatribe on the First Part of the Late History of Tithes* (London: F. Kyngstyon for M. Lownes, 1621).

Montagu, Richard, *A Gagg for The New Gospel? No: A New Gagg for an Old Goose* (London: T. Snodham, 1624).

Montgomery, John Warwick, "Cross, Constellation and Crucible: Lutheran Astrology and Alchemy in the Age of the Reformation," *Ambix*, 11 (1963), 65–86.

Moore, Andrew, et al. (eds), *The Paston Treasure: Microcosm of the Known World* (New Haven, CT: Yale University Press, 2018).

More, Henry, ΨΥΧΑΘΑΝΑΣΙΑ *Platonica: Or, a Platonicall Poem of the Immortality of Souls, Especially Mans Soul* (Cambridge: R. Daniel, 1642).

Morel, Philippe, *Les Grotesques: Les Figures de l'imagination dans la peinture italienne de la fin de la Renaissance* (Paris: Flammarion, 1997).

Morgan, George Blacker, *Historical and Genealogical Memoirs of the Dutton Family of Sherborne, in Gloucestershire* (Privately printed, 1899).

Morrissey, Mary, *Politics and the Paul's Cross Sermons, 1558–1642* (Cambridge: Cambridge University Press, 2011).

Moshenska, Joe, *A Stain in the Blood: The Remarkable Voyage of Sir Kenelm Digby* (London: Windmill, 2016).

Mosley, Adam, "Tycho Brahe and John Craig: The Dynamics of a Dispute," in Christianson et al. (eds), *Tycho Brahe* (2002), 70–83.

Muir, Edward, "Images of Power: Art and Pageantry in Renaissance Venice," *American Historical Review*, 84/1 (1979), 16–52.

Mulgrave, J. R., and Margaret Shewring (eds), *Theatre and Government under the Early Stuarts* (Cambridge: Cambridge University Press, 1993).

Mulherron, Jamie, and Helen Wyld, "Mortlake's Bouquet of the Senses: The Five Senses Tapestries at Haddon Hall, Derbyshire," *Apollo*, 175 (March 2012), 122–8.

Mulherron, Jamie, and Helen Wyld, "Mortlake's Big Swim," *National Trust Historic Houses and Collections Annual* (2011), 20–9.

Munk, William, *The Roll of the Royal College of Physicians of London*, i. 1518–1700, 2nd edn (London: The College, 1878).

Murdoch, Steve, "Robert Anstruther, a Stuart diplomat in Norlan Europe," *Cairn*, 1 (1997), 46–55.

Murdoch, Steve, *Britain, Denmark–Norway and the House of Stuart, 1603–1660: A Diplomatic and Military Analysis* (East Linton: Tuckwell, 2000).

Museo di storia della scienza, Florence, *Catalogo* (Florence: Giunti, 1991).

Myers, Anne, *Literature and Architecture in Early Modern Europe* (Baltimore: Johns Hopkins University Press, 2013).

Naiden, James, *The Sphaera of George Buchanan (1506–1582): A Literary Opponent of Copernicus and Tycho Brahe* (n.p.: s.n., 1952).

Nance, Brian, *Turquet de Mayerne as Baroque Physician: The Art of Medical Portraiture* (Amsterdam: Rudopi, 2001).

Nardi, Giovanni, *Lactis physica analysis* (Florence: P. Nestius, 1634).

Nardi, Giovanni, *Noctes geniales* (Bologna: G. B. Ferroni, 1656).

Nason, Arthur Huntington, *James Shirley Dramatist* (New York: A. H. Nason, 1915).

Nausea, Friedrich, *A Treatise of Blazing Stars in General* ([1577]; London: B. Alsop, 1618).

Naworth, George, *A Prognostication for the Year of our Redemption 1642* (London: J. Okes, 1642).

Neuber, T. R. W., and Claus Zittel (eds), *The Making of Copernicus: Early Modern Transformations of the Scientist and his Science* (Leiden: Brill, 2015).

Newberry, Timothy J., "Toward an Agreed Nomenclature for English Picture Forms: 1530–1795," *International Journal of Museum Management and Curatorship*, 5/4 (1986), 357–66.

Newland, Henry, *The Life and Contemporaneous Church History of Antonio De Dominis* (Oxford: Henry and Parker, 1859).

Newman, J., "Inigo Jones and the Politics of Architecture," in Sharpe and Lake (eds), *Culture* (1993), 229–55.

Nicius, Janus [Gian Vittorio Rossi], *Pinacotheca imaginum illustrium, doctrinae vel ingenii laude, virorum, qui, auctore superstite, diem suum obierunt* (Cologne: C. von Egmont, 1643).

Nichols, John (ed.), *The Progresses, Processions, and Magnificent Festivities of King James the First*, 4 vols (London: Nichols, 1828).

Nicolson, Marjorie Hope, "English Almanacks and the New Astronomy," *AS* 4 (1939), 1–33.

Nicolson, Marjorie Hope, *Science and Imagination* (Ithaca, NY: Cornell University Press, 1962).

Noldus, Badeloch, "Loyalty and Betrayal: Artist–Agents Michel le Bon and Pieter Isaacsz, and Chancellor Axel Oxenstierna," in Cools and Keblusek (eds), *Humble Servant* (2006), 51–64.

Noldus, Badeloch, "A Spider in its Web: Agent and Artist Michel le Blon and his Northern European Network," in Keblusek and Noldus (eds), *Double Agents* (2011), 161–91.

Noldus, Badeloch, and Juliette Roding (eds), *Pieter Isaacsz (1568–1625): Court Painter, Art Dealer and Spy* (Brussels: Brepols, 2007).

Nonnoi, Giancarlo, *Saggi galileiani: Atomi, immagini e ideologia* (Cagliari: AM & D, 2000).

Nonnoi, Giancarlo, "La scienza e la filosofia galileiane nel *New World* di John Wilkins," *Nuncius*, 16/1 (2001), 49–84.

Norgate, Edward, *Miniatura, or the Art of Limning*, ed. Martin Hardie (Oxford: Oxford University Press, 1919).

Norsworthy, Laura L., "The Lady of Corfe Castle," *Cornhill Magazine*, 150 (1934), 66–81.

Notestein, Wallace, *A History of Witchcraft in England from 1558 to 1718* ([1909]; Washington: ACLS, 1968).

Norlind, Wilhelm, *Tycho Brahe, mannen og verket: Efter Gassendi med kommentar* (Lund: Glaerup, 1951).

O'Callaghan, Michelle, "*Coryats Crudities* (1611) and Travel Writing as the 'Eyes' of the Prince," in Wilks (ed.), *Prince Henry* (2007), 85–103.

O'Connell, Michael, *Robert Burton* (Boston: Twayne, 1986).

Ogilby, John (ed. and trans.), *The Fables of Aesop Paraphras'd in Verse and Adorned with Sculptures* (London: T. Warren, 1651; repr. Los Angeles: William Andrews Clark Memorial Library, 1965).

Ogilby, John, *Africa* (London: T. Johnson, 1670).

Ogilvie, Charles, *The King's Government and the Common Law, 1471–1641* (Oxford: Oxford University Press, 1958; Westport, CT: Greenwood, 1978).

O'Grady, Hugh, *Strafford and Ireland: The History of his Vice-Royalty with an Account of his Trial*, 2 vols (Dublin: Hodges, Figges, 1923).

Omodeo, Pietro Daniel, *Copernicus in the Cultural Debates of the Renaissance* (London: Brill, 2014).

Onori, Lorenzo Mochi, et al. (eds), *I Barberini e la cultura Europea del seicento* (Rome: De Luca, 2007).

Ord, Melanie, "Returning from Venice to England: Sir Henry Wotton as Diplomat, Pedagogue and Italian Cultural Connoisseur," in Thomas Betteridge (ed.), *Borders and Travellers in Early Modern Europe* (Aldershot: Ashgate, 2007), 147–67.

Ord, Melanie, "Venice and Rome in the Addresses and Dispatches of Sir Henry Wotton," *SC* 22/1 (2007), 1–23.

Ord, Melanie, *Travel and Experience in Early Modern English Literature* (New York: Palgrave, 2008).

Orgel, Stephen, and Roy Strong, *The Theatre of the Stuart Court*, 2 vols (Berkeley and Los Angeles: University of California Press, 1973).

Ornsby, George, *Selection of the Household Books of Lord William Howard of Naworth Castle*, Surtrees Society, Publications, 68 (London: Gilbert and Rivington, 1878).

Osborne, Toby, "Van Dyck, Alessandro Scaglia and the Caroline Court," *SC* 22/1 (2007), 24–41.

Ovid, *Metamorphosis: Englished, Mythologized, and Represented in Figures*, trans. George Sandys (Oxford: J. Lichfield, 1632); repr., ed. K. K. Hulley and S. T. Vandersall (Lincoln: University of Nebraska Press, 1970).

Oxford University, *Oxoniensis academiae parentalia: Sanctissimae memoriae potentissimi Monarchae Iacobi…dicata* (Oxford: J. Lichfield, 1625).

Oxford University, *Musarum oxoniensium ΕΠΙΒΑΤΗΡΙΑ: Serenissimae reginarum Mariae ex Batavia feliciter reduci* (Oxford: L. Lichfield, 1643).

Oy-Marra, Elizabeth, "Paintings and Hangings for a Catholic Queen: Giovan Francesco Romanelli and Francesco Barberini's Gifts to Henrietta Maria of England," in Cropper (ed.), *Diplomacy* (2000), 177–93.

Pace, Claire, "'Delineated Lives': Themes and Variations in Seventeenth-Century Poems about Portraits," *Word and Image*, 2/1 (1986), 1–17.

Pace, Claire, "Virtuoso to Connoisseur: Some Seventeenth-Century English Responses to the Visual Arts," *SC* 2 (1987), 167–88.

Pagnini, Caterina, *Costantino de' Servi, architetto-scenografo fiorentino alle corte d'Inghilterra (1611–1615)* (Florence: Società editrice fiorentina, 2006).

Palme, Per, *A Triumph of Peace: A Study of the Whitehall Banqueting House* (Stockholm: Almqvist and Wiksell, 1956).

Palumbo, Genoveffa, *Giubileo giubilei: Pellegrini e pelligrine, riti, santi, immagini per una storia dei sacri itinerari* (Rome: RAI, 1999).

Panofsky, Erwin, *The Life and Art of Albrecht Dürer* (Princeton: Princeton University Press, 1971).

Parker, Derek, *Familiar to All: William Lilly and Astrology in the Seventeenth Century* (London: J. Cape, 1975).

Parker, Henry, *A Discourse Concerning Puritans: Tending to a Vindication of those who Unjustly Suffer by the Mistake, Abuse, and Misappropriation of that Name* (London: R. Bostock, 1641).

Parr, Richard (ed.), *The Life of the Most Reverend Father in God, James Usher…with a Collection of Three Hundred Letters* (London: N. Ranew, 1686).

Parry, Graham, *The Trophies of Time: English Antiquarians of the Seventeenth Century* (Oxford: Oxford University Press, 1995).

Pastor, Ludwig, *The History of the Popes*, 40 vols (London: Kegan Paul et al., 1891–1953).

Patterson, Annabel., *Censorship and Interpretation: The Conditions of Writing and Reading in Early Modern England* (Madison: University of Wisconsin Press, 1984).

Patterson, Annabel, *Fables of Power: Aesopian Writing and Political History* (Durham, NC: Duke University Press, 1991).

Patterson, William Browne, *King James VI and I and the Reunion of Christendom* (Cambridge: Cambridge University Press, 1997).

Pav, John I, "Wenceslaus Hollar in Germany, 1627–1636," *Art Bulletin*, 55/1 (1973), 86–105.

Peacham, Henry, *Graphice, or The Most Auncient and Excellent Art of Drawing and Limning* (London: W.S. for John Brown, 1612).

Peacham, Henry, *The Compleat Gentleman* ([1622]; London: J. Legate, 1634, 1638).

Peacock, John, "The Politics of Portraiture," in Sharpe and Lake (eds), *Culture* (1993), 199–228.

Peacock, John, *The Stage Designs of Inigo Jones: The European Context* (Cambridge: Cambridge University Press, 1995).

Peck, Linda Levy, *Northampton: Patronage, Policy and the Court of James I* (London: George Allen & Unwin, 1982).

Peck, Linda Levy (ed.), *The Mental World of the Jacobean Court* (Cambridge: Cambridge University Press, 1991).

Peck, Linda Levy, *Court Patronage and Corruption in Early Stuart England* (London: Routledge, 1993).

Peck, Linda Levy, "Uncovering the Arundel Library at the Royal Society," Royal Society of London, *Notes and Records*, 52 (1998), 3–24.

Peck, Linda Levy, *Consuming Splendour: Society and Culture in Seventeenth-Century England* (Cambridge: Cambridge University Press, 2005).

Peckard, Peter, *Memoirs of the Life of Mr Nicholas Ferrar* (Cambridge: J. Archdeacon, 1790).

Pegge, Samuel, *Sketch of the History of Bolsover and Peak Castles* (London: J. Nichols, 1785).

Penrose, Boies, *Urbane Travelers 1591–1635* (Philadelphia: University of Pennsylvania Press, 1942).

Pesce, Mauro, "Il copernicanismo e la teologia: Perché il caso Galileo non è chiuso," in Bucciantini et al. (eds), *Caso* (2011), 33–46.

Petersson, R. T., *Sir Kenelm Digby: The Ornament of England 1603–1665* (London: J. Cape, 1956).

Piccininni, Renata, "La girondola e Castel Sant'Angelo," in Cavazza, *Fuochi* (1982), 83–97.

Pickel, Margaret B., *Charles I as Patron of Poetry and Drama* (London: F. Muller, 1936).

Pieper, Anton, *Die Propaganda-Congregation und die nordischen Missionen im siebenzehnten Jahrhundert* (Cologne: J. P. Bachem, 1886).

Pigatto, Luisa, "Galileo and Father Paolo: The Improvement of the Telescope," in Pigatto and Zanini (eds), *Astronomy* (2010), 37–50.

Pigatto, Luisa, and Valeria Zanini (eds), *Astronomy and its Instruments before and after Galileo* (Padua: CLUEP, 2010).

Piles, Roger de, *The Art of Painting and the Lives of the Painters* ([1706]; London: J. Nutt, 1744).

Pin, Corrado (ed.), *Ripensando Paolo Sarpi* (Venice: Ateneo Veneto, 2006).

Plot, Robert, *The Natural History of Oxford* (Oxford: L. Lichfield for C. Brome, 1705).

Ponsard, François, *Galilée, drame en trois actes et en vers* (Paris: M. Lévy, 1867).

Pontificale romanum Clementis VIII. primum, nunc denuo Urbani VIII. auctoritate recognitum (Paris: Officinus ecclesiasticus, 1664).

Poole, William (ed.), *John Wilkins (1614–1671): New Essays* (Leiden: Brill, 2017).

The Popes Nuntioes, or, The Negotiation of Seignior Panzani, Seignior Conn, etc. (London: R. Bostock, 1643).

Popofsky, Linda S., "*Habeas corpus* and 'Liberty of the Subject': Legal Arguments for the Petition of Right in the Parliament of 1628," *Historian*, 41 (1979), 257–75.

Popofsky, Linda S., "The Crisis over Tonnage and Poundage in Parliament in 1629," *Past and Present*, 126 (1990), 44–75.

Portal, Ethel M., "The Academ Roial of King James I," British Academy, *Proceedings* (1915–16), 189–208.

Powell, Amy Knight, "Squaring the Circle: The Telescopic View in Early Modern Landscapes," *Art History*, 39/2 (2016), 282–301.

Powell, Anthony, *John Aubrey and his Friends* (New York: Barnes and Noble, 1964).

Powell, Robert, *Depopulation Arraigned, Convicted and Condemned by the Lawes of God and Man* (London: R.B., 1636).

Prest, Wilfrid R., *The Inns of Court under Elizabeth I and the early Stuarts, 1590–1640* (London: Longman, 1972).

Prest, Wilfrid R., *The Diary of Sir Richard Hutton, 1614–1639* (London: Selden Society, 1991).

Price, Bronwen (ed.), *Francis Bacon's* New Atlantis: *New Interdisciplinary Essays* (Manchester: Manchester University Press, 2002).

Price, W. Hyde, *The English Patents of Monopoly* (Cambridge, MA: Harvard University Press, 1913).

Probes, Christine McCall, "Calvin on Astrology," *Westminster Theological Journal*, 37/1 (1974), 24–33.

Prynne, William, *Healths-Sicknesse, or A Compendious and Brief Discourse, Proving the Drinking and Pledging of Healths, to be Sinful* (London: A. Matthews, 1628).

Prynne, William, *The Unlovelinesse of Love-Lockes* (London: s.n., 1628).

Prynne, William, *A Pleasant Purge, for a Roman Catholique, to Evacuate his Evill Humours* (London: M. Sparke, 1642).

Prynne, William, *Romes Master-peece, or, The Grand Conspiracy of the Pope and his Jesuited Instruments, to Extirpate the Protestant Religion* (London: M. Sparkes, 1643; repr., with Laud's marginal remarks, in Laud, *Works* (1847–60), iv. 463–503.

Prynne, William, *The Popish Royal Favourite, or, A Full Disclosure of his Majesties Extraordinary Favours to, and Protection of Notorious Papists, Priests, Jesuits, against all Prosecutions and Penalties of Laws Enacted against them* (London: M. Sparkes, 1643).

Prynne, William, *Hidden Workes of Darkenes Brought to Publike Light, or, A Necessary Introduction to the History of the Archbishop of Canterbury's Triall* (London: M. Sparkes, 1645).

Ptolemy, *Tetrabiblos*, trans. F. E. Robbins (Cambridge, MA: Harvard University Press, 1964).

Pumfrey, Stephen, and Frances Dawbarn, "Science and Patronage in Early Modern England 1570–1625," *History of Science*, 42 (2004), 137–88.

Quarles, Francis, *Emblemes* (London: G.H., 1635).

Quarles, John, *Fons lachrymarum: or, A Fountain of Tears whence Doth Flow Englands Complaint* (London: J. Macock for N. Brooks, 1648).

Questier, Michael (ed.), *Newsletters from the Caroline Court, 1631–1638: Catholicism and the Politics of Personal Rule* (Cambridge: Cambridge University Press, 2005).

Questier, Michael, "Catholic Loyalism in Early Stuart England," *English Historical Review*, 123/504 (2008), 1132–65.

Quintrell, Brian W., "Charles I and his Navy in the 1630s," *SC* 3/2 (1988), 159–79.

Rabb, Theodore K., *Jacobean Gentleman: Sir Edwin Sandys, 1561–1629* (Princeton: Princeton University Press, 1998).

Rahn, Thomas, "Die Erde als Mond," in Neuber and Zittel (eds), *Copernicus* (2015), 155–200.

Ranke, Leopold von, *A History of England Principally in the Seventeenth Century*, 6 vols (Oxford: Oxford University Press, 1875).

Rasmussen, Mikael Bøgh, "Maiestatis regiae pictor," in Noldus and Roding (eds), *Isaacsz* (2007), 139–49.

Raunce, John, *Astrologia accusata pariter & condemnata: or, The Diabolical Art of Judicial Astrologie, Receiving the Definitive Sentence of Final Condemnation* (London: J. Clowes for W. Leaner, 1650).

Ravelhofer, Barbara, *The Early Stuart Masque: Dance, Costume, and Music* (Oxford: Oxford University Press, 2006).

Raymond, John, *An Itinerary Conteyning a Voyage Made through Italy in the Years 1646 and 1647* (London: H. Moseley, 1648).

Raylor, Timothy (ed.), "The Cavendish Circle," *SC* 9/2 (1994), 141–87.

Raylor, Timothy, '"Pleasure Reconciled to Virtue:' William Cavendish, Ben Jonson, and the Decorative Scheme of Bolsover Castle," *Renaissance Quarterly*, 52/2 (1999), 402–39.

Redondi, Pietro, *Galileo Heretic* (Princeton: Princeton University Press, 1987).

Redondi, Pietro, "Dietro l'immagine: Representazioni di Galileo nella cultura positivistica," *Nuncius*, 9/1 (1994), 65–116.

Redondi, Pietro, "La nave di Bruno e la pallottola di Galileo: Uno studio di iconografia della fisica," in Adriano Prosperi et al. (eds), *Il piacere del testo: Saggi e studi per Albano Biondi*, 2 vols (Rome: Bulzoni, 2001), i. 285–363.

Redworth, Glyn, *The Prince and the Infanta: The Cultural Politics of the Spanish Match* (New Haven, CT: Yale University Press, 2003).

Rees, Graham, "Mathematics and Bacon's Natural Philosophy," *Revue internationale de philosophie*, 159/4 (1986), 399–426.

Reeves, Eileen, *Evening News: Optics, Astronomy and Journalism in Early Modern Europe* (Philadelphia: University of Pennsylvania Press, 2014).

Reifferscheid, H. M. A. (ed.), *Briefe G.M. Lingelsheims, M. Berneggers und ihre Freunde* (Heilbronn: Henniger, 1889).

Reindel, Ulrik, *The King's Tapestries: Pomp & Propaganda at Kronborg Castle* (Copenhagen: Palaces and Properties Agency, n.d.).

Reinmuth, Howard S., "Lord William Howard (1563–1640) and his Catholic Associations," *Recusant History*, 12 (1973–4), 226–34.

Remmert, Volker R., "In the Service of the Reich: Aspects of Copernicus and Galileo in Nazi Germany's Historiographical and Political Discourse," *Science in Context*, 14 (2001), 333–59.

Remmert, Volker R., "In the Sign of Galileo: Pictorial Representation in the 17th Century Galileo Debate," *Endeavour*, 27:1 (2003), 26–31.

Remmert, Volker R., *Widmung, Welterklärung und Wissenschaftslegitimierung: Titelblätter und ihre Funktionen in der wissenschaftlichen Revolution* (Wiesbaden: Hasserowitz, 2005).

Remmert, Volker R., '"Docet parva pictura, quod multae scripturae non dicunt:' Frontispieces, their Functions, and their Audiences in Seventeenth-Century Mathematical Sciences," in Sachiko Kusukawa and Ian Maclean (eds), *Transmitting Knowledge: Words, Images and Instruments in Early Modern Europe* (New York: Oxford: Oxford University Press, 2006), 239–70.

Rice, Warner G., "The Grand Signior's Seraglio: Written by Master Robert Withers," *Modern Language Notes*, 43/7 (1928), 450–9.

Riis, Thomas, *Should Auld Acquaintance Be Forgot...Scottish–Danish Relations 1450–1707*, 2 vols (Odense: Odense University Press, 1988).

[Roberts, Henry], *The Most Royall and Honourable Entertainement, of the Famous and Renowned King, Christiern* [!] *the Fourth* (London: H.R., 1606).

Robb-Smith, A. H. T., "Harvey at Oxford," *Oxford School Medical Gazette*, 12 (1957), 70–6.

Robinson, John Martin, *The Dukes of Norfolk* (Chichester: Phillimore, 1995).

Rochot, Bernard, "La Vie, le caractère et la formation intellectuelle," in *Pierre Gassendi: Sa vie et son oeuvre* (Paris: Centre international de synthèse, 1955), 11–54.

Roche, J. J., "Harriot, Galileo, and Jupiter's Satellites," *Archives internationales d'histoire des sciences*, 32 (1982), 9–51.

Roding, Juliette, "The Seven Ages of Man: The Decorative Scheme of the Great Hall at Rosenborg," in Noldus and Roding (eds), *Isaacsz* (2007), 181–203.

Roding, Juliette, et al., *Dutch and Flemish Artists in Britain 1550–1800*, Leids kunsthistorisch jaarboek, 13 (Leyden: Primavera, 2003).

Rogers, Malcolm, *William Dobson 1611–46* (London: National Portrait Gallery, 1983).

The Roman Breviary: Reformed by Order of the Holy Oecumenical Council of Trent...and Revised by Clement VIII and Urban VIII, trans. John, Marquess of Bute, 2 vols (Edinburgh and London: Blackwood, 1879).

Rosenblatt, Jason P., *Renaissance England's Chief Rabbi, John Selden* (Oxford: Oxford University Press, 2006).

Rosenthal, Earl, "Plus ultra, non plus ultra, and the Columnar Device of Emperor Charles V," *JWCI* 34 (1971), 204–28.

Ross, Alexander, *Commentum de terrae motu circulari* (London: T. Harper, 1634).

Ross, Alexander, *Religions Lotterie, or, The Churches Amazement. Wherein Is Disclosed how Many Sorts of Religion There Is Crept into the Very Bowels of this Kingdome* (London: T.F. for S.F., 1642).

Ross, Alexander, *The New Planet No Planet: or, The Earth No Wandring Star, except in the Wandring Heads of Galileans…and Copernicus his Opinion, as Erroneous, Ridiculous, and Impious, Fully Refuted* (London: J. Young, 1646).

Ross, Alexander, *The History of the World…from the Year of the World 3806…till the End of the Year 1640 after Christ* (London: J. Saywell, 1652).

Ross, Alexander, *Leviathan Drawn out by a Tooth: or, Animadversions upon Mr Hobbes his Leviathan* (London: T. Newcomb for R. Royston, 1653).

Rossi, Paolo, *Francis Bacon: From Magic to Science* (London: Routledge and Kegan Paul, 1968).

Rossi, Paolo, "Galileo e Bacone," in Carlo Maccagni (ed.), *Saggi su Galileo Galilei* (Florence: G. Barbera, 1972), ii. 248–96.

Roth, Cecil., "Leone da Modena and England," Jewish Historical Society of England, Transactions, 11 (1924–7), 206–27.

Rothman, Aviva, *The Pursuit of Harmony: Kepler on Cosmos, Confession, and Community* (Chicago: University of Chicago Press, 2017).

Rous, John, *Diary*, ed. M. A. E. Green, Camden Society, 66 (London: Nichols and Sons, 1866).

Rowell, Christopher, "A Seventeenth-Century 'Cabinet' Restored: The Green Closet at Ham House," *Apollo*, 143 (April 1996), 18–23.

Rowell, Christopher, *Ham House. 400 Years of Collecting and Patronage* (New Haven, CT: Yale University Press, 2013).

Rowse, A. L. *Four Caroline Portraits: Thomas Hobbes, Henry Marten, Hugh Peters, John Selden* (London: Duckworth, 1993).

Royal Academy of Arts, *In the Age of Giorgione* (London: Royal Academy of Arts, 2016).

Royal Academy of Arts, *Charles I King and Collector* (London: Royal Academy, 2018).

Rubin, Deborah, *Ovid's* Metamorphoses *Englished: George Sandys as Translator and Mythographer* (New York: Garland, 1985).

Rudolf, Stella, "Mezzo secolo di diplomazia internazionale, fra realtà ad allegoria, nelle opere del pittore Carlo Maratti," in Cropper (ed.), *Diplomacy* (2000), 195–228.

Ruggle, George, *Ignoramus: A Comedy*, trans. Robert Codrington ([1630]; Cambridge: Chadwyck-Healy, 1996).

Ruigh, Robert E., *The Parliament of 1624: Politics and Foreign Policy* (Cambridge, MA: Harvard University Press, 1971).

Rusche, Henry, "Merlini anglici: Astrology and Propaganda from 1644 to 1651," *English Historical Review*, 80 (1965), 322–33.

Russell, Conrad, *The Origins of the English Civil War* (New York: Barnes and Noble, 1973).

Russell, Conrad, *The Fall of the British Monarchies 1637–1642* (Oxford: Oxford University Press, 1991).

Russell, John H., "The Copernican System in England," in Dobrzycki (ed.), *Reception* (1972), 189–239.

Rutgers, Jaco, "A Frontispiece for Galileo's *Opere*: Pietro Anichini and Stefano della Bella," *Print Quarterly*, 29 (2012), 3–12.

Salmon, Vivian, "Joseph Webbe: Some Seventeenth-Century Views on Language Teaching and the Nature of Meaning," in Salmon, *The Study of Language in Seventeenth-Century England* (Amsterdam: J. Benjamin, 1988), 15–36.

Sanders, Julie, *Caroline Drama: The Plays of Massinger, Ford, Shirley and Brome* (Plymouth: Northcote House, 1999).

Sanderson, William, *Graphice: or, The Use of Pen and Pensil, in Designing, Drawing, and Painting* (London: R. Crofts, 1658).

Sanderson, William, *A Compleat History of the Life and Raigne of King Charles* (London: H. Moseley et al., 1658).

Sandys, Edwin, *A Relation of the State of Europe* (London: V. Sims for S. Waterston, 1605).

Sandys, George, *The Relation of a Journey Begun an: Dom: 1610…Containing a Description of the Turkish Empire* ([1615]; London: T. Cotes for A. Crocke, 1637).

Sandys, George, *A Paraphrase upon the Psalms of David* (London: A. Hebb, 1636).

Sarpi, Paolo, *The Historie of the Councel of Trent…In which [Is] Declared Many Notable Occurrences…And, Particularly, the Practices of the Court of Rome, to Hinder the Reformation of their Errors, and to Maintaine their Greatnesse*, trans. Nathaniel Brent (London: R. Barker and J. Bill, 1620; London: R. Young and J. Raworth for R. Whittaker, 1640³).

Sarpi, Paolo, *The History of the Quarrels of Pope Paul V with the State of Venice*, trans. Christopher Potter (London: John Bill, 1626).

Savorelli, Alessandro, "Galileo 'positivista,'" *Galilaeana*, 7 (2010), 27–39.

Scarisbrick, Diana, "For Richer for Poorer," *Country Life*, 184/40 (4 October 1990), 136–9.

Schirrmacher, Thomas, *Legends about the Galileo Affair and Other Creationist Essays* (Hamburg: Reformatorischer Verlag, 2001).

Schmitz, Götz, "Satirical Elements in Latin Comedies Acted on the Occasion of Royal Visits to Cambridge," in Hogg (ed.), *Jacobean Drama* (1995), 217–30.

Schoppe, Kaspar, *Autobiographische Texte und Briefe*, i. *Philoteca scoppiana: Eine früh-neuzeitliche Autobiographie 1576–1630*, ed. Klaus Jaitner, 2 parts (Munich: Beck, 2004).

Schreiber, Roy E., *The First Carlisle: Sir James Hay…as Courtier, Diplomat, and Entrepreneur, 1580–1636* (Philadelphia: American Philosophical Society, 1984). (*Transactions*, 74/7.)

Schuchard, Margret, *John Ogilby, 1600–1676. Lebensbild eines Gentleman mit vielen Karrieren* (Hamburg: P. Hartung, 1973).

Schuler, Robert M., "Three Renaissance Scientific Poems," *Studies in Philology*, 75/5 (1978), 1–152.

Scott, Jennifer, *The Royal Portrait: Image and Impact* (London: Royal Collection Enterprises, 2010).

Scott, Sir Walter, *Demonology and Witchcraft* (New York: Bell, 1970).

Selden, John, *Titles of Honour* (London: W. Stansby for J. Helms, 1614).

Selden, John, *The Historie of Tithes that is, the Practice of the Payment of them* (London: s.n., 1618).

Selden, John, *Mare clausum seu de dominio maris* (London: W. Stranesby, 1635).

Selden, John, *De jure naturali et gentium, iuxta disciplinam Ebraeorum libri septem* (London: R. Bishop, 1640).

Selden, John, *De synedriis & praefecturis veterum Ebraeorum* [libri tres] (London: J. Elesher, 1650–5).

Selden, John, *Of the Dominion and Ownership of the Sea*, trans. Marchamont Nedham (London: W. Du-Gard, 1652).

Selden, John, *Table Talk: Being the Discourses of John Selden... his Sense of Various Matters of Weight and High Consequence; Especially Relating to Religion and the State* [1689]; ed. S.W. Singer (London: J. R. Smith, 1856²).

Sellers, David, "A Letter from William Gascoigne to Sir Kenelm Digby," *Journal for the History of Astronomy*, 37/4 (2006), 405–16.

Sells, Arthur Lytton, *The Paradise of Travelers: The Italian Influence on Englishmen in the Seventeenth Century* (Bloomington: University of Indiana Press, 1964).

Selvelli, Pierluigi, and Paolo Molaro, "Early Telescopes and Ancient Scientific Instruments in the Paintings of Jan Brueghel the Elder," in Luisa Pigatto and Valeria Zanini (eds), *Astronomy and its Instruments before and after Galileo* (Padua: CLEUP, 2010), 193–208.

Sergi, G., "Il monumento di Galileo a Parigi," *Nuova antologia*, 35 (1900), 211–21.

Serlio, Sebastiano, *The Five Books of Architecture*, ed. Robert Peake (London: R. Peake, 1611).

Shadwell, Charles Lancelot (ed.), *Registrum oriense: An Account of the Members of Oriel College, Oxford*, 2 vols (London: H. Frowde, 1893–1902).

Shalev, Zur, "Measurer of all Things: John Greaves (1602–1652), the Great Pyramid, and Early Modern Metrology," *JHI* 63 (2002), 555–75.

Shalev, Zur, "The Travel Notebooks of John Greaves," in Alistair Hamilton et al. (eds), *The Republic of Letters and the Levant* (Leiden: Brill, 2005), 77–103.

Shank, Michael, "Setting the Stage: Galileo in Tuscany, the Veneto, and Rome," in McMullin (ed.), *Church* (2005), 57–87.

Shapiro, Barbara, *John Wilkins 1614–1672: An Intellectual Biography* (Berkeley and Los Angeles: University of California Press, 1969).

Sharpe, Kevin, *Sir Robert Cotton 1586–1631* (Oxford: Oxford University Press, 1979).

Sharpe, Kevin, "Introduction: Parliamentary History 1603–1629: In or out of Perspective?" in Sharpe (ed.), *Faction* (1985), 1–42.

Sharpe, Kevin (ed.), *Faction and Parliament: Essays on Early Stuart History* ([1978]; London: Methuen, 1985).

Sharpe, Kevin, "The Image of Virtue: The Court and Household of Charles I, 1625–1642," in David Starkey (ed.), *The English Court from the Wars of the Roses to the Civil War* (London: Longman, 1987), 226–60.

Sharpe, Kevin, *The Personal Rule of Charles I* (New Haven, CT: Yale University Press, 1992).

Sharpe, Kevin, *Reading Revolutions: The Politics of Reading in Early Modern England* (New Haven, CT: Yale University Press, 2000).

Sharpe, Kevin, *Image Wars: Promoting Kings and Commonwealths in England, 1603–1660* (New Haven, CT: Yale University Press, 2010).

Sharpe, Kevin, and Peter Lake, "Introduction," in Sharpe and Lake (eds), *Culture* (1993), 1–20.

Sharpe, Kevin, and Peter Lake (eds), *Culture and Politics in Early Stuart England* (Stanford: Stanford University Press, 1993).

Shaw, Dougal, "Thomas Wentworth and Monarchical Ritual in Early Modern Ireland," *Historical Journal*, 49 (2006), 331–55.

Shea, William, "Shakespeare and Milton," *Galilaeana*, 13 (2016), 1–27.

Shearman, John K., *Raphael's Cartoons in the Collection of Her Majesty the Queen and the Tapestries for the Sistine Chapel* (London: Phaidon, 1972).

Sheppard, F. H. W., *Survey of London, xxxvi. The Parish of St Paul Covent Garden* (London: Athlone, 1970).

Shirley, James, *The Triumph of Peace* (London: J. Norton for W. Cooke, 1633 [1634]).

Shirley, James, *The Gamester* ([1637]; Cambridge: Chadwyck-Healey, 1994).

Shirley, John William, "The Scientific Experiments of Sir Walter Ralegh, the Wizard Earl, and the Three Magi in the Tower, 1603–1617," *Ambix*, 4 (1949), 52–66.

Shohet, Lauren, *Reading Masques: The English Masque and Public Culture in the Seventeenth Century* (Oxford: Oxford University Press, 2010).

Shriver, Frederick, "Orthodoxy and Diplomacy: James I and the Vorstius Affair," *English Historical Review*, 85 (1970), 449–74.

Sibbes, Richard, *The Soule's Conflict with Itself* (London: M. Flesher, 1635).

Simon, Robert Jean, *Robert Burton (1677–1640) et l'Anatomie de la Mélancolie* (Paris: Didier, 1964).

Simonutti, Luisa, "La filosofia incisa: Il segno del concettuale," in Fabio Meroi and Claudio Pogliano (eds), *Immagini per conoscere dal Rinascimento alla Rivoluzione scientifica* (Florence: Olschki, 2001), 81–112.

Sitwell, Gerard, "Leander Jones's Mission to England, 1634–5," *Recusant History*, 5 (1960), 132–82.

Skovgaard, Joachim Anthany, *A King's Architecture: Christian IV and his Buildings* (London: H. Evelyn, 1973).

Sluiter, Engel, "The Telescope before Galileo," *Journal for the History of Astronomy*, 28 (1997), 223–32.

Smith, David L., *Constitutional Royalism and the Search for Settlement c.1640–1643* (Cambridge: Cambridge University Press, 1994).

Smith, Logan Pearsall, *The Life and Letters of Sir Henry Wotton*, 2 vols (Oxford: Oxford University Press, 1907). (Cited as *SL*.)

Smith, Thomas, *Vitae quorundam eruditissimorum et illustrium virorum* (London: D. Mortier, 1707).

Smuts, Malcolm R., *Court Culture and the Origin of a Royalist Tradition in Early Stuart England* (Philadelphia: University of Pennsylvania Press, 1987).

Snell, Willebrord, *Descriptio cometae qui anno 1618 mense novembri primum effulsit* (Leyden: Elsevier, 1619).

Snider, Alvin M., *Origin and Authority in Seventeenth-Century England: Bacon, Milton, Butler* (Toronto: University of Toronto Press, 1994).

Söderlund, Inga Elmqvist, *Taking Possession of Astronomy: Frontispieces and Illustrated Title Pages in 17th-Century Books on Astronomy* (Stockholm: Swedish Academy of Sciences, 2010).

Solinas, Francesco, "Portare Roma a Parigi," in Elizabeth Cropper et al. (eds), *Documentary Culture: Florence and Rome from Grand-Duke Ferdinando I to Alexander VII* (Bologna: Nuova Alpha, 1992), 227–61.

Sommerville, J. P., "James I and the Divine Right of Kings: English Politics and Continental Theory," in Peck (ed.), *Mental World* (1991), 55–70.

Sondheim, Moriz, "Shakespeare and the Astrology of his Time," *JWCI* 2/3 (1939), 243–59.

Southgate, Beverley C., *"Covetous of Truth:" The Life and Work of Thomas White, 1593–1676* (Dordrecht: Kluwer, 1993).

Southgate, Beverley C., "A Medley of Both: Old and New in the Thought of Thomas White," *History of European Ideas*, 18 (1994), 53–60.

Spedding, James, *An Account of the Life and Times of Francis Bacon*, 2 vols (Cambridge: Houghton, Osgood, 1878).

Spelman, Henry, *Aspilogia*, ed. Edward Bysshe (London: R. Norton for J. Martin & J. Allestrye, 1654).

Spelman, Henry, *The English Works* (London: D. Browne et al., 1727).

Spelman, John, *A View of the Printed Book Intituled "Observations upon His Majesties Late Answers and Expresses"* (Oxford: L. Lichfield, 1642).

Spelman, John, *A Protestants Account of his Orthodox Holding in Matters of Religion* (Cambridge: R. Daniel, 1642).

Spelman, John, *Certain Considerations upon the Duties Both of Prince and People* (Oxford: L. Litchfield, 1642).

Spelman, John, *The Case of our Affaires in Law, Religion, and Other Circumstances* (Oxford: H.H. for W.W., 1643).

Spencer, Edmund, *The Faerie Queene* [1596], ed. A. C. Hamilton (London: Longman, 1977).

Sprang, Felix C. H., *Londons Fountaine of Arts and Sciences: Bildliche und theatrale Vermittlungsinstanzen naturwissenschaftlichen Denkens im frühneuzeitlichen London* (Heidelberg: Winter, 2008).

Sprinzels, Franz, *Hollar: Handzeichnungen* (Leipzig: R. Passer, 1938).

Stainton, Lindsay, and Christopher White, *Drawing in England from Hilliard to Hogarth* (London: British Museum, 1987).

Steele, Mary, *Plays and Masques at Court during the Reigns of Elizabeth, James I and Charles I* (New York: Russell & Russell, 1968).

Steggle, Matthew, *Richard Brome: Place and Politics on the Caroline Stage* (Manchester: Manchester University Press, 2004).

Stein, Meir, "Christian IV's Programme for the Decoration of the Great Hall at Rosenborg in Copenhagen," *Leids kunsthistorisch jaarboek*, 2 (1983), 111–26.

Stein, Meir, *Christian den Fjerdes billedverden* (Copenhagen: G. E. C. Gad, 1987).

Stein, Meir, *Kronborg: Dansesalens malerier* (Copenhagen: Boligministeriets samlinger på Kronborg, 1989).

Stevenson, Allan H., "Shirley's Years in Ireland," *Review of English Studies*, 20 (1944), 19–28.

Stewart, J. Douglas, "Prudentia, Patrons and Artists," in Onori et al. (ed), *Barberini* (2007), 619–28.

Stone, Lawrence, "The Market for Italian Art," *Past and Present* (November 1959), 92–4.

Strafford, Thomas Wentworth, Earl of, *The Last Two Speeches* (London: s.n., 1641).

Strafford, Thomas Wentworth, Earl of, *Letters and Dispatches*, 2 vols (London: W. Boyer, 1739).

Strode, William, *The Floating Island* ([1636]; London: T. C. for H. Twiford, 1655).

Strong, Roy, *Van Dyck: Charles I on Horseback* (New York: Viking, 1972).

Strong, Roy, *Henry, Prince of Wales and England's Lost Renaissance* ([1986]; London: Pimlico, 2000).

Stuart, Elizabeth, Queen of Bohemia, *The Correspondence*, ed. Nadine Akkerman, 2 vols (Oxford: Oxford University Press, 2015).

Strutt, Joseph, *A Biographical Dictionary Containing an Historical Account of all the Engravers, from the Earliest . . . to the Present Time*, 2 vols (London: Faulder, 1785–6).

Summers, Montagu, *The Geography of Witchcraft* (Evanston: University Books, 1958).

Summerson, John, *The Unromantic Castle* (London: Thames and Hudson, 1990).

Summerson, John, *Inigo Jones*, ed. Howard Colvin (New Haven, CT: Yale University Press, 2000).

Terry, William Henry, *The Life and Times of John, Lord Finch* (London: Simpkin, Marshall, 1936).

Tesauro, Emmanuele, *Il cannochiale aristotelico* ([1654]; Rome: G. Hallé, 1664).

Thomas, Keith, "English Protestantism and Classical Art," in Gent (ed.), *Classicism* (1995), 221–38.

Thompson, Christopher, "The Divided Leadership of the House of Commons in 1629," in Sharpe (ed.), *Faction* (1985), 245–84.

Thompson, James Westfall, *A History of Historical Writing*, 2 vols (New York: Macmillan, 1942).

Thomson, William George, *A History of Tapestry* (East Ardley: E. P. Publishing, 1973^3).

Thornton, Peter, and Maurice Tomlin, "Franz Cleyn at Ham House," *National Trust Studies* (1980), 21–34.

Thrush, Andrew, "The French Marriage and the Origins of the 1614 Parliament," in Clucas and Davies (eds), *Crisis* (2003), 25–35.

Thrush, Andrew, and John P. Ferris, *The House of Commons 1604–1629*, 6 vols (Cambridge: Cambridge University Press, 2010).

Tillesley, Richard, *Animadversions upon M. Seldens History of Tithes* (London: J. Bill, 1619).

Tognoni, Federico, "Galileo nel terzo centenario della nascita: Eroe italiano a santo laico," *Galilaeana*, 1 (2004), 211–31.

Tognoni, Federico, "La Sapienza e il mito di Galilei: Storia di un monumento," in Romano Paolo Coppini and Alessandro Tosi (eds), *La Sapienza di Pisa* (Pisa: Plus, 2004), 161–83.

Tognoni, Federico, *"Naturamque novat": Simboli e significati delle medaglie di Galileo* (Pisa: ETS, 2013).

Tognoni, Federico, *Galileo: Il mito tra otto e novecento* (Pisa: Pacini, 2014).

Tomkis, Thomas, *Albumazar: A Comedy Presented before the Kings Majestie at Cambridge* (London: N. Oates for W. Burre, 1615).

Tonini, Camillo, "Appendice iconografica," in Pin (ed.), *Ripensando* (2006), 697–720.

Torrini, Maurizio, "Il caso Galileo nell'apologetica cattolica tra ottocento e novecento," *Galilaeana*, 7 (2010), 63–84.

Toomer, G. J., *John Selden: A Life in Scholarship*, 2 vols (Oxford: Oxford University Press, 2009).

Toynbee, Margaret, and Peter Young, *Strangers in Oxford: A Sidelight on the First Civil War, 1642–1646* (London: Phillimore, 1973).

Tracy, Richard, *Of the Preparation to the Crosse, and to Deathe* (London: T. Berthelet, 1540).

Tradescant, John, Jr, *Musaeum Tradescantianum: or, A Collection of Rarities* (London: J. Grismond, 1656).

Trevor, Douglas, *The Poetics of Melancholy in Early Modern England* (Cambridge: Cambridge University Press, 2004).

Trevor-Roper, Hugh R., *Catholics, Anglicans and Puritains: Seventeenth Century Essays* (London: Secker & Warburg, 1987).

Trevor-Roper, Hugh R., "Mayerne and his Manuscripts," in Howarth (ed.), *Art* (1993), 264–93.

Trevor-Roper, Hugh R., *Europe's Physician: The Various Lives of Sir Theodore de Mayerne* (New Haven, CT: Yale University Press, 2006).

Tucker, E. F. J., "Ruggle's Ignoramus and Humanistic Criticism of the Language of the Common Law," *Renaissance Quarterly*, 30 (1977), 341–50.

Turner, Anthony J., "Mathematical Instruments and the Education of a Gentleman," *AS* 30 (1973), 51–88.

Turner, Anthony J., "William Oughtred, Richard Delamain and the Horizontal Instrument in 17th-Century England," IMSS *Annali*, 6/2 (1981), 99–125.

Turner, Simon, "Van Dyck and Tapestry in England," *Tate Papers*, 17 (Spring 2012).

Tutino, Stefania, *Thomas White and the Blackloists: Between Politics and Theology during the English Civil War* (Aldershot: Ashgate, 2008).

Tyacke, Nicholas, "Science and Religion at Oxford before the Civil War," in Donald Pennington and Keith Thomas (eds), *Puritans and Revolutionaries: Essays in Seventeenth-Century History Presented to Christopher Hill* (Oxford: Oxford University Press, 1978), 73–93.

Tyacke, Nicholas, "Arminianism and English Culture," in A. C. Duke and C. A. Tamse (eds), *Church and State since the Reformation* (The Hague: Nijhoff, 1981), 94–117.

Tyacke, Nicholas, "Archbishop Laud," in Fincham (ed.), *Church* (1993), 51–70.

Tymme, Thomas, *A Dialogue Philosophical: Wherin Natures Secret Closet Is Opened … Together with the Wittie Invention of an Artificial Perpetual Motion* (London: T. S. for C. Knight, 1612).

Upton, Nicholas, *De studio militari*, ed. Edward Bysshe (London: R. Norton for J. Martin & J. Allestrye, 1654).

Urbánek, Vladimír, "The Comet of 1618: Eschatological Expectations and Political Prognostications during the Bohemian Revolt," in Christianson et al. (eds), *Tycho Brahe* (2002), 282–91.

Van Eerde, Katherine S., *Wenceslaus Hollar: Delineator of his Time* (Charlottesville: University Press of Virginia, 1970).

Van Eerde, Katherine S., *John Ogilby and the Taste of his Times* (Folkstone: Dawson, 1976).

Van Helden, Albert, *Catalogue of Early Telescopes* (Florence: Giunti, 1999).

Varley, Frederick John, *The Siege of Oxford: An Account of Oxford during the Civil War, 1642–1646* (Oxford: Oxford University Press, 1932).

Varley, Frederick John, *A Supplement to the Siege of Oxford* (Oxford: Oxford University Press, 1935).

Varley, Frederick John, *Mercurius aulicus: The Earliest Regular English Newspaper, Produced at Oxford during the Siege of 1643–1645* (Oxford: Blackwell, 1948).

Veevers, Erica, *Images of Love and Religion: Queen Henrietta Maria and Court Entertainments* (Cambridge: Cambridge University Press, 1989).

Venner, Tobias, *Via recta ad viam longam* (London: T.S. for Richard Moore, 1638).

Vicari, E. Patricia. "Saturn Culminating, Mars Ascending: The Fortunate/Unfortunate Horoscope of Robert Burton," in Patricia Brückmann (ed.) *Familiar Colloquy: Essays Presented to Arthur Edward Barker* (Ontario: Oberon, 1978), 36–112.

Victoria History of the Counties of England. Cumberland, 2 vols, ed. James Wilson (London: Constable, 1901–5).

Victoria History of the Counties of England. Dorset, ii, ed. William Page (London: Constable, 1908).

Victoria History of the Counties of England. Middlesex, iii, ed. Susan Reynolds (London: Oxford University Press, 1961).

Victoria History of the Counties of England. Oxford, iv, ed. Alan Crossley (London: Constable, 1979).

Victoria History of the Counties of England. Surrey, ii, ed. H. E. Malden (London: J. Street, 1905).

Victoria History of the Counties of England. Wiltshire, v, ed. R. B. Pugh and Elizabeth Crittall (Oxford: Oxford University Press, 1957).

Vigne, Randolph, "Mayerne and his Successors: Some Hugenot Physicians under the Stuarts," Royal College of Physicians, *Journal*, 20/3 (1986), 222–6.

Villani, Stefano, "Britain and the Papacy," in Visceglia (ed.), *Papato* (2013), 301–22.

Vinge, Louise, *The Five Senses: Studies in a Literary Tradition* (Lund: Lärmedel, 1975).

Virgil, *The Works*, trans. John Ogilby (London: T.R. and E.M. for John Cook, 1649; London: T. Warren, 1654).

Visceglia, Maria Antonietta (ed.), *Papato e politica internazionale nella prima età moderna* (Rome: Viella, 2013).

Walkington, Thomas, *The Opticke Glasse of Humours, or the Touchstone of a Golden Temperature* ([1607]; London: W. Turner, 1639).

Wallace, Andrew, "Placement, Gender, Pedagogy: Virgil's Fourth Georgic in Print," *Renaissance Quarterly*, 56 (2003), 377–407.

Wallace, W. M., *Sir Edwin Sandys and the First Parliament of James I* (Philadelphia: s.n., 1940).

Wallis, P. J., "William Oughtred's 'Circles of Proportion' and 'Trigonometries,'" *Transactions of the Cambridge Bibliographical Society*, 4/5 (1968), 372–82.

Walpole, Henry, *The Works*, 5 vols (London: Robinson and Edwards, 1798).

Walpole, Henry, *Anecdotes of Painting in England with Some Account of the Principal Artists*, ed. George Vertue and James Dalloway, 3 vols (London: Bohn, 1862); also in *Works* (1798), iii.

Walsham, Alexandra. *Church Papists: Catholicism, Conformity and Confessional Polemic in Early Modern England* (Woodbridge: Boydell, 1993).

Walten, Maximilian Graff, Introduction, Notes, and Appendix, in Fuller, *Holy State* (1938), vol. i.

Walton, Izaak, *Lives of John Donne, Henry Wotton, Richard Hooker, and George Herbert*, ed. Henry Morley (London: Routledge, 1888).

Warburton, B. E. G., *Memoirs of Prince Rupert and the Cavaliers*, 3 vols (London: s.n., 1849).

Ward, Seth, *Vindiciae academicarum* (Oxford: L. Litchfield for T. Robinson, 1654).

Warneke, Sara, *Images of the Educated Traveler in Early Modern Europe* (Leyden: Brill, 1995).

Waterhouse, Ellis Kirkham, "Salvator Rosa and Mr Altham," *Burlington Magazine*, 102/684 (1960), 122.

Waterworth, J., *The Canons and Decrees of the Sacred and Ecumenical Council of Trent* (London: Burns and Oates, 1889).

Watson, Andrew G., "Thomas Allen of Oxford and his Manuscripts," in M. B. Parkes and Andrew G. Watson (eds), *Medieval Scribes, Manuscripts and Libraries* (London: Scolar, 1978), 279–314.

Watson, F. J. B., "On the Early History of Collecting in England," *Burlington Magazine*, 85 (1944), 223–8.

Watson, Katherine, and Charles Avery, "Medici and Stuart: A Grand Ducal Gift of 'Giovanni Bologna' Bronzes for Henry Prince of Wales," *Burlington Magazine*, 115 (August 1973), 493–507; repr. in Avery, *European Sculpture* (1981), 94–113.

Webbe, Joseph, *Minae coelestes affectus aegrotantibus denunciantes hoc anno 1612* (Rome: G. Facciottus, 1612).

Weber, Kurt, *Lucius Cary, Second Viscount Falkland* (New York: Columbia University Press, 1940).

Wedderburn, John, *Quatuor problematum quae Martinus Horky contra Nuntium sidereum de quatuor planetis novis disputanda proposuit, Confutatio* (Padua: P. Marinelli, 1610) (OG iii/1. 149–78).

Wedgwood, C. V., *The King's War 1641–1647* ([1958]; New York: Book of the Month Club, 1991).

Wedgwood, C. V., *Thomas Wentworth, First Earl of Strafford 1593–1641: A Revaluation* ([1961]; London: Phoenix, 2000).

Weinberger, Jerry, "On the Miracles in Bacon's *New Atlantis*," in Price (ed.), *Bacon's New Atlantis* (2002), 106–28.

Weldon, Anthony, *The Court and Character of King James: Whereunto Is Now Added the Court of King Charles* (London: R. Ibbitson, 1651).

Werrett, Simon, *Fireworks: Pyrotechnic Arts & Sciences in European History* (Chicago: University of Chicago Press, 2010).

Westfall, Richard S., *Science and Religion in Seventeenth-Century England* (New Haven, CT: Yale University Press, 1958).

Westman, Robert S., *The Copernican Question* (Berkeley and Los Angeles: University of California Press, 2011).

Weston, Giulia Martina, "After Galileo: The Image of Science in Niccolò Tornioli's *Astronomers*," *Art History*, 39/2 (2016), 302–17.

Wharton, George, *An Astrological Judgment upon his Majesties Present March Begun from Oxford, May 7. 1645* (Oxford: H. Hall, 1645), in Wharton, *Works* (1683), 209–22.

Wharton, George, *The Works*, ed. John Gadbury (London: H.H. for John Leigh, 1683).

Whinney, Margaret, and Oliver Millar, *English Art 1625–1714* (Oxford: Oxford University Press, 1957).

White, Christopher, *Anthony van Dyck: Thomas Howard, the Earl of Arundel* (Malibu: Getty Museum, 1995).

White, John, and John Shearman, "Raphael's Tapestries and their Cartoons," *Art Bulletin*, 40 (1958), 193–221, 299–323.

White, Michelle Anne, *Henrietta Maria and the English Civil Wars* (Aldershot: Ashgate, 2006).

White, Peter, "The Via Media in the Early Stuart Church," in Fincham (ed.), *Church* (1993), 211–30.

Wilkins, John, *The Discovery of a World in the Moon* (London: Sparke and Forest, 1638).

Wilkins, John, *A Discourse Concerning a New World & Another Planet* (London: J. Maynard, 1640).

Wilkins, John, *Mercury, or, The Secret and Swift Messenger* (London: J. Maynard and T. Wilkins, 1641).

Wilkins, John, *The Mathematical and Philosophical Works* (London: J. Nicholson et al., 1708).

Wilks, Timothy, *The Court Culture of Prince Henry and his Circle*, 2 vols, D. Phil. Thesis, Oxford, 1988.

Wilks, Timothy, "The Picture Collection of Robert Carr, Earl of Somerset (c.1587–1645), Reconsidered," *Journal of the History of Collections*, 1/2 (1989), 167–77.

Wilks, Timothy, "Art Collecting of the English Court from the Death of Henry, Prince of Wales, to the Death of Anne of Denmark," *Journal of the History of Collections*, 9/1 (1997), 31–48.

Wilks, Timothy, "'Forbear the heat and haste of building:' Rivalries among the Designers at Prince Henry's Court, 1610–1612," *Court Historian*, 6/1 (2001), 49–65.

Wilks, Timothy, "The Peer, the Plantsman, and the Picture Maker: The English Embassy to the Court of Christian IV of Denmark 1603," *Court Historian*, 12/2 (2007), 155–71.

Wilks, Timothy (ed.), *Prince Henry Revisited: Image and Exemplarity in Early Modern England* (London: Paul Hoberton, 2007).

Wilks, Timothy, "Art, Architecture and Politics," in Barry Coward (ed.), *A Companion to Stuart Britain* (Oxford: Wiley-Blackwell, 2009), 187–213.

Williams, Ethel Carleton, *Anne of Denmark* (London: Longman, 1970).

Williams, Michael E., *The Venerable English College in Rome* (Leominster: Gracewing, 2008[2]).

Williamson, George, "Mutability, Decay, and Seventeenth Century Melancholy," *Journal of English Literary History*, 2 (1935), 121–50.

Williamson, George Charles, *Portrait Miniatures* (London: George Bell & Sons, 1898).

Wills, Garry, *Venice, Lion City: The Religion of Empire* (New York: Simon and Schuster, 2001).

Wilson, D. H., "James and his Literary Assistants," *HLQ* 8 (1944), 35–57.

Wilson, Jean S., "Sir Henry Spelman and the Royal Commission on Fees, 1622–1640," in J. Conway Davies (ed.), *Studies Presented to Sir Hilary Jenkinson* (London: Oxford University Press, 1957), 456–70.

Wilson, Michael I., *Nicholas Lanier: Master of the King's Musick* (Aldershot: Scolar Press, 1994).

Winton-Ely, John, "'Classic Ground': Britain, Italy, and the Grand Tour," *Eighteenth-Century Life*, 28/1 (2004), 136–65.

Wischnitzer-Bernstein, Rachel, "The Three Philosophers by Giorgione," *Gazette des beaux arts*, 27 (1945), 193–201.

Wither, George, *A Collection of Emblemes, Ancient and Modern* ([1635]; Columbia, SC: University of South Carolina Press, 1925).

Wohlwill, Emil, "Melanchthon und Copernicus," *Mitteilungen zur Geschichte der Medizin und Naturwissenschaften*, 3 (1904), 260–7.

Wolfe, Karin, "Protector and Protectorate: Cardinal Antonio Barberini's Art Diplomacy for the French Crown at the Papal Court," in Burke and Bury (eds), *Art* (2008), 113–32.

Wood, Jeremy, "Orazio Gentileschi and Some Netherlandish Artists in London: The Patronage of the Duke of Buckingham, Charles I and Henrietta Maria," *Simiolus*, 28/3 (2000–1), 103–28.

Wood, Jeremy, "Nicolas Lanier (1588–1666) and the Origins of Drawings Collecting in Stuart England," in Christopher Baker, Caroline Elam, and Genevieve Warwick (eds), *Collecting Prints and Drawings in Europe, c.1500–1750* (Aldershot: Ashgate, 2003), 85–122.

Woodford, Robert, *The Diary, 1637–1641*, ed. John Fielding (Cambridge: Cambridge University Press, 2012).

Woods, T. P. S., *Prelude to Civil War 1642: Mr Justice Malet and the Kentish Petitions* (Wilton: M. Russell, 1980).

Woodward, John, *Tudor and Stuart Drawings* (London: Faber and Faber, 1951).

Woolf, Daniel R. "John Selden, John Borough and Francis Bacon's *History of Henry VII*, 1621," *HLQ* 47 (1984), 47–53.

Worden, Blair, "Ben Jonson among the Historians," in Sharpe and Lake (eds), *Culture* (1993), 67–89.

Worsley, Giles, *Inigo Jones and the European Classicist Tradition* (New Haven, CT: Yale University Press, 2007).

Worsley, Lucy, *Cavalier: A Tale of Chivalry, Passion, and Good Horses* (London: Faber and Faber, 2007).

Wotton, Henry, *The Elements of Architecture: Collected…from the Best Authorities and Examples* (London: J. Bill, 1624; repr. Charlottesville, VA: University of Virginia Press, 1968).

Wotton, Henry, *A Parallel between Robert, Late Earl of Essex, and George, Late Duke of Buckingham* (London: s.n., 1641).

Wotton, Henry, *A Panegyrick of King Charles: Being Observations upon the Inclinations, Life, and Government of our Sovereign Lord the King* (London: R. Marriott, 1649).

Wotton, Henry, *A Philosophical Survey of Education, or Moral Architecture*, ed. H. S. Kermode (London: Hodder & Stoughton, 1938).

Wright, Louis B., "The Noble Savage of Madagascar in 1640," *JHI* 4 (1943), 112–18.

Wyld, Helen, [On Cleyn], in Moore, *Paston Treasure* (2018), 386–7.

Wyld, Helen, "Charles I and Raphael's 'Acts of the Apostles,'" in Royal Academy, *Charles I* (2018), 190–203.

Yarker, Jonathan, "A Question of Education," in Moore, *Paston Treasure* (2018), 238–43.

Zanardi, Mario, "Vita e esperienza di Emanuele Tesauro della Compagnia di Gesù," *Archivum historicum Societatis Jesu*, 47 (1978), 1–96.

Zittel, Klaus, "Zeichenkunst und Wissenschaft: Stefano della Bellas Frontispize zu Werken Galileo Galileis," in Albrecht et al. (eds), *Tintenfass* (2014), 369–403.

IMAGE CREDITS

Figure 1 National Trust Photographic Library/Derrick E. Witty/Bridgeman Images.

Figure 2 National Trust Photographic Library/Derrick E. Witty/Bridgeman Images.

Figure 3 Courtesy of The Linda Hall Library of Science, Engineering & Technology.

Figure 4 Courtesy of The Linda Hall Library of Science, Engineering & Technology.

Figure 5 Yale Center for British Art, Paul Mellon Collection.

Figure 6 Wellcome Collection (CC BY).

Figure 7 The Bodleian Libraries, University of Oxford (L.P. 85).

Figure 8 Bavarian State Library/Internet Archive.

Figure 9 Virginia Museum of Fine Arts, Richmond. Adolph D. and Wilkins C. Williams Fund. Photo: David Stover/© Virginia Museum of Fine Arts.

Figure 10 Galleria Palatina, Palazzo Pitti, Florence. Peter Horree/Alamy Stock Photo.

Figure 11 Courtesy of The Linda Hall Library of Science, Engineering & Technology.

Figure 12 Private collection. Photo © Philip Mould Ltd, London/Bridgeman Images.

Figure 13 Museo del Prado. Photo12/Ann Ronan Picture Library/age fotostock.

Figure 14 Private collection. Photo © Christie's Images/Bridgeman Images.

Figure 15 Tallguyuk/Wikimedia Commons (CC BY-SA 3.0).

Figure 16 Sudbury Hall, Derbyshire. National Trust Photographic Library/ Bridgeman Images.

Figure 17 The Bodleian Libraries, University of Oxford (4° W 9 (3) Art, p. 55).

Figure 18 The Walters Art Museum, Baltimore.

Figure 19 The Walters Art Museum, Baltimore.

Figure 20 Royal Collection Trust © Her Majesty Queen Elizabeth II, 2019. Bridgeman Images.

Figure 21 The Devonshire Collections, Chatsworth. Reproduced by permission of Chatsworth Settlement Trustees/Bridgeman Images.

Figure 57 The Bodleian Libraries, University of Oxford (Vet. A3 b.24, p. 160).
Figure 58 Governing Body of Christ Church College, Oxford.
Figure 59 Beinecke Rare Book and Manuscript Library, Yale University.
Figure 60 Courtesy of The Linda Hall Library of Science, Engineering & Technology.
Figure 61 Courtesy of The Linda Hall Library of Science, Engineering & Technology.
Figure 62 © The Norton Simon Foundation.
Figure 63 Yale Center for British Art, Paul Mellon Collection.

INDEX

Owing to the program used to assist readers of the digital text, indexed terms that span two pages (e.g., 52–53) may, on occasion, appear on only one of those pages. Titled people appear under their family names, except for Arundel. The asterisk indicates an entry in the Glossary.

*Abbot, George 17–18, 50–51, 55, 69–70, 182–183, 268–269, 311
 Trent 23, 25–26
Academ Roial 139–140
Accademia dei Lincei 35, 79–80
Act of Supremacy 100
Acteon 256–257, 280–282, 287–289
adiaphora. *See* irenicism
Aeneas. *See* Troy
*Aesculapius 290–292, 344–345
Aesop 298–300
ages of man 258–261, 263–266
*Albert VII, Archduke of Austria 28–31, 132
Alberti, Leon Battista 334
*Albumazar 206–207
alchemy 129, 236–237, 250–251
Alcinous 176–177
Alexander VI, Pope 350
*Allen, Thomas 187
almanac 202–203
Altham, Edward 97
alum 223–224
Ambrosian hymn 212
American Academy of Arts and Sciences 381
anamorphosis 255, 283
*Andrewes, Lancelot 27–28, 51–52, 60–61, 66
 learning 19, 56, 182–183
 religion 53–56, 67

 sermons 53–55, 60, 111, 113–115, 137–138, 174–175
 and Stuart kings 53, 70, 72
Anglicanism 72
*Anna of Denmark 47–50, 61–62, 127, 133, 145–146, 150, 271
 art and music 46–47, 152–153
 masques 145–150
*Anstruther, Sir Robert 266–268
antimasque 149
antiperistasis 68–69
Arabic and astronomy 311–313
arbitrary commitment 93–94;
 see also habeas corpus
Archie the Fool 66, 86–87
architecture 46–47, 224
 Banqueting Hall 143–145
argutezza 282–284
Ariosto 31–32, 154, 246, 266
Aristaeus 342–343
Aristarchus 180
Aristotle 4, 9–10, 73–74, 129, 171, 175
 art and rhetoric 275, 282–284, 292–293, 328–329, 373–374
 melancholy 238–239, 246
 physics 189–190, 194–195, 210, 232
Arminianism 54–55, 72, 91, 93–94, 308
*Arminius, Jacobus 54
array, commissions of 123–124

Arundel, Lady (Alethea Talbot) 46, 80,
 83–84, 146, 152–153
Arundel, Thomas Howard, 14th Earl
 of 96, 153–154, 222–223, 235–236,
 254–255, 323–325
 art 45–46, 135, 138–139, 152–153,
 158–159
 monopolist 109–110
 other culture 45–46, 138–139
 politics 82, 90
 religion 88–89, 120–121,
 158–159
 travels 123, 158–159, 235, 330–332
*Ashmole, Elias 319
astral history and politics 103, 128–129,
 176, 182–183, 197–199, 210
 Buckingham 209–210
 Charles I 199, 208–209, 295
 Wentworth 208–209;
 see also Astrology/Astronomy
astrologers 180–182, 184–185, 187, 195,
 319–322, 379–380
Astrologers, Society of 321–322
astrology 379–380
 argot 203–207
 Copernican theory 32–34, 197, 361
 natural 193–197, 200
 popes 195
 Stuarts 182, 197–199, 201–202,
 208–209, 295, 319–322
astrology/astronomy
 Church Fathers 194–196
 Coelum britannicum 163–165
 comets 88–89, 176, 180–183, 199–202,
 209–210
 conjunctions and trigons 139, 192–193,
 198–199, 210–211
 gentleman's dose 24, 127–128, 140,
 156–157, 163, 165–166, 196, 213,
 306–307, 332–333
 metaphors 47–48, 146–147, 248–252
astronomy 111, 170–172, 318
 fiction 368–369

history of 172–173, 176, 296–298,
 311–313
 in Sandy's Ovid 292–293
astronomy vs physics 169–172, 231–232
attainder 116–117
Aubrey, John 319
Augustus Caesar, Emperor 282–284
Austria 89, 104–105; see also Palatinate
*Aylesbury, Thomas 140, 318

Bacchus 74–75, 145–146, 287–289, 342
*Bacon, Francis 40–41, 96–97, 142,
 185–186, 292–293, 314
 his program 39, 141–143, 151–152, 218,
 362
 history and essays 41, 135, 137–140
 marriage and medicine 228–229, 249,
 341–342
 Novum organum 39–40, 142, 217–218,
 347–348, 368
 physical science 194, 217–218, 230
 Sarpi's group 38–41, 360, 367
*Bainbridge, John 180–183, 311–313
Baldi, Ottaviano (Wotton, Henry) 43
Bankes, Christopher 56–57
*Bankes, John 1, 4–8, 12, 304–305,
 309–310
 melancholy 238–241
 "our painting" 2, 312–314, 329, 332–333
 travels 338–339
*Bankes, Sir John 2, 4–8, 12, 56–57, 112,
 136–137, 220, 252–253, 282,
 301, 306–307, 315–316, 327,
 333–334, 380
 astrology/astronomy 103, 303–304
 and Charles I 100, 113, 115, 122–123,
 301–302
 Gray's Inn 58–59, 113–115
 Laud and Wentworth 60–61, 116–117,
 222–223
 legal career 95–97, 101–103,
 105–112, 116
 Oxford 57–58, 60–61, 73, 126, 314, 324

Parliament 59, 88–94, 122–126, 301–302
 personal 96–99, 107–108, 112, 114, 301,
 307, 309–310
 religion 53, 56–57, 60–61, 115
 technology 103–108, 238, 317–318,
 354, 362
*Bankes, Lady Mary 97, 99–100, 309–310
*Bankes, Sir Ralph 379–380
Banqueting Hall. See London
*Barberini, Francesco, Cardinal 35, 78–79,
 235–236
Barclay, John 363
*Barlow, William 153–154
Baskerville, Sir Simon 219
*Bastwick, John 75–76;
 see also triumvirate
Bath, England 341
Beast, Number of 21, 81, 138–139
*Bedell, William 20–21, 24–25, 223
Bedford, Earl of. See Russell, Francis
beer 109–110
bees 342–343
*Bellarmine, Robert 19–20, 24–25, 63–66,
 75–76, 190, 249
Benedict XVI, Pope 385
*Bentivoglio, Guido 28–31, 53, 78, 311, 359
 on England 49–50
 on Galileo 175–176
Berg, Sir Christopher van 107
Berkeley, Sir Robert 115
*Bernegger, Matthias 4, 176–177
Bernini, Gian Lorenzo 159
Berti, Gasparo 311
Bierberbach, Ludwig 386
Birkenhead, John 303
bishops 77, 82–83, 117
 tithes 137–138; see also divine right
bishops' wars 82–83, 110–111, 224–226
Blackfriars 158
Blacklo. See White, Thomas
*Blackwell, George 50
Blundeville, Thomas 135–136
*Bodley, Sir Thomas 8, 187

Bohemia, Kingdom of 63
Bolsover Castle 278, 281
Bolton, Edmund Mary 139–140
Bon, Ottaviano 311–312
Bonham, Thomas 237
Boswell, Sir William 84
*Brahe, Tycho. 137–138, 163–164, 170, 257,
 280–282, 295, 322, 351–353, 373–374
 his system 170–171, 183–184, 251
 and James I 127–128
Bramhall, John 220, 226
Brandmüller, Walter 384–385
Brecht, Berhold 386–387
*Brent, Nathaniel 73, 162, 301–302, 311,
 314–315
 and Sarpi's Trent 23, 82, 353
Brewster, David, Sir 382
British Museum 298
*Bruno, Giordano 17–18, 35, 179, 186
 Coelum britannicum 164–165
 his monument 355
Brute, founder of Britain 139
*Buchanan, George 128, 153, 170
Buckingham, Lady 108
bugonia 342–343
*Burton, Henry 67, 75–77, 184;
 see also triumvirs
*Burton, Robert 11, 45, 239–240, 243–245
 extremes of melancholy 241–249
 horoscope 243–245
 Philosophaster 252–253
 world system 245–246, 248–252
Buckingham. See Villiers, George

Cabeo, Niccolò 231–232
Cadiz 90–91
Cadmus 287–289
Caesar, Julius, his comet 285, 290–292
*Caesar, Sir Julius 51–52
calendar reform 35–36, 93–94, 107–108,
 134, 292–293, 313, 362
Calvin and Calvinists 17, 49
 on astrology 193–194

Cambridge University 91, 134, 162, 180
 and Bacon 347–349
 entertains James I 150–151, 206–207
 satirizes Oxford 253
*Camden, William 135, 139
*Campanella, Tommaso 189, 198–199
 on Galileo 187–188
 Urban 195
Candeman, Thomas 109, 237–238
Canterbury, Archbishops of 17–18,
 50–51, 72, 182–183, 219, 319
Cardano, Girolamo 321
Carew, Thomas *Coelum britannicum*
 163–165
*Carleton, Dudley 23, 46, 150, 155, 158
*Carleton, George 23, 194–195
*Carlo Emanuele II, Duke of Savoy
 61–62, 68
*Carpenter, Nathaniel 183–184
*Carr, Robert, 1st Earl of Somerset 46,
 87–88, 136
Cartwright, William 203
*Cary, Lucius, 2nd Viscount
 Falkland 125–126, 316–317, 319
caterpillars of the republic 112
Catholics in England 11–12, 49–50,
 56–57, 60, 78, 82, 133–134, 247
 art and culture 140, 152–153
 Civil War 93–94, 307–308
 emancipation 62–66, 68, 70, 77–78,
 85, 238
 and Rome 78–81, 184–186, 195,
 307–308, 366
 Stuart queens 49–50, 61–66
Cavaliers 308–309, 323–325, 337
*Cavendish, William, 2nd Earl of
 Devonshire 41
*Cavendish, William, 1st Duke of
 Newcastle 163, 278, 313–314
 Bolsover riddle 279–281
 his circle 184–187, 279–280
*Cecil, Robert, 1st Earl of Salisbury
 28–32, 87–88
*Cesi, Federico 35

Ceyx and Alcyone 289–290
Chapels Royal 56, 85
Chardin, Teilhard de 384
*Charles I, King of England 4–7, 12, 46,
 94, 136, 145, 166, 280–282,
 284–285, 317, 322–323, 347
 art 99, 145, 157–162, 350
 astrology/astronomy 70–71, 155–157,
 295, 320–322
 and Catholics 50–51, 77–78, 80–81, 85,
 159, 307–308, 359
 character 69–71, 85, 96, 113, 124–125,
 303–305, 307
 doctors 220, 231, 234–237
 finances 82–83, 86, 90–92, 94–96,
 101–106, 120–121, 224
 Galileo 363–365
 government 67–68, 94–96, 104–105,
 112, 115–116, 118–121
 masques and plays 151–152, 162–163,
 167–168
 prerogative/privilege 71, 93–94,
 165, 306
 as Prince of Wales 62–67, 79
 religion 72, 93–94, 365
 travels 73–74, 80–83, 118, 120–122, 126,
 208–209, 301–302
 and Wentworth 116–117, 224–226, 365
Charles II, King of England 71–72,
 95–96, 121, 322, 380
*Charles–Louis, Elector Palatine 334–336
*Charleton, Walter 314
Chelsea College 140–141
*Chilmead, Edmund 178–179, 239–240, 314
Choissay, Aegidius 85
*Christian IV, King of Denmark 46–47,
 51–53, 62, 92, 257
 art 145, 152, 255–257, 266–267
 astronomy 257–259
 and English wars 82–83, 121, 266–268
*Christina of Loraine 37–38
*Ciampoli, Giovanni 79–80, 174–175
Civil War 125–126, 304–305, 323–326
 astrology 319–322

attempts to avert 122–126
Oxford 301–305, 307–308, 322–323
Clarendon, Earl of. *See* Hyde, Edward
*Clavius, Christoph 15–37, 196
Clayton, Thomas 316
*Clement VIII, Pope 15–17, 79–80
*Cleyn, Francis 7, 11–12, 112, 160, 177,
229–230, 235, 255–256, 268–269,
339–340
book illustrator 8, 284–285, 293,
295–300
Denmark and Italy 221–226, 260–267
with Dobson and Jones 268, 323–326
family 268–269, 333–334, 339–340
house decorator 278, 280–282
Last Supper 318–319
learning 240–241, 243, 284, 298,
334–336
"our painting" 1–3, 259–263, 286–292,
329–330, 332–337, 372–375
portraitist 266, 326–329, 333–334
storyteller 254–255, 286–292
tapestry designer 4–7, 145, 269–278, 350
coffee 228
*Coke, Sir Edward 91–92, 97–99, 123
Coke, Sir John 73
Colepeper, John 125–126
Collins, Samuel 162
Columbus 36–37, 374
comet. *See* astrology/astronomy
Common Pleas, Court of 113, 115, 122, 237
*Conn, George 83–84, 128, 186–187, 359
art 151–152, 158–159
"Connverts" 17, 78–81
Galileo 174–175
conversions 179, 210, 226–228
Conway, Edward, 2nd Viscount 361
Copenhagen 257–259
Rosenborg 255–256, 258–259, 266
*Copernicus, Nicholas, and his System 4,
31–32, 38–39, 44, 129–131, 166,
170, 196
adherents 8–10, 17–18, 177–184, 191;
see also Galileo, Kepler

counterintuitive 211–213
fence sitters 12, 37, 197, 230–232,
249–252, 360
lunar voyages 189
metaphors 180–182, 205,
207–211, 361
opponents 14, 32–34, 35–36, 37, 39, 69,
79–80, 184, 189–190
Corbet, Richard 201–202
Corfe Castle 97–100, 123, 282
besieged 309–310
*Coryate, Thomas 42, 44–45, 154
Cosimo II, Grand Duke of Tuscany.
See under Medici
Cosin, John 72
*Cottington, Sir Francis 67, 77–78, 88–89,
96–97, 109, 158
*Cotton, Sir Robert 135–137, 140,
182, 284
Rayne of Henry III 136
Cottrell, Sir Charles 325–326
Council of Trent 19–23, 27–28, 37–38;
see also Sarpi
Cowley, Abraham 337
*Crane, Sir Francis 268–269, 271–272
Cranford, Lionel 88–90
Crawley, Sir Edward 102–103
Cressy, Hugh 226–228
Cromwell, Oliver 103, 140–141, 327,
339–340, 379–380
Crosswaithe, Cumberland 57
currants 109–110
customs charges 104, 109, 111;
see also T&P

dancing 146–147, 222, 249–250, 361
Daniel, Prophet 347–348, 377
*Daniel, Samuel 47–48, 149–150
Twelve Goddesses 147
*Davenant, William 298, 330–332
Salmacida spolia and *Britannia
triumphans* 165–166
Temple of Love and *Luminalia* 166
Gondibert 210

Davies, John 147
Davys, Thomas 107–108
deafforestation 104, 117–118
*De Caus, Solomon 154–155
*De Dominis, Marc'Antonio 19–20,
 25–26, 31–32, 41, 51, 69–70, 151–152
 return to Rome 25–27, 68–69
 and Sarpi's group 24, 27, 31
 writings 24–26
*Dee, Arthur 236–237
*Dee, John 4–7, 93, 135–136, 182, 187, 196,
 209, 218–219, 221, 344
 angelic conversations 269
*Delamain, Richard 155–157, 209
*Della Bella, Stefano 9–10, 344
Della Porta, Giambattista 206, 344–345
*Democritus 245–246, 249–250
Denham, John *The Sophy* 168
Descartes 187, 218
*De' Servi, Costantino 153–155
*Devereux, Robert, 2nd Earl of Essex 43
*Devereux, Robert, 3rd Earl of Essex
 124–125, 322–323
Devil, the 35–37, 133–134, 251
 inventor of astrology 194–195
*D'Ewes, Sir Simonds 91, 103
Deza, Diego 374–375
dialectics 296–298
Digby, John, 1st Earl of Bristol 88–89
*Digby, Sir Kenelm 67–68, 110, 140,
 186–187, 292–293
*Digges, Sir Dudley 91, 96, 209–210, 286
*Digges, Thomas 171–172, 209
*Diodati, Elie 176–177
*Diodati, Jean 21, 176–177
dissimulation. *See* masquerade
divine right 53–54, 72–73, 90, 93, 101,
 137–138, 145
*Dobson, William 323–327
doge 18–19, 21, 356–357
 demotion to 82, 87, 117–120, 125–126, 128
*Donne, John 139–140, 250, 373
 Ignatius his Conclave 35–37, 188–189
 Second Anniversary 37

Dort, Synod of 54–55
Dou, Gerrit 334–336
Douai 50, 186
dowry 61–63
drainage 103–104, 106–107
Drake, William 27–28
*Drebbel, Cornelius 129–133, 154
drink 145, 341–342, 344; *see also* feasts
 distilling 110, 238
Drummond, William 250–251
Dublin 222, 224, 316
*Duppa, Brian 315, 318–319, 360
Dürer, Albrecht 241–242, 247, 263
*Dutton, Sir John 325, 327

*Earle, John 318–319
East India Company 108
Edgehill, Battle of 126
Edict of Nantes 15
Edinburgh 82, 145–146, 208–209
Eglisham, George 54–55
elements, four 272–274, 286–287, 292
*Eliot, Sir John 91, 94–95
*Elizabeth I, Queen of England
 43, 98–99, 135
Elizabeth Stuart, Queen of Bohemia.
 See Stuart, Elizabeth
emblems 1, 381–387; *see also*
 hieroglyphs
English character 49, 139, 321, 363
 and Italy 154–155, 158
English constitution 100, 139, 305–306;
 see also prerogative/privilege
eppure si muove 381–385
Essex, Earls of. *See* Devereux
Evelyn, John 333–334

Falkland, Viscount. *See* Cary, Lucius
Fanshaw family 302
feasts 52, 62, 72, 154
Feingold, Mordechai 182–183
*Felton, John 94, 238–239
fens. *See* drainage
Ferdinando I, Grand Duke of Tuscany 43

Feyerabend, Paul 386–387
Ficino, Marsilio 241
*Fiennes, William, 1st Viscount Saye and
 Sele 122, 125–126
*Finch, Sir John 58, 96–97, 115, 122
 Parliament (1626) 95
fines and forfeitures 108–110
 recusancy 50, 71–72, 77–78, 92, 104, 112
fireworks 263–266
fish, pious 134
fisheries 108, 145–146
Five Knights Case 91–92
Fletcher, John 205
Florence, Italy 348, 385
 Santa Croce 312, 355
foolosophy 28–31, 39, 216
*Fortescue, George 34–35, 140
Foster, Samuel 183–184
*Frederick V, Elector Palatine, King of
 Bohemia 61–63, 90, 271
frogs 229–230, 299–300
frontispieces 284–285, 305–306, 351
 Cleyn's 283, 293, 295
 Della Bella's 5, 9–10, 344–345, 351
 Marshall's 192, 345, 347–348, 366
 stagesets 47–48, 351
 world systems 5–6, 130, 177, 191–192,
 351–352, 358
*Fuller, Thomas 332–333
 Holy State 305–307
fuller's earth 111
fuzzy thinking 357–358;
 see also prerogative/privilege

Gadbury, John 379–380
*Gage, George 63, 140
*Gage, George (priest) 83–84
*Galen 287–289
*Galilei, Galileo 10, 32–35, 38–39, 174, 178,
 180, 186, 207–208, 218–219
 ambiguity 356–358, 362, 366–367, 373,
 381–387
 astronomy 8–9, 31–32, 37–38, 171,
 189–190, 202, 313, 351–353

Bentivoglio and Urban 28–31, 172–176,
 354–355
 character 31–32, 187, 250, 344–345,
 360, 381–382, 387
 Compasso and Saggiatore 155–156,
 172–174, 176
 Dialogue 8–10, 35, 79–80, 175–177,
 183–185
 frontispiece 3–6, 9–10, 197
 English commentators 17, 36–40, 190,
 250, 356, 367–368
 epistemology 9–10, 185, 368, 370, 378
 hermeneutics 37–38, 176–177, 212,
 306–307, 384–385
 humanist 246, 266, 348–350, 387
 mechanics 231, 361, 370
 and Oxford 8, 313–314, 318–319, 333
 and Rome 3–4, 32–35, 37–38, 78, 172–175,
 184–185, 190, 359–360, 366, 381
 Sidereus nuncius 8–9, 31–32, 39–40,
 154, 178
 tides 15–40, 131–133, 370
Galilei, Vincenzo 154
gap of merit 344–351
Garter, Order of 121, 159, 318–319
Gell, Robert 321–322
*Gellibrand, Henry 183–185
Gentileschi, Artemisia 160
Gentileschi, Orazio 160
*Geree, John 77, 194–195
Gheeraerts, Marcus 298
Gherardi, Silvestro 382
Gheyn, Johannes II 241–242, 244
Giambologna 155
Giorgione 350–351
*Godwin, Francis 188
Gondomar. See Sarmiento de Acuña,
 Diego, Conde de
Gonzaga collection 158
Gonzales, Domingo 188
gout 219, 221
Grand Remonstrance 118
gravity and levity 217–218, 230–231
Gray's Inn. See London

Great Seal 122
Great Tew 316–319
*Greaves, Sir Edward 236, 302–303, 312–313
*Greaves, John 311–315, 332–333, 353
Greaves, Thomas 312–313
*Green, Giles 123, 310
greenwax 110
Gregory XV, Pope 25–27, 68–69
Greville, Robert, 2nd baron Brooke 211
Grienberger, Christoph 34–35
grievances 92–93, 118, 224–225;
 see also T&P
grotesque 256–257, 266, 274
Grotius, Hugo 105
Gunpowder Plot 24, 53–54, 177–178

habeas corpus 89–90, 93, 95
Habington, John 168
Haddon Hall 274
*Hall, Joseph 28–31, 42–43, 67
Hall, William 61
Ham House 280–282
Hamond, Walter 332
*Hampden, John 101–102, 118–119, 322–323
Hampton Court 50–51, 118–119, 322
*Harington, Sir John 60, 149, 154
*Harriot, Thomas 177–178
*Harvey, William 234–236, 311, 314–315,
 366–367
*Hatton, Sir Christopher 98–99
*Hatton, Lady Elizabeth 98–99
*Hatton, Sir William 98–99
Hawtrey, Mary. See Bankes, Lady Mary
Hawtrey, Ralph 97
*Heath, Sir Robert 91–93, 96–97, 136–137
*Heckstetter family 57–58, 106–107
Heidelberg 25–26, 154–155, 256–257
*Henrietta Maria, Queen of England 4–7,
 70, 74, 95–96, 162–163, 221, 302,
 323–325
 and Charles I 71–72, 85, 118–119;
 see also Masques
 Civil War 120–121, 301–305, 308

religion 71–72, 77–80, 83,
 96–97, 159
Henry III, King of England 136
*Henry IV, King of France 24, 53–54,
 145
*Henry, Prince of Wales 46–47, 70–71,
 153, 179–180, 233–234
 brides 61–62
 entourage 71, 153–155
Hercules 290–292, 298, 347–348, 377
Hero and Leander 272–274, 289–290
herrings, red 107–108
*Heydon, Sir Christopher 197, 319, 361
*Heydon, Sir John 319
*Heylin, Peter 27–28, 74, 303
 Mikrokosmos 27–28, 315, 332
hieroglyph 1, 47–48, 149, 207
 Aesop's 298–300; see also Astrology/
 Astronomy; Emblem
*Hill, Nicolas 179, 200
Hippocrates 245–246
Hippolytus 290–292
historical study 128, 135–138, 306–307
 and astrology/astronomy 171–173,
 176, 213
Hitler, Adolf 386
*Hobbes, Thomas 68, 187, 218, 313–314
 and Galileo 184–185, 370
Holbein, Hans 158–159
*Hollar, Wenceslaus 160, 235, 323–325
*Holles, Denzil 122, 124–125
Holmes, Sherlock 12
Holstein, Lucas 311
Honthorst, Gerard van 163
Horace 282–284, 286–287
Horky, Martin 32–34
*Howard, Alethea, Lady Arundel.
 See Arundel, Lady
Howard, Frances 87–88
*Howard, Henry, 1st Earl of
 Northampton 87–88,
 199–200
Howard, Philip, Saint 88

*Howard, Thomas, 14th Earl of Arundel.
 See Arundel
*Howard, Thomas, 1st Earl of Suffolk
 87–88
*Howard, Lord William 45–46, 60, 90
 culture 45, 60, 136–137
 and Sir John Bankes 55, 59–60
*Howell, James 67–68, 208
Hues, Robert 178–179, 314
Hull Arsenal 121
humors, four 229–230, 278;
 see also melancholy
Huntington, Henry, Lord Hastings 295
Hven. *See* Uraniborg
*Hyde, Edward 122, 316–319

*Ignatius of Loyola, Saint 35–37, 188–189
impositions 86–87
Index of Prohibited Books 16, 19–20,
 37–38, 174, 186, 257, 386
indulgences 16–17
Ingoli, Francesco 174
innovation/restoration 212, 300,
 356–357, 362, 376–377
 church 40, 186
 in Hell 24–25, 362
 politics 82, 93, 95, 101; *see also*
 novelty
Inns of Court 58–59; *see also* London
Inquisition 14, 16, 69
 and Copernicus 14, 37, 69
instruments 131–133, 154–157,
 167, 330
intelligencers 141–142, 160, 257, 268
 Cleyn 266–268
Ireland 37, 229
 under Wentworth 85, 219–220,
 222–224
irenicism 15–16, 68–69, 128–129, 176,
 285–286
 adiaphora 51–52, 317–318
 astrology/astronomy 182, 197
Isaacson, Henry 213–214

*Isaacszon, Pieter 255–256, 258–259, 266,
 268, 287–289
*Isham, Justinian 315, 339
Italy, attractions 17, 42–45
 travels around 42–45, 312, 338–339

Jackson, Gilbert 333–334
James II, King of England 156–157
*James VI and I, King of Scotland and
 England 14–16, 28, 37, 43, 75–76
 astrology/astronomy 32, 127–128,
 170–171, 193–194, 200–201, 322
 Banqueting Hall 143–145
 cultural connections 128, 135–145,
 149–151, 170, 268–269
 death and doctors 70, 234, 359
 dynastic connections 52, 61–66, 127,
 266–268
 government by divine right 19, 24,
 62–63, 86–89, 137
 religion 49–51, 53–55, 81, 140–141
 Selden 104–105, 137–138
 and Venice 23–24, 52–53, 55, 68
 witchcraft 133–134
Jerusalem 285–286
Jesuits 16, 42–43, 54–55, 69–70, 384–385
 denigrated 19–20, 35–37, 83–84
 entertainments 104–105, 235–236
 world system 28–31, 34–35, 171, 221–222
Jews 18, 42, 229, 308
Job 113–115
John I, King of England 98–99
John Paul II, Pope 384–385
*Jones, Inigo 139–140, 149–150, 153–154,
 165, 224, 229–230, 328–329
 building 143–145, 157, 159, 280
 and Italy 10–11, 46–48
 masques 147, 149–150, 163
*Jonson, Ben 42, 58, 139–140, 149–150, 179
 astrology/astronomy 35, 151, 204–205
 Hero and Leander 274
 masques and plays 18–19, 136–137,
 147–150, 152, 163, 220

Joshua 129–131, 171
Jubilee of 1600 14–17
*Junius, Franciscus 159–160, 334–336
*Juxton, William 182–183, 311

*Kepler, Johannes 40, 44, 51, 128–129, 176,
 191, 197, 386
 world system 35, 128–129, 171–172,
 198–199, 202, 353
Keswick 56–57, 106–107
King James Bible 53–54, 141, 180–182
King's Bench, Court of 91–94, 115
Kingston Lacy 12, 97, 310, 380
Kircher, Athanasius 231–232, 311
Knole House 275–278
Koestler, Arthur 386–387

Lachrymae musarum 296–298
Lanier, Nicholas 152, 274, 325–326
Lansbergen, Philipp 351
La Rochelle 90, 92–94
Last Supper attributed to Cleyn 318–319
latitude and longitude 312–313
*Laud, William 12, 51, 81, 90, 98–99,
 105–106, 110, 157, 179–180,
 268–269, 303
 Bankes, Wentworth and Williams 61,
 96–97, 219–223
 and Oxford 73, 182–183, 311
 religion 73–76, 78, 81–84, 101,
 317–318
Laurent, Jean Antoine 381
law 59, 89–90
 of the sea 105, 137–138, 235–236
lawyers 139, 150–151
 antiquarians 135–139
 as Charles' instruments 115–116
Lee, Tsung–Dao 385
Lely, Peter 379–380
Leo X, Pope 21–23
liberal arts, seven 259–263, 295–298
libraries 135–136, 141–142, 310–311
Lievens, Jan 334–336
*Lilly, William 320–322

*Lister, Sir Mathew 220, 236
*Littleton, Sir Edward 102, 108
logarithms 155–156, 182
*Lomazzo, Giovanni Paolo 11, 334
Lombard, Peter 37
London 103–104, 157, 272, 320–321
 City of, and Livery Companies
 118–119, 160–162, 238
 College of Physicians 218–219, 221,
 237–238, 314, 341
 Covent Garden 157, 339
 elsewhere 60–61, 143, 157, 183–184,
 280, 311
 Gray's Inn 57–58, 61, 97, 113–115, 151,
 338–339, 344
 Tower, guests of 75, 88, 90–91, 95,
 177–178, 225–226
*Longomontanus, Christian
 Sørenson 257–259, 351–353
Lotti, Ottaviano 32, 154
*Louis XIII, King of France 70, 82, 90
Lucian 188–189
Ludovisi, Ludovico, Cardinal 69
*Lumley, Lord John 152–153, 155
Luther 16–17
*Lydiat, Thomas 179–180
Lyly, John 204–205
Lyme Park 272
Lynxes. *See* Accademia dei Lincei

Machiavelli 36–37, 62–63, 196–197
Madagascar 109–110, 330–332
Madrid 63–66
Maffi, Pietro 383–384
Magna carta 91–93, 98–99, 139
man machine 232–233
Marcley Hill, Herefordshire 321–322
Margaret, Duchess of Newcastle
 278
*Maria Anna, Infanta of Spain 63, 65–68,
 104–105
Maria Maddelena of Austria 154
Marlow, Christopher 274
Marmion, Shackerly 207

*Marshall, William 192, 305–306, 345, 347–349
Mary, Queen of Scots 78–80, 128
masquerade 10, 42–44
masques 145–150, 167, 371–372
 cost 146–149
 politics of 147, 151–152, 162–163, 167–168
Massinger, Philip 205–206
mathematics, misdirected 40–41, 241–242, 371–372
 to art 370–371
*Matthew, Tobie 17, 39–40, 42–43, 83–84, 108, 140
 and Bacon 38–39, 41
 Spanish match 63, 66–68
*Matthew, Tobie, Archbishop 85
Mawhood, Jane (Lady Williams) 220
Maximilian I, Duke of Bavaria 104–105, 266–268
*Mayerne, Théodore Turquet de 221, 233–234, 236–238, 295, 314
 distilling 110, 238
Maynard, Sir John 310
*Mayne, Jasper 112, 315
*Medici, Cosimo II, Grand Duke of Tuscany 41, 61–62, 154–155
*Medici, Marie de', Queen of France 61–62, 70, 82, 263
medicine 221, 228–230; see also physicians, royal
 Bacon's 228–229
 licensing 237–238; see also London, Royal College
 melancholy 238–240, 245–249
melancholy 73–74, 302–303, 341
 defined 238–240, 245–246, 334, 371
 extremes 240–241, 245, 247–249, 252, 319
 scholars 11, 211, 240–242, 306–307, 329, 339, 371
*Melanchthon, Philip 193
Menippus 188–189
Mercator 154
Merchant Adventurers 89–90

Mercurio, Girolamo 342
Mercurius aulicus 303–304
metempsychosis 165, 290–292
*Micanzio, Fulgenzio 20–21, 38–39
 on Bacon 40–41
 on kings and popes 21, 26, 50–69
 on Sarpi's group 24, 26–27, 68–69, 176
Middleton, Thomas 69–70
Militia Bill 119–120, 123–124
 and Sir John Bankes 123
*Milton, John 13, 356
mining 57, 97, 106–107
mixed government. See English constitution; prerogative/ privilege
*Modena, Leone 42
monopolies 92–93, 106–109
 Statute of Monopolies 106, 110
Monson, Sir John 107
*Montagu, Richard 55
moon voyages 31, 35, 151, 187–188, 246, 313–314
 and Copernican theory 188–189
More, Henry 211–212
More, Thomas 249
Morley, George 318–319
Morpeth 90, 92
Mortlake works 4–8, 112, 145, 223–224, 268–272, 280, 284, 339–340
 yield 268–269, 282
Moryson, Fynes 42–43
Murray, William 280–282
muses, nine 295
music and musicians 152
 and Copernican system 314;
 see also dancing, Kepler
Mussolini, Benito 386
Mycilius 290–292
*Mytens, Daniel 46, 64

Napier, John 155–156
Narcissus 287–289
Nardi, Giovanni 344–345
Naseby, Battle of 321

National Trust 272, 275–278, 326–327
*Neile, Richard 72
Nero, Roman emperor 256–257
New England 73–74, 220
Newton, Adam 154
*Nijs, Daniel 23, 46, 158
Niobe 289
Noble Horses 289
noli me tangere 55, 77, 198–199
*Norgate, Edward 45–46, 272, 326–328
Northumberland, Earls of. See Percy
novelty 129, 190, 250–251, 363
 vs renewal 51–52, 93, 95, 101, 200;
 see also innovation/restoration
*Noy, William 74, 94, 96–97, 116, 136–137
 novel taxes 101–102, 104

Oath of Allegiance 24, 26–27, 50, 81, 186,
 365–366
*Ogilby, John 222, 298–300, 339
*Oliver, Isaac 152
omens 127, 134, 321
 comets 200–202;
 see also astrology; witchcraft
opium 228
*Oughtred, William 156–157
Ovid 284–292
Oxford 17–18, 73, 85, 128, 162, 217,
 252–253, 285–286, 307–308,
 314–315, 324
 astrology/astronomy 8, 156, 180–183,
 187–188, 196–197, 201–203,
 314–315, 319–320, 333
 and Bacon 141, 347–349
 and the Bankes 57–58, 60–61,
 73, 301
 Bodleian Library 8, 155, 162
 Civil War 126, 301–305, 307–308,
 314–315, 323–326
 Dominus illuminatio mea 378
 Technogamia 151, 207–208
Oxford colleges
 All Souls 54, 303, 318
 Balliol 311, 333

Christ Church 73, 112, 178–179,
 184–185, 201–203, 239–240,
 251–252, 315, 318, 333
 halls, Gloucester and St Mary's
 177–178, 187
 Merton 162, 182–183, 311, 314–315
 Oriel 217, 301–303, 332–333
 other 182–184, 302–303, 312–313
 Queen's 28, 56–58, 333
 St John's 179, 217–219, 275–278,
 326, 333

Padua, University of 14, 75–76, 217,
 237–238, 311–313
painting 45, 159, 218–219, 284, 334–336
 collecting 152–153, 158–162
 and mathematics 370–371
Palatinate 66, 68, 70, 87, 104–105,
 266–268
 Arundel's mission 235–236
*Palladio 46–47, 143, 145, 229–230
Pallavicino, Sforza 174–175
Panzani, Gregorio 78, 81
papal agents 78–81
papal soap 109
*Paracelsus 36–37, 220–221
parallax 170–172, 202, 282–284
Parker, Henry 120
Parker, Thomas 44–45
Parliaments 95, 301–302, 314–315
 and Sir John Bankes 88–94, 122,
 309–310
 Charles I's 83, 85 (1629), 94–95,
 117–119 (1640–1), 125–126 (1642)
 James I's 70, 86–87
Parmigianino 254–255
Paschini, Pio 384–385
Patrizzi, Francesco 135–136
*Paul V, Pope 21, 24, 37–38, 201, 257
 interdict 19–20
Paul VI, Pope 384
Paul, Saint 317
*Payne, Robert 101, 317–318, 333
*Peacham, Henry 13, 45–46, 196, 332–333

Peake, Robert 295
*Percy, Algernon, 10th Earl of
 Northumberland 116, 122
 and Sir John Bankes 124–126
*Percy, Henry, 9th Earl of Northumberland
 (Wizard Earl) 177–178, 318
Perseus and Andromeda 278–279, 289
Perth, Articles of 81–82
Pesaro, Jacopo 350
Petition of Right 93–95
Phaeton 292–293
Pharmacopoeia Londinensis 221, 238
Philip III, King of Spain 25–26, 61–62
*Philip IV, King of Spain 63–66,
 69–70, 90
physicians, royal 151, 220–221, 234–238
 deaths of royals 233–234, 236
piracy 70, 102, 105, 186–187, 223
Pisa 217–218, 382–384
Pitman, Colonel 310
planetary motion 169–172
 physics of 231–232
Plutarch 31–32, 342
Pococke, Edward 312–313
Polidoro da Caravaggio 275–278,
 280–282
politics, of masques 147, 151–152,
 166–168
 of portraits 160–162
Polybius 176
Pontanus, Johannes Isaacsz 178–179
popish plots 43, 83–85; *see also*
 Gunpowder Plot
*Porter, Sir Endymion 67–68, 83–84, 121,
 140, 158, 275–278, 317, 325,
 330–332
 monopolist 108–109
Porter, Lady Olivia 80
portraiture 11, 154–155, 159, 161, 323–326,
 334–336
 distrust of 327–329
 politics 160–162, 337
 theory 326, 334–336
Potter, Christopher 28

Poupard, Paul 384–385
powder of sympathy 67–68
Pratt, Roger 380
prerogative/privilege 86–87, 102–103,
 125–126, 305–307
 Sir John Bankes on 91, 93, 100, 357
Privy Council 66, 83, 88–91, 116, 224
 and Sir John Bankes 96, 113,
 301–302
 war measures 224–225
Protestants 49–50, 268–269, 307–309
 Puritans 74, 77
 Tew variety 317–318
 Venetian 18, 21
Prudentius (Charles I) 73–74, 167
*Prynne, William 162–163, 208
 targets 72, 74–76, 327–329
 triumph 75–77, 83–84;
 see also triumvirs
Ptolemaic system 4, 9–10, 129–130,
 169–170, 311–312, 320–321
*Ptolemy 139, 178, 212, 295
pursuivant 108–109
purveyance 86–87
*Pym, John 116, 118–119
Pythagoras 290–292

*Quarles, Francis 213–216, 363
*Quarles, John 345, 365
quintessence 169–170, 292–293
Qur'an 313

Radcliffe, George 226
Raleigh, Sir Walter 62–63
Raphael cartoons 145, 155–156, 269–271,
 339–340
Ray, John 111
recusancy laws 63–66, 112
Renan, Ernest 385–386
Rheticus, Georg 198
rhetoric 282–284
Ribera, José de 275
Robert-Fleury, Joseph-Nicolas 381
*Robinson, Giles 57

*Robinson, Henry 56–58
Robusti, Domenico 46
Rome 16–17, 217–218, 263, 265, 303, 385
 Collegio Romano 28–31, 34
 English College 17, 56–57, 188–189,
 207, 311
*Ross, Alexander 189–190, 313, 359–360
 on sects 308–309
Rossetti, Carlo 85
Rostock 255–256, 258–259
Rowlett, Thomas 295
*Rubens, Sir Peter Paul 143–145, 160, 263,
 269–271
Ruggle, George 150–151
*Rupert, Prince of the Rhine 121, 322–326,
 330–332, 336
*Russell, Francis, 4th Earl of Bedford
 103–104, 116, 157

Sabbatarians 75–77, 150, 247
*Sagredo, Gianfrancsco 9, 175
Saint Omer 50
Salisbury, Earl of. See Cecil, Robert
*Salviati, Filippo 9–10, 175
*Sandys, Edwin 15–16, 21, 86–87, 91,
 284–286
*Sandys, Edwin, Archbishop 56–57
*Sandys, George 284–286
 Ovid 286–293, 342–343
 Psalms 317
*Sarmiento de Acuña, Diego, Conde de
 Gondomar 62–63, 68–70, 137, 234
*Sarpi, Fra Paolo 22, 31–32, 73, 221,
 311–312, 333
 and the English 20–22, 38–39, 54–55,
 68, 120, 138–139, 162
 Galileo 31, 38–39, 355, 376–377
 on kings and popes 19–23, 28
 monument 355
 religion 20–21, 24–26, 40, 366
 Trent 21–23, 27–28, 56, 60, 154, 174–177,
 376–377
Saturn 240–245
*Savile, Henry 156, 180–183, 361

Savilian professors 311, 333;
 see also Bainbridge; Greaves
Saye and Sele, Viscount. See Fiennes
Scamozzi, Vincenzo 46
*Schoppe, Kaspar 79–80
Scotland 81–83, 118, 128
scripture and astronomy 190–191,
 195–197
 see also Inquisition; Job; Joshua
Sebastiano del Piombo 350–351
sedition 85, 111–112, 202–203, 210, 358,
 363–364
Sejanus, Lucius Aelius 136
*Selden, John 74, 94, 121–122, 138–140,
 185–186, 284, 312
 antiquities and astronomy 135–139,
 212, 362
 politics 91–92, 95, 105, 117–118, 293
 religion 80, 138, 212
Seneca 176–177
senses, five 274–276, 295
Seraglio 211, 311–312
Serlio, Sebastiano 46–47
Shakespeare, William 18, 145–146
 astrological snippets 38, 133–134,
 203–204
Sheba, Queen of 52–53
Sheldon, Gilbert 318–319
ship money 101–105, 115, 117–118, 167
*Shirley, James 222
 The Gamester 167–168
 Triumph of Peace 74, 167
Shrewsbury 139
Sibbes, Richard 61
*Simplicio 9–10, 175, 189–190
*Sir Politic Would-Be 18–19, 44–45
skepticism 186–187, 232, 361–362, 382
Snell, Willibrord 202
Solomon (James I) 52–53, 139–145
Solomon's House 142–143
sortes virgilianae 342–343
Spain 89–90, 92, 104–105
 English match 62–66, 201–202
 trade 223, 285–286

*Spelman, Henry 135–137, 140, 284, 305–306
*Spelman, Sir John 305–306
Spencer, Edmund 198
stagecraft 10–11, 47–48, 147–149, 165
and Inigo Jones 47–48
Star Chamber, Court of 75–76, 115, 117–118, 164–165
Strafford, Earl of. See Wentworth, Thomas
Strasbourg 176
Strode, William 304
Floating Island 73–74, 151–152, 167
*Stuart, Elizabeth 61–63, 105–106, 149–150, 271
Stuart, Mary (wife of William of Orange) 88–89, 323–325
Sutcliffe, Matthew 140–141

tapestries 271–272, 275–278
Draught of Fishes 269–271
Five Senses 274–275
Hero and Leander 272–274, 289–290
Noble Horses 278–279, 289
telescope 32, 81, 188, 206–207, 210–211, 292–293
early 28–32, 129–131, 312
telescope as metaphor 9, 137, 163, 165, 168, 192, 211–213, 216, 275, 360
jocose 66, 166, 202, 207–208, 283, 292–293
morbid 128–129, 213–216
Tesauro, Emanuele 282–284
theater 206, 222
Galileo's *Dialogue* 10
political 69–70, 73–74, 112; see also masque; stagecraft
The Hague 63
The Philosophers 347–348
Tiberius, Roman Emperor 136, 342
tides 38–39, 186, 217–218, 250, 313–314, 370
Drebbel's machine 129–133
Tintoretto 259
Tiresias 287–289

tithes 137–138
Titian 44–45, 66, 113, 224, 275–278, 280–282, 350
titles 137
Tito, Santi di 154–155
tobacco 180–182, 208, 228
tonnage and poundage (T&P) 91–95, 112, 117–118, 139
Tracy, Robert 134
Tradescant, John 339–340
Travel. See Italy
Trent. See Council of Trent
Triennial Act 117–118
trigon 320–321
triumvirs (Bastwick, Burton, Prynne) 75–77, 101, 365
Troy 266, 292, 339–340
Tycho. See Brahe
*Tymme, Thomas 129–131

universities 141–142, 187, 237, 246
Philosophaster 252–253
scholars 245–246, 248–249
Uraniborg, Hven 127–128, 171, 258–259, 373–374
*Urban VIII, Pope 4, 26–27, 69, 83, 172–174, 212–213, 225, 342–343
art 159
astrology/astronomy 8–9, 50, 195
English affairs 78–79, 307–308, 366
Galileo and Sarpi 354–355, 365
*Ussher, James 27–28, 85, 136–137, 179–180, 182–184, 211, 222–223, 312–313
creation 32–34, 313
portents 134, 201
Ut pictura poesis 328–329

Van der Heyden, Jacob 6, 351, 358
*Van Dyck, Sir Antony 46, 99, 152–153, 160, 224, 329, 371
portraits 323–326, 330–332
tapestry 256, 271, 275–278, 350

Velasquez, Diego 65
Venice 24–25, 28, 334–336, 350;
 see also doge
 attractions 18, 21, 42, 279–281
 government 18–20, 52, 128
 and Rome 14–15, 19–20, 52–53, 355
*Venner, Tobias 341–342
Veronese, Paolo 272–274
Vespasian, Roman emperor 113–115
Villamena, Francesco 46–47
*Villiers, George, 1st Duke of
 Buckingham 67–68, 71–72,
 88–89, 134, 139–140, 234
 art 152–153, 160
 factotum 90–91
 impeachment and death 91, 93–94
 Spain 63–66
Villiers, Ladies 66, 69–70, 234
*Virgil 189–190, 222, 266, 342–343, 370
Virginia Company 285–286, 330
voluntarism 8–9, 172–175, 186
*Vorstius, Conrad 54–55, 68

Walker, George 111–112
Ward, Seth 314–315
wardship 86–87
*Warner, Walter 178
*Webbe, Joseph 184–185
Wedderburn, John 32–34
Welbeck 184–185, 278
*Wentworth, Thomas, 1st Earl of
 Strafford 4–7, 96, 116–117,
 208–209, 219, 222
 and Charles I 76, 116–117, 224–227
 in Ireland 85, 219–226
*Weston, Richard, 1st Earl of
 Portland 77–78, 88–96, 109
 and Sir John Bankes 96–97, 99
Wharton, Sir George 171, 199,
 319–320, 322
Wharton, Lord Philip 125
*White, Richard 39–40, 186
*White, Thomas 185–187

Whitehall 157, 159
*Wilkins, John 177, 187–188, 190–191,
 314–315
 Discovery of a World 189
William of Orange 120–121
*Williams, Sir Maurice 2, 217–222, 224,
 238–240
 and Bacon 218–219, 228–232
 Copernicus 230–232, 360–361,
 368–369
 Italian connections 217–218, 230–231
 medical 218, 229–230, 232–233, 341
 Oxford 217, 219, 301, 307, 312–314,
 329–330
 religious and royal 220, 226, 228, 231,
 304–305
 Wentworth 219–222, 225–226
*Windebank, Sir Francis 77–78, 83, 96, 280
witchcraft 133–134
Wither, George 348
*Woodford, Robert 76–77
Wooton Bassett 88–89
*Wotton, Sir Henry 40, 46–47, 79–80,
 140, 152–153, 155, 159–160, 201
 art 45–47, 143, 159–160, 278, 327–328,
 334–336, 371–373
 on education 46–47, 332–333
 and English writers 35–36, 40,
 46–47
 Italy 26, 39–40, 42, 52–53, 280
 Sarpi's group 20–21, 23–24, 32, 162,
 367, 373–374
 Stuart kings 24–25, 62, 156–162
Wren, Christopher, Bishop 184
*Wright, Edward 154–156
Wright, Gerard 112

York 125–126, 303–304
York, Archbishops of 15–17, 72

Zichichi, Antonino 385
Zollern, Friedrich Eitel von 79–80
Zubarán, Francisco de 374–375